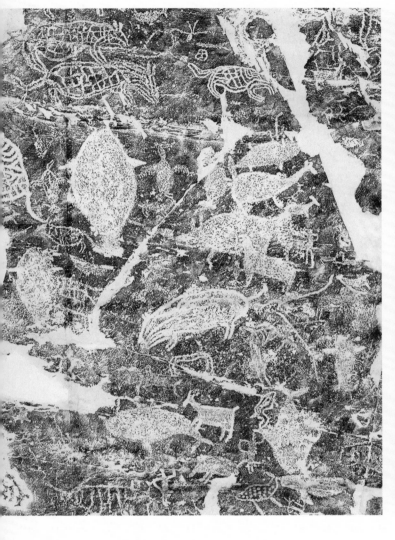

殊院記

春如清平山者古

雲山而文殊院者

普賢院也初禪師

自唐東于新羅國

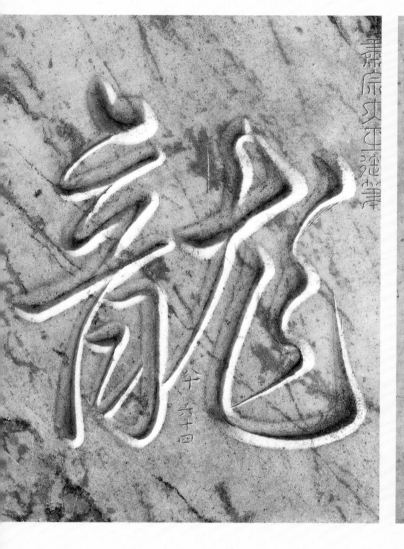

初聲ㄱ。如：감爲柿·ᄀᆞᆯ

ㅋ爲未春稻ㅋᅮᆯ爲大豆

爲獺새ᅦ爲流澌ㄷ

爲墻ㅌ。如고티爲繭ᄐ

ㄴ。如노로爲獐납

ㄴ。如미ᄅᆡ爲獺무ᅙᅵᆷ

BEYOND

BEYOND LINE

THE ART OF KOREAN WRITING

Edited by
Stephen Little
Virginia Moon

Essays by
Insoo Cho
Lee Dongkook
Stephen Little
Yi Wanwoo

Additional contributions by
Christina Gina Lee
Stephen Little
Natalie Mik
Audrey Min
Virginia Moon
Joon Hye Park
Eunsoo Yi

Los Angeles County Museum of Art

DelMonico Books•Prestel Munich, London, New York

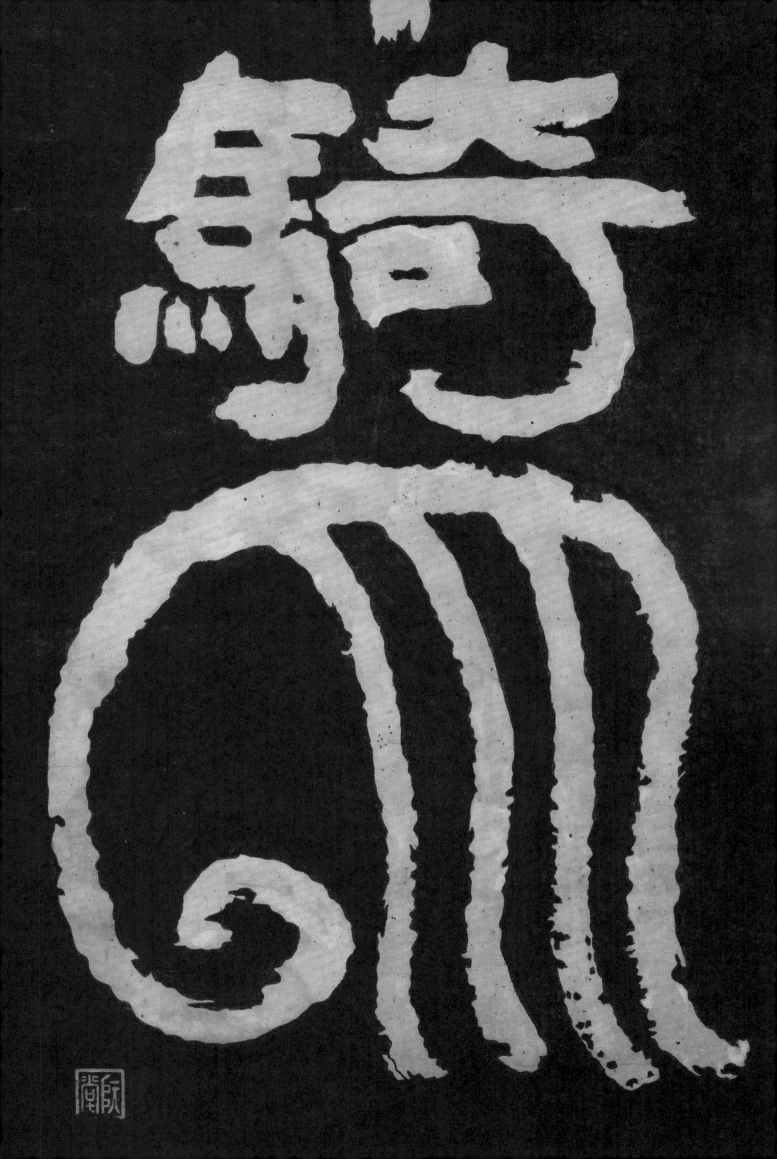

CONTENTS

11 Foreword
13 Acknowledgments
16 Periods and Dynasties
16 Note to the Reader
17 Map of Korea

18 The Art of Korean Writing
 Stephen Little

51 Map of Korea during
 the Three Kingdoms Period

52 Ancient and Medieval
 Korean Calligraphy
 Yi Wanwoo

84 Writings in the Joseon
 Dynasty
 Insoo Cho

112 The Evolution of Form and
 the Recovery of Poetic
 Language: The Development
 of Modern and Contemporary
 Korean Calligraphy and
 the Path to the Twenty–
 First Century
 Lee Dongkook

CATALOGUE

143 Prehistory
147 Tools and Materials
157 Buddhist Calligraphy
181 Royal Calligraphy
209 *Yangban* (Scholar–Officials') Calligraphy
266 The Advent of *Hangeul*
290 Gim Jeonghui, a Calligraphic Master
321 The Early Modern Period
347 Beyond the Modern

376 Glossary
386 Selected Bibliography
396 Index
404 Board of Trustees
406 Contributors to the
 Catalogue
407 Photograph Credits

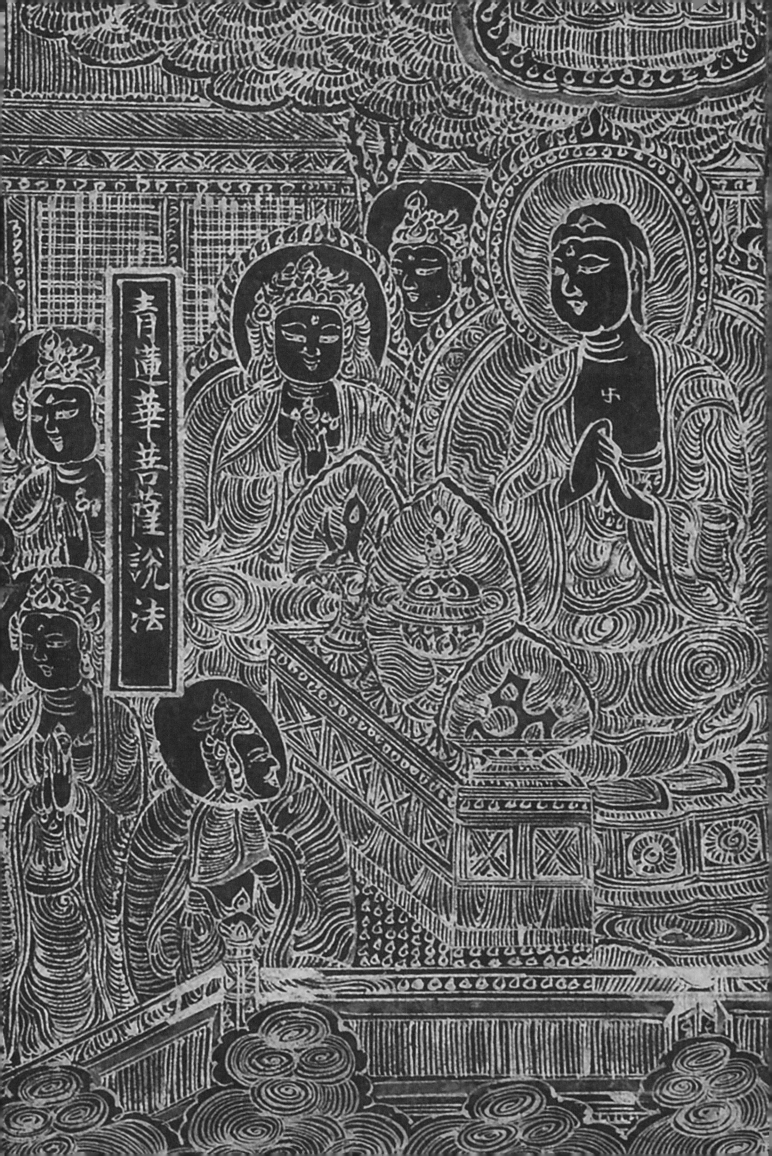

青蓮華菩薩説法

FOREWORD

Beyond Line: The Art of Korean Writing is the first comprehensive exhibition organized in the West to examine the history of Korean calligraphy. While there have been numerous exhibitions in the United States since the 1970s on Chinese and Japanese calligraphy, the history and art of Korean calligraphy have never before been the focus of an international loan exhibition of this scope. *Beyond Line* presents a deep and nuanced exploration of the subject for both general and scholarly audiences. The exhibition includes some 120 works of art spanning nearly two millennia, many of which are national treasures and important cultural properties that rarely leave Korea. In addition, *Beyond Line* is the first in a series of exhibitions to focus on Korean art, which constitutes a key element of LACMA's ongoing ten-year partnership with the Hyundai Motor Company. This partnership also includes future exhibitions of Korean art and leadership support for LACMA's Art and Technology program.

Beyond Line delves into multiple realms, including but not limited to history, politics, religion, secular and religious literature, and the relationship of calligraphy to painting and media such as ceramics, metal, and wood. The exhibition foregrounds the important historic and social role of writing and calligraphy in Korean society, demonstrating calligraphy's development as an art form throughout Korean history and exploring its continued relevance in Korea today. This fully illustrated catalogue, with scholarly essays by curators and academics representing a range of interdisciplinary perspectives, is the first published overview of the history of Korean calligraphy in any Western language; it surveys calligraphy on the Korean Peninsula from the time of the earliest-known examples of writing in the first centuries CE to the present.

I commend exhibition curators Stephen Little, LACMA's Florence & Harry Sloan Curator of Chinese Art, and Head, Chinese, Korean, and South and Southeast Asian Art Departments, and Virginia Moon, Assistant Curator of Korean Art, on this long overdue and groundbreaking contribution to scholarship, which is also a once-in-a-lifetime opportunity for visitors. *Beyond Line* has special resonance and import in Los Angeles, as our city is home to the largest Korean population in the world outside of Korea. The exhibition presents a new window into Korean history, culture, and identity through the lens of calligraphy as both conveyer of content and an abstract art of the highest degree of intellectual and artistic refinement.

Michael Govan
CEO and Wallis Annenberg Director
Los Angeles County Museum of Art

ACKNOWLEDGMENTS

Beyond Line offers an expansive view of the history of calligraphy in Korea, with a focus on the humanity of a wide range of people—including kings, queens, officials, monks, and even slaves—who produced calligraphic works in a variety of media. During the Goryeo (918—1392) and Joseon (1392—1897) dynasties, Korea made great advancements in printing processes; as a result printing and typography also play key roles in the exhibition. *Beyond Line* looks at the way calligraphy developed over the course of Korean history, exploring its role in different social strata and tracing the histories of many individual writers. By examining the literary and formal qualities of each work, the exhibition shows how these examples of Korean writing reflect the concerns of both calligraphers and their audiences.

We hope that *Beyond Line* will find its place within the ongoing study and exploration of East Asian calligraphy and, more importantly, illuminate the humanity of a country through its writing. The impetus for the exhibition, the first of its kind outside of Korea, began with the launch of the partnership between LACMA and the Hyundai Motor Company in 2015, the longest and largest programmatic commitment in the history of LACMA. Michael Govan, LACMA's CEO and Wallis Annenberg Director, and Daehyung Lee, Art Director, ARTLAB, Hyundai Motor Company, played central roles in supporting the Korean Art Scholarship Initiative within The Hyundai Project, of which this exhibition and catalogue are key parts.

Korean museums and institutions—both large and small—have generously lent works to the exhibition, including the Daejeon Goam Art & Culture Foundation; Dongguk University Library; Gana Art and Culture Foundation; Geonbongsa (Geonbong Temple), Jogye Order; Gyeongju National Museum; Jangseogak Archives at the Academy of Korean Studies; Kansong Art Museum; Korea University Museum; Lee Ungno Museum, Daejeon; Leeum, Samsung Museum of Art; National Folk Museum of Korea; National Hangeul Museum; National Museum of Korea; National Museum of Modern and Contemporary Art (MMCA); National Palace Museum of Korea; Seokdang Museum of Dong–A University; Seoul Museum of History; and Woljeon Museum of Art, Icheon. We would like to extend a special and warm thanks to Venerable Jisang of the Jogye Order and Sinheungsa Temple, and his assistant, Songyi Han, for their generosity, vision, and good faith.

We would like to thank Director Nakjung Kim and Exhibition Curator Heeseon Choi of the Korean Cultural Center Los Angeles (KCCLA) and Director Hyeonseon Choi and Program Coordinator Amy Choo of the Korean Foundation Los Angeles for their continuous support and loyalty to the Korean Department at LACMA and this exhibition.

We also wish to thank the private individuals and artists who graciously lent cherished works: Jessica Youn for Kim Sun Wuk; Ilamgwan, the private museum of Sin Seongsu; the Park Jeonghoe collection; the Hampyeong Museum of Art; the Yi Sejong Collection; Sukyungsil; the Choi Hyosam Collection; and other private collections. We were equally honored to meet contemporary calligraphers who continue their artistry and craft today: Ahn Sang-soo (Nalgae), Kyungwoo Chun, Jung Do-Jun, Kim Jongweon, Lee Kang-so, Park Dae Sung, and Suh Se Ok.

In preparing both the exhibition and catalogue, we have been humbled to work with three of the leading Korean calligraphy scholars and experts in South Korea, Insoo Cho of the Korea National University of Arts, Lee Dongkook of the Seoul Calligraphy Art Museum in the Seoul Arts Center, and Yi Wanwoo of the Academy of Korean Studies, who not only contributed essays to the catalogue, but also generously shared with us their extensive knowledge of the subject. We are also deeply grateful for the advice of Park Sung Won of the National Museum of Korea. Special thanks go to Lee Dongkook, who went above and beyond to assist us with negotiations, photography, and logistics.

In addition to the efforts and creations of our Korean colleagues, we would like to acknowledge the steadfast work of the team at LACMA. Melissa Bomes, Katie Kennedy, and Brandy Wolfe in Development played key roles in raising funds to support the exhibition. Victoria Behner, Zoe Kahr, and Sabrina Lovett in Exhibition Programs, along with Registrars Errin Copple and Erika Franek, and Julia Latané in Art Preparation and Installation, were indispensable in making this ambitious exhibition a reality. This comprehensive catalogue would not have been possible without the guidance of Publisher Lisa Gabrielle Mark, and the skill and dedication of Editors Claire Crighton and Ann Lucke, Piper Severance in Rights and Reproductions, and Translators Chi-Young Kim and Natalie Mik. Its sensitive design was conceived by Lorraine Wild and Xiaoqing Wang of the Green Dragon Office. Jean Patterson meticulously read the proofs, and Kathy Preciado compiled the index. We thank Kristin Bengtson and Jane Burrell for developing important educational programming. In the department of Korean Art, we celebrate the diligent work of Curatorial Administrator Vikki Cruz, as well as the interns and fellows who contributed catalogue entries and lent tremendous support in every way possible: Jinyoung Kim and Suyoung Kim of Chonbuk University; Audrey Min, Andrew W. Mellon Undergraduate Curatorial Fellow; Joon Hye Park, Mellon Summer Graduate Fellow; Eunsoo Yi and Christina Gina Lee, Korea Foundation Museum Interns; and Natalie Mik, performance artist and intern. Our thanks, too, to Wan Kong, LACMA's Tsao Fellow, and Curatorial Assistant Einor Cervone, who provided valuable assistance in researching several of the catalogue entries.

Stephen Little
Florence & Harry Sloan Curator of Chinese Art, and Department Head,
Chinese, Korean, and South and Southeast Asian Art

Virginia Moon
Assistant Curator, Korean Art

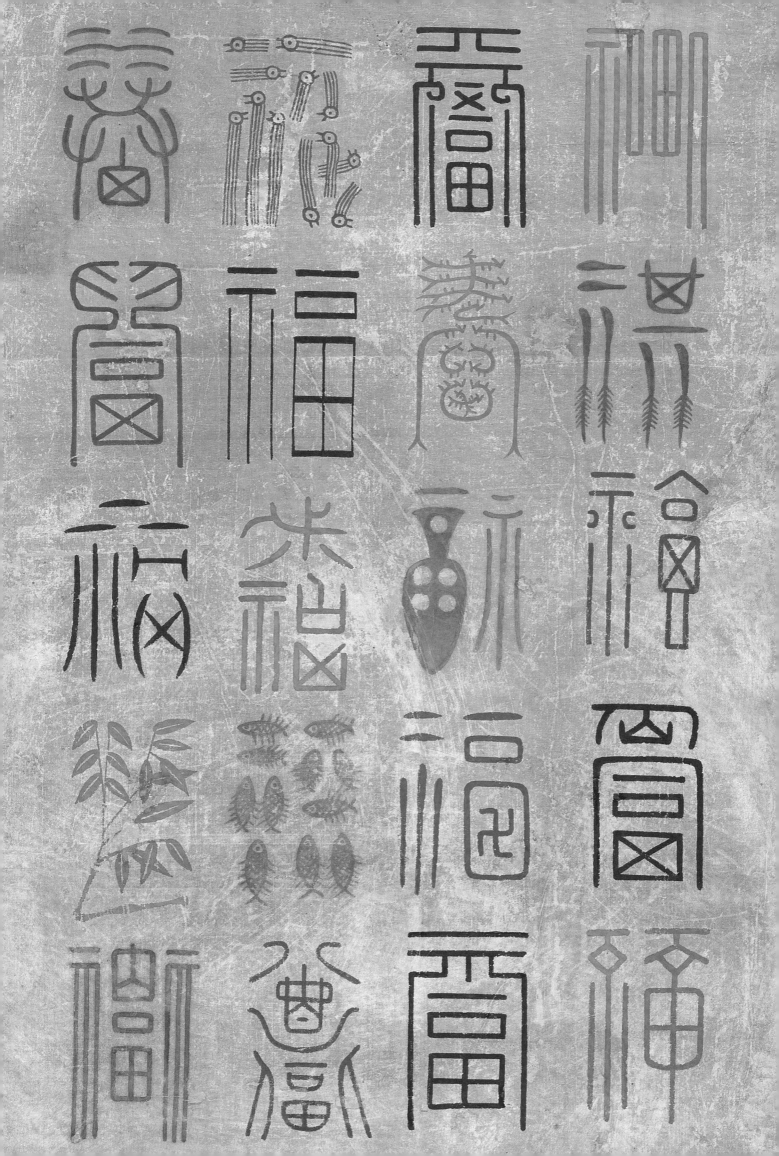

KOREAN PERIODS AND DYNASTIES

Gojoseon period (?—108 BCE)
Jin confederacy (4th century BCE—
2nd century BCE)
Proto—Three Kingdoms (Wonsamguk)
period (ca. 1 BCE—300 CE)
Three Kingdoms period (57 BCE—668 CE)
 Goguryeo Kingdom (37 BCE—668 CE)
 Baekje Kingdom (18 BCE—660 CE)
 Silla Kingdom (57 BCE—935 CE)
 Gaya Confederacy (42—562)
North–South States period (698—926)
 Unified Silla dynasty (668—935)
 Balhae Kingdom (698—926)
Later Three Kingdoms period (892—936)
 Later Baekje Kingdom (892—936)
 Taebong Kingdom (901—18)
 Unified Silla dynasty (668—935)
Goryeo dynasty (918—1392)
Joseon dynasty (1392—1897)
Korean Empire (1897—1910)
Japanese Colonial period (1910—45)
Provisional Government (1919—48)
Division of Korea
 Military Governments (1945—48)
 North Korea (1948—present)
 South Korea (1948—present)

CHINESE PERIODS AND DYNASTIES

Shang dynasty (ca. 1600—ca. 1050 BCE)
Zhou dynasty (ca. 1050—256 BCE)
 Western Zhou (ca. 1050—771 BCE)
 Eastern Zhou (770—256 BCE)
 Spring and Autumn (Chunqiu)
 period (770—476 BCE)
 Warring States (Zhanguo)
 period (475—221 BCE)
Qin dynasty (221—206 BCE)
Han dynasty (206 BCE—220 CE)
 Western Han dynasty
 (206 BCE—8 CE)
 Xin (Wang Mang) dynasty (9—23)
 Eastern Han dynasty (25—220)
Three Kingdoms period (220—80)
 Wei Kingdom (220—65)
 Shu Kingdom (221—63)
 Wu Kingdom (222—80) (Wu not
 absorbed by Jin until 280)
Jin dynasty (265—420)
 Western Jin dynasty (265—316)
 Eastern Jin dynasty (317—420)
Northern and Southern dynasties
(386—589)
 Northern dynasties (386—581)
 Northern Wei dynasty
 (386—581)
 Eastern Wei dynasty (534—50)
 Western Wei dynasty
 (535—57)
 Northern Qi dynasty (550—77)
 Northern Zhou dynasty
 (557—81)
 Six Dynasties (Southern Dynasties)
 period (420—589)
 Liu–Song dynasty (420—79)
 Southern Qi dynasty
 (479—502)
 Liang dynasty (502—57)
 Chen dynasty (557—89)
Sui dynasty (581—618)
Tang dynasty (618—906)
Five Dynasties and Ten Kingdoms period
(907—60)
Liao dynasty (916—1125)
Song dynasty (960—1279)
 Northern Song dynasty (960—1126)
 Southern Song dynasty
 (1127—1279)
Western Xia dynasty (1038—1227)
Jin dynasty (1115—1234)
Yuan dynasty (1260—1368)
Ming dynasty (1368—1644)
Qing dynasty (1644—1911)
Republic period (1912—49)
People's Republic of China
(1949—present)

Note to the Reader

All dimensions are listed in inches and centimeters. Measurements are given as height by width (by depth).

Korean *hangeul* words are romanized according to the Revised Romanization system, with the exception of names of modern and contemporary individuals. Bibliographic references to publications reflect the way that they were published. Chinese words are romanized according to the Pinyin system, and Japanese words are romanized according to the Hepburn system.

Korean and Chinese names are written with the family name first, except for those individuals who work primarily in English.

By traditional Korean and Chinese count, individuals are considered to be one year (*sal/sui*) old when born; thus, thirty *sal/sui* is equivalent to twenty-nine years of age.

MAP OF KOREA

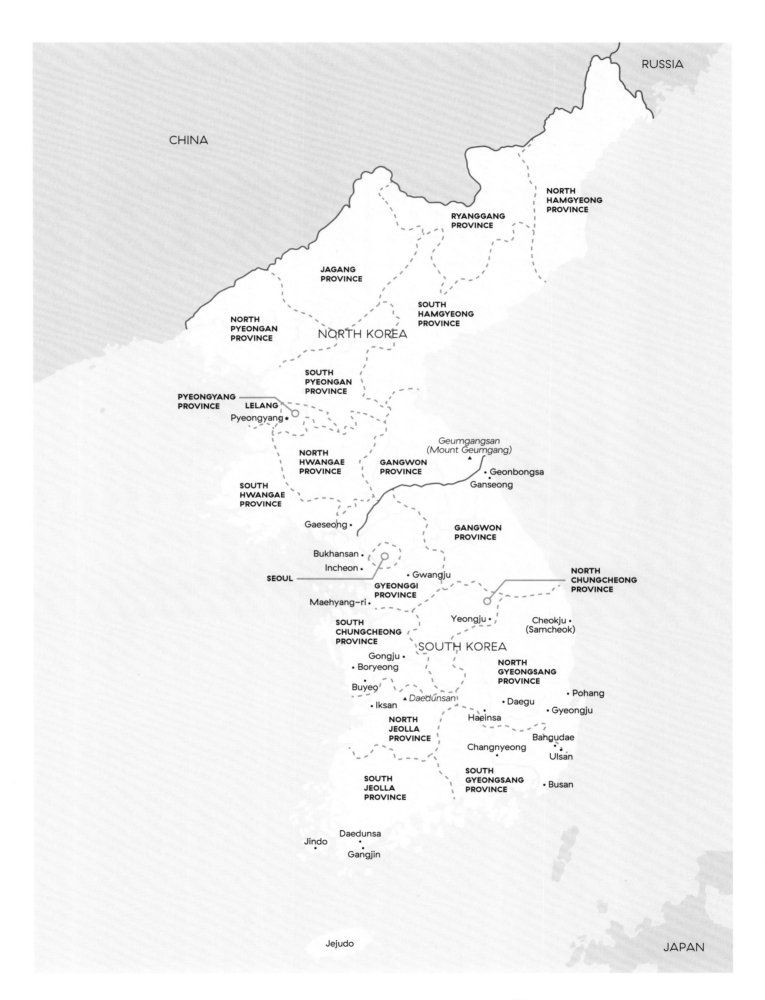

CHINA

RUSSIA

NORTH HAMGYEONG PROVINCE

RYANGGANG PROVINCE

JAGANG PROVINCE

SOUTH HAMGYEONG PROVINCE

NORTH PYEONGAN PROVINCE

NORTH KOREA

SOUTH PYEONGAN PROVINCE

PYEONGYANG PROVINCE — LELANG

Pyeongyang ★

Geumgangsan (Mount Geumgang) ▲

NORTH HWANGAE PROVINCE

GANGWON PROVINCE

• Geonbongsa

Ganseong

SOUTH HWANGAE PROVINCE

Gaeseong •

GANGWON PROVINCE

Bukhansan •

Incheon •

• Gwangju

NORTH CHUNGCHEONG PROVINCE

SEOUL —

GYEONGGI PROVINCE

Maehyang-ri •

Yeongju •

Cheokju • (Samcheok)

SOUTH CHUNGCHEONG PROVINCE

SOUTH KOREA

Gongju •

• Boryeong

NORTH GYEONGSANG PROVINCE

Pohang •

Buyeo •

▲ *Daedunsan*

• Daegu

• Gyeongju

• Iksan

Haeinsa •

Bangudae

NORTH JEOLLA PROVINCE

Changnyeong •

Ulsan •

SOUTH GYEONGSANG PROVINCE

• Busan

SOUTH JEOLLA PROVINCE

Daedunsa •

Jindo •

• Gangjin

Jejudo

JAPAN

Stephen Little

18

THE ART OF KOREAN WRITING

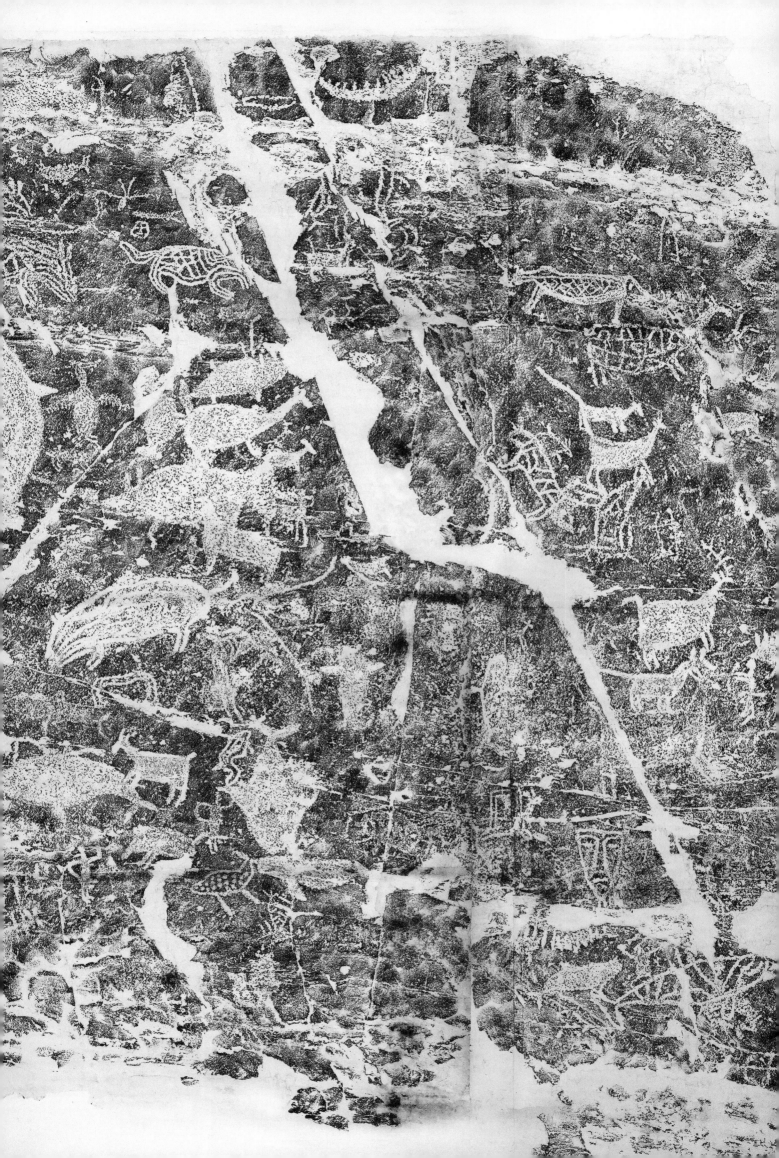

1
For a concise history of Chinese and Korean calligraphy, see Kim Jong-heon and Yoon Eun-seop, *Seoyega boinda: Seoye yeoksawa jakpum: Seoyegareul hannune bol su inneun, seoye immunseo* [Calligraphy at a glance: Calligraphy history, works, and calligraphers] (Seoul: Mijinsa, 2015); for a survey of the history of writing in Korea, see *Munja, geu hu: Hanguk godae munjajeon* [Ancient writing and thereafter: Korean ancient writing exhibition], exh. cat. (Seoul: National Museum of Korea, 2011).

2
On the Six Arts, see Lothar Ledderose, *Mi Fu and the Classical Tradition of Chinese Calligraphy* (Princeton, NJ: Princeton University Press, 1979), 28—29.

While there have been numerous exhibitions in the United States since the 1960s focusing on Chinese and Japanese calligraphy, *Beyond Line: The Art of Korean Writing* is the first exhibition held outside of Asia to center on the history of writing and calligraphy in Korea.[1] *Beyond Line* presents the first Western-language survey of the history of calligraphy on the Korean Peninsula from the time of the earliest-known examples of calligraphic writing to the present. The exhibition is conceptualized as an introduction to this subject for a broad audience.

As in China and Japan, in Korea calligraphy has long been considered one of the highest art forms, in large measure because it is believed to mirror one's qualities as a human being—one's mind and heart—in ways unmatched by any other art form. From ancient times in East Asia, calligraphy was categorized as one of the Six Arts, which also included ritual, music, archery, charioteering, and calculating numbers.[2]

Beyond Line presents a narrative spanning nearly two millennia and is organized both conceptually and chronologically. It explores the role of calligraphy through different strata of Korean society, focusing on the human aspect of calligraphy as it developed over the course of Korean history by examining the lives and legacies of individual (and groups of) writers and calligraphers. In many cases the exhibition explores both the literary content and formal structure of the presented works, demonstrating how these works reflected the needs of calligraphers and their audiences. *Beyond Line* includes examples of calligraphy by Korean kings, queens, officials, scholars, diplomats, painters, Buddhist monks, and slaves and features important examples of writing and calligraphy on paper, silk, stone, ink rubbings, ceramics, bamboo, wood, metal, and lacquer. In addition, as early as the Goryeo dynasty (918—1392), Korea was a leading innovator in the art of woodblock printing and during the Joseon dynasty (1392—1897) led in the art of printing texts with movable metal type. We have included notable examples of these media.

Calligraphy in Korea can be divided into two broad categories: Chinese ideographic or pictographic characters known as *hanja* and the unique Korean phonetic script known as *hangeul*. The earliest-known examples of writing in Korea, dating to the first and second centuries, were written using *hanja*. Because of China's geographical proximity, the evolution of Korean calligraphy has long had a close relationship with the calligraphy of China, yet at the same time has witnessed transformations in style that are uniquely Korean. Korean *hanja* calligraphy can reveal structural differences that set it apart from the canons of Chinese calligraphy—changes that can be pronounced or subtle. *Beyond Line* explores Korean calligraphers' interactions over many centuries with such Chinese calligraphers as Wang Xizhi (307—365), Ouyang Xun (557—641), Yan Zhenqing (709—785), Su Shi (Su Dongpo; 1037—1101), Zhao Mengfu (1254—1322), Dong Qichang (1555—1636), Weng Fanggang (1733—1818), and Ruan Yuan (1764—1849), among others.

3
On the Bangudae petroglyphs, see Ho-tae Jeon and Jiyeon Kim, eds., *Bangudae: Petroglyph Panels in Ulsan, Korea, in the Context of World Rock Art*, Bangudae Petroglyph Institute, University of Ulsan (Seoul: Hollym Corp. Publishers, 2013).

4
The Bangudae site is one of many prehistoric petroglyph sites in Korea. The nearby site of Cheonjeon-ri, on the Daegokcheon stream in Ulju County, is a similar cliff covered with petroglyphs ranging in date from the late Paleolithic through the Neolithic periods and Bronze Age, with Unified Silla dynasty *hanja* inscriptions interspersed among earlier petroglyphs; see *Munja, geu hu*, 30—31.

5
For an example of Dong Qichang's use of Korean ink, see Wai-kam Ho and Judith G. Smith, eds., *The Century of Tung Ch'i-ch'ang, 1555— 1636*, 2 vols., exh. cat. (Kansas City, MO: Nelson-Atkins Museum of Art, 1992), vol. 2, 10.

Beyond Line consists of roughly 120 works of art selected from public and private collections in Korea and the United States. The exhibition presents an ambitious and sweeping survey of the history of Korean calligraphy over a period of nearly two millennia and provides an overview of the social, political, religious, and art historical events that have informed the development of writing and calligraphy in Korea. We also have sought to be mindful of the relationship between a text's content and the choices an artist makes in rendering it in calligraphic form.

PREHISTORY

The earliest work in the exhibition is a representation of the most famous Korean Neolithic petroglyph site, carved into the side of the Bangudae cliff, located near Ulsan on the peninsula's southeast coast and dating from about 5500 to 4700 BCE (cat. 1).[3] Represented by a series of scroll-mounted ink rubbings made directly from the cliff face, the Bangudae petroglyphs are significant as early examples of the human urge to create visual images of the world and as individual and communal expressions of identity and interactions with nature. While distinct and far preceding the earliest-known use of *hanja* pictographic characters in Korea, these petroglyphs nonetheless convey the power of pictographic forms in expressing real and symbolic narratives that were of significance to their makers (the petroglyphs include, among other things, the first known images of whale hunting anywhere in the world).[4] The large scale of the Bangudae cliff site is significant for its resonance with oversized calligraphic works created in later periods of Korean history (for example, the nearly twenty-one-foot-tall *Gwanggaeto Daewang Stele* of 414 CE; cat. 22).

MATERIALS, TOOLS, AND CALLIGRAPHIC FORMS

The basic materials and tools of Korean calligraphy consist of brushes, ink, inkstones, paper, and silk (cats. 2—9). For many centuries the first four of these were known as the "four treasures of the scholar's studio" (*munbang-sau*). Brushes are usually made of animal hair (often from rabbits or goats) attached to bamboo handles. Ink is generally made from pine soot mixed with an animal-skin glue; sometimes other materials are added, such as incense. Inkstones are the palettes on which molded cakes or sticks of ink are ground into small pools of water. Often fabricated from slate or from various types of ceramic, inkstones are usually made with a concave upper surface into which water is dropped prior to grinding the ink stick into the stone.

Korean handmade paper (*hanji*) has traditionally been created from the pulp of mulberry trees. By the seventeenth century, Korean paper was highly valued in China for its strength and smooth surface texture. The late Ming dynasty (1368—1644) painter, calligrapher, collector, and theoretician Dong Qichang was a great admirer of Korean inks and paper.[5] One of Dong's finest

6

For a discussion of this work, including a transcription of what remains of the original Korean document still faintly visible under Dong Qichang's painting, see Ju Hsi Chou, *Silent Poetry: Chinese Paintings from the Collection of the Cleveland Museum of Art* (Cleveland: Cleveland Museum of Art, 2015), 308—12.

paintings, the handscroll *River and Mountains on a Clear Autumn Day* (ca. 1624—27), in the collection of the Cleveland Museum of Art, is painted over an erased Korean document listing tribute gifts presented to the Wanli emperor (r. 1572—1620) from King Seonjo (r. 1567—1608) of the Joseon dynasty.[6]

BASIC FORMS OF *HANJA*

Over time, Chinese calligraphy developed many forms, the primary five of which are (in chronological order of their development): seal script (*jeonseo*; fig. 1), clerical script (*yeseo*; fig. 2), standard script (*haeseo*; fig. 3), semicursive script (*haengseo*, or "running script"; fig. 4), and cursive script (*choseo*, or "grass script"; fig. 5).

Seal script is one of the oldest-known forms. It was first used in the inscriptions on ancient Chinese ritual bronze vessels of the late Shang dynasty (ca. 1600—ca. 1050 BCE). Seal script is still widely practiced by many Korean calligraphers and is also the script most often used for the legends (inscriptions) on seals. Traditional Chinese scholars historically divide seal script into so-called large seal script, used in China's Bronze Age until the late third century BCE, and small seal script, devised after the unification of China under the Qin dynasty (221—206 BCE).

Clerical script is believed to have been devised by scholars and scribes at the Han dynasty (206 BCE—220 CE) court. This script is recognized for its elegant brushwork and the varying width of its brushstrokes.

Standard script evolved in China during the third and fourth centuries; in this script, each brushstroke is clearly visible and legible, and individual characters reveal carefully balanced structures. This is the script typically used today for texts written or printed with *hanja* characters.

Semicursive, or running, script is an abbreviated form of standard script. Fewer brushstrokes are employed in the writing of a given *hanja* character, and there are often variations in individual characters' sizes and in the speed and momentum of the brush movements.

Cursive script is a highly abbreviated form in which entire characters are sometimes written in a single brushstroke. Despite their often wild appearance, the forms of cursive-script characters are governed by strict rules.

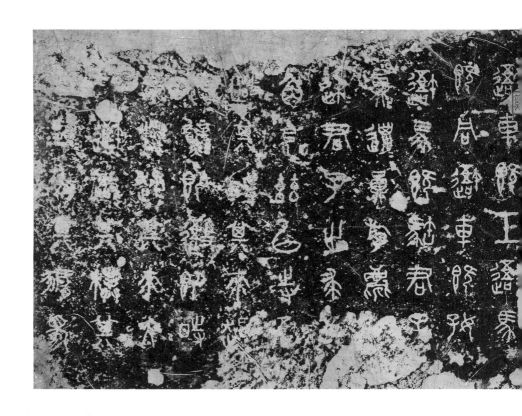

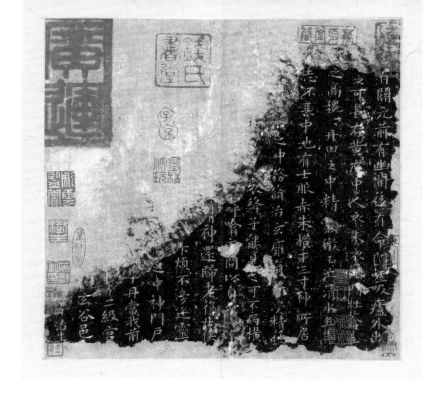

7
For a report on the excavation of sites associated with the Lelang Commandery carried out in 1924, see Oba Tsunekichi et al., *Rakurō kanbo: Taishō jūsannendo hakkitsu chōsa hōkoku* [Lo–lang Han tombs: Volume I, Report of excavations conducted in 1924] (Nara: Rakurō Kanbo Kankōkai, 1974—75); see also Hamada Kōsaku et al., *Rakurō saikyō chō ibutsu shūei* [Select specimens of the remains found in the Tomb of Painted Basket of Lo–Lang] (Pyeongyang: Heijō Meishō Kyūseki Hozon Kai, 1935).

The earliest use of *hanja* on the Korean Peninsula dates to the first and second centuries. These characters are associated with the Han and Wei Chinese commandery at Lelang, in the northern part of what is now North Korea.[7] In the 1920s the site was excavated by Japanese archaeologists, who discovered traces of early calligraphy on lacquers and ceramic tomb tiles. A basket depicting ninety–four paragons of filial piety, excavated at Lelang and now kept at the Korean State Central History Museum in Pyeongyang, is an example of early brush writing in Korea (fig. 6). In this rare work, which may have been imported to Lelang from Sichuan Province in southern China, the painted images of paragons of filial piety are each accompanied by their names, written with Chinese characters. These images make a didactic statement regarding social order and the importance of observing Confucian norms and honoring one's parents. The forms of the characters are consistent with other late Han dynasty characters that appear on objects archaeologically excavated in China, ranging from wooden and bamboo slips to burial ceramics and books written on silk.

The exhibition includes several ceramic tomb tiles from Lelang, impressed with distinctly angular clerical–script *hanja* characters that were stamped into the tiles' sides. These tiles were often dated, making them useful as documentary evidence of early calligraphic forms on the Korean Peninsula. Among the treasures of the National Museum of Korea in Seoul is a set of excavated tomb bricks from Lelang (cat. 10), several of which bear Chinese reign dates. These clerical–script forms are similar to contemporaneous forms used on tomb bricks in China. Much larger and bolder variants of these clerical–script forms appear in the earliest-known Korean royal stele inscription, on the *Gwanggaeto Daewang Stele*, mentioned above, and on tomb bricks from contemporaneous burials in Korea (cat. 11).

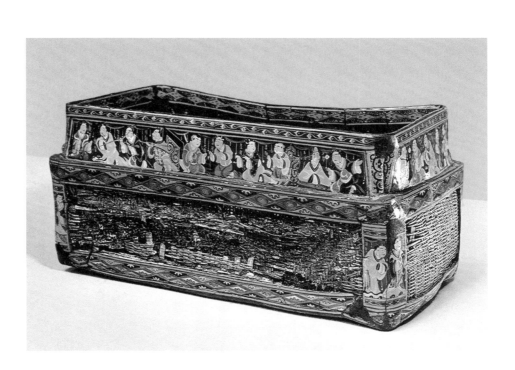

FIGURE 6
Basket Depicting Ninety–Four Paragons of Filial Piety, Korea. Lacquer. State Central Historical Museum, Pyeongyang, North Korea

BUDDHIST CALLIGRAPHY

Having originated in India, the Buddhist religion was introduced to Korea from China in the fourth century CE and quickly spread throughout the peninsula and through the full range of social classes, from royalty to farmers and peasants. Buddhism still plays an important role in Korea today. Many of the most important and artistically beautiful examples of calligraphy created throughout Korean history were made in the service of Buddhism; this section of the exhibition explores the functions of these works of art, which were inscribed to promote Buddhist belief in the world of the living and attain merit in the afterworld.

SACRED BUDDHIST TEXTS (SUTRAS)

The sacred texts of Buddhism, known as sutras (K. *gyeong*), had many functions, among them to record the teachings of the historical Buddha Shakyamuni, to articulate the Buddhist cosmology centered on Mount Sumeru (the cosmic *axis mundi*), to expound on the illusory nature of perceived reality, and to provide the basis for Buddhist rituals and meditative practices. An example of an early Buddhist sacred text dates to the Baekje Kingdom (seventh century) and comprises a chapter of the Diamond Sutra incised into gold sheets bound together as a hinged book (cat. 12). This rare work was one of several relics excavated in 1965 from the foundation of a five-story stone pagoda at Wanggung-ri, Iksan, in North Jeolla Province. Since pagodas function as Buddhist reliquaries, this discovery illustrates that books were among the several types of relics buried under such monuments, with the express purpose of being preserved for the coming of the next cosmic time cycle, or *kalpa*.

The single greatest Buddhist treasure of Korea is the *First Tripitaka Koreana*, a set of more than eighty-one thousand wooden blocks for printing the entire Buddhist canon of sacred texts, carved between 1236 and 1251 to replace an eleventh-century set of blocks destroyed in the Mongol invasion of 1232. Known as the *Goryeo sinjo daejang gyojong byollok*, this set of nearly 1,500 texts was based on a Buddhist canon carved during the Liao dynasty (916–1125) in China. Kept at the Haein Temple (Haeinsa), a UNESCO World Heritage site in South Gyeongsang Province, this miraculously preserved set of printing blocks was designated a Korean National Treasure in 1962. *Beyond Line* includes a rare surviving eleventh-century printed paper scroll from the *Avatamsaka (Flower Garland) Sutra* (K. *Hwaeomgyeong*), printed from the original set of blocks that was destroyed in 1232 (cat. 13). This work illustrates the importance of woodblock-printing technology in the dissemination of Buddhist texts and the special role the commissioning of complete sets of printing blocks for the Buddhist canon played in preserving that faith's teachings, in addition to demonstrating the belief in the power of the Buddhist canon to protect the royal family and the nation as a whole.

8

On the technique of making ink rubbings, see Kenneth Starr, *Black Tigers: A Grammar of Chinese Rubbings* (Seattle: University of Washington Press, 2008).

Among the most beautiful and refined examples of Buddhist calligraphy are the illuminated sutras of the Goryeo dynasty. Examples dating to the mid-fourteenth century consist of chapters from the *Avatamsaka Sutra* and the *Lotus Sutra* (cats. 14, 15). The text of the *Avatamsaka Sutra* scroll is inscribed in gold on indigo-dyed paper, with the sutra itself preceded by a detailed painted illumination depicting the Buddha preaching to a multitude of followers.

BUDDHIST STELE INSCRIPTIONS

The earliest surviving Buddhist texts in Korea are temple dedications carved onto stone steles, a practice that had begun in China in earlier centuries (Buddhism first appeared in China in the mid-first century CE). Stone-carved inscriptions had several advantages: if well made, they lasted for centuries before the inscriptions wore out and became illegible; they could render texts on a monumental scale (thereby conveying prestige and authority); and, perhaps most importantly, multiple copies could be made from any stone-carved inscription using the technique of creating ink rubbings on paper.[8] With relatively few exceptions, such ink rubbings were (and continue to be) made directly from the original stone-carved monuments. Ink rubbings are not only actual-size facsimiles of stele inscriptions, but also could be mass-produced, facilitating the widespread knowledge of their texts and calligraphic styles. The carvers who traced original manuscripts written with brush and ink on paper and then carved the characters into stone were able to transfer the exact forms of the original brush-drawn characters onto a stele's surface, capturing every nuance of the calligrapher's brush movement, including such effects as split brush tips and the fine ligatures linking characters. In making ink rubbings from the stone-carved inscriptions, the carved characters were exactly replicated onto sheets of paper, on which the characters appeared white on a heavily inked black ground—the opposite of the original calligrapher's text, in which the characters were written in black ink on white paper.

Most steles sit on stone bases, often carved in the shape of a tortoise, an animal closely linked in East Asia to the origins of both writing and divination. Above the base rises the vertical shaft on which the texts are carved, often on front and back surfaces, with a capstone at the top. The art of stele carving is still practiced in Korea; for example, inscribed Buddhist steles are still being erected on significant occasions and at sacred sites.

The steles included here are represented through the medium of ink rubbings taken directly from their surfaces. The earliest of these is the *Sataekjijeok Stele* (654; cat. 16), from the Baekje Kingdom (18 BCE—660 CE), on the peninsula's west coast—one of the Three Kingdoms that ruled prior to the unification of the country under the Unified Silla dynasty (668—935). The stele's brief, formal inscription is carved within a grid and records the dedication of a Buddhist temple commissioned by a Baekje government official named Sataekjijeok. This is a relatively common type of stele inscription, often found on the grounds of Buddhist temples.

9
See *Shodō zenshu* [Complete compendium of calligraphy], 24 vols. (1965; reprint, Tokyo: Chūōkōron-sha, 1990), vol. 8, pl. 62.

10
See the lengthy biography of Gim Saeng, compiled from numerous sources, in O Sechang, *Geunyeok seohwajing* [Geunyeok's collection of calligraphy and painting] (Gyeongseong [Seoul]: Gyemyeong gurakbu, 1929), 3—5. O Sechang's 1929 biographical dictionary of Korean calligraphers and painters, originally written in classical Chinese, has been translated into Korean and republished as *Gukyeok geunyeokseohwajing* [The collection of Korean paintings and calligraphic works translated into Korean] (Seoul: Sigongsa, 1998).

11
Quoted in O, *Geunyeok seohwajing*, 3; translation by Stephen Little.

The second stele, the *Stele Commemorating the Enshrining of the Amitabha Statue at Mujangsa*, dated to about 801, is known only from several inscribed fragments (cat. 92). The first fragment was discovered in 1770 by the epigrapher Hong Yangho (1724—1802); in 1817 a second fragment was found by the calligrapher Gim Jeonghui (1786—1856); another was found in the early twentieth century. Although modern scholars have cast doubt on this claim, both Korean and Chinese scholars have traditionally believed that the characters seen in the Mujangsa fragments were chosen from different works by the Chinese master Wang Xizhi, the Chinese "sage of calligraphy" of the Eastern Jin dynasty, and that this is an early example of the practice of *jipja*, or "borrowing characters" in the composition of a stele inscription. This practice of borrowing characters from Wang Xizhi's calligraphic works began in China in the early Tang dynasty, as exemplified by the famous *Shengjiao Xu Stele* of 672, with its text composed by the Tang emperor Taizong (r. 626—49; figs. 7, 71), and its characters selected by the monk Huairen from works by Wang Xizhi, a process that took twenty years to complete.[9]

The first major master of Korean calligraphy was Gim Saeng (711—?), known for his extreme skill in clerical, semicursive (running), and cursive scripts. Gim modeled his style on that of Wang Xizhi.[10] Korean critics placed Gim Saeng's calligraphy in the divine (K. *sin*; Ch. *shen*) class, and his work was also deeply admired in China. An anecdote recorded in the section on biographies in the *Samguk sagi* (History of the Three Kingdoms), compiled in the early twelfth century by Gim Busik (1075—1151), reads as follows:

> In the Chongning period [1102—6, during the reign of the Northern Song dynasty emperor Huizong], the [Korean] scholar Hong Gwan was promoted to be an emissary to the Song court and was officially sent to Bianliang [the Northern Song capital, now Kaifeng]. At the time the [Chinese] Hanlin [Academy] editorial assistants Yang Qiu and Li Ge were appointed to wait upon the emperor, [during which time] calligraphies and paintings were brought out [for viewing]. Hong Gwan showed them a handscroll of [combined] running and cursive script by Gim Saeng. The two [Yang Qiu and Li Ge], startled, said, "It is unimaginable today to see a calligraphy from the hand of Wang Youjun [Wang, the General of the Right—Wang Xizhi]!" Hong Gwan said, "Not so—this is none other than the calligraphy of Gim Saeng of Silla." The two men laughed and said, "Under Heaven, aside from Youjun, how can there be such a marvelous brush as this?" Hong Gwan repeated his statement, but to the end they were still unbelieving![11]

FIGURE 7
The Shengjiao Xu (Preface to the Sacred Teachings) Stele Inscription, China, 672. Ink rubbing; ink on paper; 89½ × 37⅞ in. (227.4 × 96.1 cm). Smithsonian, Freer/Sackler Gallery, Washington, D.C., gift of Peking University, F1976.32

12
Fully published in facsimile in *Choe Chiwon Jingam seonsa tapbi* [Choe Chiwon's pagoda epitaph for the Seon master Jingam], *Hanguk seoye myeongjeok* 5 [Famous traces of the art of Korean calligraphy 5] (Seoul: Seoul Calligraphy Museum, n.d.).

13
Published in *Shodō zenshu* [Complete compendium of calligraphy], 24 vols. (1965; repr., Tokyo: Chūōkōron-sha, 1990), vol. 7, pls. 62—65.

While none of Gim Saeng's original works survive, a work traditionally believed to best transmit the essence of his style is the *Stele Commemorating the Great Master Nanggong at the Taeja Temple* (cat. 17), a text composed by the early Goryeo dynasty scholar Choe Inyeon (868—944) and inscribed with combined standard- and cursive-script characters borrowed by the Buddhist monk Danmok from the works of Gim Saeng still extant in the early tenth century.

A more modest ninth-century stone stele in the exhibition is known as the *Stone Tablet from the Buddhist Sarira Pagoda at Beopgwangsa* (cat. 18). This work dates to 828, during the Unified Silla dynasty. It records the dedication of a Buddhist pagoda at the Beopgwang Temple in Pohang, North Gyeongsang Province, and the internment of Buddhist relics (*sarira*) at the base of the pagoda. Steles on this smaller scale were often commissioned by individual lay Buddhists.

One of the most famous monuments of Unified Silla calligraphy is the *Pagoda Epitaph for Seon Master Jingam,* composed by the eminent scholar-official and Buddhist Choe Chiwon in 881 (figs. 8, 9).[12] This work is significant for both its standard and seal script. The epitaph itself is written in standard script, in the vigorous and beautifully balanced style of the early Tang calligrapher Ouyang Xun, whose *Stele Inscription for Wen Yanbo, Duke Gong of Yu* (fig. 10) closely resembles this work.[13] However, in contrast, the title is written in wildly asymmetrical seal-script characters within a square panel at the top of the stele (fig. 9). Here, the characters take on a life of their own, with highly eccentric and expressive structures and brushstrokes with tapered ends that vary in width and undulate across the surface. This remarkable combination of different scripts, one elegantly formal and the other wildly expressive, had important precedents in China. After the fall of the Han dynasty in 220, seal script began to change, becoming, from the (Chinese) Three Kingdoms period through the Northern and Southern dynasties period, increasingly bold and experimental in its formal structures. It exhibited a tendency toward eccentricity, in which many of the structural and proportional rules of "small seal" script were routinely broken. This can be seen as early as the stylistically groundbreaking Wu Kingdom *Divine Omen Stele* of 276, with its

FIGURE 8
Choe Chiwon, detail from the standard-script portion of *Pagoda Epitaph for Seon Master Jingam,* Korea, 881

FIGURE 9
Choe Chiwon, detail from the seal-script portion of *Pagoda Epitaph for Seon Master Jingam,* Korea, 881

FIGURE 10
Ouyang Xun (557—641), detail from the *Stele Inscription for Wen Yanbo, Duke Gong of Yu,* China. Ink rubbing; ink on paper; page: 11⅛ × 5¾ in. (28.2 × 14.5 cm). Private collection

不憚崐丘之峻探珠者不
憚驪龍之深遂得慧炬則
光融五乘嘉肴則味飲六
籍競使千門入善能令一
國興仁而學者彧謂身與
國與仁而學者彧謂身毒

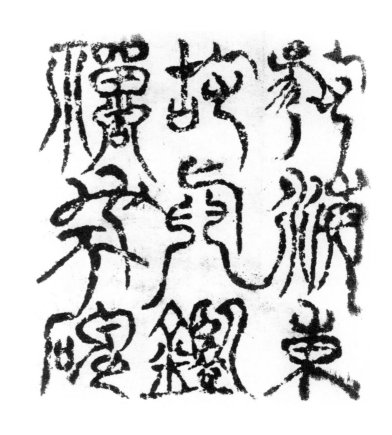

太中大夫言爲
准的行成廊川
無於異華岳之

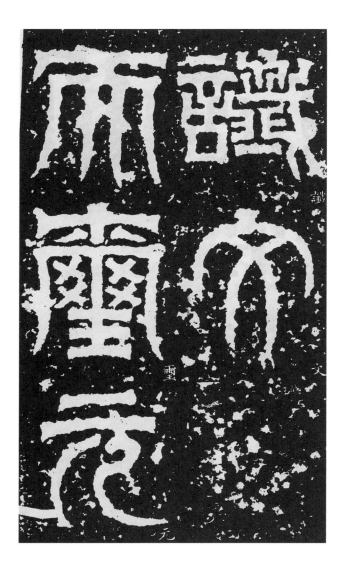

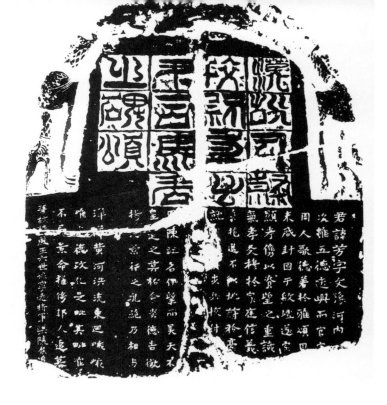

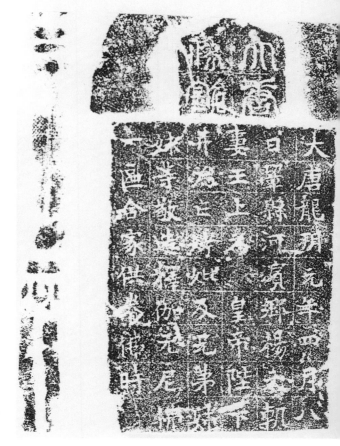

FIGURE 11
Detail from the *Divine
Omen Stele*, China, 276.
Ink rubbing; ink on
paper. Private collection

FIGURE 12
*Epitaph Stele for Sima
Fang*, China, ca. 416—
23. Ink rubbing; ink on
paper; 41¾ × 38⅝ in.
(106 × 98 cm)

FIGURE 13
*Epitaph Stele for the
Wife of Yang Wenchao*,
China, 661. Ink rubbing;
ink on paper; 13 × 7⅛ in.
(33 × 18 cm)

14
See Nakata Yūjirō, ed., *Chinese Calligraphy* (New York: Weatherhill, 1983), pl. 12, 167.

15
Published in Zhang Hongxiu, *Beichao shike yishu* [The art of stone carvings of the Northern dynasties] (Xi'an: Shaanxi renmin meishu chubanshe, 1993), pls. 87, 133.

16
On this text, the most famous work in the history of Chinese calligraphy (and much admired in Korea since the Unified Silla dynasty), see Han Chuang [John Hay], "Hsiao I Gets the Lan-t'ing Manuscript by a Confidence Trick," *National Palace Museum Bulletin* 5, no. 3 (July—August 1970); and vol. 5, no. 6 (January—February 1971).

17
On Zhao Mengfu and his calligraphy, see Robert E. Harrist, Jr., and Wen C. Fong, eds., *The Embodied Image: Chinese Calligraphy from the John B. Elliott Collection*, exh. cat. (Princeton, NJ: Princeton University Art Museum, 1999), 124—27; and in the same volume, Zhixin Sun's essay, "A Quest for the Imperishable: Chao Meng-fu's Calligraphy for Stele Inscriptions," 302—19.

18
See the biography of Yi Am in O Sechang, *Geunyeok seohwajing*, 29—30.

dynamic shapes combined with flowing, tapering lines (fig. 11).[14] Even closer prototypes can be seen in two Chinese epitaph steles: the Northern Wei *Epitaph Stele for Sima Fang*, datable to about 416—23 (fig. 12), and the early Tang *Epitaph Stele for the Wife of Yang Wenchao*, datable to 661 (fig. 13).[15] The similarities between these examples and the *Pagoda Epitaph for Seon Master Jingam* are not surprising, given the close ties between the Tang and Unified Silla courts. The eccentric shapes of Choe Chiwon's seal script go even further than the Chinese works, however, in their freedom of expression.

Two well-known Goryeo dynasty stele inscriptions document and celebrate renovations of old temple halls and the building of new halls. These are the monk Tanyeon's *Record of the Renovation of the Manjushri Hall* (1130) and Yi Am's *Stele Inscription for the Sutra Storage Hall of the Munsusa* (1327). Tanyeon's work (cat. 19), now known only from ink rubbings, dates to the mid-Goryeo period and reveals new influences from Tang dynasty China. While the style of Tanyeon's semicursive running script falls solidly within the tradition of Wang Xizhi's calligraphy, one can also detect the influence of the Tang emperor Taizong's informal yet bold calligraphic style. Taizong was a great aficionado of Wang Xizhi's calligraphy and amassed a huge collection of the Eastern Jin dynasty master's work, including the famous *Lanting xu* (*Orchid Pavilion Preface*).[16]

The work of the late Goryeo dynasty (early fourteenth-century) calligrapher Yi Am heralds a new development in Korean calligraphy, namely the influence of the protean Chinese Yuan dynasty calligrapher Zhao Mengfu.[17] Zhao, known today as both a painter and calligrapher, was a high-ranking official at the court of Khubilai Khan, the first Mongol emperor of China. Yi Am's *Stele Inscription for the Sutra Storage Hall of the Munsusa* (1327; fig. 14) represents a new phase in the development of Korean *hanja* calligraphy, in which the impact of Zhao Mengfu is unmistakable. Yi Am's stele inscription, known only from ink rubbings, begins with a formal seal-script title, written in the carefully controlled and highly architectonic style of the Chinese eighth-century seal-script master Li Yangbing (figs. 15, 16). The main body of the text, however, is much influenced by Zhao Mengfu's semicursive script (fig. 17), and several literary sources demonstrate that Yi Am took Zhao as his main font of inspiration.[18] The two masters were roughly contemporaries, and it is significant that the text of the *Stele Inscription for the Sutra Storage Hall of the Munsusa* was composed by Yi only five years after Zhao Mengfu's death. We will return below to the lasting influence of Zhao's calligraphy in the early Joseon dynasty.

One of the largest Buddhist stone epitaph steles in the exhibition dates to the mid-Joseon dynasty and stands nearly eight feet tall. This work is a magnificent monument, carved in 1730 and inscribed in standard script with the epitaph of a venerable Buddhist monk, Great Master Unpa (Cloud Slope; cat. 20). The stele stands on the grounds of the Geonbongsa, an ancient temple in Gangwon Province in the northeast corner of South Korea. The stele sits on a base in the form of a tortoise whose head is turning into that of a dragon,

with distinct horns: an ancient symbol of transformation. The stele's double capstone combines images of waves and dragons (respectively, symbols of the yin and yang energies that govern all events in the phenomenal world) with a dharma wheel (Sk. *dharmachakra*), symbolizing the power of Buddha's teachings.

ROYAL CALLIGRAPHY

Throughout Korea's history, kings, queens, princes, and princesses have played important roles in the realm of brush-written calligraphy. Beginning in the Three Kingdoms period, Korea's rulers were expected to be masters of calligraphy, for one's writing was seen as a mirror of one's moral character; this held for both style and content. Royals were expected to manifest high degrees of leadership, wisdom, and experience, and writing played a key role in defining royal personae, as it was both a means of communication and a performance art. Almost all calligraphy in East Asia has a performative dimension, with impressive and daring displays of skill extolled by leading poets and connoisseurs who, more often than not, were themselves master calligraphers. The art of brush writing still manifests this dimension in Korea, where exhibitions of works by contemporary calligraphers often open with performances of antique music followed by dramatic displays of calligraphy executed using brushes the size of brooms on giant paper scrolls rolled out on the floor.

FIGURE 14
Yi Am (early 14th c.),
Stele Inscription for the Sutra Storage Hall of the Munsusa, Korea, 1327. Album of ink rubbings; ink on paper. Private collection

FIGURE 15
Yi Am (early 14th c.),
Seal Script Title for the Stele Inscription for the Sutra Storage Hall of the Munsusa, Korea, Goryeo dynasty, 1327. Ink rubbing; ink on paper. Private collection

FIGURE 16
Li Yangbing (8th c.), detail from *The Thousand-Character Classic*, China, 8th c. Ink rubbing; ink on paper. Private collection

FIGURE 17
Zhao Mengfu (1254—1322), detail from *Four Anecdotes from the Life of Wang Xizhi*, China, 1310—20. Handscroll; ink on paper; image: 9⅝ × 46 in. (24.4 × 117 cm). The Metropolitan Museum of Art, New York, Bequest of John M. Crawford Jr., 1988, 1989.363.30

Three of the earliest-known Korean royal stele inscriptions reveal some of the different purposes served by such monuments. This section of the exhibition explores the use of inscribed steles as vehicles of dominance and political power. The clearest example of this is the monumental *Gwanggaeto daewang Stele,* a four-sided stone monolith that measures nearly twenty feet (640 centimeters) tall (fig. 18; cat. 22). The original stele still stands in China's Jilin Province, which once formed part of the Goguryeo Kingdom. This monument and its inscription were overtly political, designed to express the power of King Gwanggaeto, who established the northernmost boundary of the Goguryeo state and subsequently died in 413; the stele was erected the next year by his son. The stele's massive size and the large *hanja* characters with which the king's speech is inscribed were designed to be overwhelming. The bold, massive characters of the *Gwanggaeto Daewang Stele* are derived from late Han dynasty (first—second century) clerical script.

A sixth-century stele, the *Monument Marking King Jinheung's Inspection of Mount Bukhan* (located in Seoul), announces the achievements of the Silla Kingdom ruler Jinheung (r. 540—76) in conquering the Gaya Confederacy on Korea's south coast (cat. 24). The stele also states Jinheung's ideals as a king and asks for the obedience of the region's local government officials.

ROYAL FUNERARY EPITAPHS AND BURIAL OBJECTS

Calligraphy played a key role in royal burials, particularly in documenting the lives and accomplishments of members of the ruling families who had passed. The practice of placing written epitaphs and inscribing burial objects in tombs mirrored similar practices in China. These types of writings were usually inscribed in neat standard script, as such inscriptions needed to be easily legible in the underworld. Royal epitaphs include those for the Baekje queen of King Muryeong (dated 526; cat. 25) and the Silla king Heungdeok (dated 836; cat. 27).

FIGURE 18
The Gwanggaeto Daewang Stele in situ, Ji'an, Jilin Province, China. Photograph: early 20th c.

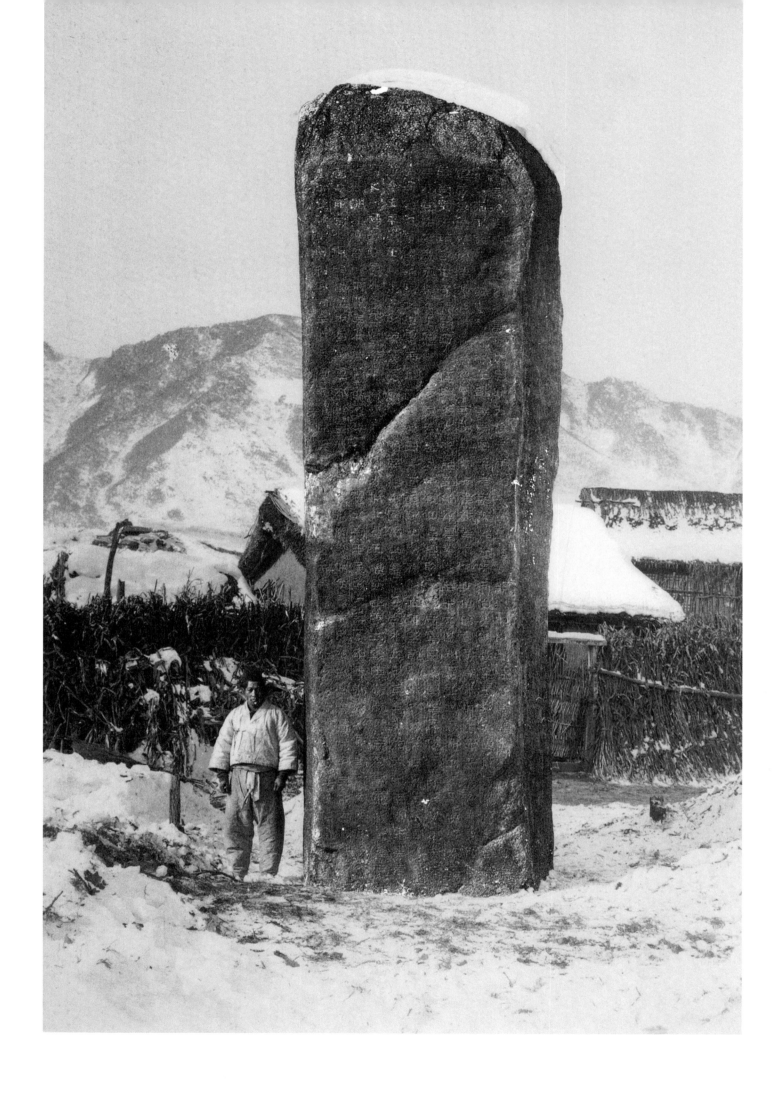

先生在海外時
自題小照云雲罩
溪云嗜古經去
堂云不旨人云
忽云兩分之言畫
吾平生胡為乎
海天一笠忽似
佑罪人

阮小堂先生真影

門生小峴許鍊未臯

19

For a thorough discussion of this scroll, see Ahn Hwi–joon, "An Kyon and 'A Dream Visit to the Peach Blossom Land,'" *Oriental Art* 26, no. 1 (Spring 1980): 60—71; the painting is also published in Burglind Jungmann, *Pathways to Korean Culture: Paintings of the Joseon Dynasty, 1392—1910* (London: Reaktion Books, 2014), 20, fig. 3.

20

Anpyeong's colophon is published in Jungmann, *Pathways to Korean Culture*, 23, fig. 4. For a translation of Tao Yuanming's text, see John Minford, ed., *Classical Chinese Literature: An Anthology of Translations* (New York: Columbia University Press, 2002), 515—17.

21

Ahn, "An Kyon," 64. For an excellent example of Zhao Mengfu's small standard script, see Fu Shen and Glenn D. Lowry, *From Concept to Context: Approaches to Asian and Islamic Calligraphy*, exh. cat. (Washington, DC: Freer Gallery of Art, Smithsonian Institution, 1986), 30—31, cat. 6. For further discussion of this style, see Wang Lianqi, "An Examination of Zhao Mengfu's *Sutra on the Lotus of the Sublime Dharma* (*Miaofa lianhua jing*) in Small Standard Script," in *Out of Character: Decoding Chinese Calligraphy*, ed. Michael Knight and Joseph Z. Chang, exh. cat. (San Francisco: Asian Art Museum, 2012), 71—104.

22

Burglind Jungmann, "Sin Sukju's Record on the Painting Collection of Prince Anpyeong and Early Joseon Antiquarianism," *Archives of Asian Art* 61 (2011): 107.

23

See Kwon S. Wong, *Masterpieces of Sung and Yüan Dynasty Calligraphy from the John M. Crawford Collection*, exh. cat. (New York: China Institute in America, 1981), 19, 72—76, cat. 13.

CALLIGRAPHIC MANUSCRIPTS AND MODEL CALLIGRAPHY BOOKS

In their lives members of Korea's royal families practiced and wrote calligraphy on a daily basis. The exhibition presents several examples of royal autograph calligraphy from the Joseon dynasty, including a work by the renowned early Joseon prince Anpyeong (1418—1453), consisting of a statement on the importance of filial devotion to one's parents (cat. 28).

Anpyeong (also known by his official title, Daegun, or Grand Prince) was a son of King Sejong (r. 1418—50), at whose court the Korean phonetic *hangeul* script was created. Prince Anpyeong's activities as a scholar, bibliophile, calligrapher, collector, musician, and patron of the arts are well known from contemporaneous literary accounts. He was the principal patron of the court painter An Gyeon (active ca. 1440—70), and in 1447 commissioned from An a famous handscroll entitled *Dream Journey to the Peach Blossom Land* (*Mongyu dowon do*).[19] This handscroll not only features An's brilliant painting, the prince's title, and an added colophon inscription, but also includes twenty-one added inscriptions by multiple scholar–officials and one monk. Following the painting is a long colophon in standard script written by the prince, in which he tells the story of his dream visit to the Peach Blossom Spring, a utopian land first conjured in the story of the same name composed by the Chinese poet Tao Yuanming (365—427).[20] As Ahn Hwi–joon has shown, the prince's elegant standard script in his colophon follows that of Zhao Mengfu.[21] It is noteworthy in this regard that Prince Anpyeong owned twenty–six calligraphic works by Zhao Mengfu, which formed a significant part of his collection of 225 scrolls; the majority of these were paintings, 86 percent of which were by Chinese artists.[22] It is significant that Zhao Mengfu himself followed the lineage of Wang Xizhi and that Zhao's calligraphy continued to be a key source of inspiration for Korean calligraphers well into the Joseon dynasty.[23]

The practice of royal calligraphy is reflected in a rare calligraphic practice book by King Hyojong (r. 1649—59; cat. 29) and a large hanging scroll by Princess Jeongmyeong (1603—1685) with two enormous *hanja* characters reading "illustrious governance" (cat. 30).

One of the hallmarks of Korean calligraphy was the creation of books that reproduced model works by the most exalted calligraphers of the royal family. These books were used to transmit a ruler's calligraphic style to his or her subjects and followers. A remarkable example of such a book is *Calligraphy of Successive Sage–Rulers* (cat. 31), an eighteenth–century woodblock–printed

FIGURE 19
Heo Ryeon, *Ink Rubbings of Wandang's Works*, 1877 (cat. 91, detail)

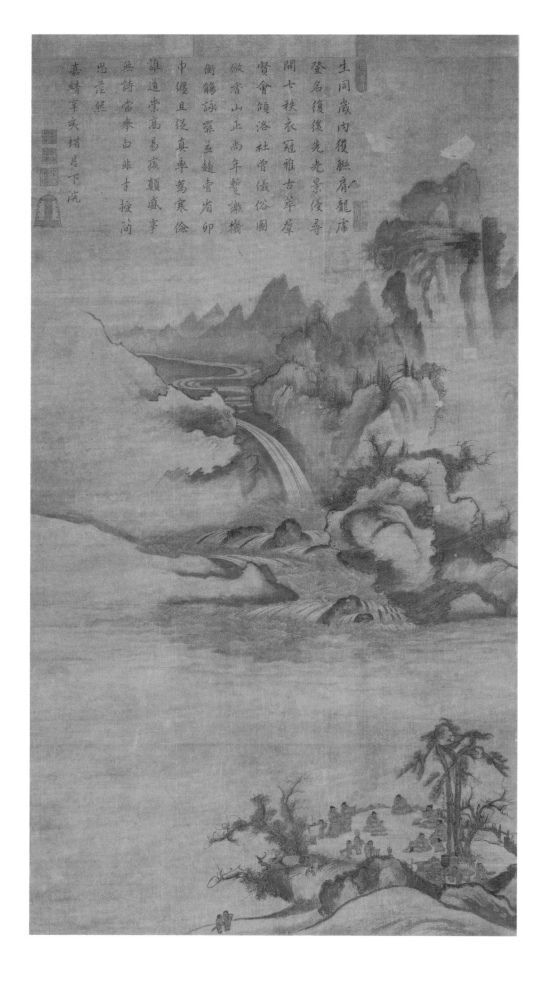

FIGURE 20

*Gathering of
Government Officials,*
Korea, Joseon dynasty,
1551. Ink on silk;
51 × 26¾ in.
(129.5 × 67.9 cm). The
Metropolitan Museum
of Art, New York

The Art of Korean Writing

40

24

In the context of these model calligraphy books, it is noteworthy that model letters, written by Chinese calligraphers and reproduced in woodblock-printed books, were republished in Korea during the Joseon dynasty; see Bai Qianshen, "Chinese Letters: Private Words Made Public," in Harrist and Fong, *The Embodied Image*, 391.

25

On this subject and its history, see Ahn Hwi-joon, "Literary Gatherings and Their Paintings in Korea," *Seoul Journal of Korean Studies* 8 (1995): 85—106.

26

For a discussion of this subject, see Soyoung Lee et al., *Art of the Korean Renaissance, 1400—1600,* exh. cat. (New York: Metropolitan Museum of Art, 2009), 25—30, cat. 8.

album that reproduces several Joseon kings' calligraphy, including superb examples of cursive script.[24] Other examples of royal handwriting were traced and then carved onto stones, from which ink rubbings could be made by later generations; examples consist of large calligraphic characters written by King Sukjong (r. 1674—1720; cat. 32) and King Yeongjo (r. 1724—76; cat. 33).

A rare personal seal of King Jeongjo (r. 1776—1800), carved with dragons (symbols reserved for royalty), points to the important role seals have played in Korean culture since the earliest appearance of written characters on the peninsula (cat. 34). Seals conveyed both individual and communal authority and were key indicators of authenticity and ownership on paintings and calligraphies. Seal carving is an art still widely practiced in Korea today, including by some of the country's most eminent contemporary painters.

YANGBAN CALLIGRAPHY

The exhibition's largest section is devoted to calligraphy produced by and for members of the scholar-official (*yangban*) class. Korean scholar-officials used calligraphy both as a communication tool and as a means of maintaining their position in society. The high status enjoyed by the scholar-official class was given special prominence during the Joseon dynasty by paintings that recorded gatherings of virtuous elders and literary meetings of official colleagues.[25] Such paintings are almost always accompanied by prominent calligraphic inscriptions indicating the gathering's title or circumstance and listing the participants and their official titles or accomplishments (fig. 20).[26]

POETRY

It was expected in traditional Korean culture that educated individuals (and especially scholar-officials) would be able to compose poetry on any subject on any occasion. Poetry was a key means of communication and self-expression among Korea's educated elites. Scholar-officials were also expected to be well versed in classical Chinese and Korean poetry. During the Goryeo and Joseon dynasties, poetry appeared not only in the medium of calligraphy on paper and silk, but also on textiles, ceramics, and metalwork. While poetry was mostly composed by scholar-officials, it was also known, used, and enjoyed by lower social classes, such as merchants.

27
Translation by Stephen Little. The poem references the Tang dynasty poet and calligrapher He Zhizhang, famous for his love of wine and celebrated as such in the poet Du Fu's "Eight Immortals of the Wine Cup."

28
Li He's poem is translated in J. D. Frodsham, *The Collected Poems of Li He* (Hong Kong: Chinese University Press, 2016), 98—99.

That poetry appeared beyond the usual media of paper and silk is indicated by two Goryeo dynasty green-glazed celadon stoneware vessels, each inscribed with Chinese poems. A twelfth-century double-gourd vase in the collection of the National Museum of Korea features an anonymous poem inscribed with a brush using iron oxide pigment under the glaze (cat. 35). The poem is a quatrain, inscribed in semicursive script:

> Finely carved gold flowers on a green jade vase—
> Among noble families one responds by happily lifting the vessel!
> Surely you've heard of Old He, riding in elation,
> Enveloped in the depths of spring, drunk on Mirror Lake.[27]

This poem contains a reference to the Tang dynasty poet and calligrapher He Zhizhang (ca. 659—744), famous for figuring in the first line of Du Fu's poem "Eight Immortals of the Wine Cup." A fourteenth-century *maebyeong* (plum [blossom] vase) from the collection of the Leeum, Samsung Museum of Art is inscribed with a poem by the Tang dynasty poet Li He (790—816) entitled "Bring in the Wine" (fig. 21).[28]

A key theme explored in this section is the Chinese philosophy known as Neo-Confucianism, which was adopted as the intellectual underpinning of the Joseon state at its founding in the late fourteenth and early fifteenth centuries. This philosophy stresses personal responsibility in all social interactions, the creation of an orderly society, and the study of the deeper principles underlying the structure of the cosmos. Knowledge of Neo-Confucian philosophy and literature was widespread among Joseon dynasty scholar-officials. This is illustrated by several calligraphic works, for example, a folding screen in the collection of the National Palace Museum, Seoul, inscribed by the royal regent Yi Haeung (1820—1898) with excerpts from the Neo-Confucian philosopher Zhu Xi's (1130—1200) *Letter to Chen Shilang*, a text that discusses the ideal behavior of high-ranking government ministers and officials (fig. 22).

FIGURE 21
Prunus Vase with Plum, Bamboo, and Willow Design and Inscription of Li He's Jangjinju (Ch. Jiang jin jiu) Poem, Korea, 14th c. Stoneware with carved and inlaid decoration and celadon glaze; 11⅛ × 1⅝ × 4½ in. (28.3 × 4.1 × 11.5 cm). Leeum, Samsung Museum of Art, Seoul, Treasure no. 1389

FIGURE 22
Yi Haeung, Heungseon Daewongun (1820—1898), *Excerpts from Zhu Xi's Letter to Chen Shilang,* Korea, 19th c. Ten-panel screen; ink on paper; each panel: 48¼ × 10⅞ in. (122.5 × 27.4 cm). National Palace Museum of Korea, Seoul

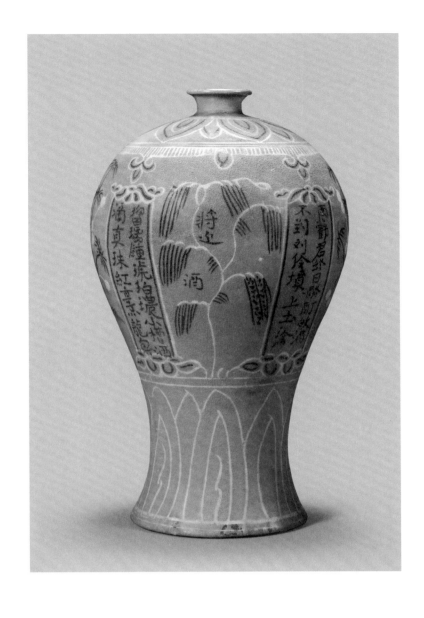

國植起 ... 行年放於侍桓事多久處之左曰明年出行尚河於讀究者

謀九中秋久正為金羅殺損及使殺後軍放改殿中侍郎遷侍卽史起廉念

大之文學十二年春久出為開口給按及使使還拜武禮部耶申明年丁歸城

終咸史郎中是契達更識之東雪伊讀事當在書同列有鄭知常奉命京公也即

明日召中翰谷人金夫等連繫有昱志父懷賜不軌之訟眩誤 上意千謀萬計協

 按寫卽在朝者非韃德不備無不服從武畏屬讀隨者有之公與知常奏文協

不泰及處是久精四人疑定知章尊依詠然後知公有逐諫逢鑒也

 臣之輸曰某試人疑之者自立書石益豢連威升扌擇逐如國子

 與諭聖試可讀和科樹者由 朝大金明行受國以倚祿部尚書知西面軍兵馬事知門會

平以鑒闕路按余史威拜圉吉舍 賜諮文金烏及八開會

 之名書高書石溪相景門建絵枚司徒貞左正言言知制誥

 舍 召春局 院事遷迴遠事綸太學士皇統六年

 今官同知賁某學士兼大司成為行公遂國子監大司成寧三年 今

舜峯太閏守子兼左藏矢久武士卽政放方

右文月 召令凱孝多立鬼元十時谷爸愿勿韓焉使盈之官逐執

 高書進部事志有權臣小高公益誠鎬開何柑伐元界上章毒

與人敦文子之閒 右令凱孝多立界上章毒

While not an official, Sin Saimdang (1504—1551) was a brilliant writer, poet, painter, and calligrapher who grew up in a *yangban* family (cat. 37). When she was young, her father encouraged her to develop her talent, and today she is the most famous woman painter and calligrapher of the Joseon dynasty; her portrait appears on the South Korean 50,000-*won* banknote.

PROSE

Many Korean scholar-officials were superb writers of prose. An excellent example carved onto a stone stele was by the scholar-official and talented calligrapher Heo Mok (1595—1682), considered the greatest master of *hanja* calligraphy of the seventeenth century. Heo was a master of several calligraphic forms. His most famous work in seal script is the *Eulogy to the East Sea (The East Sea Stele Inscription)*, dated 1661 (cat. 40). This text, addressed to the Dragon King who rules the seas, was written to help prevent dangerous tidal waves that caused enormous suffering in the southeastern coastal region where Heo was posted as governor at the time. Both Heo's original draft of this stele inscription (cat. 41) and ink rubbings of the original stone stele survive.

EPITAPHS

The practice of burying calligraphic epitaphs was widespread throughout premodern Korea, with many examples surviving from the Goryeo and Joseon dynasties. *Beyond Line* contains several of these, commissioned for officials and members of their families; *Epitaph of Choe Ham* (1160; fig. 23) dates to the Goryeo dynasty. Surviving funerary epitaphs from the Joseon dynasty are generally made of stone slabs or glazed ceramic tiles.

INSCRIBED OBJECTS FROM THE JOSEON DYNASTY

Many utilitarian objects surviving from the Joseon dynasty bear calligraphic inscriptions; these illustrate the many uses of calligraphy for both practical and decorative purposes. A late Joseon medicine chest, for example, has drawers inscribed with the names of the drugs and herbs contained within (cat. 48). Other inscribed objects used in daily life include iron brush stands, sundials, ritual scepters, magnetic compasses used in geomantic divination (K. *pungsu*; Ch. *fengshui*), incense burners, padlocks, cannons, and blue-and-white porcelains. Such objects were often inscribed with painted or inlaid *hanja* characters reading "longevity" (*su*) and "good fortune" (*bok*). A good example is the iron padlock, inlaid in silver, with an inscription reading, *gang neyong bu*

FIGURE 23
Epitaph of Choe Ham,
Goryeo dynasty, 1160
(cat. 46, detail)

29
For general introductions to *hangeul*, see *Hangeul: Korea's Unique Alphabet* (Seoul: Korea Foundation, 2010); and Kim Sang-tae, ed., *History of Hangeul* (Seoul: National Hangeul Museum, 2015).

30
The text is fully translated in Kang Shinhang and Shin Sangsoon, *Hunminjeongeum as Read in the Modern Korean Language* (Seoul: Gungnip bangmulgwan munhwa jaedan, 2014).

31
Published in Kansong Art and Culture Foundation, *Kansong munhwa* [Kansong culture] (Seoul: Kansong Art and Culture Foundation, 2015), 242–45, cat. 95.

su (health, peace, good fortune, longevity; cat. 53). Perhaps the most dramatic objects included here are branding irons used for marking human criminals, their tips cast in the form of the *hanja* characters *geum* (forbidden) and *go* (punishment) (cat. 50).

PAINTING AND CALLIGRAPHY

In Korea, painting and calligraphy share a common theoretical basis, grounded in closely related concepts of self-expression, practical elements of brushwork, and common tools and materials, notably brushes, ink, paper, and silk. The two arts are thus closely related. The connections are especially evident in works that depict such symbolic subjects as bamboo and orchids, in which the brushwork resembles the brushstrokes used in calligraphy. Examples include a painting of orchids by Min Yeongik (1860—1914; cat. 68) and a painting of an oddly shaped stone by Heo Ryeon (1808—1893; cat. 67).

THE ADVENT OF *HANGEUL*

The Korean phonetic script known as *hangeul* was invented in the fifteenth century and is the calligraphic form most widely used in Korea today. The story of its development and proliferation is the focus of one section of the exhibition, which traces its evolution from the fifteenth century onward. *Hangeul* first appeared in 1446, created by a group of scholars at the behest of King Sejong of the Joseon dynasty.[29] One of the desired (and achieved) results of the development of a uniquely Korean phonetic script was a rise in literacy among a broad range of society, from women of elite social classes to the common people. Another consequence was the proliferation of colloquial novels and the publication of books on how to pronounce words in foreign (non-Korean) languages.

One of the most important works directly related to the creation of *hangeul* script was *Hunminjeongeum* (The proper sounds for the instruction of the people), a seminal book published in 1446 that explains the basic structure and sounds of the *hangeul* phonetic system (fig. 24).[30] Because original copies of this book are extremely rare, the exemplar in the exhibition is a facsimile recently created by the Kansong Museum in Seoul, which owns the finest surviving copy of the original woodblock-printed book.[31]

Among other significant changes that resulted from the development of *hangeul* was the increasingly widespread translation of Chinese books into Korean, now using phonetic *hangeul* instead of ideographic *hanja* characters. This was especially prevalent from the early seventeenth century onward. These included Confucian classics, Buddhist texts, and popular fiction. The exhibition includes the *Comprehensive Manual of Military Arts Explained*,

FIGURE 24
Hunminjeongeum,
Joseon dynasty, 1446.
National Treasure no. 70
(cat. 69)

用字例

初聲ㄱ。如:감為柿。ᄀᆞᆯ為蘆。

ㅋ。如우·케為末春稻。콩為大豆。

ㆁ。如러·울為獺。서에為流澌。

ㄷ。如·뒤為茅。담為墻。

ㅌ。如고·티為繭。두텁為蟾蜍。

ㄴ。如노로為獐。납為猿。

ㅂ。如ᄇᆞᆯ為臂。:벌為蜂。

ㅍ。如·파為葱。·풀為蠅。

ㅁ。如·마為薯藇。

32

For an exhibition catalogue devoted to Gim Jeonghui, see Ung–chon Choe, *Chusa Kim Jeong–hui: Hagye ilchi ui gyongji* [A great synthesis of art and scholarship: Painting and calligraphy of Gim Jeonghui] (Seoul: National Museum of Korea, 2006).

an abridged Korean translation and compendium of classical Chinese texts on military strategy, translated by the order of King Jeongjo (cat. 73), and a *hangeul* translation of the popular Chinese novel *Dangjin Yeoneui* (Tales of Prince Qin of Tang) (cat. 74).

Among the accomplishments in printing and scholarship that were encouraged by the use of *hangeul* are the publication of editions of such *hangeul* books as *Jineonjip* (1569; cat. 71), which facilitated the reading of the Siddham characters derived from Sanskrit and widely used in Buddhist rituals, and the *Cheophaesineo*, a 1767 edition of a book by Gang Useong that facilitated the reading of Japanese phonetic *hiragana* script while simultaneously functioning as a guide to Japanese diplomatic protocols (cat. 72). These books illustrate the increasingly international uses and functions of *hangeul* script.

A major technical innovation that led to the quick spread of *hangeul* script was the invention of movable metal type during the Joseon dynasty, which greatly reduced the time needed to print books. The exhibition includes examples of movable metal type and a Joseon movable–type book illustrating the appearance of printed *hangeul* phonetic symbols with their corresponding metal–type bits (cats. 75—77). Today, *hangeul* is the most widely used script in Korea.

GIM JEONGHUI (1786—1856)

Gim Jeonghui (additionally spelled Kim Chonghui), known also by his literary name, Chusa, is widely acknowledged as the greatest calligrapher of the Joseon dynasty.[32] In 1810, at the age of twenty–four, he accompanied his father on a diplomatic mission to Beijing, where he met the famous Chinese epigraphers Weng Fanggang and Ruan Yuan. Ruan's ten–volume book reproducing and transcribing ancient Shang, Zhou, and Han dynasty bronze inscriptions, *Jigu zhai zhongding yiqi kuanshi* (Recorded inscriptions on ritual vessels, bells, and *ding* [tripods] from the Studio of Accumulated Antiquities; 1804), made a strong impression on the young Gim Jeonghui, who subsequently became a famous scholar of early Chinese and Korean writing and epigraphy. Like many of his contemporaries, Gim mastered both *hanja* and *hangeul* calligraphy, but he attained a name by creating his own unique style, known as Chusache, which included extreme calligraphic distortions and wildly eccentric calligraphic forms; for example, he vertically compressed some character shapes (or individual components) and horizontally stretched others.

Gim returned from China to Korea with a lifelong interest in antiquity and for the remainder of his life pursued the study of ancient bronze and stone–carved inscriptions alongside his work as an official. Among his major discoveries was one of the fragments of the Unified Silla stone stele discussed above, *Stele Commemorating the Enshrining of the Amitabha Statue at Mujangsa* (cat. 92). Gim was also knowledgeable about Chinese painting, as evidenced by his album *Comments on Shitao's Paintings* (Shitao: 1642—1707; cat. 86).

Gim Jeonghui had a distinguished but ultimately difficult life as an official and late in life was banished from the court. He was a practicing Buddhist, and many of his works were written for Buddhist temples or allude to his Buddhist practice. To demonstrate Gim's multivalent interests, *Beyond Line* includes his secular and Buddhist calligraphy, a painting of one of his inkstones, letters to his wife and daughter–in–law written in *hangeul,* two of his own paintings, and an album of ink rubbings compiled by his pupil Heo Ryeon, consisting of reproductions of Gim's calligraphy.

THE KOREAN EMPIRE (1897—1910) AND THE JAPANESE COLONIAL PERIOD (1910—45)

The increasing political and military influence exerted over Korea by Japan, beginning in the Korean Empire period, led to enormous changes in Korean society. In the realm of calligraphy, this manifested in several ways. Two parallel trends that are focal points here are the continued examination of ancient calligraphic forms as sources of inspiration and the innovative use of the phonetic *hangeul* syllabary to modernize means of communication. The former movement, an extension of the interest in calligraphic forms rooted in antiquity, was a natural continuation of the late Joseon dynasty study of archaeologically discovered calligraphic monuments—particularly ancient cast-metal and stone–carved inscriptions (known generically as bronze and stone writings, or *geumseokmun*)—exemplified by the activities of Gim Jeonghui and his followers. The leading exemplar of this movement in the modern period was the calligrapher and epigrapher O Sechang (1864—1953). O's epigraphical studies are reflected in a 1925 folding screen consisting of copies and transcriptions of ancient Chinese seal– and clerical–script inscriptions on Bronze Age ritual vessels and Han dynasty roof tiles and tomb bricks (cat. 96). O Sechang was also a hugely influential art historian, and his groundbreaking 1929 biographical dictionary, *Geunyeok seohwajing* (Geunyeok's collection of calligraphy and painting), is still an important reference work for the study of Korean calligraphy.

During the Korean Empire and Japanese Colonial periods, calligraphy written with traditional *hanja* characters was used by patriots as a strong marker of Korean (and particularly anti–Japanese) identity. This is reflected in the works of the patriot and anti–Japanese martyr An Junggeun (1879—1910), who, on the verge of Korea's annexation by Japan, assassinated Itō Hirobumi (1841—1909), the Japanese former colonial resident–general of Korea. A fiercely nationalistic calligraphic hanging scroll by An is punctuated by his inked hand-print, which functions as both a personal seal and a bold statement of his political identity; this work provides a focal point for examining the links between politics and calligraphy in early twentieth–century Korea (cat. 100).

Simultaneously, increasing modernizing tendencies in the early Korean Empire period led to a greater interest in establishing the independence of the Korean language from Chinese; this resulted in a focus on *hangeul* as an easily readable script that could help bring the entire Korean population into the modern world. This movement accelerated after the annexation of Korea by Japan in 1910. Several works mirror the growing nationalism and desire for democratic practices in the early decades of the twentieth century, beginning with the earliest newspaper, *Dongnip Sinmun* (*The Independent*), published entirely in *hangeul,* as well as in English, dating to the 1890s (cats. 102—3). On a parallel level, Yu Yeol's *Cards with Diagrams of Hangeul Mouth Movements* from 1947 are flash cards designed to help students learn the scientific methods underlying the *hangeul* phonetic script (cat. 101).

KOREAN CALLIGRAPHY IN THE CONTEMPORARY WORLD

The final section of *Beyond Line* follows the narrative of Korean calligraphy from the end of World War II to the present. With the end of the Japanese Colonial period in 1945, the Korean War in the 1950s, and Korea's spectacular economic growth from the 1960s onward, writing, calligraphy, and typography have gone through many changes. Following World War II, traditional *hanja* forms continued to be practiced, exemplified by a calligraphy in traditional *hanja* script by Korea's first post—World War II president, Syngman Rhee (1875—1965; cat. 107). Since the late 1980s, however, *hangeul* has largely supplanted *hanja* in many areas of Korean society. This is reflected in Kim Choong Hyun's pair of hanging scrolls from 1990, inscribed in *hangeul* script with a poem on the Diamond Mountains, a sacred Buddhist mountain range located in southeastern North Korea (cat. 112).

Beyond Line ends with an examination of contemporary Korean painters and photographers whose profound grounding in traditional calligraphy infuses their otherwise unambiguously modern creations. The endlessly inventive works by the artists Kim Sun Wuk (cat. 108), Lee Ungno (cat. 110), Suh Se Ok (cat. 111), Kim Jongweon (cats. 113, 114), Ahn Sang-soo (cat. 115), Yoon Kwang-cho (cat. 116), Kyungwoo Chun (cat. 117), Jung Do-Jun (cat. 118), Lee Kang-so (cat. 119), and Park Dae Sung (cats. 120, 121), which either incorporate or are directly inspired by ancient calligraphic forms, constitute a significant part of this exploration of the uses of calligraphy in a wider visual context.

It is hoped that *Beyond Line* will inspire further study of the rich world of Korean calligraphy and result in greater familiarity with an art form that provides an astonishing window into both traditional and contemporary Korean culture.

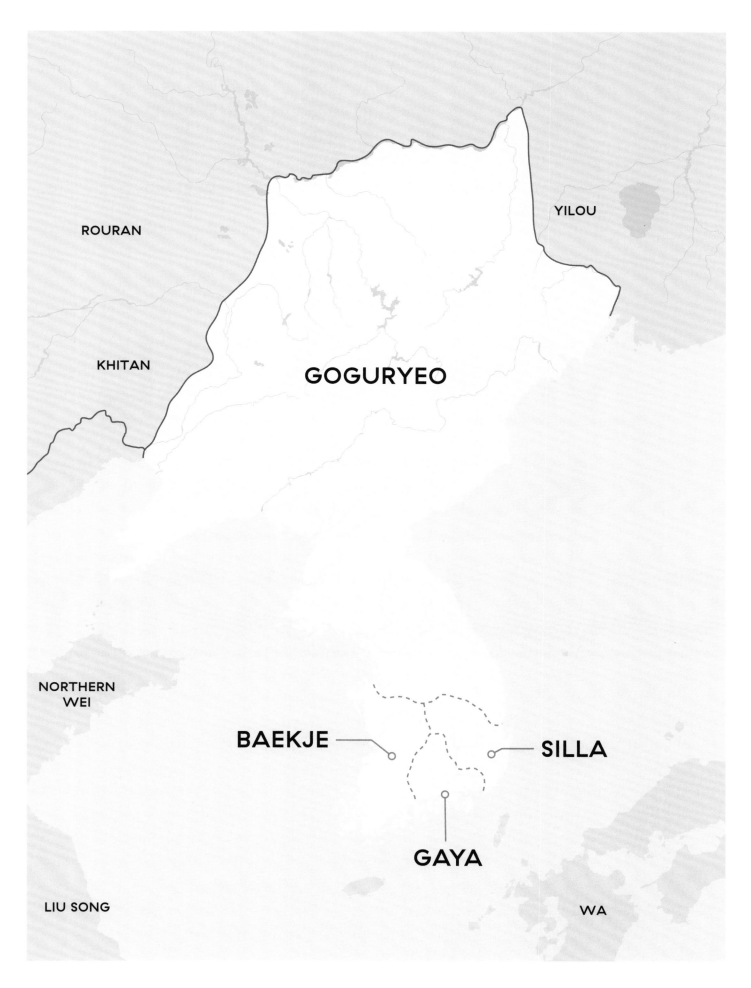

ROURAN

YILOU

KHITAN

GOGURYEO

NORTHERN
WEI

BAEKJE

SILLA

GAYA

LIU SONG

WA

Yi Wanwoo

ANCIENT AND MEDIEVAL KOREAN CALLIGRAPHY

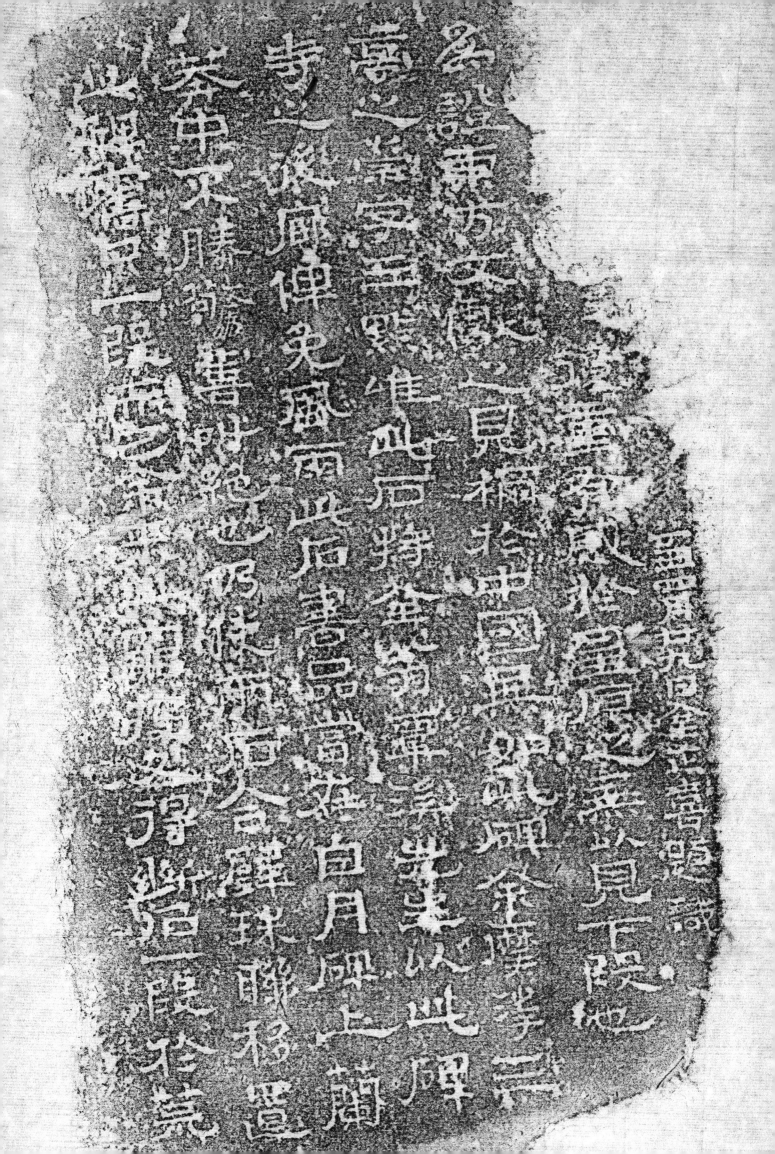

The earliest Korean historical records date back to the Gojoseon period (?—108 BCE). The Gojoseon was followed by the Three Kingdoms period (57 BCE—668 CE), when Korea consisted of Goguryeo, Baekje, Silla, and other smaller ancient kingdoms; these were later combined into the Unified Silla dynasty (668—935). The Unified Silla dynasty is also referred to as the Nambukguk sidae (the North–South States period), as it coexisted with Balhae (698—926), a kingdom located in the northern Korean Peninsula. This ancient epoch was followed by the medieval Goryeo dynasty (918—1392).

A text-based culture likely existed during the Gojoseon period, but neither text documents nor relics that would verify this assumption have remained. Circles and lozenge patterns carved on Bronze Age petroglyphs excavated in the southern Korean Peninsula are considered ancient text forms that hold meaning (fig. 25). They certainly represent a formative stage of text usage and therefore serve as a starting point for inquiry into Korean calligraphy. Other relics, such as brushes and knives, were discovered inside Tomb no. 1 at the Dahori site (dating to before and after the beginning of the common era). They give further evidence that a text culture existed in this period. Classical Chinese character inscriptions on Han mirrors and Osu coins found inside tombs from the Wonsamguk period (ca. 1 BCE—300 CE) show that people from this time used Chinese texts.

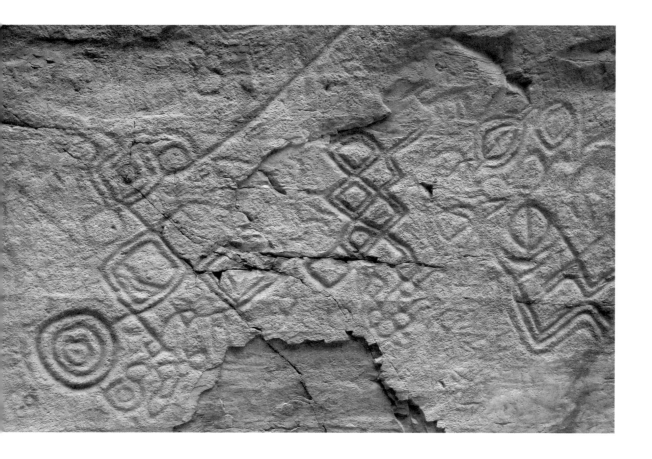

FIGURE 25
Detail of *Petroglyphs of Cheonjeon-ri*, Dudong, Ulju, Ulsan, South Korea, Bronze Age. Height: approx. 106⅜ in. (270 cm), width: approx. 374¼ in. (950 cm). National Treasure no. 147

Some of the earliest calligraphic works from the Three Kingdoms period are thought to date back to the fourth century, directly following the Wonsamguk period. The examples for which an exact or approximate date can be speci-fied are no earlier than the fifth century. Most of them are stone inscriptions (such as epigraphs on memorial stones), tombstones, inscribed swords and coins, and *sarira* (relics) shrines. A few death certificates written with ink on wooden tablets that were buried next to corpses have also been found.

Some of these inscriptions relate to the history of Buddhism in Korea. Buddhism was introduced to Korea in the late fourth century. During the Goguryeo period, in 372 (the second year of King Sosurim's reign), the monk Shundo (K. Sundo) from the Chinese Qin dynasty helped transfer Buddhist scriptures to Korea. His missionary work was followed by the efforts of A Dao (K. Ado), a monk from the Chinese Eastern Jin dynasty. King Sosurim built a temple for both monks and helped them stay in Goguryeo. In 384 the Indian monk Marananta came to Baekje. He was gifted a residence in the form of a temple by King Chimlyu. Later, more temples and Buddhist schools were established, which further led to the growth of Buddhism in all three kingdoms. In 552 (the thirtieth year of King Seong's reign) Baekje sent ambassadors to Japan, and they played a crucial role in the formation of Japanese Buddhist culture. The Goguryeo monk Mukhoja introduced and taught Buddhist writings to King Nulji (r. 417—58) of the Silla Kingdom. Later, Silla's royalty tried to establish Buddhism as a state ideology. After its initial failure owing to the resistance of aristocrats, Yi Chadon (501—527), a powerful adviser to the king, managed to establish Buddhism as the ruling ideology in 527 (the fourteenth year of King Beopheung's reign). Buddhism was supported by all three kingdoms, which used Buddhism primarily to strengthen their reigns.

Goguryeo Calligraphy

The Goguryeo Kingdom (37 BCE—668 CE) was located in what is now north-east China and the northern Korean Peninsula. From the second century CE on, Goguryeo expanded its territory immensely. King Micheon of Goguryeo (r. 300—331) reconquered the Nangnang (Lelang Commanderies) military zone, a strategic battlefield for Gojoseon and the Chinese Han dynasty. Later, King Gwanggaeto (r. 391—413), the nineteenth monarch of Goguryeo, further expanded his territory by conquering the surrounding areas. His first son, who became King Jangsu (r. 413—91), moved the capital from Guknaeseong (now Ji'an in Jilin Province, China) to Pyeongyang, which helped him actively pursue a policy that further strengthened Goguryeo's colonial rule in the south.

The historical events described above can be found on one of Goguryeo's most famous relics: the *Gwanggaeto Daewang Stele* (see fig. 18 and cat. 22). The stele was erected in 414 in the city of Guknaeseong. A large piece of tuff was used to create a rectangular stone monument measuring more than twenty feet high. Its 1,775 carved characters tell the founding myth of

Goguryeo, list the reign chronology of past monarchs, and document the accomplishments of King Gwanggaeto. The inscription text also includes instructions and the ritual procedure for death memorials. The text holds great value as one of the oldest records to allow insight into Goguryeo's foreign policy.

Despite the existence of such monuments as the *Gwanggaeto Daewang Stele*, only a small number of relics from Korea's ancient period have remained. As for calligraphy script styles, inscription texts largely adopted the elegant clerical script of the Western Han dynasty (206 BCE—8 CE). The brushstrokes form straight lines and the format is strict, as if the characters are sitting in a square grid. The dots are bold and vigorous, seeking to reflect the valiant spirit of Goguryeo. This type of calligraphy also appeared on bricks and bronze jars found inside the Houchong Tomb (early 5th c. CE; fig. 26) in Gyeongju. The old clerical script, or *goye*, was used for ceremonial rituals.

Another representative Goguryeo relic is the *Chungjugoguryeo Stele*. It was erected by King Jangsu after he conquered several tribes south of the Han River. The stele is square and approximately five feet tall. It shows a relatively polished surface, which was atypical for steles made during this period. The script resembles the Chinese Northern and Southern dynasties standard script combined with remnants of old clerical script. A similar script was used for small gilt–bronze Buddhist statues in the fifth and sixth centuries and for inscribed bricks that were used to build the fortress of Pyeongyang in the late sixth century.

A few epitaphs written with ink on paper have remained, too. They were excavated from two famous graves near Pyeongyang. The first is the Anak Tomb no. 3, which was built for Dongsu, who lived in exile during the reign of King Gogugwon (r. 331—71), the sixteenth monarch of Goguryeo. The second tomb is located in Deokeung–ri (Deokeung village) and was built for Jin, who served King Gwanggaeto as one of his highest officials. Both epitaphs, which consist of dynamic and quickly written characters, present a script style that was unusual for the Chinese Northern and Southern dynasties period. A burial mound was made in the capital city of Guknaeseong for Moduru, who also served King Gwanggaeto in North Buyeo (mid–5th c.; fig. 27). The walls of the burial show that about eight hundred characters (eighty–one lines, each with ten characters) were carved; however, only 250 characters are readable. The writing is about the life and achievements of Moduru's ancestors and, together with the *Gwanggaeto Daewang Stele*, is considered to hold great value with regard to research into Goguryeo's sociopolitical climate in the fourth and fifth centuries. The calligraphy features a standard script with strong semicursive elements and vibrant lines.

At present, no concrete examples of calligraphy from the seventh century have been found. Despite the lack of surviving examples, however, it is clear that Goguryeo preferred the calligraphy of Ouyang Xun (557—641). Ouyang Xun's biography in the *Old Tang History* states that King Gojo of Goguryeo (r. 618—42) sent an ambassador to China because he admired Ouyang Xun's calligraphy.

Baekje Calligraphy

Baekje (18 BCE—660 CE) was a kingdom in the midwestern Korean Peninsula. Hanseong, alongside the Han River, was one of its oldest cities; the name also denotes the early period of the Baekje Kingdom. During this time, Baekje evolved out of a small agricultural tribe by adopting the culture of Goguryeo. By the time of King Goi's reign (r. 234—86), Baekje had grown into one of the three most powerful ancient kingdoms of Korea. It rapidly expanded its territories during the reign of King Geunchogo (r. 346—75) and later focused on political and cultural exchanges with the Chinese Eastern Jin dynasty and Japan. After the capital city was moved to Gongju in 475 during the Ungjin period (475—538), Baekje continued to correspond with the Chinese Northern and Southern dynasties. In 538, during the Sabi period (538—660), the kingdom officially started an alliance with the Chinese Northern dynasties and further fostered an elegant and refined culture.

Baekje's state ideology was Confucianism, and various institutions were set up to encourage and curate the growth of a text culture based on it, such as an examination system for training scholars in Confucian ideals. During the reign of King Geunchogo, the scholar Goheung wrote the *Seogi*, which is considered one of the most representative historical books of the Baekje Kingdom. Another important book, *Baekje Bon-gi* (Historical records of Baekje), was produced during the reign of King Wideok (r. 554—98). Baekje transferred Confucianism to Japan and the Gaya Confederacy. Per King Geunchogo's order, the scholar Wang-in took prominent Confucian scriptures—including the *Thousand-Character Classic* and the *Analects of Confucius*—to Japan as gifts. The examination system, known as the *O-gyeong baksa* system, which was designed to train Confucian scholars in five different disciplines, was introduced to Japan during the reigns of Kings Muryeong (r. 501—23) and Seong (r. 523—54).

No text records remain from the Hanseong period, and it is difficult to determine the specific calligraphy trends of this time. In contrast, a large number of relics from the Baekje Ungjin and Sabi periods have survived, such as two memorial stones, one dating to 525 and the other 529, from the Great Mausoleum. They were found inside the tomb of Sama, the mother of King Muryeong (r. 501—23). These memorial stones are the two best-known relics from the Ungjin period. The inscription on the first stone documents the birth and death dates of the king. The second inscription is a *maejigwon*, which is usually a text inscription written on stone or a jar to wish the deceased a safe and peaceful rest. A similarly inscribed stone was buried

with King Muryeong's queen (cat. 25). These are the only artifacts from this period that give insight into the burial rituals of the Baekje Kingdom. The writing is characterized by soft and graceful brushstrokes. Another inscription on a brick that was excavated from Songsan-ri Tomb no. 6 reads, "Admiration for the Liang dynasty roof architecture." It is considered one of the earliest pieces of evidence of cultural exchange with the Chinese Southern dynasties.

Recently, a collection of valuable epigraphs from the Sabi period that contain information on the founding history and chronology of the Baekje Kingdom were discovered. Among them was an epigraph carved into a *sarira* stone shrine, which was found inside a wooden tower at the Neungsanlisaji (Neungsanli Temple). *Sarira* shrines were created to preserve and store the sacred relics of the Buddha or acclaimed Buddhist masters. The twenty-character inscription text is about King Wideok's elderly princess, who took care of the *sarira* shrine. The calligraphy is composed, but mostly resembles a script that was used for the memorial stones created for King Muryeong. Another example is a *sarira* vessel at the Wangheungsaji (Wangheung Temple) wooden pagoda. The twenty-nine-character inscription reads, "In the year 577, King Changwang [later King Wideok] built a temple for the dead prince. Two pieces of *sarira* became three through the blessing of god during the burning of the body."

The *Geumjesaribongangi* was found inside the center pillar of the Mireuksaji (Mireuk Pagoda), Korea's oldest Buddhist pagoda, located in the city of Iksan. The gilded tablet includes a text that documents the donation of King Mu's (r. 600—641) and Queen Sataekjeokdeok's daughter to the monastery. The object was made in 639 to pray for the well-being of the royal family. The front and back of the tablet are inscribed with 193 characters. The script is based on standard script, which was commonly used at that time, and combines it with elements of an ornate script known as *byeonryeoche* (*byeonryeo* script).

A later script style from the Baekje period can be seen on the *Sataekjijeok Stele* (cat. 16). The stele was erected by Sataekjijeok, the highest official of King Uija (r. 641—60). The inscription text is a short poetic essay in which Sataekjijeok bemoans the transience of life and praises efforts to build a Buddhist pagoda using gold and jade. The back of the stele is cut off, and only fifty-six characters, written in a very ornate *byeonryeoche*, are readable. The calligraphy resembles a standard script that was widely used during the Chinese Sui and early Tang dynasties, but the dots have been placed more firmly, and the overall layout is upright and solid.

Various oblong wooden sticks carved by ordinary people of no authority or power were also among the group of recently discovered objects. One example is the wooden stick (fig. 28) that was excavated at the Gungnamji garden facility in Buyeo County. It shows an administrative record written by a general official who was stationed at the western part of the garden facility.

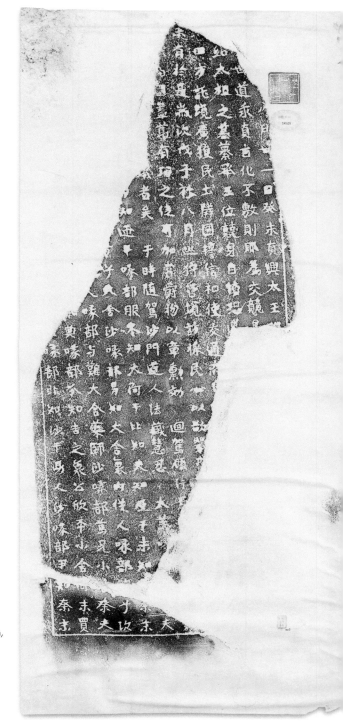

FIGURE 28
Gungnamji wooden stick with ink inscription, 6th c. Bamboo; 13⅞ × 1⅞ × ½ in. (35 × 4.5 × 1 cm). National Research Institute of Cultural Heritage, Buyeo

FIGURE 29
Hwangchoryeong jinheungwangsunsu Stele, 568. Ink rubbing; ink on paper, 51¼ × 19¾ in. (130 × 50 cm). National Library of Korea, Seoul

The earliest records of the Silla Kingdom (57 BCE—935 CE) date back to the Saro Kingdom and its federation with six tribes located in the southeast Gyeongju plain. King Naemul (r. 356—402) strengthened Silla's sovereignty, and King Nulji (r. 417—58) managed to break Silla free from Goguryeo's influence. In the sixth century, King Jijeung (r. 500—514) established a strong regime that transformed Silla into one of the most powerful kingdoms in ancient Korea. Thereafter, Kings Beopheung (r. 514—40) and Jinheung (r. 540—76) conquered Gaya, which had been a federal kingdom consisting of smaller tribes located south of the Nakdong River. King Jinheung's aggressive "north policy" resulted in the colonial rule of several territories located east and south of the Han River that were formerly governed by Goguryeo and Baekje.

Inscribed objects from this era, including vessels, gilded belts, swords, and other metal artifacts, have been excavated from mound stone–wood burials (late 4th—early 6th c.) in the Gyeongju region. Their inscriptions consist of short texts: most feature one or two characters, with the longest inscription consisting of twenty characters. Metal inscriptions like this were rarely elaborate.

Inscriptions can also be found on various stone monuments from the sixth century that were excavated between 1960 and 2018. The majority of these monuments are made of stones that are unprocessed or lightly sanded to achieve a rough, natural aesthetic. The *Pohang Jungseongni Stele*, a stone monument dating to 501 excavated in Jungseong (see cat. 23), documented the administrative judgments of the king after a dispute among residents of the Pohang region. The *Yeonilnaengsuri Stele* (503) served as a written royal certificate that documented the fortunes and inheritance of the statesman Jeolgoeri. The *Uljinbongpyeong Stele* (524) reported the achievements of the king and his officers. The *Yeongcheoncheongje Stele* (536) recounted the building of a water reservoir, including its construction size and the date. The *Danyangjeokseong Stele* (545—50) was erected after Silla conquered the former Goguryeo territory of Jeokseong. Its purpose was to honor and console the Yaichi, the native residents of Jeokseong. The *Changnyeongsunsu Stele* (561) was erected after King Jinheung conquered the Bisabeol Kingdom of Gaya (4th or 5th c.—early 6th c.). Lastly, the *Myeonghwalsanseongjakseong Stele* (551) and *Namsansinseong Stele* (591) documented the construction, location, size, and builders of mountain fortresses in these respective areas.

The calligraphic inscriptions on the abovementioned steles hold immense value, as they present the earliest examples of *idu*, text written in classical Chinese with Korean orthography. Furthermore, they give vivid records of the six Silla districts, including information on their central management, administrative systems, official ranking systems, labor systems, and administrative text cultures in general. As Silla adapted foreign cultures later than Goguryeo and

Baekje, its calligraphy was unrefined. The script seen on these steles is uneven in size and lines, and the composition lacks continuity. The brushstrokes are simple and plain. The *Danyangjeokseong Stele* is the most refined of these steles: its stone surface is smooth and the calligraphy layout shows a more regular grid.

Later, stone monuments were created to commemorate King Jinheung's territorial expansion and his sophisticated ritual of *sunsu,* or royal inspection tours to the mountains. King Jinheung was known for making *sunsu* and praying to the ancestors through rituals. Examples of *sunsu* steles are the *Hwangchoryeong–jinheungwangsunsu* (*Hwangchoryeong Stele*) in the Maunryeong region of Hamgyeong Province (568; fig. 29) and the *sunsu* stele on Mount Bukhan in Seoul (568—76; see cat. 24). They were erected after King Jinheung conquered the territories south of the Han River. Their inscriptions mainly document the accomplishments of the king, while also providing regulations for the new tribute states and a list of names of the officials who were involved in the conquest process. The *sunsu* steles were commonly made from stones that were cut and polished into long rectangles. The top of the stele was usually covered by another stone. The characters were consistent in size and layout.

THE CALLIGRAPHY OF THE UNIFIED SILLA DYNASTY

During the Unified Silla dynasty (668—935), Korean text culture and calligraphy became tightly interwoven with the Chinese calligraphy tradition. In 648, Silla's ambassadors had visited the Chinese Tang dynasty to engage in cultural and political exchange. After conquering Baekje and Goguryeo with the help of an alliance with the Tang dynasty, Silla was attacked by the Tang state in 672. Later, it reestablished a peaceful relationship with Tang, and new exchanges in the cultural field occurred. A large number of scholars and monks from Silla went to Tang to study Chinese culture. At the same time, Silla was striving to internally unify Goguryeo and Baekje by constructing a collective identity based on a coalescent and hybrid culture that reflected the needs of all the former kingdoms.

Silla's ruling ideology was Buddhism, and the majority of text relics from this period relate to Buddhism. Buddhist sutras, also known as *sagyeong* (sutras on paper) and *ingyeong* (sutras on wood), were produced in the form of sophisticated text scriptures on paper that were printed from carved wooden tablets. Together with other miscellaneous inscriptions carved into diverse stone objects, the writings describe the lives of Buddhist monks and the Buddhist dharma. Reliquary caskets and pagodas were other popular objects that featured sacred inscriptions. From the ninth century on, the Buddha's sermons were inscribed into steles, which further give great insight into the calligraphy style of this period.

The calligraphy of the Unified Silla dynasty was mainly based on the calligraphy forms of the Chinese Jin and Tang dynasties. Unified Silla calligraphers widely used a standard script (*haeseo*) that was based on the early script styles of the Tang dynasty. Stone inscriptions from this period and after the seventh century show this influence. The script of the text inscribed on the five-story Jeongrimsaji (Jeongrim Pagoda; 660), written by Tang military officials after they conquered Baekje, resembles the script of Chu Suiliang (597–658).
An epitaph for the Tang general Yuinwon, made in 663, uses a script similar to that of Yu Shinan (K. Yu Senam; 558–638), a calligrapher of the early Tang dynasty. Two epitaphs for King Muyeol's first and second sons, King Munmu (r. 661–81) and Gim Inmun (629–694), closely resemble the script of Ouyang Xun. King Muyeol's turtle and dragonhead gravestones (dating to ca. 661) bring to mind early Tang scripts.

Eighth- and ninth-century inscriptions mostly used early Tang scripts, and the Ouyang Xun script was the most popular among them. This trend lasted until the Goryeo dynasty. Famous examples are the *Bojoguksa Cheching Stele* and a memorial stone inscription by Seodanghwasang Wonhyo. Both writings show an elaborate adaptation of Ouyang Xun's semicursive script. Cheching (804–890) was one of the most prominent practitioners of Seon Buddhism and the third leader of the Gajisan Buddhist school. One of the most famous text inscriptions of this time, honoring Cheching, was found on a pagoda built to commemorate the life of this Buddhist master at the Borimsa Seon Buddhist monastery. Wonhyo (617–686) did not belong to any school and was a distinguished scholar known for his own Buddhist philosophy.

Almost all the writings in *haengseo* (semicursive) script from this period were based on the script of Wang Xizhi (307–365). The Chinese emperor Taizong (r. 626–49) was a supporter and admirer of Wang Xizhi's calligraphy. In 672, a *jipja* (a compilation of *hanja* characters, in this case borrowed from different calligraphic works by Wang Xizhi) was created for use in the stone stele carved with a text composed by Taizong titled *Daedangsamjangseonggyoseo* (Ch. *Da Tang Ji Wang Shengjiao Xu*, or *Preface to the Sacred Teachings*; fig. 7). Ink rubbings from this famous stele led to the wide distribution and use of Wang Xizhi's calligraphic style. A script that is almost identical to Wang Xizhi's was found at the Hwangboksa (Hwangbok Temple) in Gyeongju, the city in which the Silla royal family resided. Several other Silla *jipja* texts from the ninth century collected and reorganized Wang Xizhi's writings. One famous writing from 801 documents how Queen Gyehwabuin prayed for her husband, King Soseong (r. 799–800). The inscribed Amitabha Buddha sculpture, commissioned by the queen, is located at the Mujangsa (Mujang Temple; see cat. 92). The writings of many prominent Silla calligraphers were also based on the Wang Xizhi script.

Text inscriptions on the top of dragonhead stone monuments show the use of the script also known as *jeonseo* (seal script). One of the earliest examples is found on the *Taejongmuyeolwangjibi* (*King Taejong Muyeol Stele*), which includes an eight-character inscription (fig. 30). The layout of the characters is regular and strict, and the brushstrokes are straight and consistent. A few more examples of stone monuments from the eighth century exist, but little about the form and structure of the calligraphy can be deciphered, as the inscriptions have been damaged or lost. Most stele inscriptions from the ninth century use a small seal script with a relatively loose layout and soft lines. The writing on the *Pagoda Epitaph for Seon Master Jingam* (881) by Choe Chiwon demonstrates a cursive seal script, which was an unusual script for use on steles at that time (fig. 9).

Sagyeong, Ingyeong, and *Seokgyeong*

Buddhist sutras were meticulously inscribed onto stones and wooden tablets. For researching calligraphy, original inscriptions and handwritten copies of Buddhist sutras are important artifacts that show the use of standard scripts of that time. Texts on paper are called *sagyeong,* wood inscriptions are referred to as *ingyeong,* and inscriptions on stone are known as *seokgyeong.*

Two scrolls that include ink writings from the *Hwaeomgyeong* (Avatamsaka [Flower Garland] Sutra, books 1—10 and 44—50) are the oldest-known Korean Buddhist texts (fig. 31). The Hwaeom Sutra had been translated from Sanskrit to Chinese about 420 by the Indian monk Buddhabhadra. According to the twenty-sixth and fourteenth lines in the last chapter, monk Yeongibeob from the Hwaryongsa (Hwaryong Temple) wrote and produced the first copy of the scrolls between the first day of the tenth lunar month of 754, and the fourteenth day of the second lunar month of 755, to commemorate his father and to pray for the Buddhahood of all people. The scrolls hold high historical value because they also include information on the making of the scrolls, associated rituals, writers' names, and titles. Each column of text is approximately eight inches long and consists of thirty-four characters. The distance between each character is only one quarter of an inch, and each character is approximately one eighth of an inch high. Despite this small scale, the lines and marks are extremely precise. The text is written in a clear and firm style, demonstrating an excellent overall ability on the part of the writer. The scroll paper, made from the pulp of the mulberry tree, was dyed a dark blue color using indigo. The work also includes unique paintings, made with gold, which are the only such paintings known from this period.

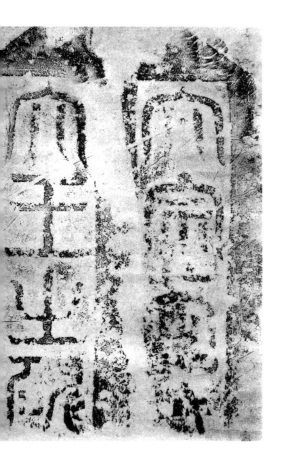

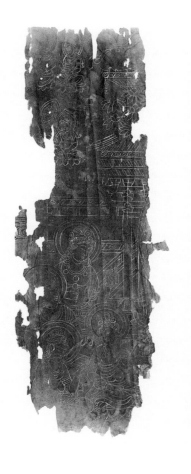

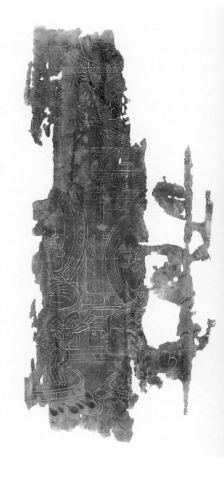

FIGURE 30
Ink rubbing of King Taejong Muyeol Stele, ca. 661. Granite; height: 82¾ in. (210 cm). Seoakdongobun, Gyeongju, North Gyeongsang Province, National Treasure no. 25

FIGURE 31
Fragment of *Hwaeom gyeong (Flower Garland) Sutra,* ca. 754— 55. Ink on paper; 11½ × 547½ in. (29 × 1,390.6 cm). Leeum, Samsung Museum of Art, Seoul, National Treasure no. 196

FIGURE 32

Silla Village Documents, ca. 695—815. Approx. 11⅞ × 22⅞ in. (30 × 58 cm). Shosoin, Nara, Japan

FIGURE 33

Mugujeonggwang daedarani gyeong, before 742. Print from wooden block; 1 × 1 × 99½ in. (2.6 × 2.6 × 252.7 cm). Central Buddhist Museum, Seoul, National Treasure no. 126

With regard to the aforementioned scrolls, the *Silla chollak munseo* (Silla Village documents) from the Shōsōin imperial repository located at the Tōdaiji, Nara, Japan (fig. 32), should be considered. These previously sealed documents were found inside the *Hwaeomgyeongnon* (Hwaeom Buddhist Sutra) when it was opened for conservation. The documents present demographic details of four villages located in Seowongyeong (now Cheongju). The information includes the size of the villages, the ages and sexes of the residents, the population growth over three years, the number of cows and horses, the number of rice fields and farms, and the number of mulberry and pine nut trees. There are different estimates for when these documents were created, including the years 695, 755, and 815. They are the only text relics from this period.

The *Mugujeonggwang daedarani gyeong* (*Pure Light Dharani Sutra*) is another famous artifact from the eighth century (fig. 33). The text of the sutra was carved into a wooden tablet that was discovered during the restoration of the two-story pagoda at the Bulguksa (Bulguk Temple) in Gyeongju. In October 1966 the Geumdongje *sarira* shrine and a few other relics were found inside the pagoda. The *Mugujeonggwang daedarani gyeong* was translated from Sanskrit into classical Chinese between 701 and 704. As a sacred text, it was believed to help wash away sins and prolong life when stored inside a pagoda.

Each line consists of six to nine characters. The text is 2½ inches high. Excerpts from another famous sutra, titled *Mujujeja*, were deciphered in 2007. This sutra was widely used during the reign of the Tang empress Wu Zetian (690–704). Accompanying text pieces that were found with the sutra text document the two restorations of the pagoda, the first in 1024 and the second in 1038. The text also reveals that the pagoda was built in 742 (corresponding to the first year of the Tang Tianbao reign period), which means it is the world's oldest-known wooden tablet from which ink rubbings could be made.

Lastly, sutras were inscribed onto stones; these are referred to as *seokgyeong*. Examples of ninth-century stone sutras include the *Beophwa seokgyeong* (*Beophwa Stone Sutra*) at the Changrimsa (Changrim Temple); the *Geumgangseokgyeong* (*Geumgangseok Sutra*), which was excavated from the mountains of Chilbulam; and the *Hwaeomseokgyeong* (*Hwaeomseok Sutra*, ca. 885) at the Hwaeomsa (Hwaeom Temple). Scholars disagree on the creation date of the Hwaeom stone-carved inscription, but many believe that it was written after King Heongang (r. 875–86), who created the Hwaeom assembly and commissioned the sutra, writing to wish good fortune on his successor, King Jeonggang (r. 886–87). The script is based on the Ouyang Xun script. The calligraphy is not consistent, which means that multiple writers were commissioned to inscribe the characters. However, the carving presents excellent craftsmanship. The lines are precise and clear. The quality of the inscription is considered to exceed that of Tang stone texts.

Representative Calligraphers

From the Unified Silla dynasty onward, individual authors and calligraphers of writings are known, and many gained fame through their writings. Gim Saeng (711–?) of the Unified Silla dynasty is by far the most famous Korean calligrapher. He is the only Korean calligrapher whose life and work are mentioned in the historical records of the *Samguk sagi* (History of the Three Kingdoms; 1145), as the result of which his fame and reputation grew. An amusing conversation between Goryeo scholar Hong Gwan and Chinese teachers at the Song dynasty's Hanlin Academy can be found in the *Samguk sagi*:

> In the Chongning period [1102–6, during the reign of the Northern Song dynasty emperor Huizong], the [Korean] scholar Hong Gwan was promoted to be an emissary to the Song court and was officially sent to Bianliang [the Northern Song capital, now Kaifeng]. At the time the [Chinese] Hanlin [Academy] editorial assistants Yang Qiu and Li Ge were appointed to wait upon the emperor, [during which time] calligraphies and paintings were brought out [for viewing]. Hong Gwan showed them a handscroll of [combined] running and cursive script by Gim Saeng. The two [Yang Qiu and Li Ge], startled, said, "It is unimaginable today to see a calligraphy from the hand of Wang Youjun [Wang, the General of the Right—Wang Xizhi]!" Hong Gwan

1
Quoted in O Sechang, *Geunyeok seohwajing* [Geunyeok's collection of calligraphy and painting] (Gyeongseong [Seoul]: Gyemyeong gurakbu, 1929), 3; translation by Stephen Little.

said, "Not so—this is none other than the calligraphy of Gim Saeng of Silla." The two men laughed and said, "Under Heaven, aside from Youjun, how can there be such a marvelous brush as this?" Hong Gwan repeated his statement, but to the end they were still unbelieving![1]

Despite chances of exaggeration, this text reveals that Gim Saeng's early writings bore a strong resemblance to Wang Xizhi's calligraphy. One of Gim's typical writings is the *Jeonyuamsangaseo* (fig. 34). Based on the Wang Xizhi script, this writing features dynamic brushstrokes characteristic of Gim's work. In comparison, his *jipja* work *Bonghwa Taejasa Haengjeok* (832—917; see cat. 17) shows a very different calligraphy, with flat and thin brushstrokes. It has a then-revolutionary layout, and the brushstrokes demonstrate a marked distance from the Wang Xizhi script. Gim's calligraphy has been praised by critics who appreciate his pairing of classical Chinese calligraphy styles with innovative brushwork. It is this combination that made Gim's calligraphy unprecedented and highly acclaimed. He was often referred to as the unparalleled, finest calligrapher of Korea.

The Buddhist monk Yeongeop from the Donggyesa (Donggye Temple) was known for his outstanding calligraphy, which was inspired by Wang Xizhi's semicursive script. There is only one primary written record of Yeongeop's calligraphy: the epigraph (813) he wrote for the monk Shinhaengseonsa (704—779), who resided at the Dansoksa (Dansok Temple). The epigraph was commissioned by Lee Gan, grandson of King Wonseong (r. 785—98). The fact that Yeongeop received a commission from a royal family member demonstrates that he was already regarded as a distinguished calligrapher during his lifetime. His script was based on Wang Xizhi's, but his brush-strokes were drier and more resolute.

Yo Geuk–il, a prominent literary figure, was active after the ninth century. He was famous for his striking brushwork, which was based on the Ouyang Xun script. His work is mentioned in the historical records of the *Samguk sagi* in Gim Saeng's biographical chapter. According to the *Samguk sagi*, Yo Geuk–il's brushstrokes are strong and decisive, resembling the brushwork of Ouyang Xun. His artistry is not at the level of Gim Saeng's, but his writing was still considered among the most exquisite in the kingdom. Examples of his writings are the *Jeokinseonsa Tower Stele* (872) at Daeansa (Daean Temple), and the Chalju Nine–Story Wooden Pagoda at the Hwaryeongsa (Hwaryeong Temple) in Gyeongju. It is suspected that Yo Geuk–il transcribed the *Samrangsabi* (*Samrang Temple Stele*) from a text that was originally written by Park Geomul, as well as the memorial stone inscription for King Heungdeok (r. 826—36).

Records from the Chinese Tang dynasty praise the calligraphy of Choe Chiwon as among the best of the time. His work mixed characteristics of the Ouyang Xun script and late Tang scripts, resulting in an original style that is lively and elastic. One of his most representative works is the epitaph at the

伐玄泰　報德寺　金生書

逗迢嵩嶺此遊世法城東

閟吳陶潛柳伎云原隱器漆

蕚霆澄明月琴上引清風

誰繼逐名利納日事主

Ssanggyesa (Ssanggye Temple). The epitaph was written for the Buddhist monk Jingam Seonsa Hyeso (774—850), who was famous for his practice of Fan Bai, a hymn of praise to the virtue of Shakyamuni. Another of his epitaphs was created to honor King Wonseong. It includes information on the foundation history of Daejungsa (Daejung Temple) in Gyeongju. A third example is the memorial stone inscription at Jirisan (Mount Jiri) in Hongryudong Valley. Choe's script was also discovered on a few stone inscriptions from the early Goryeo dynasty period (tenth century).

THE CALLIGRAPHY OF THE GORYEO DYNASTY

King Wanggeon, better known as Taejo of Goryeo (877—943), founded Goryeo in 918 by reunifying the divided late Silla kingdoms. Goryeo implemented a centralized regime during the reign of King Seongjong (r. 981—97) and an aristocracy during the reign of King Munjong (r. 1046—83). It was then led by military officials for a hundred years after a military revolt in 1170.

The kingdom underwent a number of foreign invasions. The Khitan attacked Goryeo in 993, 1010, and 1015—18, but Goryeo was able to withstand the invasions. After the third invasion, the two kingdoms maintained a peaceful relationship until the Khitan regime ended in 1125. A subsequent invasion was led by armies of the Chinese Jin dynasty, who asked for tributes, with which the weakened Goryeo dynasty complied. In 1232 the Mongols began a series of attacks. Goryeo moved its capital city from Gaeseong to Ganghwa and resisted the Mongols for twenty-eight years but eventually surrendered. The war resulted in hundreds of civilian deaths and a huge financial loss. In 1232, the *Tripitaka Koreana* (1011—29), which was kept at Buinsa (Buin Temple) on Palgongsan (Mount Palgong), was destroyed by fire (see cat. 13). In 1238, the Hwangryongsa Nine-Storied Wooden Pagoda (634), a symbol of Ho-guk Buddhism that represented the protection of the nation from outside forces, burned down. In 1270 Goryeo became a tribute state of the Yuan dynasty and remained so for eighty years. In 1392, Yi Seonggye (1335—1408), a former military leader of Goryeo, founded the Joseon dynasty.

Buddhism shaped the daily lives of many ordinary people in Goryeo. Confucianism, the ruling ideology, modeled the ideal lifestyles of Goryeo scholars and military officers. Toward the end of the Goryeo period, the noblemen of the kingdom actively incorporated Neo-Confucian ideas from the Yuan dynasty into the ruling ideologies of Goryeo. During this time, Goryeo also engaged in vibrant cultural exchanges with the Chinese Song dynasty, as well as with the Yuan. This exchange is reflected in the adoption of these dynasties' ornamental aesthetics into Goryeo's artistic productions.

Goryeo's history of calligraphy can be divided into three periods: tenth to eleventh century; mid-twelfth to thirteenth century; and fourteenth century. The writings were heavily influenced by Buddhism and existed in various forms, including stone inscriptions and epigraphs. Stone inscriptions were

mostly texts for memorial stones or Buddhist stone pagodas. The things they documented include the foundation histories of temples, the biographies of notable Buddhist monks, and notes on the Tripitaka scriptures. As for script style, most of the texts were written in standard and semicursive script. During the Japanese Colonial period, around two hundred epigraphs were excavated around the Gaeseong region. Most of them include their creation dates; they were written at various times during the Goryeo dynasty and therefore serve as excellent guides to the development of Goryeo calligraphy. For example, the script used for memorial stones that were erected on the ground was more strict and regular than that used for monuments that were buried in the ground next to tombs, which show a more cursive and natural script.

Meanwhile, during the mid- and late Goryeo period, there was a movement of writers and literary scholars whose works paired paintings with writings. Unfortunately, few of these artworks have remained.

Tenth and Eleventh Centuries

A large number of stone-monument inscriptions from tombs and Buddhist temples have survived from this period. Their script style, based on early Tang scripts, was strongly influenced by Ouyang Xun's calligraphy. Only one known stone monument used an unusual semicursive script in combination with that of Ouyang Xun. Among the most famous calligraphers of this period was Yi Hwanchu. He created and wrote most of the inscriptions for King Taejo, together with Choe Eonwi (864—944), who was another acclaimed writer. One of Yi Hwanchu's outstanding works is the *Jincheoldaesa Yi Eom Stele Monument* (937). As the name suggests, the stele was made to honor Yi Eom (870—936), who was a well-known Buddhist monk at Jincheolsa (Jincheol Temple). He was also one of the most senior advisers to King Taejo. The script is based on the Ouyang Xun script and features precise and firm brushstrokes that sought to capture a determined and strong image of the king. Yi Hwanchu's calligraphy was taught and passed down to many generations of scholars.

Another influential calligrapher was Jang Danyeol, who taught at the Hallimwon during the reign of King Gwangjong (r. 949—75). The Hallimwon was an institution responsible for composing and documenting the words and orders of the king. Jang Danyeol's early calligraphy was inspired by the Yu Shinan script, named after Yu Shinan (558—638), another famous calligrapher of the Tang dynasty in China. Later, Jang developed his own innovative script, which in comparison with the Yu Shinan script featured thinner lines and softer strokes (fig. 35).

Jigwangguksa Haerin's (984—1070) pagoda inscription (1085) presents one of the last textual remains of the eleventh century. The great Buddhist monk Guksa was the leader of the Beobsangjong Buddhist denomination and an important adviser to King Munjong (r. 1046—83). His tomb and memorial stones were some of the most showy and ornamental monuments from the Goryeo period. The memorial stone presents noticeably decorative and

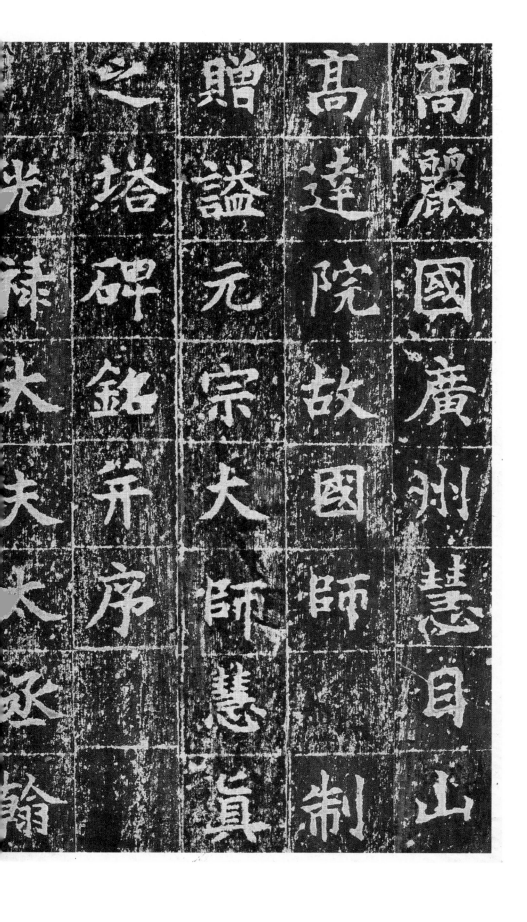

光祿大夫大丞翰

之塔碑銘幷序

贈謚元宗大師慧眞

高達院故國師制

高麗國廣州慧目山

FIGURE 35
Jang Danyeol,
Wonjongdaesa Stele,
975. Ink rubbing;
11½ × 7 in.
(29.2 × 17.8 cm).
Private collection (orig–
inal stone in collection
of National Museum of
Korea, Seoul)

FIGURE 36
Jigwangguksa Stele,
Buron, Wonju,
Gangwon Province,
1085. Inscription:
117 × 56 in.
(297 × 142 cm).
National Treasure
no. 59

FIGURE 37
An Minhu, detail from
*Jigwangguksa Stele
Inscription*, 1085.

FIGURE 38
Detail from
*Jingongdaesa Stele
Inscription* (with chara-
cters borrowed from
the calligraphy of Tang
Taizong), 941. Ink rubb-
ing. National Museum
of Korea, Seoul

detailed patterns and forms (fig. 36). They include turtle and dragon sculptures supporting the stele at the bottom, a phoenix, floral patterns that depict Sukhavati, decorative patterns that encircle the monument, and cloud and dragon images on the sides. An Minhu wrote the inscriptions in a script based on Ouyang Xun's formal principles (1085; fig. 37) to match this ornamental style.

A few examples of standard script have remained, too. These include the *Jingongdaesa Stele* (941), Gim Saeng's *jipja* inscription on the *Nanggongdaesa Stele* (954; see cat. 17), and the *Hyeonhwasa Stele* (1022), which was erected to document the life and health of King Hyeonjong (r. 1010—31). Despite the existence of these excellent works, it is difficult to fully understand the practice and development of standard script during this time because of the limited number of relics. The Wang Xizhi script was used for two of these steles, including the *Jingongdaesa Stele*, written by King Taejo during the twenty-fourth year of his reign. He was known to be an admirer of Wang Xizhi's calligraphy. The *Hyeonhwasa Stele* inscription was written by Chae Chungsun (?—1036). Chae merged characteristics of the Wang Xizhi script with basic forms of the Ouyang Xun script. Overall, a preference for the Wang Xizhi script can be found in steles of the era. This tendency lasted throughout the eleventh century.

The Jingongdaesa (Jingongdae Temple) monument (fig. 38) is the oldest-known *jipja* inscription from the Goryeo dynasty. It was erected in the Heungbeopsa (Heungbeop Temple) site, located in the city of Wonju, Gangwon Province. The monument was named after Jingongdaesa Chungdam (869—940), who was a Silla aristocrat and later became a great monk of the Heungbeopsa. Chungdam studied in the Chinese Tang dynasty and also served as one of the most important advisers to King Taejo. Taejo himself wrote Chungdam's epigraph text in 941. For the stone inscription, Choe Eonwi's son Choe Gwangyun created a *jipja* text that features the *Oncheonmyeong* (Warm springs record) script Tang emperor Taizong created in 646. According to the *Samguk sagi* (under records for the year 648; Queen Jindeok chapter 2), Silla's ambassador Gim Chunsu (later King Muyeol) had received the *Oncheonmyeong* text together with the *Jinsamyeong* text from Emperor Taizong. These two writings served as invaluable and popular material for many future *jipja* works. Choe's *jipja* was created three hundred years after Taizong's writings came to Silla.

Remnants of a carved stone mural were discovered in 2012. At the same site, a large number of Goryeo relics were found while investigating the Dobong-seowon (Dobong Memorial Hall), a former Neo-Confucian institution from the Joseon dynasty located at Mount Dobong in Seoul. The findings include gilt-bronze objects, such as the *Geumgangryeong* and *Geumgangjeo*, as well as bronze objects, such as the *Gongyanggu*. The *Beophwaseokgyeong* (Beophwaseok Sutra) stone inscription and a *Cheonjamun* stone inscription were found, too. In 2017, another stone inscription was found at the Yeongguksa (Yeongguk Temple). The stone relic was part of a stele titled *Hyegeoguksabi*

(Hyegeoguksa Stele; ?—974). These excavations proved that the Dobongseowon was located north of the Yeongguksa. Among the various findings, four pieces from the *Beophwaseokgyeong* stone inscription and one *Cheonjamun* (*Thousand–Character Classic*) stone inscription attracted special attention. The *Beophwaseokgyeong* features the Ouyang Xun standard script and was most likely created during the Unified Silla period. The *Cheonjamun* inscription is a small piece of stone featuring six characters also written in the Ouyang Xun standard script. Among the six characters, the character *chi* (治) is missing its last vertical stroke. The writer intentionally avoided completing the character, as it was identical to King Seongjong's (r. 981—97) name, Wang Chi. This detail reveals that this writing was created after 981. It is the oldest-known *Thousand–Character Classic* inscription not only from the Goryeo period, but in all of Korean history.

Twelfth and Thirteenth Centuries

During the twelfth and thirteenth centuries, calligraphy styles from the mid-Tang and Northern Song dynasties were widely in use. One of the oldest text records from this period is about the 1106 reconstruction of the Seunggagul, a stone cave located in Bukhansan (Mount Bukhan). The author is not known, but the script closely resembles the late standard script of Yan Zhenqing (K. An Jingyeong; 709—785) and could therefore be classified as a *jipja* writing. Several other stone inscriptions that mirror the Seunggagul texts also used the An Jingyeong standard script. A considerable number of writings adapted and modified the thin lines and flowing calligraphy of Wang Xizhi.

Tanyeon (1068—1158), Goryeo's most prominent calligrapher, lived during this period of time. His family name was Sun, and he grew up in Miryang, in Gyeongsang Province. Tanyeon was a Buddhist monk; Tanyeon was his monastic name. He later served as an adviser to the king. After his retirement, he stayed at the Dansoksa (Dansok Temple), trained many students, and worked on the development of Korean Seon Buddhism. Tanyeon was honored as a national preceptor. His honorary pen name was Daegam. The *Munsuwonjungsugi* (1130; fig. 39) is the only known stone inscription written by him. The epitaph was found in the Cheongpyeong Mountains in Gangwon Province. The epitaph text was originally created by Gim Bucheol (1079—1136), who was a chief instructor at the Gukjagam (a school for higher education in Goryeo). It memorializes Jillakgong Lee Jahyeon (1061—1125), who left his post as a statesman and moved to the Cheongpyeong Mountains to practice the life of a Seon Buddhist. The back of the epitaph shows a funeral oration written by the monk Hyeso at Gyeongbulsa (Gyeongbul Temple). The large writing on the front uses the Yan Zhenqing script combined with Soshikche (Soshik script). The overall semicursive text is also based on the thin, elegant lines of Wang Xizhi. The standard script for the funeral oration adopted the elements of the Yan Zhenqing script (fig. 40). This epitaph was broken in the eighteenth century, and cracked into many smaller pieces during the Korean War (1950—53). Only a few pieces have remained.

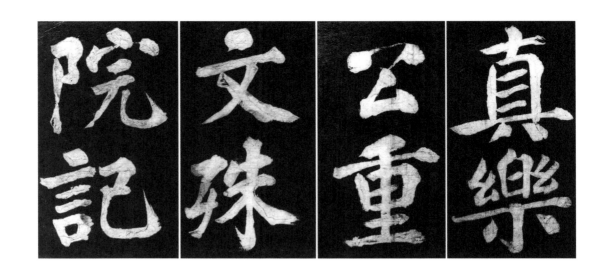

真樂公重

文殊院記

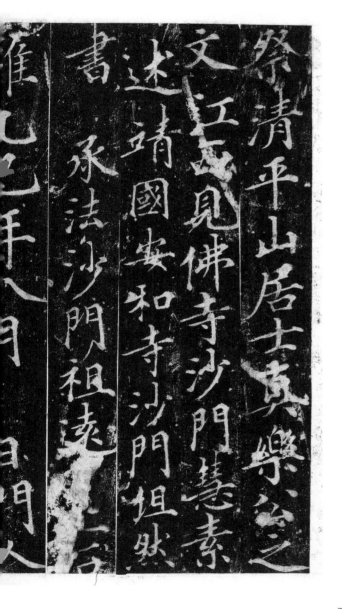

書承法沙門祖遠一
文江山見佛寺沙門慧素
述靖國安和寺沙門坦然
祭清平山居士真樂公之

FIGURE 39

Tanyeon (1068—1158),

Munsuwonjungsugi

Epitaph, 1130. Ink

rubbing. National

Museum of Korea,

Seoul

FIGURE 40

Tanyeon (1068—1158),

Jillakgong Epitaph. Ink

rubbing; 12¾ × 8½ in.

(32.2 × 21.3 cm).

Jangseogak Archives,

Academy of Korean

Studies, Seongnam

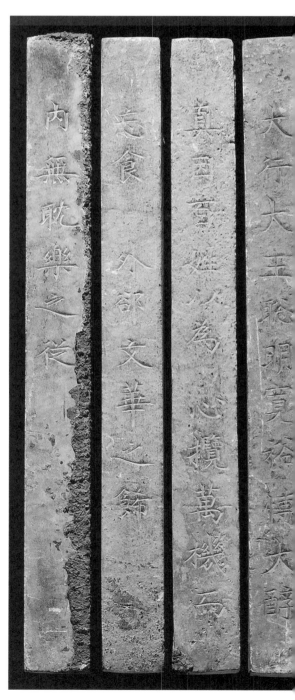

Tanyeon's calligraphy was popular during the twelfth century. Well-known writers, including Mun Gongyu (1088—1159), wrote in the Tanyeon script. Tanyeon's students, including one named Kijun, adopted his writing style. Owing to Tanyeon's influence, funeral orations were written in standard script and epigraphs were written in semicursive script; this tradition lasted through the thirteenth century. A text document (fig. 41) written by King Gojong to the monk Hyeshim (1178—1234) in 1216 was found at Jingakguksa (Jingakguk Temple). It proclaims that Tanyeon was given the highest post at Daeseonsa (Daeseon Temple), an institution of Seon Buddhism. Because of its layout, script, and use of multicolored silk (instead of paper), the text resembles documents from the Song dynasty. It was probably written by Seoryeongsa Hwang, who served as a *yebu*, an officer at the royal court responsible for the preservation and execution of ceremonies and rituals. The writing features thin, elegant brushstrokes. A document from 1281 (the seventh year of King Chungnyeol's reign) is official permission given by the royal court to Wonoguksa's (Wonoguk Temple) Cheonyeong (1215—1286), who had asked if his slave—a gift from his father, Yang Taekchun—could protect the Tripitaka at Suseonsa (Suseon Temple). These two text documents prove that Tanyeon's scripts were also used by lower-ranking officials for administrative purposes.

While Tanyeon's calligraphy gained popularity, Wang Xizhi's script was still widely used and respected. For example, Bogakguksa Iryeon (1206—1289), the author of the *Samguk yusa*, wrote an epigraph in the Wang Xizhi script. Other writings used the Yu Shinan script. Examples of such writings include the *Wongyeongwangsabi* (*Wongyeongwangsa Stele,* 1125), written by Yi Wonbu, and a poem collection titled *Injongsichaek* (1146; fig. 42), which was a gift to King Injong (r. 1122—46).

As a result of the Mongol invasions, fewer text artifacts from the thirteenth century have remained; many writings were lost or damaged. A stele for the Jingakguksa monk Hyeshim, commissioned by King Gojong, and a 1257 stone inscription written by Choe Hang (1209—1257), the third leader of the Goryeo military regime, are two examples from the small number of extant relics from this time. Their calligraphy is similar to that on objects created during the twelfth century.

Fourteenth Century

After the reign of King Chungnyeol (r. 1274—1308), Goryeo's relationship with the Yuan dynasty grew closer. Various elements of Yuan culture were transmitted to Goryeo, and calligraphy was among them. King Chungseon (r. 1308—13) played a crucial role in the transfer of Yuan culture to Goryeo. He lived in Yanjing (K. Yeongyeong; Yuan's capital city—now Beijing, also known in the Yuan dynasty as Dadu) for a long time before returning to Goryeo to rule the kingdom after his father's death. After reigning for five years, he transferred the regime to Prince Chungsuk and returned to Yanjing. There he built a library called Mangwondang and invited Yi Jehyeon (1287—1367)

from Goryeo. He introduced Yi to the Chinese writings of Yao Wei (K. Yosu), Zhao Mengfu (K. Jo Maengbu; 1254—1322), and Yuan Mingshan (K. Won Myeongsun). The calligraphy of Songxue (K. Songseol) Zhao Mengfu began to spread quickly in Goryeo.

One of the earliest calligraphers who incorporated Yuan text culture into his work was Haengchon Yi Am (1297—1364). His most famous work is the *Stele Inscription for the Sutra Storage Hall of the Munsusa* (1327; fig. 14), located on Cheongpyeong Mountain. The text was originally created by Yi Jehyeon. It is about an empress who sent a Tripitaka to the Munsusa (Munsu Temple) to preserve it. People prayed for the emperor and empress and donated money on their birthdays, which allowed them to look at the Tripitaka. The text was written in a semicursive script, which bore a strong resemblance to the Zhao Mengfu script. That is why the Joseon calligrapher Seo Geojeong (1420—1488) praised Yi Am's writing, saying that "his calligraphy is the only one in Korea that truly embraces the spirit of Songxue Zhao Mengfu."

However, the calligraphy trends from Yuan were not the only styles adopted during this time. In fact, the majority of writings were still using previously popular script styles and modifications of them. For example, the *Jajeonggukjonbi* (*Jajeonggukjon Stele*; 1342), written by Jeon Wonbal (1288—1358) at the Beopjusa (Beopju Temple), shows several elements of the scripts of Tanyeon and Yan Zhenqing (K. An Jingyeong). Hansu (1333—1384), a famous calligrapher from the late Goryeo period, and his uncle Gwonju (?—1394) created simple and peaceful writings by adapting and further modifying the Yu Shinan script.

The only example of a clerical script from this period is found in the stone inscription (1377) created for Seongakwangsa Hyegeun (1320—1376) at Hwaeomsa (Hwaeom Temple) in Gyeonggi Province. Seongakwangsa Hyegeun was a student of the Indian monk Jigonghwasang (?—1363) and introduced the Im Jejong and Seonpung to Goryeo. The inscription text was composed by the Goryeo statesman and scholar Yi Saek (1328—1396). Handwritten copies were the work of Gwon Junghwa (1322—1408), a calligrapher of the late Goryeo to early Joseon dynasty. The text is somewhat poor in quality but represents the level and use of clerical–script calligraphy during the late Goryeo period.

Buddhist Scripts

Buddhist scripts from the Goryeo dynasty have been found in Korea, Japan, and other parts of the world. The materials, calligraphy, artistry of the accompanying paintings, and workmanship are noticeably different from objects created in China or Japan. These scriptures are known for their splendid yet graceful appearance. They are deemed typical of the art of Goryeo and therefore hold considerable art–historical value.

During the Goryeo dynasty, the king often commissioned transcriptions of the Tripitaka scriptures. The Sagyeongwon, a dedicated conservatory solely responsible for Tripitaka writing matters—including translations and transcription—was established. Later, King Chungnyeol (r. 1274—1308) built two more conservatories dedicated to creating Tripitakas that were written with gold and silver. During this time, a large number of skilled transcribers, who were also serving as Buddhist monks, were trained. Some of them also moved to Yuan dynasty China and practiced their skills abroad. Only three examples of dated scriptures created during the eleventh century remain; older scriptures cannot be verified because they lack dates. Two thirteenth-century scriptures created during the Mongol invasions and during the Goryeo military regime (1170—1270), respectively, remain; their exact creation dates cannot be verified. The rest of the scripts were made after the reign of King Chungnyeol. Before his reign, transcribers were not credited, as commissioned works were organized by the royal conservatories. Later, monks and ordinary people acted as transcribers, too. Various types of Buddhist Tripitaka works were transcribed. Among them, the *Beophwagyeong* (*Lotus Sutra*) and the *Hwaeomgyeong* (*Avatamsaka Sutra*) were the most popular sutras. Gold or silver was used to write on paper that was dyed with persimmon or later made from oak trees, resulting in red paper. In other instances, black ink was used to write on white paper. Early scriptures were rolls. Later, in 1290, paper was folded and bound to make books. After 1340, the majority of scriptures began to be produced as bound books.

The calligraphy script style for these scriptures is similar to that used for steles, but the development and modification of Chinese scripts occurred more slowly. During the eleventh century, the writings consisted of determined and detailed brushstrokes based on the Ouyang Xun script (fig. 43). In the twelfth century, the writing followed a slimmer layout, with flowing brushstrokes that mix various scripts, including the Tanyeon, Yan Zhenqing, and Yu Shinan scripts. Later in the fourteenth century, most writings continued to use the calligraphy from previous periods, or slight modifications thereof. No artifacts have been found that use the calligraphy of the Yuan school. Eleventh-century drawings and paintings feature simple representations of the Bodhisattva or Buddha giving sermons. Later in the fourteenth century, depictions of the Buddhist guardian Hobeopshinjang (also known as Witacheon; C. Weituotian) were prominent. Images of him feature powerful and dynamic brushstrokes. After the fourteenth century, many paintings of the Buddha giving sermons were created and combined with repetitive, splendid brushstrokes and complicated imagery.

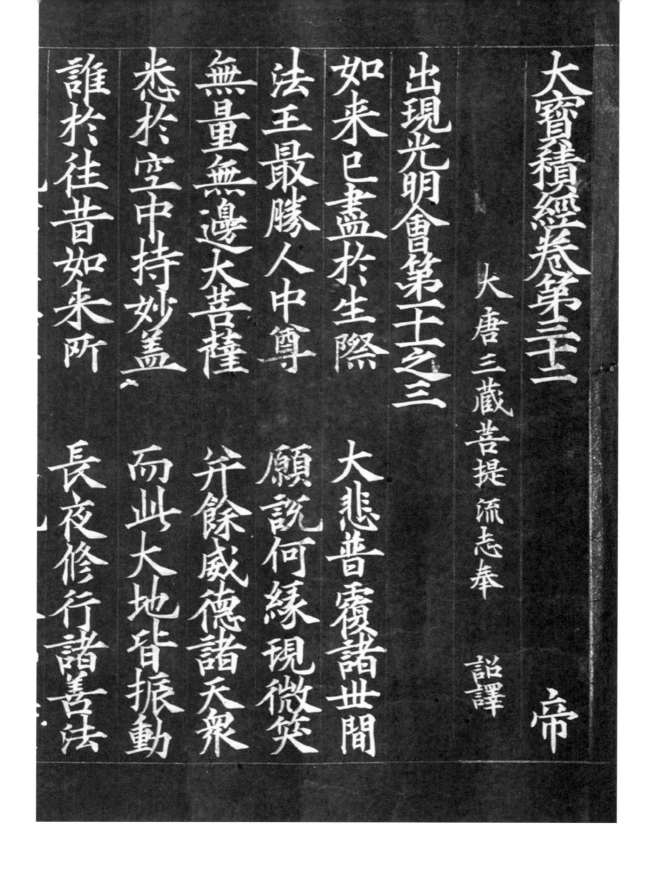

大寶積經卷第三十一

大唐三藏菩提流志奉　詔譯

帝

出現光明會第十一之三

如來已盡於生際

法王最勝人中尊

無量無邊大菩薩

悉於空中持妙蓋

誰於往昔如來所

大悲普覆諸世間

願說何緣現微笑

并餘威德諸天眾

而此大地皆振動

長夜修行諸善法

CONCLUSION

This essay has examined the calligraphy of ancient and medieval Korea. The calligraphic works of the Three Kingdoms period share similar features, using popular Chinese scripts while beginning to modify them. Calligraphy is powerful and vibrant in the Goguryeo Kingdom, soft and sophisticated in the Baekje Kingdom, and unassuming and simple in the Silla Kingdom. The Unified Silla dynasty adopted the calligraphy practice of the Chinese Tang and Jin dynasties; the standard Ouyang Xun script and semicursive Wang Xizhi script were especially prominent.

Goryeo in the tenth and eleventh centuries continued to create writings based on previous calligraphic works. Tanyeon's lavish script, consisting of thin brushstrokes, entered the calligraphy scene in the twelfth century. His early calligraphy was inspired by Chinese Tang and Song works. He later developed his own innovative script, known as the Tanyeon script. During the thirteenth century, the Mongol invasions impeded the evolution of script styles. Yuan calligraphy was introduced to Goryeo in the fourteenth century, but most ordinary writings still followed previous calligraphy styles.

When Joseon's royal department for calligraphy was established, Korean calligraphy was able to develop further. The late Goryeo period was characterized by a revival of ancient script styles, such as the Wang Xizhi script, and the emergence of new modern scripts, including the Zhao Mengfu script. All these movements created an important framework for a new development of Korean calligraphy in the Joseon period.

Insoo Cho

WRITINGS IN THE JOSEON DYNASTY

1

Yi Wanwoo, *Yeongjo eopil* (Suwon: Suwon Museum, 2015), 202.

With its ruling ideology of Confucianism, the Joseon dynasty (1392—1897) was structured as a merit–based society. Individuals were appointed to public office based on ability, in contrast to the preceding Goryeo dynasty (918—1392), in which social standing was based on hereditary rank. To become a high–ranking official in the Joseon dynasty, one dedicated oneself to the study of Confucian texts and had to pass difficult civil service examinations—regardless of one's inherited status. This system established a bureaucracy in which scholar–officials nearly overpowered royal authority. Even within the ruling class, the scholar–official (*munin*), a man of letters who devoted himself to the study of Confucian classics, was ranked higher than the military officer (*muin*), who perfected his martial arts skills. The scholar–official was also in a higher position than those in technical fields, such as law, medicine, and astronomy. In all practicality, focusing on one's education was the sole path to success in Joseon society.

Literacy was the most important factor in determining status. As symbols of learning, books and documents were treasured and produced in great quantities. Script and books were not merely means for communicating information but were also important media through which power, rank, gender, and wealth were made visual and material. Works of calligraphy can therefore be seen not only as art objects but also as embodiments of the Joseon dynasty's visual and material culture.

Writings can be sorted by various criteria: rank (royalty, scholar–official, middle class, commoner, monk), material (paper, silk, wood, stone, metal), format (document, book, scroll, large–scale monument, small crafts), content (official document, religious scripture, work of literature, record, letter, *hyeonpan*, or signboard affixed to a building), form (size, script type, writing style), or space (where the writing is being created and where it is being read). The object on which script is written is capable of transformation, often moving through rank, material, format, content, and form. For example, the phrase *wiseon* (do good deeds), written with brush on paper or silk by King Yeongjo (r. 1724—76), was later engraved in stone (see cat. 33), made into a rubbing, and included in the book *Yeongmyo eopil* (King Yeongjo's writing; fig. 44). The king's handwriting was copied by a scribe, carved by an engraver, and made into a rubbing by a master craftsman, then published after the king's death by his grandson and successor, King Jeongjo (r. 1776—1800), who distributed it to members of the court. Of the thirteen examples of King Yeongjo's writing included in *Yeongmyo eopil*, the largest is *wiseon*, a favorite phrase of the king derived from ancient Chinese Confucian classics. In fact, King Yeongjo frequented a building named Wiseondang (Hall of Good Deeds) in Gyeonghuigung (Gyeonghui Palace).[1] The phrase passed through various hands and was reproduced and disseminated in a number of ways, with each example revealing a different textuality and visuality.

Not merely a combination of words that communicates meaning, calligraphy acts with agency, mediating among people. In order to understand the writings of the Joseon dynasty, we must consider not only the famous calligraphers but also the existence of unnamed transcribers. Both the large-scale writing on objects, such as signboards, and the small script on commemorative stones gave precedence to the overall visual effect rather than legibility, bringing these scripts closer to nonfigurative art; the scripts are more notable for how they look than what they say. In addition, given their inherent documentary qualities, it is important to consider how the writings were collected, remembered, and reproduced. With this in mind, this essay examines works in the exhibition in order to explore the writings of the royal family, of the literati, of daily life, and of *hangeul*, another form of script.

FIGURE 44
Ink rubbing of the phrase *wiseon*, from *Yeongmyo eopil* (*King Yeongjo's Writing*), 1776. Ink on paper; 16⅜ × 11¼ in. (41.5 × 28.4 cm). Jangseogak Archives, Academy of Korean Studies, Seongnam

2
Some crown princes, like Crown Prince Hyojang, received a certificate of investiture from the Qing emperor. Today, thirty–two certificates of investiture remain. See Kim Gyeong–mi, "Gyomyeong of the Joseon Dynasty in the National Palace Museum Collection," *Palace Culture* 2 (2008): 61—83.

3
See JaHyun Kim Haboush, *The Memoirs of Lady Hyegyong: The Autobiographical Writings of a Crown Princess of Eighteenth–Century Korea* (Berkeley: University of California Press, 1996).

4
Images of *uigwe* (royal protocols) for the royal wedding of Crown Prince Sado on the National Museum of Korea's Oegyujanggak Uigwe website at http://museum.go.kr /uigwe/content/viewer?id=uig _157&contentid=uig_157_0090.

5
See National Palace Museum of Korea, *Royal Investiture Books of the Joseon Dynasty: Gyomyeong, Bamboo Books, Gilt Books* (Seoul: National Palace Museum of Korea, 2017), 120—25.

As a monarchy Joseon highly valued scripts related to the royal court. In royal investiture ceremonies—such as those for a king, queen, crown prince, or crown princess—the writing was the most important element on the attendant certificate of investiture, royal investiture book, and royal seal. Joseon kings received certificates of investiture and royal seals first from the Ming and later from the Qing emperors in China. In turn, Joseon kings bestowed certificates of investiture (*gyomyeong*), royal investiture books (*eochaek*), and royal seals (*eobo*) on the queen, crown prince, and crown princess.[2] When a crown princess later became queen, she underwent a new investiture ceremony and received a new certificate of investiture, royal investiture book, and royal seal marked with script specific to that ceremony. When a new honorary title was bestowed on a king or queen during his or her lifetime or posthumously by the court or succeeding kings, a new royal seal and royal investiture book were created.

Lady Heongyeong, better known by her residential palace title, Lady Hyegyeong, became crown princess upon her marriage to Crown Prince Sado (1735—1762) in 1744.[3] A white paper (*baekseo*) includes a detailed record of the extravagant wedding, complete with specific illustrations to ensure a flawless grand procession.[4] At the head of the procession, soldiers and courtiers escort three large palanquins carrying the certificate of investiture, royal investiture book, and royal seal. Created specifically for the event, these three objects are currently in the collection of the National Palace Museum of Korea.

Lady Hyegyeong's certificate of investiture is in the form of a scroll, made of five pieces of different–colored silk mounted together and elaborately decorated; at the beginning, King Yeongjo's requests to his new daughter–in–law were written in neat script (fig. 45).[5] The words "certificate of investiture" on the first part of the scroll were written in *jeonseo* (seal script) by Second Vice Premier Jo Hyeonmyeong (1690—1752). The main text was composed by First Vice Premier Song Inmyeong (1689—1746) on behalf of the king, and transcribed in neat *haeseo* (standard script) by Nakpunggun Yi Mu, a member of the royal family.[6] The text includes a glowing passage about Lady Hyegyeong,

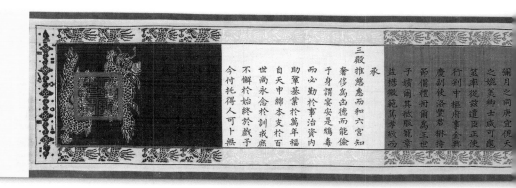

6
For detailed information on this certificate of investiture, see Gyujanggak Library, *Haejejip Uigwe in Gyujanggak Library Collection* 3 (Seoul: Seoul National University Gyujanggak Library, 2005), 404.

7
See *Royal Investiture Books of the Joseon Dynasty*, 306—9.

8
See National Palace Museum of Korea, *Royal Investiture Books of the Joseon Dynasty: Jade Books* 5 (Seoul: National Palace Museum of Korea, 2017), 22—28.

9
Royal investiture books were produced continuously from the beginning of the Joseon dynasty, but all books kept in the Jongmyo Shrine were lost during the Byeongja War (1636). The extant royal investiture books all hail from after that time. See Kim Mun-sik, "The Present Condition and the Distinct Features of Joseon-Period Royal Investiture Books," *Palace Culture* 9 (2016): 9—37.

which states that she was born to a good family, her disposition is gentle, she comports herself with modesty, her figure is as lovely as that of a heavenly being, and she is the same age as Crown Prince Sado. But the pair's marriage did not last very long: in 1762 Crown Prince Sado, suffering from mental illness and acting erratically, was locked by his father in a wooden rice chest, where he perished.

Royal investiture books were generally made of bamboo, jade, or gilded metal, and Lady Hyegyeong's, made from bamboo, praised her good deeds.[7] To make it, six long, flat bamboo pieces were connected together, and the top and bottom were covered in red silk. This was then secured against a gilded metal plate to make a flat surface, and six such plates were joined with rings to create a single book. In ancient times, books had been made by linking wooden plates together, and the Chinese character for "album" (冊) originated from their appearance. The royal investiture book was a descendant of that form.

After Crown Prince Sado's tragic early death, his son ascended to the throne as King Jeongjo. Known for his deep filial piety, King Jeongjo celebrated the sixtieth birthday of his mother, Lady Hyegyeong, in 1795 by bestowing on her an honorary title and commemorating this event with a royal investiture book made of jade.[8] This jade book is composed of ten plates, with each plate made from five jade strips tied together. This was the fourth royal investiture book King Jeongjo gifted to his mother, who received a total of nine such books. The collection of the National Palace Museum of Korea currently contains 294 royal investiture books—the majority of the royal investiture books that had been stored in Jongmyo Shrine, the Joseon dynasty's royal ancestral shrine.[9]

The inscription of a royal investiture book followed a complex process. In the case of the bamboo royal investiture book mentioned above, made in 1744, Buhogun Yi Deoksu (1673—1744) composed the passage, and Jo Myeong-gyo (1687—1753), the deputy governor of Gaeseong, inscribed it. The jade royal investiture book of 1795 was composed by deputy chief scholar of the Office of Special Advisers Gu Sang (1730—?) and inscribed by administrative clerk

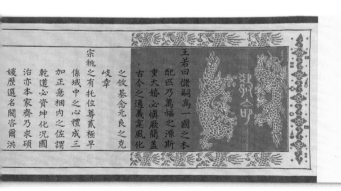

FIGURE 45
Hyeongyeongwanghu gyomyeong (Queen Heongyeong's Certificate of Investiture), 1744. Ink on silk; 14 × 114¼ in. (35.5 × 290.2 cm). National Palace Museum of Korea, Seoul

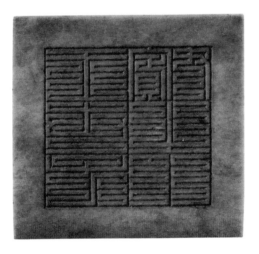

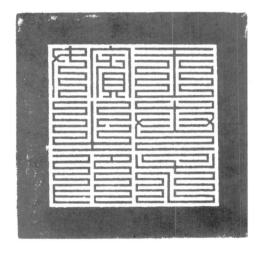

FIGURE 46
*Jade Seal of Queen
Heongyeong*, 1744.
Jade; 3⅝ × 4 × 4 in.
(9.1 × 10.1 × 10.1 cm).
National Palace
Museum of Korea,
Seoul

FIGURE 47
Bottom view and
impression of *Jade Seal
of Queen Heongyeong*

10
See Jang Uel-Youn, "Bibliographical Consideration of the Manuscripts of Answers on Policy and Stratagem for the Final Round of Civil Service Examinations," *Journal of the Institute of Bibliography* 33 (2009): 185—213.

11
Cultural Heritage Administration, *Royal Seals of the Joseon Royal Family*, vol. 1 (Seoul: National Palace Museum of Korea, 2010), 648—49.

12
See National Palace Museum of Korea, *The Royal Seal, A King's Symbol* (Seoul: National Palace Museum of Korea, 2012), 226.

Gweon Eom (1729—1801). This was then copied by a court calligrapher (*sajagwan*), cut into appropriate sizes, pasted onto the bamboo or jade strips, engraved in hollow relief by an engraver, and painted in with gold powder by a court painter.[10]

The royal seal received by Lady Hyegyeong on the occasion of her wedding is made of jade and has a turtle-shaped handle (figs. 46, 47). On the bottom are the words *wangsejabinjiin* (seal of the crown princess).[11] After the death of Crown Prince Sado, Lady Hyegyeong was no longer able to use this seal owing to her changed status; she received a new royal seal engraved with the words *hyebinjiin* (seal of Princess Hye). But once her loyal son ascended to the throne, he restored her to the rank of crown princess and made her jade royal seals on four separate occasions.

The king's royal seal verified state documents and was the most important object embodying royal authority. The ceremony at which the crown prince became the new king concluded with the transfer of the previous king's royal seal to the new king. Beyond their administrative authority, royal seals were also made for ceremonial purposes, and many such seals were created in the Joseon dynasty. Records indicate the creation of 368 royal seals; today, 327 are still in existence.[12] Many of these were made on the occasion of a change in rank or a new honorary title. Still in existence today are twenty-four seals made for Queen Sinjeong (1808—1890), mother of King Heonjong (r. 1834—49). Royal seals were usually made of jade, silver, or gilded metal, and their handles took the form of a dragon or turtle. On the bottom of the seal, symmetrical *jeonseo* (seal-script) characters were engraved in relief. The number of characters on a royal seal ranged from as few as four, on a seal that said *joseonwangbo* (seal of the king of Joseon), to as many as 116, as in the example of the seal of the posthumously crowned king Munjo (1809—1830).

The king and his court consulted on the characters that were to be carved on a royal seal. A courtier or royal with an excellent *jeonseo* hand was selected to write the characters. Lady Hyegyeong's first royal seal was written in the hand of Jo Myeonggyo. For the royal seal, a few options were drafted and presented to the king for his selection. The court calligrapher copied the characters, a court painter drew them on the face of the seal, and an engraver engraved them.

Certificates of investiture, royal investiture books, and royal seals were objects that visually and materially confirmed the king's authority. The owner of one of these objects was identifiable, and his or her special qualities were commemorated through the inscribed characters. As palace treasures, they were enveloped in many layers of wrapping cloths (*bojagi*) and boxes and secured with decorative cords, keys, and locks. These were stored in the palace's living spaces during the owner's lifetime and permanently enshrined at Jongmyo Shrine after the owner's death.

13
See Song Jinchoong, "The Life of Sajagwan Seolbong Gim Uisin and His Calligraphic Styles," *Art History* 34 (2017): 7—31.

14
See Busan Museum, *Paintings and Calligraphy in the Busan Museum Collection* (Busan: Busan Museum, 2016), pls. 67, 222.

The king never personally wrote on any of these objects. A courtier with excellent literary skill was usually tasked with writing the long passages of the certificate of investiture and royal investiture book. The person who composed various documents for the government and the royal family was a document official (*jesulgwan*). A courtier or royal member of the family talented in *jeonseo* or *haeseo*—a scribe official (*seosagwan*)—copied these documents. Many who passed the royal examinations excelled in calligraphy, and as they rose in rank they were often tasked with the writing of important passages on a royal investiture book or royal seal.

Court calligraphers (*sajagwan*) were government clerks who worked in offices handling diplomatic and royal documents. Their main task was to neatly copy diplomatic documents composed by document officials to retain legibility so the recipients could read them with ease. Court calligraphers often joined envoys to China or Japan and copied diplomatic documents in situ. As previously discussed, court calligraphers were also charged with copying important writings that needed to be engraved on bamboo, jade, or stone. Many of the royal documents and objects we see today were written in the hand of these court calligraphers.

Han Ho (1543—1605) was a famous court calligrapher and a favorite of King Seonjo (r. 1567—1608). Han wrote important documents for the state and the royal family and with his excellent ability to write in Wang Xizhi's (307—365) classical style, established the standard court calligrapher style of calligraphy (see cat. 39). Although Han was from a family of impoverished scholar-officials, court calligraphers usually belonged to the secondary class of "middle people" (*jungin*) and were of lower rank, along with court painters, interpreters, and doctors. Even today, the works of court calligraphers have largely been overlooked in the study of calligraphic history. Since they used a neat, established style in public documents, the individual styles of the court calligraphers were not revealed. Therefore, not much is known about their work as calligraphers, and few of their signed works remain in existence.

A rare exception to this relative invisibility of the court calligrapher is Gim Uisin (d. after 1663).[13] He worked as a court calligrapher for more than forty years, and in 1643 and 1655 he traveled as a member of diplomatic missions to Japan. Several signboards he wrote during his trip remain in Japanese monasteries. A number of calligraphy works he made in Japan still exist as well. One example is *Myeonggu* (*Famous Adage*), in the collection of the Busan Museum (fig. 48). The character for luck (福; K. *bok*; Ch. *fu*) is written at the very top in large *haengseo* (semicursive or running script), and underneath are three lines of *choseo* (cursive script): "Wishing ever-increasing luck in the future and hoping for fairness renewed daily." This follows the character arrangement on calligraphy scrolls that were popular in Japan at the time. At the end, Gim Uisin signed with his pen name, Seolbong, and pressed his seal. The *haengseo* and *choseo* he employed in this work were not used in official documents; moreover, he even left his signature.[14]

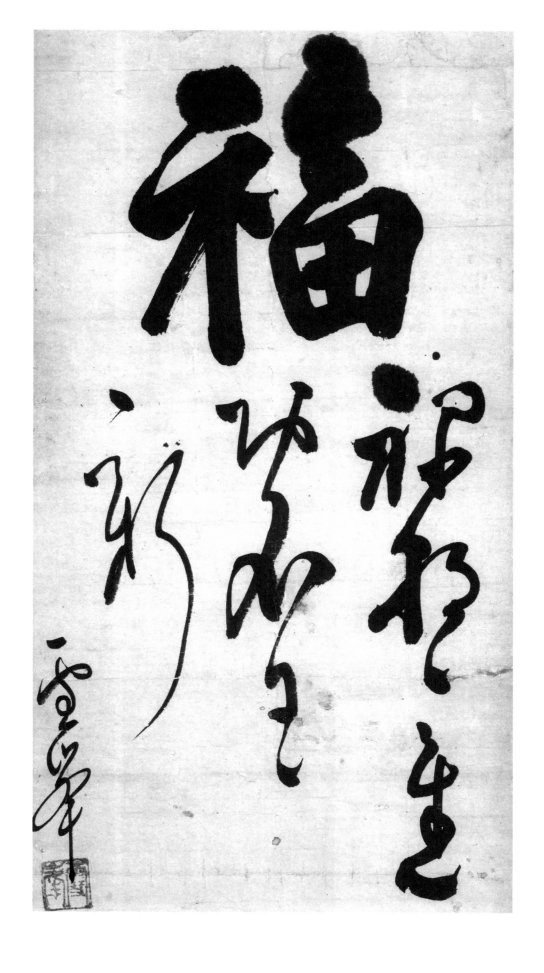

FIGURE 48
Gim Uisin (d. after 1663),
Myeonggu (*Famous
adage*), 17th c. Ink
on paper; 23 × 11¼ in.
(58.3 × 28.5 cm).
Busan Museum

15
Quoted in Hwang Jeong-yeon, *A Study of the Repositories of the Paintings and Calligraphy of the Joseon Dynasty* (Seongnam: Shingu Publishing, 2012), 327.

16
Song, "The Life of Sajagwan Seolbong Gim Uisin," 25.

17
See Hwang, *A Study of the Repositories,* 164, 236.

18
See Yi Wanwoo, "Publication and Distribution of *Yeolseongeopil* in the Late Joseon Dynasty," *Jangseogak* 30 (2013): 146—93.

The calligraphic works Gim Uisin produced in Japan are remarkable in that they are not written in the neat, small *haeseo* characters that he used in his official capacity, but in large, distinctive script. Nangseongun Yi U (1637—1693), an excellent calligrapher and King Seonjo's grandson, knew Gim Uisin very well, and when Gim died he praised his calligraphy: "His writing prompted the price of paper to rise high, and it is as if a fish might jump from his inkstone."[15] This passage suggests that Gim's work was so popular that paper grew scarce in the market and that his strokes were as dynamic as a fish leaping out of his inkstone and thrashing on the paper. Later, however, famous art collector and critic Yi Ha-gon (1677—1724) opined that Gim's writing was "excellent but has the flaw of being crude."[16] This negative opinion about Gim's skillful and refined but utilitarian writing style reveals the bias against the lower-status group to which court calligraphers belonged.

Although their writing was not on certificates of investiture, royal investiture books, or royal seals, the kings of Joseon were scholars, excellent stylists, and calligraphers. From a young age, they received strict educations and cultivated deep knowledge and refinement. Through affairs of state or their personal literary activities, Joseon kings left many writings and works of calligraphy. They personally wrote certificates of appointment for certain officials, sent letters requesting counsel from courtiers, and dispatched private letters asking after family and relatives. From time to time, the kings also wrote passages that would be engraved on stone memorials.

The king's compositions were called *eoje* and the king's writings were called *eopil*. The king's compositions and writings conveyed his disposition and the dignity of the dynasty; they were, therefore, treasured and safeguarded. But the Imjin War (1592—98) and the Byeongja War (1636) resulted in the destruction of earlier kings' writings. After the wars, the palace made efforts to collect previous kings' writings that were still extant. A large reward was given for examples that were discovered outside the palace and returned, which caused a number of people to make fakes to offer to the court.[17] The kings' writings were stored in various archives with other important royal documents, and they were sometimes copied and given out to royal family members or courtiers.[18]

In 1662, under the supervision of the Office of Royal Genealogy, *Yeolseong eopil* (Calligraphy of successive sage-rulers), a collection of the nine preceding kings' writings, was published for the first time (see cat. 31). Nangseongun Yi U, the calligrapher who had praised Gim Uisin, oversaw the project. Later, when a new king ascended to the throne, the preceding king's writings were added, and the volume was republished. The books were printed in two ways: from slate plates with the characters engraved in hollow relief, and from woodblocks with embossed characters. The 1725 edition of *Yeolseong eopil* included a compilation of 102 pages of writings by kings up to King Sukjong (r. 1674—1720). Of the three hundred books produced, half were printed from woodblocks and half were printed from slate plates. They were distributed to royal relatives and courtiers. Later, King Yeongjo compiled his own writings, and *Yeongmyo eopil,* discussed earlier, was published posthumously.

19
Jeongjoeochal, exh. cat. (Seoul: National Palace Museum of Korea, 2011), 184—85.

20
See An Dae–hui, *Jeongjo's Secret Letters* (Paju: Munhak Dongne, 2010).

Within the category of kings' writings are *eochal,* or letters written in the king's hand. Letters were an important mode of communication in the Joseon dynasty, and it was no different for a king. Unusually for a monarch, King Jeongjo was a prolific letter writer, and today more than 1,200 letters he authored remain in existence. The letters can be divided into those he sent to relatives and those he sent to his courtiers. King Jeongjo's letters were straightforward and thoughtful, and it is said that the descendants of his recipients were moved when reading them. Even nonrelatives were touched by the king's writing: Yi Sangsu (1820—1882) was moved to tears when he happened to read over Yun Jeonghyeon's (1793—1874) shoulder the king's kind words asking after his favored courtier, Yun's father, Yun Haengim (1762—1801).[19]

There were also secret letters. Over a period of four years, King Jeongjo sent more than 350 letters to Sim Hwanji (1730—1802), the leader of the faction that opposed him and the person who was later rumored to have fatally poisoned him. The two had negotiated behind the scenes over complicated affairs of state and personnel issues. King Jeongjo had ordered Sim to destroy the letters after he read them, but Sim did not carry out this directive.[20] Thanks to Sim's disregard of royal orders, we are able to appreciate King Jeongjo's fluid handwriting and discover his impatient, humorous side. King Jeongjo would refer to a courtier who did not follow his orders as "someone who is so flippant to the point of dizziness that he can't tell [the difference] between east and west" and expressed colloquialisms in Chinese characters that had the same pronunciation as the Korean sayings (fig. 49).

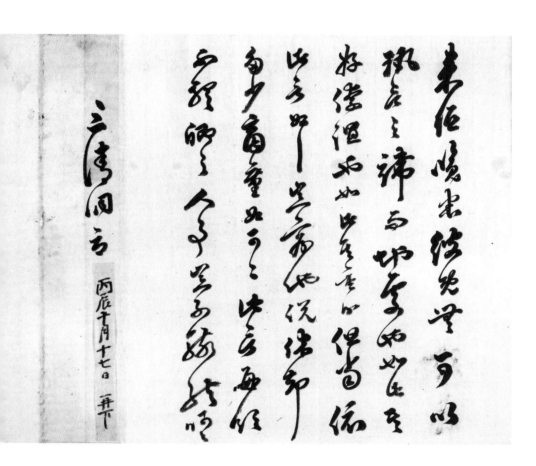

FIGURE 49
King Jeongjo (r. 1776—1800), *Letter Sent to Sim Hwanji,* 1796. Ink on paper; 12½ × 11½ in. (31.5 × 29 cm). Private collection

21
O Sechu took the exam in a *siknyeon* year, when a total of one hundred people passed, and was chosen as the fifty–fifth of the third class, which was the eighty–fifth place overall. See *National Palace Museum: Exhibition Catalogue* (Seoul: National Palace Museum of Korea, 2007), 37.

22
See *Sigwon: Listening to the Wisdom of State Management* (Seongnam: Academy of Korean Studies, Jangseogak Library, 2015).

23
See Ahn Hwi–joon, "Literary Gatherings and Their Paintings in Korea," *Seoul Journal of Korean Studies* 8 (1995): 85—106.

Knowledge and culture were regarded highly in the Confucian Joseon dynasty, and thus education and competition were the axes that maintained society, as reflected in the system of civil service examinations employed to select government officials. By the late Joseon dynasty, despite the fairly constant number of positions available, the number of candidates had grown continuously, and competition had become fiercer. Though thousands came to take the tests, only about thirty people could become highest–level officials each year.

A *sigwon* was the answer sheet completed by a test taker, on which the grader recorded results. When a candidate passed the exam, the *sigwon* was returned to him with the certificate of passage and was treasured for generations by proud descendants. Starting at the end of the sixteenth century, the candidate's handwriting was also judged, and, therefore, two exam questions were issued, with one to be completed in *haeseo* and the other in *choseo*. On the *sigwon* of one O Sechu (b. 1645), completed in 1676, the front is written in neat *haeseo* and the back is written in florid *choseo* (figs. 50, 51).[21] The practice of writing the exam in two styles continued until 1740. Later, when cheating became more prevalent, a system was established to ensure that the grader could not recognize the candidate's handwriting, with clerks copying answers for the grader to judge.[22]

After passing this difficult civil service examination, a scholar received his post and began his work. In the Joseon dynasty, documentary paintings were created in vast quantities, and a significant proportion of them were *gyehoido*, or paintings made at literary gatherings composed of people who passed the civil service examination in the same year or who worked together in a specific government office (see fig. 20).[23] Literary gatherings were held both in the open air and indoors, and the participants dined, drank, and enjoyed song and dance performances. These *gyehoido* depicted landscapes or buildings, depending on the gathering spot. In many examples at the top the name of the gathering was written in *jeonseo*, at the bottom the participants' positions were listed in *haeseo*, and in the middle a poem was written in *choseo*. The title and poetry were written by an official with excellent calligraphy skills, and the painting was made by a professional artist, while the list of names at the bottom was written in a classical–script style by a court calligrapher.

As we saw in the example of King Jeongjo's correspondence, letters were used for quick exchanges of news between intimates. Their contents were easy to understand and included specifics, and the writing was usually in *haengseo* and *choseo*. But a new phenomenon occurred when the famous sixteenth–century Confucian scholar Yi Hwang (1501—1570) published a collection of letters by the respected Chinese scholar Zhu Xi (1130—1200); this gave rise to a new method of reading letters. Yi also selected twenty–two of his own letters and compiled them into a book to encourage cultivation and introspection. Letters now assumed the role of guidelines for behavior and morals. Letters also allowed thinkers who lived far away from one another to engage

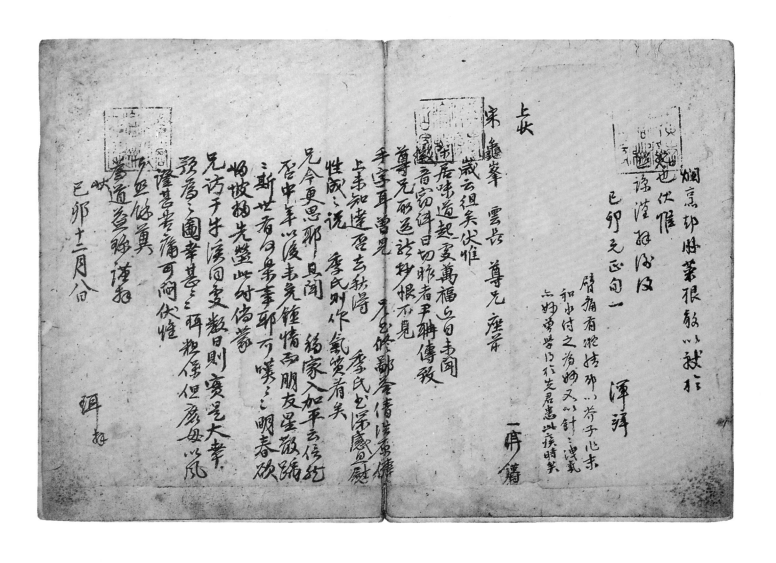

FIGURE 52
Yi I (1536—1584),
Letters to Song Ikpil,
from *Samhyeonsugan*
(*Handwritten Letters
of Three Wise Scholars*),
16th c. Ink on paper;
14⅝ × 10½ in.
(37 × 26.5 cm). Private
collection

24
See Hwisang Cho, "The Epistolary
Brush: Letter Writing and Power in
Choson Korea," *Journal of Asian
Studies* 75, no. 4 (2016): 1055—81.

25
See *The Three Teachers' Letters*
(Yongin: Hoam Art Museum, 2001).

26
See *Crown Prince Sado* (Suwon:
Suwon Hwaseong Museum, 2012),
266—67.

in scholarly debates. From time to time, such exchanges of letters took on the characteristics of a public debate. Philosophical discussions between Yi Hwang and Gi Daeseung (1527—1572) attracted the interest of scholars across the kingdom and as a result played a large role in increasing the influence of *sarim* (recluse scholars) in the sixteenth century. To that end, letters went beyond a simple method of communication and played a role in developing a collective political awareness.[24]

Descendants and disciples valued letters written by both ancestors and teachers and included them in literary collections or made special collections of letters. *Samhyeonsugan* (Handwritten letters of three wise scholars) contains ninety–eight letters exchanged for more than thirty years between the great sixteenth–century thinker Yi I (1536—1584; sobriquet Yulgok), Seong Hon (1535—1598), and Song Ikpil (1534—1599), compiled into four volumes by Song's son.[25] Their correspondence, which began when the three men were in their twenties, touches on daily life, debates about scholarship, political opinions, and longing for Yi, who was the first among them to die. Song's handwriting is dynamic, Yi's is nimble, and Seong's is smooth (fig. 52). In such cases, letters were now being read by a third party, changing their function; Sim Hwan–ji's disobedience of King Jeongjo's orders to destroy their secret letters can be understood in this context.

In addition, the ability of letters to allow the quick exchange of opinions made them vehicles for collective appeals to the king. Traditionally, a courtier would write a memorandum to the king about his views on policy, and in the Joseon dynasty, Confucian scholars, both alone and in groups, let their views be known through memorandums. As collective appeals grew larger in scale in the late eighteenth century, the *maninso*, a joint memorandum signed by ten thousand people, became a phenomenon. Such appeals occurred a total of seven times. One example was in 1855, the 120th anniversary of the birth of Crown Prince Sado, when the Namin, the political faction of the southeast, sent a *maninso* that argued that Crown Prince Sado should be honored as a king. According to the surviving draft, 10,432 people signed the petition, which was about 44 inches high and 316 feet long (1.1 by 96.5 meters).[26]

Confucian scholars of the Joseon dynasty did not focus solely on the practical aspects of writing. They were also very interested in calligraphy and appreciated the artistic value of writing. The reason Yi Ha–gon considered court calligrapher Gim Uisin lowly was because Yi collected calligraphy as art objects. For him, it was not art if the handwriting was not imbued with the writer's personality or was created for the purpose of recordkeeping. Yun Jeonghyeon, who treasured King Jeongjo's letter to his father, primarily did so out of loyalty to the king and his father. However, he also appreciated the art of calligraphy, as evidenced by his thirty–year wait for his pen name, Chimgye, to be written in a style both classical and innovative by his teacher, master calligrapher Gim Jeonghui (1786—1856; see cat. 80).

27
See Hwang, *A Study of the Repositories,* 119—21.

28
See *Model Book of Calligraphy: Chinese Rubbings* (Seoul: National Museum of Korea, 2014), 101, n. 31.

29
See Yoo Ji-bok, "Study of Haedongmyeongjeok Woodblock Book," *Journal of the Institute of Bibliography* 65 (2016): 213—41, and "Study of Haedongmyeongjeok Slate Book," *Jangseogak* 36 (2016): 32—76.

Many people coveted great works by famous calligraphers. Yi Mun-geon (1495—1597), who was exiled to Seongju, Gyeongsang Province, invited Hwang Giro (1521—1567), renowned as the foremost writer of *choseo,* to his house many times and showered him with hospitality in an attempt to receive one of his works.[27] Opportunities to obtain excellent calligraphic examples grew, along with the development of copying methods. The handwriting of renowned calligraphers was carved into wood or stone and then made into rubbings, which were compiled and published as books. Among such books was *Sunhwagakcheop* (Model letters in the Imperial Archives in the Chunhua era), published by the Song imperial family in China, reengraved and reprinted in the Ming dynasty, and introduced to Joseon in the fifteenth century.[28] This publication influenced the production of books composed of rubbings of historically famous works by Korean master calligraphers, and the first such book was *Haedongmyeongjeok* (Renowned writings of Korea), a woodblock-printed book published by Sin Gongje (1469—1536), the governor of Changwon.[29] Across 169 pages, 106 works by forty-two calligraphers from the Silla Kingdom to the early Joseon dynasty were featured, including Gim Saeng's (711—?) *Nanggongdaesa Stele* (*Stele Commemorating the Great Master Nanggong;* see cat. 17). This book was reprinted in 1530 from slate plates and afterward was recarved and reprinted several more times.

Not very many original writings on paper or silk survive, but numerous inscriptions on stone remain. Nangseongun Yi U collected the rubbings of old stone memorials scattered throughout the nation and in 1688 published in *Daedong geumseok seo* (Stone inscriptions in Korea). The preface to the book was composed by his friend and epigraphy expert Heo Mok (1595—1682). Heo studied the ancient epigraphs and wrote in his own unique *jeonseo* (see cats. 40—42). This volume includes more than three hundred works from the Silla Kingdom to the rule of King Sukjong, along with many examples of Buddhist inscriptions from the Three Kingdoms era and the Goryeo dynasty. As Joseon Confucian scholars disapproved of Buddhism, it is clear that Heo focused on calligraphy as an art form regardless of its religious content.

WRITINGS IN EVERYDAY LIFE

Nangseongun Yi U directed his many slaves in Gyeongsang Province to make rubbings of stones in the area to include in *Daedong geumseok seo.* Stones were often erected in everyday spaces and even when erected on a gravesite could be approached without restriction. Large stones were an important element in visual culture, not only for literati but also for the common people. Even the illiterate would have been impressed by the size, as well as the visuality and materiality of the characters carved into the stone surface.

30
See Yi, *Yeongjo eopil*, 232—35.

31
Yun Jin-yeong, "The Production of Stele Rubbings in the Joseon Dynasty," *Jangseogak* 12 (2004): 175—214.

32
See Baek Seung-ho, "A Political Tendency in the Literature of Beon-Am Chae, Jae-gong," *Jindan Hakbo* 101 (2006): 359—90.

33
See *2016 Geumseokmun Rubbing Inquiry Report: North Gyeongsang Province*, vol. 3 (Daejeon: Cultural Heritage Administration, 2016), 244—47.

In many instances a king wrote the characters to be inscribed in stone. In an attempt to manage intense political upheaval, King Yeongjo proclaimed a policy of impartiality (*tangpyeongchaek*) to find a balance between factions. In 1742 he had a large commemorative stele erected at the entrance to the Seonggyungwan, or National Academy, and had his writing stating the policy engraved on it.[30] The Seonggyungwan was the school where Confucian students who passed the civil service examination on their first attempt were educated to prepare them for futures as administrative officials. In erecting a commemorative stele there, King Yeongjo emphasized that students should not be swayed by political factions but carry out their official future duties with impartiality. King Jeongjo's handwriting also adorns many stone monuments. On the face of Yeongjo's tombstone, he wrote the name of the royal tomb in *jeonseo,* and on the back he listed the late king's accomplishments in *haeseo.* When a stele with a king's writings was created, several dozen rubbings were made and turned into elaborate scrolls to be kept in the royal family and given to officials who assisted with the making of the stele (fig. 53).[31]

One means by which Joseon Confucian scholars expressed their filial duty to their ancestors was the erection of tombstones. A *sindobi*, a large monumental stele that stood on the path to a tomb, was reserved for those who had served in government at the second-deputy rank and above. The accomplishments of the deceased were recorded in detail on the stele. Descendants requested famed scholars to compose passages praising their ancestors and renowned calligraphers to write the scripts. As manufacturing such steles was costly and arranging for famed writers and calligraphers to participate was difficult, it often took a long time after the individual died before a *sindobi* could be erected.

Among scholar-officials politics played a large part in the process of requesting the composition of an epitaph. For example, Chae Je-gong (1720—1799), a Namin who served as prime minister and lived in Hanyang (now Seoul), composed the text for tombstones of other Namin in Gyeongsang Province in order to unite the Namin faction, which was smaller than the Seoin (western) faction.[32] Likewise, when Heo Mok wrote the prologue for Nangseongun Yi U's *Daedong geumseok seo,* this went beyond friendship, as both belonged to the Namin faction.

The *sindobi* of Gim Yeon (1487—1544) in Andong, Gyeongsang Province, was erected by his descendants in 1812 (figs. 54, 55).[33] The title at the top of the stone was written by Gang Sehwang (1713—1791), who excelled at calligraphy and painting, and the epitaph, composed by Chae Je-gong, was written by his brother-in-law O Daeik (1729—1803). All three died before the stone was

朝鮮國
英宗大王元陵

英宗至行純德英謨毅烈章義弘倫光仁敦禧體天建極聖
神化大成廣運開泰基永堯明舜哲乾健坤寧翼文宣武熙
敬顯孝大王
崇禎紀元後六十七年甲戌九月十三日
誕生己卯封延礽君辛丑册封王世弟甲辰卽位丙申
三月初五日昇遐七月二十二日癸于楊州健元陵
西苇二岡亥坐之原在位五十二年壽八十三 二十二日改
崇禎紀元後一百四十九年 月 日立

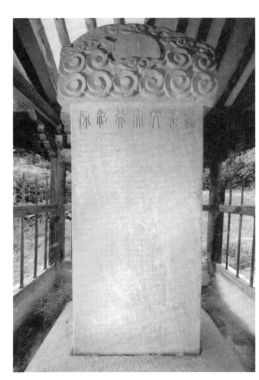

34
The use of *ssanggubeop* to depict letters was a technique used from ancient times. See Lothar Ledderose, "Chinese Calligraphy: Its Aesthetic Dimension and Social Function," *Orientations* 17, no. 10 (October 1986): 47—48.

35
See Kim Min-gyu, "Study of Stone Figures at Euneongun and Jeongyedaewongun Tombs," *Study of Art History* 295 (2018): 40.

36
LACMA acc. no. M.2002.183.1a—h.

erected; this suggests that even though the composition and calligraphy had been completed, there was a reason the stele could not be erected right away. Gim Yeong (1765—1840), the eighth-generation descendant of Gim Yeon, published a compilation of all of Gim Yeon's writings in 1783, and Chae Je-gong wrote the preface. It is likely that the composition and the calligraphy for the *sindobi* were also prepared around this time.

Engraving small script in hard rock was a complex process. Chae Je-gong composed the text, O Daeik inscribed it, and someone, possibly a court calligrapher, would have copied it onto paper. To do this, the laborious *ssanggubeop* technique was used to draw thin lines along the contours of the small characters and fill their interiors with ink.[34] In order to copy the characters and engrave them on the surface of the stone, wax was pasted on a sheet of paper onto which the characters were copied; the characters were visible through the back of the paper. Red lines were drawn along the outlines of the characters; these were sometimes handled by a professional painter. The paper was then pasted to the stone, and the face of the paper was rubbed to transfer the red lines onto the stone; the engraver cut along those lines. Not much is known about such engravers, but some names remain. There were as many engraving methods as there were writing styles: for hollow relief engraving, a wedge technique produced a deep, sharp indentation toward the inside of a stroke; a concave technique smoothly carved the inside of a stroke; a flat technique evenly and flatly carved the entire stroke; and a dome technique carved the outer edges of a stroke more deeply to make a domed middle.[35]

A monument stele stood tall above the ground in order to be easily seen, but a memorial epitaph stone was buried underground near the mound of a tomb. In the Joseon dynasty, a tomb epitaph tablet (*myoji*) was used, either by engraving on stone or by writing in cobalt pigment on white porcelain. LACMA's collection includes a series of blue-and-white porcelain epitaph tablets (*cheonghwabaekja myoji*; cat. 47).[36] For the epitaph tablets of civil servant Seo Yu-gyo (1755—1812), his relative Seo Yeongbo (1759—1816) composed the epitaph memorial, which is written on eight plates of white porcelain in a style characteristic of a court calligrapher. The eight plates were stacked in order

FIGURE 53
Ink rubbings from *King Yeongjo's Tomb Stele*, 1776. Ink on paper; each: 60⅝ × 23⅞ in. (153.7 × 60.6 cm). Jangseogak Archives, Academy of Korean Studies, Seongnam

FIGURE 54
Ink rubbing from *Sindobi of Gim Yeon*, 2016. Ink on paper; 71⅛ x 36½ in. (180.5 × 93 cm). Central Buddhist Museum, Seoul

FIGURE 55
Sindobi of Gim Yeon, 1812. Stone; height: 104¾ in. (266 cm). Andong, North Gyeongsang Province

37
See National Research Institute of Cultural Heritage, *Korean Art Collection of the Los Angeles County Museum of Art, U.S.A.* (Daejeon: National Research Institute of Cultural Heritage, 2012), 389, 407.

38
National Palace Museum, *The Art of Ornamentation and Arrangements* (Seoul: National Palace Museum, 2008), 64—65.

39
See Jang Gyeong-hui, "Analysis of Types and Content of *Donggwan-wangmyo Eoje Hyeonpan*," *Munhwajae* 49, issue 3 (2016): 52—77.

and buried in the ground in a large white porcelain bowl. Seo Yeongbo also composed an epitaph for Seo Yu-gyo's son Seo Heonbo (1775—1815). The characters were engraved in hollow relief on two stone plates, and this object is also in LACMA's collection (fig. 56). Seo Yeongbo composed the epitaph in honor of his younger relative; Seo Heonbo's friend Pak Jonghun (1773—1841) was the calligrapher. The unnamed engraver used the wedge technique to engrave the characters with care.[37] The tomb epitaph tablet, which included the deceased's name, genealogy, and life events, was buried underground without any indication of its presence aboveground; perhaps the use of materials and techniques that would not degrade indicated the hope that the deceased would be remembered for a long time.

Also prevalent in daily life were signboards (*hyeonpan*), wooden plates engraved with large writing that were hung above gates to structures or on walls. Many had the building's name engraved on them. For important palace buildings, courtiers sometimes lettered the signboards, and other times the king did so himself. A signboard made of the king's writings had the symbolic function of demonstrating the king's power and presence in a tangible way. In these cases the word *eopil* (king's writings) was engraved in small characters on the signboard. The signboard of Gyeongungung Palace was written in 1905 by King Gojong (r. 1863—1907), and was gilded to look even more splendid. When Gyeongbokgung Palace, which burned down during the Imjin War, was rebuilt in 1867, King Gojong lettered the various signboards that would go on a number of structures; the drafts remain in book form.[38]

Signboards featuring kings' writings also existed on structures outside the palace. As many as fifty-one signboards are at Donggwanwangmyo (the Eastern Shrine of Guan Yu), which enshrined the deified Guan Yu, China's Shu Kingdom general, based on the cult of Guan Yu that originated in China. Seven are by Kings Sukjong, Yeongjo, and Gojong, while the rest were written by emissaries and generals of China's Ming and Qing dynasties.[39] In Myeongryundang (Hall of Illuminating Ethics) at Seonggyungwan, there are many signboards on the ceiling (fig. 58). Among the most notable is a large one engraved with King Jeongjo's *Taehakeunbaesiseo* (Preface of poem bestowing silver goblets at the School of Great Learning; fig. 57). After administering a test to Seonggyungwan students in 1798, King Jeongjo bestowed on them food and silver liquor goblets and composed this commemorative writing, asking the students to study hard so that they could become excellent scholar-officials and important thinkers for the country. As is evident, passages written by kings and other well-known figures appeared in various living spaces throughout the Joseon dynasty.

通訓大夫弘文館校理兼
經筵侍讀官春秋館記注
官徐君諱憲輔宇邦彥公
達城高祖諱頠領議政文孝公
諱宗泰曾祖府左議政文翼公
諱懋命均祖府使諱秀軒公
公諱懋修考郡守諱有教母
慶州金氏府乙未九月三
君以英宗辛酉成進士
日生當寧辛酉記賜第甲戌
章末春魁到例付典籍歷
居殿試第一文學文重
禮曹佐即除副校理尋
入玉堂首選也累為校理
獻納皆俗撰副修撰乙亥秋為平
修撰副修撰以親老不赴
安道京試官

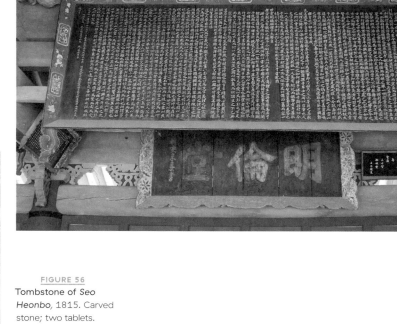

FIGURE 56
Tombstone of *Seo
Heonbo*, 1815. Carved
stone; two tablets.
Shown here:
a) 9⅜ × 14⅝ × 1½ in.
(23.8 × 37.2 × 3.8 cm).
Los Angeles County
Museum of Art, gift of
Patricia Suh and Joseph
Kim in honor of J.
Ha-Yong and Charlie B.
Suh, M.2002.183.2a

FIGURE 57
Wooden signboard
of *Taehakeunbaesiseo*,
1798. Wood.
Seonggyongwan, Seoul

FIGURE 58
Interior view of
Myeongryundang (Hall
of Illuminating Ethics),
1606. Seonggyungwan,
Seoul

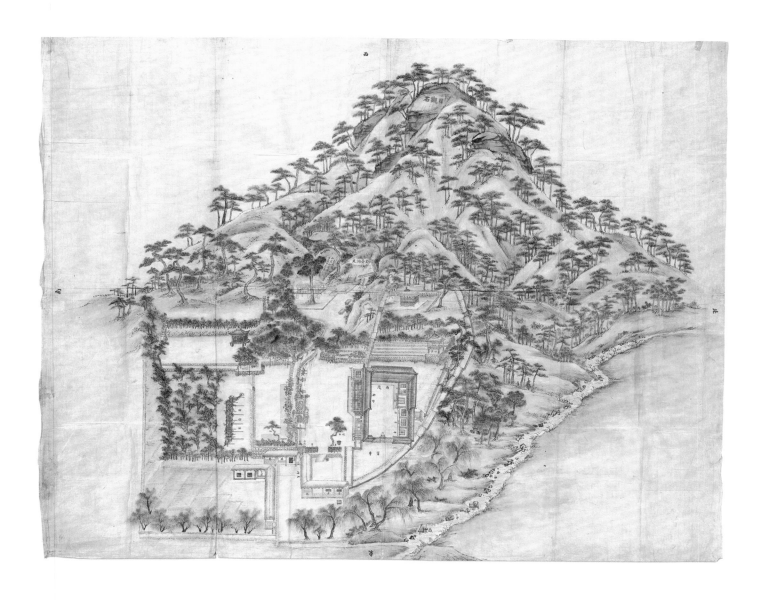

FIGURE 59
Okhojeongdo (*Painting of Okhojeong Pavilion*), 19th c. Color on paper; 59¼ × 74⅞ in. (150.3 × 190 cm). National Museum of Korea, Seoul, gift of Yi Chun-nyeong

FIGURE 60
Detail of *Okhojeongdo*

40

See Jang Jin–a, "About Okhojeongdo in the National Museum of Korea Collection," *Misul Jaryo* 91 (2017): 133—51.

41

See Sim Yeong–hwan, *Study of Choseo of Ancient Documents in the Joseon Dynasty* (Seoul: Sowadang, 2008).

The literati of Joseon sometimes took a break from their arduous studies and enjoyed the scenery at renowned destinations, such as Hanyang, the capital, which was surrounded by mountains and featured beautiful hills and valleys. People enjoyed nature and from time to time engraved calligraphy on boulders. Even today, in places around Seoul, one can find examples of ancient calligraphy engraved in rock. The painting *Okhojeongdo* (*Painting of Okhojeong Pavilion*) by an unknown artist, in the collection of the National Museum of Korea, depicts a large home (figs. 59, 60). On boulders behind the house at the foot of the mountain and on the mountain peaks, red calligraphy is visible, and the words read, *Okhodongcheon* (Jade Flask [Pavilion] at Celestial Grottoes) and *Hyesaengcheon* (Fountain of Giving Life). Located in Samcheongdong, just north of Gyeongbokgung Palace, and thought to have been established in 1815, Okhojeong Pavilion was the property of Gim Josun (1765—1831), the powerful father–in–law of King Sunjo (r. 1800—1834).[40] According to records, the word *Okhodongcheon*, which can be seen in large script on the rock, is engraved from calligraphy by Seo Yeongbo, the person who composed the writing on the epitaph tablets discussed earlier. Seo not only wrote small characters for epitaph tablets to be buried underground for the deceased, but also wrote on large boulders for the enjoyment of the living.

Calligraphy was everywhere in daily life. People exchanged various documents with government offices; requests were written in *haeseo*, while government decisions were written in *choseo*. Provincial government documents were usually composed by clerks, who wrote in *choseo*; while this script would have enabled the quick review of a pile of documents, it would also have allowed the maintenance of secrets and warded off counterfeit documents. Among the attributes of *choseo* was its ability to be read and written only by well–trained and highly educated people. Various documents concerned the transfer of slaves and land as well as adoption.[41] In addition, words were used to decorate clothing; on women's formalwear, such as garments for weddings, characters symbolizing long life, luck, health, and many sons were written in gold leaf or embroidery. These auspicious characters also adorned household objects, such as ceramics, incense burners, padlocks, and cigarette cases, in large sizes (see cats. 51—60). Design was prioritized for such usage, resulting in characters morphing into forms that were difficult to read.

42
Many such cases are introduced in *Hangeul, the Writing System of Communication and Consideration* (Seongnam: Jangseogak Archives, Academy of Korean Studies, 2016).

43
See Suwon Hwaseong Museum *Jeongjo, Practicing Art* (Suwon: Suwon Hwaseong Museum, 2009), 8—11.

44
See *Hangeul, the Writing System of Communication and Consideration,* 72—93.

A noteworthy characteristic of the Joseon dynasty's writing culture was the coexistence of *hanja*—Chinese characters—alongside *hangeul*. *Hangeul,* which was jointly created by King Sejong (r. 1418—50) and learned scholars, was a logical, simple, and easy-to-learn system, especially compared with other ancient writing systems. Unlike *hanja*, which originated in China, *hangeul* conformed to daily Korean speech, and thus was welcomed by average people, especially women. Paradoxically, the wider the reach of *hangeul,* the more it was shunned by the elite, who monopolized *hanja*; they referred to *hangeul* as *eonmun,* or vulgar writing, and treated it with disdain.

Despite the objections of the elite, *hangeul* took root in the Joseon dynasty. As soon as *hangeul* was created, the palace translated Confucian and Buddhist scriptures into it, and even kings used *hangeul* in their written communications with women, children, and subjects.[42] King Yeongjo gathered examples of model behavior demonstrated by early kings and translated those narratives into *hangeul* for the benefit of his crown prince, which unfortunately did not lead to Crown Prince Sado becoming a great king. In 1764, at the age of seventy-one, King Yeongjo made the crown prince's thirteen-year-old son a *hangeul* book that included ten moral lessons. The boy was more open to his grandfather's instruction and later became King Jeongjo.

There remain many *hangeul* letters sent by kings to their female relatives. When King Sukjong's mother paid a long visit to her married daughter outside the palace, the king sent his mother a *hangeul* letter urging her to return in haste. Having shown an inclination for letter writing at a young age, King Jeongjo ended up penning a staggering volume of letters. In a collection of letters by young Jeongjo, there is a *hangeul* letter he sent around age eight to an aunt, asking after her health (fig. 61).[43] As is evident in the case of Gim Jeonghui, male literati often wrote *hangeul* letters to their wives and daughters (see cats. 88, 89).

Hangeul was also useful in issuing royal proclamations.[44] King Seonjo, who fled to the northern frontier during the Imjin War, distributed a *hangeul* proclamation that stated that people would not be questioned for collaborating with the Japanese if they had been forcibly taken and that they should return quickly (fig. 62). This document reveals that some who had been exploited by corrupt officials welcomed and cooperated with the Japanese forces who defeated them. King Yeongjo also printed and distributed *hangeul* prohibition orders on alcohol consumption and decrees against wearing large, heavy wigs. The existence of these *hangeul* documents in fact suggests that people did not adhere to these royal edicts. King Jeongjo also ordered the translation of textbooks for the military (see cat. 73) into *hangeul*. In these ways *hangeul* effectively conveyed the kingdom's policies and decrees to the ordinary person.

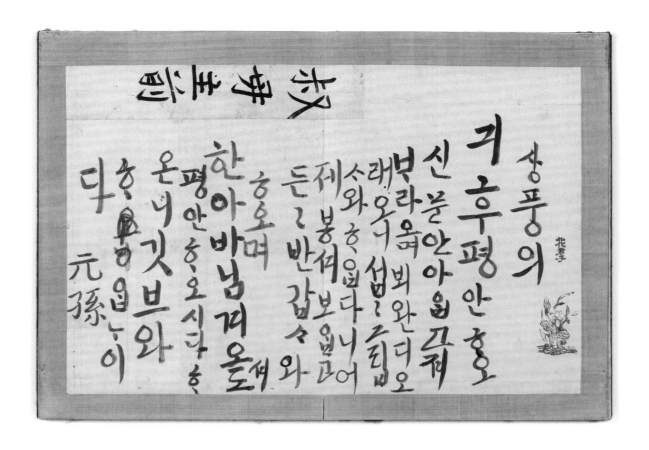

FIGURE 61

King Jeongjo (r. 1776–1800), *Letter to Aunt Min*, from *The Royal Album of* Hangeul *Letters of King Jeongjo*, 18th c. Ink on paper; 17⅝ × 12½ in. (44.5 × 31.5 cm). National Hangeul Museum, Seoul

FIGURE 62

King Seonjo (r. 1567–1608), *Royal Edict*, 1593. Ink on paper; 31½ × 14¾ in. (80 × 40 cm). Private collection

FIGURE 63
Jingsebitaerok: Stories That Are Moral Lessons for the People, 19th c. Ink on paper; 12½ × 8½ in. (31.6 × 21.6 cm). Jangseogak Archives, Academy of Korean Studies, Seongnam

45
See Cho, "The Epistolary Brush."

Hangeul also brought lasting changes to the writing lives of women. Despite exceptions like Sin Saimdang (1504—1551), the majority of women were excluded from studying Chinese classics (see cat. 37). Therefore, *hangeul* afforded women the ability to express their thoughts and record their stories. Lady Hyegyeong, whose husband died, having been confined to a rice chest by his own father, and who had to raise their son in tumultuous circumstances, penned a *hangeul* memoir at age sixty. It is said that her son, King Jeongjo, shed tears upon reading it. Women's writings were jotted down in *hangeul* and published, such as a story about a woman with a husband in exile who had a difficult time eking out a living alone, along with detailed practical information about various household matters. Ordinary people created land-sale documents or tax payment receipts in *hangeul,* and women wrote down their complaints against a patriarchal society to petition government offices. As women began to more actively use *hangeul,* elite men, threatened, referred to the homegrown writing system as *amgeul*—women's script.

The invention of *hangeul* also expanded letter writing. Women, who left their families upon marriage and lived with their husbands' families, maintained familial connections through letters. Unusual letters composed by turning the paper ninety degrees counterclockwise became popular beginning in the fifteenth century; it is possible that this format was intended to make the letter difficult to decipher.[45] These "spiral letters" were developed by women and later expanded into *hanja* letters written almost exclusively by men.

With the growing popularity of *hangeul,* writing styles also became numerous. In the beginning, *hangeul* shapes for printing were similar to today's gothic script, with fixed thicknesses and geometrically balanced letters. A style like *haeseo* was later developed, which was still legible but emphasized the curvilinear beauty of brush writing. In the case of handwritten documents or letters, many writing styles linked characters together, like *haengseo* or *choseo. Hangeul* documents related to the palace were executed by designated scribes; *seosasanggung* (palace matron calligraphers), the female equivalents to *seosagwan,* or court calligraphers, were tasked with composing lists of goods, writing letters, and transcribing popular novels. As a result, a particular palace style of *hangeul* writing was developed (fig. 63), with vertical strokes—the vowels of *hangeul,* like "ㅣ"—placed in similar positions to please the eye and to be legible.

Lee Dongkook

THE EVOLUTION OF FORM AND THE RECOVERY OF POETIC LANGUAGE

THE DEVELOPMENT OF MODERN AND CONTEMPORARY KOREAN CALLIGRAPHY AND THE PATH TO THE TWENTY–FIRST CENTURY

Depending on the times and social transformation, all art eventually changes in look and aesthetics—that is the history of art. Such, too, was the case with Korean calligraphy in the twentieth century, when every aspect of calligraphy was transformed, from its definition to its characteristics, from its subject matter to trends, and even from characters and writing styles to tools and materials. This metamorphosis was attributable to the last hundred years of colonization and Westernization, which pushed calligraphy, once at the center of traditional art, to the periphery. During this time, calligraphy—and its universality and uniqueness—were sharply interrogated. These qualities remain valid in our search for what calligraphy should become in the twenty–first century.

As we search for a path toward a new calligraphy in the "written word–image" era of the twenty–first century, we must respond to questions, such as: Isn't calligraphy all but dead? What is the point of "writing" with a brush when "typing" on a keyboard has become commonplace in the machine age? How will we be able to seek cultural diversity, which will become more necessary as the East and the West increasingly become one?

Keeping these questions in mind, I will first examine the uniqueness of Korean calligraphy in the historical context of East Asian calligraphy. Next, I will consider the characteristics and development of modern and contemporary Korean calligraphy in the twenty–first century. In particular, I will explore contemporary calligraphy from the perspective of its fundamental elements: characters and tools. Ultimately, these two aspects become one, as *saui* (focusing on the spirit of the subject rather than its form). In other words, the essence of calligraphy is that it contains the poetry of its characters and the way they are expressed by brush and ink.

Despite this, Korean calligraphy developed in the twentieth century with form, rather than content, as a foremost concern. As a result, calligraphy was criticized for the underlying assumption that the writing and the writer were separate entities. Thus, although the lifeblood of calligraphy is the expression of one's interior self, the writer's existence, spirit, and emotions were not evident in the writing. That fundamental absence led to the loss of poetry. Such problems related to *saui* become a core concern with the advent of artificial intelligence, as the presence of spirit is what differentiates humans from machines.

In our daily writing lives, typing on a keyboard has long since replaced writing with a brush. The more one types, the more one becomes similar to a machine, and the more one writes, the more one cannot help but become more human. What can be done about this? Simply put, there is no other way but to take up a brush in one hand while holding a smartphone in the other. Today's reality of coexisting with machine–age robots equipped with artificial intelligence is unprecedented. With the acceleration of artificial intelligence, art will become even more important, with its power to disarm our machine civilization using human sensibilities.

As calligraphy is the foundation of all art, this essay takes the position that form is content and that a creative dismantling of writing structures and calligraphy styles is necessary in order to return to *pilmuksi* (visual–character poetry using brush and ink). Brush and ink, rather than being just tools and materials, are in fact the DNA of calligraphy and the language of *pilmuksi*. In short, the task of calligraphy in the twenty–first century will be to unify all the languages in the world—such as words, pictures, and the body—with calligraphic language.

THE UNIVERSALITY AND UNIQUENESS OF KOREAN CALLIGRAPHY

In Korea, calligraphy generally brings to mind *hanja* calligraphy. This is inevitable from a historical standpoint. However, because *hanja* is composed of Chinese characters, it is often believed that Korean calligraphy is an imitation of Chinese calligraphy and that *hanja* and *hangeul* calligraphy are separate; many people think that *hanja* calligraphy is Chinese and *hangeul* calligraphy is Korean. This belief became even more prevalent in the twentieth century.

This misconception stems from the introduction of Western art and the Japanese colonial policy to obliterate *hangeul,* and it continues today as the exclusive use of *hangeul* becomes more common in reaction to the attempt to eradicate it. Perhaps the gap created between *hanja* and *hangeul* in traditional calligraphy, which also created an ever–increasing distance between calligraphy and art, was inevitable.

Hanja and Hangeul

Hanja, however, is not the written language of China alone; it is shared throughout East Asia. Before *kana* was created in Japan or *hangeul* was created in Korea, Chinese characters were used throughout East Asia for 2,500 to 3,000 years. Though the spoken languages in Korea, China, and Japan were distinct, their written language was one and the same.

With *hanja* as their foundation, the unique writing systems of *kana* and *hangeul* were developed as visual languages for Japan and Korea, respectively. The ancient roots of calligraphy that these writing systems have in common reveal the universal and unique art history and culture of East Asia and *hanja*. In examining East Asia through *seo* (writing), it is clear that the region is not divided into Korea, China, and Japan. Culturally, the three nations are one large brush–and–ink community. Within this community unique calligraphy developments have occurred in each country and each era up to the present day.

Sacred hieroglyphs, such as oracle bone scripts and bronze vessel inscriptions, were created in central Asia about 3,500 years ago, and the carvings were made by engraving. After the brush was invented in the Chinese Han era, writing expanded to Japan through the Korean Peninsula, transforming and

evolving from *zhuanshu* (K. *jeonseo;* seal script) to *lishu* (K. *yeseo;* clerical script), and from *caoshu* (K. *choseo;* cursive script) and *kaishu* (K. *haeseo;* standard script) to *xingshu* (K. *haengseo;* semicursive script).

Meanwhile, around the ninth century, the *hanja* written language culture joined Japan's spoken language to produce the written language of *kana*. In the fifteenth century, it met the Korean language to create *hangeul*. When the *hanja* tradition met the spoken Japanese and Korean languages, similar but different transcending forms called *kana* and *hangeul* were created. *Kana* has a rhythmic and musical character structure with a foundation of *caoshu* (cursive script). Unlike *kana* or *hanja*, *hangeul* was created by joining the phoneme units of consonant letters and vowel letters. This led to *hangeul*'s musical and architectural form. Therefore, *hangeul*, unlike *hanja* and *kana*, has yet another unique language structure and gestalt.

The Language and Calligraphy of China, Korea, and Japan

Now we will examine the history of Korean calligraphy through *hanja* script styles. In particular, I will explore it through the Wang Xizhi—style of calligraphy, *tiepai* (K. *cheobpa*) (hereafter, Wang style), and the older *beipai* (K. *bipa*) style, revealing a different conclusion from the earlier perception that Korean calligraphy is an imitation of the Wang Xizhi—style calligraphy of China.

Take, for example, the Goguryeo Kingdom's *Gwanggaeto Daewang Stele*, which was erected in 414 in what is now China (fig. 64). The script on this stele, created about the year 400, spatially divides the calligraphy history of East Asia. At the time, the Eastern Jin dynasty's *tiepai* calligraphy, based on the script of Wang Xizhi (307—365), had dominated the Southern Qi area south of the Yangtze River. North of the Yangtze, another ethnic group, in Goguryeo, was developing *beipai* calligraphy. Yet another strand of mainstream script style appears on the *Gwanggaeto Daewang Stele*, which influenced Japan, as is evident in the inscription in the Silla Kingdom's Houchong Tomb, in characters written on the swords with decorated hilts excavated from the Geumgwanchong Tomb, and in the "Chiljido," a sword that was gifted to Japan by the Baekje Kingdom.

The two styles—the model Wang–style script and the *beipai* style, centered on the *lishu* of the Han dynasty and *xingshu* of the Six Dynasties period— bisected the continent and developed side by side. The *Stele Commemorating the Great Master Nanggong at the Taeja Temple*, erected in 954, was a collection of 2,500 characters borrowed from the works of Gim Saeng (711—?) of the Unified Silla dynasty, who reinterpreted the Wang style through the aesthetics of integration (fig. 65; see cat. 17). Although Wang Xizhi was venerated as the foremost calligrapher of East Asia, about the eighth century his work was reinterpreted and followed a different line of development in Korea and Japan, as well as in China.

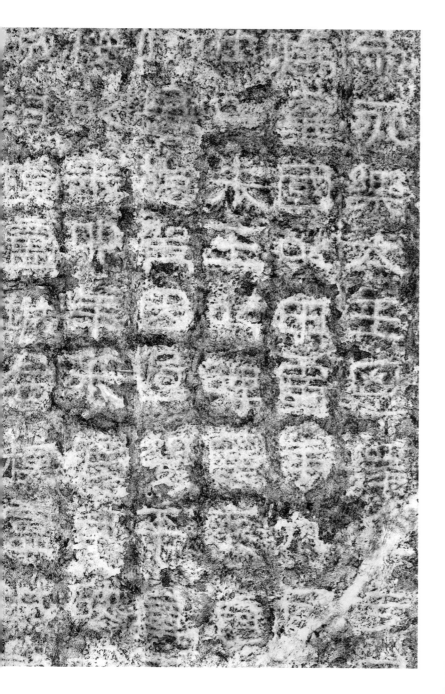

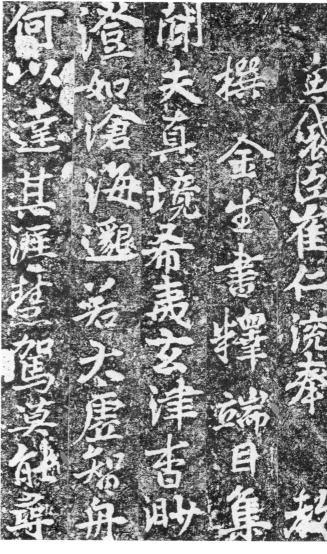

FIGURE 64
*The Gwanggaeto
Daewang Stele
Inscription*, 414
(cat. 22, detail)

FIGURE 65
*Ink Rubbing of the
Stele Commemorating
the Great Master
Nanggong at the Taeja
Temple*, Unified Silla
dynasty—Goryeo
dynasty (cat. 17, detail)

China's Yan Zhenqing (K. An Jingyeong; 709—785), a contemporary of Gim Saeng's, criticized the Wang style and created a movement of innovation, while Japan's Kūkai (K. Gonghae; 774—835) ushered in an individualistic calligraphic style of picturesque aesthetics. In the early nineteenth century, which marked the end of the traditional era and the beginning of modernity, the paradigm of calligraphy in East Asia was turned inside out again. In the Joseon era, Gim Jeonghui (artist name Chusa; 1786—1856) developed his Chusache style by merging the *beipai* style with the *tiepai* style of Wang Xizhi and Yan Zhenqing, which had been the center of reinterpretation of calligraphic history after the Tang dynasty, thus creating a third calligraphic culture (fig. 66).

At that time, the Qing dynasty scholar–official Ruan Yuan (K. Wan Won; 1764—1849) posited the Northern Steles and Southern Modelbook Theory (K. *Bukbi namjeom non*) and the Southern and Northern Schools of Calligraphy Theory (K. *Nambuk seopa non*) and raised the question of which of the two theories was the mainstream. Such artists as Deng Wanbai (K. Deung Wanbaek; 1743—1805), Yi Bingshou (K. Yi Byeongsu; 1754—1815), and Zhao Zhiqian (K. Jo Jigyeom; 1829—1884) developed calligraphy centered on *beipai*. Their *beipai* texts were epigraphs in the *lishu* style of the Han dynasty and the *xingshu* style of the Six Dynasties period, which had been prevalent before the advent of the Wang style.

But as twentieth–century Korean calligraphy met Western art, it began to evolve differently. This was the case with the birth of new calligraphies in Japan, such as *zenei shodou* (avant–garde calligraphy), which developed through exposure to abstract art, using a new language with different roots from calligraphy. In Korea the names of new, experimental calligraphies are *muksang* and *mukyeong* (various techniques resulting in images created by ink bleeds) or contemporary calligraphy.

THE DEVELOPMENT OF MODERN AND CONTEMPORARY KOREAN CALLIGRAPHY

After *hanja* was introduced to the Korean Peninsula, the major developments in Korean calligraphy largely aligned with those of Chinese calligraphy. With regard to the style of Korean calligraphy characters, the beginnings of Korean calligraphy history are directly connected to Gojoseon (Old Joseon), when *hanja* was introduced, and the watershed moment was in the early Joseon dynasty, when *hangeul* was created.

Until then, *hanja* calligraphy continued to develop on its own. However, with the creation of *hangeul* in the fifteenth century, *hanja* and *hangeul* calligraphy coexisted along two separate paths. Of course, if one considers petroglyphs (prehistoric pictorial symbols) as the origins of calligraphy, the history of calligraphy on the Korean Peninsula goes back to the Neolithic period, eight thousand years ago; this aligns with the development of prehistoric art history throughout the world. From petroglyphs to *hanja* to *hangeul,* the use of calligraphy expanded and expressed Korean calligraphy's individuality in each time period.

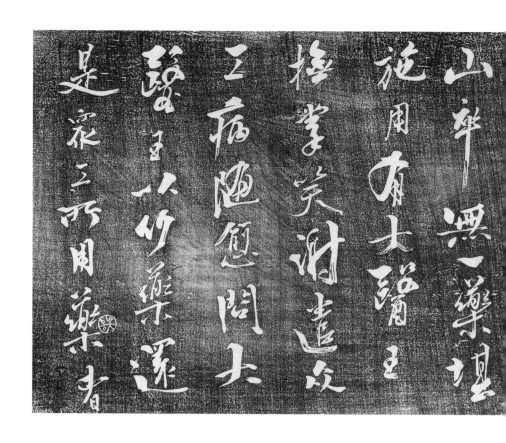

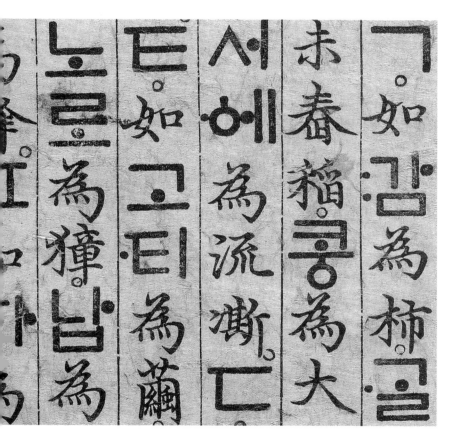

FIGURE 66
Gim Jeonghui (1786—
1856), *Sosik's Poem on
Seokgak's (Ch. Shi Ke's)
Painting of Yu Ma
(Vimalakirti)*, 19th c.
(cat. 87, detail)

FIGURE 67
Hunminjeongeum,
1446 (cat. 69, detail)

Even when limited to *hanja* calligraphy—as seen in the *Gwanggaeto Daewang Stele* of the Three Kingdoms period, or Gim Saeng's inscription on the *Stele Commemorating the Great Master Nanggong* of the Unified Silla dynasty, or the creation of Gim Jeonghui's Chusache style in the late Joseon dynasty— the universality and individuality of Korean calligraphy is clear in the context of East Asian calligraphic history. The Chinese *lishu* style of the Han dynasty and *kaishu* style of the Six Dynasties period had been Koreanized through the aesthetics of the Three Kingdoms of Korea.

Furthermore, the Chinese Wang and Tang styles, flowing through Korea's Three Kingdoms period and Unified Silla, Goryeo, and Joseon dynasties, were reinterpreted by famed calligraphers, such as Gim Saeng, Tanyeon (1068– 1158),[1] Yi Yong (1418–1453), Han Ho (1543–1605), and Yun Sun (1680–1741). And the *beipai* style of China's Qing dynasty, introduced to Korea in the late Joseon dynasty, was the foundation for a third style pioneered by Gim Jeonghui and his followers; this new style reorganized calligraphy in East Asia beyond Joseon. Amid these developments, the most important characteristic of Korean calligraphic history is the fact that *hangeul* calligraphy, derived from King Sejong's (r. 1418–50) creation of the *Hunminjeongeum* (*The Proper Sounds for the Instruction of the People*; cat. 69), progressed along- side existing *hanja* calligraphy (fig. 67).

From *Seohwa* to Calligraphy and Painting

On a macro level, twentieth-century Korean calligraphy can be traced back to petroglyphs, leading to *hanja*, then to *hangeul* and to a confrontation with newly introduced Western abstract art. For Korea, the twentieth century was the modern and contemporary era, and it was intertwined with colonialism and Westernization. Broadly defined, the modern and contemporary era stretched back to the Korean enlightenment movement in the mid- to late nineteenth century, then forward to the Japanese Colonial period, liberation and the Korean War, the industrialization of the 1960s and 1970s, and the democratization of the 1980s and 1990s.

Calligraphy echoed these changes, in a way that cannot be explained through the development of traditional calligraphy alone. With the appearance of Western art, calligraphy was excluded from fine art genres, and as a result was excluded from art schools. Traditional *seohwa*, which incorporated both calligraphy and painting, became separated in the modern and contemporary era into calligraphy (*seo*) and painting (*hwa*), and calligraphers searched for a way to escape the rejection of their medium by adopting Western art tendencies. With the birth of new systems, such as private calligraphy acad- emies and exhibition contests, along with the excavation of historical calligraphic materials, yet another style was developed, and the artist's status in the art world changed. It was also during the modern and contemporary era that tools and materials underwent changes that made them different from those of the traditional era.

2
Yangdong Kim, "Hanguk geundae seoye ui Jeongae wa Yangsang" [Developments of modern Korean calligraphy], in *Hanguk seoye ilbaek-nyeon* [One hundred years of Korean calligraphy] (Seoul: Seoul Art Center, 1988), 308.

All of these changes began in Japan, where artists defined calligraphy differently from the traditional era. About the late nineteenth century, Japanese artists working in Western art styles, such as Koyama Shotaro (1857–1916), denigrated calligraphy, declaring that it was not art. This debate triggered the establishment of the meaning of art in modern Japanese cultural history. In Japan, the word *bijutsu* (K. *misul*; fine art) was created to mean what is now called *yesul* (arts) in Korean. But because of the influence of Italian painting and sculpture teachers, such as Antonio Fontanesi and Vincenzo Ragusa, who were instructors at Kobu Bijutsu Gakko (est. 1876), art schools taught only painting and sculpture and excluded music and literature, and the term *bijutsu* was used in a limited sense. That diminished concept of fine art, *misul*, was also transferred to and accepted by the Joseon dynasty.

As a result, calligraphy was not "art," and it was not even considered "fine art." At best, it was thought of in the context of design or applied arts. *Seo* and *hwa*, which were always thought of as one—*seohwa*—in East Asian art history, were no longer one entity or of the same origin. This result came about because *seohwa* was measured against the criteria of Western art, which did not even include the East's calligraphy as part of the concept of art.

Calligraphy was excluded from "fine art" in Japan beginning with the 1915 Joseon Industrial Exposition. Judging calligraphy based on Western criteria immediately affected colonial Joseon as well. Calligraphy became the first art genre that was discarded when Japan, with the power of Western imperialism behind it, colonized Joseon.

The same criteria were applied to calligraphy during colonial Joseon. That is evident in the Japanese Government General of Korea—sponsored *Joseon misul jeollam hoe* (*Joseon Fine Arts Exhibition*), which was first held in 1922. The category of calligraphy was entirely excluded after the tenth exhibition in 1931. From the first to the tenth exhibitions, the display was divided among Asian painting, Western painting, and calligraphy. This exclusion of calligraphy after 1931 had important repercussions for twentieth-century Korean calligraphy. Only painting, and not calligraphy, was included in institutional fine art educational systems as traditional *seohwa's* role in fine arts was being debated.[2]

In sum, Western art and exhibitions introduced through colonial policies resulted in the separation of the concept of *seohwa*, which had been unified in traditional society. An episode dramatizing the severity of this division occurred when the Korean Fine Arts Association seceded from the existing Daehan Fine Art Association in June 1955:

> In terms of calligraphy, we can call it a disturbance; it is stuck in a fight between larger forces and is being negatively impacted. A segment of calligraphers was misused by artists who took the lead in creating a new association. The artists' absurd argument was that since calligraphy wasn't art, it should be excluded from the exhibition that concentrated on painting.... Therefore, in the provisional general

3
Kiseung Kim, *Hanguk seoyesa*
[History of Korean calligraphy] (Seoul:
Jeongeumsa, 1975), 911.

meeting in 1955, when a heated discussion erupted over this issue, the calligraphers protested the injustice of this suggestion by leaving en masse. And the artist who insisted on this ridiculous position took that opportunity to pass an illegal resolution to exclude calligraphy. Therefore, for a while it was a Daehan Fine Art Association that did not include calligraphers. But their plotting didn't stop there. They recommended that the government exclude calligraphy in the *Gukjeon* (National Exhibition).[3]

In sum, in no organization did calligraphy and fine art coexist. Calligraphy was taught only at private academies. As a result, professional calligraphers appeared only through these academies, the *Joseon Fine Arts Exhibition*, and exhibition contests, such as the *Republic of Korea Fine Arts Exhibition*, created in 1949. Examples of these academies are Kim Choong Hyun's Dongbangyeon-seohoe (Dongbangyeon Calligraphy Society) and Gim Giseung's Daesongseo yewon (Daeseong Calligraphy Academy), established in 1956; Yi Cheolgyeong's Galmul Hangeul seohoe (Galmul Calligraphy Society), established in 1958; and Yu Huigang's Geomyeo seowon (Geomyeo Calligraphy Academy), established in 1960.

Still, it became problematic that professional artists were created through the education of informal private academies, rather than through national or public institutions, thereby replacing the amateur *munin* (scholar–officials) of the traditional era. Calligraphy, which deals with characters where form and content—in other words, image and text—are one, proceeded by overly concentrating on form, while treating text and poetry as a secondary issue or neglecting it entirely.

For example, from 1949 to 1982, although the overall number of works featured in national exhibitions increased, not a single calligraphy work of an original poem was included. According to Gim Yangdong's "A Portrait of Contemporary Korean Calligraphy," published in the November 1996 issue of *Wolgan Misul*, in the first exhibition 129 works were submitted, by the early 1970s around three hundred works were submitted per year, and beginning in the late 1970s the number of works submitted grew to two or three times that many. In 1981, its thirtieth iteration, the exhibition was turned into a privately organized competition, and the awarded entries grew to more than 1,300 works. Since 1982, more than three hundred exhibitions have been held in the private sector, with a continued decline in works with original poetry.

After 1988 calligraphy education at the university level began in earnest, with programs established in universities, such as Wonkwang University, Keimyung University, Daegu Arts University, Daejeon University, and Kyonggi University. By 2018, however, only Daejeon University and Kyonggi University still offered such courses, and judging from the characteristics of the works produced by these university graduates, one can see that there is not much difference between their calligraphy and the works submitted in exhibition contests.

This state of affairs reveals that half of calligraphy, which had treated content and form as one, has become only nominally seen as art and that the remainder has lost its function. Poetry, the main content of calligraphy, is selected from the ancient classics, rather than being original, and the form is merely at the level of copying one's teacher.

Of course, all art begins with copying from a model, which is part of the process of learning. But for a work to become true art, one has to go beyond copying and establish one's own universe. In calligraphy the new forms that are established in this kind of creative step must include original poetry, which is an expression of the writer's identity. Calligraphy is truly complete only when content and form become one.

It is important to have original poetry in calligraphy now and in the future, not only because of its content, but also because that means the artists themselves are working freely with the language they are using as subject matter. All the scripts in the world, from *hanja* to *hangeul* to the alphabet, are calligraphy's subjects. Freely using these scripts as a subject of creativity through poetry is the highest stage of art and achieves a level of playfulness and discriminating knowledge (*prajna*). This is the ultimate stage for the calligrapher, whose being becomes one with calligraphy.

For a calligrapher, an original poem is destiny. And it is for the calligrapher, as the creator of the art, to select the form and the way in which to make the stroke and use the ink. For a class, such as the scholar-officials of the traditional era, calligraphy was possible for anyone, though there were some differences in ability. But calligraphy has become exclusively the province of professional calligraphers in modern and contemporary times. This is because of the abandonment of poetic content, which crystallizes an artist's beliefs, thoughts, and emotions. As intellectuals exchange the brush for Western writing implements, today's ranks of calligraphers have thinned out, with their works growing plain and uniform.

Development of Modern and Contemporary Korean Calligraphy: Succession of Tradition and Experimental Calligraphy

In the transition period of twentieth-century modern and contemporary Korean calligraphy, those who continued calligraphy as an extension of Joseon's *munin* (scholar-official) tradition existed side by side with professional artists produced by private academies and exhibition contests. Paradoxically, viewing calligraphy chiefly from the perspective of form, one can appreciate the various styles in which it flourished, with tradition and experimentation mixed together in a way rarely seen in any other era or society. This is the legacy of the last hundred years, promoted by professional calligraphers, in which Korean calligraphy sustained itself through private academies and exhibition contests.

The biggest change in modern and contemporary calligraphy is the fact that *The Book of Wei* from China was introduced to Korea indirectly through Japan and grew popular as it was being reinterpreted. This was also the time when more documents from ancient China were becoming known, such as the oracle bone script that was excavated in 1899 at Yinxu, as well as bronze vessel inscriptions.

In East Asia's calligraphic history, the discovery of hieroglyphs (such as the oracle bone script) a hundred years ago was a major development that provides calligraphic direction in today's "written word–image" era. If oracle bone scripts and bronze vessel inscriptions were the written word–image language in the mythical age 3,500 years ago, it is only too clear how calligraphy should develop in our new twenty–first–century mythical age, in which the virtual reality of artificial intelligence has become commonplace.

In addition, with Japan's colonial policy hurtling toward the obliteration of Korea at the end of the 1930s, *hangeul* calligraphy was emphasized in reaction and went beyond transcription to create fine art. The influence of Western abstract art that began in earnest in the 1960s and 1970s created experimental, avant–garde, *muksang, mukyeong,* and contemporary calligraphy, disassembling and deconstructing traditional calligraphy. It is yet another paradox that although Western abstract art was influenced and sparked by East Asian calligraphy, East Asia in turn imported and copied Western trends.

Moreover, the core of calligraphy, the stroke itself, is abstract, transcending lines. In the *hanja* culture of East Asia, concrete expression and abstraction, or exterior and interior worlds, are not separate but fundamentally unified. The expression of a human's inner world, or the objective depiction of a subject, was solved in a single act of calligraphy, using brush and ink. Drawing boundaries around a subject and depicting the contours of an object are not mere lines but the result of strokes. Even before it creates the structure of a character, the stroke expresses a distinct sculptural language, such as *taese* (thick and thin), *jangdan* (long and short), *jisok* (slow and fast), and *nongdam* (dark and light). As such, each person's unique strokes are determined primarily by the tools of calligraphy: brush and ink.

Paradoxically, the loss of individuality inherent in typing on a keyboard can be supplemented by the writing of a brush. The practice of calligraphy and the loss of calligraphic language in twentieth–century Korean art, with *seohwa* transitioning to fine art, are related to the loss of identity for Korean art.

The birth of script as the expression of human identity marks the birth of calligraphy and of aesthetics. East Asian *hanja* civilization, which cultivated the language of *seohwa,* in which concrete expression and abstraction are one, is fundamentally different from Western norms, which privilege abstract art as separate from concrete expression. The collision of East Asian norms with various Western styles threw the identity of calligraphy into confusion.

Now, we will examine developments within Joseon calligraphic traditions. About the year 1900, among the calligraphers who carried on the tradition of Joseon's *munin* (scholar-officials) while participating in the enlightenment movement, in the independence movement against the Japanese, or as politicians were Gim Okgyun (1851—1894), Yun Yonggu (1853—1937), Yu Giljun (1856—1914), Bak Yeonghyo (1861—1939), Gim Gu (1876—1949), Syngman Rhee (1875—1965), and An Junggeun (1879—1910).

As the Joseon dynasty waned, some Korean artists continued the traditional *tiepai* (K. *cheobpa*) calligraphy, along with the styles favored by Chinese calligraphers Yan Zhenqing and Huang Tingjian that were popular during the Japanese Colonial era. The artists steeped in these traditions included Hyeon Chae (1856—1925), Gim Donhui (1871—1936), Seo Byeong-o (1862—1935), An Jongweon (1874—1951), and Yu Changhwan (1870—1935). They used excellent *haengseo* and *choseo*, while at times incorporating *jeonye* (seal [*jeonseo*] and clerical [*yeseo*] scripts).

Still other artists created a style of *beipai* (K. *bipa*) or a new style combining *beipai* and *tiepai*, influenced by Gim Jeonghui in the late Joseon dynasty. These artists were inspired by the excavation and introduction of new evidence of the use of such characters as *da zhuan* (K. *daejeon*: great seal script) and *xiaozhuan* (K. *sojeon*: small seal script), along with oracle bone script and *zhongding wen* (bell-cauldron script), as well as the expanded use of *zhuanshu* (K. *jeonseo*; seal script). These artists included O Sechang (1864—1953), Gim Taeseok (1875—1953), Yi Giu (1921—1993), Gim Gwangeop (1906—1976), Go Bongju (1906—1993), and An Gwangseok (1917—2004). They newly interpreted and expanded the hieroglyphic aspect of characters. These artists clearly revealed the characteristics of modern and contemporary calligraphy that differ from traditional calligraphy centered around *tiepai*, and they were even skilled at engraving in seal script.

On the other hand, China's *kaishu* style of the Six Dynasties period, Northern Wei style, and the *lishu* style of the Han dynasty found popularity in modern and contemporary Korean calligraphy, and leading artists of this style were Gim Donhui and his pupil Son Jaehyeong (1903—1981), who led the *Republic of Korea Fine Art Exhibition*, along with Hyeon Junghwa (1907—1997), Gim Giseung (1909—2000), Yu Huigang (1911—1976), Kim Choong Hyun (1921—2006), and Gim Eunghyeon (1927—2007).

Thus, one of the most important characteristics of twentieth-century modern and contemporary calligraphy was the expansion of the *beipai-tiepai* script of the Chusache calligraphy group to the *kaishu* style of the Six Dynasties and the *zhuan-li* style. As discussed earlier, the Chusache style was developed by Chusa (Gim Jeonghui) in the nineteenth century by using the *tiepai* of the Wang Xizhi style and incorporating an even older *lishu* of the Western Han dynasty (*seohanyeseo*) from before Wang's time to change the paradigm of East Asian calligraphy.

The popularization and expansion of these various styles and trends of modern and contemporary Korean calligraphy in the twentieth century occurred through exhibition contests, such as the *Joseon Fine Arts Exhibition* during Japanese colonial times, and the *Republic of Korea Fine Arts Exhibition*, which took root after World War II. Such artists as Hyeon Junghwa (1907—1997) and Yu Huigang (1911—1976) mastered the *kaishu* style of the Six Dynasties period with an international perspective through their studies in Japan and China. Representative artists who continued the calligraphic trend of incorporating *beipai and tiepai* styles include Son Jaehyeong (1903—1981), Kim Choong Hyun (1921—2006), Hyeon Junghwa (1907—1997), and Yu Huigang. If Son Jaehyeong revolutionized *hangeul* calligraphy through *jeonseo* strokes in the *sojeon* tradition and form, Kim Choong Hyun developed a new calligraphic language from stroke to structure that mixed *jeonye* and *haengcho*. Rare for a calligrapher in Japanese colonial times, Hyeon Chunghwa studied abroad, leading the study of the *kaishu* style of the Six Dynasties period in his thirties and forties. In his fifties and sixties, he returned to Korea and incorporated *haengchoseo* with *jeonye* and the *kaishu* style of the Six Dynasties period. In his seventies and eighties he developed a unique style of his own, breaking away from the mold and creating *haengchoseo* (a fusion of semicursive and cursive scripts) by balancing the *jeonhyeong* (original model) with *ya–il* (wild script). In this vein twentieth–century Korean calligraphy does not mark a rupture from the nineteenth century but rather reveals a continuation of the study of steles and an incorporation of *beipai* and *tiepai* styles. If Chusa succeeded in creating a new *beipai–tiepai* style on the foundation of the *lishu* of the Han dynasty, Son Jaehyeong, Kim Choong Hyun, Yu Huigang, and Hyeon Junghwa created yet another new *beipai–tiepai* style while expressing the *kaishu* style of the Six Dynasties period on the foundation of *haengcho*.

Next is *hangeul* calligraphy. At the end of the 1930s, with Japan's colonial policy objective of annihilating the Korean nation reaching extremes, *hangeul* calligraphy was especially promoted, owing to the strong sentiment that the Korean language and writing—the soul and spirit of the Korean nation—should not be destroyed. Yung Baekyeong (1888—1986) and Yi Cheolgyeong (1914—1989) continued the tradition of *gungche* (court–style) script that had been refined in the late Joseon dynasty.

Based on their understanding of the fundamental principles of the *Hunminjeongeum,* Kim Choong Hyun and Gim Eunghyeon (1927—2007) articulated their belief that the origin of the *hangeul* style could be traced to the old seal script of China and thus the writings of *hanja* and *hangeul* stem from *goche* (old script) and *gungche* (court–style script). Son Jaehyeong and Seo Huihwan (1934—1998) were artists who interpreted *hangeul*'s form in traditional and experimental ways in the style of *hanja jeonseo*. Jeong Jusang (1925—2012) expressed *hangeul* in the Wang Xizhi—style *tiepai*'s elegant, dynamic, and melodic strokes.

At the same time, there were artists who studied under the tradition of *seohwa*. These included An Jungsik (1861—1919), Seo Byeong-o (1862—1935), Gim Gyujin (1868—1933), and Gim Yongjin (1878—1968). Unlike them, there were some artists trained as traditional calligraphers or *seohwa* practitioners who began to attempt experimental calligraphy in the late twentieth century. Influenced by Western abstract art, they played up the tool's characteristics, for instance, by deconstructing characters, playing with the darkness or lightness of ink, spraying it, and experimenting with new forms of calligraphy. Representative artists of these new forms are Lee Ungno (1904—1989), Gim Giseung (1909—2000), and Jeong Hwanseop (1926—2010). Gim Giseung not only extensively used *jeonye* and *haehaengcho* (the three basic styles: *haeseo, haengseo,* and *choseo*), but also created a unique style of *hangeul* and even incorporated abstract art in experimenting with *mukyeong*. Below is a chart of the artists mentioned thus far based on their calligraphic styles:

Jeonseo/ Jeongak	Yukjo	Haehaengcho	Jeonye and Haehaengcho	Hangeul	Seohwa	Experimental
O Sechang		Gim Okgyun	Gim Donhui	Yun Baekyeong	Seo Byeong-o	
Gim Taeseok		Bak Yeonghyo			Gim Gyujin	
		Syngman Rhee			Gim Yongjin	
		Gim Gu				
		An Jongweon				
		Hyeon Chae	Son Jaehyeong		Lee Ungno	Lee Ungno
		Yu Changhwan	Kim Choong Hyun	Yi Cheolgyeong	Song Seongyong	Jeong Hwanseop
Go Bongju	Hyeon Junghwa	Gim Giseung	Hyeon Junghwa	Kim Choong Hyun	Choi Jeonggyun	Yu Huigang
Yi Giu	Yu Huigang	Song Seongyong	Yu Huigang	Gim Giseung		Gim Giseung
Bae Gilgi	Gim Eunghyeon	Im Changsun	Gim Eunghyeon	Seo Huihwan		Jo Suho
		Jeong Jusang	Gim Gwangeop			
		Jo Suho				

The above chart is merely an attempt to sort the artists by their overall tendencies. Especially notable are the artists who worked in the *jeonseo* and *kaishu* styles of the Six Dynasties period, atop a foundation of traditional calligraphy, and those working in experimental calligraphy. In particular, such artists as Son Jaehyeong, Hyeon Junghwa, Yu Huigang, Gim Eunghyeon,

Kim Choong Hyun, Gim Gwangeop, and Gim Giseung had a command of these calligraphy styles, along with engraving styles. It is also a characteristic of Korean modern and contemporary calligraphy that these various calligraphic styles and trends were widely used and reinterpreted.

THE DIRECTION OF CALLIGRAPHY IN THE TWENTY-FIRST CENTURY

Above, we examined the characteristics and development of Korean calligraphy in the twentieth century. In addition to *tiepai*, *beipai*, and *beipai-tiepai* combinations, it expanded to include *hangeul*, the incorporation of *seohwa*, and experimental calligraphy. With experimental calligraphy in particular, the domain of calligraphy grew more than in any other era. The problem remains that calligraphic form is prioritized over all else, even in traditional calligraphy. This is because calligraphy had been excluded from fine art, which in turn provoked the reaction to emphasize calligraphy as art. In considering the true essence of calligraphy, this development was only halfway successful; from the perspective of content or text, it is more akin to atrophy. Specifically, another person's poem has taken the place of the original poetry that once signified the existence of an artist. Even if the poem were to be selected from the ancient classics, it becomes a problem when there is less room for the writer's identity and *saui*. From the viewer's perspective, so much less is inspiring when the content has nothing to do with the writer. In short, there existed a vast discord between form and content in twentieth-century calligraphy. The move from traditional calligraphy—which treated poetry, calligraphy, and painting as a unified whole—to the separation of each part is the story of modern and contemporary calligraphy in Korea. This is the underlying cause of the demise of calligraphy in current times.

Unity of Form and Content and *Saui*

Then what should be the direction of calligraphy in the twenty-first century? It goes without saying that form and content should be rejoined and that poetic language should return to calligraphy. With calligraphy, which values ambiguity, there can be many ways toward that goal, but we must concentrate on uniting characters, melding form and content with brush and ink.

That means that we must creatively deconstruct and reinterpret the character structure and calligraphic styles of traditional poetic calligraphy to find a new twenty-first-century poetic calligraphy through unity of form and content. We must use brush and ink not merely as the tool and material for calligraphy but as the purpose of calligraphy. In other words, we must express poetry through the language of brush and ink. This is a kind of *pilmuksi* that is built into characters themselves. For it to be possible, literary feeling and *saui* would need to be integrated into typing or robot-generated machine writing.

We have gone beyond writing with a brush and moved on to typing on a keyboard. Machine letters use characters whose form has become standardized. In our daily writing environment, we have already bypassed writing with

a brush and even writing with a pen. In such a situation, how should we incorporate content into twentieth-century Korean calligraphy's focus on form in order to revive it?

That would be to add poetic spirit from the artist's soul, heart, and emotions into the structure of characters so that they can become one. Simply put, it would be the recovery of *saui*. In this context, twenty-first-century calligraphy can spark the creation of a third calligraphic paradigm that would revive the unity of content and form. In other words, we can consider this "text-image," which is the joining of text and image in calligraphy. Pictorial symbols are an important driver of twenty-first-century Korean calligraphy, as well as of global calligraphy. If one were to look for the principles of accomplishment or a historical guide, an example from long ago would be 3,500-year-old hieroglyphs, and an example that is closer to today would be nineteenth-century Eastern folk painting, in which classical anecdotes are incorporated into the strokes of a Chinese character.

The twenty-first century, in which machines and humans coexist, is a world where boundaries between the East-West division of writing civilizations like *hanja, hangeul,* and the alphabet, as well as between typography and calligraphy, have collapsed. However, from the perspective that tools, materials, and characters are ultimately one, twentieth-century Korean calligraphy was unable to get beyond brush and ink and *hanja* and *hangeul*. We cannot continue this pattern in today's keyboard-typing era. For calligraphy to develop in our current artificial intelligence era, we must review what calligraphy is from the perspective of characters, as well as of tools and materials.

Creative Deconstruction of Character Structure and Calligraphy for All Languages

Without characters, there cannot be calligraphy. It goes without saying that tools and materials—such as brushes, ink, and paper—would not have been created without characters. Human civilization would still rely on hieroglyphs carved into stone or bone. Characters and brushes and ink provide the necessary and sufficient conditions of calligraphy. It is not a relationship of master and servant. Characters and brushes and ink are the objectives of calligraphy. Calligraphic styles are the result of brush and ink expressing characters. Because of the existence of brush and ink, East Asian characters, like those of *hanja, kana,* and *hangeul,* unlike characters of other writing civilizations, went beyond the everyday to be sublimed as art.

In other words, in order to communicate with other writing civilizations, it is a task for twenty-first-century calligraphy to express arabic letters or the alphabet with brush and ink. The future of calligraphy depends primarily on creatively deconstructing the existing character structure and calligraphic styles and creating a new system befitting the twenty-first-century written word-image era.

We must first examine the properties of characters. We will examine them through *hanja* characters, which are ideograms, and *kana* and *hangeul* characters, which are phonograms. Character language is the intersection and multiplication of spoken and pictorial languages. This is evidenced by the creation of hieroglyphs four or five thousand years ago, ending thirty thousand years of humanity's illiteracy. The character language unites content and form, bringing together spoken language as text and pictorial language as image.

If the birth of *hanja* in the script-language history of East Asia is the primary foundation, the development of *kana* and *hangeul* is the next level of expansion. *Hanja, kana,* and *hangeul* are representative of the calligraphic characteristics of each country. The universality and characteristics of calligraphy, a unique art in East Asian *hanja* culture, are the results of the structural properties of characters.

These three scripts, though born from the same *hanja* culture, were linked to their own spoken languages and contain different structures and aesthetics. In order to create a new script and calligraphic style in today's written word-image era, a creative deconstruction must be carried out in concurrent reinterpretations.

As we well know, the structure of *hanja* begins with pictograms, which are hieroglyphs that imitate the shapes of objects, such as mountain (山) and stream (川). Next are ideographs, which turn into figuration such abstract concepts as up (上) and down (下), and compound ideographs, where one (一) and large (大) come together to become sky (天). New *hanja* characters are continually being made following principles of phono-semantic compounds, derivative cognates, and phonetic loan characters in line with the changes in the times and the world.

Unlike *hanja,* which began with the foundation of pictograms and ideographs, *kana,* the visualization of the Japanese language, is based on the *choseo* script of *hanja*. In *kana* it is rare to see the strokes or structures of *jeonseo* or *lishu*. The expression of strokes is mainly centered on elegant *gokoek* (curved strokes). In particular, a visual melody is created in the contrast of the yin and yang of *gokoek*'s use of thick and thin and long and short lines, born from the harmony of the speed and pressure of writing. Inevitably, one can see in *kana* the characteristics of Japanese script, not to mention the fundamental aspect of Japanese culture. The *gokoek* script creates an exquisite harmony with the knifelike *jikeok* (straight strokes), considered a unique characteristic of Japanese culture. From these works you can even see the ultimate plane of stroke, beyond even the wild cursive of *hanja*.

The creation of *hangeul* by King Sejong began with the desire for the Joseon people, who had a different language from the Chinese, to easily see and write what they meant. An adaptation of China's ancient seal script, *hangeul* was made with strokes and structures stemming from the classical seal script of *hanja*. As such, it is different from *kana* in that it can express not only the

jeon and *ye* scripts, but also all the curves and straight lines that are the basis of the *hae, haeng,* and *cho,* in all the five basic calligraphic styles. The structure of unifying consonant syllables and vowel syllables (gestalt)—the joining of the principle of form and the principle of negative and positive—creates a constructive beauty in *hangeul goche* (old script), along with a rhythmic beauty, as is evident in *jeongche* (regular script), *heullimche* (cursive writing), and *jinheullimche* (running script used in the court palace).

In sum, the point where *hangeul* and *kana* are structurally similar and different is in the rhythm of *haengcho,* in the strokes of *gokjik* (right and wrong), and whether there is a geometric beauty in *jeonye.* Today, calligraphy fluidly links *hanja* and *kana, hanja* and *hangeul,* and even *hanja* and the alphabet. As such, in *hanja* culture, similar and different scripts deriving from *hanja* are combining to become one. Thus, the deconstruction of script and the hybridization of scripts, from *hanja* to *hangeul* to the alphabet, can be considered the beginning of the future of twenty-first-century calligraphy.

Here, we can apply the principle of six rules for forming Chinese characters (K. *yukseo*), which created *hanja* in ancient times. Already in today's written word-image/artificial intelligence era, objects and events have emerged that cannot be expressed by existing spoken and written language.

Calligraphy was born from nature. In other words, the entire universe is the matrix of calligraphy. As calligraphy is a living entity, a new character is created and reinterpreted by brush and ink as new objects and events are born into the world. The history and principle of script creation in Japan and Korea, where a spoken language was unified with a different written language, offer guidelines for a new written language in today's written word-image era.

The Creation of the Sixth and Seventh Calligraphic Styles for the Artificial Intelligence Era

In addition to the creative deconstruction of the existing script language, we need to consider the existing styles that form the body, or pillar, of calligraphy. In the artificial intelligence era, in which humans and machines converse, the fact that we continue to practice calligraphy in the five styles created thousands of years ago is a problem. That is why we must creatively deconstruct existing calligraphy to create the sixth and seventh calligraphic styles. Simply put, the history of calligraphy is the history of the stroke. The result consists of the five styles of *jeon, ye, hae, haeng,* and *cho.* But these did not evolve in a linear fashion without relation to the times and the surrounding world. The history of calligraphic styles is the history of transcendence.

The evolution of calligraphic styles from *jeonseo* to *yeseo* to *haeseo* is the result of the force of transcendence inherent within tradition. The evolution from *jeonseo* to *yeseo* was made possible by the invention of the brush. And why was the brush invented? The invention of the brush was important not just as the creation of a simple writing tool but also as the embodiment of poetry through the use of ink, defining the very purpose of calligraphy. This is

the transformation of the poetic spirit—in other words, this *is* the content within the characters or what allows the expansion of text. Along with changes in the times and the world at large, the human spirit had also changed.

Seen on a macro level, the change from *jeonseo* to *yeseo* signals the leap of East Asia's intellectual world from the mythical to the human world, from gods to humans. This can be understood in the same vein as the appearance of the keyboard in our current time. Like brush and ink, the keyboard is not simply a tool with which to type characters; as typography itself, it contains poetic spirit.

In any case, the calligraphers who are shouldering the development of Korean calligraphy today draw from the history of such continual change in calligraphic styles. Placing the five scripts on the same plane, they are selecting the individual script they prefer; they are deconstructing the existing character structure to create a new script language. It is as if we are witnessing the harbinger of new language creation through the destruction of today's written language.

Today's calligraphers are going beyond copying calligraphy from a standard form without referencing a theoretical archetype or emulating a master's work, using their own interpretations to embody a tradition of transcendence. Only through tradition that contains transcendence can we transform a writing civilization. As such, the evolution of script styles from *jeon* to *ye* to *choseo* and *haehaeng* is more than a simple change in writing styles. It is a result of innovation or transcendence of tradition and the transformation of stroke. The creation of calligraphic styles is the result and token of great transformations in human civilization. The present era cannot be an exception to this, as we live through another major transformation of human civilization in our keyboard–typing era. It is our task to create a new calligraphic style that befits the machine age.

Brush and Ink as Poetry and *Pilmuksi*

As tool and material, brush and ink were the basis of poetry before poetry, or perhaps poetry that has transcended poetry. These kinds of works break down the definition of calligraphy, and their content is incomprehensible. There is no start or end to the mass of a stroke, whose order or disorder is too consistent to be considered a mere scribble or painting with tree sap. It appears as though the brush moved wherever it pleased. However, a strong sense of identity or spirit, which is impossible without skill, is emitted from the face of the painting. These are works that are only possible in the unplanned or subconscious realm.

Kim Jongweon's work *Tongnyeongsinmyeong–Gounseonhwa sinbuljido* can be understood in this vein (fig. 68). A poem by Lu You and a response from his former wife, Tang Wan, are written with emotion. Lu You and Tang Wan had once been married, and ten years after they parted, they met again by

chance. Lu You expressed his sorrowful feelings in the poem, which he sent to Tang Wan, who responded plaintively:

錯錯錯
難難難
莫莫莫
瞞瞞瞞

Wrong, wrong, wrong
Difficult, difficult, difficult
No, no, no
Fooled, fooled, fooled

Her deep regret is evident even today. After composing her poem, Tang Wan died of sorrow. The mournful poetic feelings of Lu You and Tang Wan are expressed by Kim Jongweon, not through brush and ink but through his strokes. This calligraphic language is impossible without the calligrapher experiencing madness, something that cannot be understood by existing calligraphic principles. The structure of the script is brutally collapsed, and the strokes howl. The artist has stated, "In this work, calligraphy is not seeking

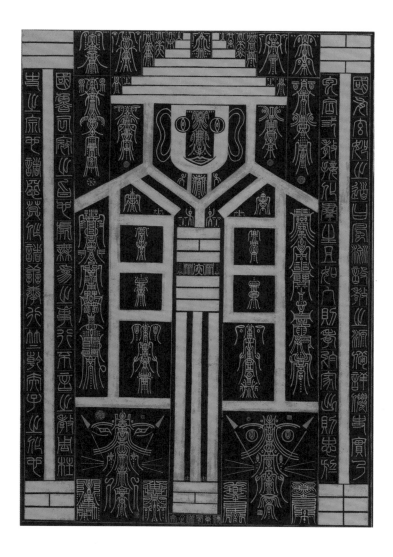

4
Kim Jongweon, in discussion
with the author.
5
Ibid.

the beauty of form. It is a composition of the poetic spirit and my emotions that emerged through strokes from my reading of this poem."[4] Kim Jongweon's calligraphic work translated the poetic language and text of the poem into a language of strokes. The artist has explained, "My calligraphic works are literature, based on a language of calligraphic strokes, and the literature of the other side."[5] In short, it is not merely a re-creation of a text but a calligraphic reconfiguration of the meaning and emotion of a text. It is literature that has gone beyond words. From a historical perspective, in considering whether the content and form of the characters are being written as one with the writer's emotions, Kim Jongweon's work surpasses the literary principles of the wild cursive of Huaisu and Zhang Xu of the Tang dynasty or Hwang Giro of the Joseon dynasty. China's Wang Dongling's work on Li Bai's "The Ballad of Mount Lu for Imperial Servant Lu Xuzhou" can be understood in the same vein (for a work in a similar style, see fig. 69). This is also different from the avant-garde calligraphy that was popular in Japan after World War II. Moreover, Kim's work is not considered an example of experimental calligraphy or contemporary calligraphy in Korea.

FIGURE 69
Wang Dongling
(b. 1945), *The Heart Sutra*, 2016. Ink on Xuan paper; 12⅝ × 37⅞ in. (32 × 96 cm). Los Angeles County Museum of Art, promised gift of Gérard and Dora Cognié

Another example of a myth or poem composed with brush and ink is Japanese calligrapher Suzuki Kyozen's calligraphy. It uses oracle bone script that is so pale that the bone is visible through the stroke. The stroke that forms the frame of 神 (spirit; K. *sin*) is extreme in its spare use of ink. Even the bone has been crushed. With only the extreme darkness and lightness and glossy and dry strokes of the ink, it creates a divine visual image. Thus, brush and ink are soul and spirit and feeling. They are the DNA of East Asian culture.

At this juncture, it is somewhat meaningless to judge works such as these by twentieth-century standards of calligraphy and abstraction. These works refuse to be compared to Western abstract art in the name of avant-garde, experimental, or contemporary calligraphy. This is because the line of the West and the stroke of East Asia are fundamentally different. Calligraphy thus is defined by how the writer's meaning is being expressed with script and with the strokes of brush and ink.

Calligraphy produces countless languages from visual formation to poetry by merging content and form (or text and image) with stroke. In terms of expressing *saui*, results vary, depending on whether the structure of the strokes, as in *daejaseo* (large–character script), presents only one or two characters as a tableau with a strong pictorial element, or whether consideration is given to the harmony between characters, as in poetry. If we deconstruct characters and make an issue of the characteristics of the stroke itself, calligraphic language expands infinitely, as seen above. With the addition of engraving— the language of the blade—calligraphic languages multiply into infinity.

From Blade to Brush to Keyboard: Unification and Symbiosis of Language

The blade is important to calligraphy because it forms the matrix of brushstrokes. It is the blade that makes it possible for a two–dimensional line to turn into a three–dimensional stroke. In other words, a brush implies a blade. In sum, the blade is the grandparent of the keyboard. That is the reason why the blade cannot be excluded from the creation of true calligraphy in the keyboard-typing era.

In the history of writing, the blade gave rise to seal–script engraving. The blade is something that should have disappeared upon the arrival of the brush. But instead of disappearing, it lives on in the unique genre of engraving/carving in the realm of brush and ink, maintaining a close relationship with writing. Today, we live in the midst of typing, not engraving or writing with a brush. The symbiosis of blade, brush, and keyboard is necessary for the history of our civilization. How can brush writing resolve the tension with keyboard typing, which has taken over our daily writing lives? The historical point where blade and brush met offers important implications for the challenges facing today's calligraphers.

The development of human civilization from the mythical to the historical to the machine era is also the history of writing, from blade to brush to keyboard. The evolution of these tools and civilizations suggests the unification and symbiosis inherent among engraved, written, and typed language. In this context, the direction of calligraphy in the artificial intelligence era points to contemplations and practices that lead toward absolute control of not only human writing but also the environment of machine writing. Inversely, it is how machine letters can be imbued with literary feeling and *saui*.

If the stroke is the body of calligraphy, then poetry can be considered the heart. Without poetry, true calligraphy cannot exist. That is why original poetry is even more precious and important in our current era, in which calligraphy is heading toward being valued only in terms of form. The calligrapher's critical mind and spirit can be seen clearly in poetry before it is written. In this context the recovery and practice of poetic spirit are essential. Ideal calligraphy is realized when the poetic spirit and the spirit of the stroke become one.

When brush and ink are used with poetic spirit to critique the times or compassionately embrace the pain within society, calligraphy, whose brush is more terrifying than a blade and whose literary aspects are stronger than physical might, can be even more influential. Does not a calligrapher's sense of identity, in other words, the act of expressing one's own times and society with images, constitute art? It is this result that brings the writer and the world together to breathe and sing as one.

The fundamental nature of art has not changed, though the times and society have transformed, as is evident in the cave drawings of Altamira, Spain; the petroglyphs of Bangudae, one of Korea's national treasures (fig. 70; see cat. 1); and today's cutting-edge written word–image era. As such, there is no other art that is as practical and fundamental as calligraphy, which treats script as the tool and purpose of the art. We must remember that calligraphy is an art form that cannot be separated from characters, for which content and form are one. The content I speak of here is, more precisely, the calligrapher's sense of identity and poetic spirit.

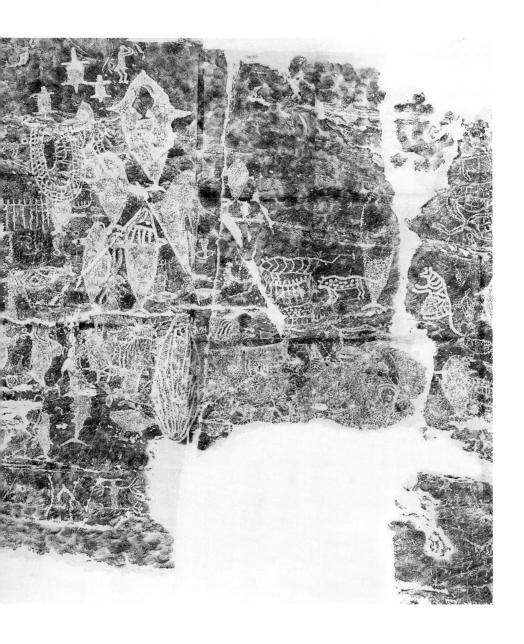

FIGURE 70
Bangudae Petroglyphs,
5500—4700 BCE
(cat. 1, detail)

In this context, twentieth-century modern and contemporary Korean calligraphy that was overly focused on the pursuit of form can be seen as the regression of calligraphy. The modernization of calligraphy by reclaiming its fundamental values through the expression of one's interior life must return to composing and expressing the author's true self as poetry, more so than flashy experiments of form. The art of calligraphy, calligraphic principles, and calligraphic direction must be found on the path where the daily life of calligraphy is expressed in poetry.

IN LIEU OF A CONCLUSION: WHAT IS CALLIGRAPHY?

In this essay I have discussed the characteristics and development of modern and contemporary Korean calligraphy and proposed a direction for the twenty-first century by examining the universality and individuality of Korean calligraphy. I concluded that Korean calligraphy has taken part in the larger developments of East Asian calligraphy while maintaining its distinct identity.

With the foundation of prehistoric petroglyphs on which *hanja* calligraphy appeared layer after layer, *hangeul* calligraphy appeared and developed, with each stage of evolution expanding era after era to today. In regard to *hanja*, China's *lishu* style of the Han dynasty and the *kaishu* style of the Six Dynasties period were interpreted through the aesthetics of the Three Kingdoms period. In addition, the Wang and Tang styles were uniquely interpreted by famed calligraphers throughout the Unified Silla, Goryeo, and then Joseon dynasties.

In particular, the traditional Wang-style *beipai-tiepai* was mixed in with the Qing dynasty's *beipai* style, introduced at the end of the Joseon dynasty, creating Gim Jeonghui's Chusache style, which can be considered the third calligraphic style. This marked the end of the traditional era and the beginning of modern times, and this accomplishment changed the paradigm not only of Joseon but also of East Asian calligraphy. In addition, the creation of the *Hunminjeongeum* by King Sejong afforded an opportunity for *hangeul* calligraphy to develop alongside existing *hanja* calligraphy.

On top of this foundation consisting of three types of traditional calligraphy, twentieth-century Korean calligraphy reinterpreted Western abstract art from a calligraphic point of view, and the calligraphic environment and infrastructure evolved again. In twentieth-century modern and contemporary Korean society, interspersed with colonization and Westernization, calligraphy was not considered art. This was around the time that *seohwa*, which traditionally treated calligraphy and painting as one, was divided into the separate spheres of calligraphy and painting as a result of being judged from a Western art perspective. With this development, calligraphy was excluded from systematic art education in elementary, middle, and high schools, and over the last hundred years professional calligraphers were trained through nonmainstream private calligraphy academies and exhibition contests.

Despite these conditions twentieth-century Korean calligraphy gave rise to various styles, such as *tiepai, beipai,* and *beipai-tiepai,* and even incorporated *seohwa* and experimental calligraphy. In particular, through the excavation of such ancient materials as oracle bones, the increasingly exclusive use of *hangeul,* and the introduction of Western abstract art, traditional calligraphic styles were rediscovered and experimentation was encouraged.

The strand of experimental calligraphy that included the avant-garde, *muk-sang, mukyeong,* and contemporary expanded calligraphy into new territories. In particular, Lee Ungno (Yi Eungro) (1904—1989; see cat. 110 and detail p. 113), Jeong Hwanseop, and Gim Giseung interpreted characters with a focus on form—or the use of brush and ink—to break down barriers between Western abstract art and calligraphy.

Whereas O Sechang and Yi Giu interpreted *jeongak* and *jeonseo* from a traditional viewpoint, Gim Donhui, Son Jaehyeong, Yu Huigang, Kim Choong Hyun, Hyeon Junghwa, and Jeong Jusang interpreted traditional calligraphy in a modern way through a mixture of *beipai-tiepai* style. Working with *hangeul,* Yi Cheolgyeong expressed *gungche* as united with *hanja,* and Kim Choong Hyun, Seo Huihwan, and Gim Giseung merged *goche* with *hanja.*

However, both experimental and traditional twentieth-century modern and contemporary Korean calligraphy gave more weight to the pursuit of form than of content. Calligraphy considers characters that contain both form and content as one unit. However, the tendency of calligraphy at the time was to rely on ancient classics, in which content was predetermined and treated as an afterthought. Using poetry that someone else had already created and relying on a master's example were common practices.

In sum, poetry was treated as an afterthought. Calligraphy with poetry as its core—the exclusive property of the literati of the traditional era—had lost poetic language in modern and contemporary times and become relegated to the exclusive property of calligraphers.

As such, when considering the direction of twenty-first-century Korean calligraphy, we must solve the problems of modern and contemporary calligraphy and find a way for it to thrive in the machine era led by artificial intelligence. First, we must creatively destroy the structure of characters/ script and create a calligraphic language that communicates directly with all languages. Second, we must create sixth and seventh calligraphic styles beyond the existing five, and third, we must broaden the concept of brush-and-ink poetry. Of course, this is based on the premise that the past, present, and future were built on the foundation of traditional calligraphy that innately includes transcendence. By examining how merging character with brush and ink could be expressed through poetic language using form and content, brush and ink are not merely the tool and method, but the basis of calligraphy, signifying the potential to elevate and transform into a brush-and-ink language. This would make it possible to insert literary spirit and *saui* into keyboard typing or machine writing.

Above all, calligraphy that is open to all languages through the creative decon-struction of structure and strokes is the calligraphy of the artificial intelligence era. In particular, characters—a hybrid of spoken and pictorial languages—are amenable to spoken words and pictures. The creative deconstruction of calligraphy can be understood using the pictographs/ideographs/compound ideographs/derivative cognates/phonetic loan characters of *hanja*. The creative deconstruction of *hangeul*'s principle of yin and yang—in other words, the joining of consonant and vowel syllables (gestalt)—is another direction for calligraphy in the machine age. As a result, *hanja* and *kana*, *hanja* and *hangeul*, and *hanja* and the alphabet are used freely together today. The destruction of character language or the hybridization with other writing systems begins now.

If *daejaseo* can be equated with architecture, the strokes can be thought of as pillars, walls, ceiling, and floor. Each character is as infinite as each individual person. A single character of *daejaseo* is the calligrapher's self-portrait. Many kinds of houses have been built since humans appeared on earth, and char-acters, too, have come all this way with infinite forms. Calligraphy has as many different styles as there are beings in the world. In particular, twenty-first-century calligraphy links directly not only to spoken sound and body language, along with poetry, music, and dance, but also to the language of machines.

I discussed how the strokes—the body or pillars—of calligraphy should be creatively dismantled in order to create a sixth and seventh calligraphic style for the artificial intelligence era. For example, the change from the engravings of *jeonseo* to the brush writings of *yeseo* to the characters' transformation signified the leap of East Asia's intellectual universe from the world of myth to the world of humans, from gods to humans. The same can be understood about our need for a new calligraphic style with the keyboard dominating our society.

Calligraphy illuminates one's thoughts through structure and sentences, brush-strokes and ink. It is our civilization's task to resolve the tension between keyboard typing and brush writing. The point where blade and brush meet lends important context for present-day calligraphers. The development of human civilization from the myth to the historical to the machine era is also the history of character/writing civilization from blade to brush to keyboard. Therefore, calligraphy in the artificial intelligence era must take over historical calligraphy. Inversely, we must find ways to incorporate literary spirit and *saui* into machine language.

I advocated for the expansion of *pilmuksi*. In this context, *pilmuksi* and the content of poetry must treat brush and ink as poetry before poetry, or poetry beyond poetry. In other words, brush and ink are not merely tools and materials of calligraphy. Their purpose and language must be interpreted as poetry.

Specifically, in referring to *pilmuksi*, I considered how transcendentally and antiaesthetically calligraphic language is used. If a stroke is the body of calligraphy, poetry is its heart. Without poetry, true calligraphy cannot exist. Original poetry is even more invaluable and important in today's calligraphic tendencies, where the focus is on the search for form. Poetry is at the peak of being one with the calligrapher and the world. Although visual character poetry may appear to be scribbles, as a whole, a mass of strokes reveals an orderly disorder. As a result of concentrated effort, the identity and spirit of the calligrapher fill the tableau.

Such *pilmuksi* breaks down the definition of existing calligraphy, but because the content remains, it is different from experimental calligraphy of the twentieth century. Works by Kim Jongweon or China's Wang Dongling are examples of this type of calligraphy (figs. 68, 69). Their calligraphy goes beyond the beauty of the forms of the characters that constitute the poem. The poetic spirit and the artist's emotion in relation to the poem are expressed in the language of brushstrokes.

As discussed previously, it is clear that twenty–first–century calligraphy is evolving toward calligraphy reclaiming the basis and peak of all art. Even in an age led by artificial intelligence, calligraphy must take its crucial place in art. As such, with future calligraphy as an intermediary, one can gauge the indivisible relationship between human and machine. It is important to make a cognitive leap from the linear thinking of the timeline consisting of the past to the present to the future.

Here is where the hieroglyphs of the mythic era can be linked directly with the cyber era's written word–image language. That is why it is even more important to reestablish brush and ink language in the keyboard–typing era. In this context *hanja* and brush and ink are much more than the subject or tool or materials of calligraphy. They form the DNA of East Asian art.

The expression of an artist's self–identity is visible through calligraphy. Calligraphy is linked directly with the infinite expressions of the subconscious that lurk around all forms of expression, such as writing, speaking, painting, poetry, song, and dance. I believe that the development of twenty–first–century Korean calligraphy of the artificial intelligence era rests on how the stroke can be incorporated into the written, spoken, visual, and body languages of East and West.

Entry Authors

Christina Gina Lee (CGL)
Stephen Little (SL)
Natalie Mik (NM)
Audrey Min (AM)
Virginia Moon (VM)
Joon Hye Park (JHP)
Eunsoo Yi (EY)

PREHISTORY

The creation of rock–cut images by human beings has a long history extending into prehistoric times, beyond the Neolithic and into the Upper Paleolithic period. Petroglyphs first appeared over 40,000 years ago, during the Ice Age, but flourished in the Neolithic period (ca. 10,200—2000 BCE). Significantly, petroglyphs are known from nearly every human culture. These mysterious images are early manifestations of human beings giving visual form to their experiences of the world. The Neolithic petroglyphs on the Bangudae cliff, situated near Korea's southeast coast, date from about 5500 to 4700 BCE. These carvings include small images of humans dominated by images of many animals, including gigantic whales.

1

Bangudae Petroglyphs
울주 대곡리 반구대 암각화

Neolithic period, 5500—4700 BCE
Ink rubbing (1971 or after); ink on paper
118⅛ × 393¾ in. (300 × 1,000 cm)
Woljeon Museum of Art, Icheon,
National Treasure no. 285

Petroglyphs are images carved on natural rock surfaces. Rock reliefs have been made in many ancient cultures, mostly on vertical surfaces, and are known from sites all over the world. Such images are important, as they represent the incipient stage of written communication among prehistoric peoples. As the oldest-known examples found on the Korean Peninsula, the Ulsan Bangudae petroglyphs are believed to be significant precursors to the advent of writing in Korea.[1] Discovered in 1971 by an investigative team from Dongguk University in Seoul, these petroglyphs are carved onto a cliff face on the west bank of the Daegokcheon Stream, a branch of the Taehwa River, in the city of Ulsan, near Korea's southeast coast.[2] The petroglyphs were recognized

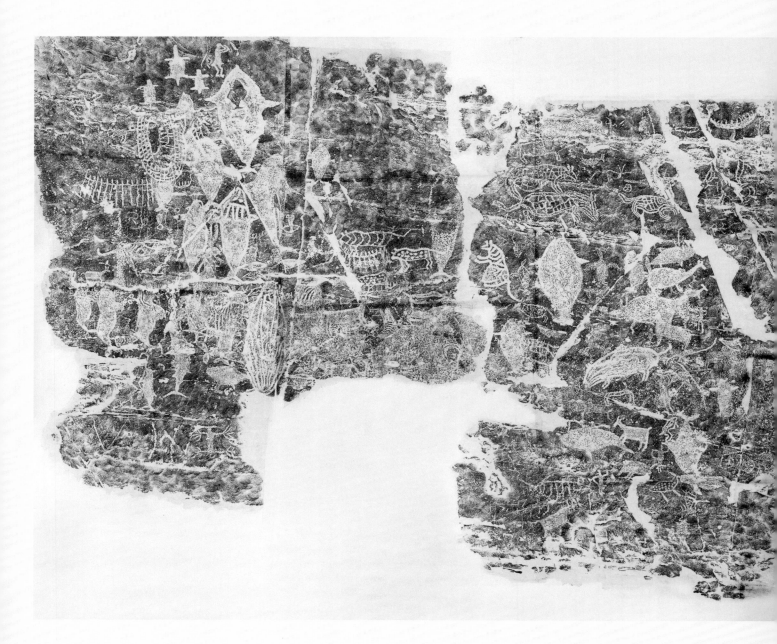

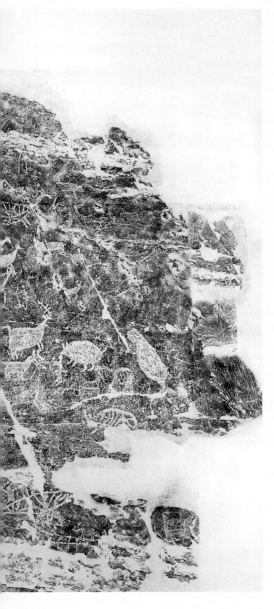

as a national treasure by the South Korean government and are currently candidates for UNESCO World Heritage designation.

Based on archaeological study and analysis of their geographical environment, the Bangudae petroglyphs, or *Bangudae Amgakhwa*, are believed to date to the Neolithic period. Given the absence of concrete evidence, however, the exact date of the carvings remains unknown.[3] The petroglyphs present more than two hundred motifs, including such sea and land creatures as whales, turtles, sharks, seals, tigers, panthers, wolves, and foxes, as well as hunting scenes, manmade tools, and human and shamanistic figures, along with multiple indeterminate images. As symbolic forms of communication, the images reflect the initial phases of pictograms in Korea. These incised drawings are the primary representations of myriad symbolic, mythical, and ritual images identified as the earliest phases of such pictographic art. The images range from animals rendered in a realistic style to geometric patterns. They also reflect daily customs and religious rituals based on the ancient peoples' need for food and desire for fertility, as well as their understandings of the cycle of life and that of nature.

The carvings are mainly found on the flat surface of a vertical rock that measures about 16 feet, 5 inches (5 m) high and 26 feet, 3 inches (8 m) wide, located in the lower part of a cliff that is 98 feet, 6 inches (30 m) long. Korean experts have conducted studies of how the

petroglyphs were carved and carried out iconographical analyses of each image. The petroglyphs were apparently made in four to five separate phases, with each stage of carving indicating the date and function of the incised images and the type of people who produced them. Comparative studies of the iconography have revealed both universal and specific features; the Bangudae petroglyphs include, among other things, the oldest-known images of whale hunting anywhere in the world and as such are significant as they may allude to early totemic rituals involving whales practiced within the maritime fishery culture of the north Pacific coast.[4]

As visual and material representations of prehistoric worldviews, the Bangudae petroglyphs provide a glimpse into a primary stage of Korean civilization, and interdisciplinary research is required to understand them more comprehensively. Given the ongoing erosion of the cliff on which the petroglyphs are carved, ink rubbings are of great importance; such documentation provides a connection to maritime art and life in the prehistoric era and may allow us to understand the origin of pictographic communication in Korea.

JHP

1
For a thorough study of the Bangudae petroglyphs, see Ho-tae Jeon and Jiyeon Kim, eds., *Bangudae: Petroglyph Panels in Ulsan, Korea, in the Context of World Rock Art*, Bangudae Petroglyph Institute, University of Ulsan (Seoul: Hollym Corp. Publishers, 2013).

2
The set of ink rubbings of the Bangudae petroglyphs shown here is published in Jung Hyun Sook, *The Beauty of Ancient Korean Calligraphy: Inside Its History* (Icheon: Woljeon Museum of Art, 2010), 24—33, cat. 1.

3
See Ho-tae Jeon, "Hanguk ui seonsa mit godae chogi yesulgwa Bangudae Amgakhwa" [Early art in the prehistoric age and ancient times in Korea and the Bangudae petroglyphs], *Yeoksa wa gyeonggye* [History and the boundaries] 85 (December 2012): 1—47.

4
For an analysis of distinctive aesthetic features, see Kim Ho-suk, *Geurim euro sseun keoksa chaek Bangudae Amgakhwa* [*Bangudae petroglyphs: A history book written by drawings*] (Seoul: Yemaek, 2013).

TOOLS
AND
MATERIALS

The essential tools and materials used to create calligraphy in Korea have not changed for nearly two millennia. This section introduces brushes, ink, inkstones, and examples of paper used for writing. These are the same basic resources used by painters throughout East Asia, and calligraphy and painting are closely linked on a theoretical as well as a practical level. Both arts are vital forms of self-expression. Brush-written calligraphy has long been admired in Korea as a means of communicating meaning, as an abstract art, and as a way to judge a person's character.

This section ends with two sets of stamped ceramic tiles whose inscriptions are examples of early writing on the Korean Peninsula. Such tiles were embedded into the walls of underground tombs between the first century BCE and the seventh century CE and were stamped with inscriptions that often include dates, wishes for good fortune, and entreaties for the preservation of the tomb. These tiles are included here to emphasize that calligraphy can take many forms other than writing with a brush on paper, silk, wood, or bamboo—in Korea, it appears in many media, including ceramics, metals, and lacquer.

2

Ink Stick
석가탑 출토 먹

Unified Silla dynasty, 8th c.
Soot and glue
Length: 2⅛ in. (5.4 cm)
Central Buddhist Museum, Seoul
Not in exhibition

3

Ink Stick
먹

Late Joseon dynasty
Ink
3⅝ × 1⅜ × ⅜ in. (9.3 × 3.4 × 0.95 cm)
National Folk Museum of Korea, Seoul

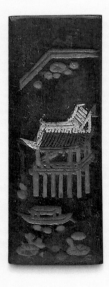

4

Ink Stick Stand
먹상

Late Joseon dynasty
Wood
1 × 5¾ × 1½ in. (2.5 × 14.5 × 3.7 cm)
National Folk Museum of Korea, Seoul

There are four essential tools used by the calligrapher. Known as the four treasures of the scholar's studio (*munbangsau*), they are paper, writing brush, ink stick, and inkstone.

The brush is the essential tool for writing and painting. It is made of animal hair— of a sheep, fox, rabbit, tiger, deer, mountain rabbit, wolf, dog, or horse—assembled with glue and set inside a bamboo or wood handle. An excellent brush can require much care and effort to make. Brushes were sometimes named; this depended on the brush's use. Korean brushes were considered to be as good as Chinese brushes.[1]

The oldest-existing inkstones on the Korean Peninsula were found in the ruins of the Han dynasty Lelang Commandery, now located within North Korea. These were made of stone, ceramic, earthenware, and other materials. The mark of a high-quality inkstone is that it does not allow the ink inside it to dry for ten days. They come in various sizes and shapes and are often carved with designs of dragons, cranes, turtles, grapes, plums, orchids, chrysanthemums, bamboo, persimmons, and fish. Round shapes have been prevalent since the Three Kingdoms period. The Unified Silla dynasty produced lotus designs on inkstones. The Goryeo dynasty produced square shapes. Inkstones made during the Joseon dynasty were more decorative and naturalistic.[2]

Ink sticks are black and hard. To make ink they are ground by hand with water on the surface of an inkstone, and the density of the ink is controlled by how much water is used. The brush is then ready to be dipped into the ink to begin writing or painting. It is unclear when ink sticks were first made in Korea. Ancient records indicate that a Goguryeo man paid taxes to the Chinese Tang dynasty with ink sticks. In one Goguryeo tomb alone, eighty-one ink sticks were excavated. Records also show that ink sticks were given as rewards within the royal courts.

Ink sticks are generally made from soot and animal glue. Soot is made by burning such oils as soybean oil, lard, or even pinewood. Animal glue is used to bind the soot together and can be made from fish

5

Writing Brush
필
Late Joseon dynasty
Wood and animal hair
Length: 14¼ in. (36.2 cm)
National Folk Museum of Korea, Seoul

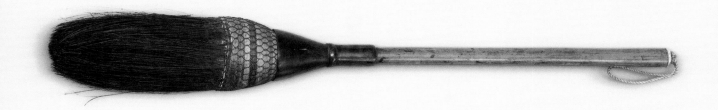

6

Writing Brush
붓
Late Joseon dynasty
Bamboo and animal hair
Length: 10¼ in. (26 cm)
National Folk Museum of Korea, Seoul

7

Writing Brush
붓
Late Joseon dynasty
Wood and animal hair
Length: 9½ in. (24 cm)
National Folk Museum of Korea, Seoul

8

Ink Slab Case
벼루함

Late Joseon dynasty
Wood and stone
6¾ × 11⅜ × 7½ in. (17 × 28.9 × 19 cm)
National Folk Museum of Korea, Seoul

skin or oxhide. Preservatives, such as cloves and white sandalwood, are added, and the mixture is then kneaded and pressed into molds to give it its form. The sign of an excellent ink stick is its ability to be smoothly ground into an inkstone. While ink sticks are usually rectangular, other shapes have also been made for specific occasions.[3]

Korean handmade paper was a crucial material used for various purposes in daily life, including calligraphy, letters, and books; for floors, walls, windows, and doors; for furniture, umbrellas, lanterns, fans, and boxes; and for clothing, shoes, and many other items.[4] Despite the ubiquitous

9

Letter Paper
편지를 쓰는 데 사용하는 종이

Joseon dynasty
Mulberry paper
Each sheet: 11 × 19 in. (27.8 × 49.2 cm)
National Museum of Korea, Seoul

presence of paper in Korean daily life, the origin of Korean papermaking is not known, as no written documents describing its beginnings have survived. Scholars assume that papermaking must have spread from China to its neighboring countries at an early stage. Paper existed in Korea at least before the end of the sixth century. Some scholars claim that Koreans used paper before the fourth century, based on a piece of paper that was excavated from the ancient Tomb no. 116 in Jechubjeong by the Joseon Archaeological Site Group in 1931.[5] As early as the tenth century, several Chinese books remark on the excellent quality of Korean paper and on its use as one of the

main tribute products taken to China during the Goryeo dynasty.[6]

The Joseon dynasty was a Neo-Confucian state with a strong class of aristocrats and literati (*yangban*). Administrative documents and royal protocols were written or printed on paper and bound into books. The Joseon kings made an effort to revive papermaking skills by establishing a government-led papermaking

department. When the increasing popularity of book publication led to a dearth of material, the Joseon government sent papermakers to China and Japan to learn from their papermaking methods, which used different types of raw materials. For example, in 1430, King Sejong (r. 1418—50) sent papermakers to Japan, who then introduced mulberry cultivation to Korea.[7] Various materials were mixed with basic paper ingredients, including pine bark, rice straw, and bamboo, and became more common from the Joseon dynasty onward. Previously, the raw material from mulberry trees had been mixed with the ash of rice straw and stalks of beans, cotton, red pepper, buckwheat, and oakwood.[8]

The peaceful early Joseon culture ended in 1592 with the Japanese invasion of Korea under the warlord Toyotomi Hideyoshi (1537—1598). During the six years of war, Japan pillaged many Joseon cultural properties, and Korean craftsmen were taken as slaves to Japan. After the war the Joseon government had to pressure Buddhist monasteries to supply paper, as the Japanese invasion had greatly damaged the papermaking industry, and monks were already producing papers on their own for religious texts. Even so, Joseon and its papermaking industry could not meet China's heavy demand for tribute in the form of paper, and the quality of paper produced in this period declined.[9]

Nevertheless, the culture of paper and its various uses remained throughout the Joseon period. Letter paper was valued not only as a medium on which to write but also as an important tool of communication that helped to cultivate relationships between people inside the royal family and later among the literati of noble society. People would customarily exchange poems and letters to express their political or personal feelings, as well as their longings and appreciation for the arts.[10] Depending on the addressee and the situation, different paper designs, forms, and patterns were used. After the nineteenth century, paper became increasingly accessible to people beyond the royal family and nobility.

VM/NM

[1]
"But" [Writing brush], *Hanguk Minjok Munhwa Daebaekgwasajeon* [Encyclopedia of Korean culture], published 1996, http://encykorea.aks.ac.kr/Contents/SearchNavi?keyword=%EC%84%9C%EC%97%90%20%EB%B6%93&ridx=0&tot=3064.

[2]
"Byeoru" [Inkstone], *Hanguk Minjok Munhwa Daebaekgwasajeon* [Encyclopedia of Korean culture], published 1996, http://encykorea.aks.ac.kr/Contents/SearchNavi?keyword=%EB%B2%BC%EB%A3%A8&ridx=0&tot=23.

[3]
"Inkstick," Wikiwand, last modified December 2, 2017, http://www.wikiwand.com/en/Inkstick.

[4]
Hyejung Yum, "Traditional Korean Papermaking: Analytical Examination of Historic Korean Papers and Research into History, Materials, and Techniques of Traditional Papermaking of Korea" (research paper, Graphics Conservation Laboratory, Cornell University Library, Ithaca, NY, 2003), https://ecommons.cornell.edu/bitstream/handle/1813/13022/Papermaking.pdf?sequence=1&isAllowed=y.

[5]
Ibid.

[6]
Ibid.

[7]
Ibid.

[8]
Lee Hyeonggwon, "Jang Yong-hun: A Lifetime Dedicated to Papermaking," *Koreana* 16, no. 3 (August 2002): 50—53.

[9]
Ibid.

[10]
Son Ke-young, "Joseon sidae gomunseo e sayong doen jongi bunseok" [An analysis of papers used in historical manuscripts], *Journal of Korean Society of Archives and Records Management* 5, no. 1 (June 2005): 79—105.

2

3

4

5

6

7

8

9

10

Tomb Bricks with Inscriptions
「경원원년」이 새겨진 벽돌

Wei (K. Wi) Kingdom, 260
Stamped clay
Variable sizes
National Museum of Korea, Seoul

The *hanja* characters in clerical script stamped onto the sides of these tomb bricks are among the earliest-known examples of writing on the Korean Peninsula. Found in brick-chamber tombs excavated at the Lelang Commandery (now situated in North Korea) in the early twentieth century during the Japanese Colonial period, these and other similar tomb bricks range in date from the Chinese Han dynasty through the Three Kingdoms period.[1]

The six examples shown here date to the mid-third century. One is stamped with an inscription that includes a reign date and title: *Gyeongwon wonnyeon* (Ch. *Jingyuan yuan nian;* first year of the Gyeongwon [Ch. Jingyuan] reign), corresponding to the year 260, during the reign of the Cao Wei emperor Cao Huan (posthumously known as Yuandi; r. 260– 66). The stamped inscriptions on the other bricks comprise auspicious phrases, such as, "May the prince live for a thou- sand autumns and ten thousand years!" These script forms closely resemble forms used on tomb bricks in late Han dynasty China. Variants of these script forms appear on the earliest-known Korean royal stele, the *Gwanggaeto Daewang Stele* of 414 (cat. 22), and on Goguryeo tomb bricks from contemporaneous burials in Korea (cat. 11).

The Lelang Commandery was first estab- lished in 108 BCE during the reign of the Han dynasty emperor Wudi and lasted until the commandery was overrun by the Korean state of Goguryeo in 313 CE.

SL

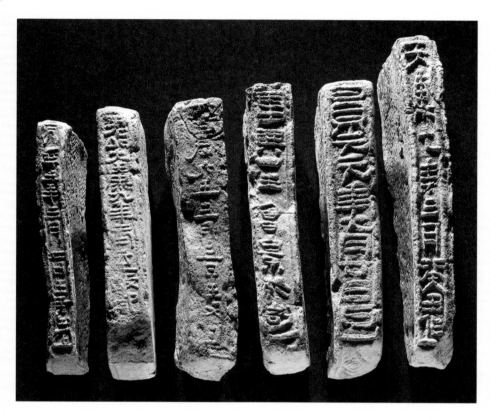

1

For a report on the excavation of sites associated with the Lelang Commandery carried out in 1924, see Oba Tsunekichi et al., *Rakurō kanbo: Taishō jūsannendo hakktsu chōsa hōkoku* [Lo-lang Han tombs, vol. I, Report of excavations conducted in 1924] (Nara: Rakurō Kanbo Kankōkai, 1974—75); see also Hamada Kōsaku et al., *Rakurō saikyō chō ibutsu shūei* [Select specimens of the remains found in the Tomb of the Painted Basket of Lo-Lang] (Pyeongyang: Heijō Meishō Kyūseki Hozon Kai, 1935). For a general discussion of excavated finds from the Lelang Commandery, see Jung In-seung, "The Material Culture of the Lelang Commandery," in *The Han Commanderies in Early Korean History,* ed. Mark E. Byington (Cambridge, MA: Korea Institute, Harvard University, 2013), 137—64.

1

Inscribed Tomb Bricks
글자가 새겨진 벽돌

Three Kingdoms period, Goguryeo Kingdom,
4th and 5th c.
Molded and stamped earthenware
Average length: 11 in. (28 cm)
National Museum of Korea, Seoul

These bricks date to the fourth and fifth centuries. They were found among heaps of collapsed stones and ceramic roof tiles from the Taewangneung and Cheon-chuchong tombs, associated with royal burials of the Goguryeo Kingdom. The tombs are located in what is now Jilin Province, China, parts of which were encompassed by the ancient Goguryeo state. The bricks were made of fine clay hardened during firing. The Chinese

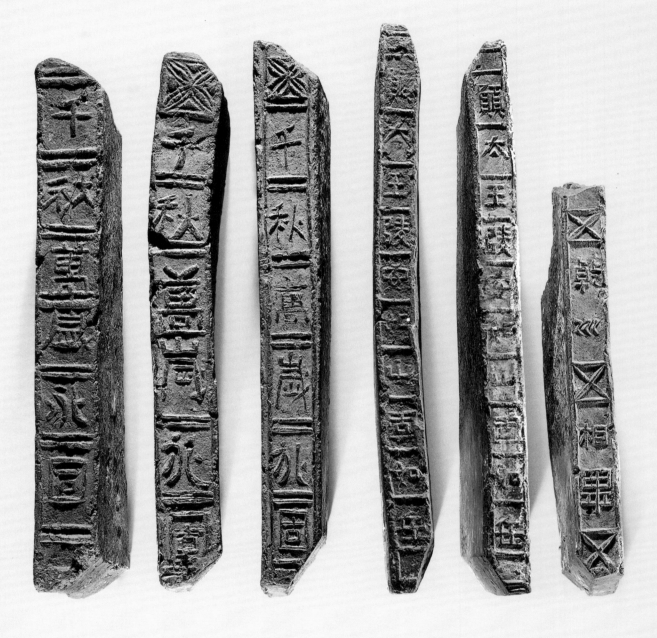

characters stamped into one side of the bricks constitute prayers for the eternal preservation of the tomb. Some of the phrases read, "We pray that the Taewang tomb is as safe as a mountain and as solid as a sacred peak"; "We pray that the tomb stays strong and solid forever"; and "We pray that the grave is preserved until the end of heaven and earth."[1] The formal and architectonic clerical style of calligraphy seen in these stamped inscriptions closely follows that of the earlier Lelang Commandery tomb bricks, inscribed in Han dynasty clerical script (see cat. 10).

From the Bronze Age through the Three Kingdoms period, such artificially constructed stone mounds covered with earth as the Taewangneung and Cheonchuchong tombs were built for kings and royal family members. The stones that lined the tombs' inner walls were processed into square blocks.[2] Bricks with prayer inscriptions were used as additional material, together with roof tiles, to construct whole buildings on top of these large-scale royal stone-mound tombs. The Goguryeo stone-mound tombs were unique in their structure and shape compared with tombs in neighboring countries. One of the oldest historical records that explains the philosophy and construction of these tombs is the twelfth-century text *Samguk sagi* (History of the Three Kingdoms).[3] According to this text, the Goguryeo people believed that life after death continued in heaven, and, therefore, the corpse was placed on a carefully arranged stone pedestal on top of the ground and not buried underground. For individuals of high social status, trees and gardens were built on top of the stone-mound tombs. The Taewangneung tomb is a square staircase-shaped tomb believed to have been built for King Gwanggaeto (r. 391—413).[4] The nearby Cheonchuchong tomb is believed to have been constructed slightly earlier, in the late fourth century.[5]

NM

[1]
"Geuljaga segyeojin byeokdol" [Bricks with inscriptions], National Museum of Korea, accessed September 21, 2017, https://www.museum.go.kr/site/korm/relic/search/view?relicId=522.

[2]
Moon Sig Ha, "Yonam jiyeok eui dolmujimudeom yeongu" [A study of the stone mound tombs in the Lianan area], *Seonsa wa gode* [Journal of prehistory and ancient history] 38 (2013): 57.

[3]
Samguk sagi [History of the Three Kingdoms] is a historical record of the Three Kingdoms of Korea: Goguryeo, Baekje, and Silla.

[4]
"Taewangneung," National Institute of Korean History, accessed September 21, 2017, http://contents.history.go.kr/mfront/ti/view.do?treeId=02005&levelId=ti_005_0150.

[5]
"Cheonchuchong," *Hanguk Minjok Munhwa Daebaekgwasajeon* [Encyclopedia of Korean culture], published 1996, http://encykorea.aks.ac.kr/Contents/Index?contents_id=E0056066.

BUDDHIST
CALLIGRAPHY

The Buddhist religion, which first emerged in India, reached China in the first century CE and Korea in the fourth century. Buddhism arrived in Korea with a sophisticated body of teachings regarding life, death, rebirth, suffering, compassion, transience, the illusory nature of perception, and enlightenment, expressed in sacred texts known as sutras (K. *gyeong*). The majority of sutras embodying the conceptual underpinnings of Buddhism in East Asia were originally written in Sanskrit in India and were later translated into Chinese. Because of their mastery of written Chinese characters (*hanja*), Korean Buddhist monks were among the most literate members of society. Chinese was the written language of Buddhism in East Asia, playing a role similar to that once played by Latin in the writings and rituals of the Catholic Church. It is noteworthy, however, that the written forms of Buddhist mantras in Korea were not written in Chinese, but in Siddham characters derived from Sanskrit. (One of the remarkable and rare works encountered in a later section is a Joseon dynasty woodblock-printed book transliterating Siddham mantras into the phonetic *hangeul* script.)

This section focuses on two categories of Buddhist calligraphy. The first comprises sacred Buddhist texts, among which the most glorious are Goryeo dynasty illuminated sutras, written and painted in gold on indigo-dyed paper. The second includes beautifully written epitaphs of famous monks and records of new and renovated temple buildings carved into the surfaces of stone steles.

Diamond Sutra
금강경
金剛經

Baekje Kingdom, 7th c.
Gold
5⅞ × 130⅛ in. (14.8 × 330.6 cm)
National Museum of Korea, Seoul,
National Treasure no. 123
Not in exhibition

After the historical Buddha passed into Nirvana, his enlightenment was honored by enshrining his *sarira* (relics) in South Asian stupas (reliquary mounds).[1] It was believed that relics of the Buddha's physical body symbolized the permanence of his teachings. Such relics were usually placed inside smaller reliquaries made of gold, silver, or bronze to ensure their preservation.

Gradually, it became commonplace to enshrine sutras (sacred Buddhist texts) with *sarira* within the foundations of stupas or pagodas, as another way of preserving the Buddha's teachings. This group of nineteen incised gold sheets is inscribed in standard script with the

Diamond Sutra. It was discovered interred, along with several small reliquaries, inside the first story of a five-story stone pagoda in Wanggung-ri, Iksan, North Jeolla Province. The pagoda, which had gradually been tilting for years, was reconstructed in 1965, leading to the accidental discovery of the relics. The sheets were found inside a gold casket, which was itself encased within a bronze casket. The gold sheets had been folded and tied together with two metal bands and then hinged together. When fully opened, the book measures nearly eleven feet in continuous length.

The text of the Diamond Sutra was incised into the thin gold sheets. The sutra is arranged in seventeen vertical text columns per sheet, with each column containing seventeen clearly legible characters. It is rare to find such a well-preserved gold-sheet Diamond Sutra book.[2]

The *Diamond Sutra* is an important text of Mahayana Buddhism. It consists of a dialogue between the historical Buddha Shakyamuni and an elder monk named Subhuti. One of its several goals is to explain the illusory nature of all phenomena. The sutra comprises thirty-two sections; the last of these contains the following short poem (*gatha*):

All conditioned phenomena
Are like a dream, an illusion, a bubble,
 a shadow,
Like dew or a flash of lightning;
Thus we shall perceive them.[3]

This and other gold-sheet sutras are distinguished by their delicate calligraphy. The flowing and refined calligraphy has been praised by many scholars. Compared with other, more carefully composed calligraphic characters incised or hammered into gold sheets, which tend to be more rectilinear in their overall compositions, this calligraphy reveals its lively strokes, resonating with naturalness, embodying a style of calligraphy closer to that written with a brush. While there has been ongoing discussion of the manufacturing methods used to create these gold-sheet sutras, the methods remain unclear.[4]

Analyzing the text's calligraphic style is crucial since it hints at the book's date of production, which is somewhat controversial. There have been various assessments of its overall style, which is a form of standard script that nonetheless has many semicursive characteristics. Because of its polished style, it is believed that the script was influenced by Chinese calligraphy of the Six Dynasties period.[5] After the script of this *Diamond Sutra* book was compared with similar calligraphy incised into a rectangular gold plate excavated from a Baekje Kingdom pagoda at the Mireuksa (639) in Iksan, the style of the calligraphy on the present sutra was identified as Baekje calligraphy, influenced by calligraphic styles of China's Northern dynasties (the Northern Wei, Eastern Wei, and Northern Qi dynasties).[6] It has a style similar to that observed on the even earlier stone memorial tablet for the queen consort of the Baekje king Muryeong (dated 526; cat. 25).[7] Despite dissenting views among scholars, the consensus is that the *Diamond Sutra* comes from the Baekje Kingdom. The value and significance of this gold *Diamond Sutra*, itself buried as a type of *sarira*, lie in the fact that it reflects not only the expression of religious faith but also the aesthetic sophistication of calligraphy and the overall level of craftsmanship during this period.

CGL/SL

[1]
The Buddha's relics often comprised teeth or bones. This practice also applied to the relics of famous Buddhist teachers and saints. With the spread of Buddhism throughout East Asia (China, Korea, and Japan), the architectural form of stupas found in South and Southeast Asia was architecturally transformed into that of multistory pagodas.

[2]
Cultural Heritage Administration, "Gukbo je 123–1 ho Iksan Wanggung–ri O cheung seoktap nae balgyeon yumul sungeum Geumganggyeong pan bu geumdae 2 gae" [National Treasure no. 123–1: Pure gold sutra and two gold belts found in a five-story pagoda at Wanggang–ri, Iksan], accessed June 12, 2018, http://heritage.go.kr/heri/mem /selectHaejeDetail.do?s_code1=99&s_code2 =11&s_code3=&s_query=&s_query2=&s_mnm =&s_kdcd=11&s_asno=01230100&s_cnum =0001&s_ctcd=00&s_dcd=&s_pcd=&s_page=3&s _hgsv=0&s_from_asno=&s_to_asno=&searchGubun =s_mnm1&searchCond=&searchPage =1&pageIndex=1&searchPageSize=10&searchDisp =1&listGubun=list.

[3]
See Chung Tai Zen Center of Sunnyvale, "The Diamond of Perfect Wisdom Sutra," section 32, accessed June 15, 2018, http://ctzen.org /sunnyvale/enUS/index.php?option=com_content &task=view&id=141&Itemid=57.

[4]
On the production technique of these gold-sheet sutras, see Jo Won–gyo, "Iksan Wanggung–ri ocheung seoktap balgyeon Sarijangeomgu e daehan yeongu" [A study of a *sarira* reliquary found in a five-story stone pagoda of Wanggung–ri in Iksan], *Baekje yeongu* 49 (February 2009): 77.

[5]
Song Il Gie, "Iksan Wanggung–ri 'Geumjigangsa-gyeong' ui Munheonhakjeok Jeopgeun" [A study of the textual bibliographic approach to the Kumji-Geumgang–sagyeong found in Wanggung pagoda at Iksan], *Seojihak yeongu* 24 (December 2002): 140—42.

[6]
Sohn Hwan–il, "Baekje Baengnyeongsanseong Chulto Myeongmungiwa wa Mokgan ui Seoche" [The calligraphy of inscribed roof tiles and wooden tablets excavated at Baekje's Baekryeong Mountain fortress wall], *Gugyeol hakoe* 22 (February 2009): 123—49.

[7]
Kang Woo–bang, *Bul sari jangeom* [The art of the *sarira* reliquary in Buddhism] (Seoul: National Museum of Korea, 1991), 189—92.

Avatamsaka (Flower Garland) Sutra, Chapter 13, from the First Tripitaka Koreana

초조대방광불화엄경

初雕大方廣佛華嚴經

Goryeo dynasty, 11th c.
Handscroll; ink on paper
11 × 59 in. (28 × 150 cm)
National Museum of Korea, Seoul

The *First Tripitaka Koreana* was a massive printing project of the eleventh century, the goal of which was to print the entire Buddhist canon in the early Goryeo dynasty. *Tripitaka* is the traditional term for a compendium of Buddhist scriptures containing the teachings of the Buddha. The first known historical record of the *First Tripitaka Koreana* appears in the *Collection of Literary Works of Minister Yi of Goryeo (Donggukisanggukjip)* in 1241, written by the Goryeo dynasty government official Yi Kyubo (1168—1241). According to this source, the officials and people of the Goryeo dynasty donated funds to commission the production of the *First Tripitaka Koreana* to elicit the protection of the Buddha when the Khitans invaded Goryeo territory in 1011. At the time, King Hyeonjong (r. 1009—31) sought refuge in the southern part of the Korean Peninsula, evacuating Songak, Goryeo's capital city from 918 to 1392.[1] This scroll, made of *hanji*, the traditional Korean paper fabricated by hand from mulberry tree bark, is the *Avatamsaka Sutra*, chapter 13 (out of 60), which was first translated from Sanskrit into Chinese by the Indian Buddhist monk Buddhabhadra (359—429) during China's Eastern Jin dynasty. Buddhist sutras are canonical scriptures, many of which are regarded as records of the oral teachings of the Shakyamuni Buddha. Each page contains twenty-five lines, and each line is composed of fourteen characters.

Although Yi Kyubo's book provides the historical context for this work's production, other cultural factors ensured that the project could be completed. In 991, an ambassador of Goryeo, Han Eongong (940—1004), brought an official version of the Chinese Buddhist *Tripitaka* (*Gwanpandaejanggyeong*), printed between 971 and 983, to Goryeo from China's Northern Song dynasty; this was the first complete Chinese translation of the *Tripitaka* to enter Korea (all Buddhist sutras in Korea were written or transcribed using *hanja*, or classical Chinese characters, even though when read aloud they were pronounced in Korean). King Hyeonjong needed strong political and

moral support from the populace, and he thought the production of a *Tripitaka* as a national project could unite his kingdom.[2]

The *Avatamsaka Sutra* was a product of the Mahayana (Great Vehicle) school of Buddhism and is the fundamental sutra of the Flower Garland (Ch. Huayan) sect, which was one of the most influential Buddhist sects in Goryeo dynasty Korea. Mahayana Buddhism originated in India around 100 BCE and entered Korea from China in the fourth century. It criticized the former schools of Buddhism for being exclusive to monks, claiming instead that all people, with a certain effort, could attain Buddhahood without leading the

lives of celibate and cloistered monks. The Flower Garland sect of Goryeo took it a step further and regarded all creations in the universe as incarnations of the Cosmic Buddha Vairocana, a personification of spiritual truth and enlightenment. The school claims to view the world from the state of nirvana and affirms every aspect of it. The *Avatamsaka Sutra* accordingly preaches and celebrates the wide and far-reaching enlightenment of the Buddha. Later, it was an important text in the founding of Seon (Zen) Buddhism.

This version of the *First Tripitaka Koreana*, printed from carved wooden blocks, is more precise, sophisticated, and detailed than the *Tripitaka Koreana* made in the later period (1236—51). The widespread development of woodblock printing during the Unified Silla dynasty allowed sutras to be made available to wider audiences. In Buddhism the sutras are regarded as manifestations of the Buddha's body and are treated as objects of devotion and worship. Since the original woodblocks were to be the foundational template for many printed sutras, the act of carving them became a pious act through which people could attain karmic merit in the afterworld. As a result, sutra block carvers were required to be highly trained and devoted to Buddhism. The style of calligraphy of Buddhist woodblock texts was designed to be extremely legible; as a result, they were written, traced, and carved in elegant standard script.

There are many theories about how long it took to make the 5,048 volumes of the *First Tripitaka Koreana,* but according to the record in the *Collection of Literary Works of the High Priest Daegak* (*Daegakguksamunjip,* 1085—97), the carving of all the printing blocks was completed during King Hyeonjong's reign in the early eleventh century, although some newly translated versions were added later. The original woodblock set was entirely burned in 1232 when the Mongols invaded the Goryeo state. About three hundred printed scrolls produced from the original woodblocks, however, still exist in South Korea.

EY

1
Kim Sungsoo, "Research on the Place and Date of Praying for the Engraving of the First Edition of Tripitaka Koreana," *Journal of the Korean Society for Library and Information Science* 45, no. 2 (2011): 76.

2
Jin Hyeonjong, *The Handbook of the Tripitaka Koreana* (Gyeonggi-do: Dulnyouk Publishing Co., 1997), 19—20.

14

*Illuminated Manuscript of the
Avatamsaka Sutra, Chapter 47*
화엄경
華嚴經

Goryeo dynasty, 14th c.
Gold on indigo–dyed paper
Each page: 13⅛ × 4⅝ in. (33.2 × 11.5 cm)
National Museum of Korea, Seoul

15

*Illustrated Manuscript of the
Lotus Sutra, Chapter 2*
법화경
法華經

Goryeo dynasty, 1385
Gold on paper (illumination) and ink on paper (text)
Each page: 14⅜ × 5 in. (36.4 × 12.7 cm)
National Museum of Korea, Seoul
Not in exhibition

Illustrated or illuminated sutra manuscripts are among the best–known artistic productions of the Goryeo dynasty. These particular iterations of the *Avatamsaka* (*Flower Garland*) *Sutra* (*Hwaeomgyeong*) and the *Lotus Sutra* (*Beophwagyeong*) date to the fourteenth century.

The volume of the *Avatamsaka Sutra* shown here consists of a gold illustration and text on indigo–dyed paper in the format of an accordion–style folded manuscript. Buddhism was the state religion of the Goryeo dynasty and was popularly practiced by elites and commoners alike. The *Avatamsaka Sutra* documents a series of lectures delivered by the Buddha. Key among its teachings is the promise of spiritual fulfillment for sentient beings who are followers of the Buddha.[1] The *Avatamsaka Sutra* was the scriptural foundation for an eponymous Buddhist school.

Goryeo–era illustrated sutras such as these were hand–painted and copied by Buddhist monks for wealthy or aristocratic patrons. It was believed that the act of sponsoring a copy of a sutra would facilitate the commissioner's entry into paradise upon rebirth.[2] The use of costly materials, such as gold, especially juxtaposed against the dark indigo paper, contributes to the elaborate and opulent aesthetic that characterized Goryeo Buddhist devotional art. The striking illumination in this volume depicts the Buddha preaching to a multitude of figures at the right, and the eleven-headed Avalokiteshvara, Bodhisattva of Compassion, seated on a lotus throne and floating above clouds at the left. These frontispiece illustrations are known as *pyeonsang* (transformation images).[3]

The *Lotus Sutra* volume shown here, dated 1385, is similarly bound as an accordion-folded book and consists of an illustration in gold on plain (undyed) paper, followed by the text inscribed in elegant standard script in ink on paper. The illumination depicts the Buddha preaching to a group of monks and bodhisattvas at the right, and a series of narrative scenes at the left, including an illustration of a burning building and hungry ghosts at the upper left.

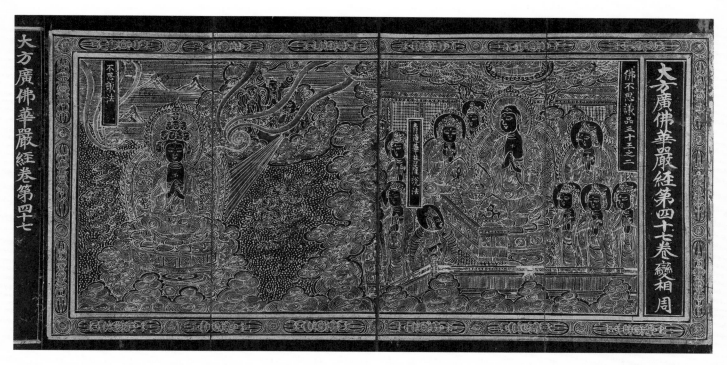

大方廣佛華嚴經第四十七卷變相周

佛不思議品三十三之二

不思議法

大方廣佛華嚴經口口口公法

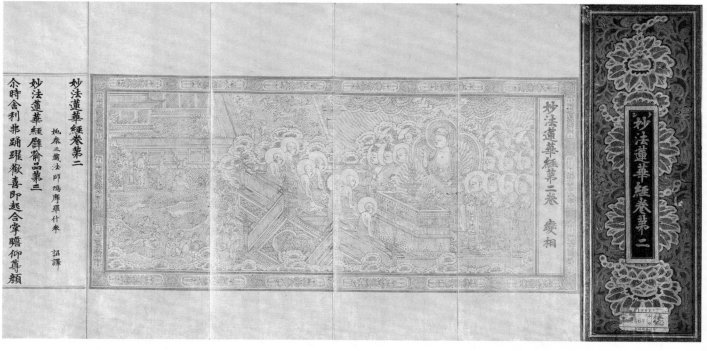

妙法蓮華經卷第二

妙法蓮華經第二卷變相

妙法蓮華經卷第二

妙法蓮華經辟喻品第三

姚秦三藏法師鳩摩羅什奉　詔譯

爾時舍利弗踊躍歡喜即起合掌瞻仰尊顏

妙法蓮華經卷第二

妙法蓮華經卷第二

The illuminations of both books have borders consisting of repeated *vajra* designs (stylized thunderbolts symbolizing the indestructibility of the Buddha's teachings) interspersed with stylized floral disks. The outer covers of both sutras contain intricate patterns of lotus flowers, known as "precious visage" flowers (K. *bosanghwa*, from the Chinese *baoxianghua*),[4] with arabesque foliage painted in gold.

Both texts comprise single constituent volumes of multivolume sutras. The standard language of Buddhist texts in East Asia was classical Chinese; as a result, such sutras in China, Korea, and Japan were all written in classical Chinese. The texts are read from right to left in vertical columns of seventeen clearly written standard-script characters. The top and bottom margins of each page are not equal; the top margins are wider than the bottom. This layout is characteristic of Korean sutras and does not occur in Japanese or Chinese sutras.[5] The folded format of the manuscript recalls the forms of early Buddhist texts from central Asia, which were translated from Sanskrit to Chinese and thus made available for East Asian audiences.

The paper on which the texts are written is *hanji*, traditional Korean paper, fabricated by hand from the pulp of the mulberry tree. It is particularly thick and sturdy and was favored among Chinese, as well as Korean, scholars and artists for its smooth surface, which was considered conducive to calligraphy.[6] Its admirers included the famous Chinese calligrapher and painter Dong Qichang (1555—1636). The paper's smooth surface was achieved through polishing with an animal horn. It is likely that this technique was applied to these manuscripts, as their contents are still clear and legible despite their age.[7] *Hanji* paper was initially a creamy white color; sutra texts were often transcribed onto paper that was dyed a deep blue, using pigment derived from the indigo plant, to contrast with the brilliant and shining gold (and sometimes silver) ink. This effect, referred to as *gamji geumni* (literally, "indigo paper–gold ink"), appealed to the sumptuous tastes of wealthy commissioners.

The gold used to illustrate and copy many Goryeo-period Buddhist sutra texts denoted their significance as religious documents. The copying of a sutra was considered an act of worship in itself, and by commissioning a sutra copy, the commissioner accrued the benefits of the action. The production of illuminated sutra manuscripts also functioned as a display of sumptuary worth on the part of the commissioner, as sutra texts had the capacity to be, and, indeed, were, widely produced and disseminated in much cheaper and more time-efficient iterations, most notably woodblock prints. Thus, only the very wealthy would have been able to afford illuminated manuscripts. Royal and aristocratic patrons would commission sutra manuscripts not only as displays of religious piety but often also as a means of commemorating special occasions or ensuring that a wish or request would be granted. Gold sutra manuscripts were greatly important within Goryeo society, to the extent that an entire government office was dedicated to overseeing their production.

AM/SL

[1]
Beth McKillop, "A Korean Buddhist Illustrated Manuscript," *British Library Journal* 24, no. 1 (1998): 158—67.

[2]
Chung Yang-mo and Judith G. Smith, eds., *Arts of Korea* (New York: Metropolitan Museum of Art, 1998), 171.

[3]
Ibid.

[4]
McKillop, "A Korean Buddhist Illustrated Manuscript."

[5]
Ibid.

[6]
Hyejung Yum, "Traditional Korean Papermaking: Analytical Examination of Historic Korean Papers and Research into History, Materials, and Techniques of Traditional Papermaking of Korea" (research paper, Graphics Conservation Laboratory, Cornell University Library, Ithaca, NY, 2003), https://ecommons.cornell.edu/bitstream/handle /1813/13022/Papermaking.pdf?sequence =1&isAllowed=y.

[7]
McKillop, "A Korean Buddhist Illustrated Manuscript."

**Rubbed Copy of the Epitaph
on the Sataekjijeok Stele**
백제 사택지적비 탑본

Baekje Kingdom, 654
Ink rubbing; ink on paper
42⅞ × 14⅛ in. (109 × 36 cm)
National Museum of Korea, Seoul

During the Three Kingdoms period, calligraphy was an important mode of expression, and Koreans sought to develop their own tradition based on Chinese styles. Calligraphy of the Baekje Kingdom, in particular, was highly influenced by clear and legible standard–script calligraphy seen on calligraphic

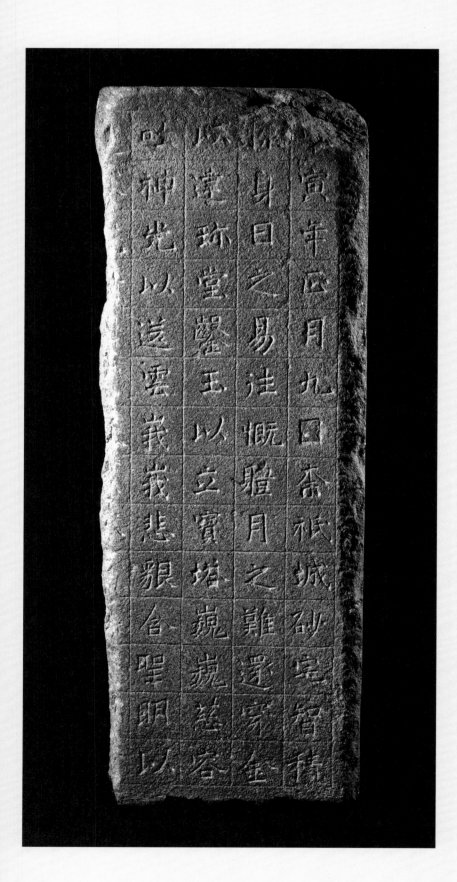

steles of both the Northern and Southern dynasties in China.

This high-quality granite stele is divided into a grid system: each row has fourteen characters, for a total of fifty-six characters, and within each square is a *hanja* character in standard script, popular during this time for memorial inscriptions.[1] The overall sentence structure was influenced by styles popularized in the Six Dynasties period and the Tang dynasty, and the stele is considered a late Baekje work. It was erected to commemorate the establishment of a Buddhist temple built by an individual named Sataekjijeok when he found Buddhism during his retirement.

Owing to its strong representation of regular script from the Baekje period, the *Sataekjijeok Stele* has been designated Treasure no. 1,845 and is protected by the Korean government. It was found on the side of the road in Gwanbuk-li[2] in Buyeo County, in South Chungcheong Province, by scholars Hwang Suyeong and Hong Sajun in 1948.[3] The stele is currently in the collection of the Buyeo National Museum.
VM

1
"Baekje sataekjijeokbi tapbon," Guknip jungang bakmulgwan [National Museum of Korea], accessed February 1, 2018, https://www.museum .go.kr/site/main/relic/search/view?relicId=2121. The stele is also published in Jung Hyun Sook, *The Beauty of Ancient Korean Calligraphy: Inside Its History* (Icheon: Woljeon Museum of Art, 2010), 98–99, cat. 17.
2
Ibid.
3
"Buyeo sataekjijeokbi," *Hanguk Minjok Munhwa Daebaekgwasajeon* [Encyclopedia of Korean culture], http://encykorea.aks.ac.kr/Contents /Index?contents_id=E0026068.

Taejasa Nanggongdaesa Baekwolseountapbi (Ink Rubbing of the Stele Commemorating the Great Master Nanggong at the Taeja Temple)

태자사 낭공대사 탑비 탁본
太子寺郎空大拓本

Goryeo dynasty, 954
Ink rubbing of a stone stele inscription (20th c.);
ink on paper
85⅞ × 40¼ in. (218 × 102 cm)
National Museum of Korea, Seoul

As the Goguryeo Kingdom continued to push its enemies the Silla and Baekje states to the south, the Silla Kingdom turned to Tang dynasty China for an alliance. The Tang court agreed that the territory south of Pyeongyang would belong to Silla if the Silla–Tang allied army won the war against Goguryeo and Baekje. In 660, Baekje was destroyed; however, the Tang ignored the earlier agreement and set up five military

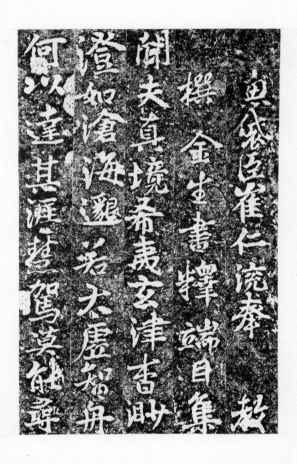
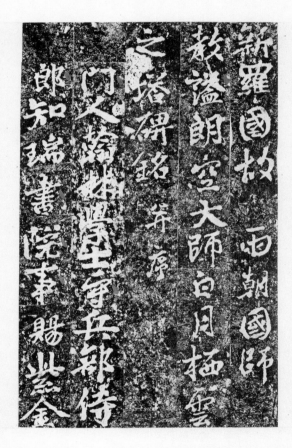

commanderies in the newly conquered region. But until Goguryeo surrendered in 668, Silla avoided direct confrontation with the Chinese. When the Chinese forces left Korea, Silla joined with the loyal forces of Baekje and Goguryeo and attacked the Chinese army, which finally led to Silla's complete unification of the peninsula and the establishment of the Unified Silla dynasty.[1]

Throughout their 267-year rule, Unified Silla's monarchs had to deal with ongoing political turmoil and revolts from forces loyal to the former Baekje and Goguryeo kingdoms. The rulers sought to promote their legacy and authority over the now-unified territory by referring to their royal lineage, and to achieve for themselves a position superior to the old aristocracy from which they had emerged.[2] Despite the political instability that lasted until the dynasty's fall, the period witnessed one of the most flourishing phases of cultural activity and a renaissance of the previous ancient Korean arts, with Buddhism and Confucianism established as state ideologies. Efforts to build a legacy by referring to past cultural achievements lasted throughout the Goryeo dynasty, Unified Silla's successor dynasty.[3]

In 954, during the Goryeo period, the *Nanggongdaesa Stele* was erected to honor the Great Buddhist Master Nanggong (832—917), one of Unified Silla's most eminent state-recognized Buddhist preceptors, whose role was to preserve the kingdom's culture and traditions. Nanggong, who had become a Buddhist monk at the Haein Temple in 855, was appointed to serve the state under the Unified Silla kings Hyogong (r. 897—912) and Sindeok (r. 912—17). The stele was originally placed at the site of the Taeja Temple in the city of Yeongju (in modern North Gyeongsang Province) before it became part of the collection of the National Museum of Korea in 1919.[4] The inscription was composed by Choe Inyeon (868—944), and the characters compiled by Buddhist master Danmok, using *hanja*

characters borrowed from works by Gim Saeng (711—?), one of the most famous calligraphers of the Unified Silla dynasty, active around 150 years before the stone monument was erected. Danmok specifically used Gim's standard and cursive script in transcribing Choe Inyeon's original text.[5]

The surviving stele's inscription can thus be categorized as a *jipja* (literally, "compiled characters"), an assembled calligraphic work. *Jipja* can be regarded as a practice of studying exemplary calligraphy from the past with the intention of creating a new text that bridges the past and the present. Although a very arduous and time-consuming process, *jipja* is still a popular calligraphic practice today, allowing the preservation, as well as the reassessment, of the present through the reconstruction of works from ancient history. At first glance, the script style of this *jipja* inscription appears to be no different from the original Gim Saeng script.

Few examples are extant of the original calligraphy by Gim Saeng from which the inscription's 2,500 characters were chosen and assembled into this new, single text. Since most of Gim's original calligraphy is lost, this compilation, preserved in ink rubbings, is considered one of the most crucial sources with which to study Gim's calligraphic style, not to speak of the Unified Silla dynasty's calligraphy traditions.[6] The inscription on the front of the monument describes the life and achievements of Master Nanggong, while the text on the back explains the social and political upheaval at the time of his death, which had prevented the erection of the monument until the Goryeo period, under the reign of King Gwangjong (r. 949—75). According to some Korean documents, such as the *Yakcheon Collected Writings* by Nam Guman, many rubbed copies of this inscription were made for Chinese connoisseurs and collectors, who, during the Goryeo dynasty, coveted examples of Gim's calligraphy.

Gim's calligraphy is known for its thick and bold brushstrokes. The text characters that the monk Danmok had collected, compiled, and carefully assembled show Gim's distinct *haengseo* script (also known as semicursive or running script). Celebrated as Korea's first distinguished native calligraphic style, the Gim Saeng script differed from the then-popular calligraphy of China's Ouyang Xun (557—641) and reveals similarities with the classical tradition of the Chinese master Wang Xizhi (307—365) from the Eastern Jin dynasty and the subsequent Southern Dynasties period. Gim's calligraphy was much admired for its firm and determined individual brushstrokes that contained "multiple facets of strength," with single strokes attaining an ideal balance between thick and thin and round and straight, regarded as one of its principal characteristics.[7]

NM

1
Peter H. Lee and William Theodore De Bary, eds., *Sources of Korean Tradition* (New York: Columbia University Press, 1997), 21, 57—59.
2
Ibid.
3
Ibid.
4
It has been designated Treasure no. 1,877; Lee Dongkook, "Seoyega Yeoljeon: Silla—Haedongseoseong Gim Saeng," *Gyeonghyang News*, July 21, 2006, 1.
5
Lee Dongkook, "Seoyero chajeun uri mihak Taejasananggongdaesa Baekwolseountapbi" [Korean aesthetics through the lens of calligraphy, part 1], *Gyeonghyang Sinmun* [Gyeonghyang news], January 24, 2014, http://news.khan.co.kr/kh_news /khan_art_view.html?artid=201401241932165.
6
Ibid.
7
Lee Dongkook, "Seoyero chajeun uri mihak Taejasananggongdaesa Baekwolseountapbi" [Korean aesthetics through the lens of calligraphy, part 2], *Geonghyang Sinmun* [Geonghyang news], February 7, 2014, http://news.khan.co.kr/kh_news/khan _art_view.html?artid=201401241932165.

Stone Tablet from the Buddhist Sarira Pagoda at Beopgwangsa
포항 법광사 석가불사리탑 석패

Unified Silla dynasty, 828
Stone
Height: 4¼ in. (10.8 cm)
Gyeongju National Museum
Not in exhibition

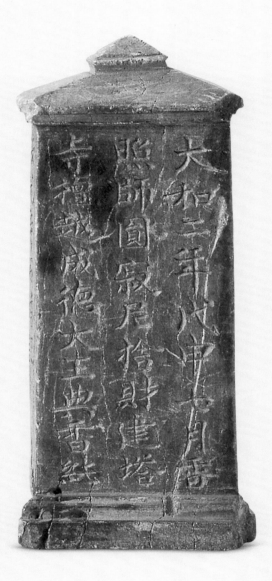

This small stone tablet was discovered in 1968 inside the base of the Sarira Pagoda on the grounds of the Beopgwangsa (Beopgwang Temple) in Pohang, a city in North Gyeongsang Province.[1] It was found alongside other stone and bronze offerings and relics (sarira) dating to the late Unified Silla dynasty. The Beopgwangsa was originally founded during the reign of King Jinpyeong (r. 579—631) of the Silla Kingdom and is still an active Buddhist temple today. An inscription is carved into the stone tablet in standard script. It reads:

On an auspicious [day] in the seventh month of the second year of the Daheo [Great Harmony] reign period, in the cyclical year *Musin-nyeon* [828], [on the occasion of] the death of the monk Josa, a nun bestowed funds to erect a memorial pagoda [so that the] beneficiaries of the convent might achieve virtuous [merit], with a ritual and incense [funded by] the great king [King Heungdeok r. 826—36), forty-second ruler of the Unified Silla dynasty].[2]

This inscription, documenting the establishment of a Buddhist reliquary pagoda, follows a pattern commonly seen in such dedicatory writings throughout East Asia. This example is noteworthy, however, in mentioning a Buddhist nun as the key donor. The inscription specifically states that the hoped-for result of building the pagoda was the achievement of merit for the residents of a convent that was perhaps attached to the temple.

SL

1
Published in *Embellishments of Buddha Halls in the World of Magnificently Decorated Buddha* (Seoul: Central Buddhist Museum, 2015), 63.

2
The inscribed relics discovered at the Beopgwangsa are described in "Discovering Gyeongsangbuk-do— Pohang City, Part 1," Korean Dreamer, published December 4, 2009, http://koreandreamer.blogspot .com/2009/12/discovering-gyeongsangbuk-do -pohang.html.

NATIONAL PRECEPTOR
DAEGAM TANYEON
대감국사 탄연
大鑑國師 坦然
1068—1158
Record of the Renovation
of the Manjushri Hall
문수원중수기
文殊院重修記
Goryeo dynasty, 1130
Album of 39 leaves; ink rubbings; ink on paper
Each page: 12⅜ × 6⅞ in. (31.5 × 17.5 cm)
Choi Hyosam Collection

Daegam Tanyeon (Great Mirror of Peace) was a high-ranking Buddhist monk granted the title national preceptor by the Goryeo royal court. He was also a famous calligrapher, whose works are now known only from ink rubbings of lost stone-carved steles. Key biographical data on Tanyeon are recorded in his memorial stele epitaph, composed by the Goryeo scholar Lee Jimu. It includes these lines:

The master's Buddhist name was Tanyeon; his secular surname was Sun. He was a native of Miryang County.

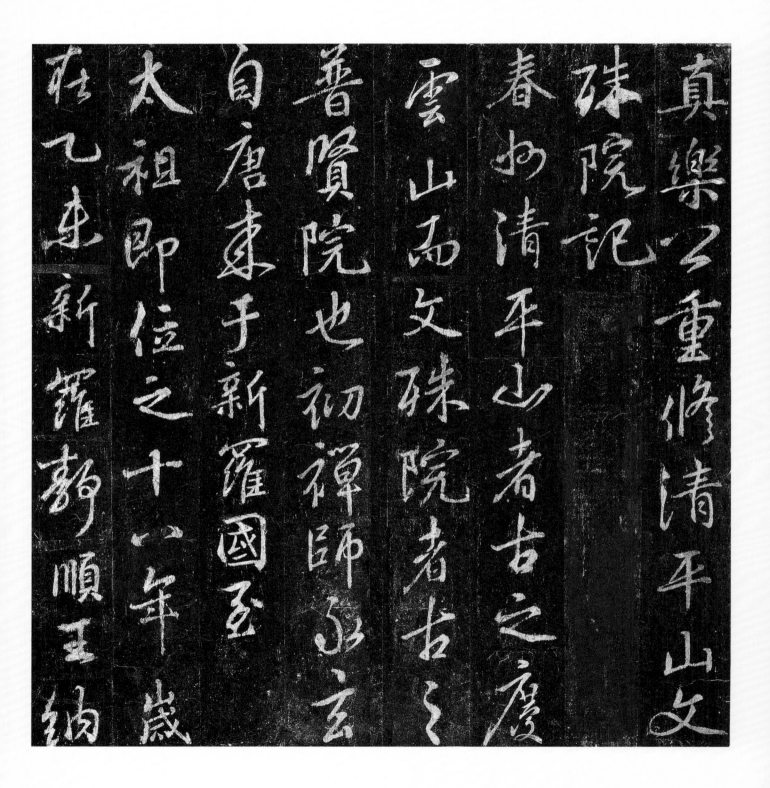

His father held the military rank of commandant (gyoul). His mother was a daughter of the An clan. The master's birth was accompanied by anomalous events.... Beginning at the age of eight, he could expound on different categories of literature, and his poetry astonished people. He also excelled at calligraphy—in his day he was considered a "thousand-mile horse" [cheollima, symbolizing an individual of exceptional talent].[1] At the age of thirteen, he studied the Six Classics.[2] ... At age nineteen, he shaved his head [and became a Buddhist monk].[3]

Another informative source on Tanyeon is the Goryeo-period compendium of discussions and critiques of Chinese poetry, the Pahan jip (Ch. Poxian ji); this reads, in part:

In the current dynasty [Goryeo], he [Tanyeon] was known as the national preceptor Great Mirror [Daegam guksa]. His studies were deep and far-reaching, and he dared to achieve fame in calligraphy. He inscribed the name tablet of the Floriate Tower and [also] a folding screen in the Treasure Palace [a royal palace].... When Jinnaggong of Cheongpyeong [Lee Jahyeon, a high-ranking official] died, the monk Hyeso [Ch. Huisu] from West Lake [Hangzhou, in China] composed a text [for an epitaph], and the national preceptor [Tanyeon] transcribed it [in his calligraphy]. Moreover, [Tanyeon's calligraphy] manifested the utmost strength. It was then carved into stone in order to transmit [the text to future generations]. The world called these [Hyeso's text, Tanyeon's calligraphy, and the stone-carved stele] the "three perfections."[4] It was definitely not the kind of thing that those of Choe's and Yang's class, with their "fat flesh and brittle bones," could attain.[5] [In contrast] there were often commentators who said, "[Tanyeon] uses stretched iron for his sinews and broken-down mountains for his bones; [his brushwork] is stronger than a carriage shaft and sharp enough to bore holes in wooden tablets." The men of Song [dynasty China] came with bolts

of white silk and marvelous [cakes of] ink, seeking the traces of the national preceptor's brush. They asked [Korean] scholars to encourage [Tanyeon] to transcribe poetry, and composed [poems] in order to submit them [to obtain Tanyeon's calligraphy].[6]

Tanyeon's best-known work is his Record of the Renovation of the Manjushri Hall, in which he transcribed an original text by the scholar-official Gim Buui celebrating the 1130 rebuilding of the Manjushri Hall at the Seunggasa, a Buddhist temple on Mount Bukhan, near Seoul.[7] The original stele does not survive; the inscription is known only from surviving ink rubbings. In Tanyeon's work the text is inscribed in running-script hanja characters that closely resemble those of the famous Jiwang Shengjiao xu (Preface to the holy teachings compiled from [characters written by] Wang [Xizhi]) stele inscription, dating to 672 (figs. 7, 71).[8] The Jiwang Shengjiao xu served as a preface to translations of Sanskrit Buddhist sutras into Chinese undertaken by the monk Xuanzang (ca. 596—664). The preface was composed by the Tang emperor Taizong in 648. As described by Lothar Ledderose:

By the order of the third Tang emperor Gaozong [r. 649—83], the monk Huairen, who was a distant descendant of Wang Xizhi, copied each character of the text [composed by Tang Taizong] from one of the many works by Wang Xizhi in the imperial collection. The entire copy then looked as if it were based on an original work by Wang Xizhi's own hand.[9] In 672 Huairen's work was cut into stone. This stone is still in the Beilin [Forest of Steles] in Xi'an. Although it was not written by Wang Xizhi himself, the Jiwang Shengjiao xu for two reasons became one of the most influential works of the Wang tradition. It was one of the first tie [K. che, calligraphic copybooks] to be cut into stone at all. That meant it could be easily and widely distributed throughout the empire in the form of rubbings, an advantage that so far had been enjoyed only by bei [K. bi; steles]. The other reason was its sheer length. The piece consists of 1,904

FIGURE 71
Detail of an ink rubbing of the Jiwang Shengjiao xu (Preface to the holy teachings compiled from [characters written by] Wang [Xizhi]), with text composed by Tang Taizong and inscribed with characters taken by the monk Huairen from the calligraphies by Wang Xizhi extant in the mid-7th c. (after Shodō zenshu [Complete compendium of calligraphy]), 24 vols. (repr., Tokyo: Chūōkōron-sha, 1990), vol. 8, pl. 62

characters, many of which are not found in the *Lanting xu* [*Orchid Pavilion Preface,* Wang Xizhi's most famous calligraphic work] and other famous pieces. To a student of Wang Xizhi's style the *Jiwang Shengjiao xu* therefore offered the greatest repertoire of forms.[10]

The *Jiwang Shengjiao xu* became the classic model for the custom of "borrowing characters" (*jipja*) from an ancient text and reusing them in a completely new context (for a Korean example of this practice, see the *Stele Commemorating the Enshrining of the Amitabha Statue at Mujangsa* of ca. 801; cat. 92). For centuries the stele text of the *Jiwang Shengjiao xu* has been taken as one of the exemplary models of Wang Xizhi's writings in Chinese history, and its fame spread to Korea and Japan. The similarities between Huairen's *Jiwang Shengjiao xu* and Tanyeon's *Record of the Renovation of the Manjushri Hall* were pointed out as early as the mid–eighteenth century, in *Wangyo seogyeol* (Round Peak's secrets of calligraphy), by the Joseon dynasty scholar Lee Gwangsa (1705–1777).[11] At the same time, Tanyeon's work reveals new influences from Tang dynasty China. While the style of Tanyeon's semicursive running script falls solidly within the Wang Xizhi running–script tradition, one can also detect the influence of Tang emperor Taizong's informal yet bold calligraphic style. Taizong was a great aficionado of Wang Xizhi's calligraphy and amassed a huge collection of the Eastern Jin dynasty master's work, including the original of the famous *Lanting xu.*[12]

SL

1

On the legend of the "thousand–mile horse," see Madeline K. Spring, "Fabulous Horses and Worthy Scholars in Ninth–Century China," *T'oung Pao* 74, no. 4/5 (1988): 173—210.

2

The Six Classics comprised the *Shujing* [*Book of Documents*], *Shijing* [*Book of Poetry*], *Yijing* [*Book of Changes*], *Chun Qiu* [*Spring and Autumn Annals*], *Liji* [*Book of Rites*], and now-lost *Yuejing* [*Book of Music*]; see James J. Y. Liu, *Chinese Theories of Literature* (Chicago: University of Chicago Press, 1975), 29.

3

The stele text of Lee Jimu's epitaph for Tanyeon is recorded in O Sechang, *Geunyeok seohwajing* [Geunyeok's collection of calligraphy and painting] (Gyeongseong [Seoul]: Gyemyeong gurakbu, 1929), 18. Translation by Stephen Little.

4

For a discussion of the more traditional grouping of poetry, calligraphy, and paintings as the "three perfections," see Michael Sullivan, *The Three Perfections,* rev. ed. (New York: Persea Books, 1999).

5

These condescending remarks may refer to the late Unified Silla (ninth–century) calligrapher Choe Chiwon; "Yang" remains unidentified. "Fat flesh and brittle bones" are negative criticisms of these calligraphers' written characters, which should ideally have lean flesh (outer appearance) and strong bones (inner structure).

6

O Sechang, *Geunyeok seohwajing,* 18. Translation by Stephen Little.

7

The ink–rubbing album presented in this exhibition is fully published in facsimile in *Seok Tanyeon Munsuwon gi* [The monk Tanyeon's *Record of the Renovation of the Manjushri Hall*], *Hanguk seoye myeongjeok* [Famous traces of the art of Korean calligraphy] (Seoul: Seoul Calligraphy Art Museum, n.d.).

8

On the *Jiwang Shengjiao xu,* see Nakata Yūjirō, ed., *Chinese Calligraphy* (New York: Weatherhill, 1983), 179—80, pl. 36; see also Lothar Ledderose, *Mi Fu and the Classical Tradition of Chinese Calligraphy* (Princeton, NJ: Princeton University Press, 1979), 14.

9

Huairen's task alone took twenty years to complete; see Nakata, *Chinese Calligraphy,* 179.

10

Ledderose, *Mi Fu,* 14.

11

Quoted in O Sechang, *Geunyeok seohwajing,* 18.

12

On this text, the most famous work in the history of Chinese calligraphy (and much admired in Korea since the Unified Silla dynasty), see Han Chuang [John Hay], "Hsiao I Gets the Lan–t'ing Manuscript by a Confidence Trick," *National Palace Museum Bulletin* 5, no. 3 (July—August 1970); and vol. 5, no. 6 (January—February 1971).

20

YI UIHYEON
이의현
李宜顯
1669—1745

Ink Rubbing of the Memorial Stele of the Great Master Unpa
운파당대사비명
雲坡堂大師碑銘

Joseon dynasty, 1730
Ink on paper
94½ × 66⅛ × 24 in. (240 × 168 × 61 cm)
Geonbongsa (Geonbong Temple), Gangwon Province

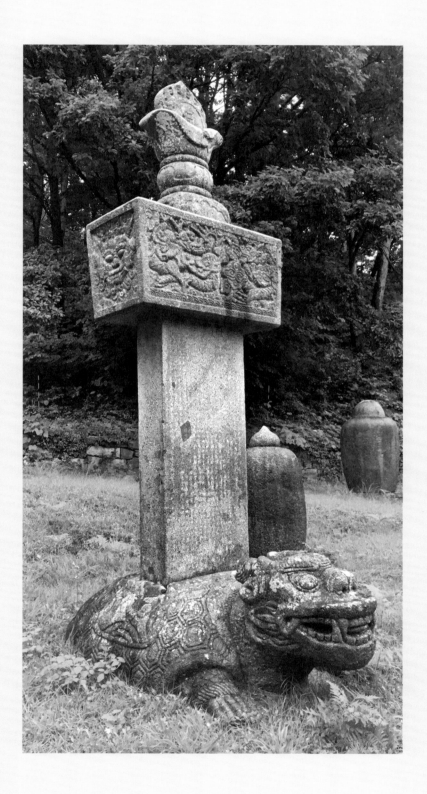

This memorial stele for the Buddhist monk Unpa Chingyaen (1651—1717) was erected in 1730 at Unpa's home temple, Geonbongsa (Geonbong Temple, or Heavenly Phoenix Temple) in the southern foothills of the Diamond Mountains in northern Gangwon Province, Korea. The inscription was written by the high-ranking official Yi Uihyeon, an expert on Neo-Confucian philosophy who rose to the rank of chief state councilor and paid two visits to the Qing court in Beijing, China, as an official emissary from the Joseon court (in 1720 and 1732, during the reigns of the Manchu Kangxi and Yongzheng emperors, respectively).[1] It is known that Yi also once visited the Diamond Mountains and wrote a detailed account of his trip.[2]

The memorial monument for Unpa is situated in a narrow valley on the grounds of the Geonbongsa. Made of granite, the stele consists of a base in the shape of a tortoise-dragon; a vertical shaft, inscribed on its front and back; a horizontal capstone carved with dragons flying among clouds and apotropaic monster masks; and a finial at the top in the shape of a flaming dharma wheel (chakra), symbolizing the Buddha's teaching. In situ, the stele rests on a slight slope; Unpa's ashes are interred in a smaller, stupa-shaped stone monument located just uphill from the epitaph stele.

At the top of the stele's front face is the title, written in large seal script, reading, Memorial Stele of the Great Master Unpa. The remaining text is inscribed in bold, elegant running script that is reminiscent of the semicursive script of the Ming Wu School master Wen Zhengming (1470—1559).[3] The first column of text presents a longer version of the title inscribed at the top: "Memorial Stele Inscription for the Great Master Unpadang of Geumgangsan (the Diamond Mountains) of the Bright Joseon Nation." This is followed by a list recounting the many official titles held by Yi Uihyeon, the compiler and author of the epitaph.

The epitaph itself follows. Unlike many epitaphs, which recount the myriad accomplishments of the deceased in ornate language, this text is written in the form of a dialogue between Yi and a Seon

(Ch. Chan; J. Zen) monk named Ssangsik. Yi was a prolific author who wrote at least two hundred epitaphs, which were praised at the time for dispensing with hyperbole.[4] The inscription reads:

When I was living in retirement on Dosan near Yangju I would wander every day along the roads with the elder Jeongyeongyasu. [Once] I was suddenly passed by a Buddhist monk on his way to visit his superiors. I inquired of him and he said, "I am the monk Ssangsik of the Geonbongsa in Ganseong. I am begging for alms and had not planned to wander far and wide along this road, and had [thus] not presumed to see you." I said, "People [who live in] the mountains do not seek [for things in] the [outside] world—how is it that you have come by me, toiling in this way?"

Sik said, "Buddhism takes nonaction [muwi; Ch. wuwei] as orthodoxy. Non-action means nonseeking. This explains the bright masters' path [which has been] transmitted to later [generations], and this is how nothing goes to waste in the realm of the dharma. Now I am preparing to engrave [a record] of my master's numinous traces [on a stele], in order to honor him in the monastery. Would that one might obtain some words from you—this is why I came by you!"

I said, "I am a Confucian. The Confucian Way and the Buddhist Way are not the same. I am unworthy to expend this effort. Moreover, I am ill and incapable. It is fine if you leave."

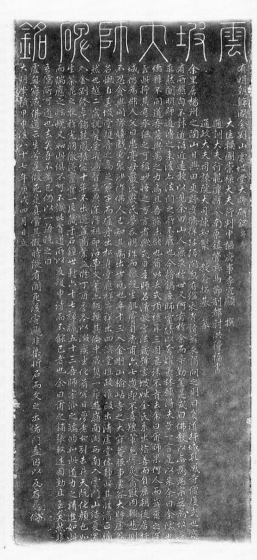

FIGURE 72
Rubbing of the front of the *Memorial Stele of the Great Master Unpa*, Joseon dynasty. Ink on paper; 71½ × 36¾ in. (181.6 × 93.4 cm)

FIGURE 73
Rubbing of the back of the *Memorial Stele of the Great Master Unpa*, Joseon dynasty. Ink on paper; 71½ × 36¾ in. (181.6 × 93.4 cm)

Sik bowed three times [and said], "I assuredly want to request [this of you], and dare not leave."

I said, "Truly, who was your master, that he has touched you so deeply in this way? Or is it a case of your praise being due to having been chosen as his [dharma] heir? Can you speak to the subtle nature of enlightenment?"

Sik said, "My master's name is Cheongan, his courtesy name is Beopjang, and his sobriquet is Unpa [Cloud Slope]. His [original] surname was Gim. He descended from a family of distinction, and since the Goryeo dynasty, their descendants have resided in Ganseong. Thus, we are fellow countrymen. His father's name was Chungnyang; his mother's surname was Eom. His mother dreamed that she ate a luminous pearl and conceived a child. When [the master] was born, his flesh was naturally fragrant. Beginning at the age of six or seven he opposed eating meat—when he saw cooked birds or animals he at once lamented and was overwhelmed with sympathy. By necessity he became a Buddhist—people knew it was a sign that he would leave the world. At age thirteen he entered the Elm Hill Temple's Hall of Great Silence [Daejeogam] in the Diamond Mountains, where he waited on Master Heogok. Heogok's alternate name was Nabaek, and he was the most eminent disciple of Chunpadang ssangeon. Ssangeon emerged from [the lineage of Master] Songwoldang Eungsang. Eungsang emerged from [the lineage of Master] Samyeongdang Yu-jeong. Yujeong emerged [from the lineage of Master] Cheongheodang Hyujeong. All these descended within the orthodox Imje [Ch. Linji; J. Rinzai] lineage. After two years Unpa cut his hair and received [Buddhist] ordination. He devoted himself to studying the Sanskrit canon, and [in this way] obtained the [mind-]seal [join] of the patriarchs. His literary works written in his spare time transcended the ordinary. In his middle age he took his staff and traveled to Hoseo in Yeongnam. In the south he

entered Cloud Gate Mountain, where he spent the summer. When he returned to the Diamond Mountains he resided at the Geonbong [Temple]. For ten years he did not emerge, [instead] engaging in high-level teaching and [self-]cultivation. In the winter of the cyclical year jeongyu [1717] he became ill and died while sitting [in meditation]. Several days prior he had dreamed that an old man came and led him to depart [the world], and [they] ascended to heaven. When [the master] died, his complexion was like that of a newborn [child]. On the night of Calling the Spirits [dabi; the cremation ritual] there was a pervasive auspicious radiance; one of his bones was [then] selected to be treasured [as a relic] in a stone chalice. His age [at the time of his death] was sixty-seven, and he had been practicing Seon for fifty-three years. My master's orthodox doctrine, the skillful progress in his discipline, and the dazzling radiance of his auspicious response [to his task] were all like this, to the extent that one cannot not record [his accomplishments]. In this way I must return [to my point] and respectfully request [that you compose words for his epitaph]; I am obliged to do this."

I said, "You have extensively quoted a fine narrative, diligently working to do your best. Yet my Confucian heritage may not be suited for this. [I must] depart—I cannot be [something I am not]." Then, with one illuminating phrase, he said, "The Master Heomu-jeongmyeol, speaking of the Buddhist path, said, 'In life there is the denial of death and its [simultaneous] reality'; one also hears of the illusory [nature of] time. Is it not a great joy to celebrate [a great life] after [a worthy individual] dies? Inscribing words into stone is a Confucian tradition! Why not return [to the temple] and preserve our social relationship?"

[Stele] erected on a day in the fourth month, eighty-seven years after the cyclical year gapsin of the Chongzhen reign of the great Ming [dynasty].

The date of Yi Uihyeon's inscription corresponds to 1730, during the reign of the Joseon dynasty king Yeongjo (r. 1724—76). The text states that Unpa died in 1717 at the age of sixty-six (by Western count); he was born in 1651.

The back of the stele is carved with the names of some two hundred individuals who contributed funds toward the stele's completion. Among these are the names of many Buddhist monks and lay believers. The text of the epitaph is recorded in the twelfth chapter of Yi Uihyeon's collected literary works, Dogokjip (1766).[5]

SL

1
See Lee Hyung-dae, "Hong Dae-yong's Beijing Travels and His Changing Perception of the West—Focusing on Eulbyeong yeonhaengnok and Uisan mundap," Review of Korean Studies 9, no. 4 (December 2006): 48—49.

2
See Jung Min, "Constructing Sectarian Pilgrimage Sites in Neo-Confucian Schools," Korean Histories 3, no. 1 (2012): 28; see also Karwin Cheung, "Journeys to the Past: Travel and Painting as Antiquarianism in Joseon Korea" (master's thesis, University of Leiden, 2016—17), 39, https://openaccess.leidenuniv.nl/bitstream/handle/1887/53224/Karwin%20Cheung%20-%20Journeys%20to%20the%20past%20-%20MA%20thesis.pdf?sequence=1.

For Yi's account of his Diamond Mountains trip, see Shin Young Ju, "Dogok Yi Uihyeon ui Yu Geumgang-sangi e gwanhan Ilgo" [A study of Yi Geumgangsan gi by Dogok Yi Uihyeon], Hanmun gojeon yeongu [Classical Chinese studies] 25, no. 107 (2012): http://www.happycampus.com/paper-doc/6177769/. For a study of the Diamond Mountains in Korean art, see Soyoung Lee, ed., Diamond Mountains: Travel and Nostalgia in Korean Art, exh. cat. (New York: Metropolitan Museum of Art, 2018).

3
Yi's calligraphy ultimately descends from the classical running script of Wen Zhengming's primary model, Wang Xizhi (307—365).

4
See the discussion of the epitaphs composed by Yi Uihyeon in Woo Jeong Kim, "Dogok Yi Uihyeon myodo mun ui dacheung jeok seonggyeok" [Multi-layered character of Dogok Yi Uihyeon's epitaph] Hanmun gojeon yeongu, accessed May 28, 2018, http://kiss.kstudy.com/thesis/thesis-view.asp?key=3127067.

5
See Korean Media Studies, accessed May 21, 2018, http://db.mkstudy.com/mksdb/e/korean-literary-collection/book/reader/8660/?sideTab=toc&contentTab=text&articleId=1158536. Translation by Stephen Little.

2
1

Woodblock for Printing Episodes from the Life of the Shakyamuni Buddha

석씨원류응화사적목판

釋氏源流應化事蹟木板

Joseon dynasty, 1637
Wood
11¼ × 25¼ in. (28.5 × 64 cm)
Central Buddhist Museum, Seoul, Treasure no. 591
Not in exhibition

In the *Woodblocks for Printing Episodes from the Life of the Shakyamuni Buddha* (*Seokshiwonryu—Eunghwasa Checkpan*), elite Buddhist teachings and discourse were transformed into simple text and paired with engaging illustrations to make Buddhism more accessible to commoners in the Joseon dynasty. In order to create such illustrated Buddhist collections, two major sets of wooden printing blocks were produced in Korea in the late seventeenth century. One set, which includes the block seen here, was commissioned by the Bulam Temple near Seoul, while the other was commissioned by the Seonun Temple in North Jeolla Province.[1]

Most of these Buddhist collections were either translations of or inspired by the Jataka (Pali and Sanskrit for "birth") tales of ancient India. The original Jataka

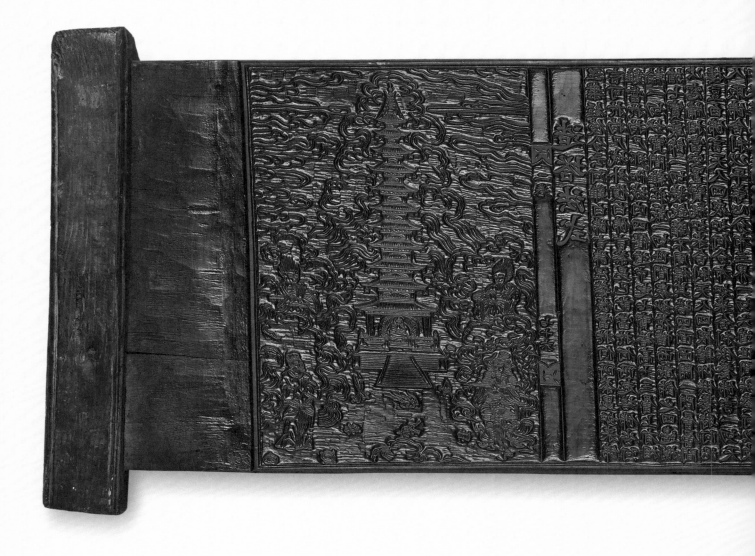

comprises a voluminous body of literature concerning the previous births of Gautama (Shakyamuni) Buddha in both human and animal form.[2] The Chinese monk Baocheng published the first Chinese Jataka collection, *Shijia rulai yinghua lu* (Record of the teachings of the thus–come Shakyamuni Buddha). The humorous and fantastical stories, written and composed for readers outside of Buddhist scholarly circles, quickly gained popularity, and more diverse versions of the short story collection were soon created in various parts of Asia. The study of these Jataka adaptations provides valuable information on how Buddhism was interpreted in and integrated into other cultures.[3]

The *Woodblocks for Printing Episodes from the Life of the Shakyamuni Buddha* use a basic set of four hundred classical Chinese characters (*hanja*) and simple sentence structures to allow for easy reading. The first and second books depict the journey of the Shakyamuni Buddha in India, whereas the third and fourth books tell stories about the Buddhist dharma (teaching) after it was transmitted to China. Each story consists of about 280 characters. It is not known precisely who commissioned the first Korean Jataka collection, although records indicate that the Korean monk Hojeong Jeongduwon traveled to Ming dynasty China and brought back several similar books, where–upon the Bulam Temple initiated the carving production of 212 wood printing blocks in the year 1637. The Bulam Temple's woodblocks are the best–preserved and most highly esteemed Jataka collection in Korea.[4] They are currently protected as Treasure no. 591.

In addition to translations of the Jataka stories, the *Woodblocks for Printing Episodes from the Life of the Shakyamuni Buddha* include the biographies of the Unified Silla dynasty monk Uisang (625—702), the Silla dynasty monk Jajang (590—658), and the Goguryeo Kingdom monk Uitong (927—988), who were crucial figures in the history of Korean Buddhism. Another unique addition to this set of woodblocks is the illustrations skillfully carved next to the texts. Further, the final block lists the names of the eighteen monks and painters who collectively worked on the woodblocks. The *Woodblocks for Printing Episodes from the Life of the Shakyamuni Buddha* have continuously inspired Korean literature, theater, opera, and other art forms, and played an important role in the cultural life of Korea, a country deeply rooted in Buddhist philosophy. Within Buddhist scholarship, this work was key to the formation and communication of ideas about the notion of karma and the place of the historical Buddha Shakyamuni in relation to other buddhas and bodhisattvas.[5]

NM

1
Song Il–gie, "Publication Fact of Seonunsa Temple Version of Seokssiwonryu," *Journal of the Korean Society for Library and Information Science* 48 (2014): 241—57.

2
Oskar von Hinueber, *Entstehung und Aufbau der Jataka–Sammlung: Studien zur Literatur des Theravada–Buddhismus* [Creation and construction of the Jataka collection: Studies on the literature of Theravada Buddhism] (Stuttgart: Franz Steiner Verlag, 1998).

3
Naomi Appleton, *Jataka Stories in Theravada Buddhism: Narrating the Bodhisatta Path* (Farnham, U.K.: Ashgate, 2010).

4
Choi Yeon–Shik, "On the Introduction and Circulation of Chinese Buddhist Short Story Collections in the Late Joseon Dynasty," *Journal of Buddhist Studies* 80 (2017): 109—36.

5
Ibid.

ROYAL CALLIGRAPHY

In Korea, as elsewhere in East Asia, a ruler's calligraphy was seen as a mirror of his or her moral character and authority. This section explores calligraphies and writings created by and for members of Korea's royal families, starting in the Three Kingdoms period. These include stele inscriptions documenting inspection tours, statements of political authority, and records of military campaigns. Royal funerary monument inscriptions include royal epitaphs and contracts governing the purchase of land for royal tombs from underworld powers. A third category, ranging in date from the Goryeo to the Joseon dynasty, are holographic manuscript calligraphies written with brushes on silk or paper by royals, among them the Goryeo grand prince Anpyeong; the Joseon kings Seonjo, Injo, Hyojong, Hyeonjong, and Sukjong; and the Joseon princess Jeongmyeong. The works presented here include brush-written and woodblock-printed model calligraphic sample books, stone-carved royal calligraphies, calligraphic exercise books, admonitions on filial piety, guidelines for good governance, and a royal seal.

The Gwanggaeto Daewang Stele Inscription

광개토대왕비 탑본

廣開土王碑搨本

Goguryeo Kingdom, 414
Set of four hanging scrolls; ink rubbings (20th c.);
ink on paper
Each: 252 × 78¾ in. (640 × 200 cm)
Woljeon Museum of Art, Icheon

King Gwanggaeto (r. 391—413) was a powerful Goguryeo monarch who rapidly expanded his territory across the northern part of the Korean Peninsula and deep into Manchuria. In 414, a year after his death, his son, King Jangsu (r. 413—91), erected a great stele adjacent to his tomb in his honor (fig. 18).[1] The stele, which still stands in China's Jilin Province, is astonishing, at nearly 21 feet (6.39 meters) tall, roughly 4 feet 3 inches to 6½ feet (1.3 to 2 meters) wide, and weighing nearly 34 tons.[2] Stone monuments of this size are rarely found, even in China, where such monuments were the first to be erected in East Asia. Made of tuff (a kind of volcanic rock), the stele has an overall shape that resembles a natural rock. The 1,775 characters carved onto the stone's four sides present a substantial historical document.[3] The inscription on the tombstone consists of three main parts: the first part describes the founding myth of Goguryeo, along with the kingdom's royal genealogy; the second part chronicles King Gwanggaeto's official activities and achievements; and the third part concerns the tomb guards of royal tombs.[4]

According to the *Samguk sagi* (History of the Three Kingdoms; early twelfth century), after the fourth century, the Goguryeo state made use of writing to promulgate policies, proclaim laws, establish the National University (Daehak) and private academies known as *gyeongdang*, and erect royal tombstones. The actual writing examples used by Goguryeo society may be seen today through such texts as those on steles, seals, and items of metalcraft, as well as through inscriptions on Buddhist statues. Inscribed steles and other inscriptions on stone were used by rulers to proclaim their lineage and achievements and to consolidate their political power.[5]

The calligraphic style of the inscription on the *Gwanggaeto Daewang Stele*—which is now registered as a UNESCO World Heritage monument—has received various assessments and is thought to be derived from Chinese clerical script (Ch. *lishu*; K. *yeseo*) of the Eastern Han dynasty. Scholars' opinions on the classification of this bold, square script have differed, as names of calligraphic scripts have changed

over time, depending on their purposes. It would be safe to take into account the shape and configuration of the characters, which clearly fall into the category of clerical script, resembling those of characters found on many stone steles of the Eastern Han dynasty in northeast China.[6] However, considering the relatively large size of the *Gwanggaeto Daewang Stele*'s individual characters, along with their bold artistry, Korean scholars have suggested a more idiosyncratic name for the calligraphic style of the inscription: Gwanggaeto Daewang Stele Script.[7] Similar configurations and straight-line strokes can be found in other inscriptions that were used for Goguryeo royal tombs, which likewise represented imperial authority. The Gwanggaeto Daewang Stele Script style was also used on Goguryeo-period seals and ceramic jars, evidence that it was eventually recognized as a commonly employed script.

NM

[1]
The stele text is discussed and fully translated in Peter H. Lee and William Theodore De Bary, eds., *Sources of Korean Tradition* (New York: Columbia University Press, 1997), 23—26.

[2]
The set of ink rubbings of the *Gwanggaeto Daewang Stele* shown here are published (and the stele's text fully transcribed) in Jung Hyun Sook, *The Beauty of Ancient Korean Calligraphy: Inside Its History* (Icheon: Woljeon Museum of Art, 2010), 40—51, cat. 4.

[3]
Lee Seong-je, "The Historical Significance of the Gwanggaeto Stele," *Journal of Northeast Asian History* 12, no. 1 (Summer 2015): 153—61.

[4]
Keum Kyung-sook, "The Gwanggaeto Stele and the Myth of Koguryo's Founder," *Journal of Northeast Asian History* 12, no. 1 (Summer 2015): 143—51.

[5]
Ko Kwang-eui, "What Stelae Reveal about Koguryo's Written Culture," *Journal of Northeast Asian History* 12, no. 1 (Summer 2015): 173—83.

[6]
Ouyang Zhongshi et al., *Chinese Calligraphy*, trans. Wang Youfen (New Haven: Yale University Press, 2008), 97—127.

[7]
Ko, "What Stelae Reveal about Koguryo's Written Culture," 173—83.

23

Ink Rubbing of the Pohang Jungseongni Stele Inscription
포항 중성리 신라비

Silla Kingdom, 501
Ink on paper (21st c.)
41⅜ in. × 19¼ in. (108 × 49 cm)
National Museum of Korea, Seoul

Stone monuments and their epigraphs are rare research artifacts that teach us about ancient Korea, as few primary sources from that time remain. Of all the ancient Korean kingdoms, the Silla Kingdom is known to have created the largest number of political and cultural stone monuments. In terms of their material symbolism, the aesthetics of their inscription texts, and their political dimensions, Silla stone monuments possess a high degree of historical and artistic significance. The *Pohang Jungseongni Stele* (fig. 74) is thought to be the oldest-inscribed Silla stone monument. It embodies a historical narrative and was an important political tool used to strengthen the monarch's reign and create order for the future. As such, the monument articulated the national politics of rule and identity through which political elites carried out their agendas and further legitimized their political power.[1]

The stele was excavated in 2009 in Jungseong, a district of Pohang in North Gyeongsang Province, situated in the southeast corner of the Korean Peninsula. Unlike the majority of early Korean steles, this stele, while having most likely been trimmed, retains its irregular natural shape and is wider at the top than at the bottom. The inscription indicates that it was erected two years before the *Pohang Naengsu-ri Silla Stele,* which was commissioned by King Jijeung (r. 500—514).[2] Neither the stele's exact content nor its commissioner is known.

Scholars have attempted to decipher the inscription, with resulting translations varying in their interpretations. However, the epigraph clearly shows to whom the stone monument text was addressed: namely, the residents of the Heunghae district, a strategically located military region that had become a new province of the Silla Kingdom and was henceforth under its jurisdiction.[3] Silla considered the Hunghae region important because it had served as a location of national defense against invasions from Japan and Goguryeo. This particular stele, which had a mainly judicial use, references names of government ministries, places, individuals, and official positions that are not recorded elsewhere; these may have been important to the Silla Kingdom before it reached

the height of its power.[4] Later, such monuments were erected in urban spaces and became parts of the city landscape, serving as points of reference and shaping the identity of specific places.[5]

A total of 203 classical Chinese (*hanja*) characters are inscribed on the irregularly shaped granite stone in twelve vertical columns composed of twenty characters each. The inscription text is largely influenced by Chinese clerical script from the late Han dynasty and Northern and Southern dynasties periods; this became a predominant calligraphic script in the Silla Kingdom. The inscription also shows hints of small seal script (in the consistent, unchanging width of the characters' strokes) and standard script, resulting in a unique style characteristic of early Silla calligraphy in the sixth century, often referred to as the Mujeong style. The style is characterized by its unadorned brush-strokes, which give the impression of having been "loosely thrown" onto the granite surface. A tendency to omit and add strokes to the characters can be seen; such improvisations would occasionally change the structure of the original Chinese characters.[6] The lack of elaborate or complex sentences suggests that the classical Chinese language was introduced to the Silla Kingdom only shortly before this stele was carved.[7]

NM

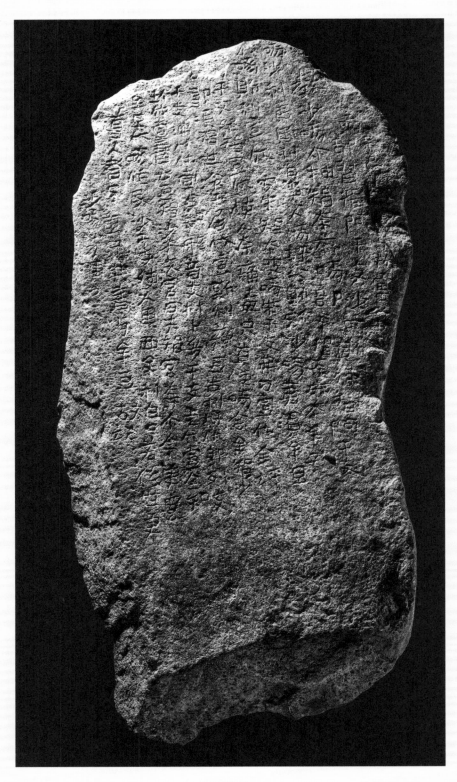

1
Cultural Heritage Administration, "Gukbo je 318 ho—Pohang Jungseongni Sillabi" [National Treasure no. 318—Pohang Jungseongni Silla Stone Monument], National Heritage, published April 22, 2015, http://www.heritage.go.kr/heri/cul/culSelectDetail.do?VdkVgwKey=11,03180000,37. The stele is also published (and its text transcribed) in *The Beauty of Ancient Korean Calligraphy: Inside Its History* (Icheon: Woljeon Museum of Art, 2010), 104—7, cat. 18.

2
Cultural Heritage Administration, "Bomul Je 1758 ho—Pohang Jungseongni Sillabi" [National Treasure no. 1,758—Pohang Jungseongni Silla Stone Monument], National Heritage, published February 22, 2012, http://www.heritage.go.kr/heri/cul/culSelectDetail.do?VdkVgwKey=12,17580000,37.

3
Lee Young-ho, "The Hunghae Region and the Silla Stele at Chungsong-ni, P'ohang," *Journal of Korean Ancient History* 12 (2009): 217—52.

4
The Beauty of Ancient Korean Calligraphy, 105.

5
Kang Jonghoon, "A Study of the Contents and Characteristics of the Newly Found Silla Monument, Jungseongni bi," *Journal of Korean Ancient History* 56 (2009): 131—69.

6
Ju Bo-don, "Structure and Contents of the Pohang Jungseongni bi Silla Stone Monument," *Journal of Korean Ancient History* 65 (2012): 117—58.

7
Ko Kwang-eui, "Calligraphy of Jungseongni bi Silla Monument at Pohang and the Life of Characters in the Period of Ancient Silla," *Journal of the Research Institute for Silla Culture* 35 (2010): 99—132.

FIGURE 74
Pohang Jungseongni Stele, Silla Kingdom, 501. Gyeongju National Research Institute of Cultural Heritage

Ink Rubbing of the Monument Marking King Jinheung's Inspection of Mount Bukhan

북한산 신라 진흥왕 순수비

Silla Kingdom, ca. 568—76
Ink rubbing of a stone stele inscription;
ink on paper (20th c.)
60⅝ × 27¼ in. (154 × 69 cm)
National Museum of Korea, Seoul
Not in exhibition

The *Monument Marking King Jinheung's Inspection of Bukhansan Mountain* (fig. 75) was carved in the mid–sixth century with an inscription describing the Silla king Jinheung's (r. 540—76) inspection tour of Mount Bukhan, located on the northern boundary of Seoul. This occurred after Silla allied with the Baekje Kingdom in 551, leading to the Silla conquest of the Han River Valley, a conquest that was further consolidated through Silla's alliance in 553 with the Goguryeo Kingdom in the north.

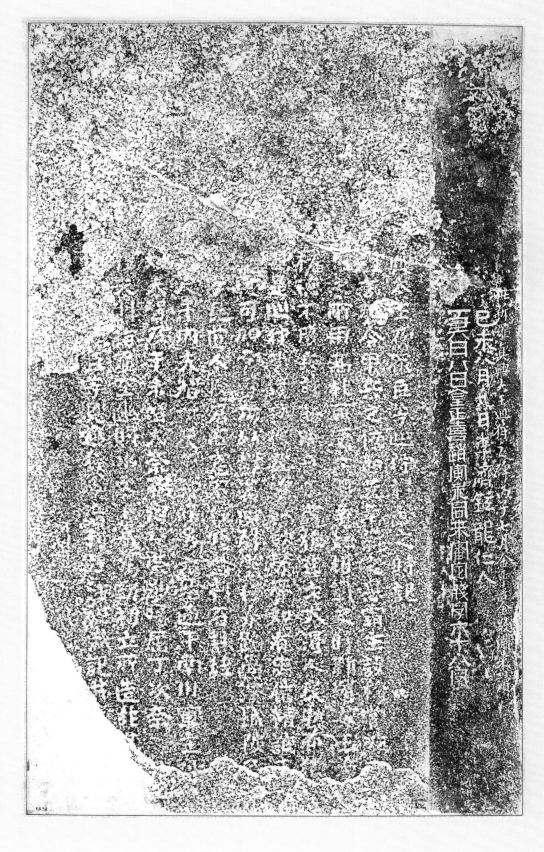

The much-abraded inscription on the front face of the stele takes up twelve vertical columns and has proved difficult to read and decipher.[1] The standard script (*haeseo*) used to inscribe the text retains many elements of the older clerical script (*yeseo*), particularly in the square structure of the characters. In this regard, the calligraphy of King Jinheung's stele is similar to other stone-carved inscriptions dating to the fifth and sixth centuries from both Korea's Three Kingdoms period and China's Six Dynasties period (the Goguryeo Kingdom *Gwanggaeto Daewang Stele* inscription of 414 is an earlier Korean example [cat. 22]).[2]

The stele's narrow right side bears three columns of calligraphy in a script nearly identical to that on the stele's face; these columns were inscribed much later by the Joseon dynasty calligrapher Gim Jeonghui (1786–1856; see cats. 80—84, 86—90, 93, 94). These added inscriptions record visits to study the stele in 1799 (by Li Jixuan), 1804 (by Gim Jeonghui), and 1817 (by Gim and the calligrapher Cho Inyeong). Gim's skillful display of archaizing standard-clerical script reflects the wide range of his calligraphic practice. Taken with such inscriptions in classical clerical script as that on one of his inkstones (see cat. 85) and those appended to the *Stele Commemorating the Enshrining of the Amitabha Statue at Mujangsa* (cat. 92), it is clear that Gim mastered a wide variety of calligraphic forms in addition to the unique Chusache (Chusa style) for which he is best known.

That this stele can be dated to between 568 and 576 (the latter being the date of King Jinheung's death) is deduced on the basis of the name Namcheonju in the inscription, for in 568 the name of Bukhansan Province was changed to Namcheon Province (Namcheonju).[3]

SL

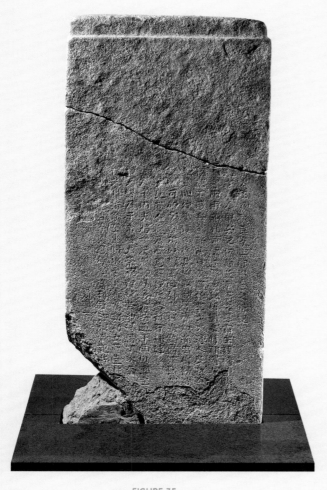

1
The inscription is published (and the surviving characters transcribed) in Jung Hyun Sook, *The Beauty of Ancient Korean Calligraphy: Inside Its History* (Icheon: Woljeon Museum of Art, 2010), 136—39, cat. 26.

2
Unlike the inscription on the *Gwanggaeto Daewang Stele*, however, several of the characters of the monument marking King Jinheung's inspection of Bukhansan Mountain reveal calligraphic flourishes in certain strokes that are absent from the Goguryeo stele of 414. For comparable Chinese examples, see the Northern Wei dynasty epitaph stele of Ju Yanyun (dated 523), and the Northern Qi dynasty cliff-face inscriptions on Mount Yunfeng (dated 565), published in *Ancient Chinese Calligraphic Rubbings*, exh. cat. (Hong Kong: Art Museum, Chinese University of Hong Kong, 2001), pls. 52, 65.

3
Jung, *The Beauty of Ancient Korean Calligraphy*, 136—39, cat. 26.

FIGURE 75
Monument Marking King Jinheung's Inspection of Mount Bukhansan, Silla Kingdom, ca. 568—76. Stone, 60⅝ × 27³⁄₁₆ in. (154 × 69 cm). National Museum of Korea, Seoul, National Treasure no. 3

25

Memorial Tablet from the Tomb of King Muryeong and His Queen Consort

무령왕릉 지석

武寧王陵 誌石

Baekje Kingdom, 526
Stone
13¾ × 16⅜ × 2 in. (35 × 41.5 × 5 cm)
Gongju National Museum of Korea,
National Treasure no. 163
Not in exhibition

Some 2,900 luxury and ceremonial objects were excavated from the sixth-century tomb of the Baekje king Muryeong (r. 501–23) and his wife (d. 526) at Gongju, South Korea, in 1971.[1] Muryeong was the twenty-fifth king of the Baekje Kingdom. Various records and monuments, including inscriptions found among his burial paraphernalia, credit him with improving Baekje's diplomatic and economic ties to China and Japan and with overseeing successful military campaigns against the neighboring kingdom of Goguryeo. Details of King Muryeong's rule and biography are found in historical chronologies in China and Japan as well as Korea, indicating the degree of international contact the Baekje Kingdom experienced under Muryeong's reign, along with the kingdom's international significance.

The tomb of King Muryeong represents a significant discovery in the study of early politics and culture on the Korean Peninsula, as there are few extant documented Baekje sites. Furthermore, the tomb contained objects that specify the years of the king's birth and his and his queen consort's deaths, thereby verifying historical records of King Muryeong's reign with archaeological evidence.

The inscription on the front surface of the stone tomb tablet functioned as a formal land-purchase certificate, while the inscription on the back states that Muryeong's queen consort (whose personal name is unknown) died and was buried beside her husband in 526. The inscription's simple format, situated within a carefully drawn and carved grid of vertical columns, and straightforward *haeseo* (standard-script) *hanja* characters are typical of most carefully inscribed and highly legible Korean tomb inscriptions.

NM

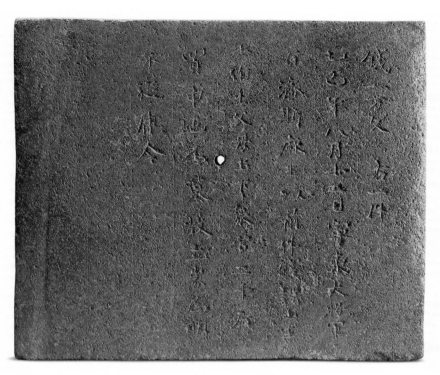

Front

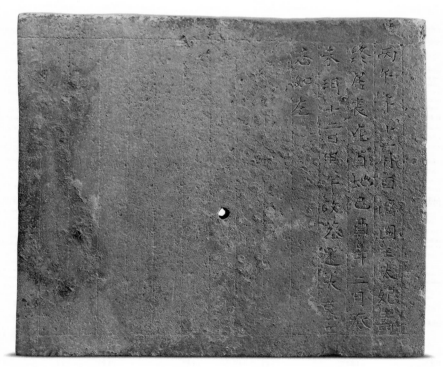

Back

1
Mark Cartwright, "The Tomb of King Muryeong," *Ancient History Encyclopedia*, accessed October 23, 2016, http://www.ancient.eu/article/963/.

The Cheokgyeong Stele: Royal Inspection Tour Inscription for King Jinheung

창녕 신라 진흥왕 척경비

Silla Kingdom, 561
Ink rubbing of a stone stele inscription; ink on paper
63¼ × 64½ in. (160.6 × 163.6 cm)
National Museum of Korea, Seoul,
National Treasure no. 33
Not in exhibition

This ink rubbing was taken from the *Cheokgyeong Stele,* one of the oldest stone monuments of the Silla Kingdom. King Jinheung (r. 540—76), Silla's twenty-fourth monarch, ordered the erection of the stele in 561 to announce his territorial expansions across the Han River and his conquest of the Gwansanseong Fortress.[1] The stele was designated National Treasure no. 33 in 1962 and is currently located in the city of Changnyeong in South Gyeongsang Province.[2]

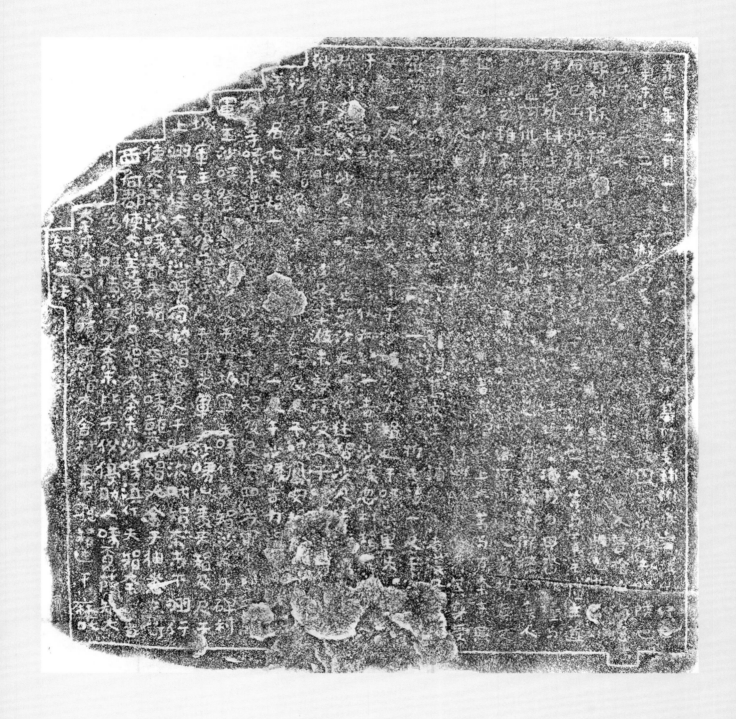

King Jinheung was a great military strategist and general. He tripled the size of Silla's territory and unified Korea by conquering the states of Baekje, Goguryeo, and Daegaya (the Gaya confederacy). His conquests were followed by several *sunsu*: royal inspection tours to the mountains, where sacred rituals were enacted and commemorative stone monuments erected. Appearing on one such monument, this inscription is closely tied to the sacred rituals involving ancestor commemoration and the establishment of political legitimacy. Furthermore, the text documents the king's military achievements and announces laws that would govern the newly established tributary provinces.[3] The *Cheokgyeong Stele* was the first among four *sunsu* stone monuments that King Jinheung erected during his reign.

On a cultural level, the Silla Kingdom valued an aesthetic of simplicity, effortlessness, and dignity. To reflect this artistic spirit, the inscription was carved into a natural, largely unfinished granite stone. The surface of the stone was lightly polished and its edges were decorated with simple lines that create a frame. The inscription lists the names, titles, and contributions of the leading military and administrative officers who attended the *sunsu* rituals.

The script style used for this inscription is referred to as *yukjo* (Six dynasties) style, featuring standard script with a hint of clerical script. This script style was developed during the Chinese Northern and Southern dynasties period and later modified during the Silla Kingdom. Bold, round, and thick brushstrokes characterize the script. The inscription has a total of 643 characters arranged in twenty-seven vertical columns. Each line consists of eighteen to twenty-seven characters; four hundred of the characters have been deciphered. The first line states, "In the [cyclical] year *sinsa*," indicating that the stone was erected in 561.

Inscribed and documented stone monuments possess great value for research, particularly as few early primary sources remain intact. Korean text documents, such as *Samguk sagi* (History of the Three Kingdoms), which are often used to study ancient Korea, were first compiled and published during the Goryeo period; assembled from a variety of sources long after the facts they describe took place, such works may therefore be limited in terms of their accuracy. As cultural, historical, and artistic objects, inscribed stone steles provide insight into the values of those in power at the time of their making. This stone monument in particular serves as evidence of the Silla monarchs' ambitions to reinforce and legitimize their power and to establish a unified and systematic administrative structure.

NM

1
Jang Chang-eun, "Changnyeong Jinheung Wang Cheokgyeongbi wa Silla ui yeongyeok hwakjeong" [The 'Changnyeong Silla Jinheung Cheokyeongbi' and Silla's territorial expansion: Focusing on the conquest of the Daegaya], *Silla Sahakbo* [Journal of the Research Institute for Silla Culture] 26 (2012): 5—49.

2
Cultural Heritage Administration, "Gukbo je 33 ho—Changnyeong Silla Jinheungwang Cheokgyeonbi" [National Treasure no. 33—Changnyeong Silla Jinheung Cheokgyeong Stone Monument], published April 22, 2015, http://www.heritage.go.kr/heri/cul/culSelectDetail.do?pageNo=5_2_1_0&ccbaCpno=1113800330000.

3
Lim Pyeong-seob, "Silla ui sancheon jesa wa Jinheung wang sunsubi ipseok mokjeok ui yeongwanseong—Bukhansan bireul jungshim euro salpyeobon sunsu haengjeok ui sa" [Relationship of Silla's rites for mountain and stream and the purpose for establishing Jinheung's *sunsu* memorial stones], *Silla munhwa* [Journal of the Research Institute for Silla Culture] 43 (2014): 73—107.

Epitaph Fragment of King Heungdeok

홍덕왕릉비잔편

Unified Silla dynasty, 836
Stone
7⅜ × 5¾ × 3⅝ in. (18.8 × 14.5 × 9 cm)
Seokdang Museum of Dong–A University, Busan

The epitaph stele of the Unified Silla king Heungdeok (r. 826—36) now exists only as a few surviving fragments. This piece, in the collection of the Seokdang Museum, is related to fragments owned by the National Museum of Korea, Seoul.[1] These fragments were excavated in Gyeongju, North Gyeongsang Province, the former capital of the Unified Silla dynasty. While the original text is insufficiently preserved to allow its complete form to be under–

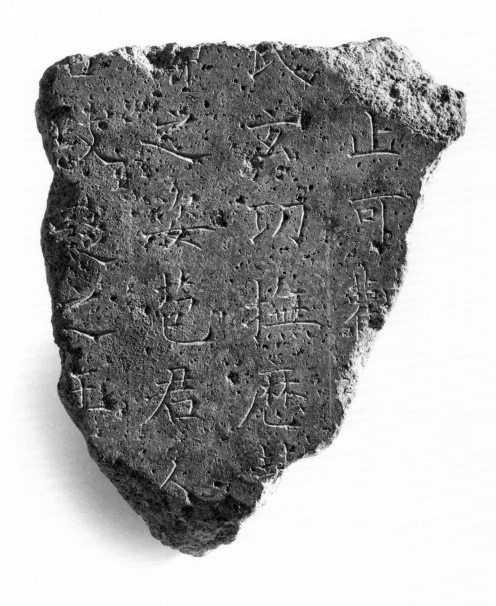

stood, it is clear from the National Museum of Korea fragments that the stele was created for King Heungdeok; his name can still be read on a piece of the stele's original title, written in seal script.

The text of the epitaph itself was composed by the ninth-century calligrapher Yo Geukil and was inscribed in an elegant standard script that closely resembles that of the early Tang dynasty calligrapher Ouyang Xun (557—641; fig. 76). The Unified Silla dynasty had close diplomatic and cultural ties with the Tang dynasty court in Chang'an (now Xi'an), and many Unified Silla monuments with standard-script inscriptions indicate that Ouyang Xun's style had a profound influence on royal, aristocratic, and official calligraphy of the Unified Silla period.[2]

SL

1
Published in *Dong-A University Museum* (Busan: Dong-A University Museum, 2001), 226, cat. 293. The fragments in the collection of the National Museum of Korea are published in Jung Hyun Sook, *The Beauty of Ancient Korean Calligraphy: Inside Its History* (Icheon: Woljeon Museum of Art, 2010), 214, cat. 289, and on the museum's website, accessed May 15, 2018, https://www.museum.go.kr/site/eng/relic/search/view?relicId=17050#.
2
See Jung Hyun Sook, "Calligraphic Style of the Three Kingdoms Period," in *The Beauty of Ancient Korean Calligraphy*, 237. See also Jung Hyunsook, "Variety of Calligraphy and Characteristics of Calligraphic Style in the Unified Silla Dynasty," Scholar, accessed June 5, 2018, http://scholar.dkyobobook.co.kr/searchDetail.laf?barcode=4010023626820#.

FIGURE 76
Ouyang Xun (557—641), *Inscription on the Sweet Wine Spring in the Jiucheng Palace* (detail), Tang dynasty, 632. Ink rubbing on paper. Private collection

ANPYEONG DAEGUN (GRAND PRINCE ANPYEONG)

안평대군

安平大君

1418—1453

Ink Traces of Anpyeong Daegun

안평대군유묵

安平大君遺墨

Joseon dynasty, 15th c.

Ink on paper

36⅝ × 13¾ in. (93 × 35 cm)

Seokdang Museum of Dong–A University, Busan

Prince Anpyeong, also known as Yi Yong, was the third son of King Sejong (r. 1418—50), who developed the *hangeul* writing system. The prince was given the royal name Anpyeong Daegun in 1428. He was an illustrious poet, calligrapher, painter, and Buddhist writing master in his own right and compiled numerous poetic anthologies relating to the Chinese Tang and Song dynasties. An avid collector of Chinese calligraphy and painting, the prince famously shared these works with the well–known painter An Gyeon, who

painted the renowned *Dream Journey to the Peach Blossom Land* (1447).[1] Prince Anpyeong also wrote and published Buddhist sutras and transcribed many for himself.

This work, written by Anpyeong Daegun in semicursive script (*haengseo*), reads, from right to left, "Bi hyo mu chin," meaning that one should not refuse filial piety to one's parents. This is a quote

taken from the *Ohyeongjang* (The writing of five rules, also known as the *Wu Jing*) in the *Hyogyeong* (Ch. *Xiao jing; Classic of Filial Piety*), in an exchange between Gongja (Ch. Kongzi; Confucius; 551—479 BCE) and his pupil Jeungsam (Ch. Zengzi; 505—435 BCE).

Anpyeong Daegun's calligraphy was highly regarded and expressed mastery of the regular style of Jo Maengbu (Zhao Mengfu; 1254—1322), a famous Chinese scholar, calligrapher, and painter of the Yuan

dynasty.[2] It is said that even the emperor of China praised the prince's calligraphy. The Jo Maengbu style is also referred to as the Songseolche (Songseol style), after Zhao Mengfu's sobriquet, Songxue (K. Songseol, meaning "pine snow"). Promoted and embraced by the prince, this style greatly affected the calligraphy styles implemented during the early Joseon dynasty.[3]

According to calligraphy scholar Yi Wanwoo, Anpyeong Daegun's own interpretation and understanding of the Jo Maengbu style were taken to be the prince's contribution to the calligraphic style of the Joseon dynasty and regarded as a significant achievement in the history of Korean calligraphy.[4] Many Joseon calligraphers and scholars, such as Nam Sumun, Yi Seokhyeong, Yi Gye, Seong Sammun, and Seo Geojang—members of the royal research institute the Hall of Worthies (Jiphyeonjeon) established in 1420 by King Sejong—not only praised and followed Anpyeong Daegun's calligraphy, but were also the key members involved in the creation of the *hangeul* alphabet, along with the prince's father, King Sejong.[5]

VM

1
For a detailed discussion of this work, see Ahn Hwijoon, "An Kyon and *A Dream Visit to the Peach Blossom Land*," *Oriental Art* 26, no. 1 (Spring 1980): 60—71.

2
For a record of Anpyeong Daegun's collection of twenty-six examples of Zhao Mengfu's calligraphy, see Burglind Jungmann, "Sin Sukju's Record on the Painting Collection of Prince Anpyeong and Early Joseon Antiquarianism," *Archives of Asian Art* 61 (2011): 107.

3
Kim Jung Nam, "Joseon wangjo sillok e natanan eopil hyeongseong e gwanhan seoyejeok gochal" [A calligraphic study on the formation of the king's handwriting in *The Annals of the Joseon Dynasty*], *Hanguk seoye hakhoe* 27 (September 2015): 112—13.

4
Yi Wanwoo, "Anpyeong daegun Yi Yong ui munye hwaldong gwa seoye" [The literary and artistic activities of Prince Anpyeong Yi Yong and his calligraphy], *Misul sahak yeongu* [Korean journal of art history] (September 2005): 90.

5
Guksa pyeonchan wiweonhoe (National Institute of Korean History), *Hanguk seoye munhwaui yeoksa* [The history of Korean calligraphic culture] (Seoul: Gyeongin munhwasa, 2011), 190.

KING HYOJONG

효종왕

孝宗王

R. 1649—59

Calligraphic Sketchbook
of King Hyojong

효종어필

孝宗御筆

Joseon dynasty, 17th c.
Album; ink on paper
Each page: 20 × 15 in. (53 × 38 cm)
Seokdang Museum of Dong-A University, Busan

King Hyojong (r. 1649—59) was the seventeenth king of the Joseon dynasty. In 1636 Hyojong and his older brother, Crown Prince Sohyeon, were taken as prisoners in the war between the Manchus and Korea. They were freed following the founding of the Manchu-dominated Qing dynasty in China in 1644: Crown Prince Sohyeon was released in 1645, and Hyojong's release followed a few months later. Shortly after being freed, Crown Prince Sohyeon, the heir apparent, died (some say it was by his father's hand,

owing to political differences). Upon the death of King Injo (r. 1623—49), Hyojong became king.[1]

The calligraphic sketches in this album were informal writings that King Hyojong wished to give to his daughter, Princess Sukan (1636—1697). This is clearly a collection of random sketches, and the pages may have been completed at different times. The pages shown here include short passages of text, individual *hanja* characters, and sketches of bamboo leaves and flowers. The calligraphic passages are written in standard, running, and cursive scripts. In the lower-left corner of the second page, for example, different versions of the cursive-script character *guk,* meaning "country" or "nation," appear.

Hyojong's calligraphic style was largely influenced by that of Zhao Mengfu (1254—1322) of early Yuan dynasty China, the Joseon grand prince Anpyeong (Anpyeong Daegun) (1418—1453; cat. 28), and Han Seokbong (1543—1605), a master calligrapher at the royal court. Compared with the work of these artists, Hyojong's style was considered more graceful and free. King Hyojong died at the age of forty-one.

VM/SL

1
Kim Jungnam, "Joseonjo eopil e gwanhan yeongu" [A study on the king's handwriting in the Joseon dynasty] (PhD diss., Sungkyunkwan University, 2015), 330.

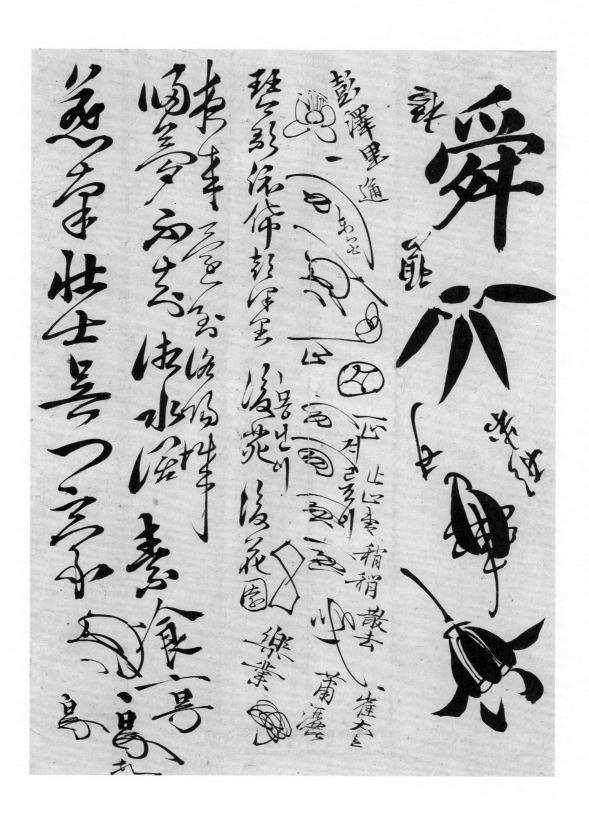

PRINCESS JEONGMYEONG
정명공주
貞明公主
1603—1685
Illustrious Governance
華政

Joseon dynasty, ca. 1663
Ink on paper
5¾ × 29 in. (14.6 × 73.5 cm)
Kansong Art Museum, Seoul

Princess Jeongmyeong was the only daughter of King Seonjo (r. 1567—1608) and Queen Inmok (1584—1632). In 1613, when the princess was eleven, she and her mother were imprisoned for crimes against the state. They were held at Deoksugung Palace and released when Princess Jeongmyeong was twenty-one.

During their confinement, Queen Inmok, who was an excellent calligrapher, taught the princess calligraphy. King Seonjo, too, was a well-known calligrapher who wrote in the style of eminent calligrapher Han Ho (1543—1605). The princess herself also became a renowned calligrapher in the style of Han Ho.

The two characters of this work—which mean "illustrious" and "governance"—display the princess's calligraphic strength and skill.[1] Written when she was about sixty years old, each character was so large it needed its own separate piece of paper. The two identical red seals read, "Princess Jeongmyeong."

VM

1
Published in *Kansong munhwa: Kansong Misul Munhwa Jaedan sollib ginyeomjeon* [The treasures of Kansong: Commemorating the founding of the Kansong Art and Culture Foundation], exh. cat. (Seoul: Kansong Art and Culture Foundation, 2014), 221—22, cat. 86.

3
1

Calligraphy of Successive Sage-Rulers
열성어필
列聖御筆

Joseon dynasty, ca. 1720—24
Woodblock-printed book; ink on paper
Each page: 18½ × 12¾ in. (47 × 32.5 cm)
National Palace Museum of Korea, Seoul

During the Joseon dynasty, when Confucianism was the prevailing ideology, calligraphies by kings were regarded as national treasures. When a king died, a grand ritual was performed: all his paintings, writings, and calligraphies were collected, published, and enshrined in a building especially established to hold them. As symbols of authority and accomplishment, kings' calligraphies were copied and bestowed upon members of the royal family, government officials, and scholars. This practice occurred for centuries. In the early eighteenth century, the accumulated calligraphies of previous kings began to be collected and published as single books entitled *Calligraphy of Successive Sage-Rulers* (*Yeolseong eopil*).[1]

The publication of the calligraphy of renowned Chinese and Korean scholars was an ongoing project of both state and private printing houses during the Joseon dynasty. Works by the famous Unified Silla dynasty calligrapher Gim Saeng (711—?), for example, were printed and distributed to the upper classes to improve their writing skills. These books were also used as guidelines for government officials in writing prayers for royal ancestral rites and diplomatic documents. In the mid-Joseon period, publishing calligraphies by previous kings became an important part of this print culture.[2]

The first historical record of the publication of *Calligraphy of Successive Sage-Rulers* can be found in the *Annals of King Hyeonjong* (*Hyeonjong sillok*), written in 1662. This account states that when Prince Yeongyang (1619—1675) and relatives of the royal family produced and distributed *Calligraphy of Successive Sage-Rulers,* King Hyeonjong (r. 1659—74) conferred a higher title of nobility on the prince. Records mentioning *Calligraphy of Successive Sage-Rulers* and its publication subsequently continued to appear in *The Annals of the Joseon Dynasty* (*Joseon wangjo sillok*).

The volume shown here was created during the reign of King Gyeongjong (r. 1720—24). Printed from carved woodblocks, it contains examples of calligraphy by Kings Seonjo (r. 1567—1608), Injo (r. 1623—49), Hyojong (r. 1649—59), Hyeonjong, and Sukjong

199

萬壽
無疆

日昌

萬華

King Seonjo was a master of the calligraphy style of Han Ho (1543—1605; sobriquet Seokbong), a prominent Joseon dynasty calligrapher whose style was known as Hanseokbongche (style of Han Seokbong). Han was a government official who wrote diplomatic documents during King Seonjo's reign. King Seonjo admired Han's calligraphy, which emulated the elegant and sophisticated style of the Chinese master Zhao Mengfu (1254—1322), popular at the time. Han

also adopted the well-structured calligraphy of earlier master Wang Xizhi (307—365), combining it with a more understated Korean aesthetic.[3] Strongly influenced by King Seonjo, King Injo also mastered Han Seokbong's calligraphic style, but Han's style was less acknowledged during King Hyojong's rule. The calligraphic styles of Kings Hyojong, Hyeonjong, and Sukjong are closer to Zhao Mengfu's style.

Because *Calligraphy of Successive Sage-Rulers* was used as a model of ideal calligraphy, it had a great influence on calligraphy styles within Joseon society. Subsequent kings often referred to the calligraphic styles of their predecessors, and, consequently, officials and scholars studied the book as models for their calligraphy. Poems celebrating the lessons of Confucian ideology that embodied the values and worldview of the Joseon state were useful for teaching the entire population. The importance of *Calligraphy of Successive Sage-Rulers* also lies in its value as evidence of the exceptionally sophisticated skills of Joseon woodblock carvers. Because the writings of kings were considered sacred objects during the Joseon dynasty, the printing blocks used to publish these books were carved by the best technicians of the country under government supervision.[4]

 EY

1
Yi Wanwoo, "The Publication of Calligraphy of Successive Rulers of the Joseon Dynasty," *Cultural Properties* 24 (1991): 147.
2
Ibid., 156.
3
Lee Dongkook, "Biographies of Calligraphers 11: Mid Joseon–Seonjo," *Gyeonghyang Sinmun*, accessed September 29, 2006, http://news.khan.co.kr/kh_news/khan_art_view.html?artid=200609291604521&code=900308.
4
Yi, "The Publication of Calligraphy," 165.

3 2

KING SUKJONG
숙종왕
R. 1674—1720
Tablet with *Model Calligraphy*
숙종대왕 어필각석
Joseon dynasty, 1674—1720
Marble
13 × 10⅜ × 3⅛ in. (33 × 26.2 × 8 cm)
National Palace Museum of Korea, Seoul

3 3

KING YEONGJO
영조왕
R. 1724—76
Tablet with *Model Calligraphy*
영조대왕 어필각석
Joseon dynasty, 1744
Marble
10⅝ × 14⅝ × 2 in. (27 × 37 × 5 cm)
National Palace Museum of Korea, Seoul

In 1674, at age thirteen, King Sukjong (given name: Yi Sun) became the nineteenth ruler of the Joseon dynasty. He was considered a brilliant politician: he oversaw the country during a time of intense factionalism, despite which his ruling period was judged to be one of the more prosperous ones. King Sukjong excelled at poetry and calligraphy, emulating the style of the Chinese calligrapher Zhao Mengfu (1254—1322), resulting in a beautiful late Goryeo/early Joseon Songseolche (Songseol style, after Zhao Mengfu's sobriquet). Sukjong's calligraphy style was renowned throughout the Joseon period.[1] Here, the carved stone tablet replicates the king's written *hanja* character for *yong* (dragon).

King Yeongjo (given name: Yi Geum) was the second son of King Sukjong. He became the twenty-first king of the Joseon dynasty after the death of his older brother. His reign lasted fifty-two years and was marked by his efforts to introduce taxation reform, rule by Confucian ethics, and minimize factionalism. He was known to have cared deeply for his people and to have lived a dedicated Confucian life. While King Yeongjo's reign is highly regarded as one of the most notable rules in the Joseon dynasty, it was also marred by the forced death of his son, Crown Prince Sado (1735—1762). Largely believed to be mentally ill, the crown prince would wreak violence on the court. The king forced him to climb into a rice chest, where, after eight days, the prince died.

King Yeongjo was greatly influenced by his father's love of calligraphy and collected many fine calligraphic pieces. At a young age, he showed talent in drawing landscapes and flowers. Sukjong greatly appreciated his son's works and wrote about them. A number of King Yeongjo's works survive, many of these in the style of Wang Xizhi (307—365).[2] The two characters carved in this tablet together mean, "to do good things."[3]

VM

[1] Gim Yeongwon, *Hanguk yeokdae seohwaga sajeon* (*Dictionary of Korean Painters and Calligraphers through the Centuries*) (Seoul: Gungrip munhwajae yeonguso, 2011), 1,212—17.

[2] Ibid.

[3] These and many other examples of Joseon kings' calligraphies replicated on carved stone panels are reproduced and discussed in National Palace Museum, *Joseon wangsil ui gakseok* [Inscriptions in stone from the Joseon royal court], exh. cat. (Seoul: National Palace Museum, 2011).

KING JEONGJO
정조왕
正祖王
R. 1776—1800

Seal

正祖印章，極

Joseon dynasty, late 18th c.
Stone
1⅞ × 1⅛ × 1⅛ in. (4.8 × 2.8 × 2.9 cm)
National Palace Museum of Korea, Seoul

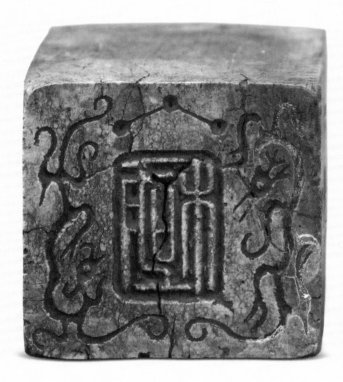

In many respects, King Jeongjo is considered one of the most enlightened kings of the Joseon dynasty. He was the son of Crown Prince Sado (1735—1762), who was murdered by Jeongjo's grandfather, King Yeongjo (r. 1724—76). Among King Jeongjo's many accomplishments was the creation of the Gyujanggak, the royal library originally built on the grounds of Changdeokgung (Changdeok Palace) in Seoul.[1] He also sponsored new encyclopedias on Korean history, geography, literature, and law.[2] King Jeongjo was a gifted calligrapher and painter and was the leading patron of famed painter Gim Hongdo (1745—ca. 1806).[3]

In Korea kings, scholars, and artists usually owned many seals. In the case of kings, these seals were carved with legends (texts) conveying their personal or alternate names, the names of their palaces, or aphorisms. Royal seals were usually carved from stone, but many were made of gilt bronze.[4]

The legend carved at the bottom of this simple yet elegant seal reads, *geuk*, meaning "extremity" or "greatest extent"—signifying the extreme breadth of the king's domain and power. As has recently been shown, "The seal is interpreted as being related to the ideology of 'imperial authority' (*hwanggeuk*) that advocated the strengthening of his [the king's] authority. This idea of 'imperial authority' comes from a verse in [the] *Hongfan* [chapter] in the [ancient Chinese] *Book of Documents* (*Shujing*) that the ruler is to rise to the top as a transcendental being and rule with impartiality."[5]

The single character rendered in seal script has carved dragons on either side, ancient symbols of royal power. Between the dragons and above the character *geuk* is a stylized Daoist constellation known as *samdae* (Ch. *santai*; three terraces), consisting of three dots joined by thin lines; this constellation appears in the northern quadrant of the sky in immediate proximity to the Northern (Big) Dipper, considered in East Asia the most powerful constellation in the heavens.[6]

SL

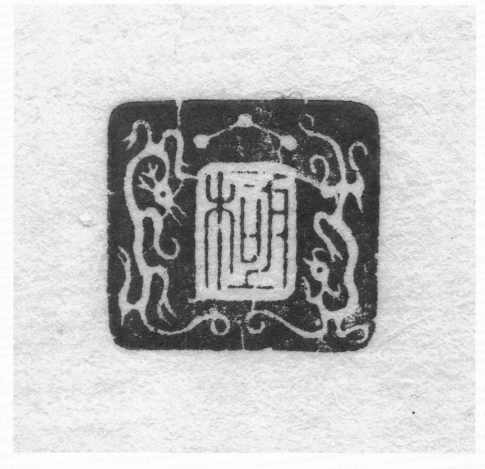

1

The former Gyujanggak library is now known as the Gyujanggak Archives and kept at Seoul National University.

2

Hongnam Kim, ed., *Splendor and Simplicity: Korean Arts of the Eighteenth Century*, exh. cat. (New York: Asia Society, 1993), 214.

3

Burglind Jungmann, *Pathways to Korean Culture: Paintings of the Joseon Dynasty, 1392—1910* (London: Reaktion Books, 2014), 242—46. For two examples of King Jeongjo's calligraphy, see Hyunsoo Woo, ed., *Treasures from Korea: Arts and Culture of the Joseon Dynasty, 1392—1910*, exh. cat. (Philadelphia: Philadelphia Museum of Art, 2014), 118—19, cats. 1—23, 1—24.

4

For an example of a royal gilt–bronze seal, see Woo, *Treasures from Korea*, cat. 1—20.

5

In Ro Myounggu and Park Suhee, eds., *The King at the Palace: Joseon Royal Court Culture at the National Palace Museum of Korea* (Seoul: National Palace Museum of Korea, 2015), 60—63.

6

See Poul Andersen, "The Practice of *Bugang*," *Cahiers d'Extrême–Asie* 5 (1989—90): 30.

YANGBAN (SCHOLAR-OFFICIALS') CALLIGRAPHY

The vast majority of calligraphic works in Korean history were created by and for members of the elite scholar–official class, (*yangban*). These works include poetry and prose inscribed on both two– and three–dimensional surfaces and a wide array of calligraphic works carved into stone. Examples range from epitaphs to calligraphies modeled after Wang Xizhi's work to Heo Mok's *East Sea Stele Inscription*——a plea to the Dragon King to put an end to a series of tsunamis. Included here is a rare example of calligraphy by the most famous Korean woman calligrapher (and painter), Sin Saimdang.

Korea was a great innovator in printing, and this section includes several important examples of this art, made with both carved woodblocks and movable cast–metal type.

During the Goryeo and Joseon dynasties, utilitarian objects were often inscribed with elegant calligraphy. The wide range of surfaces on which one finds calligraphy includes furniture, board games, brush stones, inkstones, ink sticks, padlocks, incense burners, ceramics (of earthenware, stoneware, and por-celain), lacquer, embroidery, and branding irons. This section ends with an exploration of the close traditional relationship between calligraphy and painting.

3 5

Celadon Double Gourd—Shaped Bottle with Carved Lotus and Scroll Design in Relief and Poem Inscription

시가 새겨진 청자 연꽃 넝쿨 무늬 조롱박 모양 병

詩銘 靑磁 陽刻象嵌 蓮唐草文 瓢形 瓶

Goryeo dynasty, 12th c.
Stoneware with carved and inscribed decoration and celadon glaze
Height: 15¼ in. (38.8 cm); diameter: 4⅜ in. (11 cm)
National Museum of Korea, Seoul

Part of the fame of Goryeo green-glazed celadons, or *cheongja*, stems from their subtle colors. The Chinese scholar Xu Jing (1091—1153), an ambassador from the Northern Song dynasty court who traveled to Goryeo in 1123, famously described the dynasty's celadon as the "first under heaven," referring especially to its particular jade-green hue (*bisaek*).[1] Ceramics from the Chinese Tang and Song dynasties initially inspired celadon production in Korea, but Korean celadons eventually achieved aesthetic autonomy, in part because of their color.[2] The earliest-known Korean celadons date to the ninth century, and their idiosyncratic jade-green color is considered to have been perfected by the twelfth century.[3] This color resulted from the confluence of a specific proportion of iron oxide in the glaze, a carefully controlled reduction of oxygen in the kiln atmosphere, and a high firing temperature.[4] The ideal celadons featured a translucent glaze and subtle blue hues that lent the gray-green a depth of color.[5]

The thickness of the glaze, the kiln atmosphere, and the temperature of the kiln all had to be carefully managed by the artisans to achieve the glaze's elegant jade-green color and smooth surface. Carving sophisticated and detailed patterns into the leather-hard clay was also time-consuming, even for a well-trained potter. Since the majority of shapes were teacups, teapots, and bottles and vases to hold liquor, it has been surmised that Goryeo celadons were used mostly for aristocratic gatherings and teas.

In Korea, gourds were frequently used as containers to hold various kinds of drinks from the Three Kingdoms period onward. Because gourds were both edible and useful as sturdy containers, they were regarded as one of the most important and beneficial plants. They appear in local Korean myths and folktales as symbols of fecundity, wealth, and longevity. Double gourds were well-known Daoist symbols signifying the joining of Heaven and Earth and often appear in traditional paintings of immortals and adepts who wear double gourds hanging from their waists. Goryeo celadons and ash-glazed stoneware used as liquor bottles were often made in the double-gourd shape.

This gourd-shaped celadon bottle features a poem inscribed with iron oxide pigment under the glaze. Poems on celadons are found only on Goryeo dynasty celadons, not on those produced in China and Japan.[6] This practice emerged in the mid-Goryeo period. During the rule of King Gwangjong (r. 949—75), the creation of literary works became a key part of government civil service examinations. Composing poetry was an essential ability required of Goryeo officials, and familiarity with Chinese poetry pervaded the culture of the literate classes. Xu Jing, mentioned above, who famously praised the colors of Goryeo celadon glazes, wrote, "The people of Goryeo admire the rhythm of the poetry so much, they do not make enough effort to study Confucian classics."[7] The decoration and poems found on mid-Goryeo celadon liquor containers were largely influenced by the literary tastes of their buyers.

Today, some ten Goryeo celadons decorated with poems are known. Among these, six have poems composed by the Chinese poets Bai Juyi (772—846), Wang Wei (699—761), and Li He (790—816). This anonymous poem is a quatrain with seven characters per line, inscribed in elegant semicursive, or running, script:

> Finely carved gold flowers on a green jade vase—
> Among noble families one responds by happily lifting the vessel!
> Surely you've heard of Old He, riding in elation,
> Enveloped in the depths of spring, drunk on Mirror Lake.[8]

This poem refers to the Tang dynasty poet and calligrapher He Zhizhang (ca. 659—744), famous for figuring in the first line of the Tang poet Du Fu's "Eight Immortals of the Wine Cup."[9] The other parts of the bottle are decorated with carved patterns of lotus flowers and leaves. The upper part of the neck is a replacement.

AM/SL

[1]
Kang Kyung-sook, *Korean Ceramics,* trans. Cho Yoong-jung (Seoul: Korea Foundation, 2008).

[2]
Ito Ikutaro, *Korean Ceramics from the Museum of Oriental Ceramics, Osaka,* exh. cat. (New York: Metropolitan Museum of Art, 2000).

[3]
Kang, *Korean Ceramics.*

[4]
Soyoung Lee, "Goryeo Celadon," Heilbrunn Timeline of Art History, Metropolitan Museum of Art, published October 2003, http://www.metmuseum.org/toah/hd/cela/hd_cela.htm.

[5]
Ito, *Korean Ceramics from the Museum of Oriental Ceramics.*

[6]
Yu Hongjun, "Connoisseurship of Yu Hongjun: Yi Kyubo Singing Jade Color Affection 'Young Boy Wearing Blue, Jade Color Skin,'" *Gyeonghyang Sinmun* [Gyeonghyang news], February 5, 2016, http://news.khan.co.kr/kh_news/khan_art_view.html?artid=201602051956495&code=960100#csidx35631c3a5b8a4d8ad03a750060bac9b.

[7]
Kim Yun-jeong, "Types and Attributes of Middle-Goryeo Inscribed Celadon," *History and Discourse* 76: 12.

[8]
Translation by Stephen Little.

[9]
The entire poem is translated in Shigeyoshi Obata, *The Works of Li Po, the Chinese Poet* (New York: E. P. Dutton, 1922), 185—86.

***Wang Huijiche Chogyeolbaegunga
(Wang Xizhi's Song on the
Essentials of Cursive Script in
One Hundred Rhymes)***

왕희지체 초결백운가

王羲之草訣百韻歌

Joseon dynasty
Stone
11⅞ × 8¼ × 2 in. (30 × 21 × 5 cm)
National Palace Museum of Korea, Seoul

The styles of the Chinese calligraphers
Wang Xizhi (307—365) and Zhao Mengfu
(1254—1322) inspired many Korean
calligraphers and had a great influence on
the calligraphy of the Joseon dynasty
royal court.[1] Wang Xizhi, who lived during
the Eastern Jin dynasty, was the most
celebrated calligrapher in Chinese history.
He developed new forms of semicursive
script (*haengseo*) and cursive script
(*choseo*) that transformed calligraphy into

a subtle and powerful medium of personal expression. During socially and politically unstable times, the value of calligraphy increased, as scholars sought to present themselves as more wise and capable than the existing rulers. The fourth and fifth centuries saw a major shift in the social importance of calligraphy in both China and Korea, and the value of original calligraphic manuscripts of recognized masters' works increased dramatically.[2] This change in perception allowed for more revolutionary approaches to the practice of calligraphy, with new literati and cultural producers representing their ideals through various forms of text.

The text *Song on the Essentials of Cursive Script in One Hundred Rhymes* (*Chogyeol-baegunga*; Ch. *Caojue baiyun ge*) was used for many centuries to teach the cursive-script style developed by Wang Xizhi. The complete text, which, in fact, consists of 103 (not one hundred) ten-character mnemonic rhyming phrases, comprises a series of guidelines and admonitions regarding specific brushstrokes used for individual characters as manifested in Wang Xizhi's cursive script. Even though the calligraphic examples given are based on Wang's writings, the text was neither conceived nor composed by Wang. Instead, it is believed that *Song on the Essentials of Cursive Script* was compiled by an anonymous author during the Northern Song dynasty. The earliest-surviving examples of the text date to the Ming dynasty; these exist as calligraphic manuscripts, ink rubbings taken from stone-carved steles, and woodblock-printed reproductions, demonstrating the text's widespread popularity.[3] In both China and Korea, the text was carved into stone tablets so that ink rubbings could be taken and the text and its calligraphic models widely disseminated; the text

thus functioned as a series of guidelines and an aide-mémoire for mastering Wang's elegant cursive-script style. The inscribed tablet shown here forms part of a larger set of fourteen stones on which the entire original text is reproduced. These fourteen stones in turn belong to yet a larger set of stones carved with famous inscriptions by and attributed to Wang Xizhi.[4] *Song on the Essentials of Cursive Script* is reproduced on the stones with the characters' cursive and standard forms, as in the original Chinese versions.

One should bear in mind that in these lines the anonymous author is speaking about the characters' cursive-script (*choseo*) forms, not their standard-script (*haeseo*) forms. The author compares characters whose cursive forms are similar in both overall structure and the sequence of their brushstrokes. The example on this stone reads as follows:

> Do not write *wei* [slight] like *jian* [gradual].
> How can one allow *men* [melancholy] to be written like *kun* [posterity]?
> When writing *nan* [south], observe *liang* [two] and *fu* [begin].
> When seeking *ding* [tripod], observe *ji* [thorn] and *lin* [forest].
> *Yi* [one, i.e., a single horizontal stroke] dwells below both *xiu* [rest] and *he* [aid].
> *Qi* [abandon] and *ben* [hasten] both have *qi* [seven] at the top.

Song on the Essentials of Cursive Script was used for many centuries to transmit the classic Wang Xizhi style to later generations. The fact that this set of stone carvings was made for the Joseon royal court is indicative of the text's long-lasting popularity in Korea.

NM/SL

1

"Wang Huijiche *Chogyeolbaegunga*" [Wang Xizhi's *One Hundred Rhymes on the Essentials of Cursive Script*], National Palace Museum of Korea, accessed July 2, 2018, http://www.gogung.go.kr/searchView.do?pageIndex=1&cultureSeq=00017515FU&searchRelicDiv4=&searchGubun=ALL1&searchText=%EC%99%95%ED%9D%AC%EC%A7%80.

2

Jo Min Hwan, "Hanguk eui Munhwa: Wanghiji junghwamihag jungshimeui wa Hangukseoye Jeongcheseong shitam" [Wang Xizhi neutralization-centrism and the Korean calligraphy identity exploration], *Hanguksasang gwa munhwa* [Journal of Korean thought and culture] 80 (2014): 267—93.

3

For a surviving manuscript copy inscribed by the late Ming calligrapher Han Daokun, dated to 1611 in the Wanli reign, see *Caojue baiyun ge* [*Song on the Essentials of Cursive Script in One Hundred Rhymes*] (Shanghai: Shanghai shuhua chubanshe, 2010). For a set of ink rubbings taken from stone-cut tablets, see *Chuanshi jingdian shufa beitie, 46: Wang Xizhi Caoyue baiyun ge* [Transmitted classic calligraphic stele, 46: Wang Xizhi's *Song on the Essentials of Cursive Script in One Hundred Rhymes*] (Shijiazhuang: Hebei jiaoyu chubanshe, 2016).

4

These are illustrated on the website of the National Palace Museum of Korea; see http://www.gogung.go.kr/searchList.do?pageIndex=1&cultureSeq=&searchRelicDiv4=&searchGubun=ALL1&searchText=%EC%99%95%ED%9D%AC%EC%A7%80.

SIN SAIMDANG

신사임당
申師任堂
1504—1551

Ink Traces

신사임당유묵
申師任堂遺墨

Joseon dynasty, 16th c.
Ink on paper
12 × 10⅝ in. (30.5 × 27 cm)
Seokdang Museum of Dong-A University, Busan

Regarded as the most famous woman in Korean history, Sin Saimdang is celebrated as a skilled artist, poet, and calligrapher.[1] The mother of seven children, she was also respected for her skill as a parent and her filial piety. One of her sons was the renowned Joseon Neo-Confucian scholar Yi I (1536—1584), also known by his sobriquet, Yulgok.

Sin came from a family where there were no sons and she was therefore responsible for taking care of her parents as well as her children. Her father devoted himself to educating Sin and teaching her the Chinese classics. Sin's mother was also educated in the Chinese classics.

Sin's paintings, of which approximately forty survive, primarily depict nature—especially scenes of plants and insects. Her paintings and embroidery were well known in her day. Few of her calligraphic works remain. This example is written in cursive script (*choseo*, or "grass script") that is simultaneously elegant and exuberant, with many characters joined by sinuous ligatures.[2] Sin's calligraphy transcribes a poem by the famous Chinese poet Li Bai (701—762) entitled "Playfully Presented to Zheng Liyang":[3]

Magistrate Tao[4] was drunk every day,
Unaware of when the five willows
 encountered the spring.
His plain *qin* originally had no strings,
He used his *ge*–cloth cap to filter wine.[5]
A pure wind came to rest at the
 north window,
He called himself a man of Xihuang.[6]
When will I arrive at Li[yang],
To see my lifelong friend?[7]
 VM/SL

1
For a succinct discussion of Sin Saimdang's life and artistic career, see Sunglim Kim, "Defining a Woman: The Painting of Sin Saimdang," in *Women, Gender and Art in Asia, c. 1500—1900*, ed. Melia Belli Bose (London: Routledge, 2016), 201—29.

2
Gim Yeongwon, *Hanguk yeokdae seohwaga sajeon* (*Dictionary of Korean Painters and Calligraphers through the Centuries*) (Seoul: Gungnip munhwajae yeonguso, 2011), 1071—74. For other examples of Sin Saimdang's calligraphy see Im Ho–min, *Sin Saimdang Gajok ui Si Seohwa* [Poetry, calligraphy, and painting of Sin Saimdang and her family] (Gangneung-si: Gwandong Daehakgyo Yeongdong Munhwa Yeonguso, 2006).

3
This poem is recorded in *Quan Tang shi* [Complete Tang poems] (1705; repr., Shanghai: Shanghai guji chubanshe, 1986), vol. 169.

4
The poet Tao Qian (365—427), also known as Tao Yuanming.

5
This line alludes to a passage in Tao's biography in the *Song shu* (History of the [Liu] Song [dynasty]). Tao enjoyed drinking wine too much to care about other things. We are grateful to Wan Kong for this reference.

6
Xihuang ren refers to people of the Xihuang period, meaning those who lived during the time of the ancient sage and demigod Fuxi (known alternatively as Xihuang). Because it was said that people then lived a serene and leisurely life, many recluses referred to themselves as people of Xihuang.

7
Translation by Wan Kong and Stephen Little.

YI INSANG
이인상
李麟祥
1710—1760

Ballad on an Old Cypress, Written for Gyeyoon
고백행위계윤서
古栢行爲季潤書

Joseon dynasty, ca. 1750
Manuscript; ink on paper
11⅛ × 19¾ in. (28.3 × 50 cm)
Private collection

"Ballad on an Old Cypress" is a poem by the Tang dynasty poet Du Fu (712—770), here transcribed by the late Joseon dynasty official, painter, and calligrapher Yi Insang. Du Fu, one of the greatest of all Chinese poets, was inspired to write this poem by a great cypress tree situated at the tomb of Zhuge Liang (181—234), the widely revered military strategist of the ancient state of Shu Han. At the end of his transcription, Yi added a note reading, "'Ballad on an Old Cypress,' written for

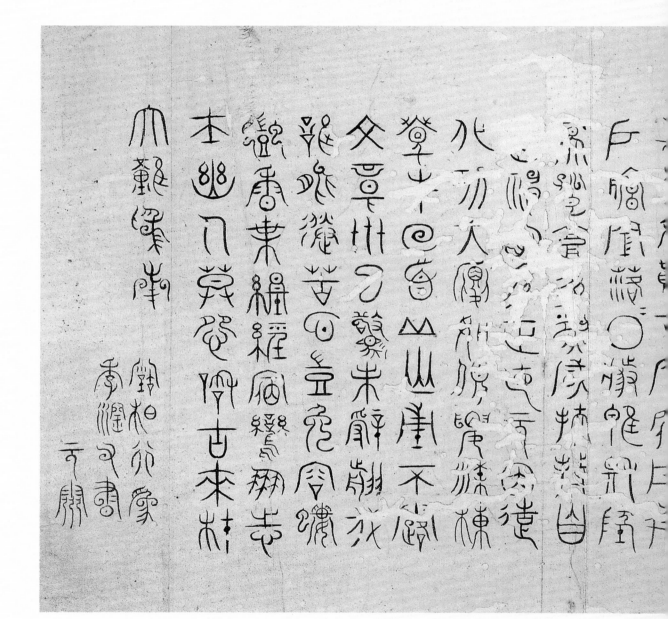

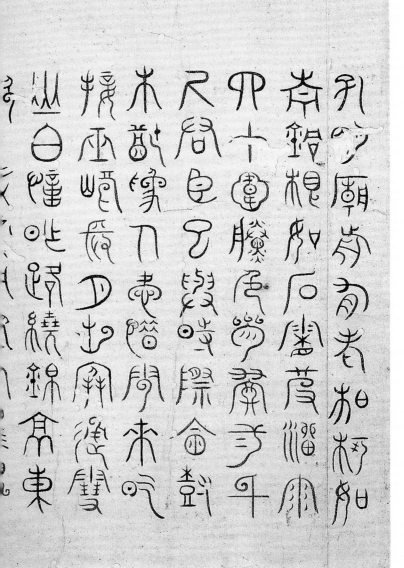

Gyeyun [by] Wollyeong." Gyeyoon was the pen name of Gim Sangsuk (1717–1792), a scholar and a close friend of Yi's who was a great admirer of Du Fu's poetry.[1] Wollyeong was one of Yi's alternate names.

Yi mastered various forms of seal script throughout his life, but was best known for his mastery of the so-called great seal script (*daejeon*) used on ritual bronze vessels—especially those dating to the Zhou dynasty—as opposed to the so-called small seal script (*sojeon*) that appeared during the Qin dynasty.[2] Although bronze vessels and their accompanying inscriptions were highly appreciated among Joseon literati, few calligraphers successfully mastered the seal script inscribed on ancient Chinese bronze vessels. This was because access to original bronzes was rare in Korea, and as a result ancient seal-script forms were best known among Korean literati from ink rubbings made from the original vessels.[3]

Growing up in a prestigious family, Yi studied seal script from his youth onward. His father passed away when he was only nine, and he was subsequently educated by his uncle Yi Choeji (1696–1774), a renowned scholar of Confucian ritual and an expert on seal carving. Yi Choeji thoroughly researched the ancient bronzes that were used for ancestral rites and collected albums that contained rubbings of their inscriptions. Provided with relatively abundant source materials and a competent teacher, Yi Insang became one of the few Joseon calligraphers to master the bronze inscription style, and many scholars tried to befriend him to obtain access to his works.[4]

Yi, however, was faced with the fact that ancient bronze inscriptions did not provide a complete set of *hanja* characters. To overcome this, he used small seal script forms mixed with those of large seal script.[5] In *Ballad on an Old Cypress*, he adapted the formal features of large seal script to the forms of small seal script to make the two look similar. Yi not only applied the formal characteristics of large seal script to small seal-script forms, but also added spirals to make his characters look even more pictographic. In addition,

he made other bold alterations. For the first character of the ninth column, *ji* (branches), for example, he added actual branches to the character's form.[6] This unconventional playfulness is one of the key elements of his seal-script calligraphy.

Yi is less known in Korea than other Joseon calligraphers, such as Han Ho (1543—1605; cat. 39) and Gim Jeonghui (1786—1856; see cats. 80—95), and yet his works have been admired by literati and calligraphers from his time to the present.[7] The prominent calligrapher, collector, and critic O Sechang (1864—1953) commented that even though Yi's seal script was spontaneous and did not strictly follow the rules, eccentricity and sturdiness could often be discovered among his brushstrokes. O Sechang surmised that the origin of this unusual aesthetic was the fact that despite his vigorous and magnanimous personality, Yi was compelled to quench his thirst for success through the vehicle of calligraphy and painting, because, being the grandson of a concubine, he was not allowed to serve in higher office.[8] Explaining his philosophy on calligraphy in a postscript to the *Collection of Works of Gim Sangsuk* (1756), Yi wrote, "The excellence of the work of ancient people was in the simplicity, not in skillfulness. It was in muscle, bone structure [the core structure of brushwork], spirit, and dignity, not in appearance, fragrance, and flavor. It is the transcendence that one does not know even when one is in its presence."[9]

The postscript to *Neunghopilcheop* (1779), an album of Yi's collected writings edited by his friends nineteen years after his death, states, "His aesthetic comes not from the splendor and skillfulness but from his unaffected liveliness—only those who know this will realize [the truth]."[10] Rather than writing aesthetically sophisticated works, Yi pursued the calligraphy that candidly exuded his personality and philosophy.
　　EY/SL

1
Yu Seungmin, "Yi Insang gwa geu ui seohwa sok simhoe" [Yi Insang and his mind in paintings and calligraphic works], in *Hangukhak geurim eul geurida* [Korean studies meets painting] (Gyeonggi-do: Thaehaksa, 2013), 52—54.

2
Ouyang Zhongshi et al., *Chinese Calligraphy* (New Haven: Yale University Press, 2008), 67.

3
Gim Yeongwon, *Hanguk yeokdae seohwaga sajeon* (*Dictionary of Korean Painters and Calligraphers through the Centuries*) (Daejeon: National Research Institute of Cultural Heritage, 2011), 1745.

4
Ibid., 1746.

5
Lee Dongkook, *Hanguk seoye ibaek-nyeon* [Two hundred years of Korean calligraphy], exh. cat. (Seoul: Wooil Publications), 267.

6
Yu, "Yinsanggwa geuui maeum sok simhoe," 55—56.

7
See O Sechang, *Gukyeok geunyeok seohwajing* [The collection of Korean paintings and calligraphic works translated into Korean] (Seoul: Sigongsa, 1998), 719—23.

8
Ibid., 723. Yi Insang started to work for the government in 1736, but had to permanently settle for a lower post. In 1754 he retired to Eumjukyeon, a small provincial town. See Gim, *Hanguk yeokdae seohwaga sajeon*, 1739.

9
Ibid., 1747.

10
Lee Dongwha, "Neunghogwan Yi Insang, jeulgeoum gwa pumgyeok euro sansu reul boda" [Neunghogwan Yi Insang, to view landscape with joy and dignity], *Incheon Ilbo* [Incheon news], July 14, 2015, http://www.incheonilbo.com/ ?mod=news&act=articleView&idxno=604751#08hF.

HAN HO
한호
韓濩
1543—1605

Album of Transcribed Poems
석봉한호해서첩

Joseon dynasty, late 16th—early 17th c.
Album; ink on paper
Each page: 14⅜ × 10¾ in. (36.3 × 27.2 cm)
Seoul Museum of History

Han Ho, whose sobriquet was Seokbong (Stone Peak), was the most representative calligrapher of the mid–Joseon dynasty. Born into a poor family in the city of Songdo (now Gaeseong, North Korea), Han was raised and taught by his mother, who worked as a rice cake vendor after Han's father and grandfather died before his tenth birthday.[1] As a child prodigy, Han learned how to read and write at an early age, but his family could not afford to buy the paper he needed to practice. Popular short stories describe Han wetting his hand with water to write letters on jars, dried leaves, and rocks.

新卯陶隱詩集跋
牧隱之文陶隱之詩吾東第一家數也東人
學為詩文者必曰唐漢以上則可否而降于
宋元猶求中原選集讀之而舍二家焉感
也抑二家集刊行不廣難有欲觀者患不可
得其僅有之者皆小字本又東人不好事之
過也余為是用新刻活字印出陶詩若干帙
興同趣者共之而早晚并與牧文更畐廣之

州之靜滕堂
十家近體詩跋
此志不忘也盖自活刻之事頗有承籍於方
伯而字取通判家藏經目壞简者也書于晉
余素不事詩律晚乃喜古人而為則襄退甚
矣不能多記集若選逈末守劂地尤不暇為
曰試新刊活字將十家近體印出若干帙以刻
自便披吟且與同襄同喜者共寫五七言不

As Han's calligraphic abilities grew and people were impressed by his gifts, his mother allowed him to study under a fellow townsman, the renowned calligrapher Sin Huinam. Han studied with Sin for ten years before passing the highest-level civil service exam in 1567 at age twenty-four. He was later selected as

a royal transcriber, with the title *sajagwan* (official scribe). Stationed at the Seungmunwon, the Joseon court's diplomatic office, Han was in charge of curating, preserving, and transcribing documents and royal letters of the Joseon kings. During his long tenure in that post, he gained fame and respect as a leading calligrapher. Han's calligraphy spread through Korea and even to neighboring countries, including China.[2]

Han's calligraphy style was initially shaped by the Chinese calligraphers Wang Xizhi (307—365) and Zhao Mengfu (1254—1322). These two figures are known for their vivid, strong, solid brushstrokes—styles that have influenced many Korean calligraphers. Whereas Han Ho's early writings show exemplary study and adaptation of these Chinese models, his unique calligraphic style started to flourish during his tenure as a *sajagwan*. He was able to join official delegations to the Ming court in Beijing five times between 1572 and 1601 and therefore gained insight into Chinese imperial calligraphy, which allowed him to develop a unique Korean calligraphy script for the Joseon court.[3]

This album contains Han's transcriptions of twenty-one of his favorite poems, including works by his close friend Choe Rip (1539—1612), a Joseon writer and poet. Han transcribed the last poem in the book, by the Chinese Tang dynasty poet Li Bai (701—762), in cursive script, whereas he wrote the other poems in a distinct standard script he had developed. This style was known as the Seokbong script, named after Han's sobriquet; it is dominated by standard script with hints of cursive- and semicursive-script elements. In 1605 King Seonjo (r. 1567—1608) commissioned

a number of copies of this album. A foreword for the album was written later by the modern calligrapher Won Chunghui (1912—1976).

This album showcases the distinct script for which Han Ho was celebrated. Han authored thirty stone inscriptions and some twenty books. He wrote most of these after he turned fifty; his writings from his thirties and forties are generally considered less significant. Han's standard script exemplifies the ideal aesthetics pursued by the royal Joseon court.[4] Han was not only chosen to be the preeminent court calligrapher, but was also commissioned by the Joseon kings he served to transcribe such works as Zhou Xingsi's early sixth-century *Thousand-Character Classic*. These books were promulgated throughout the country and were used as textbooks for calligraphy education.

NM

1
"Calligraphy of Han Seokbong," National Museum of Korea, accessed July 2, 2018, https://www.museum.go.kr/site/eng/relic/represent/view?relicId=4408.

2
Yi Wanwoo, "Seokbong Han Ho: A Calligrapher in the Middle Period of Choson Dynasty," *Art History Forum* 12 (2001): 299—319.

3
Ibid.

4
Ibid.

以皇上字小之仁以使係一國之望而神
明不相行李不達則無此理然睨睨於難而
無所歸喜非人情也蓋陳叅將有赴急之切
焉然觀其却禮謝而辭曰此自當行道理可
謂知邊吏之職謹私交之戒者不可強而歸
之然則公於狼子山惡得不禽而諸公幸公
之事惡得不為狼子山賦也乎哉公曰此吾
志也遂書以為狼子山圖詩序

4O

HEO MOK
허목
許穆
1595—1682

Eulogy to the East Sea (The East Sea Stele Inscription)

척주동해비탁본

陟州東海碑銘

Joseon dynasty, 1661
Ink rubbing; ink on paper
9¾ × 12⅞ in. (15.6 × 50 cm)
Private collection

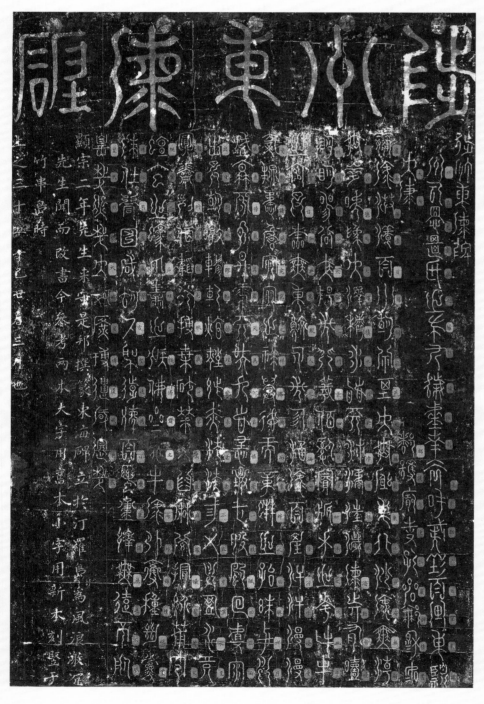

Despite being born into one of the most prestigious families of Joseon dynasty Confucian scholars, Heo Mok was unable to earn a position in government until he was sixty-three years old.[1] At thirty-two he had been involved in a political debate that infuriated King Injo (r. 1623—49), with the result that he was banned from government service for years. Heo often found himself in the middle of political strife during his eventual bureaucratic service, which lasted for three decades. Although he had a considerable reputation as a Confucian scholar, he was nonetheless critical of then-popular Neo-Confucianism, which had become so reactionary that it was significantly hindering the economic and social growth of the Joseon state. In response, Heo tried to revive the ancient Confucianism of pre—Qin dynasty China and to align it with the reality of the Joseon dynasty. He was the leader of the Namin (the Southerners), a Joseon-era Confucian school that pursued social reform and practicality. Heo served as governor of Cheokju (now Samcheok), located in Gangwon Province, along Korea's southeastern coast, from 1660 to 1662.

In addition to Confucianism, Heo was also a serious student of Daoism. He frequently quoted the ancient sage Laozi, maintaining that Confucius, in his literary works, had learned from Laozi. He often revealed his sympathy for Daoist adepts and in 1675 wrote biographies of five famous Joseon-dynasty Daoist practitioners, the *Cheongsayeoljeon* (Biographies of the assorted pure scholars).[2]

A devoted researcher and master of several calligraphic forms, Heo is considered the greatest master of *hanja* calligraphy of the seventeenth century. His skill in seal script (*jeonseo*) is illustrated by the *East Sea Stele Inscription*, his most famous work in this ancient form. Heo composed the poem known as "Donghaesong" ("Eulogy to the East Sea"), the text of the inscription, in 1661, while he was governor of Cheokju, and the stele was set up during his tenure.[3] The text was written in supplication to the Dragon King (believed to rule the oceans) to stop a series of deadly tsunamis that had inundated the local coastal zone. Both Heo's original draft manuscript of the stele inscription and ink rubbings of the original

HEO MOK
허목
許穆
1595—1682

Manuscript for the East Sea Stele Inscription
척주동해비 원고
陟州東海碑銘手稿

Joseon dynasty, 1661
Album; ink on paper
19¾ × 12⅞ in. (50 × 32.7 cm)
National Museum of Korea, Seoul, Treasure
no. 592–1

stele survive, although the original stele was severely damaged long ago and no longer exists.[4]

The poetic inscription follows the form of the ancient poetry (*gosi*) of China's Han dynasty. It is a long poem comprising forty-eight lines, with four *hanja* seal–script characters per line. The content can be divided into three parts: the first part describes the vastness of the East Sea and notes that the sun rises from there; the second part explains its abundant

resources and the various exotic species, monsters, and gods residing in the ocean; and the third part attributes the peaceful coexistence of these creatures to an ancient sage and prays for peace to last for eternity.[5] The postscript, carved on one

HEO MOK
허목
許穆
1595—1682

Calligraphy: Question Extensively
서예: 포괄적인 문제
許穆篆書

Joseon dynasty, 1674
Hanging scroll; ink on paper
50 × 17 in. (127 × 43 cm)
Seokdang Museum of Dong-A University, Busan

side of the stele in standard script, reads, "In 1661, Governor Heo Mok wrote the inscription in seal script and erected the *East Sea Stele* on Jeongrado Island. It was destroyed by high winds and waves, so he rewrote it. The new stele was carved with larger characters taken from the rubbing of the old stele and smaller characters taken from a new manuscript. It was erected again on Jukgwando Island in the spring of 1709."[6]

The influence of Daoism and related ancient Chinese systems of belief is clearly apparent in the *East Sea Stele Inscription,* in which Heo features mythic creatures borrowed from the *Sanhaegyeong* (Ch. *Shanhai jing;* Classic of the mountains and seas), a compilation of real and mythical geography composed in China during the fourth century BCE. Myths about gods and monsters and mysterious stories of exotic foreign lands cannot be directly connected to Daoism, but were nonetheless incorporated into much early Daoist lore.[7] Heo includes elements appropriated from the *Sanhaegyeong* at the beginning of the *East Sea Stele Inscription,* calling the East Sea "Daetaek" and stating that there is a place called Yanggok in the East Sea ruled by a goddess named Huibaek (Ch. Xi He). According to the *Sanhaegyeong,* a giant named Gwabo got thirsty while racing with the sun, so he drank all the waters of the Yellow and Wei Rivers. Still feeling thirsty, he ran to Daetaek, an imaginary lake, but died before arriving. Yanggok is a valley where a giant mulberry tree with ten suns sitting on its branches is rooted, and Huibaek is a sun goddess. In the following section, Heo mentions several eccentric species and creatures: *gyoin,* Cheono, and Gi, for example, who also appear in the *Sanhaegyeong* as the ones responsible for the weather of the East Sea. *Gyoin* are mermen who produce pearls with their tears; Cheono is a god of water with eight heads, legs, and tails; and Gi is a monster who looks like a blue cow with one leg, who creates blinding light and rainstorms when he enters and exits water. By borrowing key elements from the *Sanhaegyeong,* Heo brings out latent contexts and images and effectively describes the magnificence and mystery of the East Sea. In the last section of the inscription, he eulogizes the old sage for his virtuous deeds, which allowed all the different kinds of creatures in the East Sea to live in peace.[8]

While the *East Sea Stele* in Cheokju was well known for centuries as the stele erected to protect the area from such natural disasters as tsunamis, there have been academic debates on Heo's purpose in creating the stele, because no official records regarding the matter exist.[9] Some scholars argue that it was a temporary expedient to pacify the strong opposition of local landed proprietors against the oppressive rule of the central government and the locals who were suffering from natural disasters. Others consider it a metaphor for the political strife happening within the central government and claim that Heo, with the stele, wished for an end to these struggles and the arrival of a new, harmonious era.[10] Still others argue that Heo truly believed in the mystical power of the stele, based on his Daoist inclinations, and that he created it in a poetic form believed to be effective when one communicated with otherworldly beings, and that, furthermore, he wrote its inscription in an ancient seal script that looked similar to the writings on Daoist and shamanistic talismans.[11] Among the local people, the shamanistic effect of the stele was firmly believed. Many folktales about the stele and Heo were handed down to posterity, and today some local people still possess ink rubbings of the inscription as talismans of sorts.[12]

Remarkably, Heo's original handwritten *Manuscript for the East Sea Stele Inscription* survives. A prominent calligrapher, Heo created his own variant script, which has come to be known as Misuche, following his pen name, Misu, meaning "elder with long eyebrows." Misuche was based on ancient Bronze Age seal script, and the *Manuscript for the East Sea Stele Inscription* is one of the most important calligraphic works written in this style.

Heo, aware that this was the manuscript for a stele inscription, carefully arranged the characters and adjusted the spaces between them so that the calligraphy could be easily traced and carved into the stone surface of the stele. He also creatively altered and used variant forms of characters that were used repetitively, revealing his abundant knowledge of seal script and

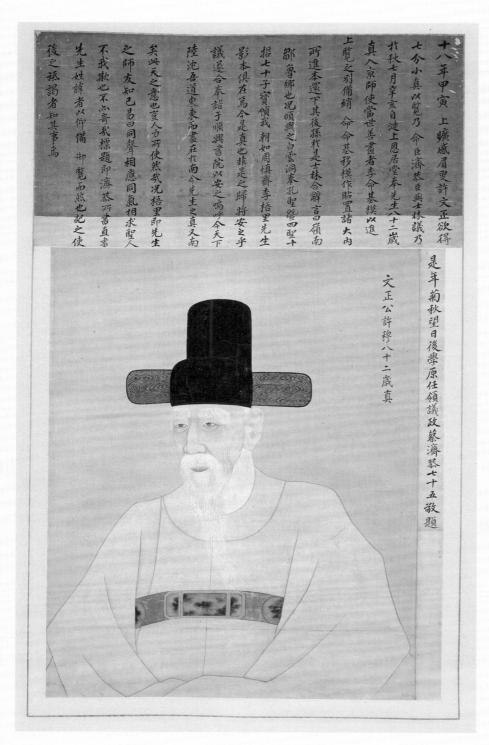

FIGURE 77

Portrait of Heo Mok (1595–1682), Joseon dynasty, 18th c. Hanging scroll; ink and color on silk; 28⅜ × 22½ in. (72.1 × 57 cm). National Museum of Korea, Seoul

combining it with his own unique aesthetic sense. The text was written on a long scroll made with *hanji,* traditional Korean paper produced from mulberry tree pulp, which was then folded like an accordion using a traditional binding technique, *cheopjang,* resulting in a twenty-seven-page album.[13] Relatively few manuscripts written for stone steles survive today in Korea.[14] While the stele carver took some liberties with Heo Mok's original character forms in the title, the main body of the text faithfully follows the forms of Heo's manuscript.

Throughout his lifetime, Heo was critical of the popular calligraphic style that imitated the Chinese master Wang Xizhi (307–365), commenting that "it is to be deplored that these days scholars try to [slavishly] copy Wang Xizhi as if they were artisans."[15] A distinctive feature of Heo's Misuche style was that his seal script was written with brush movements normally used in executing running and cursive scripts. In inventing his own style, Heo was largely inspired by the "bird-worm" and "tadpole" scripts popular in the Spring and Autumn and Warring States periods in China.[16] In Misuche the influence of the bird-worm seal script is apparent in the wavy lines, while the brushstrokes' sharpened ends are similar to the tadpole script. These features are evident in the *Manuscript for the East Sea Stele Inscription* as well, where they were exaggerated among the rapid brushstrokes.[17] Heo's unusual calligraphic style did not adhere to the well-known principles of writing, however, and was considered controversial by both his contemporaries and scholars of later generations. One of Heo's political opponents, Minister Yi Jeongyeong (1616–1686)—famous for his sophisticated standard

script, which followed the style of the Chinese Yuan dynasty master Zhao Mengfu (1254—1322)—insisted that Misuche should be permanently banned. On the other hand, Hong Yangho (1724—1802), who also served as a high-ranking minister, commented that the Misuche style of the *East Sea Stele Inscription* was creative, profound, and ancient at the same time, comparing its shape to a thousand-year-old wisteria vine.[18] Today, Misuche is especially appreciated as a calligraphic style because it expresses the unique character and aesthetic originality of Heo so well.[19]

The hanging scroll, *Calligraphy: Question Extensively,* is a fine example of Heo's idiosyncratic style of seal script. The main text consists of two enormous *hanja* characters, whose meaning can be rendered as "question extensively." While the two characters' forms are based on classical seal script, Heo has altered them in several ways: he has vertically elongated each character, resulting in attenuated forms; ended several of his brushstrokes in finely pointed "rattails" (more often seen in cursive script); and occasionally inscribed certain strokes using the "flying white" technique, in which the brush hairs are dragged across the surface of the paper, revealing the paper ground. These features are each creative violations of the characters' traditional seal script forms, yet each character retains its legibility, and the resulting forms are clear expressions of Heo's own unique artistic persona. The artist's signature appears along the lower left border in standard script: "Inscribed by the eighty-year-old man, Elder with Long Eyebrows."[20]

EY/SL

1
Today Heo Mok's portrait appears on the South Korean 1,000-won banknote.

2
Im Chaewoo, "Cheokjudonghaebi e natanan doga jeok segyegwan ui munje" [Daoist worldview in the *East Sea Stele* in Cheokju], *Dogyo munhwa yeongu* [Journal of studies of Daoist culture] 39: 64—66.

3
Kim Taesoo, "Seolhwa e natananeun Heo Mok ui salm gwa minjung uisik" [The life of Heo Mok and popular consciousness in tales: Focused on tales transmitted in Samcheok area], *Gangwonminsokhak* [Folklore of Gangwon Province], vol. 20 (Gangwondo: Society of Gangwon Province Folkart, 2006), 77.

4
In the stele's place today is a modern replica based on ink rubbings taken from the original stele.

5
Jung Jaeseo, "Cheokjudonghaebi e pyohyeon doen Sanhaegyeong ui imijideul—Jeongchiseong inga? Jusuljeok hyeonsil inga?" [A study on *Shanhaijing* images of Chuckjudonghaebi], *Yeongsang munhwa* [Visual culture] 29 (December 2016): 6.

6
Jeongra and Jukgwan Islands are small islands in the East Sea located near Samcheok. Jukgwan Island is closer to the land, so it was safer than Jeongra Island. Translation by Eunsoo Yi.

7
Jung, "Cheokjudonghaebi e pyohyeon doen Sanhaegyeong ui imijideul," 73. In philosophical texts including *Dodeokgyeong* (Ch. *Daode jing*), attributed to Laozi, and *Jangja* (Ch. *Zhuangzi*), written by Zhuang Zhou, Daoists absorbed ancient myths into their writings. For example, *Jangja* contains stories about mythic creatures such as a giant fish that transforms into a giant bird, an immortal being who drinks dew and rides a cloud, and a tree whose every year of age is equivalent to one thousand years of human life.

8
Jung, "Cheokjudonghaebi e pyohyeon doen Sanhaegyeong ui imijideul," 6—18.

9
Im, "Cheokjudonghaebi e natanan doga jeok segyegwan ui munje," 83.

10
Jung, "Cheokjudonghaebi e pyohyeon doen Sanhaegyeong ui imijideul," 18.

11
Ibid., 23. Shamans believe that poems can affect the phenomenal world with the sounds their rhymes create. Traditionally, funeral orations take the form of poetry.

12
Kim, "Seolhwae natananeun heomogui salmgwa minjunguisik," 81—82.

13
"Heomoksugobon" [Manuscripts written by Heo Mok], *Hanguk Minjok Munhwa Daebaekgwasajeon* [Encyclopedia of Korean culture], accessed October 23, 2017, http://encykorea.aks.ac.kr/Contents /SearchNavi?keyword=%ED%97%88%EB%AA %A9%EC%88%98%EA%B3%A0%EB%B3%B8 &ridx=0&tot=12736.

14
I Dongmyeong, "Gangwon munhwajae tambang, no. 23: Heomok sugobon donghaebicheop" [Gangwon cultural heritage report 23: Manuscript of the *East Sea Stele* written by Heo Mok], *Kang Won Domin Ilbo*, July 23, 2014, http://www.kado .net/news/articleView.html?idxno=690752.

15
Kim Dong-gun, "Misu Heo Mok ui jeonseo yeongu Hyeongseong gwa yangsik eul jungsim euro" [A study of seal-script calligraphy by Heo Mok], *Misulsahagyeongu* [Korean journal of art history] (June 1996): 35—38.

16
Gim Yeongwon, *Hanguk yeokdae seohwaga sajeon (Dictionary of Korean Painters and Calligraphers through the Centuries)* (Daejeon: National Research Institute of Cultural Heritage, 2011), 2425.

17
Kim, "Misu heomogui jeonseoyeongu hyeong-seonggwa yangsigeul jungsimeuro," 48.

18
O Sechang, *Gukyeok geunyeok seohwajing* [The collection of Korean paintings and calligraphic works translated into Korean] (Seoul: Sigongsa, 1998), 535—37.

19
Gim, *Hanguk yeokdae seohwaga sajeon*, 2425.

20
In Korea, as elsewhere in East Asia, individuals are considered to be a year old when born; thus, Heo Mok's indicated age of eighty is equivalent to seventy-nine years of age by Western count.

# 43

JEONG YAKYONG
정약용
丁若鏞
1762—1836

Hapicheop (Red Skirt Album)
하피첩
霞帔帖

Joseon dynasty, 1810
Album; ink on silk
Book 1, each page: 9¾ × 6⅛ in. (24.8 × 15.6 cm)
Book 2, each page: 9¹³⁄₁₆ × 6⅛ in. (24.9 × 15.6 cm)
Book 4, each page: 9½ × 5¹¹⁄₁₆ in. (24.2 × 14.4 cm)
National Folk Museum of Korea, Seoul

Hapicheop originally comprised four albums containing lessons that Jeong Yakyong, a well-known Joseon dynasty scholar, wanted to teach his two sons. He wrote the text on pages made from a worn red silk skirt his wife had sent to him in Gangjin, a small provincial town to which Jeong had been exiled in 1801. In the lessons that Jeong sent back to his sons, he counseled them as to how and why they should study, how they could earn their livings, and how to build relationships with their relatives and friends.[1]

Jeong used *hanja* characters to number the four albums *gap, eul, byeong,* and *jeong*: names of celestial stems originating from the Chinese system of ordinals. Three albums from the original set of four survive today, the missing one being the *byeong*—third—album. The first album,

gap, comprises thirty-four pages written in standard script. The second album, *eul*, consists of twenty-eight pages and was written in seal and standard script. The third remaining album, *jeong*, is composed of thirty pages written in clerical, standard, and cursive script. Most of the albums' pages consist of silk mounted on *hanji*, the traditional Korean paper made from mulberry tree pulp, while additional pages in the second and fourth albums consist of light red and blue paper.

Jeong was a renowned scholar of the Silhak academic movement, which had begun in the seventeenth century. Late Joseon society was in crisis because its tax system, which was highly inefficient and exploitative of peasants, was having a harmful impact on the economy.[2] After the Imjin War (Japanese invasions of Korea; 1592–98), a group of scholars began to argue in favor of social reform and open trade. Despite being excluded from politics in the early seventeenth century, they managed to grow into a major academic movement after the Manchu invasion of 1636, as more scholars acknowledged the urgency of social reform to strengthen national defense and rehabilitate a devastated economy. Some scholars called for fundamental modifications to Neo-Confucianism, the state ideology. This new movement was named Silhak (practical learning). It developed rapidly in the eighteenth century, and Jeong Yakyong was one of its leading exponents during the period.

Jeong was not completely against Neo-Confucianism, the philosophical foundation on which the Joseon state was built, but he was critical of its impracticality and complexity. He believed that scholarship should be empirical and practical and prioritize ordinary people and their prosperity. Furthermore, he was devoted to the progressive Silhak movement, which encompassed scientific ideas imported from the West.[3] Beginning at the age of twenty-eight, Jeong was appointed to a series of important positions in government, during which time he tried to reduce its prevalent inefficiency. He designed a bridge and a hand-operated crane, *geojunggi*, to be used for the construction of a rampart in Suwon, a new city that King Jeongjo (r. 1776–1800) planned as

a model for social reform. Jeong had many innovative ideas about how to achieve radical social reform, which King Jeongjo supported. In 1800, however, King Jeongjo died, and Jeong did not have enough political support to silence the strong opposition of aristocrats who feared losing their privileged position in society. A year after King Jeongjo's death, Jeong was embroiled in political strife and falsely accused of being a Catholic.[4] He was exiled to Gangjin, where, over the course of eighteen years, he wrote more than five hundred books across numerous academic disciplines.[5]

In the first album of *Hapicheop*, Jeong Yakyong explains how he arrived at the book's concept and why he wrote the texts. In 1806, the thirtieth year of their marriage, his sick wife sent him a red skirt that she had brought to their marriage. Jeong thought the faded red skirt could be good material on which to write. He cut it and made it into the series of albums with lessons for his sons. At the end, he wrote, "I would be deeply touched if [my sons] can feel the blessings of their parents while reading this later in the future."[6] In the first album, Jeong emphasizes the importance of family solidarity. Despite the fact that they cannot serve in the government, he asks his sons to be culturally and scholarly trained because it is the only way they can prepare for the future of their children. In the second album, to protect the reputation of his family, Jeong advises his sons to be cautious in their speech and behavior, unbiased, diligent, and frugal. In the fourth album, he hopes they will inherit his scholarly works. He encourages his sons to keep studying his vast writings and to use them to develop a more substantial academic movement.[7]

The four different kinds of script used in *Hapicheop* reveal how proficient Jeong was at writing in a broad range of calligraphic forms. *Hapicheop* is the only remaining source that contains Jeong's seal script. He learned it from the inscriptions on the ancient Stone Drums of Qin (Seokgomun), the oldest-known stone inscriptions in China (fig. 1). The seal script seen in *Hapicheop* shares some important formal features with the Stone Drums script, such as the consistency in

the thickness of lines, the rounded shapes of the start and end points of the brushstrokes, and the bilateral symmetry in the individual characters' structures. At the same time, while keeping the overall balance, Jeong changed the composition somewhat to make his script more active and lively. For the standard-script form, he followed the elegant, formal manner of the Chinese Tang dynasty calligrapher Ouyang Xun (557–641). In his running script, brushstrokes became more flexible, and the compositions show greater variation, creating fine tensions between the characters. In his cursive script, which usually manifests rounded and curving brushstrokes, Jeong used an angled brush to create greater balance between the strong and soft parts within the brushstroke lines.[8]

EY

1
Hong Donghyeon, "Dasan Jeong Yakyong ui gangjin yubae saenghwal gwa Hapicheop" [Dasan Jeong Yakyong's life of exile in Gangjin and *Hapicheop*], *Dasangwa hyeondae* [Journal of Dasan and the contemporary times] 9 (2016): 286.

2
Jang Ji Hoon, "Jeong Yakyong ui silhakjeok seohwa mihak e gwanham yeongu" [A study of Jeong Yakyong's *Silhak* based on aesthetics of calligraphy and painting works], *Dongyang cheolhak yeongu* [Journal of Eastern philosophy] 61 (2010): 509–11.

3
Ibid.

4
Kim Yong Heum, "Dasan ui gukga gusang gwa Jeongjo tangpyeong chaek" [Jeong Yakyong's national initiative and King Jeongjo's policy of impartiality], *Dasan gwa hyeondae* [Journal of Dasan and the contemporary times] 4 (2012): 397–98.

5
Jeong Min, *Dasanui jaebalgyeon* [The rediscovery of Dasan] (Seoul: Humanist, 2011), 53.

6
Hong, "Dasan Jeong Yakyongui Gangjin yubae-saenghwalgwa Hapicheop," 292.

7
Ibid., 294–96.

8
Hong Hyeon-Soon, "Dasan Jeong Yagyong ui seoye yeongu–Hapicheob eul jungsim euro" [A study on the calligraphic works of Dasan Jeong Yakyong: Focusing on *Hapicheop*] (master's thesis, Daejeon University, 2011), 60–75.

LEE SAMMAN
이삼만
李三晚
1770—1845

Radiance of Mountains, Colors of Water

산광수색
山光水色

Joseon dynasty, 19th c.
Ink on paper
22⅝ × 34⅝ in. (57.5 × 87.8 cm)
Private collection

Unlike his contemporaries, who took as their models calligraphies of the Chinese Jin and Tang dynasties, Lee Samman (sobriquet Changam) was a great proponent of older, archaic Han dynasty writings. Lee believed that mastering the calligraphy of Han dynasty China would naturally allow one to write in the styles of the dynasties that followed. When teaching, he advised his students to discern the strengths and weaknesses of each style rather than to blindly accept one or the other.[1]

Lee particularly excelled at *haeseo* (standard script)*, haengseo* (running script), *choseo* (cursive script), and *daeja* (large-

scale characters), and was influenced by Lee Gwangsa (1705—1777), famously known for his cursive script.[2] Lee's work shown here uses wild cursive script (*gwangchoseo*). His characters manifest his powerful brushwork and reveal the "bones and muscles" of their underlying structures.[3]

The four characters read *san gwang su saek* (radiance of mountains, colors of water), a phrase that appears in a poem by the Tang poet Li Bai (701—762), "At the Shrine of [Emperor] Yao in Lü County, Seeing Off District Magistrate Dou Baohua on His Return to the Western Capital." Lee Samman made this work

as a talisman to ward off snakes, which he had hated since his father had died of a snakebite.[4] As the story goes, in the first lunar month, there is a day on which one acts to dispel evil spirits. Before sunrise, Lee wrote this and placed it upside down to prevent snakes from entering his house. The written forms of Lee's cursive script have been interpreted by scholar Sin Wung Sun as images of snakes: *san* (the mountain is twisted upward), *gwang* (the snake puts forth his tongue and quickly pulls it back), *su* (it is like a stalwart rib looking downward), and *saek* (it crawls upward).[5]

VM/SL

[1]
Gim Gwang Uk, *Hanguk seoye haksa* [A history of Korean calligraphy] (Daegu: Keimyeong Daehakgyo Panbu, 2009), 268.

[2]
Go Seong Hun, *Hanguk seoye munhwa ui yeoksa* [The history of Korean calligraphy culture] (Seoul: Gyeongin Munhwasa, 2011), 259—60.

[3]
Ibid.

[4]
Go, *Hanguk seoye munhwa ui yeoksa*, 259—60.

[5]
Sin Wung Sun, "Je 8: Changam Lee Samman ui 'San Gwang Su Saek'" [Chapter 8: Changam Lee Samman's scenery of mountains and water], published August 11, 2013, https://m.blog.naver.com/PostView.nhn?blogId=sukya0517&logNo=40192825817&proxyReferer=https%3A%2F%2Fwww.google.com%2F.

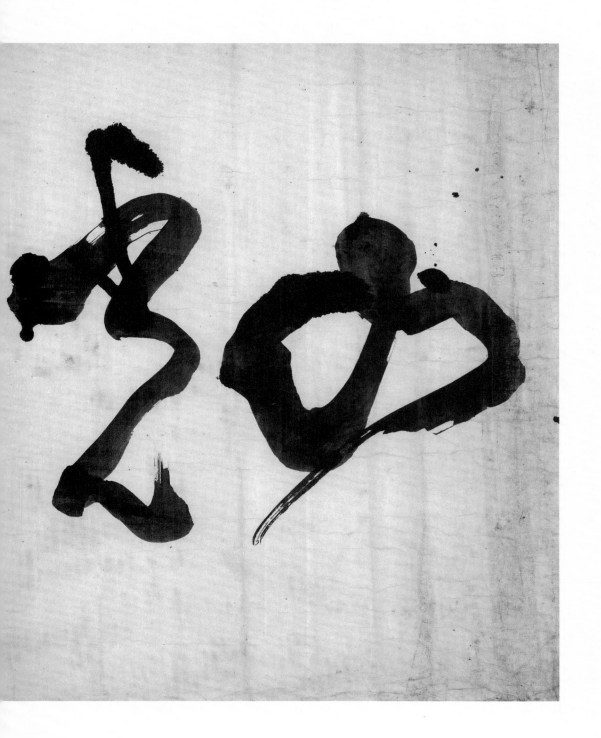

4 5

Epitaph of a Daughter of a Local Official in Gyeongju
경주 향리 딸의 묘지명

Goryeo dynasty, 918—1392
Stone
10¾ × 8½ in. (27.3 × 21.5 cm)
National Museum of Korea, Seoul
Not in exhibition

This epitaph, an inscription about the deceased written on stone, was made for the daughter of Gim Jiwon, a local clerk in Gyeongju, Gyeongsang Province, during the Goryeo dynasty. The inscription has been carved in calligraphy—in standard script—and is missing a husband's name, indicating that the daughter was unmarried at the time of her death. The flower-petal shape of the epitaph, which is unusual and remarkably feminine for this time period, hints at Gim Jiweon's deep affection for his daughter, who predeceased him.[1]

VM

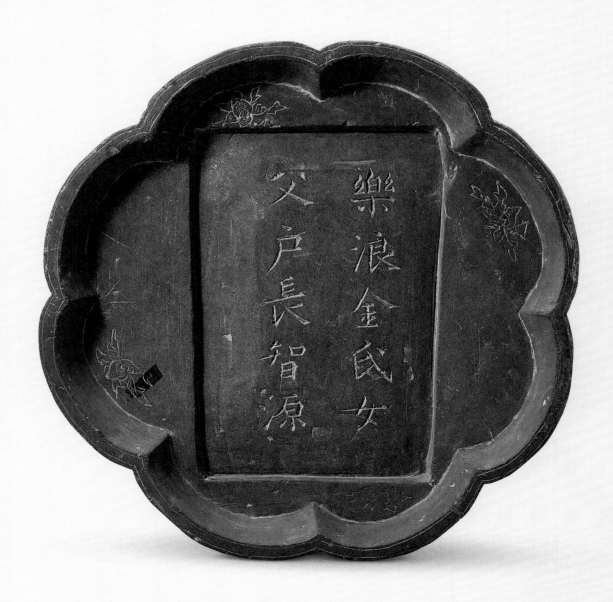

1

"Epitaph of a Daughter of a Local Official in Gyeongju," National Museum of Korea, accessed March 1, 2018, https://www.museum.go.kr/site /eng/relic/represent/view?relicId=1186.

Epitaph of Choe Ham
최함묘지명
崔諴墓誌銘

Goryeo dynasty, 1160
Stone
14½ × 28¼ × ¾ in. (36.8 × 71.6 × 2 cm)
National Museum of Korea, Seoul

The culture of epitaphs flourished during the Goryeo dynasty, from which 322 epitaphs have survived.[1] In contrast, epitaphs were scarce during the earlier Three Kingdoms period and Unified Silla dynasty. One characteristic of Goryeo epitaphs is their use of diverse calligraphic styles. The calligraphy with which epitaphs were inscribed was designed to memorialize the accomplishments of noteworthy individuals. For this reason, epitaphs did not have to conform to strict calligraphic forms.

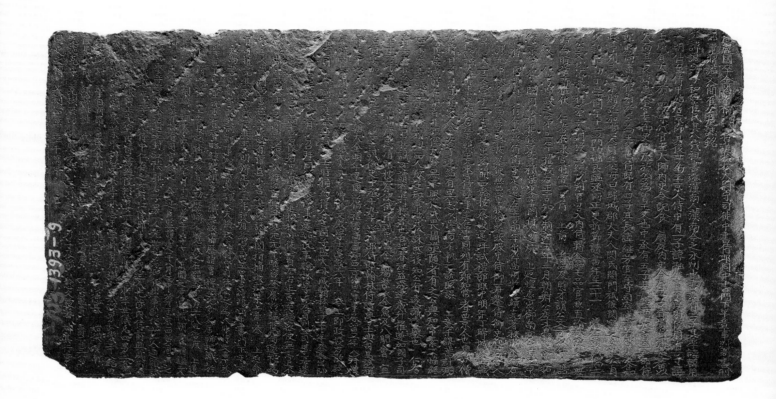

Epitaphs became so prevalent during the Goryeo period, however, that their literary quality eventually declined and they began to fall short of their original purpose, which was to memorialize a person's accomplishments and virtues. Gim Baekil, a Goryeo scholar, derided the cult of the epitaph, claiming, "People in the world solely chase after great power and achieve nothing, but they still want to relish honor in the afterlife by engraving the records on stone. This is such an absurd illusion! So I have said, 'Despite the fact that a stone cannot speak, why would you engrave your humiliations on that rocky surface?'"[2]

That being said, the study of epitaphs allows scholars to understand Goryeo society and history in greater depth. The calligraphy on epitaphs provides not only the biographical records of the deceased, but also specific information about Goryeo culture.

This epitaph, of the official Choe Ham, is arranged in forty-four vertical columns and consists of 1,443 *hanja* characters inscribed in standard script. The first line includes Choe Ham's posthumous name, Mungan, and states that he served as a first-rank civil official and was promoted to the special rank of acting commandant and minister.[3] The epitaph describes his family relationships, personality, and accomplishments. The epitaph's description of the Rebellion of Yi Jagyeom (d. 1127) in 1126 is of particular historical value:

> Five years after King Injong ascended the throne [1126], Cheok Jungyeong [d. 1144], a member of Yi Jagyeom's group, invaded the palace. Cheok Jungyeong piled up wood and set fire to Donghwa Gate. The king was intimidated and flustered and headed to the South Palace. Choe Ham served and protected the king while he sought refuge.[4]

In addition, this epitaph reveals an element of the Goryeo dynasty's international relations with the non-Chinese Jurchen Jin (K. Geum) dynasty, which ruled northern China from 1115 to 1234. The epitaph states that in 1140 Choe Ham was sent as an official envoy to the Jin court in Beijing to convey New Year greetings from the Goryeo court.[5] It is noteworthy that this passage refers to the "Great Jin" (instead of merely "Jin"), refers to the "foreign ambassador attending court" (instead of merely "an ambassador [sent as an envoy]"), and mentions the Jin dynasty reign title, Hwangtong (Ch. Huangtong; 1141—49). Moreover, there is a blank space before the word referencing the Goryeo royal family, in order to show honor and respect to them, whereas there is no blank space in front of the words signifying the Jin royal family.[6] These details reflect the pride and confidence of the Goryeo state at the time.

CGL

1
Of these surviving Goryeo epitaphs, 270 were written about men—including twenty monks—and fifty-one were written about women (one is badly damaged and thus illegible). The individuals' official titles are listed with their names, and 250 of the men were officials with royal government titles. Among these, the oldest are the epitaphs of Chae Inbeom (1024) and Yu Jiseong (1045), with chronologically succeeding epitaphs from 1051, 1059, and 1061; see Kim Yong-sun, *Goryeo geumseok mun yeongu: Dol e saegyeojin Sahoesa* [Study on epigraphs in the Goryeo dynasty: Social history engraved on the stone] (Seoul: Ilchokak, 2004), 199—202.

2
Quoted in Kim, *Goryeo geumseok mun yeongu*, 202.

3
For a full transcription of Choe Ham's epitaph, see Kim Yong-sun, *Goryeo myojimyeong jipseong* [Anthology of Goryeo dynasty epitaphs] (Gangwondo: Hallimdaehakgyo asiamunhwayeonguso, 1997), 182—85. A Korean translation is also provided in Kim Yong-sun, *Yeokju Goryeo myoji myeong jipseong (sang)* [Anthology of Goryeo dynasty epitaphs, vol. 1] (Gangwondo: Hallimdaehakgyo asiamunhwayeonguso, 2001), 284—90.

4
Kim, *Goryeo myoji myeong jipseong*, 183.

5
Ibid., 184.

6
National Museum of Korea, *A Dynamic World of External Relations in Goryeo and Joseon Dynasties* (Seoul: National Museum of Korea, 2002), 51.

47

Burial Panels and Covered Bowl Set with Inscriptions
백자청화서유교명묘지석일관

Joseon dynasty, 1812
Slab–built porcelain with underglaze blue painted decoration and clear glaze
Each tablet: 7½ × 6⅝ × ¾ in. (19.05 × 16.8 × 1.9 cm); lidded jar height: 9⅞ × 12 in. (25.1 × 30.5 cm); lidded jar diameter: 11⅞ in. (30.2 cm)
Los Angeles County Museum of Art, gift of Patricia Suh and Joseph Kim in honor of J. Ha–Yong and Charlie B. Suh, M.2002.183.1a—j

The practice of preparing and burying stone–carved tomb inscriptions, also known as *myoji,* began during the Three Kingdoms period. In the early Joseon dynasty, ceramic plaques and bowls were increasingly used as surfaces for epitaphs.[1] There were several reasons for this increase in popularity. With Confucianism as the state ideology, ancestor worship and therefore respect for one's deceased parents were

important social values. A more practical reason was the anxiety that tombs could be destroyed and their occupants forgotten.

Each set of burial epitaphs, varying in number (in this case, eight), included basic information about the deceased, such as name, birthplace, family lineage, relevant family relations, job, accomplishments, quality of reputation, birth and death dates, and the location of the tomb.[2] In this set

235

of burial epitaphs, the eight inscribed blue–and–white porcelain plaques outline a narrative of the life of Seo Yugyo, his family members, and the notable people in society with whom he had relations. Seo Yugyo's younger brother Seo Yongbo wrote the inscription, expressing his admiration for the deceased. It is clear that the younger brother viewed his older brother as a role model: "The virtuous character was naturally gifted to him. Even when he was young, his speech and behavior were not frivolous, [but] like an adult. I just respected him and did not dare be inappropriately intimate with him."[3] All the information was carefully written in standard *hanja* script to resemble an official document. Despite the invention of *hangeul,* mortuary practices of the official and upper classes generally encouraged the use of *hanja* for such commemorative inscriptions. Joseon dynasty epitaphs inscribed on ceramics comprise square panels of this type (intended to fit into a domed bowl) and various shapes and sizes of bowls and dishes.

VM

1

National Research Institute of Cultural Heritage, *Korean Art Collection of the Los Angeles County Museum of Art, U.S.A.* (Daejeon, Republic of Korea: National Research Institute of Cultural Heritage, 2012), 248.

2

"Sojangyumul geomsaek: baekjacheonghwasimseonbokjiseongmitjiseokap" [Collection research: Burial epitaphs], Seoulyeoksabangmulgwan [Seoul Museum of History], accessed February 20, 2018, http://www.museum.seoul.kr/www /relic/RelicView.do?mcsjgbnc=PS01003026001 &mcseqno1=001410&mcseqno2=00000 &cdLanguage=KOR&tr_code=m_sweb.

3

Translated by Dr. Chan Lee; English edited by Michelle Bailey, December 2008.

Medicine Chest
약장

4
8

19th c.
Wood
47⅞ × 51 × 14 in. (121.5 × 129.5 × 35.5 cm)
National Museum of Korea, Seoul
Not in exhibition

A medicine chest is a wooden cabinet used to organize individual herbs and medicines in a house or herbal medicine office. Made to be long lasting, lightweight, and resistant to insects, such chests were often made of the woods of paulownia, zelkova, persimmon, pear, ginkgo, or walnut trees. The style of a medicine chest depended on the geographic region in which it was made. Medicine chests are of varying height, but are at least eight rows high. Each drawer is labeled with standard-script *hanja* calligraphy to clearly distinguish one herb or medicine from another. Often, chests also contain medicine holders, containers, and bags; acupuncture devices to supplement the herbal medicine; and rags to squeeze out the medicine once the concoction is boiled. As a result, medicine chests required many drawers; they were typically designed with larger drawers near the bottom and smaller drawers above.[1]

VM

1
Edward Reynolds Wright and Man–Sil Pae, *Traditional Korean Furniture* (Tokyo: Kodansha International, 2000), 92—93.

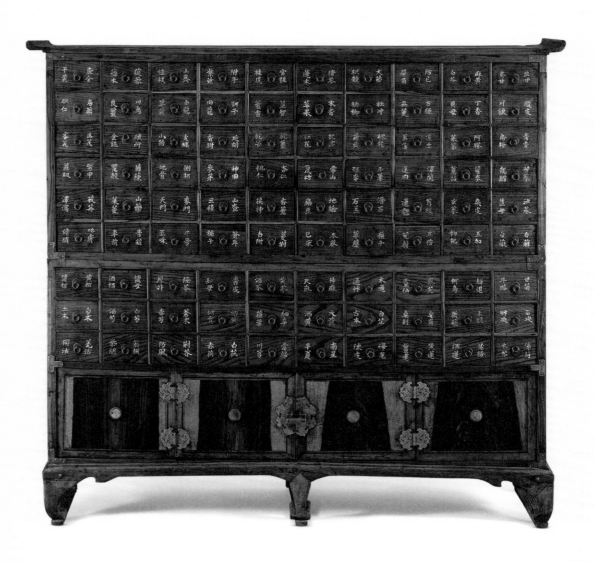

JEONG GIYEON
정기연
鄭璣淵
1877—1952
Seumnyeguk
습례국
習禮局
1919
Lacquered wood
8¾ × 14½ × 14⅜ in. (22 × 36.7 × 36.5 cm)
National Hangeul Museum, Seoul

The board game Seumnyeguk was designed by prominent Confucian scholar Jeong Giyeon in 1919. It consists of a rectangular box that functions as the playing surface or board, a six-sided die, and a set of forty-four wooden playing pieces. The box features a drawer set into its front, in which the die, the pieces, and an instruction manual are stored. The box is coated with red lacquer, while the playing pieces and die retain their natural

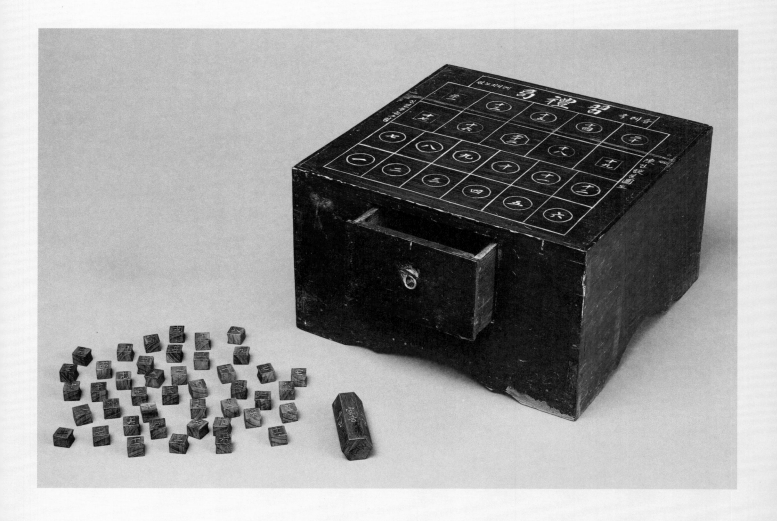

wood color. Rather than a Western, cube-shaped die, the die (*jeonja*) included with the Seumnyeguk game takes the shape of a hexagonal cylinder. Each of its surfaces is inscribed with numbers in both *hanja* and *hangeul*. The accompanying instruction manual consists of several folded pages detailing the purpose of the board game and instructions for playing.

The purpose of Seumnyeguk was to teach players the proper protocol for a Confucian practice known as *jinseol*, which entails setting a ritual table of food offerings to be used in ancestral rites. Seumnyeguk turns the process of setting the table for *jinseol* into a competitive endeavor. According to the instructions provided, two teams of players roll the die and place pieces on the board according to the numbers rolled. The pieces correspond to the twenty-two different foods to be placed on the table, each in a specific location prescribed by ritual. The first team to set all twenty-two pieces in the correct locations specified on the board wins. The board is divided into two grids carved into its surface. Each square of each grid contains a carved *hanja* number from one to twenty-two, indicating which type of food should be placed on the table, in which order. On either side of the grid, carved inscriptions in both *hanja* (right) and *hangeul* (left) state that the board displays the arrangement for the *jinseol* ritual. The game's name, inscribed in both *hanja* and *hangeul*, crowns the top of the grid.

Seumnyeguk recorded and codified the conventions of ritual table setting, laying out guidelines for customs that had been popularly practiced among the Korean Confucian upper classes for years, but had never been standardized. The game compiled and contextualized such principles within the auspices of the *jinseol* rite as a whole. For example, the game established the concept of *joyulisi*: the inclusion of four specific fruits—jujubes, chestnuts, pears, and persimmons—that represented the king, his highest government officials, governmental ministries, and the provinces of Joseon, respectively.[2] *Hongdongbaekseo*, another rule, mandated that red fruits be placed on the eastern side of the table

and white fruits be placed on the western side. These conventions are still followed in ancestral rites today, although they face opposition and nonparticipation by Protestant and Catholic Koreans alike.

The *jinseol* rites were performed as part of ancestor worship, usually upon the anniversary of the death of a family member. Worshipping one's ancestors was crucial to the Confucian social order in Korea, and correctly performing rituals displayed filial piety. Seumnyeguk demonstrates the degree to which Jeong Giyeon, its inventor, was dedicated to preserving Confucian traditions among younger generations of Koreans coming of age under the Japanese occupation.[3] Jeong designed the game in 1919, in the early years of Japanese colonial rule over Korea (1910—45) and the nation's modernization. At the time, his daughter had reached marriageable age, and the game was also intended to instruct her, as well as other girls and young women in his family, in the tradition of ancestral rites. Furthermore, Seumnyeguk contains both native Korean *hangeul* and *hanja* characters; the former were denigrated and discouraged under Japanese rule. Jeong also authored several books about Confucian traditions in Korea, particularly regarding lifestyle and ritual practices. It is evident that he sought to retain Korea's unique history of Confucian culture and customs in the face of not only rapid modernization and Westernization, but also the repression of Korean language and culture by the Japanese colonial government.

AM

1
"Seumnyeguk," National Hangeul Museum, accessed August 22, 2017, http://www.hangeul.go.kr/lang/en/museumCollection/museumCollectionView.do?pageIndex=1&collection_id=%ED%95%9C%EA%B8%B07445&lang=en&searchWordGubun=title&searchWordNm=&outResultCnt=8.
2
Kim Shi-dug, "Hangeul Usage and Ritual Culture through a Game Board, 'Seumnyeguk,'" *Korean Studies* 30 (August 2016): 257—91, http://www.dbpia.co.kr/Journal/ArticleDetail/NODE07016443.
3
Ibid.

50

Three Branding Irons
낙인

Joseon dynasty, 16th—early 18th c.
Iron
Length (left and center): 29⅛ in. (74 cm);
(right): 18⅝ in. (47.3 cm)
National Museum of Korea, Seoul

The practice of marking criminals with hot iron brands has a long history in both Asia and the West. The Romans, for example, used branding extensively to mark a wide variety of individuals deemed problematic, including slaves, gladiators, and Christians. Until the early eighteenth century, branding as a means of punishing and marking human criminals was common in Joseon dynasty Korea. However, King Yeongjo (r. 1724—76) outlawed most human branding in 1733, and in 1740 went a step further, outlawing the branding of criminals' faces.[1] It is conceivable, therefore, that the branding irons shown here date to an earlier period, prior to the promulgation of these regulations.

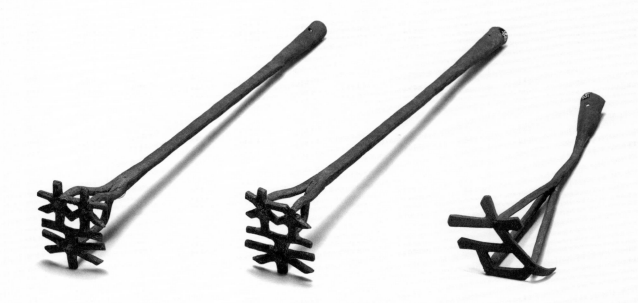

These three irons were used for branding criminals. Two of the irons are marked with the *hanja* character *geum* (forbidden), and the third is marked with the character *go* (punishment). In each case the highly legible standard-script forms of the characters are used. The use of words (in this case, *hanja* ideograms) on these branding irons is not unlike the practice over many centuries in Europe and America (now forbidden) of using letters that stood for words as the key symbols on branding irons: for example, the letter *A* for adultery, and the letter *B* for blasphemy.

SL

1
JaHyun Kim Haboush, *The Confucian Kingship in Korea: Yŏngjo and the Politics of Sagacity* (New York: Columbia University Press, 2001), 95—96.

Yangban Calligraphy

5
1

Brush Stand
철제 은상감필통

Joseon dynasty
Iron with silver inlay
7 × 3 in. (17.6 × 7.5 cm)
National Museum of Korea, Seoul

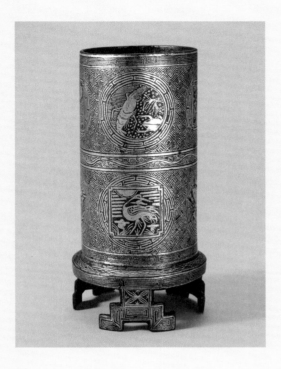

5
2

Incense Burner with Lotus and Four Trigrams Design and Inscription
「수복」 명 철제 연화문 사괘문 향로

Joseon dynasty
Iron with silver inlay
9¾ × 9 in. (24.8 × 22.7 cm)
National Museum of Korea, Seoul
Not in exhibition

These three cast iron objects for a Joseon scholar's desk feature decorative silver inlays with calligraphic details. The first, the brush stand, has a cylindrical shape supported by three legs. Brush stands were prominent ornamental receptacles, as most calligraphers stored their brushes in stands to protect the brush hairs from deformation.[1]

As calligraphy and literary culture developed during the Joseon dynasty with support from the royal court, there was also a notable development in the production of implements used in writing. Among such items, the brush stand was a popular object appreciated for its practicality and beloved as an aesthetic art object.[2] Brush stands could be made from bamboo, ceramic, pearl, oxhorn, stone, metal, or wood root, but most were made from wood and came in basic cylindrical shapes. The shape, decorative elements, and imagery of each brush stand reflected the taste and dignity of the scholar who owned it. This particular brush stand has a silver inlay, made using a technique that creates ornamental designs and patterns when ductile material is pressed into an incised, intagliated metal surface, taking advantage of the contrasting colors of the iron and silver metals. During the Joseon period, highly skilled craftsmen produced various kinds of silver-inlaid iron objects with diverse patterns.[3]

Incense burners were introduced after the transmission of Buddhism to Korea in the fourth century; they became popular objects with scholars and, later, with Joseon Confucianists. From the Three Kingdoms period to the Goryeo dynasty, Koreans mainly used incense burners for Buddhist rituals. During the Joseon dynasty, scholars started using such burners as vessels for Confucian rituals as well. The Joseon royal court used censers for ritual ceremonies, and after the nineteenth century, ding- (tripod-)shaped censers were installed in the main halls of the palaces, symbolizing royal authority.[4]

When looking at this incense burner from above, one sees a flower in the center, built into the knob. The censer's lid is decorated with four of the Eight Trigrams, known in Korea as Palgwae (Ch. Bagua),

53

Padlock with Inscription
[수부녕강」] 명은상감정

Joseon dynasty
Iron with silver inlay
3¼ × 5⅞ in. (8.2 × 15 cm)
National Museum of Korea, Seoul

traditional symbols representing the flux of yin and yang forces in the universe. These symbols, each composed of three straight lines that are either solid or broken in the center, have played a prominent role in various cultural contexts in Korea, including philosophy, religion, science, and Neo–Confucian cosmology.[5] The censer's sides are decorated with inlaid characters reading *su* (longevity) and *bok* (good fortune), as well as other auspicious symbols.

For the Joseon people, padlocks symbolized wishes for good fortune and were also considered symbols of security. As with many other utensils and tools used in the offices of Joseon scholars, practicality married to the spirit of dignity and grace prevailed in their design. Most padlocks used for such furniture as cupboards or cabinets were not very secure, suggesting that scholars enjoyed them mainly as symbolic and ornamental elements conveying blessings.[6]

The front surface of this padlock is inlaid with decorative, stylized *hanja* characters. The upper surface, on either side of the bolt, features stylized circular forms of the character *su* (longevity), while the bottom panel is inlaid with four seal–script characters reading, *gang neyong bu su* (Ch. *kang ning fu shou*; health, peace, good fortune, longevity). The same four–character phrase is inscribed on a tall blue–and–white Joseon dynasty jar elsewhere in this volume (cat. 57).

NM/SL

1
"Cheolje eunsanggampiltong" [Iron brush stand], National Museum of Korea, accessed July 2, 2018, http://www.museum.go.kr/site/main/relic /directorysearch/view?relicId=1205.

2
Lee Seon–jin, "Joseon hugi cheoljeibsa gongyepum yeongu" [Study of silver–inlaid iron crafts in the late Joseon period], *Dongak Misulsa* [Dongak art history journal] 17 (2015): 527—59.

3
Ibid.

4
Lee Jong–jin, "Samguk sidae hyangno yeongu" [A study on the incense burner of the Three Kingdoms period], *Hanguk Godesa Tamgu* [Korean ancient history research] 5 (2010): 159—216.

5
"'Subok' myung cheolje yeonhwamun sagwemun hyangno" [Incense burner with lotus and four trigrams design and inscription of 'subok'], National Museum of Korea, accessed July 2, 2018, https: //www.museum.go.kr/site/main/relic/search /view?relicId=7871.

6
Oh Seung Sik, *Jeontong jamulsoe jejak gibeop yeongu——Joseon sidae jungsim euro* [A study of traditional Korean locks of the Joseon period] (Seoul: Dongguk University Press, 2001).

Flat Bottle with Poem
청화백자시명편병

Joseon dynasty, 18th—19th c.
Blue–and–white porcelain
10 × 9⅞ ×2⅞ in. (25.3 × 25 × 7.4 cm)
Private collection

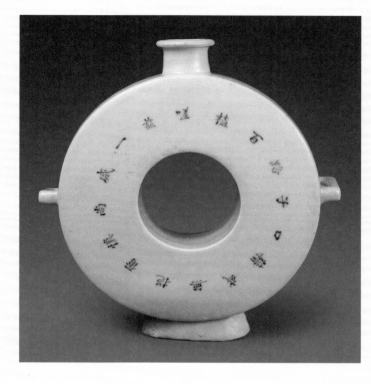

Bowl
백자청화수복명대접

Joseon dynasty, 19th c.
Blue–and–white porcelain
Height: 4⅝ in. (11.6 cm); diameter (mouth): 9⅜ in.
(23.8 cm)
National Museum of Korea, Seoul

During the Joseon dynasty, white porcelains with underglaze cobalt–blue decoration were reserved for use by royalty. While the majority of such porcelains depict auspicious symbols, including dragons, cranes, tortoises, and pines, many were decorated with calligraphy. In these four works, the calligraphy, always in *hanja* (Chinese characters), mainly comprises poems, popular sayings, and single or multiple characters conveying wishes for good fortune.

The ring–shaped bottle bears a poem composed by the Korean scholar–official Gim Changhyeop (1651—1708; sobriquet Nong–am) on the theme of wine.[1] The poem, inscribed in underglaze blue in small standard–script characters, is recorded in Gim's collected literary works.[2] It reads,

> Drinking [just] a measure [of wine]
> is difficult to manage,
> [Yet] with ladles and stones [both
> measures of wine], one ascends
> in harmony.
> When there's more than enough,
> moderation is fitting,
> How much more so is it the case when
> things are not as plentiful.
> One sighs at the sudden abundance,
> Yet be careful [when] you decant.
> There is no doubt when one makes
> a pretext—
> On a gentleman's path may there be
> a hundred bottles of wine.[3]

The inscriptions on the other three vessels are more typical of those usually found on blue–and–white porcelains, consisting of short felicitations for good fortune and longevity, with either simple or ornate decorative *hanja* characters. The bowl is made of white porcelain and is inscribed on the exterior with a series of short phrases that read,

> Many sons!
> Many good fortunes!
> Many longevities!
> Auspiciousness!
> May you get what you wish!
> Long life!
> Luck in all affairs!
> Flourishing spring!
> Wealth!

56

Quadrilateral Bottle
백자청화수복문사각병

Joseon dynasty, 19th c.
Blue–and–white porcelain
Height: 5¾ in. (14.6 cm)
National Museum of Korea, Seoul

57

Jar
백자청화수복자문호
白磁青華壽福字文壺

Joseon dynasty, 19th c.
Blue–and–white porcelain
Height: 19½ in. (49.5 cm)
National Museum of Korea, Seoul

At the center of the interior is a large *hanja* character, reading *su* (longevity), encircled by a double line. Similar designs are found on many other mid– and late Joseon blue–and–white porcelains.

The quadrilateral bottle is inscribed with repeated columns of characters. In total there are seventy *hanja* characters on the bottle, reading either "good fortune" (*bu*) or "longevity" (*su*). The characters are written in a uniform standard script. Finally, the tall, elegant jar with the curving profile is inscribed with four characters in bold semicursive script; these read, "Health, peace, good fortune, longevity." Each character is placed within a circle, also drawn in underglaze blue–cobalt pigment.

It is likely that all four vessels were made at the porcelain kilns established in the mid–fifteenth century near Gwangju in Gyeonggi Province for making wares for the royal family and members of the aristocracy.

SL

1
Published in *Samsung Misulgwan Leeum sojang gosohwa jebal haesoljip II* [Catalogue of the Leeum, Samsung Museum of Art, II] (Seoul: Leeum, Samsung Museum of Art, 2008), 195.
2
Nong–am jip [The collected works of Nong–am] (Seoul: Gim Yongham, 1928), 26. The poem appears in a section of the publication entitled "Inscriptions on Miscellaneous Vessels."
3
Translation by Stephen Little.

58

Tea Bowl Inscribed with a Poem in Hangeul
한글이 써진 찻사발

Japan, Edo period, 17th c.
Glazed earthenware
Height: 4⅜ (11 cm); diameter: 5⅛ in. (13 cm)
National Museum of Korea, Seoul
Not in exhibition

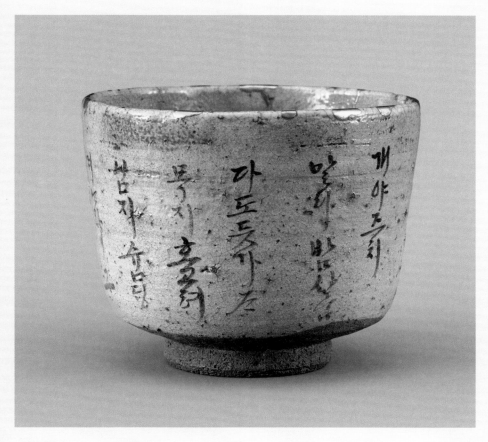

This tea bowl inscribed with a poem in *hangeul* was made in the early seventeenth century at the Hagi kilns in Yamaguchi Prefecture, located at the southern end of Honshu, Japan's main island. The Hagi kilns were established by two skilled potters, brothers Lee Jakgwang and Lee Gyeong, who were forcibly moved to Japan during the Imjin War (1592—98), when Korea was invaded by the warlord Toyotomi Hideyoshi (1537—1598). The Hagi kilns were first patronized by the Japanese daimyo (feudal lord) Mōri Terumoto (1553—1625).[1]

Made of coarse clay, the bowl has a rough surface and uneven beige glaze.[2] This is the only known Hagi ware tea bowl inscribed with a poem in Korean *hangeul* script. The poem was written on the bowl's outer surface in underglaze iron-oxide pigment with a brush. The presence of many gold-lacquer repairs indicates the bowl's long history in Japan as a prized tea-ceremony vessel.[3]

From the late fourteenth to the seventeenth century, many bowls created by potters in Korea were exported to Japan and used in tea ceremonies. The trade in Korean tea bowls began during the Goryeo dynasty and extended into the Joseon dynasty. Toward the end of Japan's Muromachi period, when Japanese monks, warriors, merchants, artisans, and courtiers began practicing the tea ceremony with increasing frequency, Korean ceramic bowls were among the most widely sought-after tea vessels. The famous tea master Sen no Rikyu (1522—1591) was one of many practitioners who developed a special fondness for Goryeo tea bowls.[4] In celebration of simplicity, he encouraged practitioners to escape from greed and vanity and instead to delve deeply into a quiet, subdued inner world.[5] Goryeo tea bowls were seen by many as the perfect expression of this ideal. Their neutral colors, straightforward shapes, rough treatment of the feet, and understated surfaces made Korean tea bowls congenial to hold and appreciate.[6]

Stemming from the increasing popularity of Korean ceramics among Japanese tea practitioners, many Korean potters were trafficked to Japan during the Imjin War. Forcibly transplanted Korean potters set

245

up the kilns at Hizen, Satsuma, Hagi, Chikuzen, and other domains, thereby exerting a lasting influence on the aesthetics of the Japanese tea culture.[7]

The poem inscribed on this bowl was written in the poetic form known as *sijo*, a traditional Korean three-line poem. This form emerged at the end of the fourteenth century; at the time it was sung and enjoyed only in the court and in great houses of the aristocracy. The popularity of *sijo* grew with the creation of the *hangeul* phonetic script in 1446, which allowed these poems to be accurately recorded. From the seventeenth century on, *sijo* poetry flourished among the common people.[8]

The elegant calligraphic style and skillful brushstrokes of the inscription indicate that the poem was executed by someone adept at writing *hangeul*.[9] The poem reads:

> Dear dog, stop barking.
> Do you think every person in the night
> is a thief?
> There is a *hogoryeo*[10] man in Jamokji.[11]
> We will visit his place.
> The *hogoryeo* has a dog, too.
> Ah, good, after hearing this, you've
> stopped barking.[12]

In the original *hangeul* poem, the word *hogoryeo*, the appellation for the Koreans who settled in Japan, was used instead of Goryeo-in (Goryeo person). This term arose as potters and other captive Koreans built their own communities in Japan.

Although there are different interpretations of the meanings of these lines, it is clear that the potter (or inscriber) sang of his daily experiences and emotions based on his identity as a Korean. Through the act of writing a *hangeul* poem on this tea bowl, the individual rendered deeply present his nostalgia for the country he had to leave, particularly because *hangeul* had only in the past two centuries become one of the most significant devices used by Koreans to express their native identities.[13]

EY/VM

[1]
For a general introduction to Hagi ware, see· Hayashiya Seizō, *Ceramic Art of the World 7: Edo Period II. Karatsu, Agano, Takatori, Satsuma and Hagi Ware* (Tokyo: Shōgakkan, 1998).

[2]
Noh Sunghwan, "Hangeul dawan gwa hagi ui Joseon poro" [A *hangeul* tea bowl and the Korean prisoners in Hagi], *Ilboneoneomunhwa* [Journal of Japanese language and culture] 17: 489—90.

[3]
On the Japanese gold-lacquer repair technique, see Christy Bartlett et al., *Flickwerk: The Aesthetics of Mended Japanese Ceramics*, exh. cat. (Münster: Hans Kock GmbH, 2008), and Steven Weintraub, Kanya Tsujimoto, and Sadae Y. Walters, "Urushi and Conservation: The Use of Japanese Lacquer in the Restoration of Japanese Art," *Ars Orientalis* 11 (1979): 54.

[4]
Kim Youngwon, "Goryeo Dawan ui giwon jeok yoji wa hyeongsik gochal" [A study of the original kilns and style of Goryeo Dawan], *Misuljaryo* [Research on art] 75 (Seoul: National Museum of Korea, 2006), 7.

[5]
Lee Mi-Suk, "Jungse ilbonui damunhwa wa idodawan e daehan sogo" [Tea culture in Middle Ages Japan and Chosun ceramics), *Gangwonsahak* [Journal of Gangwon history] 23 (2008): 133—34.

[6]
Jay A. Levenson, *Circa 1492: Art in the Age of Exploration*, exh. cat. (New Haven: Yale University Press, 1991), 427.

[7]
Morgan Pitelka, "Warriors in the Capital: Kobori Enshu and Kyoto Cultural Hybridity," in *Kyoto Visual Culture in the Early Edo and Meiji Periods: The Arts of Reinvention*, ed. Morgan Pitelka and Alice Y. Tseng (New York: Routledge, 2016), 28—29.

[8]
Richard Rutt, *The Bamboo Grove: An Introduction to Sijo* (Ann Arbor: University of Michigan Press, 1998), 2—6.

[9]
Paek Doohyeon, "Dojagie sseuin hangeul myeong-mun haedok" [A study of Korean alphabet written on porcelains], *Misuljaryo* [Research on art] 78 (Seoul: National Museum of Korea, 2009), 207—11.

[10]
Hogoryeo is a Japanese term referring to a native of Joseon Korea.

[11]
Jamokji is a place name.

[12]
Translation by Virginia Moon.

[13]
Paek, "Dojagie sseuin hangeul myeongmun haedok," 211—12.

5
9

Box with Symbols of Longevity and Calligraphic Inscription
나전 칠 함
Joseon dynasty, 18th c.
Lacquered wood with mother-of-pearl inlay,
with metal latch and hinges
9⅛ × 27⅛ × 14⅜ in. (23.3 × 68.9 × 36.4 cm)
National Museum of Korea, Seoul

Among the most refined artistic accomplishments of the Joseon dynasty were lacquers inlaid with mother-of-pearl. The box and chest shown here are representative of this art. Both objects are made of wood coated with multiple coats of black lacquer, into which designs have been carved and then filled in with carefully cut pieces of luminous mother-of-pearl (nacre, or the inner surface of abalone shells).

The box, which may have been used to store clothing, is decorated with a variety of auspicious symbols comprising both flora and fauna. From right to left, the front is decorated with two cranes, one under a pine tree among mushrooms and the other flying through the air; a male and female deer; and two turtles with flowing tails, on either side of a fantastic stone that rises from crashing waves. The plants and animals are all symbols of longevity (and, by extension, immortality), while the waves and stone are symbols of yin and yang, respectively—from a Daoist perspective, the invisible yet omnipresent forces from whose interaction all phenomena emerge. In the sky above, the sun and moon appear among stylized clouds. The two ends of the box are decorated with nearly identical images of bamboo, a blossoming plum tree, and two birds, one of which chases a large insect. The nacre used to create these designs is of the highest quality, revealing an astonishing degree of iridescence. The back is undecorated.

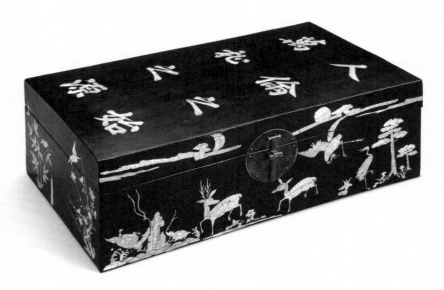

The top of the box is inlaid with eight *hanja* characters reading, "The beginning of human relationships is the origin of ten thousand transformations," suggesting the many phenomena in the world for which human relationships are a catalyst.

6
0

Chest with Myriad Su (Longevity) Characters
나전 칠 문갑
Joseon dynasty, 18th c.
Lacquered wood with mother-of-pearl inlay,
with metal latch and hinges
12⅞ × 41½ × 10 in. (32.7 × 105.5 × 25.4 cm)
National Museum of Korea, Seoul

This statement reflects a traditional Confucian ideology in which social stability is perceived as a direct result of the individual's responsibility to cultivate harmonious relationships in the course of his or her life. During the Han dynasty in China, five human relationships in particular were identified as critical to the main-tenance of social order. These were ruler and minister; father and son; husband and wife; elder and younger brothers; and friends.[1] By the Song dynasty, such Neo-Confucian philosophers as Zhu Xi (1130—1200), who was hugely influential in Korea, associated the five relationships with particular goals of human endeavor and protocol: ruler and minister with propriety; father and son with family cohesion; husband and wife with distinction of function; elder and younger brothers with orderly sequence; and friends with good faith.[2]

The sentiment expressed in these standard-script characters places human relationships and activities at the forefront of all other things, reflecting a Confucian worldview that focused primarily on the human realm at the expense of a cosmic perspective. This reflects the Joseon government's focus on conformity to Confucian values in the interest of promoting and maintaining social harmony. Nonetheless, it is significant that the symbols on the sides and the text on the top of the box combine to convey a multivalent message of Confucian propriety combined with the Daoist pursuit of longevity and immortality.

The decoration of the large and elaborate storage chest is executed in the same technique, with the black-lacquer surface carved and inlaid with mother-of-pearl. The chest may have been made as a wedding gift—perhaps as part of a dowry—or may have been a fitting birthday gift for an individual who had reached the age of sixty, seventy, or eighty. Here the majority of the images are variations on the *hanja* character *su* (Ch. *shou*; longevity). The front of the chest is decorated with four large panels, each containing fifteen variants of the *su* character. The forms of many of these are based closely on classical seal-script prototypes found

on bronze vessels and swords of the Warring States period and early Han dynasty in China, while others resemble elements of the natural world, such as fish, snakes, branches, leaves, clouds, and constellations. The origin of this specific type of calligraphic wordplay with the longevity character can be traced to the early Qing dynasty, during the Manchu occupation of China. Examples include large blue-and-white porcelain vases of the Kangxi reign (1662—1722), decorated with one hundred variations of the longevity character. It is significant that the front of the chest presents exactly sixty variations on the *su* character, as this is the precise number of years in the sexagenary cycle with which time is counted in East Asia. In Korea, as elsewhere, reaching the age of sixty was cause for great respect and celebration.

The ends of the chest are inlaid with two rectangular variants of the *su* character, surrounded by floating ribbons and symbols of scholarly achievement. The top depicts three even larger variants on the character with circular forms, the central of which resembles a complex maze. Interspersed among these characters are bats and double gourds, respectively symbols of good fortune and the joining of heaven and earth, among other auspicious symbols. The myriad and often playful variations of the *su* character on this chest present a sophisticated display of calligraphic invention.

SL

1
These relationships, the harmonious maintenance of which was seen as critical for overall social harmony, are outlined in two Bronze Age texts, the *Mengzi* (Mencius) and the *Zhong yong* (Doctrine of the mean); see Hsü Dau-lin, "The Myth of the 'Five Human Relations' of Confucius," *Monumenta Serica* 29 (1970): 27—37.
2
Ibid., 28, 33.

6

1

**A Box of Bamboo Strips Holding
Verses from the Confucian Classics**
서장통 죽간

Joseon dynasty
Wood
Case: 8¼ × 6⅛ in. (21 × 15.6 cm);
each strip: 7¼ × ¼ in. (18.2 × 0.5 cm)
National Palace Museum of Korea, Seoul

This stack of bamboo strips and their accompanying container were used as study aids by royal princes when learning the Confucian classics, on which both the princes' education and the Joseon dynasty civil service examinations were based. Among the Chinese texts on which the princes' studies were based were the

Classic of Filial Piety, the *Five Classics* (the *Shujing* [*Book of Documents*]; the *Shijing* [*Book of Poetry*]; the *Yijing* [*Book of Changes*]; the *Chunqiu* [*Spring and Autumn Annals*]; and the *Liji* [*Book of Rites*]), and the *Comprehensive Mirror for Aid in Government*. The Korean books included the *Bukjo Gogam* (Exemplary accomplishments of the monarchs, a text on the achievements of the Joseon dynasty kings), and Yi I's *Seonghak Jibyo* (Essentials of sagely learning, a compendium on Confucian ethics, self-cultivation, and statecraft).[1]

Phrases and topics from the classics were written in fine, elegant *hanja* characters on such bamboo strips, and a teacher would choose a strip at random and test the student on his knowledge of the subject.[2] Despite the invention of *hangeul* during this era, Confucian classics and learning continued to be taught using *hanja* characters. Such cases of bamboo strips were used in evaluation sessions that were regularly conducted in the palace. One such session is described as follows:

The session started with the crown prince's recitation of the Chinese character sounds learned from the previous class and his reading of the interpretation in the book. He would then repeat after the lecturer the new sounds and interpretations, followed by reading them on his own. Afterward, an honorary guest would randomly select a bamboo strip written with verses from the Chinese classics, which was read aloud. The crown prince then had to answer questions from his tutor on the selected verses.[3]

Often the cases were inscribed with characters that indicated which of the Confucian classics related to the enclosed set of bamboo strips.[4]

VM/SL

1
Ro Myonggu and Park Suhee, eds., *The King at the Palace: Joseon Royal Court Culture at the National Palace Museum of Korea* (Seoul: National Palace Museum of Korea, 2015), 48.
2
National Palace Museum of Korea: General Catalog (Seoul: National Palace Museum of Korea, 2011), 174.
3
Ro and Park, eds., *The King at the Palace*, 50.
4
Ibid.

Two-Panel Folding Screen of Characters for Longevity and Good Fortune

수복자 가리개

Joseon dynasty, 18th—19th c.
Mineral color on paper
Each panel: 79¾ × 22⅝ in. (202.5 × 57.5 cm)
National Palace Museum of Korea, Seoul

This two-panel screen is inscribed with various forms of ancient seal script.[1] The panel at the right presents forty variations on the *hanja* character *su* (longevity), while the panel at the left presents forty variations on the *hanja* character *fu* (good fortune). Many such screens, both painted and embroidered, were produced during the Joseon dynasty for royal and aristocratic households. A larger ten-panel screen in the collection of the National Palace Museum presents even more variations on the same two seal-script characters.[2]

Like similar inscriptions inlaid in mother-of-pearl on Joseon dynasty lacquer chests (cat. 60), the beautiful, architectonic characters on this screen derive from seal-script forms developed during China's Bronze Age, in the Zhou dynasty. Some of the characters copy forms seen in ancient "large seal" script, while others reproduce more ornate decorative scripts traditionally known as "bird script" and "tadpole script," which flourished during the Warring States period and the early Han dynasty; many of the forms of individual characters in these scripts are barely recognizable. As on Joseon lacquers that present similar variations, some of the characters seen here resemble such elements of the natural and mythical worlds as fish, dragons, leaves, and patterns of flowing water.

SL

1
Published in Yeon-su Kim, Chi-yeon Kim, Chong-suk Yi, and Yeong-uk Kim, *Court Paintings and Calligraphy*, exh. cat. (Seoul: National Palace Museum, 2012), 298—99, cat. 189.

2
Ibid., 308—9, cat. 195.

63

SIN YUNBOK
신윤복
申潤福
1758—after 1813

Hyewon's Painting Album
혜원화첩
蕙園畫帖

Joseon dynasty, 1808
Album of eight leaves; ink on paper
Each page: 10⅝ × 14⅞ in. (27 × 37.8 cm)
Private collection

Sin Yunbok came to painting via his family: both his father and grandfather were painters. Sin served as a painter (*hwawon*) in the Dohwaseo (Royal Painting Academy) at the court and is best known for his genre paintings of the Joseon-era *yangban* (scholar-official) class.[1] These paintings, now famous, were considered scandalous at the time for their occasionally erotic depictions of members of the *yangban* class "behind the scenes."[2]

Leaf 1

Sin was a contemporary of Gim Hongdo (1745—1806) and Gim Deuksin (1745—1822), both famous for their genre paintings (Gim Hongdo was also a court painter). Like these artists, Sin had a talent for depicting landscapes, flowers and birds, and women. Roughly a hundred works by Sin remain in existence today.[3]

Sin's sobriquet was Hyewon, meaning "gracious garden." This album, which was painted in the tenth lunar month of 1808, consists of eight leaves: two featuring calligraphy, and six with paintings.[4] The album, whose texts and images are informed by Chinese Daoist history and lore, begins and ends with leaves inscribed with short classical *hanja* poems in wild cursive script. With the possible exception of the second leaf, depicting bamboo in moonlight, all the painted leaves show places far from any urban environment: four present recluses in remote mountainous landscapes, and one depicts a Daoist immortal riding a crab over crashing waves. Unlike the unbridled displays of wild cursive script on the first and last leaves, the short inscriptions on the painted leaves are rendered in smaller and more restrained running-script characters. The inscriptions read:[5]

Leaf 1 (Calligraphy)
The "Prime Minister" of the mountains
	was Tao Hongjing;
Among *[wu]tong* trees, under Heaven,
	he alone was a genuine man,
[Unlike] Zhichuan, who from time to
	time would get drunk on the blue-
	green [colors of nature].

This text refers to Tao Hongjing (456—536), author of *Declarations of the Perfected*, who was a famous Chinese Daoist priest and alchemist, and Ge Hong (Zhichuan, 283—343?), an even earlier Daoist alchemist, from whose writings—including *Master Who Embraces Simplicity* and *Biographies of the Assorted Immortals*—much is known about medieval Chinese alchemy.[6] The phrase "genuine man" in reference to Tao Hongjing suggests his status as a perfected being (Ch. *zhenren*) of the Shangqing (Highest Clarity) school of Daoism. The inscription seems to elevate Tao, who enjoyed the patronage of the Liang emperor Wudi, over the earlier

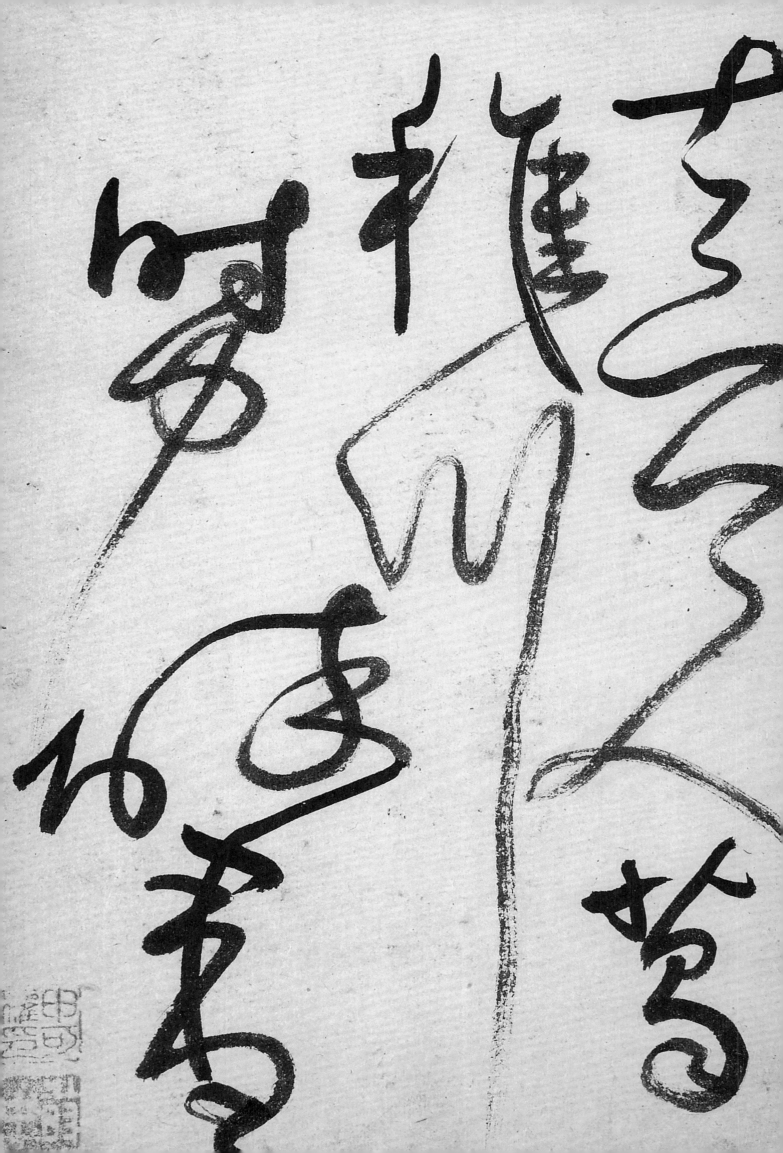

master Ge Hong. That Sin Yunbok's poem contrasts these two pivotal figures suggests a deep knowledge of Daoism on his part.

Leaf 2 (Painting: A Drunken Man Asleep on a Moonlight Night)
Sucking dry an entire vat, wine-drunk,
Lying down in the empty mountains,
Only the bright moon illuminates his
 hidden solitude.

This leaf may depict the Tang poet Li Bai, famous for drinking under the full moon. The sleeping figure, barely visible within his coat, is accompanied by several vats and jars of wine.

Leaf 3 (Painting: Bamboo in Moonlight, uninscribed)

Leaf 4 (Painting: Two Men Converse under an Overhanging Cliff While Looking at a Waterfall)
In meeting, one asks, "What of the
 world's affairs?"
[Here] there are [only] blue mountains
 and green mountains.

Leaf 5 (Painting: An Immortal Playing a Mouth Organ While Riding a Crab over Waves)
In antiquity there was the whale-riding
 immortal,
[Then] there was the crab-riding
 immortal.

The "crab-riding immortal" may refer to Lan Caihe, one of the Eight Immortals (K. palseon; Ch. baxian) of Daoism.[7]

Leaf 6 (Painting: A Solitary Man Sits with a Qin Zither under a Pine Tree in Moonlight)
The wind in the pines blows, loosening
 one's belt,
The mountain moon shines as one
 plucks a zither.

Leaf 7 (Painting: A Solitary Figure Crosses a Bridge in a Mountain Landscape)
Standing alone on a bridge over
 a stream,
In the autumn mountains to one side
 of the setting sun.

Leaf 8 (Calligraphy with a couplet from a poem by Zhao Gu, 806—853)
Composing poems for chanting among
 the mountains' colors,
There's a zither without strings in the
 brilliant light of the moon.[8]

Given the overlapping subject matter of the poems and paintings, which touch on the themes of reclusion and immortality, it is likely that all eight leaves were conceived and executed by Sin as a coherent whole.
 SL/VM

1
For other examples of Sin's genre paintings, see The Poetry of Ink: The Korean Literati Tradition, 1392—1910, exh. cat. (Paris: Musée Guimet, 2005), 216—19, cats. 123—2, 123—4; see also Burglind Jungmann, Pathways to Korean Culture: Paintings of the Joseon Dynasty, 1392—1910 (London: Reaktion Books, 2014), pls. 117—18.

2
On this subject see Jungmann, Pathways to Korean Culture, 258—59.

3
Gim Yeongwon, Hanguk yeokdae seohwaga sajeon (Dictionary of Korean Painters and Calligraphers through the Centuries) (Seoul: Gungrip munhwajae yeonguso, 2011), 1086—91.

4
Published in Samsung Misulgwan Leeum sojang gosohwa jebal haeseoljip II [Catalogue of the Leeum, Samsung Museum of Art, II] (Seoul: Leeum, Samsung Museum of Art, 2008), 134—37.

5
Inscriptions translated by Stephen Little.

6
On the role these figures played in the development of religious Daoism, see Shawn Eichman's entry on Tao Hongjing in Taoism and the Arts of China, ed. Stephen Little and Shawn Eichman, exh. cat. (Chicago: Art Institute of Chicago, 2000), 180—81, cat. 38, and Kristofer Schipper, "Taoism: The Story of the Way," in Little, Taoism, 43.

7
See Stephen Little, Ming Masterpieces from the Shanghai Museum, exh. cat. (Los Angeles: Los Angeles County Museum of Art, 2013), 31, fig. 8.16.

8
The "zither without strings" is a reference to the poet-recluse Tao Yuanming (365?—427).

JEONG YAKYONG
정약용
丁若鏞
1762—1836

Birds and Plum Tree
매조도

Joseon dynasty, 1813
Hanging scroll; ink and light color on silk
17⅝ × 7¼ in. (44.7 × 18.4 cm)
Korea University Museum, Seoul

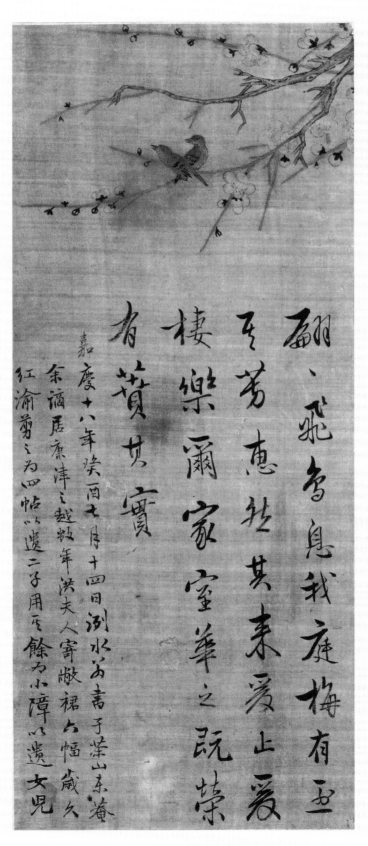

Birds and Plum Tree was painted and written by Jeong Yakyong, one of the most accomplished scholars of the Joseon dynasty. He painted branches of a plum tree and a pair of sparrows sitting closely together on one branch. Below this image, he wrote a poem. Jeong created this work in Gangjin, a small provincial town located two hundred miles south of Seoul. He was exiled there by his political opponents a year after the death of his powerful patron, King Jeongjo (r. 1776—1800), and lived there for eighteen years.[1] In 1810, nine years after Jeong was exiled, his wife sent him a red silk skirt, a dowry that she had brought to her husband on the occasion of their marriage. Using the skirt, Jeong made four albums that contained lessons for his two sons (see cat. 43) and painted *Birds and Plum Tree* for his daughter. At the left end of the work, as a sidenote, he wrote,

Yeolsu[2] writes this from Dongam[3] of Dasan[4] on the fourteenth of the seventh lunar month in 1813. It has been many years since I was exiled to Gangjin. My wife sent me an old skirt composed of six pieces of cloth. The red color of the skirt was quickly fading away, so I cut it into pieces and made it into four albums. I gave them to my two sons. With the remaining piece, I made a small screen and gave it to my daughter.[5]

Jeong was banished to Gangjin when his daughter was eight years old. At the time this work was created, he had been separated from her for more than a decade and had been unable to watch her grow up. Luckily, in 1812 she married Yun Changmo (1795—1856), one of Jeong's students in Gangjin. Jeong was also a close friend of Yun Changmo's father, Yun Seoyu (1764—1821), and was receiving a lot of help from Yun's family, rooted in Gangjin. Once married, Jeong's daughter moved to Gangjin and lived there for about a year. She had to move back to her hometown, however, with her husband in 1813. Jeong, lamenting how he had lost his daughter again after such a short reunion, created *Birds and Plum Tree* as a farewell gift to her.[6] The poem, about a pair of singing birds that flew into his

yard and alighted on a plum tree, reso-nates with his sorrow and his affection toward his daughter. It reads:

> Two birds, fluttering, rest on a plum tree
> in my garden.
> They flew in, mesmerized by its
> permeating fragrance, and
> Would stay and nestle here to please
> your family.
> Full-blown flowers should lead to
> an abundance of fruit.[7]

Each character of the poem, written in running script, is slightly slanted to the right and does not convey the feeling of rigidity and strictness associated with much of Joseon-period calligraphy. The simple and unassuming writing style, however, is coherent with the accompa-nying painting, which is equally simple, understated, and born of a personal story. Each line of the poem comprises four *hanja* characters. The poem follows the poetic form of *gusi* (literally, "old poetry"), which originated in Han dynasty China.[8] *Gusi* usually range from eight to twenty lines, and every two lines (a couplet) form a complete sentence or thought. Couplets often employ simple parallel patterns that suggest a formulaic style of composition suitable for a popular song. In *gusi*, certain themes tend to recur, like lament-ing over separation from friends or lovers. Using a bird as a metaphor for his daughter, Jeong subtly reveals his longing for his distant family and his hope for a reunion. The last two lines can also be read as a prayer for the happiness of his daughter's family.[9]

The painting not only complements the poem visually but also adds meaning to it. The sparrows, representing Jeong's daughter and her husband, are crossing their bodies, but their eyes are looking in the same direction. The plum blossom has long been loved and used by Korean scholars as a symbol of sincerity.[10] The image shows Jeong's unaffected feelings by capturing a scene of a peaceful spring day. This work is notable in that it reveals the emotional and personal side of Jeong, who was mostly known to the Korean public as a great scholar who pursued extreme rationality and practicality in his academic achievements.[11]

EY/SL

[1]
Kim Yong Heum, "Dasan ui gukga gusang gwa jeongjo tangpyeong chaek" [Jeong Yakyong's national initiative and King Jeongjo's policy of impartiality], *Dasan gwa hyeondae* [Journal of Dasan and the contemporary times] 4 (2012): 397—98.

[2]
Yeolsu, one of many pen names of Jeong Yakyong, was also a nickname for the Han River, which flows through Seoul. Jeong Yakyong's hometown, Majae (now Namyangju), has a great view of the Han River.

[3]
Dongam can be literally translated as "South Hermitage." It is a small building in which Jeong Yakyong stayed and studied during most of his exile.

[4]
Dasan was the name of the mountain on which Dongam was located.

[5]
Hong Donghyeon, "Dasan Jeong Yakyong ui gangjin yubae saenghwal gwa Hapicheop" [Dasan Jeong Yakyong's life of exile in Gangjin and *Hapicheop*], *Dasan gwa hyeondae* [Journal of Dasan and the contemporary times] 9 (2016): 293.

[6]
Ibid.

[7]
Hongkyung Kim, trans., *The Analects of Dasan, Volume 1: A Korean Syncretic Reading* (New York: Oxford University Press, 2016), frontispiece.

[8]
Wiebke Denecke et al., *The Oxford Handbook of Classical Chinese Literature (1000 BCE—900 CE)* (New York: Oxford University Press, 2017), 243.

[9]
Jeong Min, "Dasan ui bujeong i damgin maejodo du pok" [Two paintings of birds and a plum tree that show Dasan's affection for his daughter], in *Hangukhak geurimg wa mannada: Jeolmeun immunhakja 27 in ui jonghoeng mujin munhwa ilkgi* [Korean studies meets painting] (Gyeonggido: Daehaksa, 2011), 122.

[10]
Plum blossoms are one of the most beloved subjects in traditional Korean poetry and paintings. See I Sanghui, *Kkocheuro boneun hanguk munhwa* [Korean culture seen through flowers], vol. 3 (Gyeonggido: Nexus Press Ltd., 2004), 24—27.

[11]
I Gwangpyo, *Sonan ui bakmulgwan* [Museum in hand] (Gyeonggido: Hyohyung Publishing Company, 2006), 226.

6 5

GIM YUGEUN
김유근
金道根
1785—1840

Album of Inkstone Paintings
황산연산도
黃山研山圖

Joseon dynasty, early 19th c.
Album of eight leaves; ink on paper
Each page: 11⅞ × 8¾ in. (30.2 × 22.2 cm)
National Museum of Korea, Seoul

Gim Yugeun, also known by his sobriquet Hwangsan (Yellow Mountain), was a painter and calligrapher of the late Joseon dynasty. His *Album of Inkstone Paintings* embodies a theme much loved by literati artists throughout East Asia, namely strange stones (K. *goeseok*; Ch. *guai shi*). These included both famous stones and inkstones (or "inkstone mountains"). The culture of admiring and collecting

strangely shaped stones goes back to antiquity in Korea, as it does in China, and there is extensive literature on the subject in both countries. These stones, found in the earth, were valued on several levels. While they could convey social status merely through their strange beauty, stones were also seen as reflections of the basic structures underlying reality as under-stood by ancient philosophers, and many stones were perceived to be made of the purest energies left over from the creation

of the world. As the twelfth-century Chinese writer Kong Chuan wrote, "The purest essence of the energy of the heaven–earth world coalesces into rock."[1] Some stones were believed to be able to speak and to heal. Stones also symbolized the human virtues of strength and endurance.

In his famous set of six *sijo* poems, *Song of Five Friends* (*Ouga*), the Joseon dynasty poet Yun Seondo (1587–1671) celebrated stones as one of five best "friends." The sequence reads, in part,

> You ask how many friends I have? Water
> and stone, bamboo and pine.
> The moon rising over the eastern hill is
> a joyful comrade.
> Besides these fine companions,
> what other pleasure should I ask?
>
> I'm told clouds are nice, that is,
> their color; but often they grow dark.
> I'm told winds are pleasing, that is,
> their sound, but they fade to silence;
> So I say only water is faithful and
> neverending.
>
> Why do flowers fade and die so soon
> after that glorious bloom?
> Why does green grass curl to yellow
> after sending its spears so high?
> Could it be that only stone stands strong
> against the elements?[2]

More recently, Syngman Rhee (1875–1965; cat. 107), the first president of South Korea, wrote of stones,

> A strange stone is not just another
> pretty stone . . .
> One must gather one's courage
> to engage strange stones![3]

Gim Yugeun's eight-leaf album depicting stones includes several examples of the artist's calligraphy in both standard and semicursive script.[4] To judge from the leaves' different sizes, it appears they may have been put together from different sources. The accompanying inscriptions reveal the depth of Joseon scholar-officials' knowledge of stone history and lore. In the first leaf, shown here, Gim depicts the famous inkstone mountain owned by the eleventh-century Chinese artist and connoisseur Mi Fu (K. Mi Bul;

1051–1107). Although Mi Fu's original inkstone mountain had long ago disappeared, it was illustrated in Chinese woodblock-printed books as early as the fourteenth century. The poem inscribed above the stone's jagged peaks is written in robust, flowing semicursive script and speaks to Gim's rendition of Mi Fu's stone:

> In the Studio Where the Jin [Dynasty] Is
> Treasured is a little inkstone mountain,
> For a thousand years its fame has spread
> through the human realm.
> By lamplight, a sketch has emerged
> of its natural appearance,
> I should feel no shame before
> Master Mi.

This text references Mi Fu's studio, named for the Jin dynasty, during which the great calligraphers Wang Xizhi (307–365) and his son Wang Xianzhi (344–386) flourished.

The album's final leaf depicts a stone that belonged, significantly, to Gim Yugeun's contemporary Gim Jeonghui (see cats. 80–95), who clearly had a similar appreciation for such stones. The final leaf bears a colophon in cursive script by the scholar Bae Yochang, dated 1836, in which he writes admiringly of Gim Yugeun's paintings and specifically mentions Gim's "addiction to stones."

SL

1
From Kong Chuan's preface to Du Wan's *Stone Catalogue of Cloudy Forest*, translated in John Hay, *Kernels of Energy, Bones of Earth: The Rock in Chinese Art*, exh. cat. (New York: China Institute in America, 1985), 38.

2
Translated by Larry Gross, in "Korean Sijo by Yun Sondo," Sijo Masters in Translation, accessed March 20, 2018, http://www.webring.org/l /rd?ring=sijowebring;id=3;url=http%3A%2F %2Fthewordshop%2Etripod%2Ecom%2Fyunsondo %2Ehtml.

3
Slightly amended from Don and Chung Ae Kruger, "Native South Korean Stones (Seen from the West)," Viewing Stone Association of North America, accessed March 20, 2018, http://www.vsana.org /a-native-korean-stones-(seen-from-the-west) .html.

4
Published in Ung-chon Choe, *A Great Synthesis of Art and Scholarship: Painting and Calligraphy of Kim Jeong Hui*, exh. cat. (Seoul: National Museum of Korea, 2006), 57.

JO HUIRYONG
조희룡
趙熙龍
1789—1866
Orchid
난초
Joseon dynasty, 19th c.
Album leaf; ink on paper
8⅞ × 10⅝ in. (22.5 × 27 cm)
National Museum of Korea, Seoul
Not in exhibition

Jo Huiryong was a member of the *jungin* (literally, "middle people") class of professionals and civil servants during the Joseon dynasty. For most of his life he occupied a position in the military bureaucracy.[1] In painting and calligraphy, he was considered a disciple of Gim Jeonghui (1786—1856).[2] As a calligrapher Jo closely followed Gim Jeonghui's Chusa style, although Jo's calligraphy was

generally considered more graceful than Gim's. Jo was an accomplished writer, poet, and painter, as well as a collector and connoisseur of Chinese Qing dynasty paintings.

Jo's *Orchid* combines painting with calligraphy, a mode widely practiced by literati painters throughout East Asia. The album leaf depicts a common East Asian subject in a classical manner, with the tips of the leaves and the orchid alternating between broad and thin brushstrokes. Similarly, in his calligraphy Jo reflects Gim Jeonghui's influence but alters the spacing between his characters, demonstrating an elegant sensibility distinct from that of his teacher.[3]

This painting is accompanied by two inscriptions by the artist; both include quotations from the writings of the eighteenth-century Chinese painter and calligrapher Zheng Xie (Zheng Banqiao; 1693—1765), who specialized in painting orchids and bamboo.[4] The first inscription, at the upper left, which would normally be read from right to left, is written backward, from left to right.[5] The text begins with a quotation from the writings of Zheng Xie, followed by Jo Huiryong's own note:[6]

> The monk Shitao [1642—1707] resided in Yangzhou for over ten years. I [Zheng Xie] have seen many of his orchid scrolls, which manifest the utmost subtlety. [Nonetheless] I studied half and rejected [the other] half. I have not been able to study them all. It is not that I did not wish to study them all, but that truly one cannot be complete [in studying them all], and furthermore there is no need to be complete [in this study]. I [Zheng] wrote a poem that read,
>
>> Of ten things studied, seven are important and three are to be rejected,
>> Each has that which is worthy, that which is naturally to be chosen.
>> In the presence of Shitao, [there are] still those [works] that are unstudied,
>> How can one continue for a thousand miles to study "south of the clouds?"[7]
>
> In a heavy rain at the Studio of Small Fragrant Snows, I [Jo Huiryong] was testing precious ink from the Library of

Thirty Blossoming Plum Trees and reading Zheng Banqiao's [Zheng Xie's] words. Cheolsu doin [Jo Huiryong] sends this as a gift to [the owner of the] Friend of Stones Studio (Useok jae), requesting his advice.[8]

The inscription at the lower right quotes another poem by Zheng Xie, originally written on one of his own paintings depicting orchids and thorns:

> If one does not allow for thorns, one cannot achieve orchids,
> Like demons beyond the Dao, they [thorns] are viewed with a cold eye.
> The "path through the gate" includes fragrance among the weeds,
> It is the beginning of understanding the great vastness of the Buddhist dharma.

It is significant in light of Jo's quotations that Zheng Xie's paintings were much admired (and copied) in Korea during the late Joseon dynasty.

VM/SL

1
Burglind Jungmann, *Pathways to Korean Culture: Paintings of the Joseon Dynasty, 1392—1910* (London: Reaktion Books, 2014), 187, 195—97.
2
Ibid., 195.
3
Kang Jin-ho, "Ubong Jo Huiryong yesul segye mukranhwa yeongu" [A study of Jo Hee Ryong's Mook Ran Hwa and his world of art] (master's thesis, Hongik University, 2008), 35—47.
4
For a painting of orchids by Zheng Xie, see Howard Rogers and Sherman E. Lee, *Masterworks of Ming and Qing Painting from the Forbidden City,* exh. cat. (Lansdale, PA: International Arts Council, 1989), 196—97, cat. 66.
5
In this Jo Huiryong may have been inspired by the similarly structured inscription at the upper left of Gim Jeonghui's *Orchid* (cat. 83). Poems and other inscriptions written from left to right (contrary to the right-to-left practice typical in East Asia) were most often found on images connected with the Seon (Ch. Chan; J. Zen) school of Buddhism.
6
For Zheng Xie's original text, see Liu Zhongjian and Lin Cunyang, eds., *Zheng Banqiao* (Taipei: Zhishu-fang chubanshe, 2003), 152. We are grateful to Wan Kong for this reference.
7
Referring to China's southernmost province, Yunnan (South of the Clouds).
8
Both inscriptions by Jo Huiryong translated by Stephen Little.

6
7

HEO RYEON
허련
許鍊
1808—1893

Painting of Oddly Shaped Stone
괴석

Joseon dynasty, 19th c.
Ink on paper
8⅞ × 12¾ in. (22.5 × 32.5 cm)
National Museum of Korea, Seoul

Heo Ryeon's *Painting of Oddly Shaped Stone* sheds light on the symbolic representation of literati virtues. In a practice derived from the Chinese appreciation for oddly shaped stones, which were perceived both as microcosms of the universe and symbols of strength, scholar-officials during the Joseon dynasty enjoyed

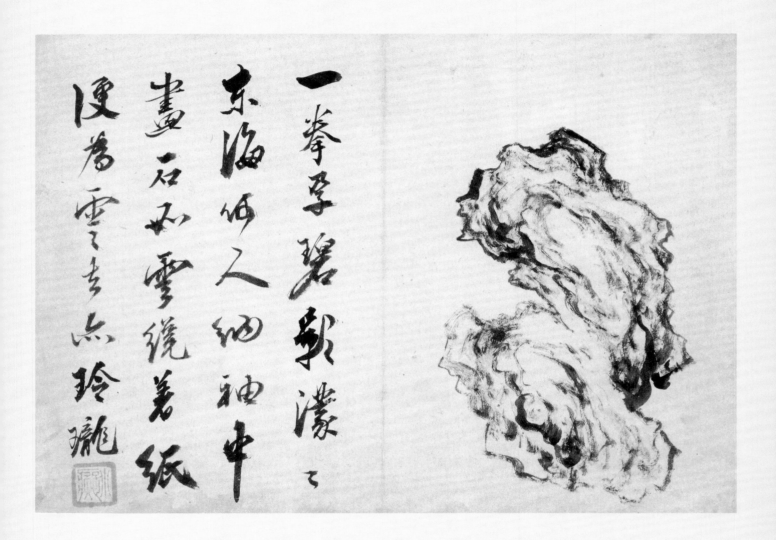

painting such objects for their own beauty and as a part of the backgrounds of "four gentlemen" (*sagunja*) paintings (referring to depictions of plums, orchids, chrysanthemums, and bamboo). Thanks to such artists as Heo, who developed the subject matter of stones into an independent genre, the motif of oddly shaped stones gained popularity during the late nineteenth century. For scholar-officials facing the vicissitudes of bureaucratic life in the

Joseon dynasty, stones served further as symbols of such Confucian values as fidelity and endurance.

Heo Ryeon was a poet, calligrapher, and painter of the late Joseon dynasty who was also well known by his pen name, Sochi. He was born into a noble family, eventually becoming a court painter for the Joseon royal family. The fact that he came from outside of the capital has contributed to readings of his paintings as embedded with a sense of regional alienation and displacement.[1] As a young man he came under the tutelage of a Korean Seon (J. Zen) Buddhist master, Choui Seonsa, under whose guidance he trained in painting and calligraphy. Later, at the age of thirty-two, Heo went to the capital to study with Gim Jeonghui (1786—1856; see cats. 80—90); this served as an opportunity for him to become acquainted with the styles of famous Chinese masters with which Gim was already familiar from his earlier visit to China in 1810.

Gim Jeonghui's influence is clearly apparent in the flowing and powerful style of calligraphy seen in the poem inscribed on *Painting of Oddly Shaped Stone*. Gim highly praised Heo's skills, which were also appreciated by King Heonjong (r. 1834—49), who elevated Heo's social status so that he could access the palace and its collections.[2] After Gim's death, Heo returned to Jindo, located in the southwestern part of Korea, where he founded a hermitage, Ullimsanbang, and practiced self-cultivation until the end of his life.

Heo was well known as a prolific artist who created numerous paintings; he also composed many documents, including his autobiography. This painting, however, appears to be unique within his body of work. The style of cursive brushwork that defines the stone's surface reflects Heo's in-depth knowledge of calligraphy and its contribution to his practice. Influenced by the Chinese "Southern School" literati style, Heo avoided precise, delicate portrayals and relied instead on strong brushwork executed with dry ink and muted colors. Here, he renders the stone in a way that highlights its rough surface texture; expressive lines convey the stone's form and volume. Heo's painterly and calligraphic style was not only aligned with the lineage of the Southern School tradition but also influenced by the advent of Korean true-view landscape painting, associated with increasing national consciousness and the import of Western ideas of topographical images. During the late Joseon period a handful of literati painters started depicting actual places in Korea, turning away from conventional depictions of imaginary utopias in landscape paintings based on Chinese traditions.[3]

Heo's style was carried on after his death by his son, Heo Hyeong, his grandsons Heo Geon and Heo Baekryeon, and other disciples, forming a key lineage within the mainstream traditional painting community in the southwestern region of Korea.[4] As a link between premodern and modern art, as well as between center and periphery, the life and art of Heo Ryeon shed light on the continuity of tradition through diffusion and transformation in a transitional period of Korean history. As part of the interwoven trajectories of Chinese traditional painting, Korean interpretations, and regional specificity, the stone and calligraphy in Heo's *Painting of Oddly Shaped Stone* serve as microcosms of threads that constituted one strand of artistic dialogue in the late Joseon period.

The artist's poem, inscribed in semicursive running script (*haengseo*), reads,

> Like a fist, pregnant with blue-green
> [colors], [it] reflects the misty rain,
> Who, East of the Sea, could take it
> in their sleeve?
> Painting a stone that resembles a cloud,
> it coils as it manifests on paper,
> Easily do clouds emerge from its
> openwork [form].[5]

Significantly, the bold, fluid lines of the artist's calligraphic inscription mirror the spontaneous and gestural brushwork that describes the stone's shifting forms.

JHP/SL

1
Kim Jiyeon et al., *Hanguk yeokdae seohwaga sajeon* (*Dictionary of Korean Painters and Calligraphers through the Centuries*) (Daejeon: National Research Institute of Cultural Heritage, 2011), 2418.

2
Ibid.

3
For details on the sociopolitical context of true-view landscape paintings in Korea in relation to Chinese traditional landscape paintings, see Burglind Jungmann, *Pathways to Korean Culture: Paintings of the Joseon Dynasty, 1392—1910* (London: Reaktion Books, 2014); and Yi Song-mi, *Searching for Modernity: Western Influence and True-View Landscape in Korean Painting of the Late Choson Period* (Seattle: University of Washington Press, 2014).

4
Robert Koehler, ed., *Traditional Painting: Window on the Korean Mind* (Seoul: Seoul Selection, 2010), n.p.

5
Translation by Stephen Little.

6 8

MIN YEONGIK
민영익
1860—1914
Orchid
묵란

Joseon dynasty, late 19th c.
Ink on paper
48⅞ × 24⅛ in. (124.2 × 61.3 cm)
Kansong Art Museum, Seoul

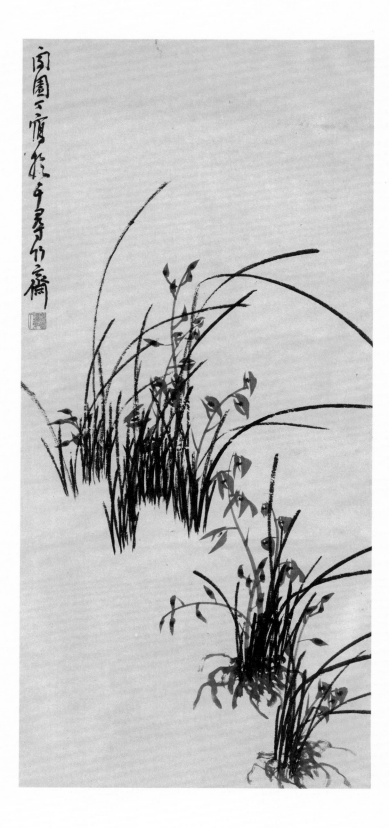

Min Yeongik was taught the art of calligraphy by his father and uncle, both of whom were students of the famed calligrapher Gim Jeonghui (1786—1856; see cats. 80—90). In 1882 Min traveled to China and interacted with calligraphers there, inviting them to his house so they could write together. From 1895 on he lived in China. After his death his style spread to Japan.[1]

With the similarities in brushstrokes between painting and calligraphy, what mostly remain are Min's orchids, bamboo, rocks, and calligraphy. In calligraphy, *haengseo* (semicursive), *yeseo* (clerical or seal), and *haengcho ganchal* were the styles he typically employed.

Min was best known for his depictions of orchids. He drew orchids in bunches, described as *chongnangdo,* with blunt strokes and tight arrangements, as if they were floating in space. Critics often say that this work exemplifies Min's character and personality. Viewers felt that the orchids, which seem to float in space with no background, were a metaphor for a country without a base. As such, this painting is read as a commentary on the regret of losing the country's sovereignty during the Japanese Colonial period.[2]

VM

1
Gim Yeongwon, *Hanguk yeokdae seohwaga sajeon (Dictionary of Korean Painters and Calligraphers through the Centuries)* (Seoul: National Research Institute of Cultural Heritage, 2011), 679—83.
2
Kansong misul munhwa jaedan (Kansong Art and Culture Foundation), *Kansong Munhwa* [Kansong culture] (Seoul: Kansong Art and Culture Foundation, 2015), 117.

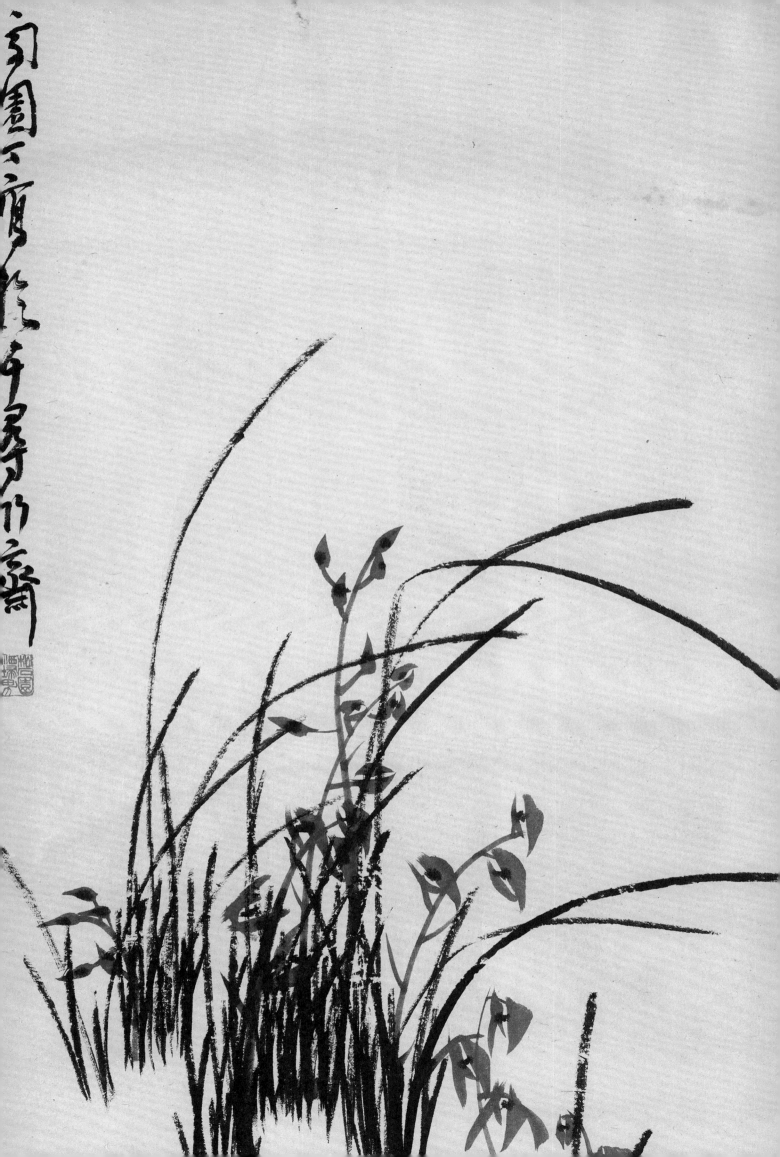

THE ADVENT OF HANGEUL

Korean *hangeul* script was created at the court of the Joseon dynasty's king Sejong in the early fifteenth century. After centuries of using borrowed Chinese ideographic characters (*hanja*) for written communication, the Koreans had, for the first time, a remarkable script with which to write all words with a far smaller group of phonetic symbols than the thousands of written ideographic characters needed to read and write classical Chinese. *Hangeul* was designed to encourage literacy among the common people, and it gradually proliferated among women and the middle and lower social classes. In the seventeenth and eighteenth centuries, the use of *hangeul* also spread to the upper classes, increasing in popularity as it came to symbolize a unique Korean intellectual and ethnic heritage, distinct from those of China and Japan. Today *hangeul* is the most widely used script in Korea.

This section includes a facsimile copy of an extremely rare and beautiful woodblock-printed book, the *Hunminjeongeum* (*The Proper Sounds for the Instruction of the People*), published in 1446, which articulates the proper ways of creating the sounds rendered by the new phonetic *hangeul* symbols. Among the

many new books that *hangeul* made possible and that, remark-ably, deal with language systems outside of Korea, are *Jineonjip* (*Compendium of Mantras;* 1569) and the *Cheophaesineo* (1676), the latter being a guide to both written and spoken communi-cations with Japanese diplomats, using *hangeul* to transliterate Japanese *hiragana* phonetic script. *Hangeul* also made possible rare printed translations of classical Chinese books into Korean; these include the *Eojeong Muye tongji eonhae* (*Comprehensive Manual of Military Arts Explained*) and *Dangjin Yeoneui* (*Tales of Prince Qin of Tang*), an abridged Korean *hangeul* translation of a Chinese late Ming novel, *Tang Qin yanyi,* which tells the story of Prince Li Shimin, who would become the Tang emperor Taizong.

**Hunminjeongeum (*The Proper
Sounds for the Instruction
of the People*)**
훈민정음

Joseon dynasty, 1446
Woodblock–printed book (facsimile); ink on paper
9¼ × 6½ in. (3.3 × 16.6 cm)
Kansong Museum, Seoul, National Treasure no. 70

*Hunminjeongeum (The Proper Sounds for
the Instruction of the People)*, first
published in 1446, was the first book to
compile, codify, and explain *hangeul*, the
native Korean script system.[1] *Hangeul*
was conceived by King Sejong (r. 1418—
50) and his court as a better approach to
transcribing the Korean language than the

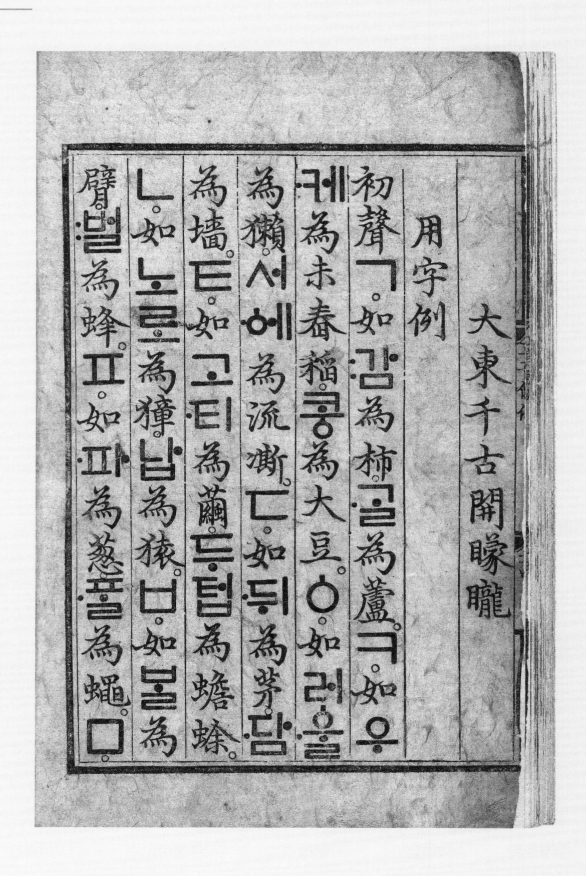

predominantly used Chinese characters known as *hanja*. Prior to the invention and dissemination of *hangeul*, Korean written texts used *hanja*, which only male scholars and aristocrats were allowed to learn. Literacy was, therefore, gated by gender and social status. Part of the motivation behind the publication of *Hunminjeongeum* came from King Sejong's intention to increase popular literacy. There were other practical reasons for the development of a Korean script: Chinese characters could not account for Korean particularities, such as proper names, native customs, and regional vernacular, and in many cases could not convey full nuances of meaning.[2] This inadequacy became apparent not only when transcribing native Korean content, but also when translating Chinese texts into Korean: the resulting text would still be rendered in *hanja*, resulting in clumsy or indirect translations at best.[3] Thus, *hangeul* was developed to provide a medium and vehicle for Korean legal, artistic, and judicial content, as enumerated in *Hunminjeongeum*.

Hunminjeongeum is a woodblock-printed book. *Hangeul* characters are displayed, along with explanations and commentary in *hanja*. The text is read from right to left in vertical columns. The side-by-side juxtapositions of *hangeul* and *hanja* make the differences between the two scripts apparent, particularly *hangeul*'s simplicity of form in comparison to Chinese *hanja*. One can also observe, however, that not all Chinese influences were left behind. For example, individual *hangeul* characters retain the square format of Chinese script. Moreover, *hangeul* has been compared to seal script, one of the earliest Chinese calligraphic forms.[4] As a text, *Hunminjeongeum* is also significant for its unprecedented inclusion of punctuation marks and spaces.[5]

Despite King Sejong's ambitions, *hangeul* did not become the official or national script of Korea until centuries after its invention. The aristocratic and scholar-official classes feared the potential for revolt and disorder as a result of the lower classes attaining literacy, and thus discouraged the dissemination and usage of *hangeul*.[6] It was adopted primarily by women and seen as a script used by marginalized members of society,

whereas aristocrats and literati continued to use *hanja*. The development of *hangeul* did, however, allow women and members of other peripheral groups who were not allowed to read or write in *hanja* a means of written communication, resulting in a rise in literacy. By the twentieth century, with the advent of Japanese colonialism and other impetuses to assert and preserve a Korean national culture, *hangeul* became a symbol of Korean cultural identity.[7] Today, *Hunminjeongeum* remains a crucial record of Korean linguistic and cultural history.

Owing to the extreme rarity of the original, the version of *Hunminjeongeum* displayed in this exhibition is a facsimile produced and loaned by the Kansong Art and Culture Foundation in Seoul, which owns the only two extant versions of the original book.[8] The original has been designated a national treasure by the Korean government and is considered a precious relic of Korean heritage. Its material significance as a cultural and historical artifact cannot be overestimated.

AM

[1]
Kim Sang-tae, ed., *History of Hangeul* (Seoul: National Hangeul Museum, 2015), 10.

[2]
Gari Ledyard, "The International Linguistic Background of *The Correct Sounds for the Instruction of the People*," in *The Korean Alphabet: Its History and Structure*, ed. Young-Key Kim-Renaud (Honolulu: University of Hawaii Press, 1997), 34.

[3]
Ibid., 33.

[4]
Sang-Oak Lee, "Graphical Ingenuity in the Korean Writing System: With New Reference to Calligraphy," in Kim-Renaud, *The Korean Alphabet*, 115.

[5]
Kim, *History of Hangeul*, 11.

[6]
Ki-Moon Lee, "The Inventor of the Korean Alphabet," in Kim-Renaud, *The Korean Alphabet*, 26.

[7]
Kim, *History of Hangeul*, 70.

[8]
The original woodblock-printed book on which this facsimile is based is published in Kansong Misulgwan [Kansong Art and Culture Foundation], *Kansong Munhwa: Kansong misul munhwa jedan seollib ginyeom jeon* [The treasures of Kansong, commemorating the founding of the Kansong Art and Culture Foundation], exh. cat. (Seoul: Kansong Art and Culture Foundation, 2014), 242—43, cat. 95.

PRINCE SUYANG
수양대군
1417—1468

Seokbosangjeol (Detailed and Abridged Compendium of Collected [Texts] on the Buddha's Life)
석보상절
釋譜詳節

Joseon dynasty, 1447
Book printed with movable metal type; ink on paper
Vol. 24, each page: 12⅛ × 8⅛ (30.7 × 20.8 cm)
Dongguk University Library, Seoul,
Treasure no. 523–2

Seokbosangjeol is a collection of stories that teach about the Buddha's life and his main sermons. It is abstracted from the Chinese sutras, including the *Lotus Sutra*, the *Ksitigarbha Sutra*, the *Amitabha Sutra*, and the *Bhaishajyaguru (Medicine Buddha) Sutra*.[1] The book was compiled and translated by Prince Suyang, who published the book in 1447 after the death of his mother, Queen Soheon, to commemorate her life and to ease her passage to the next life. As the stories were written in *hangeul*, they were available to the general population of

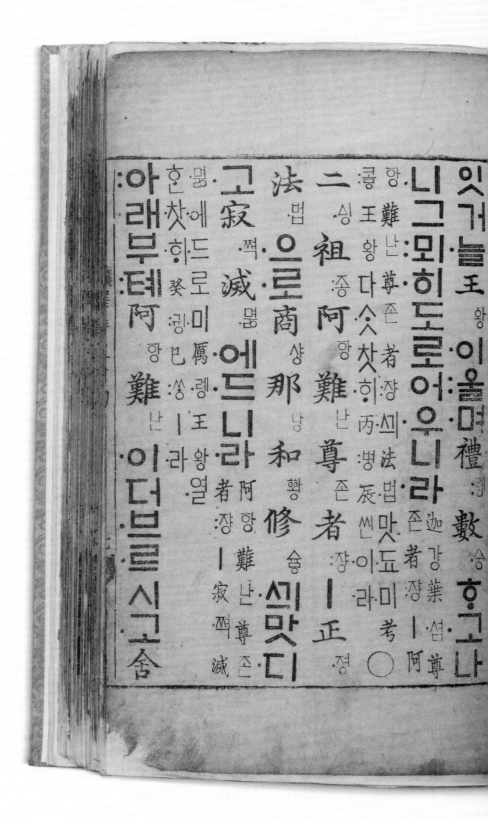

Korea and encouraged the propagation of the Buddhist faith.

In 1455, following a violent coup d'état, Prince Suyang declared himself King Sejo (r. 1455—68), seventh king of the Joseon dynasty. Despite his unorthodox ascent to the throne, King Sejo proved to be one of the ablest rulers in Korean history. He established a written administrative system that weakened the power of the official and aristocratic class (yangban).[2] He also implemented new legislation that brought administration directly under the king's control and restored the presence of non-Confucian beliefs and traditions, such as Buddhism and Daoism. Buddhism, in particular, had been greatly suppressed by the yangban class, which had established Confucianism as Joseon's official state ideology.[3] In this context, the creation of the Seokbosangjeol can be considered a political effort on the part of King Sejo to allow the Korean population wider access to written culture and to promote Buddhism in order to counterbalance the power of the yangban class in his regime.

The Seokbosangjeol was the first translation of Buddhist sutras from hanja (Chinese characters) into hangeul script in Korea. Sejo's father, King Sejong, created hangeul, formerly known as Hunminjeongeum, which allowed the lower classes unprecedented access to written culture and education in general. The Seokbosangjeol was also one of the earliest printed texts to use movable hangeul metal type. China was the first of the East Asian countries to implement woodblock printing on paper during the Tang dynasty, and the technique quickly spread to other East Asian countries. While woodblock printing on paper was practiced in China before the eighth century, printing with movable metal type was invented in Korea during the thirteenth century. For a long time, printing on paper was reserved for royal court documents until it became more commercialized and available to the general population. Seokbosangjeol was not only one of the earliest books printed with metal type, but because it was in hangeul, it could be distributed throughout various social classes of the Joseon dynasty.

NM/VM

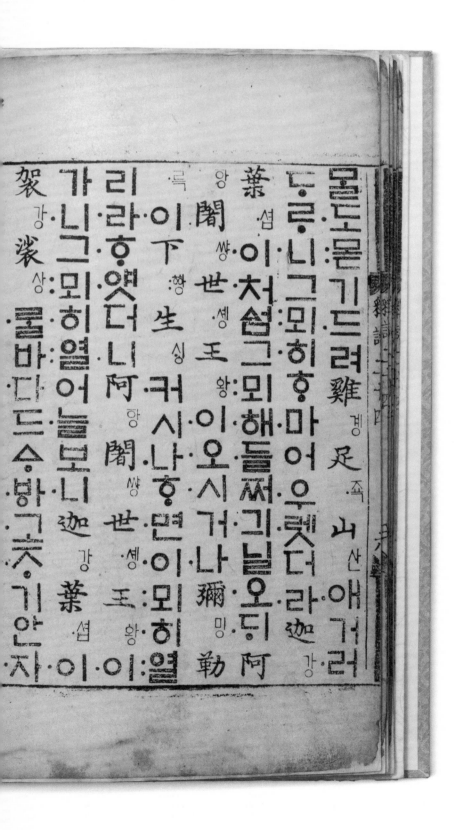

1
"Life History and Sermon of Buddha Abstracted from Buddhist Scriptures," World Digital Library, Library of Congress, updated May 24, 2017, https://www.wdl.org/en/item/4163/.
2
Peter H. Lee and William Theodore De Bary, eds., Sources of Korean Tradition (New York: Columbia University Press, 1997), 261—70.
3
Kansong Misulgwan [Kansong Art and Culture Foundation], Kansong Munhwa: Kansong misul munhwa jaedan seollib ginyeom jeon [The treasures of Kansong: Commemorating the founding of the Kansong Art and Culture Foundation], exh. cat. (Seoul: Kansong Art and Culture Foundation, 2014), 288.

71

Jineonjip (Compendium of Mantras)
진언집
眞言集

Joseon dynasty, 1569
Woodblock-printed book; ink on paper
11 × 7¼ in. (28 × 18.5 cm)
National Hangeul Museum, Seoul

Jineonjip is a woodblock-printed book that transcribes Buddhist mantras and dharanis written in East Asia in Sanskrit-derived Siddham (K. *sildam*) characters into their respective *hangeul* and *hanja* forms. Mantras are seed syllables embodying the sacred energies of Buddhist deities, while dharanis are longer passages of sacred syllables that function as spells.[1] The title, *Jineonjip,* is a combination of the words *jineon* (mantra) and *jip* (collection or compendium). This book comprises multiple mantras used in Esoteric Buddhist rituals. The purpose of *Jineonjip* was to transcribe the original Sanskrit mantras and dharanis as accurately as possible using the phonetic *hangeul* script, so that people could imitate the sounds if they could not read the *sildam* script. In addition, at the beginning of the

compilation is a note that explains the ways of transcribing the Korean spoken language into *hangeul,* extracted from the *Hunmongjahoe* (Collection of characters for training the unenlightened; 1527), and a chart of *sildam* characters.[2] Five different editions of *Jineonjip* containing *hangeul* transcriptions are known to have been published. The volume presented here is the first edition, published in 1569 by the Ansim Temple in the Daedun Mountains south of Daejeon.[3]

Buddhism was imported to the Korean Peninsula during the Three Kingdoms period and flourished through the Goryeo dynasty. At the beginning of the Joseon dynasty (1392—1897), however, the influence of Buddhism began to dwindle rapidly, as Confucianism was declared the state philosophy. The Joseon dynasty abolished many national Buddhist ceremonies, which greatly diminished the prestige of Buddhism. The government, however, could not completely purge Buddhism. On a personal level, Confucian scholars and royal family members continued to practice Buddhism and maintained close relationships with Buddhist monks.[4] In the mid- to late Joseon period, continued government control over Buddhism resulted in the relative prosperity of the Esoteric school of Buddhism, a tendency reflected in the publication of many Buddhist scriptures.[5] Most of those published were *gyeong* (sutras), *yul* (Vinaya), *non* (*Abhidharma*), and their commentaries.[6] During the reign of King Sejo (r. 1455—68), an interim government organization for the publication of Buddhist scriptures, Gangyeongdogam, was established and existed for a decade (1461—71). From the sixteenth century onward, the official publication of the Buddhist scriptures was discontinued, yet the publication of collections of mantras that were essential for conducting Esoteric Buddhist rituals increased.[7] After their steep rise in the sixteenth century, the number of publications held steady until the eighteenth century. Most of these contained *hangeul* transcriptions and were often published by monks of local temples with money donated by the laity.[8]

The reason mantras had *hangeul* transcriptions, and not translations, lies in the fact that they were sacred sounds that were untranslatable, rather than a language per se. In the Three Kingdoms, Unified Silla, and Goryeo periods, mantras and dharanis were imported into Korea via China and interspersed among many Buddhist scriptures. At the time, the sound of mantras in Korea was based on the pronunciation of *hanja* (Chinese characters) rather than their original pronunciation. The effort to transcribe the original Sanskrit sound of mantras more precisely began in the early Joseon dynasty after the creation of *hangeul.*[9]

Hangeul transcriptions of mantras first appeared in the biography of the Buddha, the *Worinseokbo,* published in 1459 using both *hanja* and *hangeul,* with the *hangeul* syllables written below the *hanja,* which still played a subsidiary role. The *Worinseokbo* followed the phonetic notation described in the *Donggukjeongun* (Korean canonical rhyme dictionary for Chinese) of 1448, the first publication that explained how to transcribe the sounds of the Korean language into *hangeul.* This was largely different from the sound of the Korean language used in real-life conversations. Therefore, there were wide discrepancies between the authentic sounds and *hangeul* transcriptions of mantras in the *Worinseokbo.*[10] *Jineonjip,* published in 1569, addressed this issue by applying the rules of transcription found in the *Hunmongjahoe,* where the actual sound could be more accurately transcribed.[11] It also emphasized the importance of *hangeul* over *hanja,* indicating that the primary purpose of the publication was to render mantras in *hangeul* as they were recited at the time in Buddhist temples.[12]

EY

1
On the use of Siddham characters in Esoteric Buddhist practice, see Robert Hans van Gulik, *Siddham: An Essay on the History of Sanskrit Studies in China and Japan* (New Delhi: International Academy of Indian Culture, 1956).

2
The *Hunmongjahoe* is a *hanja* study book written by Choe Sejin, an interpreter and a renowned scholar of the Chinese classics.

3
According to its postscript, the first edition of *Jineonjip* was a republication of an older book, *Sikbujip*: "There was a set of woodblocks known as *Sikbujip* that had the same contents, but it was impossible to print books from them because the carvings were severely damaged, so the Ascetic Hyejeung and Inju had Monk Seoreun edit and republish it."

4
Nam Heesook, "Joseon sidae daranigyeong jineonjipui ganhaeng gwa geu yeoksajeok uiui" [The publication of dharanis and *Jineonjip* in Joseon and its historical significance], *Hoedanghakbo* [The journal of Hoedang studies] 5: 68.

5
Woo Jinwoong, "Joseonsidae milgyogyeongjeonui ganhaenge daehan yeongu" [A study on the publication of Esoteric Buddhist sutras in the Joseon dynasty], *Seojihagyeongu* [Bibliography research] 49: 240.

6
Respectively, the sermons of the Buddha, the rules of monastic life, and philosophical discourses and interpretations of Buddhist teachings.

7
Nam, "Joseonsidae daranigyeong jineonjibui ganhaenggwa geu yeoksajeok uiui," 68—69.

8
Nam Heesook, "Joseonhugi bulseoganhaeng yeongu: Jineonjipgwa bulgyo uisikjibeul jungsimeuro" [A study on the publication of Buddhist texts in the late Joseon dynasty: *Chinon–chip* (Collection of mantras) and Buddhist ritual proceedings] (PhD diss., Seoul National University, 2004), 32—36.

9
An Juho, "Ansimsabon jineonjipgwa mangwolsabon jineonjibui bigyo yeongu" [A comparative study on the *Jineonjip* published by Ansim Temple and the *Jineonjip* published by Mangwol Temple], *Baedalmal* [Korean language] 31: 176.

10
Ibid., 179.

11
Ibid., 183.

12
In the *Jineonjip* published by the Mangwol Temple in 1800, Sanskrit came first, followed by *hanja* and *hangeul,* with corrections that were made to the *hangeul* transcription.

GANG USEONG
강우성
康遇聖
1581—?

Volume 2 of the Cheophaesineo
첩해신어
捷解新語

Joseon dynasty, 1676
Woodblock-printed book; ink on paper
Closed: 12¾ × 8¾ × ¾ in. (32.3 × 22 × 1.8 cm)
National Hangeul Museum, Seoul

The *Cheophaesineo* is a set of ten woodblock-printed books compiled by Gang Useong, a mid-Joseon dynasty interpreter. An explanatory note in the *Revised Cheophaesineo* (1748) indicates that the *Cheophaesineo* was originally composed in manuscript form in 1618, but the woodblock-printed set includes historical content related to Korean delegations dispatched to Japan between 1624 and 1636. Therefore, it is likely that only a portion of the book was written in 1618, and the complete version created after 1636. While the manuscript could have been completed in 1636, this set of volumes was published by the Gyoseo-gwan, a government publishing agency, in 1767, so the book went through several printings.[1] Revised editions of the book were published in 1748 and 1762. The

title *Cheophaesineo* means "learning a new language quickly"; "new language" refers to Japanese, the diplomatic use of which increased after the Japanese invasions of Korea (1592—98), known as the Imjin War.[2]

Volumes 1 through 4 of the *Cheophaesineo* comprise transcribed dialogues between Korean officials and Japanese envoys from Tsushima Island, located between the Korean Peninsula and Japan; these took place in an official residence for the Japanese who entered Joseon for diplomatic business or trade. Volumes 5 through 8 include transcriptions of conversations between Japanese officials and Korean diplomatic representatives regarding a trip of Korean envoys from Busan, a key harbor city located at the southeast end of the Korean Peninsula, to Tsushima Island, and from there to Edo (now Tokyo), the capital of Japan. Volumes 9 and 10 are supplements. Volume 9 contains conversations in which a Joseon interpreter and an envoy of Tsushima Island set the date for a banquet and an explanation of the eight provinces and sixty-six prefectures of Japan. Volume 10 transcribes conversations regarding official annual trade between Korea and Tsushima Island and an agreement concerning diplomatic trading procedures. Samples of diplomatic documents and correspondence are also included in volume 10. At the end of volumes 1 and 10 are glossaries of complicated phrases that appear in the transcribed conversations. None of the ten volumes includes an introduction or epilogue. The Japanese texts appear in a larger text size (approximately three-quarters of an inch each) and are rendered using the *hiragana* phonetic alphabet, while the *hangeul* pronunciations appear to the right, in a smaller size. *Hangeul* translations appear at the end of each phrase and are written in a smaller size.

From 1609 onward Gang Useong, the author of the *Cheophaesineo*, worked as an official Japanese interpreter and translator at the Sayeogwon, a government bureau in charge of translating foreign documents and books and interpreting conversations between government officials. Before the late sixteenth-century Japanese invasions, there was active trade between Joseon Korea and Japan. Korea dispatched delegations to the Muromachi-period Ashikaga shogunate of Japan sixty-two times over a period of two hundred years, including eight Tongsinsa delegations. The Tongsinsa (exchange based on trust) delegations were special delegations that had to meet five important conditions: Tongsinsa delegation members were to be sent from the Joseon king to the shogun of Japan; the purpose of the delegations was to solve important and urgent problems between the two states; the shogun had to agree on their necessity; higher-level envoys holding significant bureaucratic positions had to be included; and the delegates had to bring credentials and gifts for the shogun.[3]

Officials of the Sayeogwon played an important part in these delegations. Until the beginning of the Imjin War in 1592, however, they used imported children's books to study foreign languages. When Japan invaded Joseon in 1592, all diplomatic relations were ruptured, and in 1593 King Seonjo (r. 1567—1608) prohibited the use and teaching of Japanese in Korea, largely reducing the role of the Sayeogwon. The ban was lifted three years after the evacuation of the Japanese army because the Joseon state needed experts to interrogate Japanese prisoners, interact with the Japanese government to prevent further conflict, and resume trade.[4] As a result, the function of the Sayeogwon somewhat normalized, and the Joseon government found it efficient to hire people who had learned Japanese when they were taken to Japan as prisoners. Gang, who had lived in Japan for ten years as a prisoner, was one of these.[5]

Gang subsequently visited Japan three times as an interpreter of the Tongsinsa, which resumed full function in the early seventeenth century.[6] From that time onward, language study books with pronunciations and translations written in *hangeul* began to be published in Korea.[7] Fluent in Japanese and with years of experience as an interpreter with the Tongsinsa bureau, Gang wrote the *Cheophaesineo,* the Japanese language study book that replaced the use of imported children's books. The book also became essential study material for test takers of the official civil service examinations from 1768 until the Sayeogwon translation bureau was abolished in the late Joseon dynasty.[8] The *Cheophaesineo* was not only a textbook that helped officials learn essential Japanese phrases effectively, but also a useful guide for learning the protocols required of Korean delegations to Japan, for it transcribed dialogues that closely coincided with actual experiences of Tongsinsa officials as recorded in diplomatic records.[9] The book has continued to prove useful for historians and linguistic researchers today, because it provides contemporaneous material on the relative uses of Korean *hangeul* and Japanese *hiragana* in the seventeenth and eighteenth centuries.

EY

1
Chung Seunghye, "Teukjip: Joseon hugi eoneo, munja yeongu wa jisik gyoryu: Joseon hugi Jo Il yangguk ui eoneo hakseup gwa munja e daehan insik" [Recognition of language study and characters of both Korean and Japanese in the late Joseon dynasty], *Hanguk silhak yeongu* [Journal of Korea *Silhak*] 29 (2015): 87.
2
Ibid., 85.
3
"Tongsinsa," Hanguk Minjok Munhwa Daebaekgwasajeon [Encyclopedia of Korean culture], accessed July 26, 2017, http://terms.naver.com/entry.nhn?docId=795653&cid=46622&categoryId=46622.
4
Chung, "Teukjip," 84—85.
5
Lee Sang-Kyu, "17 segi jeonban waehagyeokgwan Kang Woo-Sung ui hwaldong" [Early seventeenth-century translator of Japanese language Woo-Sung Kang's activities], *Hanil gwangyesa yeongu* [Korea-Japan historical review] 24 (2006): 109.
6
Ibid., 120.
7
Chung, "Teukjip," 84.
8
Ibid., 88.
9
Ibid., 92.

73

Eojeong Muye dobo tongji eonhae (Comprehensive Manual of Military Arts Explained)

어정무예도보통지언해

御定武藝圖譜通志諺解

Joseon dynasty, 1790
Woodblock-printed book; ink on paper
Each page: 12½ × 7⅞ in. (31.8 × 20 cm)
Jangseogak Archives, Academy of Korean Studies, Seongnam

With the advent of the *hangeul* phonetic writing system, the royal Joseon court promulgated the publication of many translations of books formerly written and published in Korea in classical Chinese. One of the most popular of these was the *Eojeong Muye dobo tongji eonhae* (Comprehensive manual of military arts explained).[1] This book is a single-volume abridged translation into *hangeul* of the *Muye dobo tongji* (Comprehensive illustrated manual of military arts), a twenty-four-chapter book compiled in Korea in classical Chinese and published in four volumes, functioning as an illustrated guide to the martial arts.[2] The creation of the *Muye dobo tongji* was ordered by King Jeongjo (r. 1776—1800; see cat. 34) and compiled by General Yi

Dokmu in 1790.[3] The *Muye dobo tongji* was an assemblage of several original Chinese Ming dynasty books on the martial arts, including the late sixteenth-century text *Jixiao xinshu* (New treatise on military efficiency) by General Qi Jiguang; the *Wubei Zhi* (Treatise on armament technology), compiled by Mao Yuanyi (1621); and the *Shaolin Gunfa banzong* (Orthodox explanations of Shaolin [Temple] staff techniques), compiled by Chen Zongyu (1616).[4]

The Korean *Muye dobo tongji* comprises chapters that include discussions of the use of several varieties of weapons, including spears, swords, polearms, and staves. In addition, there are chapters on boxing, horsemanship, and military

strategy and battle formations. Significantly, the original book written in classical Chinese contains many woodblock illustrations demonstrating proper technique under each of the subject headings. The Korean translation into *hangeul*, which omits the illustrations, became widely used throughout the nation.

The text of the *Eojeong Muye dobo tongji eonhae* was beautifully printed with carved wooden blocks. Significantly, it includes both Chinese *hanja* characters and their *hangeul* equivalents. The *hanja* characters are printed in standard script, and the *hangeul* words are clearly legible and elegantly written.

SL

1

Published in *Elegance and Beauty, Korean Script as Reflected in Choson Royal Books* (Seoul: Hanguk Jeongsin Munhwa Yeonguweon Jangseogak, 2004), 84—85, no. 37. My thanks to Christina Gina Lee for her help in researching this entry.

2

For an English translation, see Sang H. Kim, *Muye Dobo Tongji: The Complete Illustrated Manual of Martial Arts* (Santa Fe, NM: Turtle Press, 2010).

3

For a brief description, see "*Muye Dobo tongji: The Comprehensive Korean Martial Arts Manual,*" Chinese Longsword, accessed May 18, 2019, https://www.chineselongsword.com/korean.

4

Ibid.

74

Dangjin Yeonui (Tales of Prince Qin of Tang)

당진연의

唐秦演義

Joseon dynasty, 18th c.
Woodblock-printed book; ink on paper
Each page: 11½ × 8¼ in. (29 × 21 cm)
Jangseogak Archives, Academy of Korean Studies, Seongnam

During the Joseon dynasty, a wide range of both Chinese and Korean novels written in classical Chinese were translated into Korean and printed using phonetic *hangeul* script. This practice reflects the enlightened literary policies of the Joseon court, as well as the deep-seated Korean admiration for classical Chinese fiction. The role of the royal court in promoting such translations is well documented. The works translated into Korean during this period include such Chinese novels as *Hongru mong* (Ch. *Honglou meng; Dream of the Red Chamber*) and *Hu Suhojeon* (Ch. *Hou Shuihu zhuan; The Later Story of Water Margin*) and such Korean novels written in classical Chinese as *Seonjin Ilsa* (Extraordinary tales of realized immortals) and *Ongnu mong* (Dream of the jade chamber).[1]

Dangjin Yeoneui is an abridged Korean *hangeul* translation of *Tang Qin yanyi* (Tales of Prince Qin of Tang).[2] This Chinese novel was written in the late Ming dynasty (early seventeenth century) by Zhu Shenglin and originally bore the title *Da Tang Qinwang cihua* (Poem tale of the great Tang prince of Qin).[3] It tells the story of Li Shimin, fourth son of the first Tang emperor, Gaozu (r. 618–26). Li Shimin, prince of Qin, succeeded his father and ruled as Tang Taizong (r. 626–49); as emperor in the early seventh century, he played a key role in the consolidation of Tang political and military control over China.

Tang Taizong was recognized for his enlightened rule. He is especially remembered in the annals of East Asian calligraphy for his admiration for the "calligraphic sage" Wang Xizhi (307–365) and his elevation of Wang as the greatest calligrapher in Chinese history. Taizong was a fanatical collector of Wang Xizhi's works, obtaining (through trickery), and then having buried in his tomb, the original manuscript of Wang Xizhi's renowned *Lanting xu* (K. *Nanjeong seo; Orchid Pavilion Preface*); today, this work is known solely through surviving tracings made at Taizong's court in the early seventh century.[4] Through early copies this masterpiece of Chinese calligraphy gained celebrity and admiration in Korea, starting in the early Unified Silla dynasty.

While the original Chinese text of *Tang Qin yanyi* comprised thirteen chapters, the Korean translation was condensed into six chapters.[5] The text, which appeared entirely in *hangeul*, was printed with beautifully carved wooden blocks. The phonetic characters are arranged in carefully aligned vertical columns and reveal elegant variations in the width of the calligraphic lines, such that they appear to have been written with a brush even though they are printed. The opening page bears the seal of the royal Joseon library, reading *Jangseogak in* (Seal of the Pavilion of Treasured Books).

SL

[1]
See *Uri hangeul ui meot gwa areumdaum: Jangseogak teukbyeoljeon* [Elegance and beauty: Korean script as reflected in Joseon royal books] (Seoul: Hanguk Jeongsin Munhwa Yeonguwon Jangseogak, 2004), 200—201, no. 94; 202—3, no. 95; 154—55, no. 71; and 182—83, no. 85, respectively. For a translation of a Joseon-period novel that exists in both classical Chinese and *hangeul* versions (*A Tale of Two Sisters, Changhwa and Hongnyeon*), see Michael J. Pettid, Gregory N. Evon, and Chan E. Park, eds., *Premodern Korean Literary Prose: An Anthology* (New York: Columbia University Press, 2018), 100—123. For an extended study of Joseon-period Korean translations of Chinese novels, see Yan Kuandong, "Zai Hanguo de Zhongguo gudian xiaoshuo fanyi qingkuang yanjiu" [Research on the translation of Chinese classical fiction in Korea], accessed May 18, 2018, http://www.literature.org.cn/Article.aspx?id=61153.

[2]
Published in *Elegance and Beauty*, 204—5, no. 96. My thanks to Christina Gina Lee for her help in researching this entry.

[3]
Robert E. Hegel, "Rewriting the Tang: Humor, Heroics, and Imaginative Reading," in *Snakes' Legs: Sequels, Continuations, Rewritings, and Chinese Fiction*, ed. Martin W. Huang (Honolulu: University of Hawai'i Press, 2004), 161.

[4]
See Han Chuang [John Hay], "Hsiao I Gets the Lan-t'ing Manuscript by a Confidence Trick," *National Palace Museum Bulletin* 5, no. 3 (July—August 1970): 1—13; and ibid., vol. 5, no. 6 (January—February 1971): 1—17.

[5]
Elegance and Beauty, 204.

Page from a Movable-Type Book

조선활자견본첩에 인쇄된 한글자와
실제 활자

Joseon dynasty
Ink on paper
Variable sizes
National Museum of Korea, Seoul
Not in exhibition

The printing of books in Korea started as early as the Silla period, with the development of woodblock-printing techniques, and continued throughout the Goryeo and Joseon dynasties (see the woodblock for printing *Episodes from the Life of the Shakyamuni Buddha,* dated 1637; cat. 21). Printing with woodblocks was a strong and effective tradition, particularly as it related to the promulgation of Buddhism, and the carving of wooden printing blocks allowed for multiple impressions of a single book. In order to enable printing several different books, however, a more modifiable and flexible option was needed. Birch wood was considered the best material for this kind of production; as a result, birch trees were occasionally in short supply.[1]

During the Goryeo dynasty, metal printing types were manufactured for the first time in human history. These were much easier to produce because they were cast rather than carved. The metal-type concept was derived from Goryeo coin casting, a technique introduced in Song dynasty China. The movable type produced in the thirteenth century was made with such metals as copper, iron, tin, lead, and zinc.[2]

The earliest book known to have been made using metal movable type was the *Nammyeong cheon hwasang song jeungdoga* (Eulogies of meditation by monk Nam Ming Chuan), written by Choi Wu in 1239, during the Goryeo dynasty. The oldest-surviving work, also from the Goryeo dynasty, is the *Jikji simche yojeol* (Selected sermons of Buddhist sages and Seon masters), produced in 1377; one copy survives in the collection of the National Library of France.[3]

Metal-type printing continued in the Joseon dynasty, with further advances in variable type, as seen in the groups of metal examples shown here. The characters, whether *hanja* or *hangeul,* display

**Representative Hanja
Movable Type**
국립중앙박물관 소장 대표 금속활자
Joseon dynasty, 1772–1858
Metal
Each piece: ½ × ⅝ in. (1.3 × 1.5 cm)
National Museum of Korea, Seoul

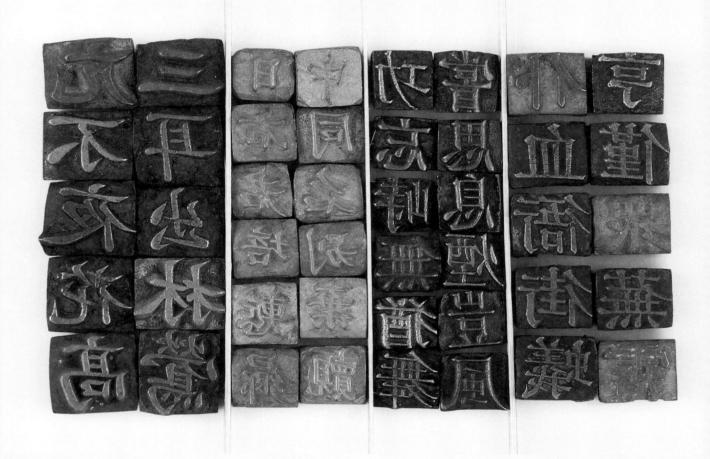

Metal Type of *Hangeul Letters*
한글금속활자-언문자금속활자
Joseon dynasty, 19th c.
Metal
Variable sizes
National Museum of Korea, Seoul

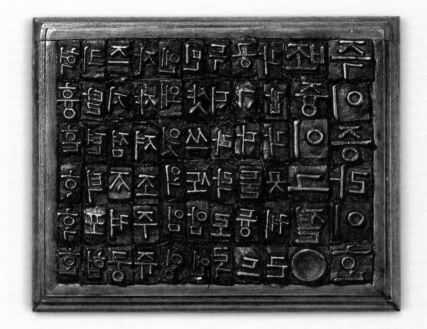

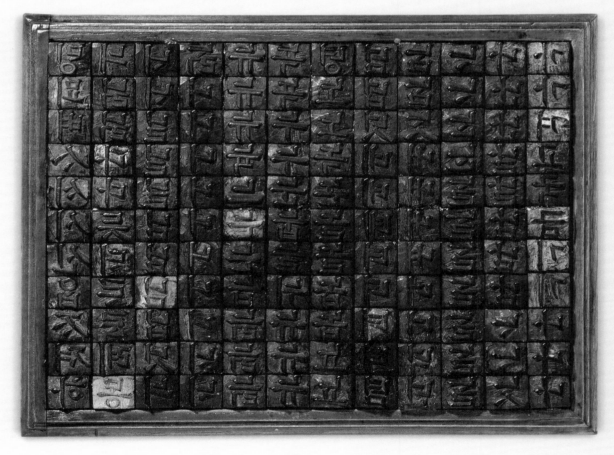

variations not only in size but also in style, from subtle to more pronounced. The successive Joseon governments, which largely controlled what was printed and how, would develop a new script style in certain years and name it after the cyclical name of the given year. For example, there is a *Gyemi*-year type (1403), a *Gyeongja*-year type (1420), and so on.[4]

The first book printed using *hangeul* metal type was a twenty-four-volume biography of the Buddha, *Seokbosangjeol* (Detailed and abridged compendium of collected [texts] on the Buddha's life), published in 1447, one year after the invention of *hangeul* (see cat. 70). Many different *hangeul* metal types were subsequently made and used simultaneously with *hanja* metal types during the Joseon dynasty. By the late nineteenth century, despite a long tradition of publication, only between fifty and two hundred copies of any given book had been printed. The printed books were circulated among royalty, upper-class government officials, and scholars; the general public rarely had access to them.[5] This disparity in access by the populace started to change in the late nineteenth century, with modernization and the influx of foreign influences. At this time Korea used its printing tradition to begin publishing magazines and newspapers, such as *The Independent* (1896; cats. 102—3) and the *Daehan maeil sinbo* (1904; cat. 105), in order to reach a broader audience.

VM

1

Pow-key Sohn, "Early Korean Printing," *Journal of the American Oriental Society* 79, no. 2 (1959): 98; Im Woogi, *National Museum of Korea*, exh. cat. (Seoul: Sol Publishing, 2005), 95—96.

2

Ibid., 99—100.

3

Ibid., 96.

4

Ibid.

5

I Sangil, "Gaehwagi yeonhwalja doipe gwanhan ilgochal" [Study on the introduction of lead types during the time of enlightenment], *Seoji hakbo* [Journal of the Institute of Bibliography] 16 (September 1995): 105—6.

A Record of Land Trade Issued by Master Gim to the Servant Sani of the Yu Family

유진사댁 전답매매명문

Joseon dynasty, 1895
Ink on paper
25⅝ × 16½ in. (65.1 × 42 cm)
Jangseogak Archives, Academy of Korean Studies, Seongnam

Hangeul, invented to eradicate illiteracy and educate the people, was initially believed to equip the public (including the lower classes and slaves) with the means to communicate in writing. Nevertheless, there is little evidence that the lower classes actually used *hangeul. Hangeul* was, in fact, utilized by the ruling class in the early Joseon dynasty; this is corroborated by personal letters (*eongan*) written in *hangeul* by members of the elite.[1]

Sanggye *Documents Written by Slaves*
노비상계문서

Joseon dynasty, mid– to late 18th c.
Ink on paper
Each page: 8⅞ × 9 in. (22.5 × 22.7 cm);
Each page: 8½ × 8⅞ in. (21.5 × 22.5 cm)
Jangseogak Archives, Academy of Korean Studies,
Seongnam

As most existing *hangeul* documents and letters were written by the upper classes in the Joseon dynasty, many scholars have concluded that only a few members of the lower classes used *hangeul*.[2] Accordingly, doubt remains as to whether *hangeul* was widely embraced by all social classes at the time.

Such documents as *A Record of Land Trade Issued by Master Gim to the Servant Sani of the Yu Family*, however, indicate that the lower classes (and in this case slaves, or *nobi*), were able to read *hangeul*. This document is a record of a property sale, written in both *hanja* and

귀업의 조긔에 곡조 二 ○곰

○봉씨의 조긔에 곡조 一 ○곰

권다○의 조긔에 곡조 四 ○곰

본질이 조○에 ○ 십재 ○곰

囍두라 곰

듕씨이 ○○의 ○씨의 ○곰

황○의 부삭씨에 상포 ○팔

囍 곰 四○ 전 곰 ○

○○이 ○○○○○○

hangeul by a Master Gim of the Changryeong Palace.[3] In the sixth lunar month of 1895, when Gim wrote the document, he delegated the authority of the transaction to Sani, a slave belonging to the Yu family. This suggests that Sani was able to read *hangeul,* since he traded the land on behalf of Gim.

The other documents shown here, referred to as the *Sanggye Documents,* clearly prove that at the time *hangeul* was also an equalizing communication tool, useful regardless of one's social status.[4] This type of document was written by slaves in the mid– to late eighteenth century to record the organization and performance of funerals; *sang* means "death," and *gye* means "gathering," with *sanggye* referring to a group gathered to take part in funerals and memorial rites held for the deceased of the lower classes.[5] This document confirms the lower classes' literary skill in *hangeul.*

According to An Seung–jun, chief researcher at the Academy of Korean Studies (Jangseogak Archives), the value and significance of *sanggye* documents

lie in the fact that slaves wrote them for their own use rather than on the order of their masters (as with the land-trade contract).[6] Such documents convey a discernable sense of identity, as the slaves' names were clearly written on them. Unlike the records of the Yu family, the *Sanggye Documents* include each slave's complete name. By convention, slaves' surnames were not stated in the records of property controlled by their masters. Nonetheless, the full names on the *Sanggye Documents* reveal that the slaves tried, in the words of An Seung-jun, to "express their civic consciousness," showing that they, too, were civilians of the nation.[7]

These documents written by slaves impel us to critically reconsider the use and scope of calligraphy in Korean society. Such documents were not considered calligraphy in the past and may still fit uneasily in that category. They are included here to challenge the assumption that calligraphy was only intended for and produced by the upper and middle classes.
CGL

1
Lee Eun Hee, "Joseon junggi eongan (Hangeul pyeonji) eul tonghan saenghwal sok ui munhae gyoyuk" [A study on literacy education within daily lives through *eongan* (Korean letters) in the mid-Joseon dynasty], *Pyeongsaeng gyoyukhak yeongu* [Journal of lifelong education] 21, no. 3 (September 2015): 161.

2
Jo Jong-yeop, "Joseonsidae Nobideul ui 'Hangeul Gyemunseo' Cheot Hwagin" [The first discovery of "hangeul document" by slaves in the Joseon dynasty], *Donga Ilbo* [East Asia daily], June 28, 2016, http://news.donga.com/3/all/20160628/78894060/1#csidx6be6181eb019e42a6b2df4dc280e15e.

3
The larger document, written in Chinese, states that the land was located in Ansangun Naemyeon Seonggot-ri Bullipo and lists its value. The smaller documents are written in *hangeul* and explain why the property is being sold. See Academy of Korean Studies, *Hangeul: A Letter of Communication and Consideration* (Seongnam: Academy of Korean Studies, 2016), 120.

4
This was one of 7,597 documents the Jaeryeong Yi family deposited on loan in the Jangseogak Archives on May 2, 2016. These had initially been stored as part of the Yi family's private collection.

5
There were originally two types of *sanggye* documents: *gyean* and *chibu*. *Gyean* were lists of group members' names, while *chibu* recorded funeral finances. These documents also mentioned the name and dates of the deceased and listed donations given to help the bereaved family; see Jo, "Joseonsidae Nobideul ui 'Hangeul Gyemunseo.'"

6
Ibid.

7
Ibid.

GIM JEONGHUI, A CALLIGRAPHIC MASTER

Gim Jeonghui (1786—1856), whose art name was Chusa (Autumn Scribe), presents a case study of a brilliant calligrapher from a high-ranking family, who was also a scholar-official, painter, epigrapher, and practicing Buddhist. He is considered the greatest calligrapher of the Joseon dynasty—indeed, one of the most creative calligraphers in Korean history. The tragic story of his political exile to Jeju Island and the development and refinement of Chusache, his unique style of *hanja* calligraphy, are well known in Korea.

As a young man, Gim studied the history and stylistic lineages of classical Chinese calligraphy, and when he was twenty-four, he traveled to Beijing with his father as part of a Korean diplomatic mission to the Qing dynasty court. In Beijing he met two of the greatest Chinese epigraphers of the day, Ruan Yuan and Weng Fanggang, both of whom encouraged Gim's passion for antique forms of writing. This period in the early nineteenth century coincided with the growing Epigraphic Movement in

Chinese calligraphy—the study of ancient bronze and stone inscriptions (Ch. *Jinshiwen*; K. *geumseokmun*)—which had a lasting impact on Gim's life and work.

Gim was a master of many calligraphic forms and styles but is most famous for the style he invented, Chusache, in which his elegant *hanja* characters underwent a series of eccentric contortions, among them extreme vertical compression. Elsewhere, he mixed calligraphic forms with abandon, and yet he was simultaneously capable of writing in the most refined Han dynasty clerical-script style.

In addition to illustrating the wide range of Gim's calligraphic work—including his commentaries on such Chinese painters as Shi Ke (active tenth century) and Shitao—this section also includes examples of Gim's painting, an inkstone, a carved wooden signboard, Buddhist calligraphies, letters written in *hangeul* script, and evidence of his activities as an archaeologist and epigrapher.

GIM JEONGHUI
김정희
金正喜
1786—1856

Calligraphic Frontispiece: Chimgye
梣溪

Joseon dynasty, ca. 1851—52
Ink on silver–flecked paper
16⅞ × 48⅜ in. (42.8 × 122.7 cm)
Kansong Art Museum, Seoul

This calligraphic frontispiece is an excellent example of Gim Jeonghui's diligent study and creative use of ancient Chinese stone–stele inscriptions from the Six Dynasties period and the Tang dynasty. The frontispiece, written on green, silver–flecked paper and possibly originally attached to a longer scroll, was executed for Gim's pupil Yun Jeonghyeon (1793—1874).[1]

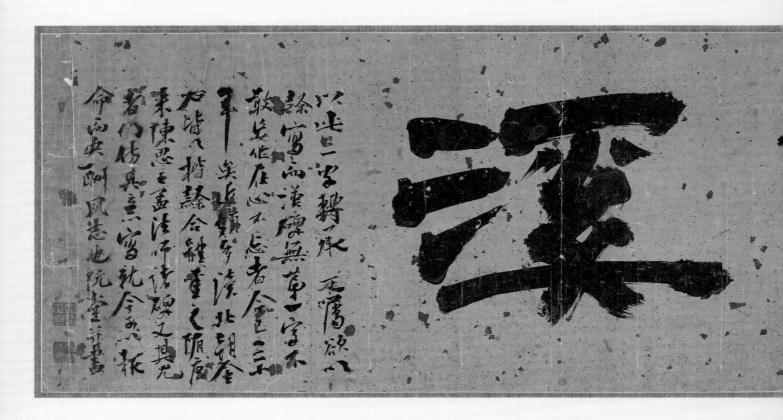

In 1851 Gim Jeonghui was exiled to Bukcheong in Hamgyeong Province. This occurred because Gim was accused at court of causing a group of officials to propose removing the ancestral tablet of Prince Hyojang, foster father of King Jeongjo (r. 1776—1800), from the royal ancestral shrine after the prince had been posthumously named King Jinjang.[2] Shortly after Gim's exile, his protégé Yun Jeonghyeon was appointed provincial magistrate of Hamgyeong Province and in this position was able to politically protect his mentor. Gim was pardoned in the eighth lunar month of 1852, and four months later Yun resigned the post of provincial magistrate. It is assumed that

Gim inscribed this work out of gratitude to Yun in late 1851 or early 1852.[3]

Reading from right to left, Gim's inscription begins with two large *hanja* characters executed in a combination of clerical and standard script that read *chimgye* (ash [tree] stream). In classic Gim Jeonghui fashion, the characters are written with thick, powerful brushstrokes that, while based on earlier calligraphic forms, also reveal elements of cursive script, particularly in the way the brush tip was dragged along the edges of certain horizontal strokes and at the end of vertical and diagonal strokes. The two large characters are followed by a longer note, written in eight vertical columns of smaller semicursive *hanja* characters. These characters, too, reveal familiar features of Gim's calligraphic brushwork, namely pronounced combinations of heavy, blunt vertical and diagonal brushstrokes with thinner horizontal brushstrokes; a tendency toward asymmetrical structures; and a consistent ignoring of the usual convention of making the characters roughly equal in size. The result is a pronounced stylistic awkwardness that nonetheless reveals a marvelous, if unexpectedly elegant, personal style.

Gim's note reads,

I was asked to write these two characters, and I wanted to copy them in clerical script, but the [surviving] Han [dynasty] steles did not have the first character. I did not presume to produce them haphazardly, so I committed them to memory so as not to forget. Now, already thirty years have passed.

Recently, I have read many Northern Dynasty [texts inscribed in] metal and stone. They all are written in a combination of the standard and clerical styles.

This phenomenon is even more pronounced on those texts made since the Sui and Tang [dynasties], including the steles for Prince Si of Chen and Dharma Master Meng. Therefore, I have copied them in imitation of their intended style, and now I happily have a chance to comply with the request that I have long wanted to do.

Respectfully written by Wandang [Gim Jeonghui].[4]

In his note Gim specifically mentions two ancient Chinese steles that inspired the style in which he wrote the two large characters *chimgye*: the stele of Prince Si of Chen, written for Cao Zhi of the Cao Wei Kingdom and later erected in Dong'e County, Shandong Province, in 597, during the Sui dynasty; and the stele for Buddhist monk Dharma Master Meng, inscribed by Chu Suiliang (597—658) in a combination of standard and clerical script, and erected in 642 during the early Tang dynasty (no longer extant but known from ink rubbings).

SL

1
Published in *Kansong munhwa: Kansong Misul Munhwa Jaedan seollip ginyeomjeon* [The treasures of Kansong: Commemorating the founding of the Kansong Art and Culture Foundation], exh. cat. (Seoul: Kansong Art and Culture Foundation, 2014), 230—31, cat. 90.
2
Ibid.
3
Ibid.
4
Translated in ibid., with minor changes.

81

GIM JEONGHUI
김정희
金正喜
1786—1856

***Mount Gonryun Rides on an
Elephant***
곤륜기상
崑崙騎象

Joseon dynasty, 19th c.
Hanging scroll; ink on paper
52⅜ × 17⅛ in. (133 × 43.5 cm)
Yi Sejong Collection

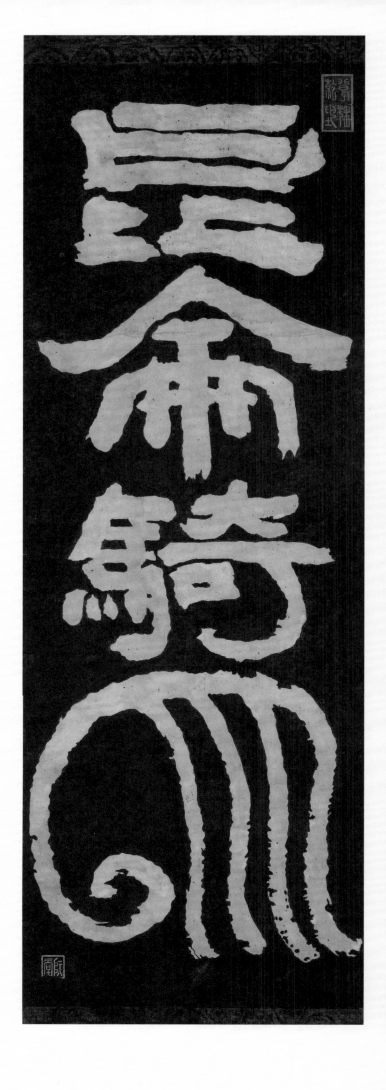

Gim Jeonghui

294

Gim Jeonghui was a renowned scholar and calligrapher and a practicing Buddhist.[1] Throughout his life, he associated with both lay Buddhists and Buddhist clergy and often spent time in Buddhist temples. It is clear that he had a profound knowledge of ancient and contemporary Buddhist texts. Among Gim's surviving calligraphic works are many transcriptions of Buddhist sutras, commentaries on Buddhist texts, and placards for Buddhist temple halls.[2]

The four-character phrase on this scroll reads, "Mount Gonryun rides on an elephant." This is a quote from the collected sayings of the Chinese late Ming dynasty Chan (K. Seon; J. Zen) Buddhist master Wuming Huijing (1548–1618), sixty-eighth patriarch of the Caodong (K. Jodong) sect.[3] The phrase refers to the Kunlun Mountains of Chinese Daoist mythology, the realm of the ancient goddess Xiwangmu (K. Seowangmo; Queen Mother of the West), said to be situated far beyond China's western border. The passage in which this phrase appears forms a complex and seemingly nonsensical Seon riddle in poetic form, part of a longer dialogue between Wuming Huijing and another monk that appears in the *Wuming Huijing chanshi yulu* (Recorded sayings of the Chan master Wuming Huijing):

> At the bottom of the sea is a clay ox,
> holding the moon as it travels,
> Beneath a cliff is a stone lion, holding
> a sleeping child.
> Like an iron snake boring through
> a diamond [*vajra*] eye,
> Mount Kunlun rides on an elephant,
> pulled by an egret.[4]

In this unusual calligraphic work, Gim demonstrates his mastery of ancient clerical script (*yeseo*) coupled with a playful creativity: the final character, meaning "elephant," is rendered as a drawing of an elephant. It is possible that this final character was borrowed from an ancient Chinese Shang dynasty bronze inscription, in which the character for elephant was rendered in a more pictographic form.[5]

SL

1
On Gim Jeonghui's Buddhist practice, see Younsoo Lee Chun, "Ch'usa Kim Chong-jui (1786–1857): The Development of Chusache (The Style of Ch'usa) through the Chinese Metal and Stone Movement" (master's thesis, University of Hawaii, 1996), 12–15.

2
See, for example, Gim's transcription of the Heart Sutra, published in *A Great Synthesis of Art and Scholarship: Painting and Calligraphy of Kim Jeong Hui*, exh. cat. (Seoul: National Museum of Korea, 2006), 26–31, cat. 7.

3
For a biography of Wuming Huijing, see *Zen Masters: Wuming Huijing (1548–1618), Patriarch of the Sixty-Eighth Generation*, accessed May 5, 2018, https://terebess.hu/zen/mesterek/WumingHuijing.html.

4
Recorded in *Wuming Huijing chanshi yulu* [Recorded sayings of the Chan master Wuming Huijing], accessed May 4, 2018, https://books.google.com/books?id=ZcuPCwAAQBAJ&pg=PT17&dq=%E6%98%86%E4%BE%96%E9%A8%8E%E8%B1%A1&hl=en&sa=X&ved=0ahUKEwjKxbn6oILbAhUV7mMKHUFqDUMQ6AEITDAG#v=onepage&q=%E6%98%86%E4%BE%96%E9%A8%8E%E8%B1%A1&f=false.

5
See, for example, *Siti da zidian* [Dictionary of four forms of (Chinese) characters], 4 vols. (Beijing: Beijing shi Zhongguo shudian, 1980), 4:1552

GIM JEONGHUI
김정희
金正喜
1786—1856

Room of the Bamboo Stove
죽로지실
竹爐之室

Joseon dynasty, 19th c.
Carved and painted wooden board
17⅜ × 57⅞ in. (44 × 147 cm)
An Baek Sun Collection
Not in exhibition

Room of the Bamboo Stove is an example of a Gim Jeonghui calligraphic title board, in which the artist's brushed calligraphy was traced and carved onto a wooden board to mark the name of a room. A superb example of Gim's eccentric mix of seal- and clerical-script forms, this work manifests the beauty and originality of Chusache, the style of calligraphy named after Gim's sobriquet, Chusa, or Autumn Scribe. This type of wooden signboard (*hyeonpan*) was usually hung on a pillar or over a door to name and make clear the function and significance of a room or building.

Given the nature of the inscribed characters, signboards attributed to Gim are mostly assumed to have been commissioned by or made as gifts for Buddhist temples.[1] Based on its calligraphic style, *Room of the Bamboo Stove* is considered to date to after Gim's first exile on Jeju Island (1840—48). Each of the four traditional Chinese characters (*hanja*) presents its own architectonic structure, resonating with the last (leftmost) character, reading, *sil* (room). The characters' bold, vertically compressed designs and dramatic spacing are both trademarks of Gim's transformation of Chinese characters into a unique personal style. The expressive force embodied in

the Chusa style reflects Gim's comprehensive study of archaeology and epigraphy.

Room of the Bamboo Stove is assumed to have been a gift from Gim to the Buddhist monk Choui (1786—1866), a master of Korean Seon Buddhism at the temple of Daedunsa (now known as Daeheungsa or Daeheung Temple), to express his gratitude for Choui's generosity in providing Gim with tea. Choui is noted as the figure who introduced the Way of Tea (*dado*) to Korea; he was also the Buddhist master of many late Joseon scholar-officials.[2] Gim had been introduced to the art of tea, Neo-Confucianism, and epigraphy during his trip to Beijing in 1810, after he passed the civil service examination. In Beijing he met several Chinese scholars, with whom he continued to correspond after his return to Korea. In particular, his encounter with Weng Fanggang (1733—1818), a key figure in Chinese epigraphy, especially broadened his perspective in that field, as well as his appreciation for Buddhism, of which he had little prior knowledge, since the official state ideology of Joseon Korea was Confucianism. After returning home, Gim continued his study of Buddhism through his lifelong relationship with Choui, whom Gim had met through Jeong Yakyong (1762—1836), another influential scholar in the Silhak (practical learning) movement.[3]

Given that Choui considered tea a way of achieving the state of Buddhist nonduality, this signboard bears rich literary and religious connotations, as the bamboo stove was a key (and easily portable) part of the tea ceremony. In Gim's words—*munjahyang* (the scent of letters) and *seokwongi* (the spirit of books)—were the essential elements of Gim's scholarly world and philosophy. He perceived these as primary human virtues that should be naturally disclosed through poetry, calligraphy, or painting by scholars who reached a certain level of academic refinement, reflecting an underlying and unremitting self-cultivation, the goal of which was the achievement of Buddhist enlightenment.

The conceptual framework of *Room of the Bamboo Stove* correlates not only with the application of Chusache as a calligraphic style but also with the fragrance of tea implied by the word *jukro* (the first two characters on the right, meaning "bamboo stove"). The form of the second character, *juk*, meaning "stove," is similar in appearance to a stove, owing to its intentionally distorted size and the position of its fire radical, *hwa*, which here resembles the small handle of the stove. The artistry of this signboard further manifests an aesthetic that integrated form and meaning, reflecting Gim's combination of "poetry, calligraphy, painting, and Seon" (*siseohwailche*). As a gift for the monk Choui, for whom tea embodied a ceaseless effort toward awareness, *Room of the Bamboo Stove* signifies a literal as well as symbolic room for meditation and self-cultivation.

JHP

1
Illohyangsil (*Room of a Tea Pot with Fragrance*) is another signboard that is assumed to have been gifted to the monk Choui by Gim Jeonghui. It dates to Gim's period of exile on Jeju Island. As *Illohyangshil* was the name of the room in which Choui was staying, the signboard is embedded with Buddhist implications, and its Chinese characters reveal architectural aesthetics consistent with *Room of the Bamboo Stove*. For more details on *Room of the Bamboo Stove*, see Hwang Ji-won, *Gim Jeonghuiui cheolhakkwa yesul* [Philosophy and art of Gim Jeonghui] (Daegu: Keimyung University Press, 2010), 142—44.

2
A surviving series of letters from Gim to Choui reveals their close friendship, as well as Gim's deep interest in tea; for more on this subject as well as a discussion about Buddhism and Confucianism in nineteenth-century Joseon, see Jeong Byungsam, ed., *Chusawa geuui sidae* [Chusa and his period] (Seoul: Dolbaegae, 2002), 162—208.

3
It is known that Gim Jeonghui gifted a wooden signboard to Jeong Yakyong while Jeong was in exile in Gangjin, on which were inscribed the words "thatched cottage of Dasan" (*Dasanchodang*). Dasan was Jeong's sobriquet.

GIM JEONGHUI
김정희
金正喜
1786—1856

Orchid
묵란도

Joseon dynasty, 1855
Hanging scroll; ink on paper
21⅜ × 12 in. (54.9 × 30.6 cm)
National Museum of Korea, Seoul, So Cheng Geun
Collection
Not in exhibition

Gim Jeonghui's *Orchid* of 1855 is regarded as an index of the highest level of literati culture in the Joseon dynasty. Gim's calligraphy was hailed as a landmark of the dynasty, reaching a new stylistic standard enabled by his proficiency in the styles of old masters. Chusache——based on one of his sobriquets, Chusa——is the name given to Gim's unique calligraphic style, which resulted from his intensive study of earlier Chinese and Korean calligraphy

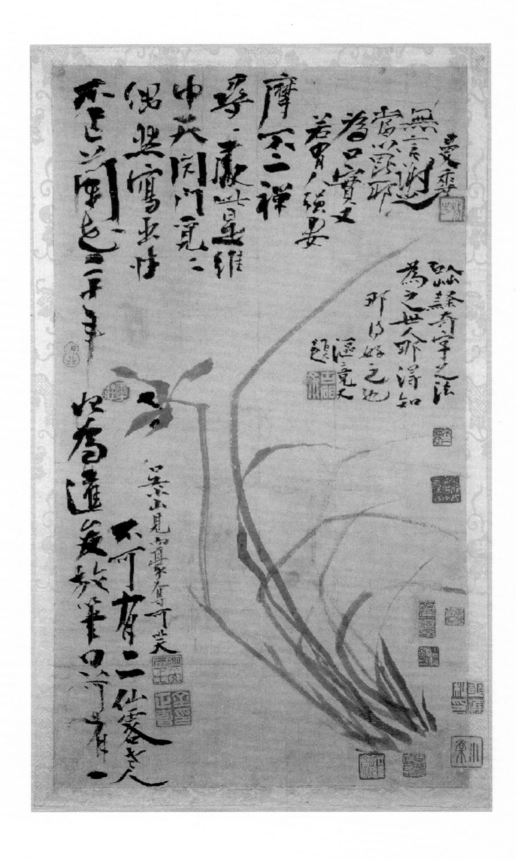

masters. The Chusa style is characterized by the harmonious juxtaposition of strong strokes with delicate lines and free-form dots. Equally admired were Gim's paintings of landscapes and orchids, which epitomized the genre and also served as models for his contemporaries and followers.

Orchid was made during Gim's time in Gwacheon, just south of Seoul, where he settled after political disputes forced him to serve two terms of exile. The work embodies two fundamental concepts of painting that Gim addressed in a letter to his son during the late years of his first exile on Jeju Island: the scent of letters (*munjahyang*) and the spirit of books (*seogwongi*).[1] These are terms Gim emphasized to define the ultimate quality of painting that could only be facilitated by the painter's in-depth knowledge and refinement as a literatus, as they are naturally revealed through the solid understanding of the essence of things. For the realization of *munjahyang* and *seogwongi*, as seen in *Orchid*, Gim deliberately used a simplified composition and simplified forms, avoiding vivid lines or colors.

The painting also has a Buddhist connotation, as revealed by the poem inscribed at the top of the scroll in highly expressive cursive script, in the style now widely recognized as the Chusache manner. The poem reads:

> I haven't painted orchids for twenty years,
> [But] finally drew an orchid I had in
> my mind.
> Seek, seek, and seek again in my closed
> inner mind,
> It is not different from the Seon [Zen]
> of [the Buddhist layman] Vimalakirti.[2]

The poem reveals Gim's familiarity with the Vimalakirti Sutra (the sutra spoken by Vimalakirti). His association of Buddhist enlightenment with the motif of the orchid bespeaks his self-confidence as a prominent literatus. During his life in Gwacheon, Gim converted to Buddhism and explored the idea of combining ink orchids with Buddhist Seon concepts.[3] His book *Jeseokpanangwon*, written in 1853, shows that Gim understood mastering orchid painting as akin to attaining Buddhist Enlightenment, which requires

immense effort and consistent study. It was during this period that Gim established his theory of the combination of "poetry, calligraphy, painting, and Seon" (*siseohwailche*), conceived as the highest stage of his art theory. The combination, or nonduality, of different visual elements, along with Buddhist Enlightenment, is a manifestation of the ultimate state of literature, as well as a means to seek harmony between the truth of nature and the nature of human beings.

The poem written on the right side of the painting states that Gim painted this work for Daljun, his pupil.[4] In the poem Gim describes the tranquil state of mind in which he was able to paint the orchid without deliberate attention or artificial effort. Such naturalness resonates with the embodiment of *munjahyang* and *seogwongi* and further aligns with the essential concepts underlying the Vimalakirti Sutra, such as emptiness (*gong*) and the forthcoming end of the dharma, or latter days of the Buddha's Law (*mubeop*), combining to create awareness of nonduality (*buli*).

As a way of expressing nonduality through the orchid as a painting (*hwa*), which is a pivotal nexus for the synthesis of the arts and religion, Gim took inspiration from the theory of the Chinese painter Dong Qichang (1555—1636) and integrated it with his own art theories. In terms of painterly style, Gim looked to the Yuan-dynasty masters Zhao Mengfu (1254—1322) and Zheng Sixiao (1241—1318) as pioneer figures in the genre of orchid painting, and especially took Zhao's "three twists" style of brushwork (*samjeonbeop*) as his primary reference.[5] This style involves applying three particular twisting movements of the brush so as to make variations in the lines of orchid leaves, as clearly manifested in each orchid leaf in this painting. Gim also applied the principles of calligraphy in *Orchid*, so that there is a clear relationship between the spontaneous, untrammeled brushwork of the painting and the accompanying calligraphic inscriptions. The twisting part of each leaf and stem resembles the brush movements of both clerical and cursive script, while the sharply pointed ends of the leaves resemble the style of Gija. The use of Bibaek, a style that derives

from clerical script but features special effects created by using a flat brush without the sharp brush tip, especially sheds light on the exceptional characteristics of *Orchid*. Gim argued in his book of orchid paintings, *Nanmaengcheop*, that one should refrain from using the Bibaek style when painting orchids. This change of mind bespeaks the transformation of Gim's art theory, which was contingent on his study of how to reach the ideal state.

Orchid exemplifies individual achievement embedded with historical specificity. The painting is considered to embody the theory of *siseohwailche*, demonstrating that Gim's comprehensive study of calligraphy, painting, and religion across multiple periods of time resulted in a conceptual framework with visual manifestations. Gim's work illustrates the close relationships and blurred boundaries between calligraphy and painting.

JHP

1
Choi Soontak, *Chusaui seohwasegye* [Calligraphy and painting of Chusa] (Seoul: Hakmunsa, 1996), 62—63.
2
Translation by Joon Hye Park.
3
For more details on different stages of Gim Jeonghui's orchid ink paintings, see Kim Hyunkwon, "Chusa Gim Jeonghuiui mukranhwa" [Gim Jeonghui's ink orchids], *Misulsahak* [Art history] (August 2005): 35—67.
4
For the translation of the original poem and its details, see Jeong Byungsam, ed., *Chusawa geuui sidae* [Chusa and his period] (Seoul: Dolbagae, 2002), 243—48.
5
Gim's stance on *samjeonbeop* is well addressed in a letter to his son. For more details, see Yu Hong-jun, *Hangukmisulsa gangui* [Korean art history lectures] (Seoul: Nulwa, 2013), 340—41.

84

GIM JEONGHUI
김정희
金正喜
1786—1856

Wintry Days
세한도
歲寒圖

Joseon dynasty, 1844
Handscroll; ink on paper
9⅜ × 546⅜ in. (23.7 × 1383.95 cm)
Private collection; on loan to the National Museum
of Korea, National Treasure no. 180
Not in exhibition

Wintry Days is regarded as Gim Jeonghui's masterpiece.[1] Painted during the latter years of Gim's nine-year exile, this work encapsulates the way his minimal and unpretentious painting style was a foil for his elegant and highly disciplined calligraphy.[2] Gim created the work in 1844 while in exile on Jeju Island. During Gim's exile his former student Lee Sangjeok (1803—1865) sent him books that had recently been published in China. Gim considered such gifts precious and

was so impressed and moved by Lee's loyalty that he painted this work, accompanied by a letter, to express his gratitude.[3]

The upper-right corner of the painting shows its Korean title, *Sehando*, written horizontally in *hanja* clerical script, and a sentence, written vertically, which reads, "Wuseon, for your appreciation!"[4] The sentence ends with Gim's signature, consisting of his sobriquet, Wandang, and a seal with his given name, Jeonghui.

The painting continues to the left. In front of a shabby cottage, an old pine tree relies on a younger pine tree for support. Two additional trees stand in close proximity. Farther to the left is the letter to Lee Sangjeok explaining the story and

significance of the painting. Gim wrote it in the *guyangsun* calligraphy style, named for the early Tang dynasty scholar and calligrapher Guyang Sun (Ch. Ouyang Xun; 557—641), whose style was initially compared with that of the Chinese Eastern Jin dynasty calligrapher Wang Xizhi (K. Wang Huiji; 307—365). Gu later embraced a more independent and defining *haeseo* (semicursive-script) form. The seal with four characters located at the lower right of the letter reads, "Let us not forget each

other for a long time."[5] The end of the letter is completed with another seal that bears Gim's artist's name, Chusa. The writing, painting, and seals work together to show his more mature style and impart a natural energy to this work.[6]

The calligraphic strokes that create the trees, house, and hills do not merely represent or "draw," but also "write" (the artist's) mind. This approach is derived from the artistic lineages of the Chinese late Ming and early Qing dynasties, which defined the Korean "Southern" literati, or *namjong*, style. The lack of a background in the painting conveys the desolation and solitude reflective of the mental state and environment Gim experienced in his exile.[7]

Gim's letter to Lee Sangjeok is translated as follows:

Last year, Lee Sangjeok sent me two books, *Manhakjip* and *Daeunsanbang mungo*, and this year, he sent the book *Hwangjo gyeongse munpyeon*. This does not happen often. It is so impressive and touching to think about what he has done, since it would have been so challenging to purchase and then send these books from such a distance.

It is human nature to seek power and its benefits. But Lee Sangjeok was not kowtowing to those in power; he was showing his respect. This reminds me of what Taesagong [Sima Qian; 206 BCE—220 CE] said: those relationships that pursue the benefits of power cannot last after those powers have burned out. Lee Sangjeok is one of the ordinary human beings. He is unaware of this power and does not perceive me as an object of power or benefit.

Gongja [Confucius; 551—479 BCE] is known to have said, "Only after the inclement weather in winter do we discover that pine trees are the only plants that do not fade." He praised the pine tree, which resiliently stays green even after the harsh winter. Similarly, Lee Sangjeok shows his unwavering respect for me even after I have been exiled.[8]

When Lee Sangjeok received this letter and painting from Gim Jeonghui, he was so honored by the gift that he traveled through Korea and China, asking notable scholars to write colophon inscriptions on *Wintry Days*. Seventeen famous scholars from China and Korea contributed; their inscriptions form the remainder of the calligraphic writings on this handscroll.

VM

1
Gim's handscroll is published in full with a complete translation of the *hanja* into *hangeul* in *A Great Synthesis of Art and Scholarship: Painting and Calligraphy of Kim Jeong Hui,* exh. cat. (Seoul: National Museum of Korea, 2006), 288—89, cat. 75.

2
Seoul Calligraphy Museum and the National Museum of Korea, *Sehando: Chusaui tto dareun jahwasang* [*Sehando*: Yet a different self-portrait of Chusa], exh. cat. (Seogwipo: Hyonseong Munhwa, 2015), 68.

3
Sung Lim Kim, "Kim Chŏng-hŭi (1786—1856) and *Sehando*: The Evolution of a Late Chosŏn Korean Masterpiece," *Archives of Asian Art* 56, no. 1 (2006): 31—60.

4
Translation by Virginia Moon.

5
Translation by Virginia Moon. As shown by Sung Lim Kim, the phrase on the seal was appropriated by Gim from a Han dynasty roof-tile inscription; see Kim, "Kim Chŏng-hŭi (1786—1856) and *Sehando*," 34.

6
Song-Sig Jo, "Chusa Gim Jeonghui 'Sehando' ui jaehaeseok: 'Sehando' wa 'Ssangsongdo' ui gwangye, geu dongin ui cheolhak jeok uimi" [A new understanding of Gim Jeonghui's *Wintry Days*], *Mihak yesulhak yeongu* 52 (October 2017): 168—69.

7
Seoul Calligraphy Museum and the National Museum of Korea, *Sehando*, 68.

8
Translation into Korean by Jo Min Hwan in *Hwajereul tonghae bon joseonhugi muninhwa: chusa gimjeonghuireul jungsimeuro* [An examination of the paintings of the late Joseon dynasty literati: With a focus on Chusa Gim Jeonghui] (Seoul: Dongyang Yesul, 2004), 204—5; translation into English by Christina Gina Lee.

YI HANBOK
이한복
李漢福
1897—1940

***Painting of an Inkstone Owned
by Gim Jeonghui***
김정희가 소장했던 벼루를 그린
그림과 발문
三硯齋硯譜
From the album ***Compendium
of Inkstones from Three Inkstones
Studio***

20th c.
Album leaf; ink on paper
Each page: 10⅝ × 8 in. (26.8 × 20.3 cm)
Private collection

Yi Hanbok was an early twentieth-century
Korean painter who attended the Tokyo
School of Fine Arts during the Japanese
Colonial period. Although he studied
Japanese Nihonga painting in Tokyo, Yi
came to specialize in traditional Korean
landscape and figure painting. Like many
late nineteenth- and early twentieth-
century artists, he profoundly respected
the late Joseon dynasty master Gim
Jeonghui (1786—1856), and his depiction
of one of Gim's favorite inkstones in
his album *Compendium of Inkstones from
Three Inkstones Studio* functions as an
homage to the great scholar, calligrapher,
and epigrapher.[1] At least four of Gim
Jeonghui's inkstones survive today, reflect-
ing his love of this traditional scholar's
implement.[2]

Yi's painting, executed in ink on paper, is a careful and sensitive rendering of one of Gim's inkstones. The painting is signed at the upper right with one of Yi's sobriquets, Muho (No Nickname); [3] this is followed by the artist's seal, which reads, Yi bu jang su (Yi's good fortune and long-lived happiness). An album leaf appended to the painting includes the following inscription by Yi, written in elegant running script:

On the back of Gim Jeonghui's inkstone is a carved inscription by Dong Wenmin [the Chinese artist Dong Qichang, 1555—1636], which reads:

Why was the Horse Liver [stone] red, And the Phoenix Flavor [stone] merely green?
The Chouchi [stone] was a precious treasure of [Su] Dongpo [Su Shi; 1037—1101],
The Mount Pei [stone] was returned to Nangong [Mi Fu; 1051—1107], and bore an inscription:
In a peaceful dwelling one sits to the right [of the host],
Together we lengthen the years [of our lives].

The top [of Gim's inkstone] has a carved inscription by [the eighteenth-century Qing dynasty poet] Weng Wenda, reading,

"How fitting are roof tiles [as ink palettes]! So antique is their disposition, and how enduring is their character!"

Gim Wandang's [Gim Jeonghui's] carved inscription reads,

"If one can achieve strength in silence, One's longevity will be eternal."

In the past, this was Master Wandang's treasure. [Later] the master's grandson Son Hanje, the professor-in-waiting, presented it to Master Min Chungjeong. The master [Min Chungjeong] loved to use it, and when he died defending his virtue it came to be owned by Gim Yeonghan, the state councilor. When he died it then came to its current owner. [4]

This inscribed leaf bears three of Yi Hanbok's seals; these read, Samyeonjae (Three Inkstones Studio), Muho, and Geum deuk cheong ga (With a zither one obtains pure relaxation).

This inscription links Gim Jeonghui's inkstone to several other famous stones in Chinese lore, including stones owned by the poet Su Shi and the artist Mi Fu, noted stone connoisseurs. Mi Fu is known to have painted a scroll depicting his favorite inkstone, and while the painting only survives in a later copy (Palace Museum, Beijing), the inkstone was reproduced in woodblock-illustrated books as early as the fourteenth century—for example, in Tao Zongyi's Chuogeng lu (Records made during respite from plowing) of 1366. [5]

SL

1
Published in A Great Synthesis of Art and Scholarship: Painting and Calligraphy of Kim Jeong Hui, exh. cat. (Seoul: National Museum of Korea, 2006), 18—19, cat. 4.
2
Ibid., 14—15, cat. 2.
3
Yi Hanbok's other sobriquet was Suja (Longevity Studio).
4
Translation by Stephen Little.
5
See John Hay, Kernels of Energy, Bones of Earth: The Rock in Chinese Art, exh. cat. (New York: China Institute in America, 1985), 20.

86

GIM JEONGHUI
김정희
金正喜
1786—1856

Comments on Shitao's Paintings
石濤畫跋

Joseon dynasty, 19th c.
Album; ink on paper
Each page: 12⅛ × 8 in. (30.7 × 20.3 cm)
National Museum of Korea, Seoul
Not in exhibition

This classic example of Gim Jeonghui's unique Chusa running-script calligraphy (named for his sobriquet, Chusa, Autumn Scribe) exemplifies Gim's tendency to break standard calligraphic rules: here he writes characters with variable sizes and spacing, contrasts thick horizontal and diagonal brushstrokes with thin vertical strokes, and unpredictably tilts characters to the right or left, off their central vertical axes.

Works by the early Qing dynasty Chinese monk-painter Shitao (Daoji; 1642—1707), a descendant of the vanquished Ming imperial family, were widely admired in Joseon dynasty Korea.[1] For an artist like Gim Jeonghui, Shitao's idiosyncratic painting style and unorthodox theories on art would have also struck a responsive chord.[2] This album bears the following two inscriptions by Gim, focusing on Shitao's rendition of a subject originally said to have been created by the Chinese poet-painter Su Shi (Su Dongpo; 1037—1101):[3]

1) The monk Kugua [Shitao] made [a version of] Pogong's [Su Shi's] painting *Traveling through Snow at Weizhou*. Suzhai [eminent Chinese scholar and epigrapher Weng Fanggang; 1733—1818] inscribed it, saying,

> I painted *Xuezhai Resting at Weizhou*,
> Moreover, I rendered it visible on
> a pavilion wall in Qiantang [Hangzhou].
> It's truly laughable that Qingxiang
> Kugua [Shitao] patched [his
> Buddhist] robe,
> He truly achieved the strength of
> a slender horse in spring and winter.

Luo Liangfeng [Luo Ping; 1733—1799] copied it; he also had Pogong's *Painting of Eating Lychees*. On the nineteenth day of the twelfth [lunar] month, Suzhai offered [me] both this work and [Su Shi's] *Portrait with Rain Hat and Sandals*. Inscribed on my birthday.

2) In [both] past and present, many calligraphies and paintings came to the east [from China to Korea]. Despite those that I have seen [literally, "those that have reached (my) ears and eyes"], still there are too few paintings by Kugua [Shitao]. I have only seen this one [*Traveling through Snow at Weizhou*] and that is all. Even in China it is rare to see them among collectors, so it is fitting [not surprising] that very few have come to the east [Korea]. I once saw Shen Xuanzhai's [Shen Shizheng's;

1707—1769] copy of the scroll *Enjoying the Moon from Atop a Bridge*, and knew that [this painting] came to the east long ago. Although Xuanzhai copied it, still there was not a single word about its reaching the level of Kugua's work—how can that be? I obtained this scroll in Goldongsa, but [at first] did not feel any great astonishment. Still, with Hwangsan [Gim Yugeun; 1785—1840] and Yijae [Gwon Donin; 1783—1859], both connoisseurs, it was remounted so it could be appreciated for a lifetime. Long ago when Hwangsan returned to Daegu he returned by my studio. Turning [direction] he arrived at Gungaekchohyeop on the sea; how is it that through his ink-karma he did not sink? Turning his head he saw Bongnae [Ch. Penglai; Isle of the Immortals] and felt the gratitude [stemming from] his old affairs among the mountains and rivers; could he could not help but be sad and anxious?
—Wandang[4]

From Gim Yugeun's death date, it is clear that the album dates to no later than 1840, the same year Gim Jeonghui was exiled to Jeju Island, and it was likely made earlier.

SL

[1]
On Shitao see Richard Edwards et al., *The Painting of Tao-chi*, exh. cat. (Ann Arbor: University of Michigan Museum of Art, 1967); and Jonathan Hay, *Shitao: Painting and Modernity in Early Qing China* (Cambridge: Cambridge University Press, 2001).

[2]
Shitao's theories of painting include, for example, "My method is the method of no-method." See Shitao, *Enlightening Remarks on Painting*, trans. Richard E. Strassberg (Pasadena: Pacific Asia Museum, 1989).

[3]
The album is published in *A Great Synthesis of Art and Scholarship: Painting and Calligraphy of Kim Jeong Hui*, exh. cat. (Seoul: National Museum of Korea, 2006), 298—99, cat. 80.

[4]
Translations by Stephen Little.

GIM JEONGHUI
김정희
金正喜
1786—1856

8
7

Sosik's (Ch. Su Shi's) Poem on Seokgak's (Ch. Shi Ke's) Painting of Yu Ma (Vimalakirti)
석각화유마송

Joseon dynasty, 19th c.
Album; ink rubbing, ink on paper
9½ × 13¼ in. (24 × 33.5 cm)
Private collection

One sign of the high regard in which Gim Jeonghui's calligraphic works were held both during his life and following his death are the late Joseon dynasty ink rubbings that replicate his writings (see, for example, those commissioned by Heo Ryeon: cat. 91). The album of ink rubbings shown here reflects Gim Jeonghui's practice and deep understanding of Buddhism. Its subject is the ancient Buddhist layman Vimalakirti, the protagonist of one of the famous Buddhist texts, the *Vimalakirti–*

nirdesa Sutra.[1] In this sutra Vimalakirti defeats Manjushri, bodhisattva of wisdom, in a debate on the ultimate nature of enlightenment.

This album reproduces a work inscribed in Gim's classic Chusache (Chusa style; see cat. 86). The text transcribes a famous poem by the Chinese poet Su Shi (Su Dongpo; 1037—1101), written as a testimonial to the eccentric tenth-century painter Shi Ke's portrait of the Indian Buddhist layman Vimalakirti:

"Testimonial on Shi Ke's Painting
 of Yu Ma [Vimalakirti]"
I see the thirty-two bodhisattvas,
All present their own understandings
 of nonduality.
But only Vimalakirti keeps his silence,
And the thirty-two understandings
 are immediately meaningless.
I do not regard the understandings
 as meaningless,
Vimalakirti does not say anything in the
 beginning.
It is like a lamp using oil and candle,
It cannot be lit without fire.
Suddenly in the silence,
[I] saw the thirty-two presentations
 are all shining.
If you Buddhist believers read the
 Vimalakirti Sutra,
[You] should take this as the correct idea.
I saw Vimalakirti's small room
That can hold nine million bodhisattvas.
Thirty-two thousand Lion Chairs
Are all contained freely.
He can even distribute a bowl of rice,
To make countless people from ten
 directions full.
[He then] takes the Wonderful Joy
 World [to this world],
Like a date leaf on top of a needle head.
[People] say that it is bodhisattva's
 unbelievable capability,
And supernatural power.

I saw that Master Shi was just an
 independent scholar,
Wearing linen shoes and a broken hat
 with his ribs uncovered.
But he can depict Vimalakirti using
 his brushes,
[This kind of] power even surpasses
 Vimalakirti's.
If [someone should] say that this
 painting does not represent a real scene,
[Then things that happened in] the city
 of Vaishali are not true, either.
If any Buddhist believers want to paint
 a Vimalakirti image
[He] should take this as a model.[2]

This album of ink rubbings is a significant reflection of Gim's interest in Buddhism and Buddhist painting. Like Su Shi, Gim Jeonghui became a practicing Buddhist and spent many years visiting Buddhist temples and conversing with Buddhist monks. Numerous examples of his sign-boards for halls and rooms in Buddhist temples survive (see cat. 82).

SL

1
See Burton Watson, *The Vimalakirti Sutra* (New York: Columbia University Press, 1997).
2
Adapted from the translation in Chen Liu, "Flowers Bloom and Fall: Representation of the Vimalakirti Sutra in Traditional Chinese Painting" (PhD diss., University of Arizona, 2011), 106—8.

8

GIM JEONGHUI
김정희
金正喜
1786—1856

Letter by Gim Jeonghui in Hangeul *to His Wife*
김정희가 부인에게 쓴 편지

Joseon dynasty, 1814
Ink on paper
Letter: 10¾ × 16½ in. (27.3 × 41.6 cm);
envelope: 11 × 2⅜ in. (27.8 × 5.9 cm)
National Museum of Korea, Seoul

By the age of thirty-three, Gim Jeonghui (sobriquet: Chusa) was a well-known scholar who had risen as a statesman in the official bureaucracy; he was also the foremost calligrapher of the Joseon dynasty. Despite this, his position was weakened by political opponents and infighting. When the political party with which his family was associated lost power, Gim was forced into exile on Jeju Island, off Korea's south coast. This was the second-most severe punishment

in the kingdom. For Gim, who had lived a comfortable life, it was a shocking turn of events, and in his later life, he often discussed how these cruel circumstances shaped his calligraphy practice. During his nine years of exile, Gim refined and perfected his most famous calligraphic style, known as Chusache (Chusa style), based on his sobriquet.[1] As a result, distinct changes in his writing became clearly visible. His former style was characterized by a dynamic and flowing elegance, but gradually his brushstrokes began to project a certain coarseness and boldness; they also became noticeably

Gim Jeonghui

308

GIM JEONGHUI
김정희
金正喜
1786—1856

Letter by Gim Jeonghui in Hangeul *to His Daughter-in-Law*
김정희가 며느리에게 쓴 편지

Joseon dynasty, 1844
Ink on paper
Letter: 9⅜ × 14⅜ in. (23.7 × 36.2 cm); envelope:
9½ × 2⅛ in. (23.9 × 5.3 cm)
National Museum of Korea, Seoul

slimmer. Scholars regard this phase as the beginning of the transformation of his famous Chusache script.

It is Gim Jeonghui's *hangeul* letters to his wife and daughter-in-law, however, that give us unusual insight into his personal and emotional struggles during this important period of time. These texts precisely express his discomforts, concerns, longing, and suffering as a human who was forced to live in solitude.[2]

Two hundred years ago, Jeju was a remote island with an unforgiving climate; it was also dangerous to reach, owing to high waves. Gim was allowed to request basic items for living, such as clothes and food, as well as such tools for writing as paper, ink, and books. He spent most of his time practicing calligraphy and writing letters to his loved ones. Gim left numerous calligraphic works from this period that include inscriptions on stone and wood, rubbings of historical epigraphs, and various works on paper, such as letters and historical studies of calligraphy. Only forty *hangeul* calligraphy works are known from

this phase of his life, however. Among them, thirty-two letters to his second wife and two letters to his daughter-in-law (a total of 15,384 *hangeul* characters) give us a rare glimpse into Gim's role as a husband and father-in-law.[3] These are written in a bold and cursive form of *hangeul*.

Gim's wife stayed a stalwart companion throughout his harsh time in exile. She was the only person to whom he could communicate his emotional suffering and his yearning for family and home. Gim's letters to his wife served also as a practical means of communication in which he requested seasonal clothes and food.[4] For example, through the letters we learn that during his exile Gim had to adjust to a new diet. He was used to eating fine meals, but all he had on Jeju Island was millet and soybean paste. It took several months for food items to be transported to Jeju Island, and any food his wife sent became inedible by the time it arrived, as indicated in this letter:

I received the letters and gifts you sent me. The summer clothing you made for me in spring finally arrived in winter. I never got to wear it so I have laid it next to me and arranged it like a folding screen. The precious food you saved for me has perished because of mold. It reminded me of your smooth forehead.[5]

Gim's wife died during his third year in exile. His last letters to her are filled with sorrow and concern. For example, he asked his wife what kind of medicine she had been taking and advised her to seek help and not to stay alone. Such intimate and vulnerable conversations cannot be found in any other letters written by Gim. Letters to his sons and friends, for example, were written in classical Chinese; in these, Gim preferred to discuss

philosophical questions, the situation of the kingdom, and his artistic interest in objects, calligraphy, and painting styles.[6]

Gim Jeonghui's letter to his daughter-in-law, written in the same cursive *hangeul* style as the artist's letter to his wife, survives with its original inscribed envelope intact.

In the late Joseon dynasty, much writing in *hangeul* script was discriminated against and regarded as inferior to writing in *hanja*. The quality and excellence of writing was measured by how well a copy was made from an existing Chinese calligraphy style. Furthermore, women, who were excluded from political activities, rarely learned how to read and write in *hanja*.

With this in mind, both Gim's Chusache script and his *hangeul* writings were out of the ordinary. When collector Kim Ilgeun published Gim's *hangeul* letters for the first time in 1979, scholars were mesmerized by how the writing resembled the Chusache script but embodied a different spirit.[7] Gim's *hangeul* script not only shows his empathy and love for his family, but is also based on his dynamic and curved strokes, grounded in his previous affection for seal (*jeon*) and semi-cursive (*haeng*) script calligraphy. Like the Chusache script, which reflected Gim's struggles during exile, Gim's *hangeul* script is composed of strong, willful strokes and is decidedly different from the majority of contemporaneous quadratic and quiet *hangeul* texts. Gim's *hangeul* writing is considered a culmination of his passion for scholarship and his artistic goal to invent a new writing style that would reflect a specific Korean aesthetic of the time.[8]

NM

1
Kim Kyungsoon, "Chusa Gim Jeong Hui ui hangeul ganchal gwa hanmunseoye wa ui sanggwanseong" [The interrelationship of the *hangeul* letters and Chinese calligraphy characters written by Gim Jeonghui], *Seoyehak yeongu* [Journal of calligraphy research] 7 (2005): 64—93.

2
Ibid.

3
Kim Kyungsoon, "Chusa Gim Jeong hui ui Hangeul Pyeonji Hedok gwa Uimi" [The meaning and interpretation of three letters of Chusa Gim Jeonghui], *Eomun yeongu* [Journal of text/calligraphy research] 75 (2013): 5—31.

4
Ibid.

5
Translated by Natalie Mik.

6
Kim, "Chusa Gim Jeong hui ui Hangeul Pyeonji Hedok gwa Uimi," 5—31.

7
Park Jeongsook, "Chusa Gim Jeonghui Hangeul Seogan Seoyemi ui Byeoncheonsajeok Gochal" [The conversation: A study on the history of the changes of the calligraphic aesthetics of Chusa Gim Jeonghui's *hangeul* letters], *Hanguk Johyeong Gyoyughak Journal* 49 (2014): 181—221.

8
Ibid.

GIM JEONGHUI
김정희
金正喜
1786—1856

The Self Becomes Buddha
자신불
自身佛

Joseon dynasty, 19th c.
Hanging scroll; ink on paper
54⅛ × 8½ in. (137.5 × 21.5 cm)
Gim Gyuseon Collection, Seoul

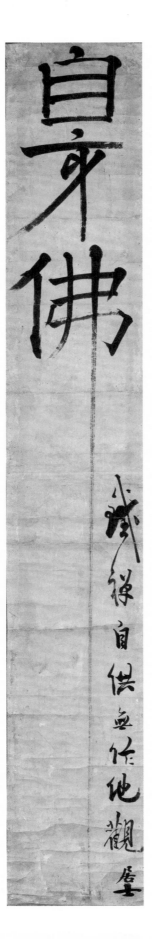

Gim Jeonghui was not only a scholar-official, calligrapher, and epigrapher, but also a practicing Buddhist with a wide knowledge of Buddhist philosophy, teachings, and texts.[1] His Buddhist writings indicate that he was a follower of the Seon (Ch. Chan; J. Zen) school of Buddhism, which was first established in Korea during the Unified Silla dynasty.

The artist's dedication to Buddhist practice is indicated in two ways in this calligraphic work: both in the content of the main text and in Gim's signature. A hanging scroll in ink on paper, the work presents three large *hanja* characters written in standard script with features slightly reminiscent of clerical script (for example, the characters' square, architectonic structure), reading, *Jasin bul* (Ch. *Zi shen Fo*), which can be translated as "The self becomes Buddha," or "One's own body is the Buddha."[2] This conveys an ancient Seon Buddhist concept: namely, that each individual human self is already enlightened, but that realization of this truth is obscured by the mind being clouded by delusions and mired in the web of samsara (the web of existence, governed by the endless cycle of birth, life, death, and rebirth, all conditioned by one's karma).[3] The three large characters dominate the upper third of the scroll's surface, with the final vertical stroke in the last character (Buddha) drawn all the way to the bottom of the scroll in a bold and determined gestural sweep of the brush. Along the lower right border is the artist's note, written in smaller running-script characters; it reads, "In the iron [discipline] of Seon one offers oneself as an offering [in worship]; [in this way] without doing [anything one achieves] another perspective [on enlightenment]." This is followed by the artist's signature, reading, *geosa* (lay follower), further indicating Gim's status as a lay Buddhist.

SL

1
For other examples of Gim's Buddhist writings, see cats. 81 and 82; see also Gim's transcription of the Heart Sutra, published in *A Great Synthesis of Art and Scholarship: Painting and Calligraphy of Kim Jeong Hui*, exh. cat. (Seoul: National Museum of Korea, 2006), 26—31, cat. 7.

2
Published in Lee Dongkook, *Chusa Kim Jeonghui, Wuseong Kim Chong Yeong*, exh. cat. (Seoul: Hakgojae Gallery, 2015), 60—63, 187.

3
This sentiment is similarly expressed in the early twentieth-century calligrapher Gim Gyujin's hanging scroll *Mind Itself Is Buddha*, for which see cat. 106.

HEO RYEON
허련
許鍊
1809—1893

Ink Rubbings of Wandang's Works

김정희 작품 탑본첩
阮堂拓墨

Joseon dynasty, 1877
Album of ink rubbings; ink on paper
Each page: 10⅛ × 6⅛ in. (25.7 × 15.6 cm)
National Museum of Korea, Seoul, Lee Hungkun
Collection

Heo Ryeon created this album honoring
his teacher Gim Jeonghui (1786—1856)
nearly two decades after Gim's death.[1]
Printed from carved wooden blocks, the
album's pages include reproductions of
both paintings and calligraphy. Heo came
from a modest background and yet
became one of Gim Jeonghui's most
favored and accomplished students. Gim
gave Heo his sobriquet, or artistic
nickname, Sochi (Little Fool), in honor of
Heo's admiration for the Chinese Yuan

dynasty master Huang Gongwang (1269–1354), whose sobriquet was Dachi (Big Fool). Gim is said to have stated, "In the past, there was Huang Gongwang and now there is Heo; Heo's painting is outstanding."[2]

The album's first page bears a title, *Wandang takmuk* (Ink rubbings of Wandang's works), written in clerical script. Wandang (Wan Hall) was one of Gim Jeonghui's sobriquets and was based on the surname of the Chinese epigrapher (and one of Gim's artistic heroes) Ruan Yuan (K. Wan Won; 1764–1849). At the lower left is a small self-portrait of Gim wearing a rain hat, with a title, *True Reflection [Portrait] of Master Wandang*, written in standard script. Heo Ryeon's short inscription at the upper left is written in running script and states that Gim painted the self-portrait during his exile on Jeju Island (1840–48). It concludes with the suggestion that this image of Gim resembles "the offender of the Yuanyou [reign, 1086–1094]"; this is a clear reference to the Chinese Northern Song dynasty poet Su Shi (Su Dongpo: 1037–1101), whom Gim also admired, and who was similarly exiled because of disagreements with policies promulgated by powerful rivals at court.

The second page bears an image of an orchid and is copied from one of Gim's own paintings. The orchid is especially significant in this context: it was an ancient East Asian symbol of upright officials whose advice was ignored by their rulers, and who were slandered by their rivals.

The third and fourth pages present a calligraphic text written in running script by Heo Ryeon, which is a paean to Gim Jeonghui. This text reads:

Master Wandang was of the heavenly class, manifesting extreme preeminence. [I have] followed his essays and calligraphies ["brush and ink"] in order to imitate [him]. It was not the sort of thing that any villager could climb [to his level] and overtake him. It was when I, as a lowly person, came from a distant town and in past years…was summoned [to visit him], that I first entered his Pavilion of Bongnae [Ch. Penglai; Isle of the Immortals], and from morning until night received instruction from him. From beyond the sea [in exile], he wrote poems by day, [always] chanting whether going or coming. Even in the depths of his isolation and loneliness, he could still listen to and discern the [music of] the heavenly sphere. From time to time one would see him unrolling paper and pouring out ink, and as for his use of the brush [as a calligrapher], out of emptiness he would manifest extremes of [both] thick and slender [brushwork], all the while preserving subtle principles. [His calligraphy] resembled a withered pine covered with ancient vines, young dragons coiling and mature dragons winding, like [the inscriptions] on ancient [bronze ritual] vessels and tripods, like clouds and thunder, transmitting [vital] transformations without exhaustion— his divine transformations were unfathomable. How dare he achieve [such] fame, how dare he [master such] forms? Now that my hair is white, many are those who travel from afar to obtain and see the master's ink [calligraphy], over and over. [Thus have I] published ink rubbings from wooden [blocks], so that both the refined and vulgar [that is, everyone] can take joy [in Gim's writings]. For those masters who practice calligraphy yet who resist "facing the pond" [referring to the late Han dynasty calligrapher Zhang Zhi,

who practiced calligraphy so incessantly by a pond that the water turned black from his ink], they can follow these carved [woodblock ink rubbing] copies, thus seeking his traces and his divine [achievements]. Even though these rubbings cannot compare with the Tang [dynasty] copies of the Jin [dynasty masters—for example, Wang Xizhi and Wang Xianzhi]—still these authentic traces can encourage discussion. For those who have never known generous-minded eyes, I say, what better than these [ink rubbings]? In the cyclical year *jeongchu* [1877], on the double ninth [the ninth day of the ninth lunar month], respectfully recorded by the student Heo Ryeon, the Little Fool.[3]

In many ways this album appears to have been meant more as an homage to Gim Jeonghui than as a facsimile of Gim's work. Nonetheless, the album speaks to the continuing influence of Gim's oeuvre several decades after his passing and reflects the deep admiration later generations had for this gifted scholar, who maintained his moral integrity despite his years of political struggle and exile.

SL

1
For an example of Heo Ryeon's calligraphy, see cat. 67. Heo's *Ink Rubbings of Wandang's [Gim Jeonghui's] Works* is published in *A Great Synthesis of Art and Scholarship: Painting and Calligraphy of Kim Jeong Hui*, exh. cat. (Seoul: National Museum of Korea, 2006), 328–30, cat. 90.

2
Quoted in Jane Portal with Suhyung Kim and Jee Jung Lee, *MFA Highlights: Arts of Korea* (Boston: Museum of Fine Arts, 2012), 122.

3
Translation by Stephen Little.

92

Stele Commemorating the
Enshrining of the Amitabha Statue
at Mujangsa
무장사 아미타불 조상비
鍪藏寺阿彌陀佛造像碑

Unified Silla dynasty, ca. 801
Stone stele fragments
Stele fragment: 13¼ x 10⅛ in. (33.9 × 25.8 cm)
National Museum of Korea, Seoul
Not in exhibition

The *Stele Commemorating the Enshrining of the Amitabha Statue at Mujangsa* (ca. 801) was erected at the Mujangsa (Mujang Temple) in Gyeongju, capital of the Unified Silla dynasty, on the occasion of the enshrining of a sculpture of the Buddha Amitabha (K. Amita Bul) by Gyehwabuin, queen consort of King Soseong (r. 799—800). The story behind the establishment of the statue and a commemorative stele at Mujangsa is recorded in the *Samguk yusa* (Memorabilia of the Three Kingdoms; compiled in 1281—83 during the Goryeo dynasty). According to this text, after King Soseong died, Gyehwabuin commissioned a statue of Amitabha, Buddha of the Western Paradise, and a memorial stele to commemorate the king's passing.[1] With the fall of the Unified Silla dynasty, the Mujangsa became dilapidated and the stele was destroyed, but during the late Joseon dynasty and subsequent Japanese Colonial era, several fragments of the stele were discovered.[2] This was a significant discovery in the history of East Asian calligraphy, as the stele's inscription was much admired for its aesthetic qualities and was close in style to calligraphic works by and attributed to Wang Xizhi (307—365), the most famous calli-grapher in Chinese history. Despite this, the calligrapher of this stele remains unknown.[3]

The first fragment of the missing stele was found in 1770 by the renowned Joseon dynasty epigrapher Hong Yangho (1724—1802). In his book *Igyejip* (The literary works of Igye [Hong Yangho]; 1843), he wrote,

> When I was serving as a mayor of Gyeongju, I heard from an old man that there was a stele that was engraved with the calligraphy of Gim Saeng [711—?] at the Mujangsa, but it was lost.[4] I sent a servant and searched for the stele, and the servant found a stone fragment. I told him to bring me ink rubbings of it, which I then read. It was a fragment of the *Stele of Documents on the Amitabha Statue at Mujangsa*, and the calligraphy was written by Gim

GIM JEONGHUI
김정희
金正喜
1786—1856

Ink Rubbing of an Inscription of the Documents on the Amitabha Statue at Mujangsa

무장사 아미타불 조상비기에 대한 김정희의 논평을 탑본한 것

鍪藏寺阿彌陀佛造像碑搨本

Joseon dynasty, 1815
Ink rubbing; ink on paper
13¾ × 9¼ in. (34.8 × 23.3 cm)
National Museum of Korea, gift of Nakamura Ginya and Ikeda On

9 3

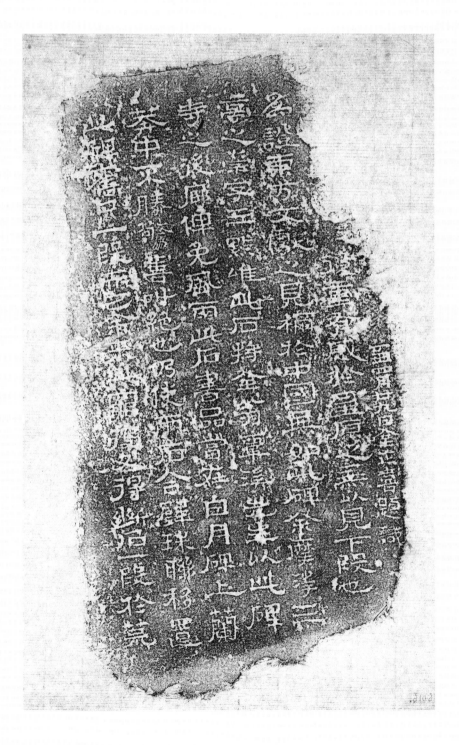

Yukjin [Gim Saeng] of [Unified] Silla, following the style of Wang Xizhi [307—365]. Its value is comparable to the Stone Drums of Qin [Seokgomun; fifth century BCE]."[5]

During a visit to Beijing in 1810, the great late Joseon calligrapher Gim Jeonghui showed an ink rubbing of this fragment to the Chinese epigrapher Weng Fanggang (1733—1818), at which point Weng and his son Weng Shukun (1786—1815) asked Gim to search for other parts of the stele.[6] In 1817, after he returned from China and forty-seven years after Hong Yangho's initial discovery, Gim explored the mountain where the Mujangsa site was located near Gyeongju and found a second fragment of the stele. After this discovery, Gim had two notes carved onto the sides of the fragments. In the note carved on the left side of the first fragment, he wrote,

> [Originally] only one fragment of the stele existed. I thoroughly searched the decayed temple site and was thrilled to find another piece. I gathered the two pieces and put them in an old building near the temple site. The calligraphy on this stele is better than that of the *Stele for Buddhist Monk Nanggong.*[7] The shape of the character *sung* appeared three times in the *Nanjeongseo* [*Orchid Pavilion Preface;* 353] written by Wang Xizhi[8] and is intact only on this stele. Weng Fanggang used it to ascertain the style of Wang Xizhi, and no other documents of Korea could be appreciated in China as much as this stele. I am deeply saddened by the fact that Weng Shukun did not live to see this. On the twenty-ninth day of the fourth month of 1817, recorded by Gim Jeonghui.

In another note that was carved onto the right side of the fragment Gim Jeonghui discovered, he wrote, "This is the left part of the stele. How can I bring Weng Shukun back to this world and celebrate our friendship connected by the epigraphy? On the day that I found this, I made the rubbing and wrote this."[9] Gim Jeonghui and Weng Shukun were close friends, but Weng Shukun never saw the second stele fragment, as he had passed away two years before Gim Jeonghui's

GIM JEONGHUI

김정희

金正喜

1786—1856

Ink Rubbing of an Inscription of the Documents on the Amitabha Statue at Mujangsa

무장사 아미타불 조성기비에 대한 김정희
의 논평을 탑본한 것

鍪藏寺阿彌陀佛像造成記碑附記搨本

Joseon dynasty, 1817

Ink rubbing; ink on paper

13¾ × 10¼ in. (33.9 × 25.8 cm)

National Museum of Korea, gift of Nakamura Ginya
and Ikeda On

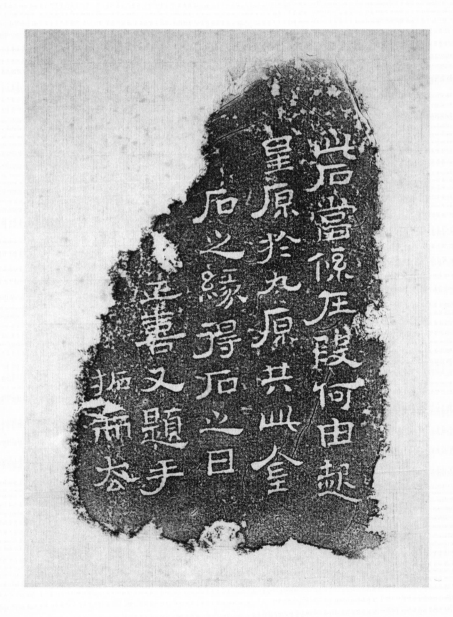

discovery. Gim Jeonghui expressed his deepest condolences by leaving these notes on the stele.[10]

Since the part of the stele inscription that specified the name of the original calligrapher was seriously damaged, there have been controversies surrounding the calligrapher's identity among Korean, Chinese, and Japanese epigraphers from the late Joseon dynasty to the present. Weng Fenggang concluded that the inscription was composed of elegant semicursive–script characters collected mainly from Wang Xizhi's famed *Orchid Pavilion Preface*. He wrote,

> Since the Tang dynasty, individual characters were collected from the calligraphy of Wang Xizhi, to be compiled and integrated into a single piece of writing.[11] People in other countries learned how to do this as well. The characters used in the stele are all identical [in style] to the characters in the *Nanjeongseo* [*Orchid Pavilion Preface*].

Weng Fanggang's son Weng Shukun also said that he "acquired two hundred and eighty–three excellent characters of Wang Xizhi from a stele fragment of Silla."[12] This theory was further promoted by the Japanese epigrapher Sueharu Katsuragi during the Japanese Colonial period, based on the similarities between the characters on the stele and those appearing in the calligraphic works by Wang Xizhi.[13] The Japanese colonial government was enthusiastic about collecting inscriptions in Korea, and Japanese scholars found an additional fragment of the stele in 1914, though this data did not add any information about the calligrapher.[14]

On the contrary, Hong Yangho and Gim Jeonghui believed Gim Yukjin (Gim Saeng) of the Unified Silla dynasty wrote the stele inscription. According to a record by Weng Fanggang, when Gim Jeonghui gave him a rubbing of the fragment, the latter said the original stele was written by Gim Saeng of the Unified Silla period.[15] Later, Gim Jeonghui agreed with Weng Fanggang's identification, saying, "The calligraphy on the stele is not composed of collected characters," adding that "Gim Yukjin [Gin Saeng] was from the late Silla period."[16]

Regardless, it is significant that most epigraphers today agree that the characters were not collected from Wang Xizhi's calligraphic works. In particular, many legible characters on the stele do not appear in the extant writings of Wang Xizhi. In a restoration project conducted by the Korean government in 2009, some characters were newly clarified; one of them was *sa* (temple), written below the *hanja* characters *hwangryong*, which completes the phrase Hwangryong Temple, the name of the largest temple of the Unified Silla dynasty. Based on this discovery and several other reasons, a new argument that the stele inscription was written by a monk of this temple has been accepted as another plausible hypothesis.[17] Since many questions about the history of calligraphy in Korea, China, and Japan could be solved by clarifying the identity of the calligrapher of the *Stele Commemorating the Enshrining of the Amitabha Statue at Mujangsa*, it is still regarded as one of the most important research topics among scholars from all three countries.

EY

1

Iryeon, comp., *Samguk yusa* [Memborabilia of the Three Kingdoms], trans. (into Korean) Kwon Sangro (Seoul: Dongsuh Munhwasa, 2007), 300.

2

These fragments and their inscriptions are transcribed and published in *A Great Synthesis of Art and Scholarship: Painting and Calligraphy of Kim Jeong Hui,* exh. cat. (Seoul: National Museum of Korea, 2006), 292—93, cat. 77.

3

Lee Eun-Hyuk, "Mujangsabiwa wanghuijicheui daebigochal" [A comparative study between the Mujangsa Stele and Wang Xizhi's texts], *Hanguk jeontong munhwa yeongu* [Journal of cultural heritage] 12 (2013): 175.

4

Gim Saeng was the most famous calligrapher of the Unified Silla dynasty; see cat. 17.

5

The Stone Drums of Qin, dating to the Spring and Autumn period, are the oldest-known stone-carved inscriptions in China; see Gilbert L. Mattos, *The Stone Drums of Ch'in,* Monumenta Serica Monograph Series, 19 (Nettetal, Germany: Steyler Verlag, 1988).

6

Lee Eun-Hyuk, "Mujangsabiwa wanghuijicheui daebigochal," 177—78.

7

A stele whose characters were compiled from surviving calligraphies by Gim Saeng; see cat. 17.

8

Nanjeongseo is the most famous calligraphic work inscribed by the Eastern Jin dynasty (fourth-century) calligrapher Wang Xizhi.

9

Choi Youngsung, "Chusa geumseokhagui jaejomyeong: Sajeok gojeung munjereul juanmogeuro" [Reinterpretation of Chusa's epigraphy: Centered on the issue of a historic research], *Dongyanggojeonyeongu* [The study of the Eastern classic] 29: 254.

10

Lee Jongmun, "Mujangsabireul sseun seoyegae gwanhan gochal" [A survey on calligrapher of Mujangsa Temple monument], *Nammyeonghag-yeongu* [Journal of Nammyonghak studies] 13 (2002): 229.

11

A famous example of this practice is the *Jipwangseonggyoseo* [Ch. Jiwang shengjiao xu; Preface to the sacred teachings on Wang Xizhi's handwriting, 672], a preface composed by the Tang emperor Taizong on the sutras translated from Sanskrit into Chinese by the monk Xuanzang; see Ouyang Zhongshi et al., *Chinese Calligraphy* (New Haven: Yale University Press, 2008), 207.

12

Choi, "Chusa geumseokhagui jaejomyeong: Sajeok gojeung munjereul juanmogeuro," 255—56.

13

Katsuragi Sueharu et al., *Joseongeumseokgo* [Epigraphs in Joseon dynasty] (Gyeonggi-do: Aseamunhwasa, 1979), 230—31.

14

Lee Jongmun, *Hanmungojeonui siljeungjeok tamsaek* [An empirical quest for Hanmun classics] (Daegu: Keimyung University Press, 2005), 265.

15

Lee, "Mujangsabiwa wanghuijicheui daebigochal," 177—78.

16

Ibid., 179—80. See also the discussions of this stele in Lee, "Mujangsabireul sseun seoyegae gwanhan gochal."

17

See Choi Youngsung, "Silla mujangsabiui seoja yeongu" [A study on the calligrapher of the monument of Silla's Mujangsa Buddhist temple], *Sillasahakbo* [Journal for the studies of Silla history] 20 (2010): 179—218.

Gim Jeonghui's Inkstone

김정희 벼루

Joseon dynasty, 19th c.
Slate
1 × 7¼ × 4¼ in. (2.4 × 18.3 × 10.7 cm)
National Museum of Korea, Seoul, National
Treasure no. 547—1
Not in exhibition

Before its 1976 acquisition by the National Museum of Korea, this inkstone was passed down as an heirloom through Gim Jeonghui's family in Yesan, South Chungcheong Province. Such stones were used by calligraphers and painters as palettes on which to grind ink sticks or cakes into water, thus creating ink. An unusual aspect of this inkstone is that both its upper and lower surfaces can

be used to grind ink. Like most inkstones, this example has a beveled indentation at its center, with a deeper depression to one side in which the liquid ink pools.

The inkstone's upper surface is incised with a poem by Gim in elegant, measured clerical script. The calligraphic style of the inscription is radically different from that of Gim's better-known works in the so-called Chusa style (see, for example, cat. 86); rather, it is close in style to the inscriptions Gim carved into fragments of the Unified Silla *Stele Commemorating the Enshrining of the Amitabha Statue at Mujangsa* (cat. 94), which had been discovered by Hong Yangho (1724—1802) in 1770 and by Gim in 1817. The ink-stone's inscription reads,

> Is it a stone from Hongnong?[1]
> Is it a roof tile from Tongque?[2]
> Polished and rubbed,
> It is a gentleman's treasure.
> Like the bamboo of the Zhan Garden,[3]
> Like the bracken of Shouyang.[4]
> Reliable and strong,
> Esteemed by gentlemen.
> Bright are its "brush-flowers,"[5]
> Elegant are the paintings and literary
> [works that emerge from its ink].
> Like four walls and a foundation,
> It is the superior man's friend.[6]

The text suggests that Gim Jeonghui was a connoisseur of inkstones and their lore, while the inkstone's rubbed edges and chipped corner are evidence of Gim's simple yet elegant taste in writing implements.[7]

SL

1
Hongnong is a city in China's Henan Province known for its inkstones.

2
Tongque is a site in China's Henan Province associated with the ancient Zhou dynasty hermits Bo Yi and Shu Qi; Han dynasty roof tiles from Tongque were often made into ink palettes.

3
The Zhan Garden was one of the Ming dynasty calligrapher Mi Wanzhong's three gardens outside of Beijing; see Philip K. Hu, "The Shao Garden of Mi Wanzhong (1570—1628): Revisiting a Late Ming Landscape through Visual and Literary Sources," *Studies in the History of Gardens and Designed Landscapes* 19, no. 3—4 (1999): 314—42.

4
A city in Shanxi Province.

5
That is, the written products of the inkstone's ink.

6
Translation by Stephen Little.

7
See the classic study on inkstones by Mi Fu (1051—1107), translated in Robert H. van Gulik, *Mi Fu on Inkstones* (1939; repr., Singapore: Orchid Press, 2006).

THE EARLY MODERN PERIOD

The establishment of the Korean Empire marked the end of a more than five-hundred-year dynasty. Although the empire lasted only four years, the change jump-started rapid modernization guided by Western ideals, which continued while the country was colonized by Japan for over three decades. During this time, *hangeul* became transformed into a beacon of nationalism, and the way the nation communicated its news to the populace was through the modern-day newspaper. While calligraphers like O Sechang and An Jungsik explored archaic styles to find meaning in the present, the political use of language reached its peak in the last few hours of a determined martyr sentenced to death by the Japanese authorities. Despite the instability of these decades, this period witnessed the beginnings of modernization and modernity as unique to Korea— the as-yet single, undivided peninsula.

96

O SECHANG
오세창
吳世昌
1864—1953

Inscriptions on Roof Tiles and Bronze Vessels
오세창이 쓴 기와 벽돌 금속에 새긴 글씨

1925
Ten-panel folding screen; ink on paper
Each panel: 48⅜ × 11½ in. (123.5 × 29 cm)
National Museum of Korea, Seoul

O Sechang was a politically active scholar, journalist, epigrapher, calligrapher, and official interpreter. Much of his life was devoted to exploring the early history of both Korean and Chinese calligraphy. O's life spanned the late Joseon dynasty, the Korean Empire and Japanese Colonial periods, and the years leading up to and including the Korean War (1950—53).[1] His father, O Gyeongseok (1831—1879), was also a professional interpreter, as well as a collector and connoisseur of antiquities who traveled to China more than a dozen times. O Sechang is best known today as a master of seal script (*jeonseo*) and a major scholar of both calligraphy and painting.

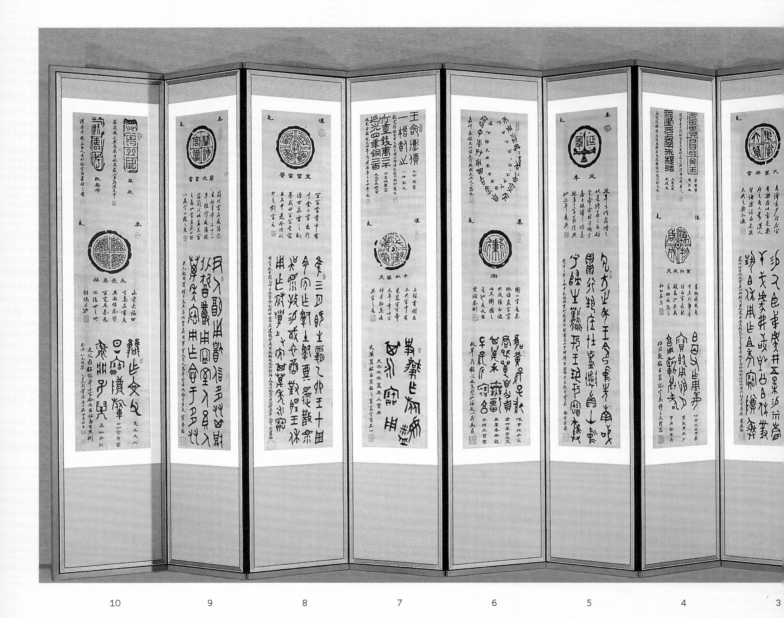

10 9 8 7 6 5 4 3

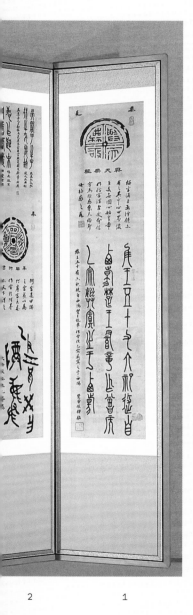

Twenty-nine inscriptions cover the surface of the folding screen shown here. The screen's ten panels present a series of copies by O Sechang of inscriptions on ancient Zhou dynasty ritual bronzes, and on Qin and Han dynasty ceramic eave tiles.[2] The sources for the majority of O Sechang's transcribed texts were late Qing dynasty woodblock-printed illustrated books containing images and explanations of ancient bronze and clay inscriptions. Ten of the screen's transcribed bronze inscriptions were copied from the late Qing dynasty epigrapher Ruan Yuan's (1764—1849) *Jigu zhai zhongding yiqi kuanshi* (Recorded inscriptions on ritual vessels, bells, and *ding* [tripods] from the Studio of Accumulated Antiquities, 1804), printed in Beijing in 1804.[3] This book was well known in late Joseon Korea, and was studied by Gim Jeonghui (1786—1856), who had personally known Ruan Yuan and was one of O Sechang's inspirations as an epigrapher (see cats. 80—95). Other bronze inscriptions O replicated on this screen appear to have been copied from such late Qing illustrated epigraphical compilations as Liang Shizheng's *Xi Qing gujian* (Ancient mirrors of the Western Qing; 1755), Feng Yunpeng's *Jinshi suo* (On bronze and stone; 1811), and Lü Diaoyang's *Shang Zhou yiqi shiming* (Inscriptions on Shang and Zhou ritual vessels; 1888).

The bronze inscriptions copied and annotated here range in date from the Western Zhou through the Han dynasty. Among the many inscriptions is one cast into a bronze bell made for Marquis Yi of Zeng (Zeng Hou Yi, ca. 430 BCE; bottom of panel 1); an inscription cast into a bronze sword made for Ji Zha of the late Spring and Autumn period (top of panel 2); numerous Western Zhou dynasty ritual-vessel inscriptions (including one from a bronze *dui* vessel dating to the reign of the Zhou king Mu [Muwang; r. ca. 976—922 BCE, bottom of panel 4]); and inscriptions dating to the Eastern Zhou and the early Han dynasty. Many ancient Chinese bronze vessel types are also represented among the screen's inscriptions, including a *ding* tripod, a square (*fang*) *ding*, a *you*-handled jar, a *zun* beaker, a *he* kettle, a *hu* jar, a *lei* jar, a *xi* water basin, and a *fu* dish.

The screen demonstrates O Sechang's wide-ranging knowledge of early Chinese history and *hanja* epigraphy. Each inscription is meticulously reproduced and then transcribed into clerical, standard, or running script, and many are accompanied by short commentaries on the work's overall calligraphic style or the derivation and variants of individual *hanja* characters contained therein. In addition, each inscription is accompanied by one of O Sechang's seals, several of which are inspired by archaeologically discovered objects, such as a seal in the shape of a round Han dynasty eave tile (top of panel 8), and another in the shape of a round Han dynasty coin with a square perforation (top of panel 10).

The second example of O Sechang's calligraphy is an eight-panel screen. Each half of the screen presents a discrete text: the right half features an account of the Tang poet Bai Juyi's (772—846) Thatched Hall on Mount Lu, while the left half bears an account of a residence of the Chinese Yuan dynasty painter, calligrapher, poet, collector, and musician Ni Zan (1301—1374). Both texts describe the inner and outer environments of the respective individual's dwellings. The calligraphy on both screens demonstrates O Sechang's superb mastery of large seal script. The individual characters' bold architectonic structures are influenced by O's study of earlier Chinese seal-script masters of the Tang through Ming dynasties (for example, Li Yangbing [eighth century] and Li Dongyang [1447—1516]). The characters also reveal O's awareness of the revival of classical large seal script practiced by such late nineteenth- and early twentieth-century masters as Wu Changshi (1844—1927).[4]

The first passage, on the screen's right half, is a quotation from Bai Juyi's text *Record of the Thatched Hall on Mount Lu* (composed in 817), which describes the poet's ideal mountain retreat. The section quoted by O Sechang reads:

> Inside the hall are four wooden couches, two plain screens, one lacquered *qin* [zither], and several Confucian, Daoist, and Buddhist books, two or three of each kind.

2 1

O SECHANG
오세창
吳世昌
1864—1953

Bai Juyi's Thatched Hall on Mount Lu and Ni Zan's Hall of Cloudy Forest
倪瓚雲林堂白居易廬山草堂

1939
Eight-panel screen; ink on paper
Each panel: 49¾ × 14 in. (126.5 × 35.6 cm)
Seokdang Museum of Dong-A University, Busan

And now that I have come to be master of the house, I gaze up at the mountains, bend to listen to the spring, look around at the trees and bamboos, the clouds and rocks, busy with them every minute from sun-up to evening. Let one of them beckon, and I follow it in spirit, happy with my surroundings, at peace within.

One night here and my body is at rest, two nights and my mind is content, and after three nights I am in a state of utter calm and forgetfulness. I don't know why it's like this, but it is.[5]

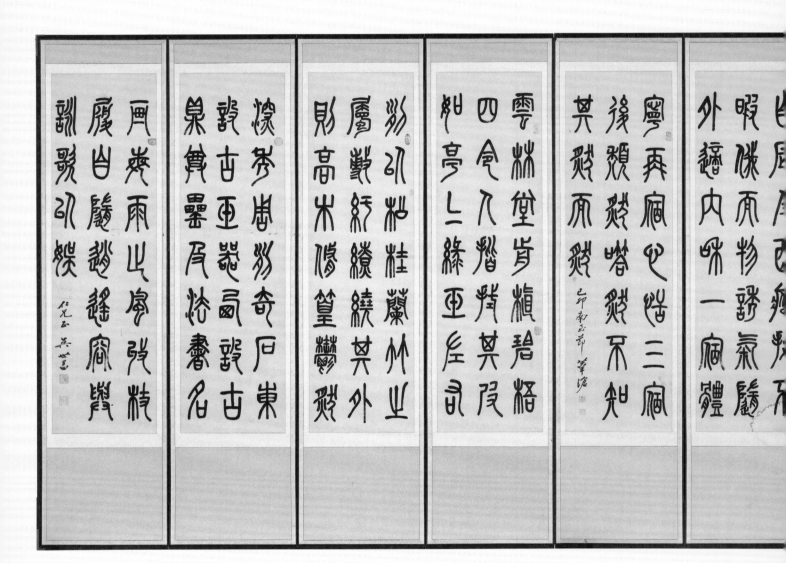

This is followed by a cyclical date corresponding to 1939, and O Sechang's signature, reading "Wichang" (the artist's sobriquet).

The second text, on the screen's left half, appears in the early Ming scholar Gu Yuanqing's (1487—1565) *Yunlin yishi* (Leftover affairs of Cloudy Forest)[6] and in the section on notes for maintaining peace and well-being in one's daily life in Gao Lian's (1573—1620) *Zunsheng bajian* (Eight discourses on the art of living) of 1591.[7] O Sechang's quotation from the original text reads:

> In front of the Hall of Cloudy Forest (Yunlin tang) are four blue-green *wutong* trees. [Ni Zan] caused people to clean off [the trees'] bark [and leaves] every day, so that the area above the hall looked like green jade. To the left and right were arranged pines, Osmanthus, orchids, and bamboo, a proliferation [of plants] twisting 'round and 'round in the wind. Beyond [the hall] were arranged tall trees and luxuriant bamboos, flourishing and profoundly elegant, and all around were marvelous stones. On the east side [of the hall] were ancient jade vessels; on the west were arranged ancient *ding*, *zun*, and *lei* ritual vessels, as well as calligraphies and famous paintings. Whenever the rain stopped and the wind changed [direction], and the branches would naturally move, he [Ni Zan] would pursue [the path of] "free and easy wandering,"[8] taking pleasure in chanting and singing.
> —For [my] elder brother's correction; O Sechang

Evidence of the depth of O Sechang's scholarship is embodied not only by his many surviving calligraphic works, but also by his groundbreaking biographical dictionary, *Geunyeok seohwajing* (Compilation of biographies of Korean calligraphers and painters), published in 1929 (based on an original manuscript completed in 1917). With its exhaustive bibliography and detailed quotations from earlier texts, this volume still presents one of the most useful and comprehensive histories of Korean calligraphy.[9]

SL

1
For a brief biography of O Sechang, see Hong Sunpyo, "O Sechang's Compilation of *Gunyeok sohwasa* (History of Korean painting and calligraphy) and the Publication of *Gunyeok sohwajing* (Biographical records of Korean painters and calligraphers)," *Archives of Asian Art* 63, no. 2 (2013): 155—63.

2
I am grateful to Einor Cervone for her research into the origins of the bronze inscriptions copied by O Sechang on this screen; her findings are incorporated into this entry.

3
See Fang Chao-ying's biography of Ruan Yuan in A. W. Hummel, ed., *Eminent Chinese of the Ch'ing Period*, 2 vols. (Washington, DC: U.S. Government Printing Office, 1943), 2: 399—402.

4
See, for example, Wu Changshi's seal-script calligraphy in Stephen Little et al., *New Songs on Ancient Tunes: Nineteenth—Twentieth Century Chinese Painting and Calligraphy from the Richard Fabian Collection*, exh. cat. (Honolulu: Honolulu Academy of Arts, 2007), 316—17, cat. 65d.

5
Translated by Burton Watson, *Four Huts: Asian Writings on the Simple Life* (Boston: Shambala, 1994), 8—9.

6
Published in Ni Zan, *Qing bi ge quan ji* [Complete (literary) works of the Pure Hidden Hall] (Taipei: Guoli zhongyang tushuguan, 1970), *juan* 11, 1b.

7
I am grateful to Wan Kong for her transcriptions of O Sechang's inscriptions on this pair of screens and for bringing these references to my attention.

8
"Free and Easy Wandering" is the title of the first chapter of the ancient Daoist classic, *Zhuangzi*; see Burton Watson, *The Complete Works of Chuang Tzu* (New York: Columbia University Press, 1968), 1—6.

9
O Sechang, *Geunyeok seohwajing* [Geunyeok's collection of calligraphy and painting] (Gyeongseong [Seoul]: Gyemyeong gurakbu, 1929).

AN JUNGSIK
안중식
安中植
1861—1919

Couplet in Seal Script
심전전서

心田篆書

Late 19th—early 20th c.
Pair of hanging scrolls; ink on paper
Each: 45⅝ × 11⅜ in. (116 × 29 cm)
Korea University Museum, Seoul

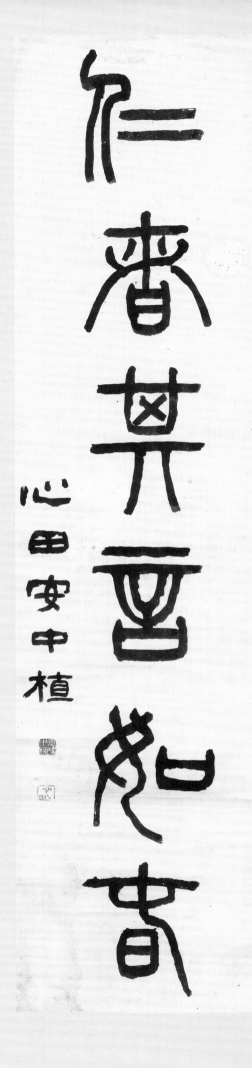

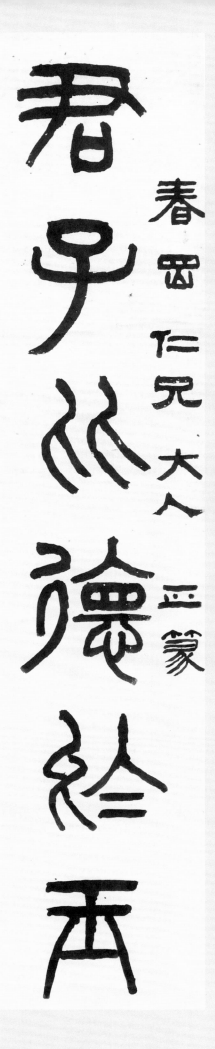

An Jungsik was a painter and calligrapher who became an inadvertent pioneer of Korean modern art as his life straddled the transitional period from the end of the Joseon dynasty to the start of the modern era.[1] He was a teacher to many notable students, including Go Huidong, Gim Eunho, Jang Seung-eop, and O Sechang (cats. 96, 97). An is known, along with colleague Jo Seokjin, for founding the Sohwa Misulhoe, the first modern art school in Korea for both calligraphy and painting. As he gained renown, An was asked to paint the royal portraits of King Gojong (r. 1897—1907) and King Sunjong (r. 1907—10), the two emperors of the Korean Empire period.[2]

An grew up in a military family, but when he was twenty years old he realized he was interested in becoming an artist and subsequently traveled to China and Japan to study. He was skilled in painting landscapes, people, and plants, as well as in calligraphy. In the latter art, he excelled in *haengseo* (semicursive script), *choseo* (cursive script), and *yeseo* (clerical script). The large size of his *hanja* characters and his broad brushstrokes are among the memorable characteristics of An's calligraphic style. Toward the end of his life, he mostly practiced calligraphy, and he left behind many works.

The pair of hanging scrolls shown here presents a couplet rendered in seal script; the text is taken from the ancient Chinese *Liji* (Book of rites), said to have been edited by Confucius:

> A gentleman's virtue is compared to jade,
> A benevolent man's speech is like
> a spring day.

The right-hand scroll bears a dedication to the couplet's recipient: "Seal script written for the correction of esteemed humane elder brother Chungang [Chungang was the alternate name of the scholar Go Jeongju (1863—1933)]." The left-hand scroll bears the artist's signature, written with both his style name and given name: *Simjeon An Jungsik*.[3] Both inscriptions, written along the scrolls' borders, were executed in clerical script.

The other work shown here is a horizontal panel that comprises four *hanja* characters written in seal script; these read, "Playing *gi* in a bamboo [grove]." *Gi* is the Korean

AN JUNGSIK
안중식
1861—1919

***The Sound of Playing* Baduk
*in a Bamboo [Grove]***
심전 안중식이 쓴 사언시
竹裏棋聲
Late 19th—early 20th c.
Horizontal scroll mounted as a panel; ink on paper
21 × 49¾ in. (53.3 × 126.4 cm)
Los Angeles County Museum of Art, East Asian
Art Council Fund, M.2009.59

pronunciation of the Chinese character *qi*, referring to the Chinese board game called *weiqi* (in Korea, *baduk*; in Japan, *go*). The earliest-known literary reference to the game dates to the fourth century BCE and is contained in the ancient Chinese text *Zuo zhuan* (The commentary of Zuo).[4] *Baduk* was introduced to Korea from China in either the late Three Kingdoms period or early Unified Silla dynasty (fifth—seventh centuries).[5] In this work by An Jungsik, the seal-script characters are tilted to the right, and the individual brushstrokes vary in width and speed, revealing his frequent use of the "flying white" stroke, in which the paper shows through the dragged brushstrokes.
VM/SL

1

For examples of An Jungsik's painting, see Hyunsoo Woo, ed., *Treasures from Korea: Arts and Culture of the Joseon Dynasty, 1392—1910*, exh. cat. (Philadelphia: Philadelphia Museum of Art, 2014), 284—85, cats. 5—5, 5—6.

2

Gim Jiyeon et al., *Hanguk yeokdae seohwaga sajeon* (*Dictionary of Korean Painters and Calligraphers through the Centuries*) (Daejeon: National Research Institute of Cultural Heritage, 2011), 1141—48.

3

Simjeon means "field of the heart."

4

Wikipedia contributors, "Go (game)," *Wikipedia, The Free Encyclopedia*, accessed April 2, 2018, https://en.wikipedia.org/w/index.php?title=Go_(game)&oldid=832139501.

5

Ibid.

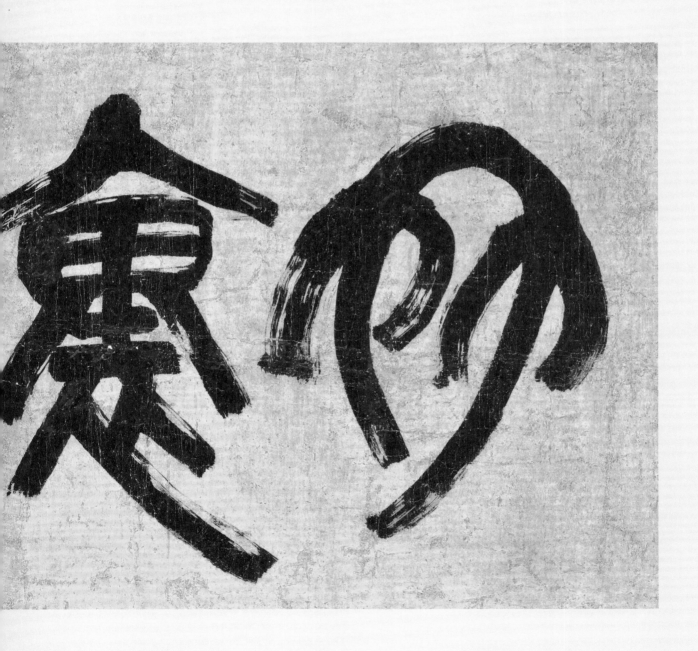

100

AN JUNGGEUN
안중근
安重根
1879—1910

Nothing Is More Painful than Overconfidence
고막고어자시
孤莫孤於自恃
1910
Ink on silk
15¾ × 29⅝ in. (39.8 × 75.3 cm)
Ilamgwan, private museum of Sin Seongsu,
Treasure no. 569–16

In 1909, a year before the official annexation of Korea by Japan, the Korean patriot An Junggeun assassinated Itō Hirobumi (1841—1909), the four-time prime minister of Japan and the first Japanese resident-general of Korea. The Eulsa Treaty between Japan and Korea, signed in 1905 at the end of the Russo-Japanese War, made Korea a protectorate of Japan. Increasing numbers of Koreans resented the obvious decline of the Joseon dynasty's royal court and Japan's increasing control of Korea's future. By 1907 An, who had previously devoted himself to education by establishing private

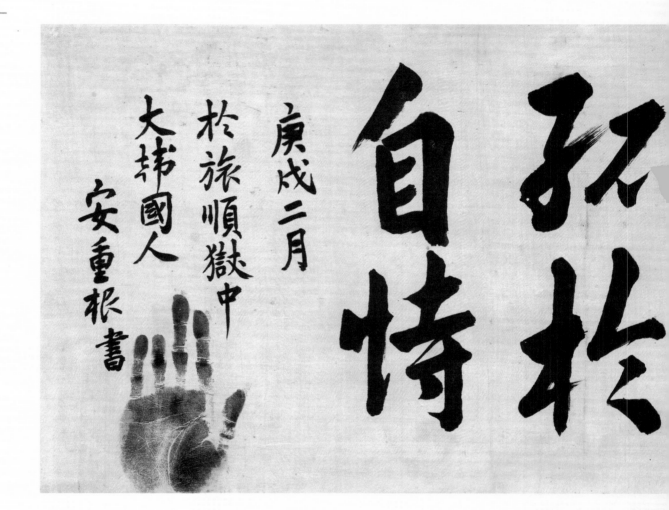

schools in Korea, had joined the armed resistance forces in Vladivostok, Russia, to fight the Japanese colonial rulers. It was at this time that An, along with eleven other compatriots, cut off one section (the distal phalanx) from his fourth finger, to express solidarity in seeking to avenge Itō's actions against Korea, which they felt were at the core of the nation's difficulties.[1] In 1909, after shooting Itō and three

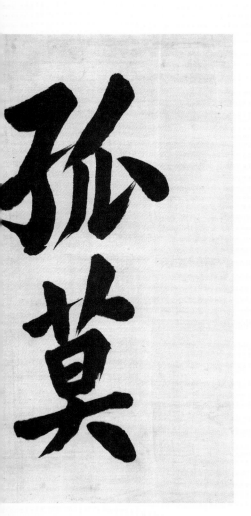

others at the Harbin railway station (in China's Heilongjiang Province), An was arrested by Russian guards and held for two days before being turned over to the Japanese colonial authorities, who sentenced him to death by hanging.

During the forty-day waiting period before his execution on March 26, 1910, An produced nearly two hundred calligraphies bearing his name. While only forty to fifty remain today, of which twenty-six are regarded as national treasures, his prolific work was intended for those he perceived to be his country's enemies. The resoluteness of An's character was such that court and prison administrators asked him for his works.[2] Each of these works was written in bold, assertive haengseo (semicursive or running script), reminiscent of the vigorous style of the Tang dynasty calligrapher Yan Zhenqing (709—785). Each calligraphic work is also accompanied by An's handprint, which functions as a kind of cipher or signature.[3]

It was a sense of profound righteousness that allowed An to assassinate Itō Hirobumi. The inscription on the work shown here reads, "Nothing is more painful than overconfidence" (*Gomakgo eo jasi*), a phrase from the *Book of Simplicity* (Ch. *Sushu*, K. *Soseo*; also known as the *Taigong bingfa,* or *The Grand Duke's Art of War*), a book on military strategy attributed to the ancient Chinese Qin dynasty hermit Huang Shigong (K. Hwang Seokgong).[4]

In 1962 An was posthumously awarded the Order of Merit for National Foundation, the highest, most prestigious award given by the South Korean government, for his sacrifice for Korean independence.

VM

1
"An Junggeun," New World Encyclopedia, accessed March 8, 2018, http://www.newworldencyclopedia.org/entry/An_Jung-geun.

2
Jeong Eunwoo et al., *Dong-a ui gukbo/bomul* [National treasures and treasures in the Seokdang Museum of Dong-A University] (Busan: Seokdang Museum of Dong-A University), 53.

3
Ibid.

4
On Huang Shigong's role in assisting in the foundation of the Han dynasty, see Burton Watson, trans., *Sima Qian, Records of the Grand Historian: Han Dynasty 1* (rev. ed.; New York: Columbia University Press, 1993), 100, 113.

FIGURE 78
Photograph of
An Junggeun

YU YEOL (RYU RYEOL)
유열
Active mid–20th c.
and
JEONG INSEUNG
정인승
1897—1986
***Cards with Diagrams of Hangeul
Mouth Movements***
한글 닿소리 홀소리 입꼴그림
1947
Ink on paper
Each: 17 × 24½ in. (43 × 62 cm)
National Hangeul Museum, Seoul

This set of cards with diagrams of *hangeul* mouth movements displays the appearance of the mouth and tongue when a speaker pronounces *hangeul* consonants and vowels. Instructions on how to pronounce a consonant or vowel are provided at the bottom of each accompanying diagram and photograph. This set consists of eleven cards. On the first card, under the title *Cards with Diagrams of Hangeul Mouth Movements*, the text reads: "Author: Yu Yeol; Copy editor: I Geukro; Recommended by: Joseon Language Society; Published by: Jungumsa." The second

card names each part of the mouth and features an anatomical drawing of the mouth. On the third card, the title "The Meaning and the Categorization of Consonants" appears above lists of *hangeul* consonants and explanations. The next five cards, with four consonants each, show different mouth shapes for each consonant. The ninth card explains the meaning of vowels and how they can be categorized, and the last two cards, with four vowels each, show the different mouth shapes for the relevant vowels.

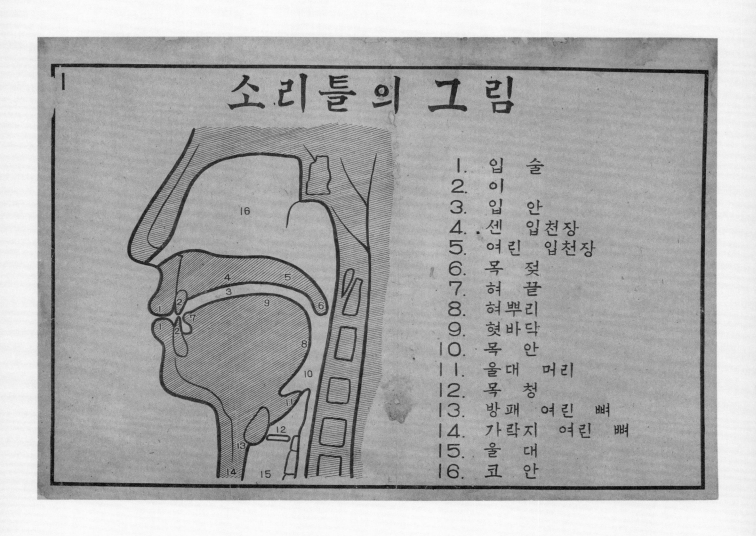

A note regarding this set of cards can be found in *The Book of Hangeul Sound,* published by Jungumsa in August 1947.[1] Written by Yu Yeol and Jeong Inseung, this picture book contains diagrams of the shapes of the mouth and vocal organs. It provides information on how *hangeul* sounds are composed and how to practice pronouncing them. The book is composed of three parts: a short introduction called "How to Teach," a section titled "Diagrams of How to Frame Sounds," and descriptions of the different parts of the vocal organs. In the

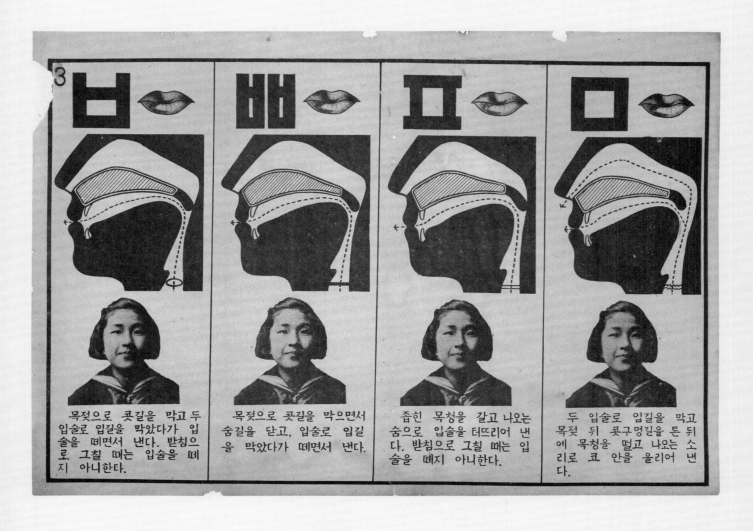

목젖으로 콧길을 막고 두 입술로 입길을 막았다가 입술을 떼면서 낸다. 받침으로 그칠 때는 입술을 떼지 아니한다.

목젖으로 콧길을 막으면서 숨길을 닫고, 입술로 입길을 막았다가 떼면서 낸다.

좁힌 목청을 갈고 나오는 숨으로 입술을 터뜨리어 낸다. 받침으로 그칠 때는 입술을 떼지 아니한다.

두 입술로 입길을 막고 목젖 뒤 콧구멍길을 튼 뒤에 목청을 떨고 나오는 소리로 코 안을 울리어 낸다.

introduction the authors reveal the purpose of the publication, stating, "This book is written to be used as a basic textbook for *hangeul* teachers. This book will help them teach the pronunciation of *hangeul* correctly to students. Teachers should make students learn about the sound of language before they start to learn how to read."[2]

In the body of the book, the authors emphasize the importance of using the diagrams of the shapes of the mouth, tongue, and vocal organs in teaching students how to pronounce the *hangeul* consonants, vowels, and their combinations. The book also recommends that teachers post the diagrams of *hangeul* mouth movements in their classrooms to help students learn more effectively.[3]

Yu Yeol was a prominent member of the Joseon ui Yeonguhoe (Society for the Study of the Korean Language), established in 1921. The main purpose of the society was to resist Japanese oppression of *hangeul* and to support its study and use. During its period of colonial rule in Korea, the Japanese government taught illiterate Koreans *hangeul*, to increase the efficiency of colonial control. At the same time, however, the Japanese discouraged the use of *hangeul* among the educated classes in Korea and forced them to use Japanese when they wrote documents or created literary works. Since the Japanese government marginalized *hangeul* and considered it only a vehicle for learning Japanese, the study of *hangeul* was severely controlled.[4]

In defiance of this oppressive policy, the linguists of the Joseon ui Yeonguhoe attempted to systematize the spelling of *hangeul* phonetic elements. They also established Hangeul Day on the anniversary of the 1446 publication of *Hunminjeongeum* (The Proper Sounds for the Instruction of the People; cat. 70) and coined the term *hangeul* to replace the derogatory term *eonmun* (sayings and writings), which was used at the time by the Japanese. The term *eonmun* had been used among Joseon dynasty scholars to refer to the Korean phonetic writing system. Because *hangeul* was considered by Confucian scholars to be inferior to *hanja* (Chinese characters), the term gradually obtained a negative connotation. Accordingly, the Japanese colonial government wanted to continue to use the term *eonmun* because they wanted the Korean public to regard their writing system as inferior, and not be proud of their own cultural heritage.[5] After the liberation of Korea in 1945, Yu worked as a lecturer at the Sejong Training Center for Advanced Hangeul Teachers, where he used his books as textbooks for classes. The set of cards shown here was likely used in those classes. During the same period, Yu joined the Disseminating Hangeul Culture Association and the Exclusive Use of Hangeul Association to participate in the movement toward reducing the use of *hanja* and enacting the Exclusive Usage of Hangeul Act. In his cards with diagrams of *hangeul* mouth movements, in elaborating the articulation of consonants and vowels based on modern phonetics, Yu intentionally used such *hangeul*–derived words as *soriteul* (to frame a sound) and *ipkkol* (mouth shape) instead of such *hanja*–derived terms as *balseonggigwan* (vocal organs) and *ipmoyang* (mouth form).[6]

EY/VM

1
Jeong Inseung and Yu Yeol, "Hangeulsoribon," Hanguk minjok munhwa daebaekgwa sajeon (Encyclopedia of Korean culture), accessed August 1, 2017, http://encykorea.aks.ac.kr/Contents /CategoryNavi?category=field&keyword=%EC%96 %B8%EC%96%B4&ridx=1013&tot=1089.

2
Ibid.

3
Ibid.

4
Ibid.

5
Ibid.

6
Ibid.

Korean Version of the Independent, Vol. 1, No. 96
"독립신문" 국문판 제1권 96호

Joseon dynasty, 1896
Ink on paper
Each page: 9¼ × 12 in. (23.5 × 30.3 cm)
National Hangeul Museum, Seoul

Dongnip Sinmun (*The Independent*) was the first private newspaper published in Korea. It was also the first newspaper published entirely in *hangeul,* with no use of *hanja* (Chinese characters). An English version was also published under the title the *Independent.* Edited by Seo Jaepil (1864—1951), the newspaper was first published on April 7, 1896.[1]

Seo was a founding member of the concurrently active Independence Club (Dongnip hyeophoe), a coalition of progressive elites, American missionaries, and activists formed at the end of the nineteenth century. It emerged in

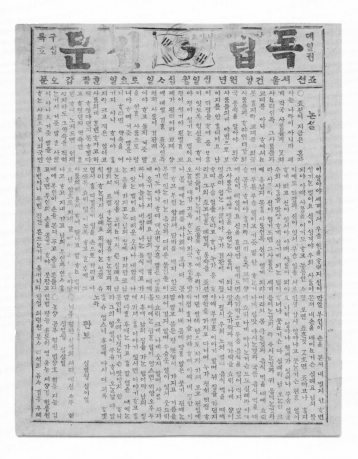

English Version of the Independent, Vol. 1, No. 102

"독립신문" 영문판 제1권 102호

Joseon dynasty, 1896
Ink on paper
Each page: 9⅛ × 12⅛ in. (23.1 × 30.8 cm)
National Hangeul Museum, Seoul

response to Korea's contested and uncertain political future, caused by the threat of colonization by Japan or the West. The Independence Club aimed to facilitate a modern, independent Korean nation-state, with *Dongnip Sinmun* as its mouthpiece. The group oversaw the construction of the Independence Gate and Independence Park, two monuments commemorating Korea's establishment as a sovereign state in 1897. It also formally proposed plans for a representative legislative assembly to the Korean national government; these plans were published in *Dongnip Sinmun*.[2]

The newspaper itself reveals the Independence Club's liberal and reformist attitude. The exclusive use of *hangeul* in *Dongnip Sinmun* was significant in that the ability to read *hanja* was strictly gated by gender and class. By contrast, the vernacular *hangeul* had been associated since its inception with the economically and socially marginalized. By publishing *Dongnip Sinmun* in *hangeul* alone, Seo intended to extend literacy and inclusion in public discourse to those historically barred from elite privileges, and to legitimize a previously castigated script.[3]

The last page of the four-page paper was published in English as part of efforts to reach the broader international community. Initially published every other day alongside the *hangeul* version, the English edition was later published only weekly. Like its *hangeul* counterpart, the English version included editorials, official bulletins, and foreign and domestic news. When *Dongnip Sinmun* was transferred to Yun Chiho (1864—1945), another Independence Club activist, in 1898, the English edition had doubled in size and began to be published separately from the *hangeul* version. The English section was discontinued later that same year, before the newspaper was shut down by the government.[4]

Dongnip Sinmun's exclusive use of *hangeul* was an implicit denunciation of the Confucian strictures that dictated human behavior in Joseon society and government. The dominant language of Confucianism was classical Chinese, manifested in *hanja* characters. The rejection of *hanja* functioned as an assertion of national identity. *Dongnip Sinmun* expressed public discourse and thought in the native Korean script form, rejecting the conventions of the rapidly deteriorating Sinocentric world order. As exemplified by *Dongnip Sinmun*, the Independence Club associated the Korean vernacular with national identity and autonomy; freedom from Chinese script also meant freedom from externally derived paradigms that impeded cultural and political integrity.[5]

The Independence Club, through *Dongnip Sinmun*, positioned the Chinese Confucian model and its perceived failures opposite

Western society, attributing the global dominance of the latter to its tradition of Christianity. For the Independence Club, Christianity would facilitate Korea's modernization and civilization, symbolized by the American Protestant values of industry, liberty, and evangelism.[6] This conception derives from the ideas of American Protestant missionary Henry G. Appenzeller (1858—1902), who worked closely with Seo Jaepil in the publication of *Dongnip Sinmun*, at one point assuming editorship of the newspaper.[7]

In 1898, the Independence Club was disbanded as a result of conflicts with the more conservative government of the Great Han Empire, the successor to the Joseon dynasty. Owing to similar disagreements, *Dongnip Sinmun* also ceased operations a year later. Despite its short life, the newspaper articulated a nationalist and reformist philosophy through both its content and means of conveyance. It was a key player in public discourse regarding Korea's political future at the turn of the century.

AM/VM

1
National Hangeul Museum, *History of Hangeul* (Seoul: National Hangeul Museum, 2015), 99.

2
Vipan Chandra, "The Independence Club and Korea's First Proposal for a National Assembly," *Occasional Papers on Korea,* no. 4 (1975): 19—35, http://www.jstor.org/stable/41490135.

3
Vipan Chandra, "Sentiment and Ideology in the Nationalism of the Independence Club (1896—1898)," *Korean Studies* 10 (1986): 13—34, https://muse.jhu.edu/article/397761/pdf.

4
Lee Kwang-rin and Yong-ho Ch'oe, "Newspaper Publication in the Late Yi Dynasty," *Korean Studies* 12 (1988): 65—67.

5
Chandra, "Sentiment and Ideology," 21.

6
Chung Yong-hwa, "The Modern Transformation of Korean Identity: Enlightenment and Orientalism," *Korea Journal* (2016): 109—38, http://bit.ly/2vjCy63.

7
Daniel M. Davies, "Building a City on a Hill in Korea: The Work of Henry G. Appenzeller," *Church History* 61, no. 4 (1992): 422—35.

Hwangseong Sinmun (Imperial Capital Gazette), Vol. 2, No. 15

"황성신문" 제2권15호

1898
Ink on paper
12¼ × 9⅛ in. (31 × 23.2 cm)
National Hangeul Museum, Seoul

The *Hwangseong Sinmun* (Imperial Capital Gazette) was a newspaper that ran from 1898 until its closure in 1910. It was published in mixed script, meaning that it used both Chinese characters (*hanja*) and Korean vernacular script (*hangeul*). Owing to its retention of a degree of *hanja*—

historically the script of the learned upper classes—it was considered an elite publication.[1] Its inclusion of *hangeul*, however, rendered it also somewhat progressive, although not as much as the more radical, *hangeul*-only *Dongnip Sinmun*. A publication's political inclinations were indicated through the types of script it employed: *Hwangseong Sinmun* assumed a reformist stance, but one predicated on adherence to concepts of Confucianism as a means of retaining Korea's national sovereignty.[2] The degree to which *hangeul* or *hanja* was used mirrored the differences in political views of the two leading newspapers. These analogues between politics and script demonstrate how language, and particularly *hangeul*, was politicized in Korea during the late nineteenth and early twentieth centuries.

In the final years of the Joseon dynasty, both politicians and intellectuals largely agreed that Korea's existence as a nation was contingent on changes in its political and social practices. The means of achieving such changes, as well as their character and extent, however, became contested topics, particularly in such public forums as newspapers. The editors and contributors of *Hwangseong Sinmun* were nationalist, Confucian reformists. They utilized a pan—East Asian rhetoric in their discourse regarding Korea's adaptation to its situation, in particular espousing a collective resistance to the advances of the imperial West. In addition to solidarity between historically Confucian societies (namely Japan, China, and Korea), *Hwangseong Sinmun* insisted on a Korean cultural identity based on Confucian ethics, arguing that principles of self-strengthening and social responsibility would bolster the nation's capacity for independence.[3]

The newspaper is printed vertically, with sentences read in columns, as was the convention for Korean writing at the time. Its title, whose *hanja* characters denote "imperial capital newspaper," is read horizontally right to left; the main text of the paper is also read right to left. The titular "imperial capital" refers to Seoul, the paper having begun publication the year following the Korean government's reestablishment as the Korean Empire (Daehan jeguk), with Seoul as its capital. The Joseon government had restyled itself as the Korean Empire in 1897 in an attempt to establish itself as a modern nation–state and consolidate its autonomy. Intellectuals and politicians at the time debated means of acclimating Korea to the modern world and avoiding its subjugation to foreign powers. *Hwangseong Sinmun* and its contemporaries represented the extension of these debates into the public sphere. Public circulation of a multiplicity of ideas occurred through newspapers and print culture, which allowed Korean citizens to be apprised of and evaluate the discussions surrounding the future of their nation.

AM

1
Andrei Lankov, "Newspaper Boom," *Korea Times*, January 17, 2008, http://www.koreatimes.co.kr/www/nation/2018/05/165_17465.html.
2
Kim Yun–hee, "The Political Nature of the Oriental Discourse of the *Hwangsong Sinmun*: With a Special Focus on the Notion of an Oriental Identity," *International Journal of Korean History* 17, no. 1 (February 2012): 111.
3
Ibid.

Daehan Maeil Sinbo (Korea Daily News)

대한매일신보 순한글판 제1권 제1호

Korean Empire, 1907
Ink on paper
18 × 12⅜ in. (45.5 × 31.5 cm)
National Hangeul Museum, Seoul

Founded by British journalist Ernest Thomas Bethell (1872—1909), the *Daehan Maeil Sinbo* (*Korea Daily News*) was first published in 1904. In many ways the newspaper modeled itself after a gazette and carried traditional news, but its main purpose was to awaken public opinion in

the face of a possible threat to the nation's survival——in this case, from Japan.[1]

In 1905 each issue of the newspaper consisted of a total of six pages: four in English, comprising two pages for news and two pages for advertisements, and two pages in Korean, printed in *hangeul* script.[2] Initially, the text was printed in two columns, one column in *hangeul* and the other column in English, until the newspaper began to be published in two separate editions, one in English and the other in Korean, the latter using both *hangeul* and *hanja*. At this time, the decision to publish in both *hangeul* and *hanja* was largely propelled by a desire to reach a larger audience than just the common population that could read *hangeul*——namely, also the intellectuals who still retained their traditional education and knowledge of classical Chinese and *hanja*.[3]

The newspaper's growing anti-Japanese sentiment quickly proved to be an issue for British-Japanese relations in general and Bethell in particular, as the funding of the paper grew more difficult. As Lee Kwang-rin explains, newspapers that expressed these views could only be run by "marginal men": those who did not come from lineages of scholar-officials but from the margins, which allowed them to criticize the society they were part of, rather than support it.[4]

In August 1910, three months before the complete annexation of Korea, the Japanese bought the *Daehan Maeil Sinbo* and renamed it the *Maeil Sinbo* (*Daily News*).[5] As the oldest continuing newspaper in Korea in circulation today, the paper changed hands in 1945 and was renamed *Seoul Sinmun*.

VM

[1]
Lee Kwang-rin and Ch'oe Yong-ho, "Newspaper Publication in the Late Yi Dynasty," *Korean Studies* 12 (1988): 70.

[2]
Chong Chin-sok, *The Korean Problem in Anglo-Japanese Relations, 1904—1910: Ernest Thomas Bethell and His Newspapers: The Daehan Maeil Sinbo and the Korean Daily News* (Seoul: NANAM Publications, Co., 1987), 52.

[3]
Lee and Ch'oe, "Newspaper Publication," 67—68.

[4]
Ibid., 71.

[5]
Chong, *The Korean Problem in Anglo-Japanese Relations*, 303—14.

106

GIM GYUJIN
김규진
金圭鎭
1868—1933

Mind Itself Is Buddha
심시불 (마음이 바로 부처이니라)
心是佛

Hanging scroll; ink on paper
47¼ × 12⅝ in. (120 × 32 cm)
Bak Jonghoe Collection

Gim Gyujin was an important modern calligrapher. He was born in Pyeongyang and despite an impoverished childhood, was able to study calligraphy with his maternal uncle, Li Heesu.[1] As a young man, Gim studied in China for nine years, and in the early 1890s, he traveled to Japan to study photography.[2] After his return to Korea in 1895, Gim served as an official in the government of the Korean Empire. With the increasing Japanese control of Korea, Gim initially collaborated with the Japanese colonial authorities, but after the Korean crown prince was forced to move to Japan in 1907, Gim left the government and became a free agent. He opened a commercial photography studio and then an art gallery, the Gogeum Seohwagwan (Gallery of Ancient and Contemporary Calligraphy and Painting). Finally, during the Japanese Colonial period, Gim opened the Calligraphy and Painting Research Institute, a school for the formal teaching of these two arts; he had many famous students there.

Later in life Gim published several influential books, including *Seohwadam* (Talks on calligraphy and painting), *Yukchepilron* (Essay on the six [calligraphic] forms of brushwork), *Seobeopjingyeol* (True essentials of calligraphic methods), *Haegang nanjukbo* (Compendium of Haegang's orchid and bamboo [paintings]), and *Seohwapyongo* (Further explorations of calligraphy and painting).[3] Gim mastered each of the basic forms of *hanja* calligraphy (seal, clerical, standard, running, and cursive), and his own calligraphy was placed in a lineage established in the late Joseon dynasty by Gim Jeonghui (1786—1856; see cats. 80—95) and Li Heesu.[4]

This scroll presents three large and boldly written cursive *hanja* script characters forming a single phrase, *Simsibul* (Ch. *Xin shi Fo*; mind itself is Buddha), accompanied by the artist's signature at the lower left, reading Haegang (Gim's sobriquet).[5] "Mind itself is Buddha" is a famous phrase in East Asian Buddhism, which has its origins in the Amitayurdhyana Sutra (K. *Bulseol gwan mulyang su bulgyeong*; Ch. *Foshuo guan wuliang shou fo jing*; Sutra on the contemplation of the Buddha Amitayus), also known as the Contemplation Sutra or the Visualization

Sutra, a key text of the Pure Land school. The text's Sanskrit title is now believed to be apocryphal, and the sutra is instead thought to have been composed in China in the fifth century, during the Liu–Song dynasty.[6] In the context of Seon (Ch. Chan; J. Zen) Buddhism, the phrase "mind itself is Buddha" is closely associated with the Chinese Chan monk Wumen Huikai (1183–1260). Huikai's recorded sayings, collected as *Wumen guan* (K. *Mumungwan*; The gateless barrier), likewise stress the identity of mind and the Buddha, implicitly suggesting that the mind is already enlightened and that seeking Buddhahood is in large measure a process of overcoming the obscurities of mind that are the primary obstacles to enlightenment. Gim Gyujin's choice of this phrase for his powerful calligraphic performance suggests a deep knowledge of Buddhist literature and culture.[7]

SL

1
Lee Seong Hea, "20 segi cho, Hanguk seohwaga ui jonjae bangsik gwa yangsang: Haegang Gim Gyujin ui seohwa hwaldong eul jungsim euro" [A study on activities of Korean calligraphic painters in the early twentieth century, focusing on calligraphic painting works by Haegang Gim Gyujin], *Dongyang hanmun hakoe* [Research on East Asian Han writing] 28 (February 2009): 284.

2
Choi In jin, "Seohwaga Haegang Gim Gyujin ui sajinhwaldong yeongu: Cheonyeondang sajingwan eul jungsim euro" [The study about calligraphy-painter Haegang Gim Gyujin's photographic career] *Hanguk geunhyeondae misul sahak* [Journal of Korean modern and contemporary art history] 15 (August 2005): 460–61.

3
Lee Ki-bum, "Haegang Gim Gyujin ui Seoye: Seoron eul Jungsim euro" [Calligraphy of Haegang Ku-jin, Kim, centering on book essay] (master's thesis, Dongguk University, 1999), 88.

4
Ibid., 87.

5
Published in *Hanguk seoye ilbaek-nyeon, 1848–1949* [One hundred years of Korean calligraphy, 1848–1949] (Seoul: Yun Ryangjung, 1988), 79.

6
Fujita Kōtatsu, "Textual Origins of the *Kuan Wu-liang-shou ching*," in Robert E. Buswell, Jr., ed., *Chinese Buddhist Apocrypha* (Honolulu: University of Hawai'i Press, 1990), 149–73.

7
For other examples of Gim Gyujin's Buddhist calligraphies see Lee, "Haegang Gim Gyujin ui Seoye," figs. 25, 32.

BEYOND
THE
MODERN

If native *hangeul* script and printing technology were embraced in new ways in the early modern period, the postwar decades on the peninsula have provided the space and global inspiration for artist–calligraphers to question what they know in order to explore. Text as image is exposed in both its literal capacities and its imaginary ones. *Hangeul* script that was once "ordinary" has revealed a personality, becoming a grand script, and the act of writing is treated as a performance. Once again, modern-day technologies—such as the camera and digital graphics—accompany the continued exploration of what writing means. Each work in this section has been chosen because it embodies an artist's questioning of traditional, centuries–old practices; nearly all started with this classical training. These individuals' artistic pursuits with ink, brush, and paper are, however, not designed to discard or repudiate the past, but rather to search for its continued power and sustainability in the present and into the future.

SYNGMAN RHEE
이승만
李承晩
1875—1965

***Calligraphy of President
Syngman Rhee***

이승만대통령유묵

20th c.
Ink on paper
13⅜ × 35 in. (34 × 89 cm)
Seokdang Museum of Dong-A University, Busan

Even after the end of the royal dynastic period and the beginning of the democratic election of presidents in Korea, the populace continued to judge people in power on their ability to execute calligraphy at a high level. Producing calligraphy was a common practice and considered an important rite in the Joseon dynasty, but unlike the dynastic kings, presidents wrote calligraphy on noted occasions, such as New Year's Day or the anniversary of significant political events, and at historical sites. Calligraphy symbolized the ideal of a politician and projected the president's image not only politically, but also culturally.[1]

Syngman Rhee was a South Korean politician who served as the first president of Korea from 1948 to 1960. As a boy he was trained in traditional Confucianism, and he later learned English while attending an American Methodist school in Korea, which subsequently allowed him to receive an American education: he graduated from George Washington University (BA), Harvard University (MA), and Princeton University (PhD). As a young man, between 1896 and 1904, after a brief stint in prison for organizing the overthrow of King Gojong (1852—1919), Rhee was strongly aligned with grassroots movements. He joined the Hyeopseong Club, led by Seo Jaepil (1864—1951), which produced a newsletter to promote its causes before the newspaper *Dongnip Sinmun* (The Independent; see cats. 102, 103) was established. He also joined Seo's Independence Club (Dongnip hyeophoe). Both clubs supported the ability of the populace to enact political change, particularly in response to Japan's growing influence over Korea. After the Japanese occupation of Korea in 1905, Rhee's main objective was to seek independence for Korea by appealing to the United States at the Treaty of Portsmouth, but his efforts were unsuccessful.

Following World War II, Rhee was promoted to president of the Korean Provisional Government, and in 1948 he was elected president in the country's first elections. He served three terms, during which he oversaw the South Korean government during the Korean War (1950—53), and was elected to a fourth term before he resigned owing to the student uprisings and protests of April 19, 1960. Rhee was exiled to Hawaii, where he lived out the remainder of his life.[2]

Rhee wrote this calligraphy while in office. The characters are written in a combination of *haengseo* and *choseo* (running and cursive script) inspired by the great Chinese Tang dynasty calligrapher Yan Zhenqing (K. An Jingyeong; 709—785).[3] They read, "Let us go forward as much as we can and build up the great nation again."[4]

VM

1
Hak Jin Chang, *Yeokdae daetongnyeong deul ui mukjeok yeongu* (A study on *mukjeok* of former presidents) (master's thesis, Wonkwang University, 2017), i—iii.

2
Soojin Chung, "Rhee Syngman, First President of the Republic of Korea," Boston University School of Theology: Boston Korean Diaspora Project, http://sites.bu.edu/koreandiaspora/individuals /boston-in-the-1920s/rhee-syngman-first -president-of-the-republic-of-korea/.

3
See, for example, "Yan Zhenqing's *Letter on the Controversy over Seating Protocol* (764)," in Amy McNair, *The Upright Brush: Yan Zhenqing's Calligraphy and Song Literati Politics* (Honolulu: University of Hawaii Press, 1998), figs. 17, 20.

4
Ibid., 74—77. Translation by Christina Gina Lee.

108

KIM SUN WUK
김순욱
1929—2012
Emptiness
무

1996
Ink with dye on paper
75 × 47½ in. (190.5 × 120.7 cm)
Collection of Gwang Min

Some scholars have suggested that Abstract Expressionism inspired such contemporary Korean calligraphers as Kim Sun Wuk to lead a group of international artists in the practice of abstract or gestural calligraphy. Whether or not this is true, Kim, whose sobriquet is Hanong (Cultivator of Lotus), sought to take traditional calligraphy beyond its confines

1
0
9

KIM SUN WUK
김순욱
1929—2012

Seals
Stone
Variable sizes
Estate of Kim Sun Wuk

and beyond the need to recognize calligraphic forms as text. To Kim, the most important thing was the spirit of figures on paper, as exhibited in his painting *Emptiness.*[1]

During his career as an artist, Kim worried about the potential demise of traditional calligraphy and tried to develop a way to sustain it as an art form. He was a pioneer and inspirational teacher who helped to expand the range of contemporary calligraphy to incorporate more creative and progressive aspects, such as the use of different colors and different media, including acrylics. His wife once spoke of her husband's work in this way: "Traditional

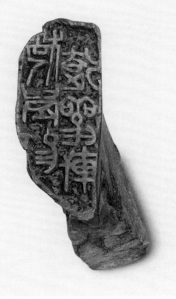

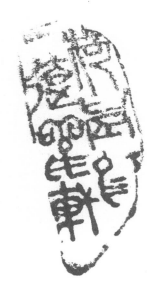

calligraphy emphasizes copying and imitation to learn; my husband is trying to go beyond that into the contemporary."[2]

Kim was also an avid and well-known seal carver. The legend (text) on seals usually consists of the artist's name written in *hanja* seal script or *hangeul,* carved within a square space. The end of the seal that bears the carved text is smudged with bright-red seal paste and stamped onto the artist's work. Artists often use more than one seal. Kim's seals were carved from stones that he found during trips all over the world. Kim once said that each stone had to have significance—or a story attached to it—before he collected it. He had such a habit of acquiring rocks that his luggage could often barely hold them all.[3]

In 1976 Kim moved from Korea to New York, where he worked as a neurosurgeon. In the United States, Kim founded a calligraphy group consisting of artists from Korea, Japan, and China who could learn from one another and broaden the concept of contemporary Asian calligraphy. The group, known as the Art of Ink in America Society, is still active today and includes artists from China, France, Italy, Japan, Korea, Romania, Switzerland, Taiwan, and the United States. Kim moved to California in 1990 and passed away in 2012.

VM

[1]
Benjamin Epstein, "Different Strokes and Art of Calligraphy Exhibit: 'Ink in America' at Golden West College Shows How the Discipline Has Expanded and Taken on New Meaning," *Los Angeles Times,* December 8, 1995.

[2]
Chung Sookhee, "Seoye reul yesulro gaecheokhan geojangui honeul mannada" [Meeting the pioneering great artist who transformed calligraphy into art], *Korea Times,* January 2, 2013.

[3]
Ibid.

1
1
0

LEE UNGNO
이응노
1904—1989
People
사람
1988
Ink on paper
51⅛ × 27½ in. (130 × 70 cm)
Lee Ungno Museum (Daejeon Goam Art & Culture Foundation)

This painting is part of Lee Ungno's People series. Beginning in 1945 Lee focused his work on the lives of the normal people (*seomin*) who were struggling with their poor environments in a turbulent period, from 1945 to 1950. With his rough and free brushstrokes, Lee embodies the figures of the people, and this became the origin of the People series.[1] The lines in the painting constitute outlines of people while also serving as an index of the artist's bodily movements, which resonates with aspects of calligraphy. The blurred boundary between calligraphy and abstraction, which Lee had explored in the 1970s, is called the style of "abstract letter." This style later gave rise

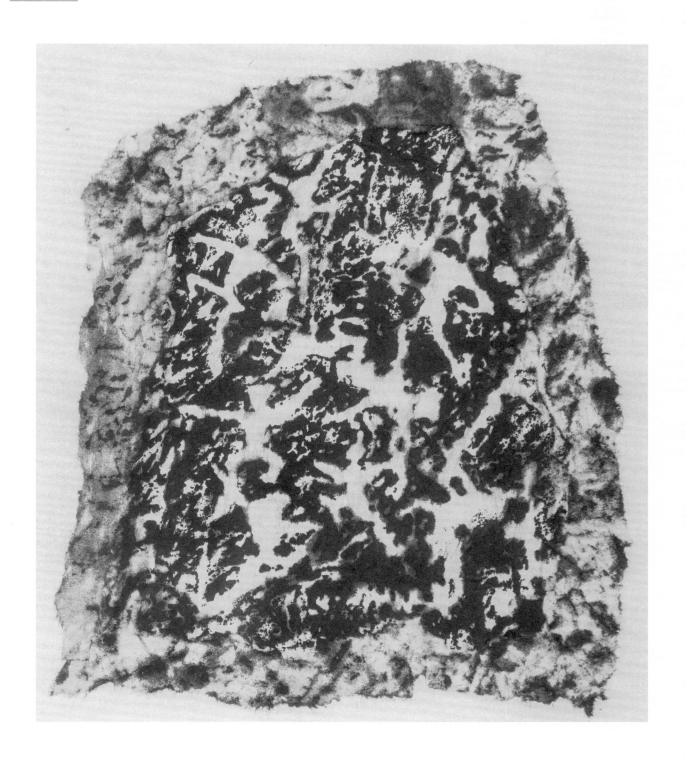

to Lee's Crowds works, which draw attention to the relationship between the figurative and the abstract. The imperative to read Lee's painting as politically charged is based on his status as an expatriate who witnessed the vicissitudes of modern Korean history, such as Japanese colonization, the Korean War (1950—53), and military regimes.

Lee went to France in 1958, where he was exposed to and became infatuated with European art movements that combined abstraction with politics. The French critic Michel Tapié (1909—1987), with whom Lee had a close relationship, promoted abstract painting and coined the term Art Informel, underscoring its connotation of political liberation. The gallery Lee signed a contract with in Paris, Galerie Facchetti, was one of those leading the Art Informel movement at the time. Living in France, Lee was recalled to Korea and imprisoned for two and a half years for his involvement in the East–Berlin Affair in 1967. He was accused of being a North Korean spy, which subsequently caused him to seek French citizenship. In France he cofounded the Academy of Oriental Painting.

As quasi–semiotic signs, calligraphic forms in Lee's paintings invite multiple significations associated with cultural, historical, and artistic threads in Korea. In an interview, Lee said, "I want to title my paintings 'peace.'... [The] life of the people (*minjung*) is peace. These are the people who have their voices and their spirits. I have been focusing on drawing these [people] for a while. I thought about this theme before I was in prison. Life in prison inspired me to form the people."[2] For Lee, calligraphy served as an intersection between East and West and past and present, which is at the heart of the contested inquiry of modern art, a concept that modern and contemporary Korean artists up to the present have sought to unravel.

Lee once stated that his ultimate interest in focusing on the human was to both explore a new artistic language and defy the assumptions of traditional ink painting in Korea.[3] For him, tradition was not alien to modern art, but a way to address a distinctive mode of modernity that was culturally specific to Korea.

Lee's painting is rife with intersecting threads from disparate time periods, traditions, and cultures, with calligraphy serving as its backbone. Calligraphic lines remain significant through changes in Lee's style, from the expression of nature in the 1960s to letterlike forms in the 1970s to human figures in the 1980s. As a later work that embodies Lee's lifetime study of the relationship between figurative and abstract, traditional and modern, national and international, *People* represents both the life of an individual artist and the significant chapters that define Korean history.

VM/JHP

1
Park Hyeongju, "Geurim jemok, 'Pyeonghwa' ra buchigo sipeotdeon, Lee Ungno migonggae 'Gunsang' gonngae," *Newsis*, accessed July 15, 2018, http://www.newsis.com/view/?id =NISX20180417_0000284141.

2
Ibid.

3
Ibid.

111

SUH SE OK
서세옥
B. 1929

Person
사람

Ink on paper
55½ × 54¾ in. (141 × 139 cm)
National Museum of Modern and Contemporary
Art, Seoul

Suh Se Ok was born in Daegu, South Korea, and graduated from Seoul National University. His achievements as an artist and professor have brought him international recognition. He was a founding member of Mukrimhoe (Forest Ink Society), a group of experimental ink painters and fellow graduates of Seoul National University who sought to modernize traditional ink painting. In this pursuit, since the 1990s, Suh has painted his Human series, still using the classical materials of brush, ink, and paper.[1]

Mukrimhoe's intentions stemmed from the history of *seohwa* (literally, calligraphy and painting as a unified whole). The two

arts of calligraphy and painting underwent a separation in the early 1920s, each to have its own identity and direction, but by the late 1940s had merged again.[2] It is this renewed sense of *seohwa* that Suh has sought to redefine and reinvigorate.

As such, works in Suh's Human series, including this piece, *Person,* embody the equal existence and importance of calligraphy and painting, an idea that scholar Kim Hyeju refers to as *seochejeok chusang* (calligraphic abstraction). This idea is based on Suh's use of the brushstroke (*huik*), as opposed to the line of Western painting, and *jasang* (word figures).[3] The visual spectrum seen in Suh's paintings ranges from forms that hew closer to classical *hanja* shapes and structures to new calligraphic manifestations that transcend traditional norms. *Person* operates on the border of calligraphy and painting, challenging ideas of what constitutes calligraphy while creating an art that is unmistakably contemporary.

VM

[1]
National Museum of Modern and Contemporary Art, Korea, *Gijungjakpum teukbyeoljeon Suh Se Ok* [Special exhibition of donated works by Suh Se Ok], (Gyeonggi–do: National Museum of Modern and Contemporary Art, 2015), 33.

[2]
Choi Byeongsik, "Muninhwaui jaehaeseokgwa hangung muninhwaui dangdaeseong munje" [Reinterpretation of Muninhwa and their contemporary issues on Korean Muninhwa], *Dongyangyesul* [Asian art] 29 (2015): 201.

[3]
Kim Hyeju, "Muninhwa ui hyeondaejeok byeonyong: Seo Se Ok ui ingan siriju" [Modern transformation of traditional ink painting: Human series of Seo Se Ok], *Hyeondae misulsa yeongu* [Modern art history research] 7 (February 1997): 38, 42—45.

112

KIM CHOONG HYUN
김충현
1921—2006

Poem on the Diamond Mountains, in Hangeul Script
금강산의 시

1990
Pair of hanging scrolls; ink on paper
Each scroll: 50 × 24¾ in. (127 × 62.9 cm)
Los Angeles County Museum of Art, purchased with funds provided by Susan Baik and Prem Manjooran, M.2016.13a—b

Prior to Korea's independence from Japan in 1945, the predominant calligraphic form for *hangeul* was the *gungche* style, which had evolved in the court and continued to be widespread during *hangeul's* subsequent five-hundred-year existence. This was largely because of the preferred use of *hanja* (Chinese characters) by those who practiced calligraphy. After independence, various styles of *hangeul* calligraphy started to develop, as both a promotion of the

national script and a reembracing of the native language. It was in this environment that Kim Choong Hyun sought to understand the origins of *hangeul* and created his distinctive *hangeul* calligraphic script, known as *goche*.[1]

Poem on the Diamond Mountains perfectly exemplifies this style. The *hangeul* characters are wide and flat yet balanced in their inner structure and placement with other characters. To write his characters, Kim must have used a generous amount of ink.[2] He was inspired by the script styles found in the original *Hunminjeongeum*, the text that originally introduced the *hangeul* alphabet in 1446 (cat. 69).[3] The poem reads,

> So this is Heolseongnu—facing it, it is
> blinding my eyes.[4]
> How can thousands of peaks accumu-
> late, swarming among the clouds?
> Alas, people will think the infinite sky
> is like a canvas.
> Although the shapes of each towering
> peak differ from one another, you,
> Heulsungru, stand out roundly shaped
> and standing tall.
> Despite an endless number of peaks,
> you [Heulsungru] look over them all.
> As the sun sets and it gets darker, the
> mountain path twists and turns.
> Peaks look like they are hanging from
> the sky. But, it is strange that they
> also look kind of low.
> As if in front of a peaceful yard, thousands
> of peaks and valleys are gathered.
> Here, there, anywhere, and there is no
> need to talk about which place is best.
> The answer to the best spot in the
> Geumgang Mountains is Heulsungru.
> A castle and thousands of peaks are
> in a world of their own.
> You feel even more rewarded to see the
> greeting face from an old house.
> Who would have guessed that this old
> painting in a pavilion [with six pillars]
> is a national treasure?
> Ten of Master Oh Do Ja [Wu Daozi;
> 680—740] of Tang dynasty could not
> match the level of Gado An Gyeon's
> [1400—1464/70] painting skills.
> The scene of Heulsungru in the old
> painting seems to be repainted,
> but its noble and mysterious scenery
> still remains.[5]

Kim not only invented one of the most identifiable styles for *hangeul* calligraphy, but he was also an influential teacher of Korean calligraphy and a prolific writer. He was the teacher of Jung Do–Jun, whose work is also featured in this exhibition (cat. 118). Kim produced a number of books on calligraphy, the most notable of which is *Uri geulssi sseuneun beop* (The way to write our language), which discusses both *gungche* and *goche*, as well as the history of classical writing in Korean.[6]

VM

1
Kim Su–chon, "Iljung Gim Chunghyeon ui gahak baegyeong gwa seoyesajeok gongheon [The family study background and the contribution to the history of calligraphy of Iljung Kim, Chunghyeon], *Seojihak yeongu* [Journal of the Institute of Bibliography] 68 (December 2016): 108—10.
2
Yeon–Ok Rue, "Gimjunghyeonui hangeul seoye yeongu" [Research on Kim Choong–Hyun's *hangeul* calligraphy] (master's thesis, Gyeonggi University, 2005), 35.
3
Kim, "Iljung Gim Chunghyeon ui gahak baegyeong gwa seoyesajeok gongheon," 110.
4
Heulsungru means "Tower of Resting in Stillness."
5
Translation by Virginia Moon and Christina Gina Lee.
6
Kim, "Iljung Gim Chunghyeon ui gahak baegyeong gwa seoyesajeok gongheon," 107.

누구든지 혜언저리 한
동이 곳치 올것 이 일루 천
방우 기 운 옛집얼 줄어 더 귀한
전적 헌리 림을 국보인 줄개 칠
하 한가 또 회권 구 할가 개칠
운오지 남이 더권 우 할가 개
환 사 던 줄 누 일야
현 엽 칠 있

주 심 가을에 정읍 강전생의
금 강 시를 쓰다 김정현의

KIM JONGWEON
김종원
B. 1954

Tongnyeongsinmyeong–
Gounseonhwa sinbuljido
(Illumination of Mind and Spirit:
The Post-Transformation of
Choe Chiwon into a Daoist Hermit)
통령신명 – 고운선화신불지도
通靈神明 – 孤雲仙化神佛之圖
2014
Ink on paper
84½ × 61 in. (215 × 155 cm)
Collection of the artist

After decades of being immersed in and
dedicated to the learning and practice
of traditional calligraphy, Kim Jongweon
sought to question his work and search
for a new calligraphy by posing the
question: what is the origin (root) of calli-
graphic forms? Inspired by a Chinese
idiom, *beopgochangsin,* which refers to
creating the new by succeeding the old,
Kim contemplated the divinity and
spirituality of not only calligraphic forms
themselves, but also their lineage
and history.[1]

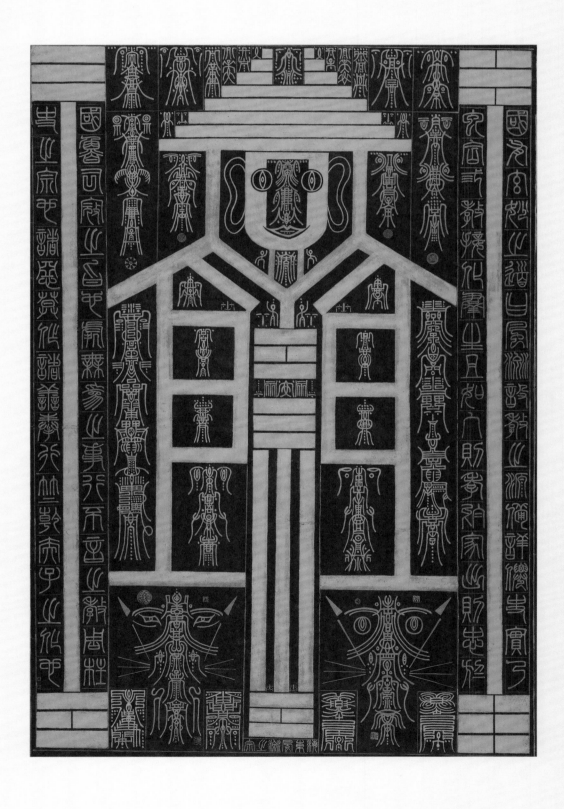

114

KIM JONGWEON
김종원
B. 1954

***Munmunjaja guemganggyeong
geu seojeok byeonsang (Words
Originating within Words:
A Calligraphic Abstract of the
Diamond Sutra)***

문문자자 금강경 그 서적 변상

文紋字孶 – 金剛經 그 書的 變相

2014
Ink on paper
84½ × 61 in. (215 × 155 cm)
Collection of the artist

Both *Tongnyeongsinmyeong
–Gounseonhwasinbuljido* and *Munmunjaja
guemganggyeong geu seojeok byeonsang*
embody Kim's working answer.
*Tongnyeongsinmyeong–Gounseonhwa
sinbuljido,* in its glaring red, is a *bujeok*—
an amulet or talisman meant to symbolize
and evoke change. The characters painted
here have been refashioned to serve
as a new contemporary character. On the
right and left sides of the painting, Kim
uses the *sojeon* Korean script form,
a variant of seal script. By using language
alongside signs and symbols, he shows

that calligraphy conveys more than just the meaning of the word, and in this way, the true meaning of *seohwa*,[2] or calligraphy and painting as a unified whole.

In *Munmunjaja guemganggyeong geu seojeok byeonsang*, *munmunjaja* refers to a pattern of a lush, growing forest, but is also a reference to the word *munja*, which means a character (or written pattern). *Guemganggyeong* is the name of the Buddhist *Diamond Sutra*, one of the sacred texts of Mahayana Buddhism, a school widely embraced in Korea. The original sutra was written in Sanskrit; it was translated into Chinese in the early fifth century by Kumarajiva, under the patronage of the rulers of the Later Qin dynasty in Chang'an.[3] The most famous surviving woodblock-printed version of this text (also the earliest-known printed book) dates to 868 (Tang dynasty) and was found in 1900 in the famous "library cave" at the Dunhuang caves along the Silk Road in China's Gansu Province.[4] Like many other sutras, it has been replicated and disseminated many times. Kim Jongweon's painting was inspired by what the artist visualized after reading the Diamond Sutra. The individual strokes embody a kind of performance akin to copying sutras.[5]

Kim has remarked that "contemporary society is so overrationalized that spiritual power has disappeared. In this society, I believe *seohwa* is art that can rehabilitate the deep meaning of that power."[6] In this way, Kim's works can be described as an altruistic calligraphy.

VM

1
Han Yun Jeong, "Geulssiin deut geurimin deut… Kim Jong Weon jakka gaein jeon 'Geulsindeulda'" [Writing or painting…Artist Kim Jong Weon's solo exhibition *Geulsindeulda*], *Gyeonghyang Sinmun*, July 14, 2015, http://news.khan.co.kr/kh_news/khan_art_view.html?artid=201507142122295.

2
Ibid.

3
On Kumarajiva and his translations, see Kenneth Chen, *Buddhism in China: A Historical Survey* (Princeton, NJ: Princeton University Press, 1964), 81—86.

4
See Neville Agnew et al., *Cave Temples of Dunhuang: Buddhist Art on China's Silk Road*, exh. cat. (Los Angeles: Getty Conservation Institute, 2016), 249—51, cats. 30, 31.

5
Kim Jongweon, "Chaosmos: Exhibition introductory text," Art Link gallery, July 2015, http://www.artlink.co.kr/artlink/exhibition03-1.asp?exhibitno=E201500006.

6
Lee Dongkook, "Chaosmosstroke," in *Kim Jongweon: Chaosmosstroke* (Seoul: Art Link, 2015), 14.

115

AHN SANG-SOO (NALGAE)
안상수
B. 1952
Bomb Fish on the Seashore
해변의 폭탄 물고기
1991
Digital print
42⅞ × 31 in. (109 × 78.8 cm)
Collection of the artist

Ahn Sang-soo is considered the most influential contemporary typographer and graphic designer in Korea. A graduate of Hongik University in Seoul, Ahn is famous for creating an eponymous font that signified a breakthrough in *hangeul* design and utility in the early digital era. While digital typefaces had existed prior to the development of Ahn's new font in 1981, Ahn was the first to eschew the square-framed arrangement of individual elements in a syllabic unit.[1]

Bomb Fish on the Seashore is a poster Ahn created for an exhibition organized by the Front DMZ Arts Movement in 1991. The photograph used for the poster was taken in Maehyang-ri, a small seaside village on the west coast of South Korea. Dummy bombs were laid on the beach following a bombing exercise led by the United States Air Force in the region. By replacing sea creatures with artificial bomb remains, the work refers to the historical tensions and border conflicts between North and South Korea since the Korean War (1950—53) and Cold War eras, as well as the environmental impact of ongoing military exercises in South Korea. The diagonal line of the seashore alludes to the dividing line, or Demilitarized Zone (DMZ), on the Korean Peninsula, which divides North and South Korea.

The juxtaposition of faux-*hangeul* phonetic elements with photography reflects and underlines the absurdity of the political reality that obtains in contemporary Korea, as indicated in Ahn's description of his *Bomb Fish on the Seashore* as a "poster with non-decipherable text placed on a non-believable photo for a non-understandable situation."[2] The graphic elements composing what appears to be a text bear some semblance to *hangeul,* especially the first two at the upper left, which look like the first and second consonants (*giyeok*) and (*nieun*) in the *hangeul* system and thus invite viewers to attempt to decipher the text. However, in spite of their resonance with *hangeul* forms, the graphic elements on the poster are not readable and do not contain any particular signs that have obvious links to the poster's theme. The font that Ahn developed for *hangeul* breaks down the phonetic elements into individual modular forms and distances them from the conventional square format of *hangeul* design. This irregularity is pushed further in *Bomb Fish on the Seashore*: Ahn has created quasi-*hangeul* in which each component alludes to interaction with another, thus seeming to present a process of signification while forever impeding it.

At first glance, these graphic elements seem like a legible text, and the bombs in the photo resemble sea creatures. The subsequent inversion of these expectations highlights the absurdity of the situation the poster implies. With their rhythmic arrangement and playfulness, the quasi-*hangeul* forms suggest yet block clear communication, intentionally destabilizing the viewer's experience. Owing to the nonindexical nature of these signs, the viewer has more leeway to impose interpretations on individual associations. Ahn's usage of quasi-*hangeul* in *Bomb Fish on the Seashore* reveals the potential of *hangeul*-derived graphic elements to serve as powerful aesthetic forms that resemble ancient petroglyphs and yet are unambiguously contemporary in appearance and function. AM/JHP

1
Kyuhee Baik, "Original Creators: Sang-soo Ahn," *Creators*, May 2, 2011, https://creators.vice.com/en_us/article/gvdkyb/original-creators-sang-soo-ahn.
2
Ahn Sang-soo, interview by Maggie Kinsler Hohle and Yun Sukmu, *THEME Magazine* 6, 2006, http://www.thememagazine.com/stories/ahn-sang-soo/.

YOON KWANG-CHO
윤광조
B. 1946

The Heart Sutra
반야심경

2001
Red clay with white slip
32½ × 16⅜ × 9⅞ in. (82 × 41.5 × 25 cm)
Gana Art and Culture Foundation

In Korea ceramics were not widely regarded as an art form until about the sixteenth century, when the popularity of the tea ceremony and the demand for the Korean ceramic aesthetic in neighboring Japan reached its peak. Yoon Kwang-cho is a renowned, somewhat reclusive ceramist who works primarily in the style of *buncheong*, a traditional Korean stoneware painted with white and beige slip (liquid clay) and often covered with carved and painted designs and patterns. *Buncheong* wares were initially introduced and popularly used in the first two hundred years of the Joseon dynasty. They are widely admired today for their freedom of expression.

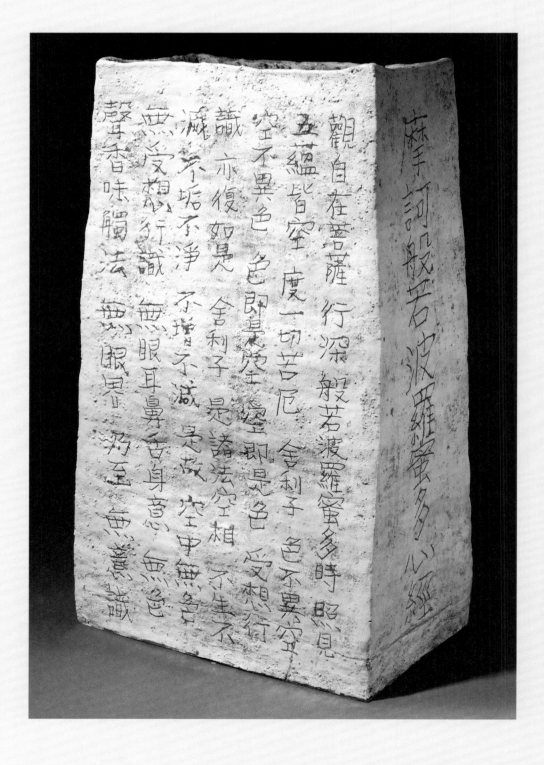

The free style seen in many of Yoon's works is exemplified by the *Heart Sutra,* in that the artist did not use a potter's wheel to create the vessel's rugged shape. Yoon prepares all the aspects of his works on his own and does not use an assistant. The surface of this vessel is covered with calligraphic forms that constitute the Buddhist text known as the *Heart Sutra.* Each *hanja* character of the text was precisely hand–carved onto the surface with a nail while the white slip was still damp.[1] In the course of inscribing the vessel, Yoon sprayed water on its surface to dampen it again as the white slip dried. The inscribed text is one of the shortest-known Buddhist sutras. It reads:

When the Bodhisattva of Independent Vision was practicing profound *prajna-paramita,* he had an illuminating vision of the emptiness of all five aggregates (form, feeling, ideation, reaction, and consciousness), which saves from all woes and troubles. Sariputra! Visible matter is no different from Emptiness nor is Emptiness different from visible matter. Visible matter is equivalent to Emptiness, and Emptiness equivalent to visible matter. Sensation, notion, action, and cognition are also like this. Sariputra! These dharmas are marked by emptiness, neither being born nor perishing, being neither soiled nor pure, neither increasing nor decreasing. For these reasons, there is in Emptiness no visible matter, nor is there sensation, notion, action, or cognition; no eyes, ears, noses, tongues, bodies, or ideas; no sight, sound, scent, taste, touch, or doc–trine, and no field of vision; nothing from nescience or its annihilation up to and including old age and death and their annihilation; no woe, or its formu–lation, or its suppression or the way

thereto; no gnosis or possession. Since there is nothing to be possessed, the bodhisattva mahasattva, by depending on *prajnaparamita,* has thought free of entrapment or obstacles; having thus nothing to fear, he separates himself from all perverse imaginings and dreamlike notions, achieving complete and final Nirvana. The Buddhas of the three ages, by relying on *prajnaparamita,* have achieved supreme enlightenment. Therefore, know this greatly luminous magical charm, this unexcelled charm, this charm that is the equal of the unequalled, that can remove all woes, that is real, not vain. I will therefore pronounce the charm of *prajnaparamita.* Straightway he pronounced the charm, saying *gate gate paragate parasamgate bodhi svaha.*[2]

Yoon is a devout Buddhist, and the *Heart Sutra,* which has been described as the essence of Mahayana teaching in spite of its brevity, is his favorite sutra. It speaks of the emptiness of existence as the true path to enlightenment. As with other Buddhist sutras, the act of copying it served as a form of meditation and cultivation of karmic merit.

AM/JHP

1
Burglind Jungmann, *Life in Ceramics: Five Contemporary Korean Artists,* exh. cat. (Los Angeles: Fowler Museum, 2010), 20.

2
Translation adapted from Leon Hurvitz, "Xuanzang (602–664) and the Heart Scripture," in *Prajnaparamita and Related Systems: Studies in Honor of Edward Conze,* ed. Lewis Lancaster (Berkeley: University of California Press, 1977), 107–8.

KYUNGWOO CHUN
천경우
B. 1969

Light Calligraphy #2

2004
Chromogenic print
39⅜ × 51¼ in. (100 × 130 cm)
Collection of the artist

For his series Light Calligraphy (2004), artist Kyungwoo Chun asked young Korean calligraphers to write anything they wanted in the air in front of a camera set to a long exposure time, using light pens instead of their usual tools of brushes and ink. Chun adjusted the exposure time to correspond to the age of each calligrapher—from twenty-three to thirty minutes—and captured their calligraphies using an analog camera that recorded the traces of light.[1] Although the final results are photographic portraits with calligraphy, the calligraphers could not see their writings during the process. Because of that and other restrictions on the space and writing tools, the content of the

calligraphy is mostly unrecognizable. It is evident, then, that the focus of this work is not the content of the calligraphy, but the formal beauty and process of writing it. These photographs can be perceived as records of the times and performances of the calligraphers who participated in them.

Traditionally, visual art media allow artists to paint over or alter their original versions to make them more aesthetically pleasing. Spending long amounts of time on a work is often regarded as a virtue. Calligraphy, however, despite its long tradition as a genre, strictly prohibits calligraphers from painting over or amending their original works. This proscription against further modification has pushed calligraphers to practice until they reach a stage at which their study and skills unconsciously permeate the calligraphy they write. Significantly, the calligraphers in Chun's work were explicitly prevented from revision, since they were writing with light pens in the air.

Furthermore, because calligraphy is typically written in a particular order to clearly convey the meaning of the text to the reader, most calligraphic works have a beginning and an end. Among the various styles of calligraphy, cursive script allows this aspect of calligraphy to be most evident. It allows the form of each character to be transformed and radically reduced so that it becomes extremely difficult to read, but also gives calligraphers the freedom to be expressive. In addition, cursive script permits more speed and movement than other scripts. Ilpilhwiji, which means writing with one stroke of a brush, is an old idiom that is frequently used even today to succinctly describe cursive calligraphy, since a calligrapher writing in the style takes fewer pauses

between strokes.[2] The calligraphies in Chun's photos evoke cursive forms owing to the restrictions imposed on the artists. This similarity, however, suggests the improvisatory aspect of the work and the visualization of the flow of time—ideas embodied by both calligraphy and Chun's photographic works.

Chun began his photographic practice by questioning the common belief that photographs had to be captured in less than a second. In his other series, such as One-Hour Portrait (2001—2) and Believing Is Seeing (2006—7), Chun took photos of his subjects while communicating with them for a long time. Historically, in early photography, subjects had to stand in front of the camera in the same position for hours to get their images recorded because of technological constraints. Chun's subjects, however, were asked to stay, leave, talk, or express their thoughts and emotions rather than pose for the camera. The final results, consequently, are composed of multiple layers of images that create blurry outlines of figures. Chun's photographs try to defy the concept that photos can only capture moments of lives; rather, his works visualize layers of time. Chun once mentioned that what fascinates him most is the "expressiveness of portrait photographs" that had been taken with long exposures over a period of time.[3]

The Light Calligraphy series is different from Chun's other portrait photos in that he gave his subjects a great deal of freedom and control over the images they produced. Decisions regarding the style, form, and length of the calligraphies were left solely to the young calligraphers. One calligrapher filled half the image with his calligraphy, while another wrote less than a sentence across his face. The expression and flow of thought unique to each calligrapher are visualized both in their portraits and in their calligraphies. This accords with Chun's belief that the

speed and meaning of time vary for each subject, since all human beings have a finite amount of time in their lives.

Chun captures calligraphy not as an artwork with a form and a theme, but as a practice. Today, the discipline of calligraphy is treated as having the aspect of a performance concomitant with the view of artists as transcendent figures with masterly skills. But Chun's artworks, created from a personal interaction between the artist and his subject, reveal that calligraphy can be an unaffected expression and a response to the flow of thoughts in the mind. His oeuvre also touches upon the fact that writing started not only from the need for communication, but also out of human beings' basic desire to express themselves.

EY

1
Soyeon Ahn, Interview with Kyungwoo Chun, Art Spectrum, 2006, http://www.kyungwoochun.de/texts-pdf/soyeon-ahn.pdf.

2
Lee Dongkook, "Seoye ga yeoljeon 10 Joseon jungi—Gosan hwangiro" [Biographies of calligraphers 10: Mid-Joseon—Gosan Hwang Giro], Gyeonghyang Sinmun, September 22, 2006, http://news.khan.co.kr/kh_news/khan_art_view.html?artid=200609221548561&code=900308.

3
Susanne Pfeffer, "Interview with Kyungwoo Chun by Susanne Pfeffer," in Kyungwoo Chun: Photographs, Video Performances, ed. Chun Kyungwoo et al. (Berlin: Hatje Cantz, 2005), 83.

118

JUNG DO-JUN
정도준
B. 1948

Generous Heart and Small Pavilion
관해정

2004
Ink on paper
68⅞ × 82⅝ in. (175 × 210 cm)
Collection of the artist

Jung Do-Jun's father, Jung Hyeonbok (1909—1973), was a prominent calligrapher, and one could thus argue that Jung Do-Jun was born into calligraphy. From a young age, he won many prestigious calligraphy competitions before studying with Kim Choong Hyun (cat. 116, Il Choong; 1921—2006), who had already established a reputation for his mastery of all forms of calligraphy, in particular the Korean phonetic *hangeul* form and the Han Chinese calligraphy form known as *yeseo* (clerical script).[1] With Kim, Jung focused his studies on the Chinese calligraphers Wang Xizhi (307—365) and Yan Zhenqing (709—785) and the Korean calligrapher Gim Jeonghui (Chusa; 1786—1856); in

this way his works are the result of continuous research and the revival of ancient and traditional calligraphic modes.[2]

In Korea today UNESCO World Heritage and national and cultural asset sites, including Gyeongbok Palace and Namdaemun (Sungnyemun) Gate in Seoul, bear the works of Jung in the form of signboards or inscriptions on ridge beams. This is an honor bestowed on a select few calligraphers; in royal times, the most prominent calligrapher would have been chosen by the king to carry these out.[3] Jung's talent lies in his ability to analyze any style of character and create a new work. The calligraphy shown here is a partial transcription of a poem he wrote on the four pillars of a traditional pavilion, Gwanhaejeong in Gyeongsangnam Province, which is Registered Cultural Property no. 2. The poem begins:

> A generous heart makes me forget how narrow a piece of land is.
> A small pavilion allows me to see many mountains.

The remainder of the poem, inscribed on the pavilion, reads:

> An energy from water cools down the stairs.
> A shadow of pine casts a shadow on the spot peacefully.[4]

The calligraphy defies the strict grid order of traditional calligraphic composition, almost to the point that the characters are challenging to read because of their wild shapes. After more than six decades of devotion to his craft, Jung, whose artist's name is Sohun, has managed to bring calligraphy and art together. Lee Dongkook, director and chief curator of the Seoul Calligraphy Art Museum, describes it thus: "It is not an expansion of the sphere of calligraphy into that of art, but the reclamation of the original domain of calligraphy."[5] As Professor George Teodorescu puts it, "[Jung's] images are much more than texts, they are the graphic expression of his emotional interpretation of literary citations, filtered through a long tradition of calligraphy."[6] Thus, instead of moving toward abstraction like Kim Sun Wuk (cats. 108 and 109), Jung experiments with the ways in which characters are interpreted in pictorial terms.

VM

1
George Teodorescu, "4000 Years of Signs Do-Jun Jung," in *Sohun Jung Do-jun Seojip* (Seoul: Ehwa munhwa chulpansa, 2001), 259.
2
Eunlog Sim, "On 'Soma-graphie': Conversations with Jung Do-Jun," in Lee Dongkook, ed., *Jung Do-Jun Stroke and Structure* (Seoul: Seoul Calligraphy Art Museum, 2017), 292.
3
Ibid., 291.
4
"Gwanhaejeong" [Gwanhae pavilion], accessed March 23, 2018, http://terms.naver.com/entry.nhn?docId=2458069&cid=46656&categoryId=4665; translation by Christina Gina Lee.
5
Lee Dongkook, "Jung Do-jun: From the Origin," in Lee, *Jung Do Jun Stroke and Structure*, 16.
6
Teodorescu, "4000 Years of Signs Do-Jun Jung," 239.

119

LEE KANG-SO
이강소
B. 1943
Emptiness 14010
허 14010
2014
Acrylic on canvas
98½ × 191 in. (250 × 485 cm)
Collection of the artist

Many of Lee Kang–so's recent works are titled *Emptiness* (*heo*). In Korea, the word does not convey the sense of forlornness with which it is usually associated in the West, but rather a sense of infinite possibility. This meaning is implied in the use of the term in a Buddhist context— as referred to, for example, in the *Heart Sutra* (*Banyashimgyeong*): "Form is emptiness; emptiness is form."[1] This suggests that what is perceived as real in the phenomenal world is actually a mere illusion; Lee Kang–so focuses on expressing this insight in his work.

Lee experimented with many art forms in his early years, including a serious engagement with performance art. Many of his recent works continue to embody performative aspects, possessing characteristics not unlike calligraphy. As Lee has said, "*Unpil* (wielding a brush) [is not what I think when I use the brush to paint]. *Unpil* is a brushstroke and a powerful performance that can be executed at the stage of harmonious integration of clear mind and body without thinking of anything that can disturb your mind."[2]

Lee uses a thick brush to carry out his signature painting technique. Critics, such as Minemura Toshiaki, argue that the brush and Lee's handling of it constitute a deep understanding that defines the core and life of his works. Minemura writes, "In brief, throughout his thirty–five-year career, what sets Lee's painting apart from all others was neither form nor color, neither shape nor image, neither subject nor object, but the working of his brush that touches upon all of these elements."[3]

VM

1
Yi Chang Su, "Muwireul chajaganeun yesulga: Misulga Lee Kang–So" [The artist who pursues emptiness: Artist Lee Kang–So], *Purideomweold Weolganji* [Freedom world daily magazine] 2,032, no. 1 (2013): 177.
2
Ibid., 174—75. Translated by Christina Gina Lee.
3
Minemura Toshiaki, "Lee Kang–so: The Deepening Middle," in *Lee Kang–so,* ed. Lorand Hegyi and Martine Dancer–Moures, exh. cat. (Seoul: Wooson Gallery, 2016), 41.

PARK DAE SUNG
박대성
B. 1945

Tall Mountains and Long River
산고수장
2017
Ink on paper
69¾ × 15¾ in. (177 × 40 cm)
Collection of the artist

The Beautiful Land of Korea
금수강산
2017
Ink on paper
68⅞ × 15¾ in. (174.9 × 40 cm)
Collection of the artist

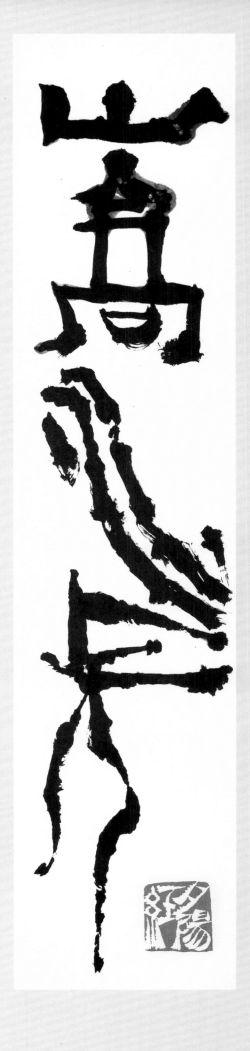

Park Dae Sung was born in 1945, the last year of the Japanese colonial occupation of Korea and five years prior to the start of the Korean War. During the Korean War, Park lost both his parents and his left arm to Communist soldiers. He found solace in painting and made art his singular devotion.

Self-taught, Park holds Gim Saeng (711–?), a prominent Korean calligrapher of the Unified Silla dynasty (668–935) and the earliest recognized calligrapher in Korea, in the highest regard, as a "teacher." Park can perfectly emulate the styles of notable Korean and Chinese calligraphers, and all his paintings show the influence of his calligraphic training. He has traveled to China to study landscape painting; taken a trip along the Silk Road to learn the origins of Chinese characters; and spent time in solitude in Gyeongju, Korea, where he now resides. As a result, his subjects and influences are varied. He is continually inspired by the arts of the Chinese Song (960–1279), Yuan (1260–1368), and Ming (1368–1644) dynasties. In the 1980s and 1990s, he branched out to experiment with color.

After 2000 Park began rendering traditional artifacts and architecture in ink. The lines in his paintings are similar to those in his calligraphy.[1] How the brush is manipulated influences the line's outcome: Park holds his brush at a ninety-degree angle, using his fourth finger to guide it. This position allows him not only to impart energy into each stroke, but also to mimic the act of chiseling wood, in the spirit of carving Buddhist wooden printing blocks.[2]

The two works featured here are embodiments of Park's belief that drawing and painting come from the same origin.[3] The style is referred to as *bangpil*: a line that is strong yet sharp.[4] While such calligraphic characteristics as speed and the amount of ink on the brush combine to describe the line, the *hanja* character for water in *Tall Mountains and Long River*, for example, resembles falling water.[5]

VM

[1]
Jiyoun Song, "A Study on Paintings of Daesung Park" (master's thesis, Hongik University, 2017), 109–10.

[2]
Park Dae Sung, *Seosan Park Dae Sung*, exh. cat. (Seoul: Lee Ho Jae, 2011), 7.

[3]
Ibid.

[4]
Song, "A Study on Paintings of Daesung Park," 43.

[5]
Ibid., 44.

GLOSSARY

Characters for each name or term appear to the right: *hangeul* characters appear to the immediate right, *hanja* to the far right.

Ahn Sang-soo	안상수	
Amita Bul	아미타불	阿彌陀佛
An	안	安
An Gyeon (Gado)	안견 (가도)	安堅 (可度)
An Junggeun	안중근	安重根
An Jungsik (Simjeon)	안중식 (심전)	安中植 (心田)
Anpyeong Daegun	안평대군	安平大君
Ansimsa (Ansim Temple)	안심사	安心寺
Ashikaga	아시카가	足利

B

baduk	바둑	
Baekje	백제	百濟
Bai Juyi (K. Baek Geoi)	백거이	白居易
balseonggigwan	발성기관	發聲器官
bangpil	방필	方筆
Bangudae	반구대	盤龜臺
Bangudae Amgakhwa	반구대 암각화	盤龜臺 岩刻畫
Banyashimgyeong	반야심경	般若心經
(Ch. *Boluo Xin jing*)		
Bei (K. bi)	비	碑
Bei (K. pae)	패	貝
Beilin (K. bilim)	비림	碑林
Ben (K. bun)	분	奔
beopgochangsin	법고창신	法古創新
Beopgwangsa	법광사	法光寺
(Beopgwang Temple)		
Beopheung Wang	법흥왕	法興王
Beophwa gyeong	법화경	法華經
Beopjang	법장	法藏
Bi hyo mu chin	비효무친	非孝無親
Bianliang (K. Byeollyang)	변량	汴梁
Bibaek	비백	飛白
bisaek	비색	翡色
Bongnae (Ch. Penglai)	봉래	蓬萊
Bongpyeong-ri	봉평리	鳳坪里
Boryeong-si	보령시	保寧市
bosanghwa	보상화	寶相花
Bulseolgwan mulyangsu	불설관무	佛說觀無量壽佛經
bulgyeong (Ch. Foshuo	량수불경	
guan wuliang shou fo jing)		

Bu	부	福
bujeok	부적	符籍
Bukcheong-gun	북청군	北青郡
Bukgyeong (E. Beijing)	북경 (베이징)	北京
(Ch. Beijing)		
Bukhansan (Mount Bukhan)	북한산	北漢山
buli	불이	不二
buncheong	분청	粉青
Busan	부산	釜山
Buyeo	부여	夫餘
byeong	병	丙
byeonsang	변상	變相

C

Cao Wei (K. Jo Wi)	조위	曹魏
Cao Zhi (K. Jo Sik)	조식	曹植
Chang'an (K. Jangan)	장안	長安
Changdeokgung	창덕궁	昌德宮
(Changdeok Palace)		
Changnyeong	창녕	昌寧
Chen Shilang (K. Jin Sirang)	진시랑	陳侍郎
Cheok Jungyeong	척준경	拓俊京
Cheokgyeong	척경	拓境
Cheokju (Samcheok)	척주 (삼척)	陟州 (三 陟)
Cheollima	천리마	千里馬
Cheolsu doin	철수도인	鐵邃道人
Cheonchuchong	천추총	千秋塚
Cheongheodang Hyujeong	청허당 휴정	清虛堂 休靜
cheongja	청자	青磁
Cheongpyeong	청평	清平
Cheongsayeoljeon	청사열전	清士列傳
Cheonjeon-ri	천전리	川前里
Cheop	첩	帖
Cheophaesineo	첩해신어	捷解新語
cheopjang	첩장	帖裝
Chikuzen (K. Chukjeon)	축전	筑前
Chimgye	침계	梣溪
Cho Inyeong	조인영	趙寅永
Choe	최	崔
Choe Chiwon	최치원	崔致遠
Choe Ham (Mungan)	최함 (문간)	崔諴 (文簡)

Choe Rip	최립	崔岦
Chogyeolbaegunga (Ch. *Caojue baiyun ge*)	초결백운가	草訣百韻歌
Choi Wu	최우	崔瑀
chongnando	총란도	叢蘭圖
Chongning (K. Sungnyeong)	숭녕	崇寧
choseo	초서	草書
Chouchi (K. Guji)	구지	仇池
Choui Seonsa	초의선사	草衣禪師
Chu Suiliang (K. Jeo Sulyang)	저수량	褚遂良
Chun Kyungwoo	천경우	
Chungcheongbuk-do	충청북도	忠淸北道
Chungcheongnam-do	충청남도	忠淸南道
Chungnyang	충량	忠亮
Chunpadang Ssangeon	춘파당 쌍언	春坡堂雙彦
Chunqiu (K. Chunchu)	춘추	春秋
Chuogeng lu (K. Cheolgyeong rok)	철경록	輟耕錄
Chusa	추사	秋史
Chusache	추사체	秋史體

D

Da Tang Qinwang cihua (K. *Dae Dang Jinwang sahwa*)	대당진왕사화	大唐秦王詞話
Dabi	다비	茶毘
Dado	다도	茶道
Daedunsa (Daedun Temple)	대둔사	大芚寺
Daedunsan (Mount Daedun)	대둔산	大芚山
Daegakguksamunjip	대각국사문집	大覺國師文集
Daegam guksa	대감국사	大鑑國師
Daegam Tanyeon	대감 탄연	大鑑 坦然
Daegu	대구	大邱
Daehan jeguk	대한제국	大韓帝國
Daehan maeil sinbo	대한매일신보	大韓每日申報
Daeheungsa (Daeheung Temple)	대흥사	大興寺
Daejeogam	대적암	大寂菴
Daejeon	대전	大田
Daeunsanbangmungo	대운산방문고	大雲山房文藁
Daimyo (K. Daemyeong)	대명	大名
Daljun	달준	達夋
Dangjin Yeonui (Ch. *Tang Qin yanyi*)	당진연의	唐秦演義
Danmok	단목	端目
Dao (K. Do)	도	道
Dasan	다산	茶山
Deoksugung (Deoksu Palace)	덕수궁	德壽宮
ding (K. jeong)	정	鼎
Dogokjip	도곡집	陶谷集
Dohwaseo	도화서	圖畫署

Dong Qichang (Wenmin) (K. Dong Gichang [Munmin])	동기창 (문민)	董其昌 (文敏)
Donga	동아	東阿
Dongam	동암	東庵
Donggukisanggukjip	동국이상국집	東國李相國集
Donggukjeongun	동국정운	東國正韻
Donghaesong	동해송	東海頌
Dongnip hyeophoe	독립협회	獨立協會
Dongnip Sinmun	독립신문	獨立新聞
Donghwamun	동화문	東華門
Dosan	도산	陶山
Du Fu (K. Dubo)	두보	杜甫
Dui (dae)	대	敦
Dunhuang (K. Donhwang /Dunhwang)	돈황 (둔황)	敦煌

E

Eom	엄	嚴
eongan	언간	諺簡
eonmun	언문	諺文
eul	을	乙
Eulsa	을사	乙巳

F

fang ding (K. bangjeong)	방정	方鼎
Feng Yunpeng (K. Pung Unbung)	풍운붕	馮雲鵬
Fu (K. bo)	보	甫
Fu (K. bo)	보	簠

G

Gaeseong	개성	開城
Gamji geumni	감지 금니	紺紙金泥
Gang Useong	강우성	康遇聖
Gang yeong bu su (Ch. Kang ning fu shou)	강영부수	康寧福壽
Gangjin	강진	康津
Gangwon-do	강원도	江原道
Gangyeongdogam	간경도감	刊經都監
Ganseong	간성	杆城
Gansu (K. Gamsuk)	감숙	甘肅
Gao Lian (K. Go Ryeom)	고렴	高濂
gap	갑	甲
Gaya	가야	加耶
Ge (K. gal)	갈	葛
Ge Hong (Zhichuan) (K. Gal Hong [Chicheon])	갈홍 (치천)	葛洪 (稚川)
Geonbongsa (Geonbong Temple)	건봉사	乾鳳寺
Geosa	거사	居士

Romanization	Hangul	Hanja
geuk	극	極
geum	금	禁
geum	금	金
Geum deuk cheong ga	금득청가	琴得清暇
Geumganggyeong	금강경	金剛經
Geumgangsan (Mount Geumgang)	금강산	金剛山
geumseokmun	금석문	金石文
Geunyeok seohwajing	근역서화징	槿域書畵徵
Gijache	기자체	箕子體
Gim	김	金
Gim Baekil	김백일	金百鎰
Gim Busik	김부식	金富軾
Gim Buui (Gim Bucheol)	김부의 (김부철)	金富儀 (金富轍)
Gim Deuksin	김득신	金得臣
Gim Eunho	김은호	金殷鎬
Gim Gyujin (Haegang)	김규진 (해강)	金圭鎭 (海岡)
Gim Hongdo	김홍도	金弘道
Gim Changhyeop	김창협	金昌協
Gim Jeonghui (Chusa, Wandang)	김정희 (추사/완당)	金正喜 (秋史/阮堂)
Gim Jiweon	김지원	金智源
Gim Saeng	김생	金生
Gim Sangsuk	김상숙	金相肅
Gim Yugeun (Hwangsan)	김유근 (황산)	金逌根 (黃山)
giyeok	ㄱ (기역)	
go	고	苦
Go Huidong	고희동	高羲東
goche	고체	固體
goeseok (Ch. guai shi)	괴석	怪石
Gogeum Seohwagwan	고금서화관	古今書畵館
Goguryeo	고구려	高句麗
Gojong Wang	고종왕	高宗王
Goldongsa	골동사	骨董肆
Gomak goeo jasi	고막고어자시	孤莫孤於自恃
gong	공	空
Gongja (Ch. Kongzi)	공자	孔子
Gongju	공주	公州
Gonryun	곤륜	崑崙
Goryeo	고려	高麗
Goryeo-in	고려인	高麗人
gosi	고시	古詩
Gu Yuanqing (K. Go Wongyeong)	고원경	顧元慶
guk	국	國
Gukyeok geunyeokseohwajing	국역 근역서화징	國譯槿域書畵徵
Gungaekchohyeop	궁액초협	窮阨蕉頰
gungche	궁체	宮體
Guyangsunche	구양순체	歐陽詢體
Gwacheon	과천	果川
gwangchoseo	광초서	狂草書
Gwanggaeto Daewang	광개토대왕	廣開土大王
Gwangjong Wang	광종왕	光宗王
Gwangju	광주	光州
Gwanpandaejanggyeong	관판대장경	官版大藏經
Gwansanseong	관산성	管山城
Gwon Donin (Yijae)	권돈인 (이재)	權敦仁 (彝齋)
Gyehwabuin	계화부인	桂花夫人
gyemi	계미	癸未
gyeong	경	經
Gyeongdang	경당	扃堂
Gyeonggi-do	경기도	京畿道
gyeongja	경자	庚子
Gyeongjong Wang	경종왕	景宗王
Gyeongju	경주	慶州
Gyeongsangbuk-do	경상북도	慶尙北道
Gyeongsangnam-do	경상남도	慶尙南道
Gyeyun	계윤	季潤
Gyoseogwan	교서관	校書館
Gyujanggak	규장각	奎章閣

H

Romanization	Hangul	Hanja
Haegang nanjukbo	해강 난죽보	海岡蘭竹譜
Haeinsa (Haein Temple)	해인사	海印寺
haengcho ganchal	행초간찰	行草簡札
haengseo	행서	行書
haeseo	해서	楷書
Hagi	하기	萩燒
Hamgyeongbuk-do	함경북도	咸鏡北道
Hamgyeongnam-do	함경남도	咸鏡南道
Han	한	漢
Han Daoheng (K. Han Dohyeong)	한도형	韓道亨
Han Ho (Seokbong)	한호 (석봉)	韓濩 (石峯)
Hangang	한강	漢江
hangeul	한글	
Hangzhou (K. Hangju [Hangjeou])	항주 (항저우)	杭州
hanja	한자	漢字
hanji	한지	韓紙
Hanlin (K. Hallim)	한림	翰林
Hanseokbongche	한석봉체	韓石峯體
Hanseong	한성	漢城
Hapicheop	하피첩	霞帔帖
Harbin (K. Habibin [Haeolbin])	합이빈 (하얼빈)	哈尔滨

He (K. hwa)	화	盉		Hyeonjong Wang	현종왕	顯宗王
He Zhizhang (K. Ha Jijang)	하지장	賀知章		hyeonpan	현판	懸板
Heilongjiang	흑룡강	黑龍江		Hyeopseong hoe	협성회	協成會
(K. Heungnyonggang)	(헤이룽장)			Hyeso	혜소	惠素
heo	허	虛		Hyogong Wang	효공왕	孝恭王
Heo Baekryeon	허백련	許百鍊		Hyogyeong (Ch. Xiao jing)	효경	孝經
Heo Mok	허목	許穆		Hyojang	효장	孝章
Heo Ryeon (Sochi)	허련 (소치)	許鍊 (小癡)		Hyojong Wang	효종왕	孝宗王
Heogok	허곡	虛谷				
Heolseongnu	헐성루	歇惺樓		**I**		
Heonjong Wang	헌종왕	憲宗王		Igyejip	이계집	耳谿集
Heungdeok Wang	흥덕왕	興德王		Iksan	익산	益山
Hiragana	히라가나	平仮名		ilpilhwiji	일필휘지	一筆揮之
Hizen	히젠	肥前		Imje	임제	臨濟
Hogoryeo	호고려			Imjin	임진	壬辰
Hong Gwan	홍관	洪灌		Injo Wang	인조왕	仁祖王
Hong Yangho	홍양호	洪良浩		Injong Wang	인종왕	仁宗王
Hongdongbaekseo	홍동백서	紅東白西		Inmok-wanghu	인목왕후	仁穆王后
Hongfan (K. Hongbeom)	홍범	洪範		ipkkol	입꼴	
Hongnong	홍농	弘農		Ipmoyang	입모양	
Hongru mong	홍루몽	紅樓夢		Iryeon	일연	一然
(Ch. Honglou meng)				Itō Hirobumi	이토 히로부미	伊藤 博文
Honshu (K. Bonju)	혼슈	本州				
Hoseo	호서	湖西		**J**		
Hu (K. Ho)	호	壺		Ja sin bul (Ch. Zi shen Fo)	자신불	自身佛
Hu Suhojeon (Ch. Hou	후수호전	後水滸傳		Jagang-do	자강도	慈江道
Shuihu zhuan)				Jamokji	조 목지	
Huairen (Hoein)	회인	懷仁		Jang Seung-eop	장승업	張承業
Huang Gongwang (Dachi)	황공망 (대치)	黃公望 (大癡)		Jangseogak	장서각	藏書閣
(K. Hwang Gongmang Daechi)				Jangseogak in	장서각인	藏書閣印
Huang Shigong (K. Hwang	황석공	黃石公		Jangsu Wang	장수왕	長壽王
Seokgong)				jasang	자상	字像
Heunghae	흥해	興海		Jejudo	제주도	濟州島
Hunminjeongeum	훈민정음	訓民正音		Jeollabuk-do	전라북도	全羅北道
Hunmongjahoe	훈몽자회	訓蒙字會		Jeollanam-do	전라남도	全羅南道
hwa	화	畫		jeong	정	丁
hwa	화	火		Jeong Giyeon	정기연	鄭璣淵
Hwaeom gyeong	화엄경	華嚴經		Jeong Inseung	정인승	鄭寅承
hwanggeuk	황극	皇極		Jeong Yakyong (Yeolsu)	정약용 (열수)	丁若鏞 (洌水)
Hwanghaebuk-do	황해북도	黃海北道		Jeongjo Wang	정조왕	正祖王
Hwanghaenam-do	황해남도	黃海南道		Jeongchu (K. Jeongyu)	정유	丁酉
Hwangjo gyeongse munpyeon	황조경세문편	皇朝經世文編		Jeongmyeong gongju	정명공주	貞明公主
Hwangryongsa (Hwangryong	황룡사	皇龍寺		Jeongyeongyasu	전경야수	田更野叟
Temple)				jeongyu	정유	丁酉
Hwangseong Sinmun	황성신문	皇城新聞		jeonja	전자	轉子
Hwangtong (Ch. Huangtong)	황통	皇統		jeonseo	전서	篆書
hwawon	화원	畫員		Jeseokpanangwon	제석파난권	題石坡蘭卷
Hyeonjong sillok	현종실록	顯宗實錄		Jeungsam (Ch. Zengzi)	증삼	曾參

Ji (K. geuk)	극	棘
Ji	지	枝
Jian (K. Jeom)	점	漸
Jigu zhai zhongding yiqi kuanshi (K. Jeokgo jaejongjeong igi gwanji)	적고재종정이 기관지	積古齋鐘鼎彝器款識
Jijeung Wang	지증왕	智證王
Jikji simche yojeol	직지심체요절	直指心體要節
Jilin (K. Jirin [Gillim])	지린 (길림)	吉林
Jin (K. Jin [dynasty, 265—420])	진	晉
Jin (K. Geum [dynasty, 1115—1234])	금	金
Jindo	진도	珍島
Jineonjip	진언집	眞言集
Jingam seonsa tapbi	진감선사탑비	眞鑑禪師塔碑
Jinheung Wang	진흥왕	眞興王
Jinnaggong	진락공	眞樂公
Jinpyeong Wang	진평왕	眞平王
jinseol	진설	陳設
Jinshi suo (K. Geumseoksaek)	금석색	金石索
Jiphyeonjeon	집현전	集賢殿
jipja	집자	集字
Jiucheng gong (K. Guseonggung)	구성궁	九成宮
Jiwang Shengjiao Xu (K. Jibwangseonggyoseo)	집왕성교서	集王聖教序
Jixiao xinshu (K. Gihyosinseo)	기효신서	紀效新書
Jo Huiryong	조희룡	趙熙龍
Jo Seokjin (Sorim)	조석진 (소림)	趙錫晉 (小琳)
Jodong (Ch. Caodong)	조동	曹洞
Join	조인	祖印
Josa	조사	照師
Joseon	조선	朝鮮
Joseon misul jeollam hoe	조선미술전람회	朝鮮美術展覽會
Joseon wangjo sillok	조선왕조실록	朝鮮王朝實錄
Joyulisi	조율이시	棗栗梨柿
jukro	죽로	竹爐
jungin	중인	中人
Jungseong	중성	中城
Jungseong-ri	중성리	中城里

K

Kaifeng (K. Gaebong [Kaipeong])	개봉 (카이펑)	開封
Kangxi (K. Ganghui)	강희	康熙
Katsuragi Sueharu	가쓰라기 스에하루	葛城末治

Kim Choong Hyun	김충현	金忠顯
Kim Jongweon	김종원	
Kim Sun Wuk	김순욱	
Kun (K. Gon)	곤	昆

L

Lan Caihe (K. Nam Chaehwa)	남채화	藍采和
Lanting xu (K. Nanjeongseo)	난정서	蘭亭序
Lee Gwangsa	이광사	李匡師
Lee Gyeong	이경	李敬
Lee Jakgwang	이작광	李勺光
Lee Kang-so	이강소	
Lee Samman	이삼만	李三晩
Lee Ungno	이응노	
Lei (K. roe/noe)	뢰/뇌	罍
Lelang (K. Nangnang)	낙랑	樂浪
Li Bai (K. Yi Baek)	이백	李白
Li Dongyang (K. Yi Dongyang)	이동양	李東陽
Li Ge (K. Yi Hyeok)	이혁	李革
Li He (K. Yi Ha)	이하	李賀
Li Shimin (K. Yi Semin)	이세민	李世民
Li Yangbing (K. Yi Yangbing)	이양빙	李陽冰
Liang (K. Ryang)	량 (양)	兩
Liang Shizheng (K. Yang Sijeong)	양시정	梁詩正
Liang Wudi (K. Yang Muje)	양무제	梁武帝
Liao (dynasty) (K. Yo)	요	遼
Liji (K. Yegi)	예기	禮記
Lin (K. Rim)	림	林
Lishu (K. Yeseo)	예서	隸書
Liu Song (K. Yu Song)	유송	劉宋
Liyang (K. Yul Yang)	율양	溧陽
Lü Diaoyang (K. Yeo Joyang)	여조양	呂調陽
Lu shan (K. Yeosan)	여산	廬山
Luo Ping (Liangfeng) (K. Na Bing [Yangbong])	나빙 (양봉)	羅聘 (兩峰)

M

maebyeong	매병	梅瓶
Maehyang-ri	매향리	梅香里
Maeil sinbo	매일신보	每日申報
Manhakjip	만학집	晚學集
Mao Yuanyi (K. Mo Wonui)	모원의	茅元儀
Men (K. Min)	민	悶
Meng (K. Maeng)	맹	孟
Mi Fu (K. Mi Bul) (Namgung)	미불 (남궁)	米芾 (南宮)
Min Yeongik	민영익	閔泳翊
Ming (K. Myeong)	명	明
minjung	민중	民衆

Mireuksa (Mireuk Temple)	미륵사	彌勒寺
Miryang	밀양	密陽
Misuche	미수체	眉叟體
Mongyu dowon do	몽유도원도	夢遊桃源圖
Mōri Terumoto	모리 데루모토	毛利輝元
Muho	무호	無號
Mujangsa (Mujang Temple)	무장사	鍪藏寺
Mujeonghyeong	무정형	無定形
Mukrimhoe	묵림회	墨林會
munbangsau	문방사우	文房四友
munja	문자	文字
munjahyang	문자향	文字香
Mumungwan (Ch. *Wumen Guan*)	무문관	無門關
Munmunjaja geumganggyeong geu seojeok byeonsang	문문자자 금강경 그 서적 변상	文紋字孶 – 金剛經 그 書的 變相
Munsusa (Munsu Temple)	문수사	文殊寺
Muromachi	무로마치	室町
Muryeong Wang	무령왕	武寧王
muwi	무위	無為
Muye dobo tongji eonhae	무예도보통지언해	武藝圖譜通志諺解

N		
nam	남	南
Nam Sumun	남수문	南秀文
Namin	남인	南人
namjong	남종	南宗
Nammyeong cheon hwasang song jeungdoga	남명천화상송 증도가	南明泉和尚頌 證道歌
Nanggongdaesa	낭공대사	朗空大師
Nanmaengcheop	난맹첩	蘭盟帖
Ni Zan (K. Yechan)	예찬	倪瓚
nieun	ㄴ (니은)	
Nihonga (K. Ilbonhwa)	일본화	日本畫
nobi	노비	奴婢
Nabaek	나백	懶白
non	논	論
Nong-am jip	농암집	農巖集

O		
O Sechang (Wichang)	오세창 (위창)	吳世昌 (葦滄)
O Doja (Ch. Wu Daozi)	오도자	吳道子
Ongnu mong	옥루몽	玉樓夢
Ouga	오우가	五友歌
Ouyang Xun (K. Guyang Sun)	구양순	歐陽詢

P		
Palgwae (Ch. Bagua)	팔괘	八卦
palseon (Ch. baxian)	팔선	八仙
Park Dae Sung	박대성	
Pohang	포항	浦項
pungsu	풍수	風水
Pyeonganbuk-do	평안북도	平安北道
Pyeongannam-do	평안남도	平安南道
Pyeongyang	평양	平壤
Pyeongyang-do	평양도	平壤道

Q		
Qi (K. Gi)	기	棄
Qi (K. Chil)	칠	七
Qi (K. Je)	제	齊
Qi Jiguang (K. Cheok Gyegwang)	척계광	戚繼光
Qiantang (K. Jeondang)	전당	錢塘
qin (K. Geum)	금	琴
Qin (K. Jin)	진	秦
Qing (K. Cheong)	청	清
Quan Tang shi (K. *Jeondangsi*)	전당시	全唐詩

R		
Rhee, Syngman	이승만	李承晚
Ruan Yuan (K. Wan Won)	완원	阮元

S		
Sa	사	寺
Sado	사도	思悼
sagunja	사군자	四君子
sajagwan	사자관	寫字官
samdae (Ch. santai)	삼대	三臺
Samguk sagi	삼국사기	三國史記
Samguk yusa	삼국유사	三國遺事
Samyeonjae	삼연재	三硯齋
samjeonbeop	삼전법	三轉法
Samyeongdang Yujeong	사명당 유정	四溟堂惟政
san gwang su saek	산광수색	山光水色
sanggye	상계	喪契
Sanhaegyeong (Ch. *Shanhai jing*)	산해경	山海經
Sataekjijeok	사택지적	砂宅智積
Satsuma	사쓰마	薩摩
Sayeogwon	사역원	司譯院
Sehando	세한도	歲寒圖
Sejo Wang	세조왕	世祖王
Sejong Wang	세종왕	世宗王
Sen no Rikyu	센노 리큐	千利休

Seobeopjingyeol	서법진결	書法真訣		Sima Qian (K. Sama Cheon)	사마천	司馬遷
seochejeok chusang	서체적 추상	書體的 抽象		Simsibul (Ch. Xin shi Fo)	심시불	心是佛
Seo Geojeong	서거정	徐居正		sin (Ch. shen)	신	神
Seo Jaepil	서재필	徐載弼		Sin Huinam	신희남	愼喜男
Seo Yugyo	서유교	徐有教		Sin Saimdang	신사임당	申師任堂
seogwongi	서권기	書卷氣		Sin Yunbok (Hyewon)	신윤복 (혜원)	申潤福 (蕙園)
seohwa	서화	書畫		sinsa	신사	辛巳
Seohwadam	서화담	書畫談		siseohwailche	시서화일체	詩書畫一體
Seohwa Misulhoe	서화미술회	書畫美術會		Soheon	소헌	昭憲
Seokbong	석봉	石峯		Sohyeon	소현	昭顯
Seokbosangjeol	석보상절	釋譜詳節		Son	손	孫
Seokgomun (Ch. Shigu wen)	석고문	石鼓文		Song	송	宋
seomin	서민	庶民		Song Huizong (K. Song Huijong)	송 휘종	宋 徽宗
Seon (Ch. Chan; J. Zen)	선	禪		Songaksan (Mount Songak)	송악산	松嶽山
Seonghak Jibyo	성학집요	聖學輯要		Songdo	송도	松都
Seong Sammun	성삼문	成三問		Songseolche (Ch. Songxueti)	송설체	松雪體
Seonjin Ilsa	선진일사	仙真逸史		Songwoldang Eungsang	송월당 응상	松月堂應祥
Seonjo Wang	선조왕	宣祖王		soriteul	소리틀	
Seoul	서울			Soseong Wang	소성왕	昭聖王
Seoul Sinmun	서울신문			Ssangsik	쌍식	雙式
Seowangmo (Ch. Xiwangmu)	서왕모	西王母		su	수	壽
Seumnyeguk	습례국	習禮局		Su Shi (Su Dongpo; Pogong) (K. Sosik [Dongpa; Pagong])	소식 (동파; 파공)	蘇軾 (東坡; 坡公)
Seunggasa (Seungga Temple)	승가사	僧伽寺		Su bu Nyeong gang	수부녕강	壽福寧康
Seungmunwon	승문원	承文院		Suh Se Ok	서세옥	徐世鈺
Shang (K. Sang)	상	商		Sui (K. Su)	수	隋
Shang Zhou yiqi shiming (K. Sangjuigiseokmyeong)	상주이기석명	商周彝器釋銘		Sukan	숙안	淑安
Shangqing (K. Sangcheong)	상청	上清		Sukjong Wang	숙종왕	肅宗王
Shaolin Gunfa Chanzong (K. Sorim Gonbeop Cheonjong)	소림곤법천종	少林棍法闡宗		sung	숭	崇
Shi Ke (K. Seok Gak)	석각	石恪		Sunjo Wang	순조왕	純祖王
Shijing (K. Sigyeong)	시경	詩經		Sunjong Wang	순종왕	純宗王
Shindeok Wang	신덕왕	神德王		sunsu	순수	巡狩
Shitao (Daoji; Qingxiang; Kugua) (K. Seokdo [Doje; Cheongsang; Gogwa])	석도 (도제; 청상;고과)	石濤 (道濟; 清湘; 苦瓜)		*Sushu* (K. *Soseo*)	소서	素書
Shouyang (K. Suyang)	수양	首陽		Suwon	수원	水原
Shu Han (K. Chokhan)	촉한	蜀漢		Suyang Daegun	수양대군	首陽大君
Shujing (K. *Seogyeong*)	서경	書經				
Sichuan (K. Sacheon)	사천	四川		T		
sijo	시조	時調		Taehak	태학	太學
sil	실	室		Taehwagang	태화강	太和江
sildam munja	실담문자	悉曇文字		Taejasa (Taeja Temple)	태자사	太子寺
Silhak	실학	實學		Taesagong	태사공	太史公
Silla	신라	新羅		Taewangneung	태왕릉	太王陵
Sim Sajeong (Hyeonjae) (Ch. Shen Shizheng [Xuanzhai])	심사정 (현재)	沈師正 (玄齋)		*Taigong bingfa* (K. *Taegong Byeongbeop*)	태공병법	太公兵法
Sima Fang (K. Sama Bang)	사마방	司馬芳		Tang (K. Dang)	당	唐
				Tang Gaozong (K. Dang Gojong)	당 고종	唐高宗

Tang Gaozu (K. Dang Gojo)	당 고조	唐高祖
Tang Taizong (K. Dang Taejong)	당 태종	唐太宗
Tao Hongjing (K. Do Honggyeong)	도홍경	陶弘景
Tao Yuanming (Tao Qian) (K. Do Yeonmyeong [Dojam])	도연명(도잠)	陶淵明 (陶潛)
Tao Zongyi (K. Do Jongui)	도종의	陶宗儀
Tie (K. Cheop)	첩	帖
Tongnyeongsinmyeong-Gounseonhwa sinbuljido	통령신명-고운선화신불지도	通靈神明 – 孤雲仙化神佛之圖
Tongque (K. Dongjak)	동작	銅雀
Tongsinsa	통신사	通信使
Toyotomi Hideyoshi	도요토미 히데요시	豊臣 秀吉
Tsushima	쓰시마	対馬

U

Uljin-gun	울진군	蔚珍郡
Ullimsanbang	운림산방	雲林山房
Ulsan	울산	蔚山
Unpa	운파	雲坡
Unpa Cheongan	운파청안	雲坡清眼
Unpadang	운파당	雲坡堂
unpil	운필	運筆
Uri geulssi sseuneun beop	우리 글씨 쓰는 법	
Useok jae	우석재	友石齋
Usyeon (K. Musin)	무신	戊申

W

Wandang takmuk	완당탁묵	阮堂拓墨
Wang Wei (K. Wang Yu)	왕유	王維
Wang Xianzhi (K. Wang Heonji)	왕헌지	王獻之
Wang Xizhi (Youjun) (K. Wang Huiji)	왕희지	王羲之
Wanggung-ri	왕궁리	王宮里
Wanli (K. Mallyeok)	만력	萬曆
Wei (K. Mi)	미	微
Wei (K. Wi)	위	魏
Weizhou (K. Yuju)	유주	濰州
Wen Yanbo (K. On Eonbak)	온언박	溫彥博
Wen Zhengming (K. Mun Jingmyeong)	문징명	文徵明
Weng Fanggang (Suzhai) (K. Ong Banggang [Sojae])	옹방강 (소재)	翁方綱 (蘇齋)
Weng Shukun (K. Ong Sugon)	옹수곤	翁樹昆

Weng Wenda (K. Ong Mundal)	옹문달	翁文達
Wollyeong	원령	元靈
Won Chunghui	원충희	元忠喜
Wongyo seogyeol	원교서결	圓嶠書訣
Worinseokbo	월인석보	月印釋譜
Wu (K. O)	오	吳
Wu Changshi (K. O Changseok)	오창석	吳昌碩
Wubei Zhi (K. Mubiji)	무비지	武備志
Wumen Huikai (K. Mumun Hyegae)	무문혜개	無門慧開
Wuming Huijing (K. Mumyeong Hyegyeong)	무명혜경	無明慧經
Wuming Huijing chanshi yulu (K. Mumyeonghyegyeong-seonsaeorok)	무명혜경선사어록	無明慧經禪師語錄
Wutong (K. Odong)	오동	梧桐

X

xi (K. se)	세	洗
Xi Qing gujian (K. Seocheonggogam)	서청고감	西清古鑑
Xi'an (K. Seoan)	서안	西安
Xihuang (K. Huihwang)	희황	羲皇
Xiu (K. Hyu)	휴	休
Xu Jing (K. Seo Gyeong)	서경	徐競
Xuanzang (K. Hyeonjang)	현장	玄奘
Xuezhai (K. Seoljae)	설재	雪齋

Y

Yamaguchi	야마구치	山口
Yan Zhenqing (K. An Jingyeong)	안진경	顏真卿
yang	양	陽
Yang	양	楊
Yang Qiu (K. Yanggu)	양구	楊球
yangban	양반	兩班
Yangzhou (K. Yangju)	양주	揚州
Yao (K. Yo)	요	堯
Yeolseong eopil	열성어필	列聖御筆
Yeongjo Wang	영조왕	英祖王
Yeongju	영주	榮州
Yeongnam	영남	嶺南
Yesan	예산	禮山
yeseo	예서	隸書
yi (K. il)	일	一
Yi	이	李

Yi Am	이암	李嵒			
Yi bu jang su	이부장수	李福長壽			
Yi Gae	이개	李塏			
Yi Haeung	이하응	李昰應			
Yi Hanbok (Muho)	이한복 (무호)	李漢福 (無號)			
Yi I (Yulgok)	이이 (율곡)	李珥 (栗谷)			
Yi Insang	이인상	李麟祥			
Yi Jagyeom	이자겸	李資謙			
Yi Jeongyeong	이정영	李正英			
Yi Seokhyeong	이석형	李石亨			
Yi Sun	이순	李焞			
Yi Uihyeon	이의현	李宜顯			
Yi Yong	이용	李瑢			
Yijing (K. Yeokgyeong)	역경	易經			
Yin (K. Eum)	음	陰			
Yo Geukil	요극일	姚克一			
yong	용	龍			
Yongzheng (K. Ongjeong)	옹정	雍正			
Yoon Kwang–cho	윤광조				
you	유	卣			
Yu Ma	유마	維摩			
Yu Yeol	유열				
Yuan (K. Won)	원	元			
Yuanyou (K. Wonwu)	원우	元祐			
Yukchepilron	육체필론	六體筆論			
Yukjoche	육조체	六朝體			
yul	율	律			
Yun Chiho	윤치호	尹致昊			
Yun Seondo	윤선도	尹善道			
Yun Sun (Baekha)	윤순 (백하)	尹淳 (白下)			
Yunlin tang (K. Ullim dang)	운림당	雲林堂			
Yunlin yishi (K. Ullim ilsa)	운림일사	雲林逸事			

Z

Zeng Hou Yi (K. Jeung Hu Eul)	증후을	曾侯乙
Zhao Gu (K. Jo Ha)	조하	趙嘏
Zhao Mengfu (K. Jo Maengbu)	조맹부	趙孟頫
Zheng Liyang (K. Jeong Yulyang)	정율양	鄭溧陽
Zheng Sixiao (K. Jeong Sacho)	정사초	鄭思肖
Zheng Xie (Banqiao) (K. Jeongseop [Pangyo])	정섭 (판교)	鄭燮 (板橋)
zhenren (K. Jinin)	진인	真人
Zhou (K. Ju)	주	周
Zhou Muwang (K. Ju Mokwang)	주 목왕	周穆王
Zhou Xingsi (K. Ju Heungsa)	주흥사	周興嗣
Zhu (K. Jo)	조	助
Zhu Shenglin (K. Je Seongrin)	제성린	諸聖鄰
Zhu Xi (K. Ju Hui)	주희	朱熹
Zhuge Liang (K. Jegal Lyang)	제갈량	諸葛亮
Zun (K. Jun)	준	尊
Zunsheng bajian (K. Junsaeng Paljeon)	준생팔전	遵生八箋
Zuo zhuan (K. Jwa Jeon)	좌전	左傳

桂業洞

工病隨面閒上

遙至以竹遙

是寂三所開游樂者

SELECTED BIBLIOGRAPHY

Academy of Korean Studies. *Hangeul, sotong gwa baegyeo ui munja* [Hangeul: A letter of communication and consideration]. Seongnam: Academy of Korean Studies, Jangseogak Archives, 2016.

Agnew, Neville, Marcia Reed, and Tevvy Ball, eds. *Cave Temples of Dunhuang: Buddhist Art on China's Silk Road*. Exh. cat. Los Angeles: Getty Conservation Institute, 2016.

Ahn, Hwi-joon. "An Kyon and 'A Dream Visit to the Peach Blossom Land.'" *Oriental Art* 26, no. 1 (Spring 1980): 60–71.

———. "Literary Gatherings and Their Paintings in Korea." *Seoul Journal of Korean Studies* 8 (1995): 85–106.

An Dae-hui. *Jeongjo's Secret Letters*. Paju: Munhak Dongne, 2010.

An Ju Ho. "Ansimsabon Jineonjip gwa mangwolsabon Jineonjip ui bigyo yeongu" [A comparative study on the Jineonjip published by Ansimsa Temple and the Jineonjip published by Mangwolsa Temple]. *Baedalmal* 31 (December 2002): 175–96.

Andersen, Poul. "The Practice of *Bugang*." *Cahiers d'Extrême-Asie* 5 (1989–90): 15–53.

Baek Seung-ho. "Beonam Chae Jegong ui munja jeongchi" [A political tendency in the literature of Beon-Am Chae, Jae-gong]. *Jindan Hakbo* 101 (2006): 359–90.

Baekje Muryeong Wangnung [The tomb of King Muryeong and his queen consort in Baekje Kingdom]. Gongju: Gongju University Baekje Cultural Research Institute, 2001.

Bai Qianshen. "Chinese Letters: Private Words Made Public." In *The Embodied Image: Chinese Calligraphy from the John B. Elliott Collection*, edited by Robert E. Harrist, Jr., Wen C. Fong, Bai Qianshen, Dora C. Y. Ching, and John B. Elliott. Exh. cat. Princeton, NJ: Princeton University Art Museum, 1999.

Bak Buja, Song Seongjae, Yi Geonsik, Yi Gigab, Yi Sanghyeok, Yi Taeyong, Yi Hyeonhee, Jeong Seunghye, Jeong Jaeyoung, and Jo Seokhwan. *Hangeul I geoleo on gil* [History of *hangeul*]. Seoul: National Hangeul Museum, 2015.

Bak Munguk, Cha Hansu, Yi Dongsu, and Sin Inju, eds. *Dong-A daehakgyo bakmulgwan sojangpum dorok* [Collection catalogue of Dong-A University Museum]. Busan: Dong-A University Museum, 2001.

Bartlett, Christy. *Flickwerk: The Aesthetics of Mended Japanese Ceramics*. Exh. cat. Münster: Hans Kock GmbH, 2008.

Busan Museum. *Paintings and Calligraphy in the Busan Museum Collection*. Busan: Busan Museum, 2016.

Buyeo National Research Institute of Cultural Heritage. *Gungnamji balgul josa bogoseo* [Investigation report on the excavation of Gungnamji]. Buyeo: Buyeo National Research Institute of Cultural Heritage, 1999.

Cambon, Pierre, and Joseph P. Carroll, eds. *The Poetry of Ink: The Korean Literati Tradition, 1392–1910*. Paris: Musée Guimet, 2005.

Caojue baiyun ge (Song on the Essentials of Cursive Script in One Hundred Rhymes). Shanghai: Shanghai shuhua chubanshe, 2010.

Chang Hak Jin. "Yeokdae daetongnyeong-deul ui mukjeok yeongu" [A study on *mukjeok* of former presidents]. Master's thesis, Wonkwang University, 2017.

Chang Jina. "Gungnip Jungang Bangmulgwan sojang Okhojeongdo e daehayeo" [A study on the painting of *Okhojeong Pavilion* from the National Museum of Korea collection]. *Misul jaryo* [Research on art] 91 (2017): 133–51.

Ch'en, Kenneth. *Buddhism in China: A Historical Survey*. Princeton, NJ: Princeton University Press, 1964.

Chen Liu. "Flowers Bloom and Fall: Representation of the Vimalakirti Sutra in Traditional Chinese Painting." PhD diss., University of Arizona, 2011.

Cheon Hyebong, ed. *Seoye/Jeonjeok* [Calligraphy/records]. *National Treasure 23/24*. Seoul: Yekyung Saneop Press, 1986.

Cheung, Karwin. "Journeys to the Past: Travel and Painting as Antiquarianism in Joseon Korea." Master's thesis, University of Leiden, 2016–17, https://openaccess. leidenuniv.nl/bitstream/handle/1887 /53224/Karwin%20Cheung%20- %20Journeys%20to%20the%20past %20-%20MA%20thesis.pdf?sequence=1.

Cho Hwisang. "The Epistolary Brush: Letter Writing and Power in Choson Korea." *Journal of Asian Studies* 75, no. 4 (2016): 1055–81.

Choe Chiwon. *Jingam seonsa tapbi* [Choe Chiwon's pagoda epitaph for the Seon master Jingam]. *Hanguk seoye myeong-jeok* 5 [Famous traces of the art of Korean calligraphy 5]. Seoul: Seoul Calligraphy Museum, n.d.

Choe, Ung-chon. *Chusa Gim Jeonghui: Hagye ilchi ui gyeongji* [A great synthesis of art and scholarship: Painting and calligraphy of Kim Jeong-hui]. Exh. cat. Seoul: National Museum of Korea, 2006.

Choi Byeongsik. "Muninhwa ui jaehaeseok gwa hanguk muninhwa ui dangdaeseong munje" [Reinterpretation of Muninhwa and their contemporary issues on Korean Muninhwa]. *Dongyang yesul* [Asian art] 29 (2015): 192—216.

Choi In jin. "Seohwaga Haegang Gim Gyujin ui sajinhwaldong yeongu: Cheonyeondang sajingwan eul jungsim euro" [A study about calligraphy-painter Haekang Gim Gyujin's photographic career]. *Hanguk geunhyeondae misul sahak* [Journal of Korean modern and contemporary art history] 15 (August 2005): 413—62.

Choi Soontak. *Chusa ui seohwa segye* [Calligraphy and painting of Chusa]. Seoul: Hakmunsa, 1996.

Choi Wansu. *Gim Chusa yeongu cho* [Study of Gim Chusa]. Seoul: Jisik saneopsa, 1976.

———. "Hanguk seoye sagang" [History of Korean calligraphy]. *Kansong munhwa* [Kansong culture] 33: 47—72.

Choi Young-sung. "Chusa geumseokhak ui jaejomyeong: Sajeok gojeung munje reul juanmok euro" [Reinterpretation of Chusa's epigraphy: Centered on the issue of a historic "research"]. *Dongyang gojeon yeongu* [Study of the Eastern classic] 29: 227—72.

Chong Chin-sok. *The Korean Problem in Anglo-Japanese Relations, 1904—1910: Ernest Thomas Bethell and His Newspapers, The Daehan Maeil Sinbo and the Korean Daily News*. Seoul: Nanam Publications, 1987.

Chou, Ju Hsi. *Silent Poetry: Chinese Paintings from the Collection of the Cleveland Museum of Art*. Cleveland: Cleveland Museum of Art, 2015.

Chuanshi jingdian shufa beitie, 46: Wang Xizhi Caoyue baiyun ge [Transmitted classic calligraphic stele, 46: Wang Xizhi's *Song on the Essentials of Cursive Script in One Hundred Rhymes*]. Shijiazhuang: Hebei jiaoyu chubanshe, 2016.

Chun, Younsoo Lee. "Ch'usa Kim Chonghui (1786—1857): The Development of Chusache (The Style of Ch'usa) through the Chinese Metal and Stone Movement." Master's thesis, University of Hawai'i, 1996.

Chung Byungmo. "Silla seohwa ui daeoe gyoseop" [Foreign exchanges of Silla calligraphy and painting]. In *Silla misul ui daeoe gyoseop* [Silla art and foreign exchanges], edited by Hanguk misulsa hakhoe [Art History Association of Korea], 101—45. Seoul: Yekyung Press, 2000.

Chung Seunghye. "Teukjip: Joseon hugi eoneo, munja yeongu wa jisik gyoryu: Joseon hugi Jo Il yangguk ui eoneo hakseup gwa munja e daehan insik" [Recognition of language study and characters of both Korean and Japanese in the late Joseon dynasty]. *Hanguk silhak yeongu* [Journal of Korean *Silhak*] 29 (2015): 81—117.

Cultural Heritage Administration. *2016 Geumseokmun Rubbing Inquiry Report: North Gyeongsang Province*. Vol. 3. Daejeon: Cultural Heritage Administration, 2016.

———. *Royal Seals of the Joseon Royal Family*. Vol. 1. Seoul: National Palace Museum, 2010.

———. *Silla baekji mukseo daebang gwangbul hwaeomgyeong* [Avatamsaka sutra in Silla]. Daejeon: Cultural Heritage Administration, 2001.

Davies, Daniel M. "Building a City on a Hill in Korea: The Work of Henry G. Appenzeller." *Church History* 61, no. 4 (1992): 422—35.

Denecke, Wiebke, Wai-Yee Li, and Xiaofei Tian. *The Oxford Handbook of Classical Chinese Literature (1000 BCE—900 CE)*. New York: Oxford University Press, 2017.

Edwards, Richard, ed. *The Painting of Tao-chi, 1641—ca. 1720*. Exh. cat. Ann Arbor: University of Michigan Museum of Art, 1967.

Fu Shen and Glenn D. Lowry. *From Concept to Context: Approaches to Asian and Islamic Calligraphy*. Exh. cat. Washington, DC: Freer Gallery of Art, Smithsonian Institution, 1986.

Fujita Kōtatsu. "Textual Origins of the *Kuan Wu-liang-shou ching*." In *Chinese Buddhist Apocrypha*, edited by Robert E. Buswell, Jr., 149—73. Honolulu: University of Hawai'i Press, 1990.

Gim Gwang Uk. *Hanguk seoye haksa* [A history of Korean calligraphy]. Daegu: Keimyeong Daehakgyo, 2009.

Gim Yeongwon. *Hanguk yeokdae seohwaga sajeon* (*Dictionary of Korean Painters and Calligraphers through the Centuries*). Seoul: Gungrip munhwajae yeonguso, 2011.

Go Seong Hun. *Hanguk seoye munhwa ui yeoksa* [The history of Korean calligraphy culture]. Seoul: Gyeongin munhwasa, 2011.

Goguryeo gobun byeokhwa [The Goguryeo tomb murals]. Donggyeong: Joseon hwabosa, 1985.

Goguryeo yeonguhoe pyeon, Jungwon Goguryeobi yeongu [Goguryeo Research Association, research on Jungwon Goguryeo Stele]. Seoul: Hagyeon munhwasa, 2000.

Gongju National Museum. *Baekje Sama Wang: Muryeong Wangnung balgul, geu hu 30 nyeon baljachwi* [Sama king in the Baekje Kingdom: Excavation of the tomb of King Muryeong and his queen consort; Retracing thirty years of the path since then]. Seoul: Tongcheon munhwasa, 2001.

Guksa pyeonchan wiwonhoe [National Institute of Korean History]. *Hanguk seoye munhwa ui yeoksa* [The history of Korean calligraphic culture]. Seoul: Gyeongin munhwasa, 2011.

Gwon Heekyeong. *Goryeo ui sagyeong* [Sutra in Goryeo]. Daegu: Geulgoeun, 2006.

Gyeongju National Museum. *Munja ro bon Silla* [Read Silla through the characters]. Seoul: Yemaek Publishing, 2002.

———. *Silla munja jaryo* [Research materials of Silla characters]. Gyeongju National Museum, 2017.

Gyujanggak Library. *Gyujanggak sojang uigwe haejejip* [Haejejip Uigwe in Gyujanggak Library Collection 3]. Seoul: Seoul National University Gyujanggak Library, 2005.

Haboush, JaHyun Kim. *The Confucian Kingship in Korea: Yŏngjo and the Politics of Sagacity*. New York: Columbia University Press, 2001.

———. *The Memoirs of Lady Hyegyong: The Autobiographical Writings of a Crown Princess of Eighteenth-Century Korea*. Berkeley: University of California Press, 1996.

Hamada Kōsaku and Sueji Umehara. *Rakurō saikyō chō ibutsu shūei* [Select specimens of the remains found in the Tomb of Painted Basket of Lo-Lang]. Pyeongyang: Heijō Meishō Kyūseki Hozon Kai, 1935.

Han Chuang [John Hay]. "Hsiao I Gets the Lan-t'ing Manuscript by a Confidence Trick." *National Palace Museum Bulletin* 5, no. 3 (July—August 1970): 1—13.

———. "Hsiao I Gets the Lan-t'ing Manuscript by a Confidence Trick." *National Palace Museum Bulletin* 5, no. 6 (January—February 1971): 1—17.

Harrist, Robert E., Jr., and Wen C. Fong, eds. *The Embodied Image: Chinese Calligraphy from the John B. Elliott Collection*. Exh. cat. Princeton, NJ: Princeton University Art Museum, 1999.

Hay, John. *Kernels of Energy, Bones of Earth: The Rock in Chinese Art*. Exh. cat. New York: China Institute in America, 1985.

Hay, Jonathan. *Shitao: Painting and Modernity in Early Qing China*. Cambridge: Cambridge University Press, 2001.

Hayashiya Seizō. *Ceramic Art of the World 7: Edo Period II. Karatsu, Agano, Takatori, Satsuma and Hagi Ware*. Tokyo: Shōgakkan, 1998.

Hegel, Robert E. "Rewriting the Tang: Humor, Heroics, and Imaginative Reading." In *Snakes' Legs: Sequels, Continuations, Rewritings, and Chinese Fiction*, edited by Martin W. Huang, 159—89. Honolulu: University of Hawai'i Press, 2004.

Ho, Wai-kam, and Judith G. Smith, eds. *The Century of Tung Ch'i-ch'ang, 1555—1636*. 2 vols. Exh. cat. Kansas City, MO: Nelson-Atkins Museum of Art, 1992.

Hoam Art Museum. *The Three Teachers' Letters*. Yongin: Hoam Art Museum, 2001.

Hong Donghyeon. "Dasan Jeong Yakyong ui gangjin yubae saenghwal gwa Hapicheop" [Dasan Jeong Yakyong's life of exile in Gangjin and *Hapicheop*]. *Dasan gwa hyeondae* [Journal of Dasan and the contemporary times] 9 (2016): 285—98.

Hong Hyeon-Soon. "Dasan Jeong Yakyong ui seoye yeongu–Hapicheop eul jungsim euro" [A study on the calligraphic works of Dasan Jeong Yakyong: Focusing on *Hapicheop*]. Master's thesis, Daejeon University, 2011.

Hong Sunpyo. "O Sechang's Compilation of *Gunyeok sohwasa* (History of Korean Painting and Calligraphy) and the Publication of *Gunyeok sohwajing* (Biographical Records of Korean Painters and Calligraphers)." *Archives of Asian Art* 63, no. 2 (October 2013): 155—63.

Hsu Dau-lin. "The Myth of the 'Five Human Relations' of Confucius." *Monumenta Serica* 29 (1970): 27—37.

Hu, Philip K. "The Shao Garden of Mi Wanzhong (1570—1628): Revisiting a Late Ming Landscape through Visual and Literary Sources." *Studies in the History of Gardens and Designed Landscapes* 19, nos. 3—4 (1999): 314—42.

Hummel, A. W., ed. *Eminent Chinese of the Ch'ing Period*. 2 vols. Washington, DC: U.S. Government Printing Office, 1943.

Hurvitz, Leon. "Xuanzang (602—664) and the Heart Scripture." In *Prajnaparamita and Related Systems: Studies in Honor of Edward Conze*, edited by Lewis Lancaster, 103—21. Berkeley: University of California Press, 1977.

Hwang Jeong-yeon. *A Study of the Repositories of the Paintings and Calligraphy of the Joseon Dynasty*. Seongnam: Shingu Publishing, 2012.

Hwang Ji-won. *Gim Jeonghui ui cheolhak gwa yesul* [Philosophy and art of Gim Jeonghui]. Daegu: Keimyung University Press, 2010.

Hwang Suyeong. *Hanguk geumseok yumul* [Korean relics: Epigraphs]. Seoul: Ilji Press, 1976.

I Gwangpyo. *Sonan ui bakmulgwan* [Museum in hand]. Gyeonggi-do: Hyohyung Publishing Company, 2006.

I Sanghui. *Kkocheuro boneun hanguk munhwa* [Korean culture seen through flowers]. Vol. 3. Gyeonggi-do: Nexus Press Ltd., 2004.

I Sangil. "Gaehwagi yeonhwalja doip e gwanhan il gochal" [Study on the introduction of lead types during the time of enlightenment]. *Seojihakbo* [Journal of the Institute of Bibliography] 16 (September 1995): 105—23.

Ikeuchi Hiroshi and Umehara Sueji. *T'ung-kou*. 2 vols. Tokyo: Nichiman Bunka Kyokai, 1938—40.

Im Chaewoo. "Cheokjudonghaebi e natanan doga jeok segyegwan ui munje" [Daoist worldview in the *East Sea Stele* in Cheokju]. *Dogyo munhwa yeongu* [Journal of studies of Daoist culture] 39: 64—66.

Im Changsun, ed. "Calligraphy." *Hanguk misul jeonjip* [Art collection Korea] 11. Seoul: Donghak Publishing, 1973.

———. "Seoye" [Calligraphy]. *Hanguk ui mi* [Korea's Aesthetic] 6. *Gyegan misul*. Seoul: Jungang ilbo, 1981.

Im Changsun, Yi Guyeol, and Yi Heungu. *Hanguk yeondae seoyesa* [History of Korean contemporary calligraphy]. Seoul: Tongcheon munhwasa, 1981.

Im Ho-min. *Sin Saimdang gajok ui si seo hwa (Poetry, Calligraphy, and Painting of Sin Saimdang and Her Family)*. Gangneung: Gwandong Daehakgyo Yeongdong Munhwa Yeonguso, 2006.

Im Woogi. *National Museum of Korea*. Exh. cat. Seoul: Sol Publishing, 2005.

Iryeon, comp. *Samguk yusa* [Memorabilia of the Three Kingdoms]. Translated (into Korean) by Kwon Sangro. Seoul: Dongsuh Munhwasa, 2007.

Isigawa Kyuyou. "Seo ui uju—Munja ga mandeureonaen dong asia" [The universe of calligraphy: East Asia made by writing]. In *Dong asia munja yesul ui hyeonjae* [Today's written arts of East Asia], ed. Seoul Arts Center, 202—6. Exh. cat. Seoul: Seoul Arts Center, 1999.

Ito Ikutaro. *Korean Ceramics from the Museum of Oriental Ceramics, Osaka*. Exh. cat. New York: Metropolitan Museum of Art, 2000.

Jang Chang-eun. "Changnyeong Jinheung Wang Cheokgyeongbi wa Silla ui yeo-ngyeok hwakjeong" [The "Changnyeong Silla Jinheung Cheokyeongbi" and Silla's territorial expansion: Focusing on the conquest of the Daegaya]. *Silla Sahakbo* [Journal of the Research Institute for Silla Culture] 26 (2012): 5—49.

Jang Chungsik. *Hanguk sagyeong yeongu* [Research on Korean stone inscriptions]. Seoul: Dongguk University Press, 2007.

Jang Ji Hoon. "Jeong Yakyong ui silhak-jeok seohwa mihak e gwanhan yeongu" [A study of Jung Yak Yong's *Silhak* based on aesthetics of calligraphy and painting works]. *Dongyang cheolhak yeongu* [Journal of Eastern philosophy] 61 (2010): 503—34.

Jang Kyung-hee. "Donggwanwangmyo ui eoje hyeonpan ui yuhyeong hwa naeyong bunseok" [An analysis of types and content of signboards inscribed with the king's writings in *Donggwanwangmyo* (East Shrine of King Guan Yu)]. *Munhwajae* [Korean journal of cultural heritage studies] 49, issue 3 (September 2016): 52—77.

Jang Uel-youn. "Chaekmun ui pilsabon e gwanhan seojihakjeok gochal" [Bibliographical consideration of the manuscripts of answers on policy and stratagem for the final round of Civil Service Examinations]. *Seoji hakbo* [Journal of the Institute of Bibliography] 33 (2009): 185—213.

Jeju National Museum. *Joseon seonbi Choe Bu, ttut bak ui Jungguk gyeonmun* [Choe Bu's diary: An unexpected encounter with China]. Exh. cat. Jeju: Jeju National Museum, 2015.

Jeon Ho-tae. "Hanguk ui seonsa mit godae chogi yesul gwa bangudae amgakhwa" [Early art in the prehistoric age and ancient times in Korea and the Bangudae Petroglyphs]. *Yeoksa wa gyeonggye* [History and the boundaries] 85 (December 2012): 1—47.

Jeon, Ho-tae, and Kim Jiyeon, eds. *Bangudae: Petroglyph Panels in Ulsan, Korea, in the Context of World Rock Art*. Bangudae Petroglyph Institute, University of Ulsan. Seoul: Hollym Corp. Publishers, 2013.

Jeong Byungsam, ed. *Chusa wa geu ui sidae* [Chusa and his period]. Seoul: Dolbegae, 2002.

Jeong Hyeon Suk. *Silla ui seoye: Sillain i geumseok gwa mokgan e sseun geulssi* [Silla's calligraphy: Metal and wood inscriptions]. Seoul: Daunsaem, 2016.

Jeong Min. "Dasan ui bujeong i damgin maejodo du pok" [Two paintings of birds and a plum tree that show Dasan's affection for his daughters]. In *Hangukhak geurim gwa mannada: Jeolmeun inmun-hakja 27 in ui jonghoeng mujin munhwa ilkgi* [Korean studies meets painting]. Gyeonggi-do: Daehaksa, 2011.

———. *Dasanui jaebalgyeon* [The rediscovery of Dasan]. Seoul: Humanist, 2011.

Ji Ne-goeng and Mewonmalchi. *Tonggu*. Tokyo: Ilmanmunhwa Association, 1938—40.

Jin Bog-gyu. "Choe Chiwon seoye yeongu" [A study on Choe Chiwon's calligraphy]. PhD diss., Gyeongju University, 2017.

Jin Hongseob et al. *Hanguk misulsa* [Korean art history]. Seoul: Munye Press, 2006.

Jin Hongseob, ed. *Hanguk misulsa jaryo jibseong* [Korean art history material collection]. Vol. 1. Seoul: Ilji Press, 1987.

Jin Hongseob and Choi Junu, eds. *Hanguk misulsa yeonpyo* [Korean art history chronology]. Seoul: Ilji Press, 1981.

Jin Hyeonjong. *Hangwon euro ingneun Palman Daejanggyeong* [The handbook of the *Tripitaka Koreana*]. Gyeonggi-do: Dulnyuok Publishing Co., 1997.

Jo Dongwon. *Hanguk geumseokmun daegye* [Korean stone inscriptions]. Vol. 7. Iksan: Wongwang University Press, 1979—94.

Jo Min Hwan. *Hwaje reul tonghae bon Joseon hugi muninhwa: Chusa Gim Jeonghui reul jungsim euro* [An examination of the paintings of the late Joseon dynasty literati: With a focus on Chusa Gim Jeonghui]. Seoul: Dongyang Yesul, 2004.

Jo, Song-Sig. "Chusa Gim Jeonghui 'Sehando' ui jaehaeseok: 'Sehando' wa 'Ssangsongdo' ui gwangye, geu dongin ui cheolhak jeok uimi" [A new understanding of Gim Jeonghui's *Wintry Days*]. *Mihak yesulhak yeongu* [The journal of aesthetics and the science of art] 52 (October 2017): 168—204.

Jo Suhyeon. *Baekje Muryeong Wangnungji Sataekjijeokbi* [Baekje king Muryeong memorial stone]. Silla Danyang Jeokseongbi, Yeongcheon Cheongjaebi [Danyang Silla Jeokseong stone stele, Yeongcheon Cheongje stele]. Seoul: Yihwa Munhwa Press, 2003.

Joseon geumseok chongnam [A survey of Korean epigraphs from the Joseon dynasty]. Vol. 1. Seoul: Hanguk Chongdokbu Press, 1919.

Joseon gojeok dobo [Ancient paintings of Korea]. Vols. 1—10. Tokyo: Gukhwa Press, 1915—18.

Ju Bo-don. "Pohang Jungseong-ri Sillabi ui gujo wa naeyong" [Structure and contents of the inscription on the Pohang Jungseongri Silla Stone Monument]. *Hanguk godaesa yeongu* [Journal of Korean ancient history] 65 (March 2012): 117—58.

Jung Hyun Sook. "Calligraphic Style of the Three Kingdoms Period." In *Yet geulssi ui areumdaum: Geu sok eseo yeoksa reul boda* [The beauty of ancient Korean calligraphy: Inside its history], edited by Jung Hyun Sook, 222—37. Icheon: Woljeon Museum of Art, 2010.

Jung In-seung. "The Material Culture of the Lelang Commandery." In *The Han Commanderies in Early Korean History*, edited by Mark E. Byington, 137—64. Cambridge, MA: Korea Institute, Harvard University, 2013.

Jung Jaeseo. "Cheokjudonghaebi e pyohyeon doen Sanhaegyeong ui imiji-deul—Jeongchiseong inga? Jusuljeok hyeonsil inga?" [A study on *Shanhaijing* images of Cheokjudonghaebi]. *Yeongsang munhwa* [Visual culture] 29 (December 2016): 1—28.

Jung Min. "Constructing Sectarian Pilgrimage Sites in Neo-Confucian Schools." *Korean Histories* 3, no. 1 (2012): 23—34 .

Jungmann, Burglind. *Pathways to Korean Culture: Paintings of the Joseon Dynasty, 1392—1910*. London: Reaktion Books, 2014.

———. "Sin Sukju's Record on the Painting Collection of Prince Anpyeong and Early Joseon Antiquarianism." *Archives of Asian Art* 61 (2011): 107—26.

Kang Jin-ho. "Ubong Jo Huiryong yesul segye mukranhwa yeongu" [A study of Jo Hee Ryong's mook ran hwa and his world of art]. Master's thesis, Hongik University, 2008.

Kang Jonghoon. "Pohang Jungseong-ri Sillabi ui naeyong gwa seonggyeok" [A study on the contents and characteristics of the newly found Silla monument, Jungseongni bi]. *Hanguk godaesa yeongu* [Journal of Korean ancient history] 56 (2009): 131—69.

Kang Kyung-sook. *Korean Ceramics*. Translated by Cho Yoong-jung. Seoul: Korea Foundation, 2008.

Kang Shinhang and Shin Sangsoon. *Hunminjeongeum as Read in the Modern Korean Language*. Seoul: Gungnip bangmulgwan munhwa jaedan, 2014.

Kang Woo-bang. *Bul sari jangeom* [The art of Sarira reliquary in Buddhism]. Seoul: National Museum of Korea, 1991.

Kansong Art and Culture Foundation. *Kansong munhwa* [Kansong culture]. Seoul: Kansong Art and Culture Foundation, 2015.

———. *Kansong munhwa: Kansong misul munhwa jaedan seollib ginyeom jeon* (*The Treasures of Kansong: Commemorating the Founding of the Kansong Art and Culture Foundation*). Exh. cat. Seoul: Kansong Art and Culture Foundation, 2014.

Keum Kyung-sook. "The Gwanggaeto Stele and the Myth of Koguryo's Founder." *Journal of Northeast Asian History* 12, no. 1 (Summer 2015): 143—51.

Kim Dong-gun. "Misu Heo Mok ui jeonseo yeongu: Hyeongseong gwa yangsik eul jungsim euro" [A study of seal-script calligraphy by Heo Mok]. *Misul sahakhoe* [Art history association of Korea] (June 1996): 35—69.

Kim Gyeong-mi. "Gungnip Gogung Bakmulgwan sojang Joseon wangsil ui Gyomyeong janghwang—Jeongjo gukjang gwanryeong uigwe bunseok eul jungsim euro" [Gyomyeong of the Joseon dynasty in the National Palace Museum collection]. *Gogung munhwa* [Palace culture] 2 (2008): 61—83.

Kim, Hongkyung, trans. *The Analects of Dasan, Volume 1: A Korean Syncretic Reading*. New York: Oxford University Press, 2016.

Kim, Hongnam, ed. *Splendor and Simplicity: Korean Arts of the Eighteenth Century*. Exh. cat. New York: Asia Society, 1993.

Kim Ho-suk. *Geurim euro sseun yeoksa chaek Bangudae Amgakhwa* [Bangudae Petroglyphs: A history book written by drawings]. Seoul: Yemaek, 2013.

Kim Hyeju. "Muninhwa ui hyeondaejeok byeonyong: Suh Se Ok ui ingan sirijeu" [Modern transformation of the traditional ink painting: Human series of Seo Se Ok]. *Hyeondae misulsa yeongu* [Modern art history research] 7 (February 1997): 38, 42—45.

Kim Jiyeon et al. *Hanguk yeokdae seohwaga sajeon* [Dictionary of Korean painters and calligraphers through the centuries]. Daejeon: National Research Institute of Cultural Heritage, 2011.

Kim Jong-heon and Yoon Eun-seop. *Seoyega boinda: Seoye yeoksa wa jakpum, Seoyega reul hannun e bol su inneun, seoye immunseo* [Calligraphy at a glance: Calligraphy history, works, and calligraphers]. Seoul: Mijinsa, 2015.

Kim Jungnam. *Joseonjo eopil e gwanhan yeongu* [A study on the king's handwriting in the Joseon dynasty]. PhD diss., Sungkyunkwan University, 2015.

Kim, Jung Nam. "Joseon wangjo sillok e natanan eopil hyeonseong e gwanhan seoyejeok gochal" [A calligraphic study on the formation of king's handwriting in *The Annals of the Joseon Dynasty*]. *Hanguk seoye hakhoe* 27 (September 2015): 101-28.

Kim Kyungsoon. "Chusa Gim Jeonghui ui hangeul ganchal gwa hanmun seoye waui sanggwanseong" [The interrelationship of the *hangeul* letters and Chinese calligraphy characters written by Gim Jeonghui]. *Seoyehak yeongu* (Journal of calligraphy research] 7 (2005): 64—93.

———. "Chusa Gim Jeonghui ui hangeul pyeonji haedok gwa uimi" [The meaning and interpretation of three letters of Chusa Gim Jeonghui]. *Eomun yeongu* [Journal of text/calligraphy research] 75 (2013): 5—31.

Kim Min-gyu. "Study of Stone Figures at Euneongun and Jeongyedaewongun Tombs." *Study of Art History* 295 (2018): 40.

Kim Mun-sik. "Joseon sidae eochaek ui hyeonhwang gwa teukjing" [The present condition and the distinct features of Joseon-period royal investiture books]. *Gogung munhwa* [Palace culture] 9 (2016): 7—38.

Kim, Sang H. *Muye Dobo Tongji: Complete Illustrated Manual of Martial Arts*. Santa Fe, NM: Turtle Press, 2010.

Kim Shi-dug. "*Hangeul* Usage and Ritual Culture through a Game Board, 'Seumnyeguk.'" *Korean Studies* 30 (August 2016): 257—91.

Kim Su-chon. "Iljung Gim Chunghyeon ui gahak baegyeong gwa seoyesajeok gongheon" [The family study background and the contribution to the history of calligraphy of Iljung Kim, Chunghyeon]. *Seojihak yeongu* [Journal of the Institute of Bibliography] 68 (December 2016): 95—193.

Kim, Sung Lim. "Kim Chŏng-hŭi (1786—1856) and *Sehando*: The Evolution of a Late Chosŏn Korean Masterpiece." *Archives of Asian Art* 56, no. 1 (2006): 31—60.

Kim, Sunglim. "Defining a Woman: The Painting of Sin Saimdang." In *Women, Gender and Art in Asia, c. 1500—1900*, edited by Melia Belli Bose, 201—29. London: Routledge, 2016.

Kim Taesoo. "Seolhwa e natananeun Heo Mok ui salm gwa minjung uisik" [The life of Heo Mok and popular consciousness in tales: Focused on tales transmitted in the Samcheok area]. In *Gangwon minsokhak* [Folklore of Gangwon Province], edited by Gangwondo minsok hakhoe [Kangneung Intangible Culture Research Institute & The Society of Kangwon Province Folklore], 75—111. Vol. 20. Gangwon-do: Society of Gangwon Province Folkart, 2006.

Kim, Woo Jeong. "Dogok Yi Uihyeon myodo mun ui dacheung jeok seong-gyeok" [Multilayered character of Dogok Yi Uihyon's epitaph]. *Hanmun gojeon yeongu* [Classical Chinese studies] 25 (December 2012): 141—75.

Kim Yang-dong. "Hanguk geundae seoye ui jeongae wa yangsang" [The current of Korean modern calligraphy]. In *Hanguk seoye ilbaek-nyeon* [One hundred years of Korean calligraphy], edited by Seoul Arts Center, 303—12. Exh. cat. Seoul: Seoul Arts Center, 1988.

Kim, Yeon-su, Chi-yeon Kim, Chong-suk Yi, and Yeong-uk Kim. *Court Paintings and Calligraphy*. Exh. cat. Seoul: National Palace Museum, 2012.

Kim Yong Heum. "Dasan ui gukga gusang gwa Jeongjo tangpyeong chaek" [Jeong Yakyong's national initiative and King Jeongjo's policy of impartiality]. *Dasan gwa hyeondae* [Journal of Dasan and the contemporary times] 4 (2012): 379—404.

Kim Yong-sun. *Goryeo geumseok mun yeongu: Dol e saegyeojin sahoesa* [Study on epigraphs in the Goryeo dynasty: Social history engraved on the stone]. Seoul: Ilchogak, 2004.

———. *Goryeo myojimyeong jipseong* [Anthology of Goryeo dynasty epitaphs]. Gangwon-do: Hallim daehakgyo asia munhwa yeonguso, 1997.

———. *Yeokju Goryeo myoji myeong jipseong (sang)* [Anthology of Goryeo dynasty epitaphs]. Vol. 1. Gangwon-do: Hallim daehakgyo asia munhwa yeonguso, 2001.

Kim Youngwon. "Goryeo Dawan ui giwon jeok yoji wa hyeongsik gochal" [A study of the original kilns and style of Goryeo Dawan]. *Misul jaryo* [Research on art] 75 (2006): 5—32.

Kim, Yun-hee. "The Political Nature of the Oriental Discourse of the *Hwangsong Sinmun*: With a Special Focus on the Notion of an Oriental Identity." *International Journal of Korean History* 17, no. 1 (February 2012): 109—40.

Kim, Yun-jeong. "Types and Attributes of Middle-Goryeo Inscribed Celadon." *History and Discourse* 76 (2010): 1—43.

Ko Kwang-eui. "Calligraphy of Jungseongni Silla Monument at Pohang and the Life of Characters in the Period of Ancient Silla." *Journal of the Research Institute for Silla Culture* 35 (2010): 99—132.

———. "What Stelae Reveal about Koguryo's Written Culture." *Journal of Northeast Asian History* 12, no. 1 (Summer 2015): 173—83.

Koehler, Robert, ed. *Traditional Painting: Window on the Korean Mind*. Seoul: Seoul Selection, 2010, n.p.

Korea Calligraphy Association, ed. *Hanguk seoyesa* [History of Korean calligraphy]. Seoul: Mijin Press, 2017.

Ledderose, Lothar. "Chinese Calligraphy: Its Aesthetic Dimension and Social Function." *Orientations* 17, no. 10 (October 1986): 47—48.

———. *Mi Fu and the Classical Tradition of Chinese Calligraphy*. Princeton, NJ: Princeton University Press, 1979.

Ledyard, Gari. "The International Linguistic Background of *The Correct Sounds for the Instruction of the People*." In *The Korean Alphabet: Its History and Structure*, edited by Young-Key Kim-Renaud, 31—87. Honolulu: University of Hawai'i Press, 1997.

Lee Dongkook. "Chaosmosstroke." In *Kim Jongweon: Chaosmosstroke*, edited by Kim Jongweon, 6—17. Seoul: Artlink, 2015.

———. *Chusa Kim Jeonghui, Wuseong Kim Chong Yeong*. Exh. cat. Seoul: Hakgojae Gallery, 2015.

———. *Dong asia pilmuk ui him* [East Asia stroke]. Pyeongchang: Representative Calligraphers of Korea, China, and Japan in Commemoration of the 2018 Pyeongchang Olympics, Seoul Arts Center, 2018.

———. *Hanguk seoye ibaek-nyeon* [Two thousand years of Korean calligraphy]. Exh. cat. Seoul: Wooil Publications, 2000.

Lee Eun Hee. "Joseon junggi eongan (Hangeul pyeonji) eul tonghan saenghwal sok ui munhae gyoyuk" [A study on literacy education within daily lives through *eongan* (Korean letters) in the mid-Joseon dynasty]. *Pyeongsaeng gyoyukhak yeongu* [Journal of lifelong education] 21, no. 3 (September 2015): 141—64.

Lee Eun Hyuk. "Mujangsabiwa wanghui-jicheui daebigochal" [A comparative study between the Mujangsa Stele and Wang Xizhi's texts]. *Hanguk jeontong munhwa yeongu* [Journal of cultural heritage] 12 (November 2013): 171—212.

Lee Hyeonggwon. "Jang Yong-hun: A Lifetime Dedicated to Papermaking." *Koreana* 16, no. 3 (August 2002): 50—53.

Lee Hyung-dae. "Hong Dae-yong's Beijing Travels and His Changing Perception of the West—Focusing on *Eulbyeong yeonhaengnok* and *Uisan mundap*." *Review of Korean Studies* 9, no. 4 (December 2006): 45—62.

Lee Jong-jin. "A Study on the Incense Burner of the Three Kingdoms Period." *Journal of Korean Ancient History Explorations* 5 (2010): 159—216.

Lee Jong-mun. "Mujangsa bi reul sseun seoyega e gwanhan han gochal" [A survey on the calligrapher of the Mujangsa Temple monument]. *Nammyeonghak yeongu* [Journal of Nammyonghak studies] 13 (2002): 223—53.

Lee Ki-Bum. "Haegang Gim Gyujin ui seoye: Seoron eul jungsim euro" [Calligraphy of Haekang Ku-jin, Kim, centering on book essay]. Master's thesis, Dongguk University, 1999.

Lee Kwang-rin and Yong-ho Ch'oe. "Newspaper Publication in the Late Yi Dynasty." *Korean Studies* 12 (1988): 62—72.

Lee Mi-Suk. "Jungse ilbon ui damunhwa wa idodawan e daehan sogo" [Tea culture in Middle Ages Japan and Chosun ceramics]. *Gangwon sahak* [Journal of Gangwon history] 23 (2018): 115—37.

Lee, Peter H., and William Theodore De Bary, eds. *Sources of Korean Tradition*. New York: Columbia University Press, 1997.

Lee Sang-Kyu. "17 segi jeonban waeha-gyeokgwan Kang Woo-Sung ui hwaldong" [Early seventeenth century's translator of Japanese language Woo-Sung Kang's activities]. *Hanil gwangyesa yeongu* [Korea–Japan historical review] 24 (2006): 101—41.

Lee Seong hea. "20 segi cho, Hanguk seohwaga ui jonjae bangsik gwa yang-sang: Haegang Gim Gyujin ui seohwa hwaldong eul jungsim euro" [A study on activities of Korean calligraphic painters in the early twentieth century, focusing on calligraphic painting works by Haegang Gim Gyujin]. *Dongyang hanmun hakoe* [Research on East Asian Han writing] 28 (February 2009): 225—86.

Lee Seong-je. "The Historical Significance of the Gwanggaeto Stele." *Journal of Northeast Asian History* 12, no. 1 (Summer 2015): 153—61.

Lee Seon-jin. "Joseon hugi cheoljeibsa gongyepum yeongu" [Study on silver-inlaid iron crafts in the Late Chosun period]. *Donghak misulsa* [Dongak art history journal] 17 (2015): 527—59.

Lee, Soyoung, ed. *Art of the Korean Renaissance, 1400—1600*. Exh. cat. New York: Metropolitan Museum of Art, 2009.

———. *Diamond Mountains: Travel and Nostalgia in Korean Art*. Exh. cat. New York: Metropolitan Museum of Art, 2018.

Lee Young-ho. "The Hunghae Region and the Silla Stele at Chungsong-ni, P'ohang." *Journal of Korean Ancient History* 12 (2009): 217—52.

Leeum, Samsung Museum of Art. *Samsung Misulgwan Leeum sojang goseohwa jebal haeseoljip II* [Catalogue of the Leeum Samsung Museum of Art, II]. Seoul: Leeum, Samsung Museum of Art, 2008.

Levenson, Jay A., ed. *Circa 1492: Art in the Age of Exploration*. Exh. cat. New Haven: Yale University Press, 1991.

Li Zhigang. *Zhongguo gu dai bei tie taben* [Ancient Chinese calligraphic rubbings]. Exh. cat. Hong Kong: Art Museum, Chinese University of Hong Kong, 2001.

Lim Pyeong-seob. "Silla ui sancheon jesawa Jinheung wang sunsubi ipseok mokjeok ui yeongwanseong— Bukhan-san bireul jungshim euro salpy-eobon sunsu haengjeok ui sa" [Relationship of Silla's rites for mountain and stream and the purpose of establish-ing Jinheung's *sunsu* memorial stones]. *Silla munhwa* [Journal of the Research Institute for Silla Culture] 43 (2014): 73—107.

Little, Stephen, ed. *New Songs on Ancient Tunes: Nineteenth—Twentieth Century Chinese Painting and Calligraphy from the Richard Fabian Collection*. Exh. cat. Honolulu: Honolulu Academy of Arts, 2007.

Little, Stephen, and Shawn Eichman. *Taoism and the Arts of China*. Exh. cat. Chicago: Art Institute of Chicago, 2000.

Liu, Wu-chi, and Irving Yucheng Lo, eds. *Sunflower Splendor: Three Thousand Years of Chinese Poetry*. New York: Anchor Press, 1971.

Liu Zhongjian and Lin Cunyang, eds. *Zheng Banqiao*. Taipei: Zhishufang chubanshe, 2003.

McKillop, Beth. "A Korean Buddhist Illustrated Manuscript." *British Library Journal* 24, no. 1 (1998): 158—67.

McNair, Amy. *The Upright Brush: Yan Zhenqing's Calligraphy and Song Literati Politics*. Honolulu: University of Hawai'i Press, 1998.

Meskill, John Thomas. *Ch'oe Pu's Diary: A Record of Drifting across the Sea*. Tucson: University of Arizona Press, 1965.

Minemura Toshiaki. "Lee Kang-so: The Deepening Middle." In *Lee Kang-so*, edited by Lorand Hegyi and Martine Dancer-Moures, 27—51. Exh. cat. Seoul: Wooson Gallery, 2016.

Minford, John, ed. *Classical Chinese Literature: An Anthology of Translations*. New York: Columbia University Press, 2002.

Moon Jungja. "Baekha Yun sun gwa Wongyo Lee Gwangsa ui simmi isang gwa seoye sul" [The aesthetic ideal and art of calligraphy of Baek Ha Yoon Soon and Won Kyo Lee Kwang Sa]. *Dongyanghak* [Journal for Asian studies] 43 (2008): 137—57.

Mun Myeongdae. *Ulsan Bangudae Daegong-ri Amgakhwa* [Bangudae petroglyphs of Daegongni in Ulsan]. Seoul: Art History Research Institute of Korea, 2014.

Nakata Yūjirō, ed. *Chinese Calligraphy*. New York: Weatherhill, 1983.

Nam Heesook. "Joseon hugi bulseo ganhaeng yeongu: Jineonjip gwa bulgyo uisik jip eul jungsim euro" [A study on the publication of Buddhist texts in the late Joseon dynasty: *Chinon-chip* (collection of mantras) and Buddhist ritual proceed-ings]. PhD diss., Seoul National University, 2004.

———. "Joseon sidae daranigyeong Jineonjipui ganhaeng gwa geu yeoksa-jeok uiui: Seoul dae Gyujanggak sojangbon ui bunseok eul jungsim euro" [The publication of dharanis and *Jineonjip* in Joseon and its historical significance]. *Hoedang hakbo* [Journal of Hoedang studies] 5 (June 2000): 67—105.

National Changwon Cultural Heritage Institute. *Hanguk ui godae mokgan* [Ancient wooden strips with inscriptions in Korean]. Changwon: National Changwon Cultural Heritage Institute, 2004.

National Museum of Korea. *Bulguksa Seokgatap yumul* [Renovation document: Bulguksa Seogatap relics 1—4]. Seoul: National Museum of Korea, Central Buddhist Museum, 2009.

———. *Goryeo Joseon ui daeoe gyoryu* [A dynamic world of external relations in the Goryeo and Joseon dynasties]. Seoul: National Museum of Korea, 2002.

———. *Munja, Geu hu* [Ancient writing and thereafter: Korean ancient writing exhibition]. Exh. cat. Seoul: National Museum of Korea, 2011.

———. *One Hundred Years of Korean Modern Painting*. Exh. cat. Seoul: National Museum of Korea, 1987.

———. *Sagyeong Byeonsangdo ui Segye: Bucheo Geurigo Maeum* [Sutra painting: In search of Buddhahood]. Seoul: National Museum of Korea, 2007.

National Museum of Modern and Contemporary Art, Korea. *Gi jeung jakpum teukbyeol jeon Suh Se Ok* [Special exhibition of donated works by Suh Se Ok]. Exh. cat. Gyeonggi-do: National Museum of Modern and Contemporary Art, 2015.

National Palace Museum. *The Art of Ornamentation and Arrangements*. Seoul: National Palace Museum, 2008.

———. *Jeongjo eochal*. Exh. cat. Seoul: National Palace Museum, 2011.

———. *Joseon wangsil ui gakseok* [Inscriptions in stone from the Joseon royal court]. Exh. cat. Seoul: National Palace Museum, 2011.

———. *National Palace Museum: Exhibition Catalogue*. Seoul: National Palace Museum 2007.

———. *National Palace Museum of Korea: General Catalog*. Seoul: National Palace Museum of Korea, 2011.

———. *Royal Investiture Books of the Joseon Dynasty: Jade Books* 5. Seoul: National Palace Museum, 2017.

———. *Royal Investiture Books of the Joseon Dynasty: Gyomyeong, Bamboo Books, Gilt Books*. Seoul: National Palace Museum, 2017.

———. *The Royal Seal, A King's Symbol*. Seoul: National Palace Museum, 2012.

National Research Institute of Cultural Heritage. *Cheonjeon-ri Gakseok* [Cheonjeon-ri stone inscription]. Daejeon: National Research Institute of Cultural Heritage, 2012.

———. *Iksan Mireuk saji seoktap sari jangeom* [Sarira reliquary of stone pagoda of Mireuksa Temple site in Iksan]. Daejeon: National Research Institute of Cultural Heritage, 2014.

———. *Miguk Los Angeles County bangmulgwan sojang Hanguk munhwajae* [Korean art collection of the Los Angeles County Museum of Art], U.S.A. Daejeon: National Research Institute of Cultural Heritage, 2012.

Noh Myeongho et al. *Hanguk godae jungse gomunseo yeongu* [Research on antique documents in ancient and Middle Ages in Korea]. Vols. 1 and 2. Seoul: Seoul University Press, 2000.

Noh Sunghwan. "Hangeul dawan gwa hagi ui Joseon poro" [A *hangeul* tea bowl and the Korean prisoners in Hagi]. *Ilbon eoneo munhwa* [Journal of Japanese language and culture] 17 (2001): 487—507.

Northeast Asian History Foundation. *Gwanggaetodaewangbi Wonseok Takbon* [Gwanggaeto Daewang stone inscription rubbing]. Seoul: Northeast Asian History Foundation, 2014.

O Sechang. *Geunyeok seohwajing* [Geunyeok's collection of calligraphy and painting]. Gyeongseong [Seoul]: Gyemyeong gurakbu, 1929.

———. *Gukyeok geunyeok seohwajing* [The collection of Korean paintings and calligraphic works translated into Korean]. Seoul: Sigongsa, 1998.

O Sechang, ed. *Geunyeok seohwahoek* [Mugunghwa paintings]. Seoul: Gyemyeong gurakbu, 1928.

Oba Tsunekichi et al. *Rakurō kanbo: Taishō jūsannendo hakktsu chōsa hōkoku* [Lo-lang Han tombs: Volume I, Report of excavations conducted in 1924]. Nara: Rakurō Kanbo Kankōkai, 1974—75.

Obata, Shigeyoshi. *The Works of Li Po, the Chinese Poet*. New York: E. P. Dutton, 1922.

Oh Seung Sik. *Jeontong jamulsoe jejak gibeob yeongu—Joseon sidae jungsim euro* [A study of traditional Korean locks of the Joseon period]. Seoul: Dongguk University Press, 2001.

Ouyang Zhongshi et al. *Chinese Calligraphy*. New Haven: Yale University Press, 2008.

Paek Doohyeon. "Dojagie sseuin hangeul myeongmun haedok" [A study of the Korean alphabet written on porcelains]. *Misul jaryo* [Research on art] 78 (2009): 207—11.

Park Dae Sung. Sosan *Park Dae Sung*. Exh. cat. Seoul: Gana Art Center, 2011.

Park Jung Sook. "Chusa Gim Jeonghui Hangeul seogan seoyemi ui byeoncheonsa jeok gochal" [The conversation: A study on the history of the changes of the calligraphic aesthetics of Chusa Gim Jeonghui's *hangeul* letters]. *Johyeong gyoyuk* [Hanguk Johyeong Gyoyukhak journal] 49 (2014): 181—221.

Pettid, Michael J., Gregory N. Evon, and Chan E. Park, eds. *Premodern Korean Literary Prose: An Anthology*. New York: Columbia University Press, 2018.

Pfeffer, Susanne. "Interview with Kyungwoo Chun by Susanne Pfeffer." In *Kyungwoo Chun: Photographs, Video Performances*, edited by Kyungwoo Chun et al., 83—91. Berlin: Hatje Cantz, 2005.

Pitelka, Morgan. "Warriors in the Capital: Kobori Enshu and Kyoto Cultural Hybridity." In *Kyoto Visual Culture in the Early Edo and Meiji Periods: The Arts of Reinvention*, edited by Morgan Pitelka and Alice Y. Tseng, 19—35. New York: Routledge, 2016.

Portal, Jane, with Suhyung Kim and Hee Jung Lee. *Arts of Korea: MFA Highlights*. Boston: Museum of Fine Arts, 2012.

Quan Tang shi [Complete Tang poems]. 1705. Reprint, Shanghai: Shanghai guji chubanshe, 1986.

Ro Myounggu and Park Suhee, eds. *The King at the Palace: Joseon Royal Court Culture at the National Palace Museum of Korea*. Seoul: National Palace Museum of Korea, 2015.

Rogers, Howard, and Sherman E. Lee. *Masterworks of Ming and Qing Painting from the Forbidden City*. Exh. cat. Lansdale, PA: International Arts Council, 1989.

Rue, Yeon-ok. "Gimjunghyeonui hangeul seoye yeongu" [Research on Kim Choong-Hyun's *hangeul* calligraphy]. Master's thesis, Gyeonggi University, 2005.

Rutt, Richard. *The Bamboo Grove: An Introduction to Sijo*. Ann Arbor: University of Michigan Press, 1998.

Schipper, Kristofer. "Taoism: The Story of the Way." In *Taoism and the Arts of China*, edited by Stephen Little and Shawn Eichman, 33—56. Exh. cat. Chicago: Art Institute of Chicago, 2000.

Seoul Arts Center. *Dong asia munja yesul ui hyeonjae* [Today's written arts of East Asia]. Exh. cat. Seoul: Seoul Arts Center, 1999.

———. *Goryeo mal Joseon cho ui seoye* [Late Goryeo—early Joseon calligraphy]. Seoul: Seoul Arts Center, 1996.

———. *Gwanggaeto Daewangbi* [Stele of King Gwanggaeto the Great]. Seoul: Seoul Arts Center, 2014—15.

———. *Hanguk seoye icheon-nyeon* [Two thousand years of Korean calligraphy]. Seoul: Seoul Arts Center, 2000.

———. *Hanguk seoye ilbaek-nyeon* [One hundred years of Korean calligraphy]. Exh. cat. Seoul: Seoul Arts Center, 1988.

———. *Hanguk ui myeongbi gotak* [Korea's famous steles]. Seoul: Seoul Arts Center, 1998.

———. *The 1,300th Anniversary of the Birth of Korean Calligraphy Master Kim Saeng (711—After 790)*. Seoul: Seoul Arts Center, 2012.

Seoul Baekje Museum, ed. *Yeongguksa and Dobong seowon Confucian Academy*. Exh. cat. Seoul: Seoul Baekje Museum, 2018.

Shodō zenshū [Complete compendium of calligraphy]. 24 vols. 1965. Reprint, Tokyo: Chūō kōron-sha, 1990.

Sim Yeong-hwan. *Joseon sidae gomunseo choseo yeongu* [Study of Choseo of ancient documents in the Joseon dynasty]. Seoul: Sowadang, 2008.

Siti da zidian [Dictionary of four forms of (Chinese) characters]. 4 vols. Beijing: Beijing shi Zhongguo shudian, 1980.

Smith, Judith G., ed. *Arts of Korea*. New York: Metropolitan Museum of Art, 1998.

Sohn, Pow-key. "Early Korean Printing." *Journal of the American Oriental Society* 79, no. 2 (1959): 98.

Son Hwanil. *Haengchon Yi Am ui Seoye* [Calligraphy of Haengchon Yi Am]. Daejeon: Seohwa Media, 2013.

Son Ke-young. "Joseon sidae gomunseo e sayong doen jongi bunseok" [An analysis of papers used in historical manuscripts]. *Hanguk girok gwanli hakhoeji* [Journal of Korean Society of Archives and Records Management] 5, no. 1 (June 2005): 79—105.

Song Jinchoong. "Sajagwan Gim Uisin ui saengae wa seopung" [The life of amanuensis Seolbong Gim Uisin and his calligraphic styles]. *Misul sahak* [Art history] 34 (2017): 7—31.

Song, Jiyoun. "Sosan Park Dae Sung eui hoehwa yeongu" [A study on paintings of Daesung Park]. Master's thesis, Hongik University, 2017.

Starr, Kenneth. *Black Tigers: A Grammar of Chinese Rubbings*. Seattle: University of Washington Press, 2008.

Strassberg, Richard E., trans. *Enlightening Remarks on Painting*. Pasadena: Pacific Asia Museum, 1989.

Sun, Zhixin. "A Quest for the Imperishable: Chao Meng-fu's Calligraphy for Stele Inscriptions." In *The Embodied Image: Chinese Calligraphy from the John B. Elliott Collection*, edited by Robert E. Harrist, Jr., and Wen C. Fong, 302—19. Exh. cat. Princeton, NJ: Princeton University Art Museum, 1999.

Suwon Hwaseong Museum. *Crown Prince Sado*. Suwon: Suwon Hwaseong Museum, 2012.

———. *Jeongjo, Practicing Art*. Suwon: Suwon Hwaseong Museum, 2009.

Uri hangeul ui meot gwa areumdaum: Jangseogak teukbyeol jeon [Elegance and beauty: Korean script as reflected in Choson royal books). Seoul: Hanguk Jeongsin Munhwa Yeonguwon Jangseogak, 2004.

Van Gulik, Robert H. *Mi Fu on Inkstones*. 1939. Reprint, Singapore: Orchid Press, 2006.

———. *Siddham: An Essay on the History of Sanskrit Studies in China and Japan*. New Delhi: International Academy of Indian Culture, 1956.

Wang Lianqi. "An Examination of Zhao Mengfu's *Sutra on the Lotus of the Sublime Dharma (Miaofa lianhua jing)* in Small Standard Script." In *Out of Character: Decoding Chinese Calligraphy*, edited by Michael Knight and Joseph Z. Chang, 71—104. Exh. cat. San Francisco: Asian Art Museum, 2012.

Watson, Burton. *The Complete Works of Chuang Tzu*. New York: Columbia University Press, 1968.

———. *Four Huts: Asian Writings on the Simple Life*. Boston: Shambala, 1994.

———. *The Vimalakirti Sutra*. New York: Columbia University Press, 1997.

Watson, Burton, trans. *Sima Qian, Records of the Grand Historian: Han Dynasty 1*. Revised edition. New York: Columbia University Press, 1993.

Wong, Kwon S. *Masterpieces of Sung and Yuan Dynasty Calligraphy from the John M. Crawford Collection*. Exh. cat. New York: China Institute in America, 1981.

Woo, Hyunsoo, ed. *Treasures from Korea: Arts and Culture of the Joseon Dynasty, 1392—1910*. Exh. cat. Philadelphia: Philadelphia Museum of Art, 2014.

Woo Jin-woong. "Joseon sidae milgyo gyeongjeon ui ganhaeng e daehan yeongu" [A study on the publication of esoteric Buddhist sutras in the Joseon dynasty]. *Seojihak yeongu* [Bibliography research] 49 (September 2011): 235—73.

Wright, Edward Reynolds, and Man-Sil Pae. *Traditional Korean Furniture*. Tokyo: Kodansha International, 2000.

Yet geulssi ui areumdaum: Geu sok eseo yeoksa reul boda [The beauty of ancient Korean calligraphy: Inside its history]. Icheon: Woljeon Museum of Art, 2010.

Yi Chang Su. "Muwi reul chajaganeun yesulga: Misulga Lee Kang So" [The artist who pursues emptiness: Artist Lee Kang So]. *2032* (January 2013): 172—77.

Yi Song-mi. "Baekje sidae seoye ui daeoe gyoseob" [Baekje-period calligraphy and foreign exchanges]. In *Baekje misul ui daeoe gyoseob* [Foreign exchanges of Baekje art], edited by Art History Association of Korea, 169—204. Seoul: Yekyong Press, 1998.

———. *Searching for Modernity: Western Influence and True-View Landscape in Korean Painting of the Late Choson Period*. Seattle: University of Washington Press, 2014.

Yi U. *Daedong geumseok seo* [Stone inscriptions in Korea]. Seoul: Gyeongseong Jeguk University Department of Law, 1932.

Yi Wanwoo. "Anpyeong daegun Yi Yong ui munye hwaldong gwa seoye" [The literary and artistic activities of Prince Anpyeong Yi Yong and his calligraphy]. *Misul sahak yeongu (Gu gogomisul)* [Korean journal of art history (formerly Art and archaeology)] (September 2005): 73—115.

———. "Goryeo sidae geulssi wa Song Won dae seopung" [Goryeo-period text and song: Yuan calligraphy]. In *Goryeo ui Daeoe Gyeoseob* [Goryeo's foreign exchanges], edited by Art History Association of Korea, 47—75. Seoul: Yekyong Press, 2004.

———. "Baekha Yun Sun gwa Jungguk seobeop" [Paekha Yun Sun and Chinese calligraphy]. *Misul sahak yeongu* [Korean journal of art history] 206 (June 1995): 29—66.

———. "Joseon hugi Yeolseongeopil ui ganhaeng gwa gwangpo" [Publication and distribution of *Yeolseongeopil* in the Late Joseon dynasty]. *Jangseogak* 30 (2013): 146—93.

———. "Joseon wangjo ui Yeolseongeopil ganhaeng" [The publication of *Calligraphy of Successive Rulers* of the Joseon Dynasty]. *Munhwajae* [Cultural properties] 24 (1991): 147—68.

———. "Seokbong Han Ho: A Calligrapher in the Middle Period of Choson Dynasty." *Art History Forum* 12 (2001): 299—319.

———. "Tongil Silla Gim Saeng ui piljeok" [Unified Silla Gim Saeng's calligraphy]. In *Seonsa wa godae* [Pre- and ancient history], edited by the Korean Association for Ancient Studies, 267—90. Hwaseong: Korean Association for Ancient Studies, 1998.

———. "Tongil Silla ui dangdae seopung ui suyong" [Unified Silla's adaption of Tang calligraphy]. In *Tongil Silla Misul ui Daeoe Gyeoseob* [Unified Silla's foreign art exchanges], edited by Art History Association of Korea, 143—72. Seoul: Yekyong Press, 2001.

———. "Uri nara ui sagyeong seopung" [Korea's Buddhist transcription calligraphy]. In *Sagyeong byeonsado ui segye, bucheo geurigo maeum* [Sutra painting in search of Buddhahood], edited by National Museum of Korea, 316—31. Seoul: National Museum of Korea, 2007.

———. *Yeongjo eopil*. Suwon: Suwon Museum, 2015.

Yoo Ji-bok. "Haedong myeongjoek seokpanbon yeongu" [Stone-carved edition of Haedong myeongjeok study of Haedongmyeongjeok Slate Book]. *Jangseogak* 36 (October 2016): 32—76.

———. "Haedong myeongjoek mokpan-bon yeongu" [Woodblock edition of renowned calligraphy of Korea]." *Seojihak yeongu* [Journal of the Institute of Bibliography] 65 (2016): 213—41.

Yoon Ji Hun. "Dogok Li Uihyeon ui Yu Geumgangsangi e gwanhan ilgo" [A study of *Yu Geumgangsan gi* by Dogok Lee Uihyeon]. *Hanmun gojeon yeongu* [Classical Chinese studies] 25, no. 107 (2012): 177—99. http://www.happy-campus.com/paper-doc/6177769/.

Yu Hong-jun. *Hanguk misulsa gangui* [Korean art history lectures]. Seoul: Nulwa, 2013.

Yu Junsang. "Urideul ui eoneo ui gwageo wa mirae" [The past and future of our language]. In *Dong asia munja yesul ui hyeon jae* [Today's written arts of East Asia], ed. Seoul Arts Center, 198—201. Exh. cat. Seoul: Seoul Arts Center, 1999.

Yu Seungmin. "Yi Insang gwa geu ui seohwa sok simhoe" [Yi Insang and his mind in paintings and calligraphic works]. In *Hangukhak geurim eul geurida* [Korean studies meets painting]. Gyeonggi-do: Thaehaksa, 2013.

Yum, Hyejung. "Traditional Korean Papermaking: Analytical Examination of Historic Korean Papers and Research into History, Materials, and Techniques of Traditional Papermaking of Korea." Research paper, Getty Foundation, 2003.

Zhang Hongxiu. *Beichao shike yishu* [The art of stone carvings of the Northern dynasties]. Xi'an: Shaanxi renmin meishu chubanshe, 1993.

INDEX

A

A Dao, 55

Ahn Sang-soo: *Bomb Fish on the Seashore, 364, 365*

ancestor worship, 235, 239

An Gyeon, 39, 194, 358

An Jongweon, 125, 127

An Junggeun, 49, 125, *331; Nothing Is More Painful than Overconfidence, 330—31*

An Jungsik, 127, 321; *Couplet in Seal Script, 326—27; The Sound of Playing Baduk in a Bamboo [Grove], 328—29*

An Minhu: *Jigwangguksa Stele Inscription, 74, 75*

Anpyeong (prince), 39, 181, 197; ink traces of, *194—95*

Appenzeller, Henry G., 338

art schools, 120, 121, 122, 327, 343

Ashikaga shogunate, 275

Avatamsaka Sutra, 26, 27, 64, 81, *161—63, 164, 165, 166*

B

baduk board game, 328

Baekje Kingdom, 16, 54, 58, 62, 169, 170, 187, 189; calligraphy, 58—59, 83, 160, 167

Bai Juyi, 211, 323, 325

Bak Yeonghyo, 125, 127

Balhae Kingdom, 16, 54

Bangudae Petroglyphs, 19, 21, *137, 143, 144—45*

Basket Depicting Ninety-Four Paragons of Filial Piety, 25

Beilin, 173

beipai style, 116, 118, 120, 125, 139

beipai-tiepai style, 125, 126, 138, 139

Beopheung (king), 55, 61

Beophwagyeong. See Lotus Sutra

Bethell, Ernest Thomas, 341, 342

Bibaek style, 299

bottles, 210, 211, 243—44

bowls, 104, 235, 236, 243, 245, 246

Box of Bamboo Strips Holding Verses from the Confucian Classics, A, 249, 250

Box with Symbols of Longevity and Calligraphic Inscription, 247, 248

Bronze Age: petroglyphs, 21n4, *54*; script, 22, 49, 225, 251

bronze vessel inscriptions, 22, 49, 56, *57,* 115, 124, 217, 248, *322—23*

brushes, writing, 21, 27, 35, 131, 136, 137, 148, *149,* 227, 299, 369, 373, 375

Brush Stand, 241

Buddha, 27, 81, 158, 164, 344; Amitabha, 63, 314; Amitayus, 343; biographies of, 273, 280, 283; relics of, 59, 160n1; Shakyamuni, 26, 159, 161, 178—79; teachings of, 35, 62, 81, 158, 161, 166, 175, 273n6; Vairocana, 163

Buddhabhadra, 64, 161

Buddhism, 26—27, 64, 100, 176, 178—79, 271, 273, 280, 343; as state ideology, 55, 62, 71, 164, 170; Beobsangjong, 72; Esoteric, 273; Ho-guk, 71; Mahayana, 159, 162, 363; Seon, 63, 76, 79, 163, 261n5, 297, 299, 311, 344

Buddhist: calligraphy, 26—44, 157—79; dharanis, 67, 272, 273; enlightenment, 157, 158, 163, 177, 297, 299, 307, 311, 344, 367; mantras, 157, 267, 272, 273; nonduality, 297, 299, 307; path, 176, 177, 367; rituals, 48, 241, 272, 273; schools, 55, 63, 162, 163, 164, 273. *See also* dharma; pagodas; Sanskrit; *sarira;* Siddham characters; sutras

Buhogun Yi Deok-su, 89

buncheong stoneware, 366

Burial Panels and Covered Bowl Set with Inscriptions, 235—36

Byeongja War, 89n9, 94

C

Calligraphy of Successive Sage-Rulers, 39, 199—203

Cao Huan (emperor), 153

Cao Quan Stele, 23

Cao Wei Kingdom, 153, 293

Catholic, 157, 229, 239

celadons: *Celadon Double Gourd-Shaped Bottle with Carved Lotus and Scroll Design in Relief and Poem Inscription, 42, 210, 211; Prunus Vase with Plum, Bamboo, and Willow Design and Inscription of Li He's Jangjinju (Ch. Jiang jin ji) Poem, 43*

certificates, 55, 61, 96, 189; of investiture, *88—89,* 91, 92, 94

Chae Inbeom, 234n1

Chae Je-gong, 101, 103

Checking, 63

Cheokgyeong Stele: Royal Inspection Tour Inscription for King Jinheung, The, 190, 191

Cheok Jungyeong, 234

Cheonjeon-ri petroglyphs, 21n4, *54*

Cheophaesineo, 48, 267, 274, *275*

chest: medicine, 45, *237*

Chest with Myriad Su (Longevity) Characters, 247, 248

Chinese: army, 169, 170; calligraphy, 20, 22, 23—24, 25, 28, 30, 32, 35—36, 57, 108, 116, 124, 126, 213, 305; system of ordinals, 228; value Korean paper, 21, 151—52; woodblock printing, 259, 271, 303, 313, 323, 363. *See also hanja;* names of individual dynasties and periods

Choe Chiwon, 69, 174n5, 360; *Pagoda Epitaph for Seon Master Jingam, 30, 31, 33, 64*

Choe Eonwi, 72, 75

Choe Hang, 79

Choe Inyeon, 30, 170

Choe Rip, 220

Choe Seongsak: *Daebojeokgyeong, 82*

Cho Inyeong, 188

Chongzhen reign, 177

choseo script, 96, 100, 107, 130, 349. *See also* cursive script

Choui, 297

Christianity, 338; Catholic, 157, 229, 239

Chungnyeol (king), 79, 81

Chungseon (king), 79

Chu Suiliang, 63, 293

civil service examination, 86, 92, 101, 211, 249, 275, 297; answer sheet, 96, *97*

clerical script, 22, 36, 49, 80, 155, 184, 186, 291, 293, 296, 299, 311, 313, 319, 327; *goye*, 56. See also *yeseo* script
Cold War, 365
colonization, 114, 337, 354
Confucianism, 58, 222, 349; as state ideology, 58, 71, 86, 170, 199, 235, 248, 271, 273, 297, 340; classics, 46, 58, 86, 211, 249—50; ethics, 25, 58, 202, 203, 205, 222, 238, 239, 248, 249, 263, 338. *See also* Neo-Confucianism
Confucius, 195, 222, 301, 327
cursive script, 22, 64, 134, 212, 213, 227, 229, 231, 253, 259; *caoshu*, 115; *heullimche*, 131; *inheullimche*, 131; *xingshu*, 116, 118, 120. See also *choseo* script

D
Daehan Fine Art Association, 121, 122
Daehan Maeil Sinbo (*Korea Daily News*), 283, 341, 342
daejaseo script, 136, 140
daejeon script, 125, 217
Dangjin Yeonui (*Tales of Prince Qin of Tang*), 48, 278—79
Danmok, 30, 170
Daoism, 222, 225, 248, 253, 255
Daoist: constellation, 206; myths, 227n7, 253, 295; symbols, 211, 247
Deng Wanbai, 118
dharma, 62, 176, 177, 179, 261, 299, 367; wheel, 35, 175
Diamond Sutra, 26, 158—59, 160, 361—63
Divine Omen Stele, 30, 32
Dongnip Sinmun, 50, 336, 337—38, 340, 349. See also *Independent, The*
Dong Qichang, 21, 22n6, 166, 299, 303
Dragon King, 45, 209, 222
Du Fu, 42, 211, 216, 217

E
Eastern Han dynasty, 16, 183—84
Eastern Jin, 16, 28, 33, 55, 58, 116, 161, 170, 174, 212, 301, 317n8
education, 86, 94, 96, 249, 271, 330, 342; art, 121, 122, 138, 220
English Version of the Independent, Vol. 1, No. 102, 337, 338
eobo, 88
eochaek, 88
eochal, 95
eoje, 94
Eojeong Muye dobo tongji eonhae (*Comprehensive Manual of Military Arts Explained*), 276—77

eopil, 94, 104; *Yeolseong eopil*, 94, 199; *Yeongmyo eopil* (*King Yeongjo's Writing*), 86, 87, 94
Epitaph Fragment of King Heungdeok, 36, 192, 193
Epitaph of a Daughter of a Local Official in Gyeongju, 232
Epitaph of Choe Ham, 44, 45, 233, 234
Epitaph Stele for Sima Fang, 32, 33
Epitaph Stele for Wife of Yang Wenchao, 32, 33
Eulsa Treaty, 330
exhibitions, 35, 120—23, 125, 138, 365; Joseon Fine Arts Exhibition, 121, 122, 126; Joseon Industrial Exposition, 121; Republic of Korea Fine Arts Exhibition, 122, 125

F
Feng Yunpeng, 323
filial piety, 25, 89, 194, 214, 239; *Basket Depicting Ninety-Four Paragons of Filial Piety*, 25; *Hyogyeong* (*Classic of Filial Piety*), 195
First Tripitaka Koreana, 26, 161—63
Flat Bottle with Poem, 243
Flower Garland Sutra. See *Avatamsaka Sutra*
Fontanesi, Antonio, 121
Fuxi, 215n6

G
Gang Useong: *Volume 2 of the Cheophaesineo*, 48, 274, 275
Gathering of Government Officials, 40
Gaya Confederacy, 16, 36, 58, 61, 191
Ge Hong, 253, 255
Geunchogo (king), 58
Gim Busik, 28
Gim Chiyang: *Cheonchutaehu*, 82
Gim Donhui, 125, 139
Gim Eunghyeon, 125, 126, 127
Gim Giseung, 122, 125, 127, 128, 139
Gim Gu, 125, 127
Gim Gwangeop, 125, 127, 128
Gim Gyujin, 127, 311n3; *Mind Itself Is Buddha*, 343, 344, 345
Gim Hongdo, 206, 253
Gim Jeonghui, 28, 48—49, 108, 120, 188, 259, 290—319, 343, 370; disciples of, 49, 99, 260, 263, 264, 292, 300, 301, 302, 312; exile, 290, 292, 296, 297(nn1—2), 299, 300, 301, 308—10, 313; inkstone of, 188, 302, 303, 318, 319

Gim Jeonghui. works. *Calligraphic Frontispiece: Chimgye*, 292—93; *Comments on Shitao's Paintings*, 48, 304, 305; *Ink Rubbing of an Inscription of the Documents on the Amitabha Statue at Mujangsa* (1815), 53, 315, 317; *Ink Rubbing of an Inscription of the Documents on the Amitabha Statue at Mujangsa* (1817), 316, 317; *Letter by Gim Jeonghui in Hangeul to His Daughter-in-Law*, 309, 310; *Letter by Gim Jeonghui in Hangeul to His Wife*, 308, 309, 310; *Mount Gonryun Rides on an Elephant*, 294, 295; *Orchid*, 261n5, 298, 299; *Room of the Bamboo Stove*, 296—97; *The Self Becomes Buddha*, 311; self-portrait, 312, 313; *Sosik's* (*Ch. Su Shi's*) *Poem on Seokgak's* (*Ch. Shi Ke's*) *Painting of Yu Ma* (*Vimalakirti*), 119, 306—7; *Wintry Days*, 300—301
Gim Josun, 107
Gim Okgyun, 125, 127
Gim Saeng, 28, 30, 68—69, 75, 100, 116, 120, 170, 199, 314—15, 316, 317(nn4, 7), 375; *Jeonyuamsangaseo*, 69, 70
Gim Sangsuk, 217, 218
Gim Taeseok, 125, 127
Gim Uisin, 94, 99; *Myeonggu* (*Famous Adage*), 92, 93
Gim Yeon, 101, 103; *sindobi of*, 102, 103
Gim Yeong, 103
Gim Yongjin, 127
Gim Yugeun, 305; *Album of Inkstone Paintings*, 258, 259
Go Bongju, 125, 127
goche script, 126, 139, 358
Goguryeo Kingdom, 16, 36, 55, 169—70, 183, 188; calligraphy, 55—58, 83, 116; *Inscribed Tomb Bricks*, 154. See also *Gwanggaeto Daewang Stele*
Goi (king), 58
Gojo (king), 58
Gojong (king; r. 1213—59), 79
Gojong (king; r. 1897—1907), 104, 327, 349
Gojoseon period, 16, 54, 55, 118
gokjik strokes, 131
gokoek strokes, 130
Goryeo dynasty, 16, 75, 80, 81, 170; celadons, 210, 211; epitaphs, 44, 45, 232—33, 234; ink rubbing, 117, 169, 170; inkstones, 148; printing during, 20, 280; stele inscriptions, 33, 34, 117; sutras, 27, 161—63, 164, 165; tributes, 71, 151
gourds, 42, 211, 248

gungche script, 126, 139, 357, 358

Gungnamji wooden stick with ink inscription, 59, *60*

gusi poetic form, 223, 257

Guyang Sun, 301

Gu Yuanqing, 323

Gwanggaeto (king; r. 391—413), 36, 55—56, 155, 183

Gwanggaeto Daewang Stele, 21, 36, *37*, 55—56, 116, 120, 153; inscription on, 25, *117*, *182—84*, 188

Gwangjong (king; r. 949—75), 72, 170, 211

gyehoido paintings, 96

Gyehwabuin (queen), 63, 314

gyeong. See sutras

gyeongdang, 183

Gyeongjong (king), 199

Gyoseogwan, 274

Gyujanggak, 206, 207n1

H

haehaengcho style, 127

Haengchon Yi Am, 80

haengchoseo script, 126

haengcho style, 126, 131, 264

haengseo script, 63, 92, 96, 111, 125, 127, 170, 230, 264, 327, 331, 349. *See also* semicursive script

haeseo script, 63, 92, 94, 96, 101, 107, 111, 116, 127, 131. *See also* standard script

Hagi, kilns at, 245, 246

Hallimwon, 72

Han Daokun, 213n3

Han dynasty, 16, 230, 248, 251; *gusi* poetic form, 223, 257; mirrors, 54; roof tiles, 49, 319n2, 323; tomb bricks, 49, 153, 155. *See also* clerical script; Lelang Commandery; *lishu* style;

Han Eongong, 162

hangeul, 20, 39, 46—47, 115—16, 118, 120, 127, 130, 131, 140, 194, 236, 266—89, 308, 347; adopted by women, 108, 111, 266, 269; alphabet, 195, 358; as phonogram, 130; *Cards with Diagrams of Hangeul Mouth Movements*, 50, *332—34*, 335; denigration of, 239, 310, 335; faux, 365; *goche*, 126, 139, 358; *hangeul goche*, 131; *Letter by Gim Jeonghui in* Hangeul *to His Daughter-in-Law*, *309*, 310; *Letter by Gim Jeonghui in* Hangeul *to His Wife*, *308*, *309*, 310; *Metal Type of* Hangeul *Letters*, *282*, 283; movable type, 280, *282*, 283; *Poem on the Diamond Mountains, in* Hangeul *Script*, 50, *357*, *358*, *359*; symbolizing Korean identity, 50, 124, 126, 139, 246, 266, 269, 321, 338, 340, 357; *Tea Bowl*

Inscribed with a Poem in Hangeul, 245, 246. *See also Hunminjeongeum*

Han Ho, 92, 120, 198, 202, 218, 219—20; *Album of Transcribed Poems*, 219, 220, 221

hanja, 20, 21, 22—25, 49, 108, 111, 115—16, 118, 138, 153, 157, 162, 266, 269, 273, 310, 338, 340, 342; as ideogram, 130, 240; culture, 108, 124, 130, 131; movable type, *281*

hanji, 21, 161, 166, 226, 229. *See also* paper, handmade

Hanlin Academy, 28, 68

Han Seokbong, 197, 202, 203

Hansu, 80

Heo Mok, 45, 100, 101, 222, 225—27; portrait of, 226, 227n1

Heo Mok. works. *Calligraphy: Question Extensively*, 224, *225—27*; *Eulogy to the East Sea*, 45, *209*, 222; *Manuscript for the East Sea Stele Inscription*, 223

Heongang (king), 68

Heongyeong (queen), jade seal of, *90*, 91; *Hyeongyeongwanghu gyomyeong (Queen Heongyeong's Certificate of Investiture)*, *88—89*. *See also* Hyegyeong (lady)

Heonjong (king), 91, 263

Heo Ryeon, 263, 306; *Ink Rubbings of Wandang's Works*, *312*, 313; *Painting of Oddly Shaped Stone*, 46, *262*, 263

Heungdeok (king), 69, 171; epitaph fragment of, 36, *192*, 193

He Zhizhang, 42, 211

hieroglyphs, 115, 124, 125, 129, 130, 141

hiragana script, 48, 267, 275

Hobeopshinjang, 81

hogoryeo, 246

Hong Gwan, 28, 68—69

Hong Yangho, 226, 314—16, 319

Houchong Tomb, 56, 116

Houchong Bronze Jar, inscription on, 56, 57

Huairen, 28, 173, 174

Huaisu, 134; *Autobiography*, 24

Huang Gongwang, 313

Huang Shigong, 331

Huang Tingjian, 125

Huibaek, 225

Huizong (emperor), 28, 68

Hunminjeongeum (The Proper Sounds for the Instruction of the People), 46, 47, 119, 120, 126, 138, 266, 268, 269, 335

Hwaeomgyeong. See Avatamsaka Sutra

Hwangchoryeong-jinheungwangsunsu Stele, 60, *62*

hwanggeuk, 206

Hwangseong Sinmun (Imperial Capital Gazette), Vol. 2, No. 15, *339*, 340

Hyeon Chae, 125, 127

Hyeon Chunghwa, 126

Hyegyeong (lady), 88, 89, 91, 111. *See also* Heongyeong (queen)

Hyeongyeongwanghu gyomyeong (Queen Hyeongyeong's Certificate of Investiture), *88—89*

Hyeonjong (king; r. 1009—31), 75, 161, 162, 163

Hyeonjong (king; r. 1659—74), 199, 203

Hyeon Junghwa, 125, 126, 127, 139

hyeonpan. See signboards

Hyeshim, 79

Hyogong (king), 170

Hyojang (prince), 88n2, 292

Hyojong (king), 199, 203; calligraphic sketchbook of, 39, 181, *196—97*

I

ideograms, 130, 240

ideographs, 20, 46, 130, 140, 266

idu text, 61

Imjin War, 94, 104, 108, 229, 245, 246, 275

improvisation, 186, 369

incarnations, 163

Incense Burner with Lotus and Four Trigrams Design and Inscription, 241

Independent, The, 50, 283; *English Version of the Independent, Vol. 1, No. 102*, *337*, 338; *Korean Version of the Independent, Vol. 1, No. 96*, *336*

Injo (king), 197, 199, 203, 222

Injong (king), 79, 234

Injongsichaek, *78*, 79

Ink Rubbing of an Inscription of the Documents on the Amitabha Statue at Mujangsa (1815), *315*

Ink Rubbing of an Inscription of the Documents on the Amitabha Statue at Mujangsa (1817), 53, *316*, 317

Ink Rubbing of King Taejong Muyeol Stele, 64, *65*

Ink Rubbing of the Memorial Stele of the Great Master Unpa, *175—76*, 177

Ink Rubbing of the Monument Marking King Jinheung's Inspection of Mount Bukhan, *187*, 188

Ink Rubbing of the Pohang Jungseongni Stele Inscription, *185*, 186

Ink Rubbing of the Stele Commemorating the Great Master Nanggong at the Taeja Temple, 116, *117*, 169, 170

Ink Rubbings of Wandang's Works, 38, *312*, 313

Ink Slab Case, 150

ink sticks, 21, 148, 150

Ink Stick Stand, 148

inkstones, 21, 94, 148, 150; *Album of Inkstone Paintings*, 258, 259; inkstone owned by Gim Jeonghui, 188, 302, 303, 318, 319

Inmok (queen), 198

Inscribed Tomb Bricks, 154

Inscriptions on the Stone Drums, 23, 229, 315, 317n5

Itō Hirobumi, 49, 330—31

J

Jade Seal of Queen Heongyeong, 90, 91

Jajang, 179

jangdan stroke, 124

Jang Danyeol, 72; *Wonjongdaesa Stele*, 73

Jang Seung-eop, 327

Jangsu (king), 55, 56, 183

Japan: collaborating with, 108, 343; cultural exchange with, 58, 152; envoys to, 55, 92, 189; exports to, 245; gifts to 58, 116; invasions from, 152, 185, 229, 245, 275; Korean captives in, 246; Muromachi period, 245, 275; resistance to, 125, 330—31, 335, 342, 349

Japanese: calligraphy, 118, 121; language 115—16, 130, 131, 275, 335; policy to denigrate *hangeul*, 115, 239, 335; sutras, 166; tea culture, 245—46. See also *hiragana* script; *kana* writing

Japanese Colonial period, 16, 49—50, 72, 126, 153, 239, 269, 316, 330, 343

Japanese Government General of Korea, 121

jars, 56, 57, 58, 184, 219, 242, 244, 255, 323

Jataka tales, 178—79

Jeokseong, 61

jeongak script, 127, 139

jeongche script. See regular script

Jeonggang (king), 68

Jeong Giyeon: *Seumnyeguk*, 238, 239

Jeong Hwanseop, 127, 139

Jeongjo (king), 86, 89, 99, 101, 104, 108, 111, 206, 229, 256, 276, 292; *Letter Sent to Sim Hwanji*, 95; *Letter to Aunt Min*, 108, 109; *Seal*, 41, 206—7; *Taehakeunbaesiseo*, 104, 105

Jeong Jusang, 126, 127, 139

Jeongmyeong (princess), 181; *Illustrious Governance*, 39, 198

Jeong Yakyong, 228—29, 297; *Birds and Plum Tree*, 256, 257; *Hapicheop*, 228, 229

jeonhyeong script, 126

jeon script, 132, 310. See also seal script

jeonseo script, 22, 64, 88, 91, 92, 96, 100, 101, 116, 125, 126, 127, 130, 139, 140, 222, 322. See also seal script

Jeon Wonbal, 80

jeonye script, 125, 126, 127

jesulgwan, 92

Jeungsam, 195

Jigonghwasang, 80

Jigwangguksa Stele, 74, 75

Jijeung (king), 61, 185

jikeok, 130

Jillakgong Lee Jahyeon, 76

Jindeok (queen), 75

Jin dynasty (265—420), 16, 259

Jin dynasty (1115—1234), 16, 71, 83, 234

Jineonjip (Compendium of Mantras), 48, 267, 272, 273

Jingakguksagosin, 78, 79

Jingam Seonsa Hyeso, 71

Jingongdaesa Stele Inscription, 74, 75

Jingsebitaerok: Stories That Are Moral Lessons for the People, 110

jinheullimche script, 131

Jinheung (king), 61, 62, 191; *The Cheokgyeong Stele: Royal Inspection Tour Inscription for King Jinheung*, 190, 191; *Ink Rubbing of the Monument Marking King Jinheung's Inspection of Mount Bukhan*, 187, 188; *Monument Marking King Jinheung's Inspection of Mount Bukhan*, 36, 187, 188

Jinpyeong (king), 171

jinseol rituals, 239

jipja writing, 28, 63, 69, 75, 76, 170, 174

jisok stroke, 124

Jo Huiryong: *Orchid*, 260, 261

Jo Hyeonmyeon, 88

Jo Seokjin, 327

Joseon dynasty, 16, 45, 71, 86, 96, 99, 121, 151, 178, 249, 273; albums, 196—97, 219, 223, 228, 252, 258, 260, 304, 306—7, 312; books, 47, 268, 270, 272, 274, 276, 278; box of bamboo strips, 249; branding irons, 46, 240; brush stand, 241; calligraphic frontis-piece, 292; calligraphy, 46, 84—111, 118, 126, 230, 330—31; documents, 284—85; handscroll, 300—301; hanging scroll, 224, 226, 294, 298, 311; incense burner, 241; ink slab case, 150; ink rubbings, 53, 175, 176, 222, 315—16; inkstand, 148; ink stick, 148; inkstones, 148, 318; ink traces, 38, 194—95, 214; lacquers, 247, 251; letter paper, 151, 152; letters, 308—9, 310; manuscript, 216; movable type, 20, 48, 271, 280, 281—82, 283; newspapers, 336—37; padlocks, 46, 242; paintings, 40, 256, 262, 264; porcelains, 235—36, 242, 243—44; screen, 251; seal, 206—7; signboard, 296—97; tablets, 85, 204, 205; woodblock, 178—79; writing brush, 149

Joseon Fine Arts Exhibition, 121, 122, 126

Joseon Industrial Exposition, 121

Joseon ui Yeonguhoe, 335

joyulisi rites, 239

Jung Do-Jun: *Generous Heart and Small Pavilion*, 370—71

Jung Hyeonbok, 370

jungin, 92, 260

Ju Yanyun, 188n2

K

kaishu style, 120, 125, 126, 127, 138. See also *haeseo* script

kana writing, 115, 116, 129, 130, 131, 140

Kangxi (emperor), 175, 248

karma, 179, 311

Khitan people, 71, 161

Khubilai Khan, 33

kilns, 21, 211, 244; in Japan, 245—46

Kim Choong Hyun, 122, 125, 126, 127, 128, 139, 370; *Poem on the Diamond Mountains, in Hangeul Script*, 50, 357, 358, 359

Kim Jongweon: *Munmunjaja guemgang-gyeong geu seojeok byeonsang (Words Originating within Words: A Calligraphic Abstract of the Diamond Sutra)*, 361—63; *Tongnyeongsinmyeong- Gounseonhwa sinbuljido (Illumination of Mind and Spirit: The Post-Transformation of Choe Chiwon into a Daoist Hermit)*, 132, 133, 360, 361

Kim Sun Wuk, 50, 371; *Emptiness*, 350; *Seals*, 351—52

Korean Empire, 16, 49—50, 321, 322, 327, 340, 341, 343

Korean Fine Arts Association, 121

Korean Version of the Independent, Vol. 1, No. 96, 336

Korean War, 50, 76, 120, 322, 349, 354, 365, 375

Koyama Shotaro, 121

Kūkai, 118

Kyungwoo Chun, 50; *Light Calligraphy #2*, 368, 369

L

lacquers, 20, 25, 147, 209, 238, 245, 247, 248, 251, 325

Lan Caihe, 255

landscape painting, 96, 253, 263, 299, 302, 327, 375

Laozi, 222

Lee Gan, 69

Lee Gwangsa, 174, 231

Lee Gyeong, 245

Lee Jakgwang, 245

Lee Jimu, 172

Lee Kang-so, 50; *Emptiness 14010*, 372—73

Lee Samman: *Radiance of Mountains, Colors of Water*, 230—31

Lee Sangjeok, 300, 301
Lee Ungno, 50, 127, 139, 353—54; *People*, 113, 353, 354
Lelang Commandery, 25, 55, 148, 153; tomb bricks, 155
Letter Paper, 150, 151, 152. *See also* paper, handmade
letters; letter writing, 42, 43, 94—96, 98, 99, 103n34, 152, 285, 297n2, 299, 300—301, 308—9, 310; by women, 111; *eochal*, 95; *eongan*, 284; model, 41n24, 100; royal, 95, 99, 108, 109, 220; "scent of letters," 297, 299; secret, 95, 99; "spiral," 111
Liang dynasty, 16, 59, 253
Liang Shizheng, 323
Li Bai, 134, 215, 220, 231, 255
Li Dongyang, 323
Li He, 42, 211; *Jangjinju Poem*, 43
lishu style, 116, 118, 120, 125, 126, 130, 138. See also clerical script
literacy, 46, 86, 266, 269, 338; illiteracy, 130, 284
Liu–Song dynasty, 16, 344
Li Yangbing, 33, 323; *The Thousand-Character Classic*, 34
Lotus Sutra, 27, 81, 164, 165, 270
Lü Diaoyang, 323
Luo Ping, 305
Lu You, 132—33

M
Manchu, 175, 196, 229, 248
mantras, 157, 272, 273
Medicine Chest, 45, 237
Memorial Tablet from the Tomb of King Muryeong and His Queen Consort, 189
Metal Type of Hangeul Letters, 282, 283
Mi Fu, 259, 303, 319n7
Ming dynasty, 16, 88, 177, 213, 220, 305, 375; books, 179, 267, 277, 278
Min Yeongik: *Orchid*, 46, 264—65
Moduru Tomb, ink inscription on north wall of, 56, 57
Mongol, 26, 33, 71, 79, 81, 83, 163
Monument Marking King Jinheung's Inspection of Mount Bukhan, 36, 187, 188
Mōri Terumoto, 245
movable type, 20, 48, 209, 270—71; *Metal Type of Hangeul Letters*, 282, 283; *Page from a Movable-Type Book*, 280; *Representative Hanja Movable Type*, 281
Mugujeonggwang daedarani gyeong, 66—67
muksang style, 118, 124, 139
mukyeong style, 118, 124, 127, 139
munbangsau, 21, 148

munin, 86, 122, 123, 125. *See also* scholar–officials
munjahyang, 297, 299
Munjong (king), 71, 72
Muryeong (king), 58, 59, 189; memorial tablet from tomb of, 189; queen of, 36, 59, 160, 189
Muyeol (king), 63, 75; *Ink Rubbing of King Taejong Muyeol Stele*, 64, 65
Myeongryundang, 104, 105

N
Nanggong: stele commemorating, 30, 100, 116, 120, 315. See also *Taejasa Nanggongdaesa Baekwolseountapbi*
Nangseongun Yi U, 94, 100, 101
nationalism, 49—50, 321, 338, 340, 357
Neo–Confucianism, 42, 71, 75, 151, 175, 214, 222, 229, 242, 248, 297
Neolithic period, 118, 143; *Bangudae Petroglyphs*, 119, 143, 144—45
newspapers, 321; *Daehan Maeil Sinbo*, 283, 341, 342; *Dongnip Simun*, 50, 336, 337—38, 340, 349; *Hwangseong Sinmun*, 339, 340; *The Independent*, 50, 283, 336, 337, 338
nirvana, 163
Ni Zan, 323, 324, 325
nongdam stroke, 124
Northern Song dynasty, 16, 162, 210, 213
Northern Wei dynasty, 16, 33, 125, 160, 188n2
novels, 46, 48, 111, 267, 278, 279n1
Nulji (king), 55, 61

O
O Daeik, 101, 103
O Gyeongseok, 322
Okhojeongdo (*Painting of Okhojeong Pavilion*), 106, 107
oracle bone scripts, 115, 124, 125, 135, 139
O Sechang, 28n10, 49, 125, 127, 139, 218, 321, 327; *Inscriptions on Roof Tiles and Bronze Vessels*, 322—23; *Bai Juyi's Thatched Hall on Mount Lu and Ni Zan's Hall of Cloudy Forest*, 323—25
O Sechu: *Sigwon*, 96, 97
Osu coins, 54
Ouyang Xun, 20, 58, 63, 68, 69, 72, 75, 76, 81, 83, 170, 229, 301; *Inscription on the Sweet Wine Spring in the Jiucheng Palace*, 193; *Stele Inscription for Wen Yanbo, Duke Gong of Yu*, 30, 31

P
Padlock with Inscription, 46, 242
Page from a Movable-Type Book, 280
pagodas, 28, 59, 62, 63, 67, 68, 69, 71, 72, 158, 159, 160; *Pagoda Epitaph for Seon Master Jingam*, 30, 31, 33, 64; *Stone Tablet from the Buddhist Sarira Pagoda at Beopgwangsa*, 30, 171
Pak Jonghun, 104
paper, handmade, 21, 94, 150—52; indigo–dyed, 27, 64, 157, 164, 165, 166; letter, 151, 152; mulberry, 21, 64, 151, 152, 161, 166, 226, 229; persimmon, 81, 82
papermaking, 151—52
Park Dae Sung: *The Beautiful Land of Korea*, 374, 375; *Tall Mountains and Long River*, 374, 375
performance art, 35, 347, 363, 369, 373
petroglyphs, 21, 54, 118, 120, 138, 143, 144, 365; at Bangudae, 19, 21, 137, 143, 144—45; at Cheonjeon–ri, 21n4, 54
phonograms, 130
photographic portraits, 368, 369
pictograms, 130, 145
pilmuksi poetry, 115, 128, 141
Pohang Jungseongni Stele, 61, 185, 186; ink rubbing of, 185, 186
porcelains, 45, 103—4, 209, 235—36, 243—44, 248
printing, 209, 283; with movable type, 20, 48, 209, 270—71, 280—81, 283; with slate plates, 94, 100; woodblock, 20, 26, 163, 271, 280
Prunus Vase with Plum, Bamboo, and Willow Design and Inscription of Li He's Jangjinju (Ch. Jiang jin jiu) Poem, 43
pyeonsang images, 164

Q
Qin dynasty, 16, 22, 55, 217, 313, 363
Qing dynasty, 16, 120, 138, 175, 196, 248; books, 323
Quadrilateral Bottle, 244

R
Ragusa, Vincenzo, 121
Record of Land Trade Issued by Master Gim to the Servant Sani of the Yu Family, A, 284, 285
regular script, 131, 168
relics, 26, 30, 54, 44, 45, 58, 62, 67, 75, 79, 177, 269; of the Buddha, 59, 158—59, 160n1. See also sarira
Representative Hanja Movable Type, 281
Republic of Korea Fine Arts Exhibition, 122, 125

Rhee, Syngman, 125, 127, 259; calligraphy of, 50, *348—49*
royal investiture books, 88, 89, 91, 92, 94
Ruan Yuan, 48, 118, 290, 313, 323
Rubbed Copy of the Epitaph on the Sataekjijeok Stele, 27, 59, *167, 168*

S

Sabi period, 58, 59
Sado (prince), 88, 89, 91, 99, 108, 205, 206, 362
sagunja paintings, 262
sagyeong sutras, 62, 64
Sagyeongwon, 81
sajagwan, 81, 92, 220
Samhyeonsugan (Handwritten Letters of Three Wise Scholars), 98, 99
Sanggye *Documents Written by Slaves,* 285—89
Sanskrit, 48, 64, 67, 157, 161, 166, 173, 177, 178, 272, 273, 317n11, 344, 363. *See also* Siddham characters
sarim, 99
sarira, 158, 160; shrines, 55, 59, 67; *Stone Table from the Buddhist Sarira Pagoda at Beopgwangsa,* 30, *171*
Saro Kingdom, 61
Sataekjijeok Stele, 27, 59, *168*; rubbed copy of epitaph on, *167, 168*
saui focus, 114, 128, 129, 136, 139, 140
Sayeogwon, 275
scholar-officials, 41, 45, 86, 92, 100, 104, 122, 125, 259, 262. *See also munin; yangban*
screens, 42, 43, 49, 173, 251, 256, 310, 322—23, 324—25
seals, 41, 88, 92, 94, 181, 184, 198, 279; artist's, 300, 301, 303, 323, *351—52*; *eobo,* 88; *hyebinjiin,* 91; *Jade Seal of Queen Heongyeong,* 90, *91*; *Seal of King Jeongjo,* 206—7; *wangsejabinjiin,* 91
seal script, 22, 30, 126, 130, 136, 217, 225—26, 229, 251, 267; "bird-worm," 226; *Couplet in Seal Script,* 326—27; *Seal Script Title for the Stele Inscription for the Sutra Storage Hall of the Munsusa,* 34. *See also jeon* script; *jeonseo* script
Sejo (king), 271, 273
Sejong (king), 39, 46, 108, 120, 130, 138, 152, 194, 195, 266, 268, 269, 271
semicursive script, 22, 28, 33, 42, 56, 63, 69, 72, 76, 79, 80, 83, 175, 211, 244, 310, 316, 331. *See also haengseo* script
Sen no Rikyu, 245
seo, 115, 120, 121
Seo Byeong-o, 125, 127
seochejeok chusang, 356

Seodanghwasang Wonhyo, 63
Seo Geojang, 195
Seo Geojeong, 80
Seo Heonbo, 104; tombstone of, *105*
Seo Huihwan, 126, 127, 139
seohwa style, 120, 121, 124, 127, 128, 138, 139, 355, 356, 363
Seo Jaepil, 336, 338, 349
Seokbosangjeol (Detailed and Abridged Compendium of Collected [Texts] on the Buddha's Life), 270—71, 283
seokgyeong, 64, 68
Seong (king), 55, 58
Seongakwangsa Hyegeun, 80
Seonggyungwan, 101, 104
Seong Hon, 99
Seongjong (king), 71, 76
Seong Sammun, 195
Seonjo (king), 22, 92, 94, 181, 198, 199, 202—3, 220, 275; *Royal Edict, 108, 109*
Seonpung, 80
Seoryeongsa Hwang, 79
seosagwan, 92, 111
seosasanggung, 111
Seoul: established as capital, 340
Seo Yeongbo, 103, 104, 107, 236
Seo Yugyo, 103, 104, 236
Seunggagul, 76
shamans, 227n11
Shang dynasty, 16, 22, 295
Shengjiao Xu (Preface to the Sacred Teachings) Stele Inscription, The, 28, 29
Shinhaengseonsa, 69
Shitao, 48, 261, 291, 305
Shōsōin imperial repository, 67
Shundo, 55
Si (prince), 293
Siddham characters, 48, 157, 272; *sildam* characters, 272, 273
signboards, 86, 87, 92, 291, 296—97, 307, 371; of *Taehakeunbaesiseo,* 104, *105*
sigwon, 96, 97
sijo poetry, 259, 246
Silhak academic movement, 229, 297
Silla Kingdom, 16, 61, 71, 83, 185; monuments, 36, 187, *188*; steles, 61, *186, 190, 191*
Silla Village Documents, 66, 67
Sim Hwanji, King Jeongjo's letter to, *95*
Sima Qian, 301
Sindeok (king), 170
sindobi of Gim Yeon, 101, *102, 103*
Sin Gongje, 100
Sin Heenam, 219
Sinjeong (queen), 91
Sin Saimdang, 45, 111; *Ink Traces, 214, 215*

Sin Yunbok: *Hyewon's Painting Album,* 252—54, 255
Six Arts, 20
Six Classics, 173, 174n2
Six Dynasties period, 16, 116, 118, 120, 125, 126, 127, 138, 160, 188
slaves, 13, 20, 79, 100, 107, 152, 240, 284, 405; Sanggye *Documents Written by Slaves,* 285—89
Soheon (queen), 270
Sohyeon (prince), 196
sojeon script, 126, 217, 361
Song dynasty, 16, 71, 79, 248, 280
Song Ikpil, letters to, *98, 99*
Song Inmyeong, 88
Song Seongyong, 127
Songxue. *See* Zhao Mengfu
Son Jaehyeong, 125, 126, 127, 139
Soseong (king), 63, 314
Soshikche, 76
Sosurim (king), 55
Spring and Autumn period, 16, 226, 317n5, 323
ssanggubeop technique, 103
Ssangsik Li, 176
standard script, 22, 36, 59, 75, 79, 168, 220, 226. *See also haeseo* script
steles: *Cao Quan Stele,* 23; *Cheokgyeong Stele,* 190, *191; Divine Omen Stele,* 30, 32; *Epitaph Stele for Sima Fang,* 32, *33; Epitaph Stele for Wife of Yang Wenchao,* 32, *33; Gwanggaeto Daewang Stele,* 21, 36, *37,* 55—56, 116, 120, *153; Hwangchoryeong-jinheungwangsunsu Stele,* 60, 62; *Ink Rubbing of the Memorial Stele of the Great Master Unpa,* 33, *175—76, 177; Ink Rubbing of King Taejong Muyeol Stele,* 64, *65; Ink Rubbing of the Pohang Jungseongni Stele Inscription,* 185, *186; Ink Rubbing of the Stele Commemorating the Great Master Nanggong at the Taeja Temple,* 116, 117, 169, *170; Jigwangguksa Stele,* 74, *75; Jingongdaesa Stele Inscription,* 74, *75; Manuscript for the East Sea Stele Inscription,* 223; *Pohang Jungseongni Stele,* 61, 185, *186; Sataekjijeok Stele,* 27, 59, *168; Seal Script Title for the Stele Inscription for the Sutra Storage Hall of the Munsusa,* 33, *34; The Shengjiao Xu (Preface to the Sacred Teachings) Stele Inscription,* 28, *29; Stele Commemorating the Enshrining of the Amitabha Statue at Mujangsa,* 188, *314; Stele Commemorating the Great Master Nanggong at the Taeja Temple,* 116, 117, 120; *Stele Inscription for the Sutra Storage Hall of the Munsusa,* 33,

34, 80; *Stele Inscription for Wen Yanbo, Duke Gong of Yu*, 30, 31; *Taejasa Nanggongdaesa Baekwolseountapbi* (*Ink Rubbing of the Stele Commemorating the Great Master Nanggong at the Taeja Temple*), 117, 169, 170; *Wonjongdaesa Stele*, 73

Stone Tablet from the Buddhist Sarira Pagoda at Beopgwangsa, 30, 171

stupas, 158, 160n1

Sueharu Katsuragi, 316

Suh Se Ok, 50, 355; *Person*, 355, 356

Sui dynasty, 16, 59, 293

Sukan (princess), 197

Sukjong (king), 41, 94, 100, 104, 108, 181, 199, 203, 205; *Tablet with Model Calligraphy*, 85, 204, 205

Sunjo (king), 107

Sunjong (king), 327

sunsu rituals, 62, 191

Su Shi, 20, 303, 305, 307, 313

sutras, 26—27, 62, 64—68, 166, 173, 270, 295, 343—44; *Avatamsaka Sutra* (*Flower Garland Sutra*), 26, 27, 64, 81, 161—63, 164, 165, 166; *Diamond Sutra*, 26, 158—59, 160, 361—63; *gyeong*, 273; *The Heart Sutra*, 134—35, 366, 367, 372; *ingyeong*, 62, 64; *Lotus Sutra*, 27, 81, 164, 165, 270; *Mugujeonggwang daedarani gyeong*, 66—67

Suyang (prince): *Seokbosangjeol* (*Detailed and Abridged Compendium of Collected [Texts] on the Buddha's Life*), 270—71

Suzuki Kyozen, 135

T

Taehakeunbaesiseo, signboard of, 104, 105

Taejasa Nanggongdaesa Baekwolseountapbi (*Ink Rubbing of the Stele Commemorating the Great Master Nanggong at the Taeja Temple*), 117, 169, 170

Taejo (king), 71, 72, 75

Taizong (emperor), 28, 33, 75, 174, 267, 278, 317n11; *Jingongdaesa Stele Inscription* (with characters borrowed from the calligraphy of Tang Taizong), 63, 74; *Jiwang Shengjiao Xu*, 173

Tang dynasty, 16, 28, 33, 62, 63, 69, 148, 168, 169, 193, 271, 292, 293

Tang Wan, 132—33

Tanyeon, 79, 80, 81, 83, 120; *Jillakgong Epitaph*, 76, 77; *Munsuwonjungsugi Epitaph*, 76, 77; *Record of the Renovation of the Manjushri Hall*, 33, 172, 173—74

Tao Hongjing, 253

Tao Yuanming, 39; as Tao Qian, 214nn4—5

Tao Zongyi, 303

Tapié, Michel, 354

Tea Bowl Inscribed with a Poem in Hangeul, 245, 246

tea ceremony, 245, 297, 366

Three Branding Irons, 240

Three Kingdoms period, 16, 54, 55, 83, 138, 167, 188, 235, 273

tie, 173

tiepai style, 116, 118, 125, 126, 139

tiles: roof, 49, 154, 155, 301n5, 303, 319, 322—23; tomb, 25, 45, 147

tomb bricks, 25, 49, 56, 59, *153—54*, 155

tombstones, 55, 101, 183; of Seo Heonbo, *105*

Tongsinsa delegations, 275

Toyotomi Hideyoshi, 152, 245

tributes, 22, 62, 71, 151, 152; tributary provinces, 191

Tripitaka scriptures, 71, 72, 79, 80, 81; First Tripitaka Koreana, 26, 161—63

tsunamis, 209, 222, 225

Two-Panel Folding Screen of Characters for Longevity and Good Fortune, 251

U

Uija (king), 59

Uisang, 179

Uitong, 179

Ungjin period, 58

Unified Silla dynasty, 16, 27, 83, 163, 170, 311; and Tang dynasty, 83, 193; epitaph fragment, *192*, 193; ink sticks, *148*; inkstones, 148; *Jeonyuamsangaseo*, 70; steles, 116, 117, 120, 188, *314*; stone tablet, *171*

Unpa Chingyaen: *Ink Rubbing of the Memorial Stele of the Great Master Unpa*, 33, 175—76, 177

Upper Paleolithic period, 143

V

vases, 42, 211, 248; *Prunus Vase with Plum, Bamboo, and Willow Design and Inscription of Li He's Jangjinju (Ch. Jiang jin jiu) Poem*, *43*

Vimalakirti, 299, 306—7

W

Wang Dongling, 141; *The Heart Sutra*, 134—35

Wanggeon. *See* Taejo

Wang Huijiche Chogyeolbaegunga (*Wang Xizhi's Song on the Essentials of Cursive Script in One Hundred Rhymes*), 212, 213

Wang-in, 58

Wang Wei, 211

Wang Xianzhi, 259, 313

Wang Xizhi, 28, 33, 63, 68—69, 75, 76, 79, 83, 92, 116, 170, 173, 174, 177n3, 220, 226, 259, 278, 301, 314, 317; *tiepai* style, 116, 118, 125, 126

Wang Xizhi. works. *Classic of the Yellow Court*, 24; *Jiwang Shengjiao xu*, 173, 174, 317n11; *The Orchid Pavilion Preface*, 24—25, 33, 174, 278, 315, 316

Wanli reign, 213n3

Warring States period, 16, 226, 248, 251

Wei Kingdom, 16, 293; *Tomb Bricks with Inscriptions*, *153*

weiqi board game, 328

Weng Fanggang, 20, 48, 290, 297, 305, 315, 316—17

Weng Shukun, 315, 316

Weng Wenda, 303

Wen Zhengming, 175, 177n3

Western art, 115, 118, 120, 121, 138

Western Han dynasty, 16, 56, 125

Western imperialism, 121

Westernization, 114, 120, 138, 239

Western Zhou dynasty, 16, 323

whales, 21, 143, 145, 255

Wideok (king), 58, 59

wiseon, 86, 87, 94

women: *hangeul* adopted by, 108, 111, 266, 269; literacy among, 46, 269;

Won Chunghui, 220

Wonhyo, 63

Wonsamguk period, 16, 54, 55

Wonseong (king), 69, 71

Woodblock for Printing Episodes from the Life of the Shakyamuni Buddha, 178—79

woodblock printing, 20, 26, 163, 271, 280

Worinseokbo, 273

wrapping cloth (*bojagi*), 91

Wu Changshi, 323, 325n4

Wudi (emperor), 153, 253

Wumen Huikai, 344

Wuming Huijing, 295

Wu Zetian (empress), 68

X

Xihuang, 215

Xuanzang, 173, 317n11

Xu Jing, 210, 211

Y

Yaichi, 61
ya–il, 126
yangban class, 151, 209, 271; calligraphy, 41, 209—65. See also scholar-officials
Yan Zhenqing, 20, 76, 80, 81, 118, 125, 331, 349, 370
Yao Wei, 80
yebu officer, 79
Yeongeop, 69
Yeongjo (king), 88, 104, 108, 177, 199, 206, 240; ink rubbings from his tomb stele, 101, 102; Tablet with Model Calligraphy, 41, 86, 204, 205; Yeongmyo eopil (King Yeongjo's Writing), 86, 87, 94
Yeongyang (prince), 199
yeseo script, 116, 131, 132, 140. See also clerical script
yesul, 121
Yi Am: Seal Script Title for the Stele Inscription for the Sutra Storage Hall of the Munsusa, 33, 34; Stele Inscription for the Sutra Storage Hall of the Munsusa, 33, 34, 80
Yi Bingshou, 118
Yi Chadon, 55
Yi Choeji, 217
Yi Cheolgyeong, 122, 126, 127, 139
Yi Dokmu, 276
Yi Eom, 72
Yi Giu, 127, 139
Yi Gye, 195
Yi Haeung: Excerpts from Zhu Xi's Letter to Chen Shilang, 42, 43
Yi Ha-gon, 94, 99
Yi Hanbok: Painting of an Inkstone Owned by Gim Jeonghui, 302, 303
Yi Hwanchu, 72
Yi Hwang, 96, 99
Yi I, 99, 214, 249; Letters to Song Ikpil, 98
Yi Insang: Ballad on an Old Cypress, Written for Gyeyoon, 216—17, 218
Yi Jagyeom, 234
Yi Jehyeon, 79—80
Yi Jeongyeong, 226
Yi Kyubo, 161—62
Yi Mun-geon, 100
yin and yang, 35, 130, 140, 242, 247
Yi Saek, 80
Yi Sangsu, 95
Yi Seokhyeong, 195
Yi Uihyeon: Ink Rubbing of the Memorial Stele of the Great Master Unpa, 33, 175—76, 177
Yi Wonbu, 79
Yi Yong, 120. See also Anpyeong (prince)

Yo Geukil, 193
Yongzheng (emperor), 175
Yoon Kwang-Cho, 50, 366; The Heart Sutra, 366, 367
Yuan dynasty, 16, 71, 79, 81, 83
Yuan Mingshan, 80
Yu Changhwan, 125, 127
Yu Giljun, 125
Yu Huigang, 122, 125, 126, 127, 139
Yuinwon, 63
Yu Jiseong, 234n1
yukjo style, 127, 191
Yun Baekyeong, 126, 127
Yun Changmo, 256
Yun Chiho, 338
Yun Haengim, 95
Yun Jeonghyeon, 95, 99, 292
Yun Seondo, 259
Yun Seoyu, 256
Yun Sun, 120
Yun Yonggu, 125
Yu Shinan, 63, 72; script, 72, 79, 80, 81
Yu Yeol and Jeong Inseung: Cards with Diagrams of Hangeul Mouth Movements, 50, 332—34, 335

Z

zenei shodou calligraphy, 118
Zeng Hou Yi, 323
Zhang Zhi, 313
Zhao Gu, 255
Zhao Mengfu, 33, 39, 80, 83, 195, 197, 202, 203, 205, 212, 226, 299; Four Anecdotes from the Life of Wang Xizhi, 34—35
Zhao Zhiqian, 118
Zheng Sixiao, 299
Zheng Xie, 261
Zhou dynasty, 16, 217, 251, 319n2, 323
Zhou Xingsi, 220
zhuan–li style, 125
Zhuge Liang, 216
Zhu Shenglin, 278
Zhu Xi, 96, 248; Excerpts from Zhu Xi's Letter to Chen Shilang, 42, 43

SPONSOR STATEMENT

Amid daily tsunamis of information, we author our paths to the future by connecting the dots of intelligence, opportunity, intuition, wisdom, emotion, and passion, which are innate to humanity.

Calligraphy reveals more than semantic information. From a simple starting point, the identity of each work springs from the actions of its writer—channeled through composition, the invocation of empty space, the proportions of lines and dots, the spectrum of colors present in shades of black ink, the flow of the brush, and the rhythm of its movements. An art born of creative choices, but also of intuition, calligraphy communicates to us on an invisible yet fundamental level—within, between, and beyond the lines. The economy and dynamism of calligraphic forms are a rich source of inspiration for many creative minds.

Hyundai Motor is delighted to support *Beyond Line,* the first exhibition of its kind in the United States. The curatorial foundation for the show is the humanity of the people who created it—kings, queens, scholar-officials, diplomats, painters, Buddhist monks, and slaves. Among the highlights of the exhibition is a section focusing on Gim Jeonghui, one of the most celebrated masters of Korean calligraphy.

Beyond Line has been organized as part of The Hyundai Project at LACMA, a ten-year partnership that is invested on the one hand in promoting and strengthening the relationship between art and technology, and on the other in drawing attention to Korean art history in a way that has never been done before. *Beyond Line* is the first of three major exhibitions supported by this project at LACMA. The Korean Art Scholarship Initiative creates a new platform and model for researching key aspects of Korean art that have never been addressed on this scale in either exhibitions or publications outside of Korea.

I would like to thank Michael Govan, Stephen Little, Virginia Moon, and all the staff at LACMA for their hard work on this wonderful project.

Euisun Chung
Executive Vice Chairman, Hyundai Motor Group

CONTRIBUTORS TO THE CATALOGUE

Insoo Cho studied Korean and Chinese art history at Seoul National University and the University of Kansas, where he received a PhD in 2002. He had held curatorial positions at the Ho–Am Art Museum in Young–in, South Korea, where he was Chief Curator from 1999 until 2001. Before he joined the Department of Art Theory at Korea National University of Arts in 2005, he had been Assistant Professor in the Department of Art History at the University of Southern California. He has edited books and published articles on Korean and Chinese arts, focusing on portrait paintings. Professor Cho is currently engaged in research on Daoist immortal images in the Joseon dynasty.

Christina Gina Lee is a Korea Foundation Museum Intern in the Chinese and Korean Art Department at the Los Angeles County Museum of Art.

Lee Dongkook is Director and Chief Curator at the Seoul Calligraphy Art Museum at the Seoul Arts Center.

Stephen Little is the Florence & Harry Sloan Curator of Chinese Art and Department Head of the Chinese, Korean, and South and Southeast Asian Art Departments at the Los Angeles County Museum of Art. An authority on Asian art, he received his PhD from Yale University in 1987. He has held curatorial positions at the Asian Art Museum of San Francisco, the Cleveland Museum of Art, and the Art Institute of Chicago, and was Director of the Honolulu Academy of Arts from 2003 to 2010 before joining LACMA's staff in 2011. His publications include *Taoism and the Arts of China* (2000), *New Songs on Ancient Tunes: 19th—20th Century Chinese Painting and Calligraphy from the Richard Fabian Collection* (2007), *View of the Pinnacle: Japanese Lacquer Writing Boxes—The Lewis Collection of Suzuribako* (2012), *Chinese Paintings from Japanese Collections* (2014), and *17th–Century Chinese Paintings from the Tsao Family Collection* (2016).

Natalie Mik is a writer, translator, and performance artist based in Berlin and Los Angeles. She holds a BA from the University of Bonn and an MA from Seoul National University and is currently pursuing a PhD in art at the Berlin University of the Arts. She was an intern in the Chinese and Korean Art Department at the Los Angeles County Museum of Art from December 2016 to September 2018.

Audrey Min holds a BA in history and art history from the University of California, Los Angeles. She is a graduate of the Ryman Arts and California State Summer School for the Arts programs and was an Andrew W. Mellon Undergraduate Curatorial Fellow in the Korean Art Department at the Los Angeles County Museum of Art from 2015 to 2017.

Virginia Moon is the Assistant Curator of Korean Art at the Los Angeles County Museum of Art. She holds a BA in art history from Yale University, an MA in East Asian studies from Harvard University, and a PhD in art history from the University of Southern California. Her PhD dissertation, written under the direction of Professor Insoo Cho, was a study of the system of designating Korean National Treasures, titled "The Grafting of a Canon: The Politics of Korea's National Treasures and the Formation of an Art History." Prior to joining LACMA's staff, she was a Visiting Assistant Professor at the University of California, Riverside.

Joon Hye Park is a PhD candidate in the Art History Department at the University of California, Los Angeles, and was a Mellon Summer Graduate Fellow in the Chinese and Korean Art Department at the Los Angeles County Museum of Art in the summer of 2017.

Eunsoo Yi was a Korea Foundation Museum Intern in the Chinese and Korean Art Department at the Los Angeles County Museum of Art in 2017.

Yi Wanwoo holds a PhD in literature from the Academy of Korean Studies, where he is now a Professor in the Art History Department.

PHOTOGRAPH CREDITS

Front cover, 357, 359: © Kim Choong Hyun, Photo © Museum Associates / LACMA; back cover, 368: © Kyungwoo Chun, Photo courtesy of the artist; front and back endpapers, 361, 362—63: © Jongweon Kim, Photo courtesy of the artist; 1 (left), 19, 137: Photo (detail) courtesy Woljeon Museum of Art, Icheon; 2 (right), 4 (left), 8: Photo (detail) courtesy Lee Dongkook; 2 (left), 15, 85: Photo (detail) © National Palace Museum of Korea; 2 (right): Photo (detail) © Seokdang Museum of Dong–A University; 3, 47, 119 (left), 265: Photo (detail) © Kansong Art and Culture Foundation; 4 (right), 364: © Ahn Sang–soo, Photo courtesy of the artist; 10, 38, 44, 106 (bottom), 162—63, 184: Photo (detail) © National Museum of Korea; 12: Photo (detail) © Jangseogak Archives; 17, 51: Map © Museum Associates / LACMA; 23 (left): Photo courtesy National Library of China; 23 (right), 24 (top), 34—35, 40: Photo courtesy The Metropolitan Museum of Art Open Access; 24 (middle), 24 (bottom): Photo © The Collection of National Palace Museum, Taipei, Taiwan; 25: Photo Credit: Heritage Image Partnership Ltd. / Alamy Stock Photo; 29: Photo courtesy Smithsonian, Freer Gallery of Art; 31 (top): Photo courtesy Seoul Calligraphy Museum; 34 (top left), 34 (bottom left): Photo courtesy National Library of Korea; 37, 53, 57 (top), 74 (right), 77 (top), 106 (top), 117 (left), 117 (right), 151, 153, 154, 158—59, 161, 168, 169, 186, 187, 188, 189 (top, bottom), 190, 210, 223, 226, 232, 233, 237, 240, 241 (top), 241 (bottom), 242, 243 (bottom), 244, 245, 247 (top), 247 (bottom), 258, 260, 262, 280, 281, 282, 298, 308, 309, 312, 314, 315, 316: Photo © National Museum of Korea; 43 (top), 243 (top), 252—53:

Photo © Leeum, Samsung Museum of Art, Seoul; 43 (bottom), 88—89, 90 (top), 90 (bottom), 97, 204 (top), 204 (bottom), 206 (top), 206 (bottom), 212, 249, 251: Photo © National Palace Museum of Korea; 54, 57, 66 (top), 70, 73, 74 (top, left), 74 (bottom, left), 78 (top), 78 (bottom): Photo courtesy Yi Wanwoo; 60 (left): Photo courtesy Buyeo National Research Institute of Cultural Heritage; 60 (right): Photo courtesy National Library of Korea, by Joonho Lee; 66—67, 148 (top), 178—79: Photo courtesy Central Buddhist Museum; 77 (bottom), 87, 102 (top), 109 (bottom), 110, 276, 277, 278, 279, 284, 285, 286—87, 288 (top), 288 (bottom), 289: Photo © Jangseogak Archives; 82: Photo courtesy Kyoto National Museum; 93: Photo courtesy Busan Museum; 95: Photo courtesy Sungkyungg wan Publishing; 98: Photo courtesy Hoam Museum; 102 (bottom left), 102 (bottom right) 105 (bottom): Photo © Cho Insoo; 105 (top), 175, 235, 328—29, 357: Photo © Museum Associates/ LACMA; 109 (top), 238, 272, 332, 333, 336, 337, 339, 341: Photo © National Hangeul Museum; 113: © 2018 Artists Rights Society (ARS), New York / ADAGP, Paris. Photo (detail) © Lee Ungno Museum; 119 (right), 306—7, 311, 385: Photo © Joonho Lee; 133: © Jongweon Kim, Photo by Juno Lee; 134—35: © Wang Dongling, Photo by Maurice Aeschimann; 144—45, 182, 183: Photo courtesy Woljeon Museum of Art, Icheon; 148 (middle), 148 (bottom), 149 (top), 149 (middle), 149 (bottom), 150, 228: Photo © National Folk Museum of Korea; 167: Photo courtesy Buyeo National Museum; 171: Photo courtesy of the Gyeongju National Museum; 172, 216—17, 222, 230—31, 294, 296—97, 302, 330—31: Photo courtesy Lee

Dongkook; 185: Photo courtesy Gyeongju National Research Institute of Cultural Heritage; 192, 194—95, 196, 197, 214, 224: Photo © Seokdang Museum of Dong–A University, Busan; 198, 264, 268, 292—93: Photo © Kansong Art and Culture Foundation; 199, 200—201, 202, 203: Photo © National Palace Museum of Korea, by Seo Heun Kang; 219: Photo courtesy Seoul Museum of History; 221: Photo (detail) courtesy Seoul Museum of History; 236: Photo (detail) © Museum Associates / LACMA; 254: Photo (detail) © Leeum, Samsung Museum of Art; 256, 326, 327: Photo courtesy Korea University Museum; 270—71: Photo © Dongguk University Central Library; 322—23: © O Sechang, Photo © National Museum of Korea; 324—25: © O Sechang, Photo © Seokdang Museum of Dong–A University, Busan; 331 (bottom): Photo © Chronicle of World History / Alamy Stock Photo; 343: Photo by URL Studio; 344: Photo courtesy National Library of New Zealand; 345: Photo (detail) by URL Studio; 348—49: © Syngman Rhee Estate, Photo © Seokdang Museum of Dong–A University, Busan; 350, 351: © Sun Wuk Kim, photo © Museum Associates / LACMA, by Paul Salveson; 353: © 2018 Artists Rights Society (ARS), New York / ADAGP, Paris. Photo © Lee Ungno Museum; 355: © Suh Se Ok, Photo © National Museum of Modern and Contemporary Art, Korea; 360: © Jongweon Kim, Photo by Juno Lee; 366: © Yoon Kwang Cho, Photo courtesy Gana Art Gallery; 370—71: © Jung Do–jun, Photo courtesy of the artist; 372—73: © Lee Kang–So, Photo courtesy of the artist; 374: © Park Dae Sung, Photo courtesy of the artist; 385: Photo (detail) by Joonho Lee

Published in conjunction with the exhibition *Beyond Line: The Art of Korean Writing* at the Los Angeles County Museum of Art, Los Angeles, California (June 16 through September 29, 2019).

This exhibition was organized by the Los Angeles County Museum of Art.

Presented by:

This exhibition is part of The Hyundai Project: Korean Art Scholarship Initiative at LACMA, a global exploration of traditional and contemporary Korean art through research, publications, and exhibitions.

The exhibition has been made possible in part by a major grant from the National Endowment for the Humanities: Exploring the human endeavor. This project is supported in part by an award from the National Endowment for the Arts. Additional support is provided by the Henry Luce Foundation.

The publication was supported by The Andrew W. Mellon Foundation.

Any views, findings, conclusions, or recommendations expressed in this exhibition do not necessarily represent those of the National Endowment for the Humanities.

Copublished in 2019 by

Los Angeles County Museum of Art
5905 Wilshire Boulevard
Los Angeles, California 90036
(323) 857-6000
www.lacma.org

and

DelMonico Books, an imprint of Prestel, a member of Verlagsgruppe Random House GmbH

Prestel Verlag
Neumarkter Strasse 28, 81673
Munich, Germany

Prestel Publishing Ltd.
14—17 Wells Street
London W1T 3PD, United Kingdom

Prestel Publishing
900 Broadway, Suite 603
New York, NY 10003

FOR LACMA

PUBLISHER Lisa Gabrielle Mark
EDITORS Claire Crighton and Ann Lucke
RIGHTS AND REPRODUCTIONS Piper Severance
DESIGNERS Lorraine Wild and Xiaoqing Wang for Green Dragon Office
TRANSLATORS Chi-Young Kim (essays by Insoo Cho and Lee Dongkook) and Natalie Mik (essay by Yi Wanwoo)
PROOFREADER Jean Patterson
INDEXER Kathleen Preciado
COLOR SEPARATIONS Echelon Color, Santa Monica

FOR DELMONICO BOOKS · PRESTEL

PRODUCTION DIRECTOR Karen Farquhar

This book is typeset in GT Haptik and Noto Sans.

Library of Congress Cataloging-in-Publication Data

Names: Little, Stephen, 1954– editor. | Moon, Virginia, editor. | Los Angeles County Museum of Art, organizer, host institution.
Title: Beyond line : the art of Korean writing / edited by Stephen Little, Virginia Moon ; essays by Insoo Cho, Lee Dongkook, Stephen Little, Yi Wanwoo ; additional contributions by Christina Gina Lee, Stephen Little, Natalie Mik, Audrey Min, Virginia Moon, Joon Hye Park, Eunsoo Yi.
Description: Los Angeles : Los Angeles County Museum of Art ; Munich ; New York : DelMonico Books"Prestel, 2019. | Includes bibliographical references and index.
Identifiers: LCCN 2018057832 | ISBN 9783791358147 (hardback)
Subjects: LCSH: Calligraphy, Korean–– Exhibitions. | BISAC: ART / Asian. | ART / Techniques / Calligraphy. | ART / Collections, Catalogs, Exhibitions / Group Shows.
Classification: LCC NK3638.A15 L673 2019 | DDC 745.6/1995707479493–– dc23
LC record available at https://lccn.loc.gov/2018057832

A CIP catalogue record for this book is available from the British Library.

Copyright © 2019 Los Angeles County Museum of Art and Prestel Verlag. Munich · London · New York

ISBN 978-3-7913-5814-7

Printed and bound in China

FRONT COVER
Kim Choong Hyun, *Poem on the Diamond Mountains, in* Hangeul *Script,* 1990 (cat. 112, detail)

BACK COVER
Kyungwoo Chun, *Light Calligraphy #2,* 2004 (cat. 117, detail)

FRONT AND BACK ENDPAPERS
Kim Jongweon, *Munmunjaja guemganggyeong geu seojeok byeonsang,* 2014 (cat. 114, detail)

PAGE 1 (LEFT)
Ink rubbing (1971 or after) of *Bangudae Petroglyphs,* 5500—4700 BCE (cat. 1, detail)

PAGE 1 (RIGHT)
National Preceptor Daegam Tanyeon, ink rubbing of *Record of the Renovation of the Manjushri Hall,* 1130 (cat. 19, detail)

PAGE 2 (LEFT)
King Sukjong, *Tablet with Model Calligraphy,* 1674—1720 (cat. 32, detail)

PAGE 2 (RIGHT)
Sin Saimdang, *Ink Traces,* 16th c. (cat. 37, detail)

PAGE 3 (LEFT)
Hunminjeongeum, 1446 (cat. 69, detail)

PAGE 3 (RIGHT)
Gim Jeonghui, *Calligraphic Frontispiece: Chimgye,* ca. 1851—52 (cat. 80, detail)

PAGE 4 (LEFT)
An Junggeun, *Nothing Is More Painful than Overconfidence,* 1910 (cat. 100, detail)

PAGE 4 (RIGHT)
Ahn Sang-soo, *Bomb Fish on the Seashore,* 1991 (cat. 115, detail)

PAGE 8
Gim Jeonghui, *Mount Gonryun Rides on an Elephant,* 19th c. (cat. 81, detail)

PAGE 10
Illustrated Manuscript of the Avatamsaka Sutra, Chapter 47, 14th c. (cat. 14, detail)

PAGE 12
Sanggye Documents Written by Slaves, mid- to late 18th c. (cat. 79, detail)

PAGE 15
Two-Panel Folding Screen of Characters for Longevity and Good Fortune, 18th—19th c. (cat. 62, detail)

PAGE 385
Gim Jeonghui, *Sosik's Poem on Seokgak's Painting of Yu Ma,* 19th c. (cat. 87, detail)

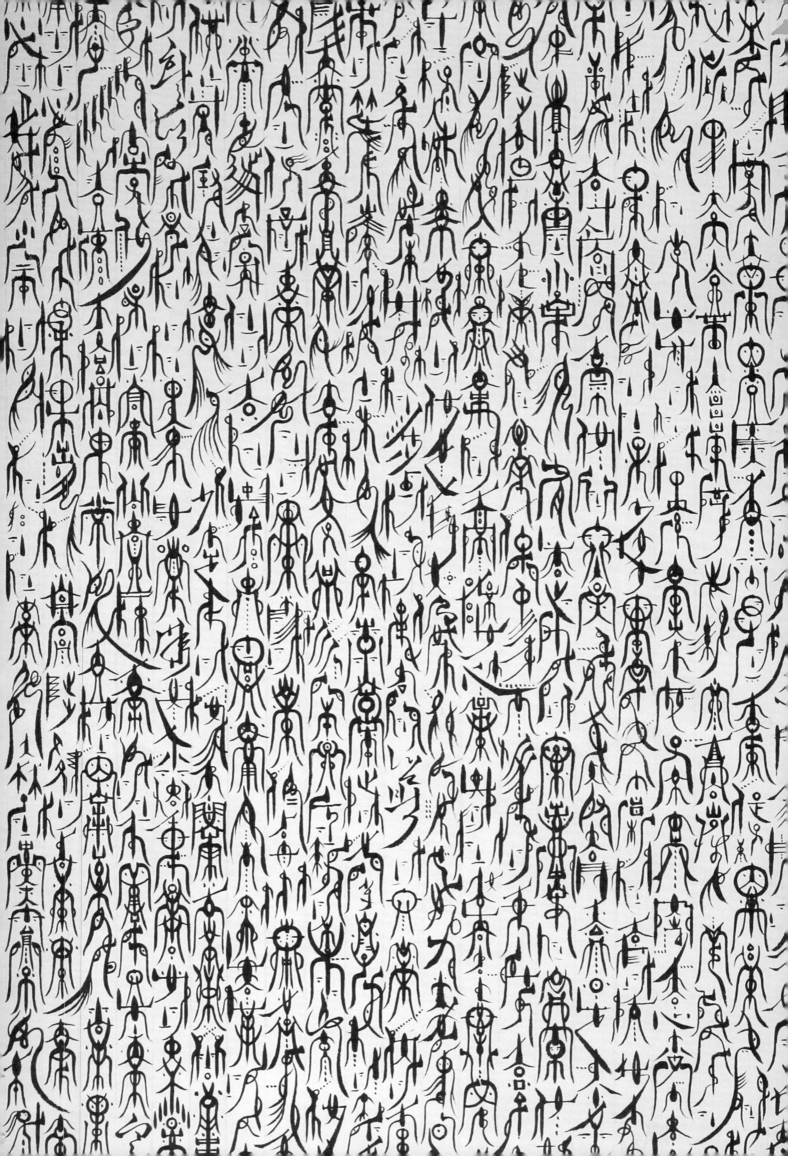